World Cultures and Modern Art

The encounter of
19th and 20th century
European art and music
with Asia, Africa, Oceania,
Afro- and Indo-America

Exhibition on the occasion
of the Games of the
XXth Olympiad Munich 1972

Development and direction:
Prof. Dr. Siegfried Wichmann

June 16 to September 30
Haus der Kunst
from 9 a.m. to 6 p.m.
Tuesday and Thursday
from 9 a.m. to 10 p.m.

Bruckmann Publishers
Munich

The Exhibition stands under the Patronage
of the International Council of Museums (ICOM)

The English Catalogue is a shortened version
of the German Exhibition Catalogue
but contains several additional contributions

Honorary Patron of the Exhibition

The President of the Federal Republic of Germany
as Patron of the Games of the XXth Olympiad
Munich 1972

D. Dr. Dr. Gustav W. Heinemann

The President of the Organization Committee
for the Games of the XXth Olympiad Munich 1972

Willi Daume

We are indebted to the following
for their co-operation and support:

The Bayerische Rundfunk (Bavarian Broad-casting Service) participated in the organization of the exhibition with film and sound recordings. The exhibition will be the subject of further German and foreign television films.

Director: Christian Wallenreiter
Television director: Dr. Helmut Oeller
Radio program director: Walter von Cube

Ferdinand Anton	München	Wilhelm Hein	Wien	Carl Orff	München
William Kay Archer	Teheran	Ernst Heins	Amsterdam	Luis de Pablo	Madrid
Simha Arom	Paris	Rose Hempel	Hamburg	Jean Louis Paudrat	Paris
Elizabeth M. Aslin	London	Jakob Wilhelm Hinder	Deidesheim	Wolfgang Pehnt	Rodenkirchen
John Ayers	London	Werner Hofmann	Hamburg	Guido Perocco	Venedig
Walter Bareiss	New York	Bohumil Holas	Abidjan	Joseph Philippe	Liège
François Bayle	Paris	S. C. Holliday	London	Roger Pinkham	London
Hans Becher	Hannover	Erich Hubala	Kiel	M. Pirazzoli	Paris
Klaus Berger	Paris	Richard Jackson	New York	Urs Ramseyer	Basel
Alfred Berner	Berlin	Hans Jaffé	Amsterdam	Guy Reibel	Paris
Oto Bihalji-Merin	Belgrad	Alfred Janata	Wien	Leopold Reidemeister	Berlin
Erika Billeter	Zürich	Boris M. Jarustowskij	Moskau	Lotte Reimers	Deidesheim
Werner Blaser	Basel	André Jolivet	Paris	Hans Peter Reinecke	Berlin
Fritz Bose	Berlin	Manfred Junius	Venedig	Kurt Reinhard	Berlin
Walther Braune	Berlin	Mauricio Kagel	Köln	Williard Rhodes	Honolulu
Bernard Broere	Amsterdam	Daniel-Henry Kahnweiler	Paris	Joseph A. Riedl	München
Surja Brata	Djakarta	Wend Graf Kalnein	Düsseldorf	Warren M. Robbins	Washington
Yvonne Brunhammer	Paris	Jacques Kerchache	Paris	Carlos Roqué Alsina	Berlin
John Cage	New York	Shigeo Khishibe	Tokyo	Axel von Saldern	Hamburg
Florence und		van Krimpel	Amsterdam	Ursula und Karl Scheid	Deidesheim
Jean-Pierre Camard	Versailles	Josef Kuckertz	Köln	Werner Schmalenbach	Düsseldorf
R. J. Charleston	London	Friedrich Kußmaul	Stuttgart	Steffi Schmidt	Berlin
Carlos Chávez	Mexico	Brita Kjellberg	Stockholm	Dieter Schnebel	München
Dieter Christensen	Berlin	Clay Lancaster	New York	Gunther Schuller	Boston
Adrian Claerhout	Antwerpen	Wolfgang Laade	Heidelberg	Thomas Schultze-	
Gottfried Cremer	Junkersdorf	Jean Laude	Paris	Westrum	München
Karl Dachs	München	François Lesure	Paris	Eberhard Semrau	München
Carl Dahlhaus	Berlin	K. W. Lim	Amsterdam	Yujiro Shinoda	Tokyo
Alain Daniélou	Berlin	Zofia Lissa	Warschau	Makoto Shinohara	Berlin
Bengt Danielsson	Stockholm	Andreas Lommel	München	Carmen Sordo Sodi	Mexico
Frederic Dockstader	New York	René de Mayer	Brüssel	Jean Soustiel	Paris
Helmuth Dotterweich	München	José Maceda	Philippines	Erich Steingräber	München
Jutta Dronke	München	David McAllester	Wesley	Rudolf Stephan	Berlin
Stuart Durand	Richmond	Ulf Martens	Berlin	Ernst Strauss	Starnberg
Vadime Elisseeff	Paris	Kurt Martin	München	Bodiel Thiam	Dakar
Roland Fischer	Washington	Narayana Menon	Bombay	Hans Thiemann	Hamburg
Herbert Fux	Wien	Yehudi Menuhin	London	Alit Veldhuisen-	
Jean Gabus	Neuchâtel	Peter Wilhelm Meister	Frankfurt	Djajasoebrata	Rotterdam
Rudolf Gelpke	Teheran	Olivier Messiaen	Paris	Tran Vân Khe	Paris
Edith Gerson-Kiwi	Jerusalem	E. R. Meyer	Amsterdam	Arminda Villa Lobos	Rio de Janeiro
Roger Göpper	Köln	Darius Milhaud	Paris	Klaus Wachsmann	Evanston
Robert Goldwater	New York	John Morley	Brighton	Hugh Wakefield	London
Peter Gradenwitz	Tel Aviv	Barbara Morris	London	René S. Wassing	Rotterdam
Bredo Grandjean	Kopenhagen	Wilhelm Mrazek	Wien	Hans Wichmann	München
Robert Günther	Köln	Alex Nathan	London	Justin Winston	New Orleans
Bo Gyllensvärd	Stockholm	Joseph H. K. Nketia	Legon	Franz Winzinger	Regensburg
Wolfgang Haberland	Hamburg	Yoshi Nomura	Tokyo	Chisaburoh F. Yamada	Tokyo
Hans-Ulrich Haedecke	Solingen	Vesna Novak-Oszrić	Zagreb	Isang Yun	Berlin
Lucie Hampel	Wien	Jorge Novati	Buenos Aires	Johanna Zick	Berlin
Kurt Haselhorst	München	Hans Oesch	Basel	Jürgen Zwernemann	Hamburg

Forewords

Europe has given the Olympic games to the world, the idea of peaceful athletic competition. Throughout long periods of history, however, there were other encounters which took place under the banner of peace. I am speaking of the broad encounter between the fine arts and the ways of life of different peoples. Whole cultures have arisen in the spirit of give and take. On this occasion of the XXth Olympic Games, we in Munich wish to illustrate how the old continent of Europe has received a rich flow of impulses from other parts of the world.

In its conception, the exhibition World Cultures and Modern Art consciously proceeds from the nineteenth century. It was precisely then that many artists and scholars began to recognize the people of foreign nations as partners and to discover the importance of this partnership. Those of us who are prepared to see and to perceive, will become aware of the extent to which every people can recognize itself in the works of art of other peoples, how close to each other the people of the earth actually are in their greatest artistic creations.

I believe that such an exhibition conforms specially well with the spirit of the Olympic Games, and I am certain that its effect will last long after its doors have closed.

Willi Daume
President of the Organization Committee for the Games of the XXth Olympiad Munich 1972

The encounter of extra-European cultures with European art has become a central problem of aesthetics. If the correlation between partial aspects of the Far-Eastern, African, Oceanian, Afro- and Indo-American receptions and European art has already been established, the inclusion of the Near East is a new aspect, particularly in the fields of architecture, painting, sculpture and handicrafts.

The recurrent encounter of European and American art with the Far East and South-East Asia—beginning in the nineteenth century and extending into the present—is demonstrated systematically in this exhibition for the first time; a model of this type has not previously been attempted. The range of the exhibition extends from thematic influences to direct appropriations, and the diversity of the individual points of encounter are organized by the principle of focusing upon the prominent exhibit and the arrangement in typical groups. Clear demarcations bring out the contours of the partial aspects and point to early processes of abstraction. The arrangement of exhibits in groups opens up perspectives which could well merit future investigation.

The research work of Robert Goldwater, New York, Jean Laude, Paris, Oto Bihalji- Merin, Belgrade, and Leopold Reidemeister, Berlin has provided an important background for the treatment of the sections Africa, Oceania and Indo-Africa. The elementary forms of pillar and block are familiar concepts which gain new significance in the exhibition. Archetypes and magic signs from the field of "Primitive Art" show the modern movement the way to elementary form. It is the object of this section to illustrate this.

New aspects are revealed by the inclusion of music within the thematically developed presentation of the fine arts. The continuation of tendencies in European music of the nineteenth and twentieth centuries culminates in the approximation of compositional and interpretational processes to extra-European traditions. An attempt to convey this synthesis of global music cultures is made in the so-called "Sound Centre."

The question of what function the museum is to fulfil today may be considered in the context of the diverse works of art contained in this exhibition. It is the main object of the exhibition to also illustrate these correlations in direct connection with the programs and activities of the Sound and Youth Centres. I should like to thank all who have assisted in this task. We are also indebted to the Japanese Foreign Ministry, the Bunka-cho, and the conservators of the Idemitsu Museum, Tokyo, for their friendly co-operation.

Professor Dr. Siegfried Wichmann
Director of the Exhibition

Development and direction of the exhibition	Prof. Dr. Siegfried Wichmann
Planning of exhibition buildings, design, and construction management	Prof. Paolo Nestler, Dipl.-Ing., Architect Project management: Architect Erich Wimmer

Art development

Section "Orient"	Prof. Dr. Siegfried Wichmann Dr. Horst Ludwig
Section "Far East and South-East Asia"	Prof. Dr. Siegfried Wichmann Dr. Monika Goedl-Roth Dr. Friedrich-Wilhelm von Hase Dr. Manfred Schneckenburger Dr. Angela Schneider Dr. Mariela D. Siepmann
Section "Africa, Oceania, Indo-America"	Dr. Manfred Schneckenburger
Section "Music Program" and "Sound Centre"	Dr. Ramón Pelinski Dr. Claus Raab
Youth and Children's Centre	Prof. Dr. Siegfried Wichmann Karin Beyler, Dipl.-Geograph Josef Walch, Assistant teacher Manfred Weihe, Assistant master Music Teaching Program: Tropenmuseum Amsterdam Educational Service Director: Dr. G. Berlijn Orff-Institut Salzburg Director: Prof. Dr. Hermann Regner Cologne Courses in New Music Director: Mauricio Kagel
Foreign Languages	Arlette Boettger, French Angela Fritsche, English Christine Langwieder, French, Italian Ludmilla Saks, Russian, English Gudrun Schiller, English
Translations and Summaries of the English Catalogue	Paul J. Dine Graham Fulton-Smith
Planning and organization, electronics, electrical engineering, film and dia-projection, sound	Project Engineer Rainer Goedl
Teahouse Urasenke	Head of the family Urasenke XV. Soshitsu Sen Management and planning of construction: Rainer Goedl
Catalogue: Editorial work Production	Dr. Monika Goedl-Roth Johannes Determann

The Management of the exhibition expresses its thanks to the museums, galleries and private collections for kindly loaning exhibition objects

Museums

Albi, Musée Toulouse-Lautrec
Amsterdam, Rijksmuseum
Amsterdam, Rijksmuseum Vincent van Gogh
Amsterdam, Stedelijk Museum
Amsterdam, Tropeninstitut
Antwerpen, Etnografisches Museum
Baden-Baden, Staatliche Kunsthalle
Barcelona, Stadt Barcelona,
 Geschenk Joan Miró
Barletta, Museo Pinacoteca di Barletta
Basel, Kunstmuseum Basel
Basel, Museum für Völkerkunde und
 Schweizerisches Museum für Volkskunde
Berlin, Brücke-Museum
Berlin, Staatliche Museen Preußischer
 Kulturbesitz; Museum für Völkerkunde,
 Musikethnologische Abteilung
Berlin, Nationalgalerie
Berlin, Staatliches Institut für Musikforschung,
 Musikinstrumentenmuseum
Berlin, Staatliche Museen Preußischer
 Kulturbesitz, Kunstgewerbemuseum
Berlin, Staatliche Museen Preußischer
 Kulturbesitz, Kunstbibliothek
Berlin, Staatliche Museen Preußischer
 Kulturbesitz, Kupferstichkabinett
Berlin, Staatliche Museen Preußischer
 Kulturbesitz, Museum für Islamische Kunst
Berlin, Staatliche Museen Preußischer
 Kulturbesitz, Museum für Ostasiatische
 Kunst
Berlin, Staatliche Museen Preußischer
 Kulturbesitz, Museum für Völkerkunde
Berlin, Universitätsbibliothek der Technischen
 Universität Berlin
Berlin, Verwaltung der Staatlichen Schlösser
 und Gärten
Bern, Berner Kunstmuseum
Biot, Musée National Fernand Léger
Birmingham, City Museum & Art Gallery
Bochum, Städtische Kunstgalerie
Bombay, National Centre for the
 Performing Arts
Bordeaux, Musée & Galerie des Beaux-Arts
Boston, Museum of Fine Arts
Bremen, Kunsthalle Bremen
Bremen, Übersee-Museum
Brest, Musée Municipal de Brest
Brighton, Art Gallery, Museum and
 the Royal Pavilion
Brüssel, Musées Royaux des Beaux-Arts
Brüssel, Musées Royaux d'Art et d'Histoire
Buenos Aires, Fondo Nacional de les Artes
Chicago, The Art Institute of Chicago
Cleveland, The Cleveland Museum of Art
Córdoba, Instituto Nacional de
 Antropologia e Historia
Dachau, Kunstsammlungen der Stadt Dachau
Dakar, Institut Fondamental d'Afrique Noire
Darmstadt, Hessisches Landesmuseum
Delft, Indonesisch Ethnografisch Museum
 Delft

Den Haag, Haags Gemeentemuseum
Douai, Musée de la Chartreuse, Ville de Douai
Duisburg, Wilhelm-Lehmbruck-Museum
 der Stadt Duisburg
Düsseldorf, Hetjens-Museum
Düsseldorf, Kunstsammlung Nordrhein-
 Westfalen
Düsseldorf, Kunstmuseum der Stadt
 Düsseldorf
Essen, Museum Folkwang
Frankfurt, Freies Deutsches Hochstift,
 Frankfurter Goethemuseum
Frankfurt/M., Historisches Museum
Frankfurt/M., Museum für Kunsthandwerk
Glasgow, Art Gallery and Museum
Glasgow, University Art Collections,
 University of Glasgow
Hamburg, Hamburger Kunsthalle
Hamburg, Museum für Kunst und Gewerbe
Hamburg, Museum für Völkerkunde
Hannover, Niedersächsisches Landes-
 museum Hannover
Karlsruhe, Badisches Landesmuseum
Karlsruhe, Staatliche Kunsthalle
Köln, Museum für Ostasiatische Kunst
Köln, Rautenstrauch-Joest-Museum
Köln, Wallraf-Richartz-Museum
Kopenhagen, Das dänische Museum für
 Kunst und Gewerbe
Kopenhagen, Königliche Porzellan-
 manufaktur
Krefeld, Kaiser-Wilhelm-Museum
Liège, Musée des Beaux-Arts
Liège, Musée du Verre de la Ville de Liège
Lima, Casa della Cultura
Linz, Oberösterreichisches Landesmuseum,
 Graphische Sammlungen
London, Bethnal Green Museum
London, Leighton House Museum & Art
 Gallery
London, National Portrait Gallery
London, Victoria & Albert Museum
Mainz, Mittelrheinisches Landesmuseum
 Mainz
Mannheim, Reiss-Museum
Mannheim, Städtische Kunsthalle Mannheim
Mexico, Instituto Nacional de Bellas Artes
München, Bayerische Staatsbibliothek
München, Bayerische Staatsgemälde-
 sammlungen
München, Bayerisches Nationalmuseum
München, Deutsches Museum
München, Stadtmuseum
München, Staatliche Sammlung Ägyptischer
 Kunst
München, Staatliche Verwaltung der
 Bayerischen Schlösser, Gärten und Seen
München, Staatliches Museum für Völker-
 kunde
München, Städtische Musikinstrumenten-
 sammlung
München, Städtische Galerie im Lenbachhaus
München, Theatermuseum
München, Zentralinstitut für Kunstgeschichte
Neuchâtel, Musée d'Ethnographie
New York, Metropolitan Museum of Art
New York, Museum of Modern Art
New York, Whitney Museum of
 American Art
Nürnberg, Germanisches Nationalmuseum
Nürnberg, Gewerbemuseum
Offenbach, Deutsches Ledermuseum

Paris, Bibliothèque Nationale,
 Cabinet des Estampes
Paris, Fondation Le Corbusier
Paris, Jeu de Paume
Paris, Musée Bourdelle
Paris, Musée Cernuschi
Paris, Musée Guimet
Paris, Musée de l'Homme
Paris, Musée des Arts Africains et Océaniens
Paris, Musée des Arts Décoratifs
Paris, Musée Marmottan
Paris, Musée National d'Art Moderne
Paris, Musée National du Louvre
Paris, Musée Gustave Moreau
Pforzheim, Schmuckmuseum
Philadelphia, Philadelphia Museum of Art
Princetone, Princetone University Library
Rotterdam, Museum voor Land en Volken-
 kunde
Saarbrücken, Saarland-Museum
Saint-Etienne-Le-Molard, Musée Municipal
 d'Art et d'Industrie
San Antonio, Marion Koogler McNay
 Art Institute
Seattle, Seattle Art Museum
Seebüll, Stiftung Nolde
Seoul, National Museum of Korea
Solingen-Gräfrath, Deutsches Klingen-
 museum Solingen
Solothurn, Museum der Stadt Solothurn,
 Kunstabteilung
Stockholm, Nationalmuseum Stockholm
Stockholm, Östasiatiska Museet
Stuttgart, Linden-Museum, Gesellschaft für
 Erd- und Völkerkunde Stuttgart e. V.
Stuttgart, Württembergische Landes-
 bibliothek
Stuttgart, Württembergisches Landesmuseum
Stuttgart, Staatsgalerie Stuttgart
Tervuren, Koninklijk Museum voor Midden-
 Afrika
Tokyo, Bridgestone Museum of Art
Tokyo, Kokusai Bunka Shinkokai
Tokyo, Nationalmuseum
Tübingen, Völkerkundliches Institut der
 Universität
Ulm, Ulmer Museum
Ulm, Städtische Sammlungen für Kunst-
 und Kulturgeschichte
Venedig, Museo d'Arte Moderna
Washinton, National Gallery of Art
Washington, The Phillips Collection,
 A Gallery of Modern Art and its Sources
Williamstown, Sterlin and Francin Clark Art
 Institute
Wien, Bundessammlung alter Stilmöbel
Wien, Graphische Sammlung Albertina
Wien, Heeresgeschichtliches Museum
Wien, Historisches Museum der Stadt Wien
Wien, Museum des 20. Jahrhunderts
Wien, Museum für Völkerkunde
Wien, Österreichische Galerie
Wien, Österreichische Nationalbibliothek
Wien, Österreichisches Museum für
 angewandte Kunst
Wuppertal-Elberfeld, Von-der-Heydt-
 Museum der Stadt Wuppertal
Zürich, Kunsthaus Zürich
Zürich, Museum Bellerive

We should also like to thank the Ministry
of Foreign Affairs of the German Federal
Republic and its representatives abroad for
their assistance in the procurement of exhibits.

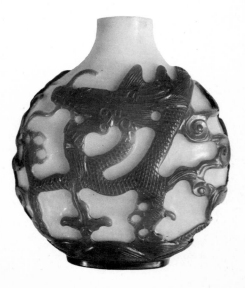

Contents

World Cultures and Modern Art

Oto Bihalji-Merin Art as a Universal-Phenomenon 2

Extra-European Portraits

Siegfried Wichmann Portraits of Extra-Europeans in the Art of the Nineteenth and Twentieth Centuries 13

Orient

Rudolf Gelpke Art and Sacral Drugs in the Orient 18

Egyptian Vogue 22

Wolfgang Pehnt The Orient and Nineteenth- and Twentieth-Century Architecture 23

Orientalizing Architecture 25

Horst Ludwig European Ceramics and their Islamic Prototypes 28

Horst Ludwig
Roger Pinkham The Iznik-Copies by Théodore Deck and his Contemporaries 28 · William de Morgan's Islamic and Oriental Sources 32 · De-Morgan-Pottery and Successors 34 · Paul Dresler 34 · Persian-Spanish Models and their Imitations 35 · Alhambra Vases 36

Metalwork 36

Wilhelm Hein Islamic Glass 38

Syrian enamelled Glass and its Reception from about 1865 to Gallé 38

Horst Ludwig Mosque Lamps and their Imitation 38 · Joseph Brocard 39 · Ludwig Lobmeyr 39 · Anonymous Glass 41 · Glass from Russia 41 · Emile Gallé 41

Siegfried Wichmann Art Nouveau Lustre Glass and the Orient 42

« The Rose-Water-Sprinkler—its Role between East and West around the Year 1900 43

Horst Ludwig Peacock Motifs 46

Oriental Textiles and European Fashion 48

Europe and the Oriental Carpet 48 · European Fashion 49 · The Indian Shawl 49 · Robes and Accessories 50 · Weapons and Appurtenances 51 · Oriental Scenes 51

Ernst Strauss Treatment of Light and Colour in the Oriental Painting 52

Siegfried Wichmann Action in the Hunting Compositions of Eugène Delacroix 57

« Hunt, Battle, Horsemen 59 · Sculptures 60 · Oriental Life, Enlightening the Palette 60 · Biblical Scenes 62 · Odalisques 62

Horst Ludwig Aspects of Oriental Ornamentation and Twentieth Century Art 64

« Graphic Art 72

« Oriental Motifs in Book Publications 75

Orientalism in Music

Ramón Pelinski Oriental Colouring in the Music of the Nineteenth Century 80

Music Program Near East 82 · Central Asia 83 · India, Japan, China 83 · Orientalism around 1900 84 · Headphone Program 84 · Instruments 85 · Stage Designs 85

East and South-East Asia

Yujiro Shinoda Chronological Survey of the Japanese Influence 86

Siegfried Wichmann Manual Technique 87

Hans Jaffé Vincent van Gogh's Search for the Serene Life in the Japanese Wood-Engraving 88

Siegfried Wichmann The Far-Eastern "Dash-Dot-Line" in the Work of Vincent van Gogh 90

« The Far-Eastern Pattern-Background Principle as Source of Initial Attempts at Abstraction in Western Painting 91

The Japanese Motif

European Handicrafts and Japanese Motifs 97

Siegfried Wichmann The Kimono 100

« Movement as an Autonomous Element in Hokusai and in the Pastels and Drawings of Edgar Degas 101

« Some Observations on the "Bridge" as a Motif in Far-Eastern and European Painting 104

« Rocks in the Sea: a Theme of Japanese and European Painters 106

« The Lily and Iris as European Picture Motifs 108

Methods of Composition

Siegfried Wichmann The Diagonal as Extreme Optical Line in the Japanese Wood-Engraving and in European Painting and Graphic Art 112

Siegfried Wichmann	"Trellis-work" within the Landscape of the Japanese Wood-Engraving and Nineteenth Century Western Art	115
«	The Detail and Asymmetrical Composition in Far-Eastern and Western Painting	116
«	Observation on the Fan Segment as "Testing Ground" of Composition for European Painters	120
«	Folding Screens (Nyôbu) and their European Successors	123
«	The "en hauteur" Picture Format under the Influence of Japanese Prototypes	126
«	The "Wave" as Picture and Ornamental Form in Japanese Art and its Influence on European Art	128
«	The Silhouette Style in Europe and the Japanese Woodcut	134
«	The Far-Eastern Pattern-Background Principle as source of Initial Attempts at Abstraction in Western Painting	136
«	Silk, Kimono and Nô-costume, Symbols of Japanese Culture	137
«	Japanese Dyeing Stencils (Katagami) and European Monochrome Graphic Art	138
Chisaburoh F. Yamada	Influences of Japanese Sumi Ink Painting on European Modern Art	143
Siegfried Wichmann	Far-Eastern "Dash-Dot-Line" Duct in the Work of van Gogh	149
«	European Symbolism around 1900 and the Influence of Hokusai's Spectres	151
«	"Abstractions" in Landscape-Representations of Japanese Chrome Wood-Engraving	154
«	The "Waterfall" – a Japanese Motif and its Adaptation by European Art	156
«	The Ornamental Hair-Comb and European Art	159
Joop M. Joosten	Java and the "Nieuwe Kunst"	163
Angela Schneider	Javanese Batiks and their Influence on the Textiles, Book Covers and Ceramics of the "Nieuwe Kunst"	168
Clay Lancaster	Japan's Contribution to Modern Western Architecture	170
«	Notes on the Influence of Japanese Architecture in Europe and North America	174

Ceramics and Glasswork

Elizabeth Aslin	The Oriental Influence on the Decorative Arts in France and England	177
Hugh Wakefield	The Influence of the Far East on British Pottery	182
Florence and Jean-Pierre Camard	The Importance of the Far East for the Renaissance in French Ceramic Art	184
Heinz Spielmann	German Ceramics from Art Nouveau to the Bauhaus Period	185
Mariela D. Siepmann	Asia and Europe Meet in Contemporary German Ceramic Ware	187
Siegfried Wichmann	The Dragon as a Decorative Motif in Far-Eastern and European Pottery around the Year 1900	188
«	Far-Eastern Vessels of Semiprecious Stone	190
«	The Pedestalled Vessel in the Far East and Europe	193
«	The Adaption of Plant Forms under the Influence of Far-Eastern Pottery	194
«	Mottled Glaces	200
Mariela D. Siepmann	The White Porcelaine of the Sung Period	200
«	Celadon Ware and its Renaissance in Contemporary Ceramic Art	201
«	"Chien-yao" and its Rediscovery in Modern Ceramic Art	202
«	The Lavender-Coloured Glazes of the Sung Dynasty	204
«	The Monochrome Glazes of the Ch'ing Dynasty (1644–1912)	205
«	The Blue Glazes	208
«	Chinese and European Covered Receptacles	209
«	Special Forms	210
«	Japanese Tea Ceramics	211
Hans Wichmann	Japanese Forms – European Commodities	214

Calligraphy

| Roger Goepper | Calligraphy in the Far East | 216 |
| Manfred Schneckenburger | Zen Buddhism, Ink Painting and Modern Art | 219 |

Asia and Music since Debussy

| Ramón Pelinski | Musical Exoticism around the Year 1900: Claude Debussy | 234 |
| « | Music Program | 236 |

Africa, Oceania, Amerindia

| Robert Goldwater | Primitivism in Modern Art | 240 |

| Werner Hofmann | The Magic Element in Modern Art | 244 |
| Jean Louis Paudrat | The Negative Reception of the Art of the Traditional Societies of Africa | 252 |

The Discovery of Primitive Art

Werner Schmalenbach	Gauguin's Encounter with the World of Primitive Peoples	256
Manfred Schneckenburger	Gauguin's Ties to Pre-Columbian America 263 · Borobudur and Buddhist Iconography in Gauguin 264 · The Tikis of Hivaoa 265 · Gauguin's Woodcuts 266	
«	The Brücke and "Primitive" Art: Some Observations	268
«	Schmidt-Rottluffs woodcuts on the life of Christ 271 · Exotic Still-Life of the "Brücke" 272 · Kirchner's Furniture 274 · Emil Nolde on New Guinea 275 · Pechstein's Indian Ink Drawings from Palau 276	
Jean Laude	French Painting and "Art Nègre"	277

African and Oceanian Contributions to the Presentation of Man

Manfred Schneckenburger	African Proportion	283
«	Masks in Tribal Art, "Masks" in Modern Art	288
	Amadeo Modigliani 292 · The Masks of Julio Gonzalez 296	

Elementary Forms: Block and Pillar

| Manfred Schneckenburger | Pre-Columbian Stone Sculpture and Modern Art | 300 |
| | "Hachas" 303 · Frank Lloyd Wright and Pre-Columbian Architecture 304 · Elementar Form Pillar 305 | |

Surrealistic, Mythical, Magic art

Manfred Schneckenburger	Magic Signs	307
«	Idol, Totem and Fetish in Modern Art	310
	Malanggans of New Ireland 316 · Totem Poles and Modern Art 317 · Nail Fetish and Material Sculpture 318	

Music of Negroes and American Indians

| Claus Raab | Difficulties in the Fusion of Jazz and Symphonic Music | 322 |

Music Program	The first Encounter with Negro Music in the Nineteenth Century	324
	Cake-walk 324 · Ragtime 325 · Blues 326 · Jazz Compositions from 1946–1954 327 · Jazz and American Composers 327 · Opera 328	
Claus Raab	Negro Music in Latin America	329
	Music Program	329
«	Latin American Dances Latin American Composers	330
Ramón Pelinski	Musical Nationalism in Latin America	331
	Music Program	332
Claus Raab	The Instruments	333
	African and Afro-American Instruments and their Use in Symphonic Music 333 · Musical Instruments of the American Indians 336 · Jazz and Symphonic Music 337 · Film Section 337	

Sound Centre

Dieter Schnebel	New World Music	338
Ramón Pelinski	The Music Program of the Sound Centre	342
Music Program	Traditional and New Music from the Near East 343 Afro-American Music and Modern Techniques of Composition 344 · Sound Enrichment by extra-European Instruments 344 · Rhythm. Improvisation. Music as gradual Process 344 · Stimulus provided by the Nô drama and the Gagaku 344 · Integration of extra-European Music 348 · Concrete and Electronic Music of the Groupe de Recherches O. R. T. F. Paris 349 · Eastern Thought influences Techniques of Composition 350 Chance, Music and Meditation 350 Asiatic Texts in Western Music 351 · Compositions commissioned for the exhibition 351 · Analytical Recordings 351	
	Films	352
	Musical Instruments	353
	Instruments at the public's disposal	354
	Program of musical and art events during the exhibition	355
	Film Sections	357

Willi Daume, President of the Organization Committee for the
Games of the XXth Olympiad expresses his thanks for the

Teahouse Urasenke

donated by Japan to the Free State of Bavaria,
and in particular to the Japanese Ambassador Fumihiko Kai
the architect and builder of the Teahouse:

Head of the family Urasenke, XV. Soshitsu Sen
from the Foundation Urasenke: Mitsuo Nomura
the landscape gardener Sentaro Iwaki
 Joji Fujii
the Ministerial Director of the Bavarian State Ministry for Economy
and Transport
 Dr. Fritz Eder
the President of the Bavarian State Administration of Castles,
Gardens and Lakes
 Levin Freiherr von Gumppenberg

The idea of including the teahouse in the exhibition was realized by
 Prof. Dr. Siegfried Wichmann
 Prof. Dr. Yujiro Shinoda

The former German Ambassador to Japan, Dr. Richard Bottler,
Deutsch-Japanische Gesellschaft in Bayern
the Director of Gardening of the Bavarian State Administration of
Castles, Gardens and Lakes, Karl Meyr and the Administration of the
English Garden, Inspector of Gardens W. F. Palten
Colonel Gerwin Schröder and the Federal German Armed Forces
City Surveyor Uli Zech and the Surveyor's office, Local Building
Commission

For special assistance and contributions to "World Cultures and
Modern Art," we thank:

Prof. Dr. Yujiro Shinoda, Tokyo, Sophia-University
Elizabeth M. Aslin, London, Victoria & Albert Museum
Dr. Herbert Fux, Wien, Österreichisches Museum für angewandte Kunst
Doz. Dr. Jan Wirgin, Stockholm, Östasiatiska Museet
Dr. Dora Heinz, Wien, Österreichisches Museum für angewandte Kunst
Prof. Dr. Clay Lancaster, USA
Dr. Stuart Durand, Richmond, England
Dr. Barbara Mundt, Berlin, Kunstgewerbemuseum
Yvonne Brunhammer, Paris, Musée des Arts Décoratifs
Prof. Dr. Roger Goepper, Köln, Museum für Ostasiatische Kunst
Dr. Steffi Schmidt, Berlin, Museum für Ostasiatische Kunst
Willibald Netto, Düsseldorf,
Prof. Dr. Dr. Franz Winzinger, Regensburg
Prof. Dr. Annemarie Schimmel, Bonn
Dr. Joop M. Joosten, Amsterdam, Stedelijk-Museum
Dr. Heinz Spielmann, Hamburg, Museum für Kunst und Gewerbe

Notes on use of catalogue:
All measurements are given in centimetres
(cm), height before width and depth

Abbreviations:

Cat. no.	— catalogue number
sig.	— signed
h	— height
w	— width
d	— depth
⌀	— diameter
Mus.	— Museum
Gall.	— Gallery
Coll.	— Collection
Inv.-No.	— inventory number

Authors' Initials:

H. L.	Horst Ludwig
R. P.	Ramón Pelinski
C. R.	Claus Raab
M. Sch.	Manfred Schneckenburger
A. S.	Angela Schneider
M. D. S.	Mariela D. Siepmann
S. W.	Siegfried Wichmann

Translators' Initials:

P. J. D.	Paul J. Dine
G. F. S.	Graham Fulton-Smith

World
Cultures
and
Modern
Art

Art as a Universal Phenomenon

Oto Bihalji-Merin

Environmental awareness creates a bridge between the old accidental and the new programmed events of human existence Marshall McLuhan

The viewpoint from which man observes himself in his existential reality and as mirrored in art has changed in the course of this century. However, the history of art has not yet devoted sufficient attention to these changes. An all-embracing historical analysis and a synthetic conspectus of all times and climes, the revision of the Eurocentric hierarchy of values and a reexamination of the changing concepts in art are clearly urgently required. And it is above all necessary that the reciprocal influencing and interpenetration of world cultures, all with an equal right to live, should be given due consideration. The artist's thinking today bridges the period from the origins to the present. There can no longer be talk of the regional, the national, and the planetary; the artistic vision is welding these into a unity amidst diversity through understanding and communication. Even if only a part of this programme can be realized in the exhibition "World Cultures and Modern Art," it will nevertheless show art in its universalist aspect.

The art of the extra-European peoples is not presented here as a mere appendix to western culture; neither is so-called primitive art treated as a subdivision of ethnology. The whole of the past is seen as a stage in the vital development towards becoming a component of the present.

The exhibition is limited in space and time to the economic and intellectual discovery of the cultures of Asia, Africa, Oceania and India which began around the year 1800. It is with their effects on the art and music of Europe and North America that the exhibition is concerned.

This merger of far and near, of space and time, this inclusion of all forms and whatever has ever been experienced in the discoveries and experiments of modern art will at times be given visual expression in the exhibition by the confrontation of contrasted pairs. Such confrontation is intended to help the viewer to recognize the hidden interconnections and relationships.

The comparisons are not intended to be direct and literal; they are by no means there to arouse thoughts of imitation. They are rather creative correspondences located in the various subdivisions of history and all tributaries of the one main stream of art.

The international character of the Olympic Games in which all nations, races and social systems take part as equals endows them with a democratic and cosmopolitan note. They appear as universal manifestations of peaceful competition in this so endangered and divided world of ours. Will the exhibition "World Cultures and Modern Art" be able to render visible an incipient cultural approximation on this shrinking planet, the beginnings of a world climate of creative influence embracing all peoples?

In sport the chances for personal talent and collective proficiency may be relatively equal; in the world of art there is no such thing as equality of opportunity. The exhibition "World Cultures and Modern Art" represents a break with the traditional concepts of the natural preordained supremacy of western art. There can be no doubt that it will be able to underline the significance of extra-European art for the metamorphoses and upheavals in modern art and to communicate to the visitor a new and truer picture of the world. However, it is not yet possible for it to document the reverse, namely that those artists who do not hail from the industrial states have also been able to profit from this worldwide horizon and thus connect up in their creative consciousness with the art of our day. Practically all the streams in European and North-American art — Impressionism, Post-Impressionism, Art Nouveau, Fauvism, Expressionism, Cubism, Dadaism, Surrealism, Action Painting, Art Informel — have taken over elements or methods from the art of Asia or from art which until then had been designated primitive. The recognition of and admiration for extra-European cultures have added to the artist's palette, have expanded his ideas on harmony, have multiplied the architectonic and plastic structures at his command in the developed countries.

The Games will take place against an expensive architectural and artistic background which not only serves national prestige but promises touristic success, too. A variety of artistic events are to promote the synthesis of "muscle and mind," to use the phrase of the founder of the modern Olympic Games, Pierre de Coubertin, which perhaps sounds rather banal today. The exhibition "World Cultures and Modern Art" is the product of far-reaching convictions: at the eighth session of the general conference of UNESCO held at Delhi in 1956 it was resolved to carry out a large scale program to further the reciprocal appreciation of eastern and western cultural values: "... in recognition of the fact that the understanding between the peoples necessary for their peaceful collaboration can only be attained on the basis of full mutual knowledge and appreciation of their respective cultures, and in the further recognition that it is of particular urgency that the appreciation of the respective cultural values must be especially deepened among the peoples and nations of the Orient and Occident..."

Whereas the term "world culture" evokes mild associations with world economy, world politics, world planning or, its opposite, world destruction, behind the combination of culture with "extra-European" there is the unspoken but conceptual association with "under-developed" countries. These countries are in need of development only in the economic, technological and scientific spheres, and in this sense the phrase is justified. It reminds the so-called "developed" countries of the important tasks which await them as a matter of conscience. However, the designation "under-developed" could be applied with greater justification to the intellectual and artistic situation in Europe and the USA. In a certain sense one could maintain of the highly developed great powers — highly developed that is from the viewpoint of technical civilization — that they have called forth psychic desolation and represent a menace to the life of the creative mind wherever their influence is felt.

Disgust with civilization, empty virtuosity and the boundless prospects opened up by the exploration of space have occasioned modern artists to look for new sources of renewal far removed from the world of technological precision.

Civilisation and the Janus Face of Europe

Our task is to realize the history of all known present and vanished cultures as a unity.
 Arnold J. Toynbee (quoted from memory)

The urge for political and economic expansion in the industrial nations carried their technological and scientific achievements to all corners of the globe as a belated gift, Europe's Trojan horse in the world. Human civilization, however, is not Europe's gift to the rest of the world. At the dawn of history early cultures

emerged, high civilizations developed while Europe was still caught in the grip of barbarism. Civilizations which have left us a written witness of their greatness developed along the river oases of Egypt and Mesopotamia.

The alphabet, one of mankind's great achievements, was the creation of the Orient. From the pictographs representing the consonants in the fourth millenium before the Christian era to the Phoenician alphabet, which already enabled men around 1300 B. C. to exchange their thoughts in writing and to read texts, the way led to Greece roughly about the year 1000, whence it has progressed practically unchanged to all parts and all ages. Among the important early achievements in the field of legislation must be numbered the remarkable code of King Hammurabi in the second millenium before our era. In the prologue of this cuneiform collection of laws we read: "Bel, the Lord of heaven and earth, who determines the destinies of the lands, has granted Marduk, the city divinity of Babylon, supremacy over mankind ... At that time Bel called upon me, Hammurabi, the god-fearing prince, to cause justice to prevail in the land, to destroy the wicked and the evil, that the strong might not oppress the weak, so that I might illumine the land and promote the well-being of the people ..."

In the first volume of his "History of Civilization" which he entitled "Our Oriental Heritage," Will Durant attributed most of the achievements of civilization to the Orient: agriculture and commerce, the horse and chariot, the minting of coins and the letter of credit, the trades and handicrafts, laws and government, mathematics and medicine, drainage systems, astronomy and geometry, the calendar and the clock, paper, ink, books, libraries, schools and much more besides. Thus, the cultural heritage Greece received from other lands was greater than what it was able to create for itself.

Christianity, in its origins an oriental religion, was intermingled and transformed by other doctrines on salvation during its long journey through the Occident. The advanced civilizations of Egypt and Mesopotamia were buried beneath Hellenism and fell into oblivion. The Middle Ages thought of Egypt as a Roman colony in which there had been various Christian communities. For the Renaissance and in fact right up to the threshold of our own times, Greece and Rome represented the focal and starting point for the culture of the world. Hellas' Promethean flame from Mount Olympus was seen as the symbol of the light with which the West illuminated the rest of the world. Such conceptions, taught for centuries at our universities, are still alive in contemporary views on culture. They not only contradict scientific findings; they even limp behind the knowledge of art history enjoyed by the layman today whose horizons have been widened in this age of worldwide communications and world wars.

If we are now going to try to place the sadly neglected extra-European cultures in the full glare of contemporary knowledge, this is not done with the intention of belittling the art of the West. We do not see the creative significance of this exhibition in the antithesis "Orient or Occident" but rather in the synthesis of the coequal cultures of the peoples, for Europe is not just a synonym for extension of power, economic expansion and imperialism. The Occident also means the displacement of mythology, the development of the sciences, the discovery of the personality. It means Aristotle, Leonardo, Johann Sebastian Bach, Marcel Proust, Pablo Picasso and Albert Einstein. Should we include the names of Siemens and Krupp as well who exported science and technology in the shape of goods and arms to the world? We just cannot excape form these two conflicting elements, from the Janus face of civilization. Columbus set out to discover a world; he was followed by the conquistadors who exterminated the pre-Columbian civilizations.

Signs of the East

For several centuries the history of West European nations and societies was directed towards the rest of the world in the sense of different kinds of "conquests." That time, the era of colonialism is finished. East is moving towards West. The Earth is being divided all anew ...
Martin Luther King

In the documented history of mankind, two main forms of relationship between the peoples of the Orient and the Occident are known: military conflicts, crusades and expeditions of plunder and destruction, on the one hand, and economic and world economic undertakings, on the other. In many, indeed probably in most, cases these two form a dialectic unity and stem from the same desire for new markets and power. And yet, at the very threshold of an incipient western civilization we find eastern cultures leaving lasting traces.

At the end of the eighth century before Christ the rigidifying Geometric style in Greece was refashioned and replaced by orientalizing impulses. Formal conceptions taken over from Egypt and the Near East leave their mark: design elements and motifs from the East. Mythical creatures, demons and hybrid creatures are completely appropriated, assimilated and further developed; they influence the decoration of Greek vases and even the form of the vases themselves.

In the Middle Ages, Arabic ornamental motifs and decorative Kufic script from Asia penetrated the world of Gothic art. Just as today artists of the Euramerican abstract school, influenced by East Asian calligraphy, use Zen Buddhist letters without being conscious of their objective signification as writing, so too Gothic artists, captivated by the beauty of the calligraphic forms, inscribed the name of Allah in Kufic script on the portals of their churches without understanding what they were writing. Venice, too, that powerful commercial centre with its universal pretensions, became one of the outstanding mediators of Turco-Islamic motifs, which became fashionable in Europe from about the year 1500 onwards. The cathedral of San Marco at Venice, that edifice built in the 12th and 13th centuries and product of multifarious formal influences, is a late medieval mixture of oriental and European traditions, a synthesis of Byzantine originals and Venetian reproductions which merge into scarcely distinguishable unities.

Christian art, when depicting Biblical history, often drew on oriental experience in the historicist manner. The church of the Holy Sepulchre (which in our day enjoys more political than theological actuality) was taken as a model and imitated throughout the entire Middle Ages, until the erection of the Capella Ruccelai in Florence.

"Religious motivation also underlies many of the other exoticisms in medieval art," writes Günter Bandmann, "which were intended to depict the realm of the devil within the framework of the Christian world order. Just as the pagan gods of Antiquity live on as dethroned spirits of nature in Christian art, so animals and monsters of exotic origin are also adapted to represent say the vices of the inhabitants of hell ..."

In this world of the fantastic belong too the hallucinatory representations of the "Temptation of St. Antony." Primeval spirits, mythical relics of the pagan world, surround the saint to tempt him out of the sacrosanct world of Christian dogma — a favourite subject influenced by the Far Eastern portrayals of the temptation of Buddha which gave Christian artists the liberty to portray the ecstasies of the imagination, sexual desire and the visions of fear.

In the Baroque world, the open-sesame of the oriental fairy tale

3

was pronounced: the fata morgana of the dream buildings from A Thousand and One Nights, the glittering splendour of the decoration, the concentrated expression on the small scale of the Persian miniature.

The fascination exercised by the oriental subject comes to the fore again musically towards the end of the 18th century in Gluck's "Les Pèlerins de la Mecque" and Mozart's "Entführung aus dem Serail."

During the Enlightenment, generals were accompanied at times by a team of scholars who added art treasures to the trophies of war. Museums of note in Europe were, so to speak, able to prosper on the plunder of conquered lands and cities. On the other hand, this also led to archaeological exploration, scientific progress and the decoding of whole cultures and scripts.

At a time when all the European powers were trying to justify their universal pretensions by an appeal to Antiquity, the Empire became the art style of the Napoleonic realm. Here for the first time extra-European symbolic forms were adopted: Egyptian monuments to power and death, pyramids, obelisks, sphinxes, souvenirs of Bonaparte's victorious campaign along the Nile.

Resistance to rationalism and Classicism, the interest shown in the emotional, the mysterious, the Middle Ages and the Orient, all find expression in the Franco-German Romantic movement in literature, painting and music. Victor Hugo's "Les Orientales," Heinrich Heine's "Almanzor" and other romances reflect the artists' interest in the Arab world. The Spanish works of the 15th and 16th centuries, especially those on the Moorish wars, provided operatic composers with both subject matter and inspiration. Cherubini wrote "Les Abencérages," Donizetti "Zoraide di Granata," Meyerbeer the unfinished opera "Almanzor."

Islam regarded this world as a mere appearance and thus avoided contact with living corporality in art, devoting itself instead to the abstract world of ornamental forms, symbolic allegories and metaphors. God and reality, the two basic themes of occidental painting, are absent in Arab pictorial art. The world mirrors God; the antitheses of this world and the next, heaven and earth, are invalid. Painting transfigures all things into a spiritual luminescent transparency.

The thematic interest in the Afro-Islamic world was intensified by the occupation of Algiers (1830). Algiers, Marocco and Tunis inspired novels, harem pictures and operas. Eclectic, decorative formal mixtures of oriental and Far Eastern exoticism exercise a mysterious, popular attraction during the nineteenth century. We see this exemplified in Bizet's "Les Pécheurs de Perles," Borodin's "Prince Igor," Saint-Saëns' "Mélodies persanes" and Verdi's monumental opera "Aida." Here the exotic and foreign elements are no more, in most instances, than the ornamental setting, magnificent and wonderful rhetorical devices, even if they are at times interrupted by musical orientalisms expressed in the compositional technique or in the tonal form.

We find corresponding themes in the harem pictures by Delacroix and Ingres, although the decorative beauty of Ingres' "Odalisque" may be purely incidental orientalizing on the eternal theme of the female nude.

After his travels in Algeria in 1832, Delacroix explored the colourful and vivid world of the Orient in his pictures of cavalry battles and lion hunts. The scintillating power of his "Femmes d'Alger," the extended limbs throbbing with animal lust for life in the Odalisque, are characteristic of a treatment of colour such as we also find in Chassériau. Delacroix's vigorous luminescent richness of colour, the influence of his experience of the Orient, is going to have its effect on the Impressionists.

Pierre Loti, the writer, was suspended from the service because he described the brutality of the colonial troops in Indochina. He also depicted the world of Islam in Africa and Asia in his "Aziyadé," "Les Désenchantées," "Le Roman d'un Spahi," and "La Turquie agonisante."

In a way different to Loti, Rudyard Kipling was the protagonist of British expansionism, of the mission of the white man to govern the "uncivilized" peoples for their own good: "Take up the White Man's burden." A master of the art of the story-teller, he depicts India's realities and dream worlds: jungle, people and philosophy.

The abandonment of perspective space and the placing of man, object and landscape in the two-dimensional plane of oriental forms find their purest expression in the work of Henri Matisse. The delicate depictive power of Persian miniatures, the purity of line, the harmonious ornamental pattern of oriental carpets, the restrained beauty of faience ware, the eastern arabesque in its never-ending melody are all part and parcel of the structural experience of a newly discovered eastern world.

In August Macke's Tunisian watercolours and still more in Paul Klee's painted reminiscences of his journey to Kairouan the play of light in desert, oasis, sun and Casbah are translated into the soaring forms of oriental semantics: the profusion of the world allegorically represented in the vanquishing of the world.

The gulf which had arisen between western and eastern art through the discovery of natural perspective by the Renaissance was narrowed or bridged entirely by the renunciation of perspective in the moderns. The reality created by the artists of the twentieth century caused a new order to arise in which all systems of art could meet.

Conceptual Art, no longer fettered to the objects of reality, is perhaps able to attain an essential character which seems closely related to the basic ideas of eastern art. It divines what Buddha meant when he said that it "is splendid to view, but terrible to be, nature..."

> From the object, which no longer appears oppressive to me, a tension is emitted which grows in luminosity and continues like an echo in all directions to the limits of the canvas. The lofty teaching of Turner and the spiritual message of Zen painting have come home to me.
>
> André Masson, 1953

The self-assertive exclusion of the world brought about by European imperialism prevented, for many long years, that encounter at a deeper level which could have laid bare the nature and art of foreign peoples. India's tremendous creative achievements in the field of art — completely comprehensible only in the symbiotic relationship with its literature and philosophy — exercised no particularly strong effect on modern art since it was wedged, as it were, between European expansion on the one hand and that of the Far Eastern powers on the other. Certainly mental sublimation and philosophical ideas with their metaphysical symbolic power did have an effect on the philosophy and literature of Europe. Also in the realm of modern dance and of music its influence has been felt, but hardly at all in the fine arts.

English scholars in a fifty-volumed work entitled "Sacred Books of the East" had drawn the attention of Europe to the mythological forms and beliefs of India.

Romanticism deepened this interest. In 1808 Friedrich Schlegel published his book "Über die Sprache und Weisheit der Inder." Schelling, Hegel and Schopenhauer all dealt with problems of Indian philosophy and literature. Novalis, Goethe and Thomas

4

Mann were deeply impressed by the mythology and poetry of India. In his flight from the brutalization and emptiness of European, western civilization, Hermann Hesse had gone to India in 1911. His "Aufzeichnungen von einer indischen Reise" and his book "Siddhartha" (1920) on the life of Buddha bear witness to the impression made on him.

The composer, Olivier Messiaen, has taken over and adapted to his own ends as the basic pattern in his "Oiseaux exotiques" the Indian tala periods. Karlheinz Stockhausen was inspired in his composition "Mantra" by the spiritual and tonal cosmos of Indian music. Speaking about the function of guided chance in music, Pierre Boulez points the parallel with the improvisation techniques, the "open forms" of Indian music, in which the interpreter also has a creative role assigned to him.

Chinese silk and porcelain had long been known in Europe and had stimulated imitation. In their parks and gardens, the owners of palaces and mansions built teahouses and bell pavilions and had artificial ponds laid out with bamboo bridges hovering over them. A decoratively bizarre and grotesque type of ornamentation was known as "à la chinoise." Sculpture, vases, pictures, lacquerware, wallpapers painted with droll scenes were admired as exotic forms and costly objects. However, the viewpoint based on the normative aesthetics of the Renaissance made it impossible for the real nature of Chinese art to be grasped. The Chinese fashion was a mere marginal phenomenon, an excursion by the aristocratic society into a mysterious but tempting Arcadia. China has only exercised a more profound influence on modern art indirectly via Japan.

Fertilized by the art of India and China, that of Japan became, through its contact with the modern world, a central source of stimulation and inspiration for Europe and America. A particular constellation of causes and effects brought it about that Japan's traditionally minded and archaic art drew closer to the spatial composition and use of colour in modern art.

In 1856, the French engraver, Félix Braquemond, discovered Hokusai's "Manga." He and his friends were thrilled by the generously simplifying interpretation of reality conveyed by these woodcuts.

Ancient Japan with its perspective system of parallel lines in a slanting cube facilitated the development of that diagonal depth and surface organization which the European artists were seeking in their emancipation from the centralizing perspective of the Renaissance. The brightly coloured, speckled asymmetrical composition of the woodcuts and paintings by Harunobu, Utamaro, Hokusai, Hiroshige, Kunisada, Kuniyoshi, and Kiyonaga furthered the emancipation from the academician's teachings on perspective and the illusionist reproduction of nature in European art. The Paris World Exhibition of 1867 with its Japanese section caused Japan's influence on the formation of modern European art to become effective. The anecdotal imitation of the first phase was soon replaced by an understanding of the very inner nature and of the structural peculiarities of Japanese art. Painters recognized in it a tendency in line with their own endeavours. Traces of this creative transformation of Japanese influences are probably to be first seen in Manet's flat composition, his foregoing of plastic effects and in the shadowless brightness of the colour surfaces.

Whistler, who placed Hokusai on a level with the creator of the Parthenon, was very strongly influenced by Japanese polychrome woodcuts. His "Old Battersea Bridge, a Nocturne in Blue and Yellow" could almost have been painted by Hiroshige. Nevertheless, this picture of the bridge over the River Thames by night, fog and pale moonlight is an authentic creation of Whistler the painter.

Claude Monet's scintillatingly colourful variations entitled "Water-lilies" are in their sensitivity and abstract simplification very close to the Japanese portrayal of nature. Degas' figures which burst the bounds of his picture, the significance of empty space for him, his close observation and reduction of lines represents a differentiated form of the Japanese influence. The abbreviated silhouette-like brushwork of Toulouse-Lautrec's pictures and posters clearly reveals their affinity with Japanese woodcuts. Japan had the same kind of importance for van Gogh as Tahiti had for Gauguin. In order to come to terms with the essential nature of Japanese art, van Gogh made studies in oil of Japanese originals. In his pictures of landscapes and bridges and in his interiors he translated the painted surfaces into an expressive system of strokes which transformed the multiple small structures of Japanese surface design into his own compositional principle.

Pure coloured flat surfaces which are separated by black contours typify the pictures of Emile Bernard, a form of composition which is repeated in Gauguin's pictures form his Pont-Aven period. They look like borrowings from Japanese woodcuts and stained glass windows.

The American painter Mary Cassatt abandoned producing the illusion of space to come close to abstraction in rhythmic arrangement of delicately coloured, decorative surfaces. The systematic small-scale composition of surfaces by the Japanese has an analogy in Georges Seurat's pointillistically juxtaposed colours of the spectrum, in his formal composition of the picture. The intimist detail and the poetic asymmetry of both Bonnard and Vuillard, the simplifying view of nature in Marquet were stimulated by Japanese art which they saw as an encouraging confirmation of their own artistic tendencies. This is also true of the Viennese Jugendstil with Klimt and the formal movements in London, Paris and Munich. The redimensioning of the organization of the picture, the intensification of spontaneity and freedom in the part of the impression portrayed in the painting of that time all provide evidence of this. The new relationship to the floral element, to the pattern and ground, the emphasis of the silhouette, the writhing, wreathing contour lines, all so essentially characteristic of Art Nouveau, link up with the influence of Japanese art.

The Far Eastern contribution to the renewal and refinement of dwelling habits and of the handicrafts in Europe was of great importance. Constructive clarity, the formal simplification of the Japanese interior, furniture and textiles, lacquered objects, porcelain, glass, ceramics and jewellery from China and Japan become the formal types of the artistic reception: the Liberty style and Mackintosh furniture in England, and the Viennese and the Munich Secession provided the main impulse for this renewal. In the field of ceramics elementary forms of the constructive stream are combined with floral stylizations. During the twenties of this century the monochrome ceramic ware of the Ming and Sung periods is added to the Japanese ware and plays its part in the never-ending process of development in European ceramic design.

The vivid irregularity of the body, the "unsuccessful firings" with the patina effect are conscious manufacturing techniques and stylistic means at the disposal of the modern ceramist. After the Far Eastern model, the everyday commodity and utensil, becomes in its colour, form and glazing a noble object, the mediator of the spiritual and artistic.

The spirit, form and technique of Far Eastern ink painting has had a profound and lasting effect on modern art in Europe and America. This is particularly true of those artists who begin to turn their backs on external reality in order to replace the reproduction and appearance by the sign and pictorial symbol of inner meditation and sensitive reaction. What these artists have

5

grasped is the capacity of the Chinese and Japanese tradition to express an impression in its essence with calligraphic means. In China and Japan writing has always been of outstanding importance. It was not only a means of committing thought to paper but also of expressing the writer's innermost being. Writing was an art; to master it one had to know how to subdivide a surface with esprit, to handle the brush with musical lightness of touch and to develop compositorial gifts with economy, feeling for form and self-discipline.

The art of expressing concepts for material objects in a picture language, in pictographs, led to the peculiar aesthetic approach to calligraphy in the Far East: writing meant producing pictures. This art, too – which is based on a strict and ancient tradition – underwent radical renewal and change of significance because of the upheavals in Japanese society since World War II. Gakiu Osawa and other modern calligraphists have cast aside the ancient principle of legibility to save writing from being consigned to the sphere of signs already rigidified into dead convention and have transformed them into the subjective expression of their own impressions.

For anyone raised in the spirit of eastern culture the forms of the letters were inextricably bound up with thought associations, too. For the artist of the Far East, the calligraphic signs are actors in a process which has already taken place in time but whose effect is still present and active. The slightest change in the form is of the greatest significance. This is why writing is not just the communication of thought but at the same time an act of artistic creation. This artistic process – and not just the beauty and harmony of the forms – has inspired many artists in Europe and America. Without completely grasping the intellectual context and cultural background, they have nevertheless sensed the inner meaning and experienced it as the expression of an ideogram, as the echo of a language which one can imbue with meaning and decode by meditation. Since the western artists engage all the intensity of their talent and their power of mental concentration, they can, in a way similar to the Zen Buddhist archers of the allegory, find through unconscious, spontaneous activity the signs which unite their beings with the meaning of the world.

In his book on Zen and the culture of Japan, D. T. Suzuki writes: "If anyone reflects and moves the brush with the object of creating a picture, he will certainly not attain the true art of painting…" This art is thus presented as a type of automatic writing. Essentially of this same spirit is the Surrealistic écriture automatique understood as a psychogram.

André Masson's sand pictures in their excited directness and passionate tranquillity form a continuation of the écriture automatique.

The influence of Far Eastern calligraphy was first of all realized in formal analogies, but then took deeper root in the aspiration of the artist to free himself from the bustle of modern life and from technological civilization and to grasp and depict the real essence and significance of things by his complete concentration.

Mark Tobey went to China and Japan in 1934 to grasp the difference between volume and the flowing line at the very source of calligraphy in Buddhist monasteries and to practise the essence of those forms whose language is intelligible to all men.

The ideograms in the painting of Willi Baumeister since 1938 are closely allied to the Chinese calligraphy with brush and ink. Whereas the "white writing" of Tobey, his muttered light lines on a dark background, evoke a mixture of landscape and time, the black painted formulae of Baumeister are the signs of a subconscious Tao. Pulsating forms, balanced, simple, like the vessels of the Han period, Julius Bissier's ink variation, the product of contemplative immersion in nature could also have been created in China. His miniatures with all the weightlessness of the spider's web are psychograms produced in meditation which, in accordance with Zen tradition, are cyclically repeated, deepened, clarified until their validity is recognized. No other artist since Paul Klee has been able to portray so truthfully and simply as Bissier the strange experiences of the inner world with its tense poise between uncertainty and perfection.

The calligraphic brushstroke works of Hans Hartung, executed with the sense of touch of inner certainty and in strict discipline, are reminiscent of Far Eastern paintings of bamboo. In view of his mesh of bent and curved lines one is inclined to quote from the writings of Zen tradition: "To become bamboo and then to forget that one is one with it while one paints – that is the Zen of bamboo, which means to move in the 'life rhythm of the sense…' which breathes in the bamboo just as it does in the artist himself. What is here demanded means a certain grasping of this sense and yet to be conscious of this. This is an infinitely difficult mental task which can be mastered only after long practice…" The inner intensity and radiance in the works of Wols, his surrender to fate, suggests a certain relationship to Tao. This utter passivity of reception and of assimilation and his doodlings almost made in a state of trance impart something impersonal, anonymous to his art. Still, for all that, they are sensitively subjective.

Pierre Soulage's pictures evocative of dark beams and scaffolding in space recall Chinese brush writing. Georges Mathieu's calligraphy owes much to Far Eastern calligraphic painting in spite of the choreographic treatment and historical designations. Finally, the modern Japanese calligraphists have also added an expressive activism to the original eastern contemplation, evidently a superstructure made necessary by our technological age. Robert Motherwell, Adolph Gottlieb and Franz Kline unite western expression with eastern meditation. A number of the apparently spontaneously executed symbols in their paintings resemble Far Eastern calligraphic compositions which have been gigantically enlarged.

Al Copley's small-scale symbolic painting lies somewhere between the salon of the réalitées nouvelles and the monasteries of Zen Buddhism.

Tachisme with its emphasis on spontaneity and intuition is also indebted to the calligraphic stroke of Far Eastern art, although the preoccupation with chance, the recourse to purely instinctive painting, is in fact contrary to the tradition of the East. Under the influence of Europe young Japanese calligraphists are transforming the meaningful signs into abstract forms. European and American painters, in contrast, are trying to give depth to their abstract creations with the help of the essential content of Far Eastern meditation. In the encounter of the two cultures, each finds in the other what it requires and assimilates those elements which most confirm the tendencies already inherent in its own art. If there is here question of the influence of Japan on modern art, then we should not forget Akiro Kurosawa's film "Rashomon." Based on a short story by Ryonosuke Akutagawa, it is a work of art, elemental in its simplicity and as deep probing as the "Schloss" by Kafka. In order to answer the question whether there is one truth and whether it can be grasped by the human mind, the camera's eye encircles the event, observes it from numerous opposed viewpoints and penetrates the invisible realities underlying it. This film can be seen as a symbol of the road Japan is progressing along: the unavoidable incorporation in modern western civilization and at the same time the preservation of her own traditions.

Dialectic Resurrection of Totem, Fetish and Idol

The world of the primitives, the history of man's origins
and early stages, endow him with a new position in the
world and in the cosmos, show him the dark soil of the
roots from which he stems and seem to be radically
destroying as an illusion his likeness to God and his
central position in the world… Erich Neumann

The twentieth century is teaching us to view things in a new way.
The passing of the main stress of historical development to the
field of technology has caused art — faced with the increasing
impoverishment of psychic substance — to direct its eyes to the
original artistic kernel. Aspiring after the grand interconnections,
artists and art lovers are turning not just to the early forms of
primitive art but also to the late forms of the naive.
The vital interest in primitive art was initiated by Paul Gauguin's
discovery of the formal world of the South Seas: the expressive
capacity of the primitive peoples (whom we unjustifiably so
name) and the reserves of energy in sun, ecstasy and intensity
are to replenish the exhausted springs of European art. In his
autobiographical novel "Noa Noa" Gauguin allowed the mythi-
cal note to sound. He attempted to answer the question of man's
origin and goal through the adventure of his own existence and
work by turning his back on civilization and returning to the lost
paradise of the archaic community. His happiness on Tahiti is
paid for with the loss of Europe. The light of the eternal Sunday
shone over the blessed isles of Polynesia as Gauguin portrays
them. In the golden green shade of paradisiacal innocence the
naked bodies of his subjects move. And yet Gauguin both saw
and at the same time saw through this world with bitter melan-
choly. Certainly he painted the inhabitants of the Happy Isles
under palm trees, but in his letters and books incorporating his
experiences he reports on the human misery there, too. This
Eden stood in a relationship of dependence to the colonial
powers which were just beginning to lock it in their deadly
embrace. The return to the legendary land remained a mystico-
natural utopia. Gauguin's pictures were able to gain in poetical
intensity in the sun of the primitives; society itself, however,
cannot return again to its archaic beginnings.
Gauguin's recourse to the primal sources drew a clear dividing-
line for the art of Europe and of the world. It marked the begin-
ning of the process of rehabilitation of the early and primitive
cultures, a process which ran parallel to the emancipation from
the dominance of classical antiquity. Primitive art came with the
old and now renewed message that the world is not what is
revealed to our gaze but what the artist knowingly experiences.
The surrender of imitation, the abandonment of illusionism
means the beginnings of a new art.
The primitive artists belong without exception to pre-industrial
economic systems; they are rooted in religious, mythical con-
ceptions. These anonymous artists feel they are a link in an
unending chain of generations and at one with their work. The
primitive sculptor concerns himself far less with the task of
rendering the forms of external visible reality than much more
with the internal significance. African animism, which is allied
with the "soul matter" of the mana conceptions in Polynesia,
created the ritual sculpture of the worship of the gods and
spirits, of the cult of the dead and of ancestor worship. The
impenetrable reserve and the tense simplicity of the broad-
surfaced, dynamically curbed matter gives the idols and masks
their magical fascination. A universally valid characteristic of
these masks is their elemental self-containment, the unity of
their plastic inspiration. This it is which gives them the power of
suprapersonal, mysterious symbolism.

In the return of European and North-American artists to the
fetishes and idols of the primitive peoples we see reflected the
crises in society and art in the age of science. Just as aboriginal
man stood, deeply moved, before the inexplicable, apparently
chaotic natural phenomena, so modern man, in spite of atomic
fission, cybernetics and the launching of rockets into space finds
himself again faced with the inexplicability of an expanded and
for him no less mysterious new reality. Modern art, its concepts
and iconography — clothed in the habit of the twentieth century —
resemble in numerous points the origins and early history of
mankind. The rising to the surface of mentally latent, uncon-
scious original pictures, collective experience and suffering
engraved in the psyche, is mirrored in the visual field of modern
design and composition. From James Joyce, Picasso, Kafka,
Max Ernst, Beckett to Henry Moore we have the same dark bond
of an iconography in which the original fear at man's beginnings
encounters his existential fear in the atomic age.
Obviously Pablo Picasso is the most voluble witness to the
attempts to form new cosmogonies, daily myths out of the
encounter with the early cultures. In his œuvre the enormity of
the adventure in which the artists of our century are engaged
becomes particularly apparent. Picasso has imbued new life
into the classical heritage with his perfect ear for the finer points,
has sundered the bonds of Eurocentric tyranny and given all
cultures access to the artistic tendencies of the present: Ibero-
archaic and pre-Romanesque forms, demonic myths of the
Mintaur, the cantilena of the figures on Attic vases, Mediterra-
nean light, the dark world of the African idol and the demonic
power of the pre-Columbian gods.
The viewpoint of Cézanne, reminiscences of Iberian forms and
the magical power of Negro masks merge in Picasso's studies
of the female nude into his composition "Les Demoiselles
d'Avignon." The native instinct and lively intelligence of this
artist enabled him to fill the spatial architecture of transposed
reality with the tension and intensity of the fetish. Nevertheless,
the Negro Period in Picasso's art comes to full realization only
in Analytic Cubism. For the first time in the history of modern art
the African mask is utilized to revitalize the non-virtuoso forms
of civilized art with the deep-rooted powers of instinct.
African art became of fundamental significance for the develop-
ment of modern art: Dérain, Vlaminck, Schmidt-Rottluff,
Pechstein, Kirchner and other painters of the Brücke group were
inspired by the symbolism, the sign language of the forms and
the impetuous vitality of the glaring colours. Emil Nolde's mask
picture originates in this area of primitive art: "I paint and sketch
and attempt to capture something of the original being. The
artistic products of the primitive races are a last survival of
primeval art…"
In Brancusi's sculptural creations we are faced with a synthesis
of creative primordialism and faultlessly refined form. The
Rumanian artist took his native folk heritage of form with him to
Paris where he combined the vision of Cubism with the formal
canon of Negro sculpture and of the meditative plastic art of
Buddhism. A number of his impressively simplified figures have
their origins in a magico-mythical sphere and recall the images
of the Cyclades. It is as if this sculptor-poet has united the poles
of time with his reverently creative hand, as if with his creations,
allocated somewhere between living being and dead matter, he
has managed to find reconciliatory myths.
Modigliani was greatly stimulated by the power of Negro
sculpture. His solemnly stylized oval female faces, owing much
to Brancusi, remind us of the dancing-masks of the secret
African societies among the Baule and the Fang.
Among the masters of modern art who sought refuge in Ameri-
ca from the barbarism of the Third Reich is to be numbered

Jacques Lipchitz. He managed to break the bounds of orthodox Cubism while adhering to its precepts on the simplification of structural composition and of rhythmic disposition. A number of his figures have the Cubist-rooted and Cubist-transposed significative proportions of African sculpture; others incorporate plastic elements of the totem-poles of the Haida Indians.
Max Ernst has created and is still creating cryptic archetypal forms which, in spite of their ironically masked designations, often have their origins in regions buried deep down in consciousness. He decorated his country house at Sedona (Arizona) with Mexican Kachinas, with other masks and fetishes and his own imaginative reliefs. In the garden of his house at Huismes (Loire) stands the bronze sculpture "The King plays with the Queen." The horned bust of the king whose arm encircles the smaller figure recalls the magical associations of the African image. It is almost a matter of indifference whether Max Ernst had the helmet masks of bull and bird produced among the Senufo tribes of western Sudan in mind when he produced his plastic work. The works of art of the primitive cultures are for him finds discovered in the realm of the impulses and instincts, essential components of the unconscious which, when combined with the supraconscious depth-experience of later epochs, are transformed into shapes and forms of extended optical reality.
In their lapidary symbolism the "idols" of the sculptor Jean Arp resemble more the sign language of the primal form than the images of the primitive cult. Like Paul Klee, Arp is not interested in catching nature as an external phenomenon but in making it perceptible in its organic process of growth. In Arp's sculptures of the trivial and at the same time significant, his creations charged with hidden power, he is sometimes in harmony with the signs and symbols of the primitives.
Also in those processes which are considered the specific invention of twentieth-century European art one can find analogies in the plastic art of the primitives: the grotesque and uncanny late-Surrealistic troubadours of machine parts, cogwheels and pieces of metal which Eduardo Paolozzi composes are not without similarities to the nail fetishes of the Bakongo tribe. Günter Uecker's bright nail-carpets and Dusan Dzamonja's fetish structures clad with a forest of spikes also belong here. And are not the cybernetic idols of modern man but transmuted forms of the archaic primeval image? Totem animals of the machine age?
While the artists of Europe and America are trying to refresh their intellectually and technologically overrefined fantasies at the sources of archaic and primitive art, to borrow instinct and vitality from the carvers of the African idols, the peoples of Africa are themselves awakening from their jungle sleep and would now like to free themselves both from the idols of their witch-doctors and from the influence of the White empires. During the next stage of its development Black Africa evidently has need above all of enlightenment, electrification and a new social order. The traditional tribal art is moribund since its encounter with technological civilization. Present-day handicraftsmen, graphic artists and sign-painters are fascinated by the superabundance of the mass media of optical communication, by the melodramatic cinema posters, the eye-catching advertisements and colourful dynamic comic strips. Almost without a period of transition, the change from the world of ancestor worship, spirits and myths to that of pure reason and machine is taking place. An elemental talent for story-telling and a strongly instinctive commitment to life imparts the power of the authentic to the dilettante painting of contemporary Africa. The representations of the human form in this painting of the new Africa are like some kind of plebeian, naive Pop Art.

The emblematic folk-painting of the young Nigerian artists has little in common with the tribal art of the bronze founders of Ife and Benin and the wood-carvers of the Yoruba. The present-day creatively gifted artists stem from the people, mainly from the lowest middle-class strata or from the proletariat in process of formation. They are turning to an external realism which combines naive anatomy and perspective with the spirit of photography. The unconscious representation of reality gives these pictures a similarity with the conscious portrayals of reality of the Pop artist who at times places the object itself in the picture in place of its reproduction. However, perhaps the memory of the ritual art of former times, which knew how to work magic and bind spells with the aid of feathers, teeth, shells and masks, still lives on in the African artists.
For the artists of the USA, Pop Art is a mere reflection of reality, a true visual projection of enormous quantities of consumer goods from the supermarket, the organized entertainment and the nightmare paradise of Disneyland. They design their "objects" like the products and creations of industry. They accept the trademark character, the advertising machine and the townee language of commercial television. If this form of art spreads in Africa, then it will not be the reflection of the reality of a consumer society but the attraction and influence of a rationalized society on the artistic sense of an unadapted and primitive imagination.

*Encounter of Ancient Amerindian Cultures
with Technological Civilization*

Until recently the fine arts employed the same means as those used by ancient man in his cave paintings – the manual means of drawing, incising, modelling, applying paint with a brush or spray technique. The computer compels art, as it were, to make the leap from the Stone Age to the Computer Age …

Herbert W. Franke

Between the past and the present of the American Continent lies the history of its discovery, conquest and subjugation, and then of a worldwide expansion of influence. The term Hispano-America points to the descent from the Spanish and Portuguese conquistadors, whereas that of Indo-America or Amerindian refers to the pre-Columbian cultures. However, besides the Iberian and pre-Columbian, the blood of the involuntary inhabitants, of the Negroes imported from Africa, also flows in the veins of the American population.
The writers and poets of Latin America hoped for a Renaissance inspired by the spirit of Latinism. On the banners of those fighting for emancipation in North America, however, the momentous signs of a "Negritude" have become unmistakable. The art of the black population, particularly of Central and South America draws its inspiration from African tradition and unites folkloristic ritual elements with naive pictorial sense.
Up until the early decades of the twentieth century, the intellectuals and artists of North America suffered from a feeling of inferiority based on their conviction of the supremacy of the ancient Mediterranean cultures and the great European art styles. The artists of the United Staates of America felt that they were living in a cultural vacuum which could only be filled and mastered when America's self-confidence had been consolidated by its rise to economic and world power.
The discovery of the cultures buried beneath the soil of America, the resurrection of the pre-Columbian gods, the rediscovery of the Indian totem-poles and of Negro music made out of the lack

of classical cultural heritage the virtue of an unprepossessed and independent art. The effects were also felt far beyond the frontiers of America.

Henri Rousseau's exotic motifs in his "Mexican" jungle pictures preceded Surrealism and have perhaps come to life again in Max Ernst's dream forests. The symbolic language of the Mayan calendar and the Indian totem-pole provided the magic ideogrammic painting of the twentieth century with inspiration. Aboriginal Indian symbols appear in the work of Torres-Garcia and Gottlieb, in the ideogrammic ciphers of Willi Baumeister and André Masson. We find associations of this same tendency transposed into figures in Atlan, Victor Brauner and Paul Klee. Diego Rivera and his circle combined the modern formal concepts of Cubism with the powerful resources of the pre-Columbian past and Mexican folk-art. The mural was composed in emblematic pictographs to ensure that the broad masses of the people would get its message and to serve the concept of social liberation. This monumentén enlarged biblia pauperum which enabled the artistic gap between people and artist to be bridged via the simplicity of modern primitivism was also charged with naive, archaic forcefulness. Diego Rivera, José Clemente Orozco and David Alfaro Siqueiros produced their epic cycles on the walls of the cities of Mexico in their easily comprehensible grandiose compositions. Syntheses of pre-Columbian gods, demons and the dance of death with the power and powerlessness of capitalism and the antitheses of the industrial age were the result. This passionately committed art was the starting-point of a peinture engagée and of the self-renewal of a conscious Mexican culture.

The art of the Incas of Peru had also affected that of Ecuador, Colombia and Argentina. Far from the sacred places of the ancient peoples and the archaic geometrizing forms on the sun gates of the megalithic edifices, Argentine artists of the second half of this century have developed via Paris a constructive geometrizing art imbued with light and movement. Is it mere significant chance that Julio Le Parc, Horacio Garcia Rossi, Francisco Sobrino, Marta Boto, Vardanega, Hugo Demarco have given Paris and the world the electrified and kinetic suns of visualized light as a late reflection of the pre-Columbian cult of the sun? The stone-block compactness and the intense monumentality of their architectonic sculptural works are the weightiest contribution of ancient American art to the material-conditioned abstraction of the moderns and to the evocation of dead mythical realms.

Frank Lloyd Wright, the imaginative and creative American architect, emancipated himself from the limitations of the classical European building styles. He combines an architecture of the block-oriented mass with emblematic ornamentation in a way similar to that of the structures of northern Yucatan or at Mitla. The sculptor Henry Moore was deeply impressed by the magic unequivocalness of ancient Mexican sculpture. He wrote: "It soon became evident that Mexican sculpture seemed true and right to me—perhaps because I suddenly came across similarities with the eleventh-century sculpture I had seen as a lad in the churches of Yorkshire. Their stone character, by which I mean their conformity with the material, their tremendous power—without loss of sensitivity—their astonishing richness and their fertility in the invention of forms—all that raises Mexican sculpture to a rank that has been surpassed by no other epoch of stone sculpture..."

As only the most significant artists are able to take over the past and master it, so Moore has experienced the architectonic severity, the cubic formal power and the magical intensity of the Chac-Mool figures at Chichén Itza and transposed them for his own ends. The sungod's head is held at right angles to the body

and views all with the implacability of a mask. The god holds with both hands the bowl intended for the hearts of the human victims or of the vegetative offerings. These figures stemming from the Toltec and early Mayan cultures are paralleled in Moore's variations on the reclining female. Their quiet composure, elemental weight of the creature, and the draped beauty of their forms which transform architectural and natural space by their existence are perhaps but a belated emissary of the Great Mother in primal-modern form.

The reclining figure created by the Austrian sculptor Fritz Wotruba is also essentially related to the stone god of the Chac-Mool from Ihuatzio. Not only the rigid weight of the material witnesses to this, but still more the conscious recourse and return to the atmosphere of the original language in stone. Formal profusion, power and emotional tension in the art of ancient Mexico and Peru have met with a profound response in the world art of the moderns. In recent years New York has been exporting new programs of radical art to the world. In New York the artistic climate of our era is in preparation: from Action Painting to Pop Art and Conceptural Art, from Environment to Cybernetic Art. Perhaps America is that region where the heterogeneous forces of the twentieth century are meeting head-on: the modern primitives and the technocrats, the city nomads and the computer engineers.

Musical Universalism

> In Messiaen we find the remarkable, continuous contact with the exotic, and yet still contemporary, cultures; in Jolivet everything seems to rise from the depths of time...
> Antoine Goléa

A universal history of music, free from the value judgments of Eurocentric aesthetics, has yet to be written. And even if we lend a willing ear in listening to extra-European music, we receive it only with the musical views of our European heritage and can hardly expect to understand it profoundly. Only after we have shed our own traditions and studied the laws of extra-European music can real communication take place.

Herder's "Stimmen der Völker in Liedern" already opened up those perspectives of the cosmopolitan spirit which attempted to imbue itself with the melodic language of all peoples. Through their concern with the folk music of foreign peoples the Romantic composers drew closer to the exotic and far-distant both in subject and colouring. However, these are but preliminary excursions which remained mere marginal phenomena until the self-sufficient framework of the European musical system could be discarded.

Debussy's encounter with the tonal system of Javanese gamelan music at the Exposition Universelle at Paris in 1889 was of the greatest significance. It confirmed Debussy in his efforts to consciously confront Wagner's high-flown chromatism with the "impressionistic" scintillating tonal surface of asymmetrical rhythmic divisions and with the reduction of the melodic patterns available.

Around the turn of the century Mahler, Busoni, Stravinsky and other musicians came to real terms with Chinese, Japanese and Indian music.

In "The Rite of Spring" Stravinsky took up an archaic myth: primitive man and the unknown; the fear of the sovereign power of nature and the instinctual, demonic emergence of magical possession; the mystical union with the primeval powers brought about by a sacrificial death.

Stravinsky's works of his Russian period, like "The Firebird" and "Petrushka," correspond roughly to Picasso's Negro Period.

The Russo-Asian melodic heritage offered the composer the insatiable vitality and archaic rhythm of the collective unconscious which Picasso found in the magic-laden world of Negro sculpture.

Many contemporary musicians, such as Stravinsky, Milhaud, Honegger, Aaron Copland, Křenek and others have taken over the sound-language of Jazz instrumentation. The emotional musicality of the Afro-Americans in their spirituals, the collective plaint of a black community, Negro minstrel songs, above all in their passionate dance rhythms — spread throughout the whole of America by the early Dixieland bands — have influenced the ear for music of our age.

The encounter of the primitive African rhythm as embodied in the Christian hymns of the black American with the classical music of the machine age was followed, one might say, by the emancipation of the percussion instruments and the rhythmic accumulation of the sounds of the city, the tonal phenomena of a technological world.

Olivier Messiaen characterizes the basic idea of his music as the exploration of rhythm: "The essential element in my rhythmic system is that it recognizes neither the measure of the beat nor that of time. I have studied the rhythms of the Hindus, the Greeks, the Rumanians, the Hungarians, the rhythm too underlying the movement of the stars, of the atoms, of human bodies..." Messiaen has not only been influenced in his rhythms by Asian music; his transformations — modi — of harmony and melody are also conditioned by Indian and Chinese scales. The tonal and rhythmic enrichment of his musical language is being developed by his followers.

Here, too, one can see certain parallels to those abstract, calligraphic aspirations of the painters who attempt through meditation and inner experience to formulate the signs and essential content of things. "As opposed to the complete rationalization of European composition techniques, we now have a new freedom in all realms of music. In the process, principles become effective in western music which are derived both from purely musical considerations and from the mentality of extra-European civilizations: the I-Ching, mandalas, mantras, meditation, and so on. Thus, some composers base their work on the Zen Buddhist teaching of the immediate experience of reality. The inclusion of the element of chance in notation (Cage) recalls eastern calligraphy. In aleatoric music, finally, we notice impulses that are based on the practice of musicians in India to perform according to fixed schemata (Boulez)..." (Ramón Pelinski.)

During his Asian travels Karlheinz Stockhausen visited Buddhist and Shintoistic temples and monasteries. In 1970 he sketched out his composition "Mantra" at Osaka. Of this work he says: "Of course, the uniform construction of 'Mantra' is a musical miniature of the uniform macro-structure of the cosmos, and it is likewise an enlargement into the acoustic time-field of the uniform micro-structure of the harmonic vibrations in sound itself..." The term mantra can be understood as saying, song, prayer, and, perhaps in Stockhausen, as sacred word or magical poetry.

Arnold Schoenberg's emotionally charged Expressionism burst the bounds of the traditional aesthetic by means of the atonality which he ordered in his twelve-note system: the artist's production, says Schoenberg, is instinctive; consciousness has little influence in the process. It is, Schoenberg continues, as if what the composer should write is dictated to him. He is the executor of a hidden will, of the instinct, of the subconscious in himself. Edith Gerson-Kiwi points out that Schoenberg's serial compositions have certain characteristics in common with the techniques of Arab, Indian, Persian and oriental-Jewish music. This is probably a case of unconscious congruence between twelve-note music and extra-European musical conceptions. This hypothesis appears all the more important when we remember that serial music continues to influence post-serial, electronic, concrete music and the aleatoric method.

The exhibition "World Cultures and Modern Art" aims to document the universalist tendencies and aspirations in modern music and to make people conscious of this through actual performances. The musical material of Asia, Oceania, Africa and America with their rhythmic structures, characteristic melodic forms, tonal impressions and in the multiplicity of their musical instruments is now freely at the disposal of the creative spirit of our age. The occidental system of tempered music has now been placed in the historical context of the manifold musical systems of the world. A synthesis of musical cultures has now become possible.

The Unity of the World in the Vision of Art

We know that the world is changing and that man is changing the world and the world man.

Jean Paul Sartre

Worldwide emancipationist movements of peoples and races which run parallel to the revolutionary restratification of the peasant and proletarian masses are rapidly producing changes in the map of the world. Customs, rites, religions and arts of the vast regions of Asia and Africa are being shaken to the roots by the encounter with western culture and developed technology and are subject to radical transformations. Opposed social systems and mental worlds are changing and interpenetrating. Those peoples and tribes still living in primitive social structures which are in process of throwing off the supremacy of the White imperial powers often abandon with their ancient traditions their own mythically inspired art, too.

Wherever archaic or primitive cultures are unprepared for contact with technological civilization, there follows a crisis which also effects the field of art. Not only do the antipoles of tradition and revolution, of consolidation and dissolution appear: the development is no continuous forward process. Parallel to the movements for emancipation among the peoples and the advance of industrial civilization, there also arise backward-looking tendencies which correspond to the conceptions of a primitive world before it has reached the stage of reflective self-knowledge.

Messianic movements in Africa and in America spring up everywhere: the Black Moslems, Hindu and Islamic religious tendencies, sects and denominational groups, based on racist or nationalist ideas. These religious tendencies are at times accompanied by cultically-disposed primitive art movements, as for example the Vodu religion by the naive painting of Haiti.

The youthful crusade of the "cultural revolution" combined the primordial magical viewpoints of ancient China with the theses and dogmas of socialist reality. Mixtures of an archaic collective interpretation of the world of Taoism and Buddhism with the functionalism of a technological neo-primitivism.

A large proportion of the population of India lives in the cut-and-dry world of the totem clan reordered in castes, inspite of the modern views of a thin stratum of highly cultured people. Magic, religious beliefs and superstition live side by side with knowledge and understanding. The enlightenment can no longer be made retrogressive, but the old traditions continue to exercise their influence in the background.

Extra-European Portraits

Whereas in the past foreign continents and zones were regarded as unattainably and impenetrably distant because men were then rooted spatially and temporally in their own self-contained worlds, today we can encompass the world in a brief space of time, and events can be experienced and registered in all parts almost simultaneously.

Encounters of the cultures in the twentieth century no longer imply mere cognizance of heterogeneous social and artistic formations. They now lead to the bursting of the bounds set by space and time, to a creative crisis, to new tasks and possibilities. To see the world as a potential unity is by no means the same as denying the variety and diversity of cultures. The creative fantasy manifested in all cultures can find expression in the manifold colours and forms of the landscapes of all the corners of the earth: their uniformity is to be seen in equitable conditions for their pluralist existence.

Scientific research methods and their results exert an effect in the most distant and backward regions of the world. However, alongside the worldwide powers of communication and progress, there still exists inequality in the social and economic realities. In our so easily surveyable world, need and misery have become particularly visible. The majority of mankind still has no share in the affluence created by civilization. The unequal levels of development at which the peoples are situated exclude the possibility that scientific, technological and aesthetic knowledge can be equally assimilated. Gauguin, discoverer of exotic worlds, painted shortly before his death a South Seas composition which he entitled "D'où venons-nous? – Que sommes-nous? – Où allons-nous?" These questions could be given no valid answer either by his tragic life or by his creative œuvre which signposted new ways for modern art. Yet, for all that, Gauguin's work underlines the necessary links of the European man and artist with the peoples and cultures of the entire world.

In its creative moments, art acts as a mediator between the world of reality and that of possibility. From Babylon to Vietnam human society has destroyed what it has built up. Will that mankind formed by science and technology, by mass communications media and cybernetics be able to find the way to end this process of destruction?

The art of this century is no longer specifically national in the fields where it is highly developed. We are living in an age of a world culture in process of formation. Relapses into the instinctual and racist primal urges must not lead us astray: the main line of development leads to the mastering of the particularisms of tribes, peoples, castes, to the dissolution of divisions and of the totems of isolation.

An intellectual community embracing manifold tendencies and formed by reciprocal effects is being ushered in on this dully shining planet we call earth.

Translation P. J. D.

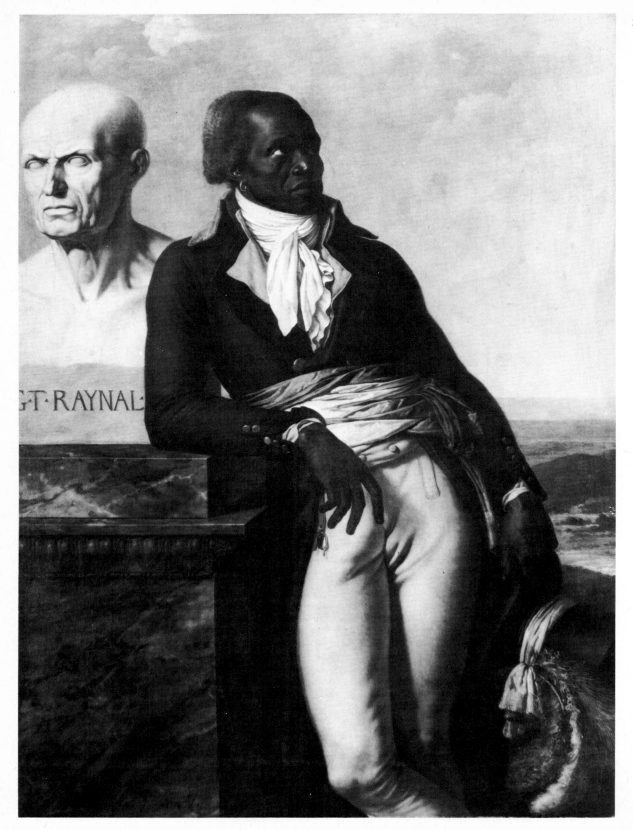

G·T·RAYNAL·

Portraits of Extra-Europeans in the Art of the Nineteenth and Twentieth Centuries

Siegfried Wichmann

Here it is our intention to examine the way the extra-European was portrayed during the nineteenth century. If until now it was the concept of dignity, based perhaps on the exaggerated insistence on grandeur in the portraits of kings and queens, which was all important, the art of the bourgeois realism of the eighteenth century is dominated by the egalitarian principle which is no longer willing to distinguish its subjects by their bearing and gestures. The idiosyncratic and individual elements in the person portrayed are discovered and now determine the form the portrait takes. It is certainly not without interest that nineteenth-century portraits differ in their external characteristics from those of the twentieth. The portraits presented in the Hall of the Nations have also been selected to underline these differences. This viewpoint has determined the grouping of the exhibits in the first section of the exhibition "World Cultures and Modern Art". The porcelain figurine of the "Chinese Emperor" and the Moorish group near the entrance to the room at once exemplify the rather obsequious bearing which almost forms the European ideal of the "exotic." This is a product of the extravagant chinoiserie which completely misunderstood both the facts and the reality, a cliché presentation of the outlandish such as is to be found only in Europe. The individual behind the externals had been completely buried beneath, utterly annulled by this theatrical, alienating conventional use of gestures. In contrast, the artists of the nineteenth century endeavoured to recognize a partner to be treated on equal terms in their portrayals of Asians, Africans and people from the Near East. The necessary prerequisites for this change were all present; although numerous they were, however, fragmented. Personal decisions and the aim to discover the world were to bring them to full realization.

Nevertheless, the portraits of the inhabitants of other continents are to remain during the nineteenth and twentieth centuries to a certain extent indebted to the European imaginary conceptions of foreign peoples which have been formed in the first place by popularizing scientific publications. Accounts of travels and

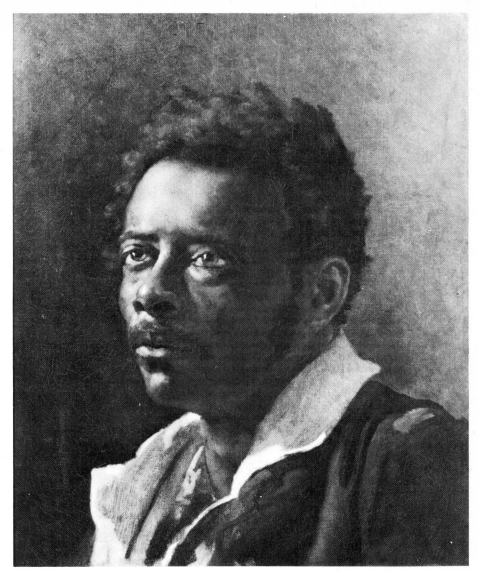

5 Géricault, Negro

guide books stimulate and arouse European interest in far lands and their inhabitants. The "Illustrated London News," the first number of which was published in a first edition of five million copies in 1842, mediated a whole new world of impressions and gave information on the way of life of foreign peoples, the effect of which should not be underestimated. Literature also did its part, like the novel "Robinson Crusoe", an early best-seller, or the novels of discovery which, although full of the most far-fetched details, encouraged interest in the peoples of distant lands. As early as 1840 there was hardly a school which did not have its maps of the five conti-

nents, and the geophysicists and geographers began to provide surveys which also helped to form the attitude of European artists and provided them with impulses and stimuli. As late as 1860, vast tracts of Africa, Central Asia, Arabia and the Amazonian regions were still terrae ignotae on the maps. The mounting economic interests of the European nations ensure that all this is a matter of topical interest in the newspapers. We must remember that the information provided in the journals was just as one-sidedly influenced by the magnates of commerce and industry as the scientific publications of the time. The enormous interest in trade and commerce, in an

13

intricate interplay of trade connections and traffic routes drew representatives of the European powers overseas.

The nations of the continents in their progress towards greater self-assurance and strength slowly but surely compelled the technicians and traders to study the colonial peoples and the mentality of those among whom they lived. This in turn meant that the question concerning the nature of the various peoples who go to make up the human race became even more topical. The history of mankind and the existence of the different races and tribes were made the subject of scientific research and it was disputed whether it was more appropriate to call the new science anthropology or ethnology. This dispute, which continued for many years before the solution was found, only created a confusion of ideas which merely contributed towards buttressing the imperial way of thinking still further.

9 Bodmer, Pehriska-Ruhpa

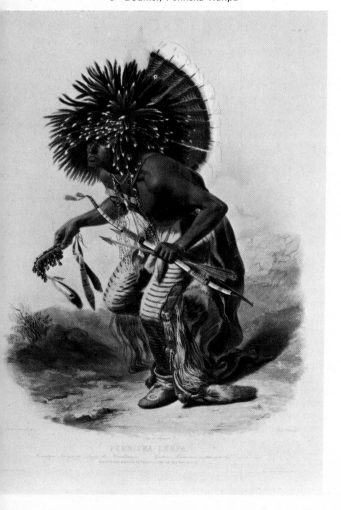

The artists, however, who first of all travelled through the lands adjoining Europe and then through Central Asia, Africa and South America, discovered the various peoples of the world for themselves. They depicted them as they saw them, without preconceptions and prejudice, from the standpoint of artistic freedom and underlining what is individual and different about the people they were portraying. It is above all the social milieu which was thus given greater significance. The scientific views of the ethnologists now began, too, to recognize the essential interconnections between the nature of the country and of its inhabitants, just as Delacroix had so acutely observed and depicted on his journey to Algeria. Determinism gave rise to the science of geopolitics which aimed at showing that everything is subject to strict laws of development. The concept of the "biological form" was created. A connection was seen between man's existence and his natural environment. The unending variety of human adaption and the multiplicity of types arising as a result were to receive adequate confirmation.

The French and English oriental painters depicted the rich variety of forms which is to be traced back to these environmental influences – they can be said to have presaged in a certain sense these later developments. It was the illustrations in the various publications which reproduced humanity in all its manifold forms. In this way certain subconscious types were impressed on the mind of the European: the defiant upturned glance of the slave or the Red Indian stealthily approaching in true Robinson Crusoe tradition, the fast-running and quick-witted Indian warrior, those are all cliché pictures worthy of the novelistic extravagance of the time.

To Eugène Delacroix must go the honour of having penetrated right to the very innermost being of the peoples of North Africa in his portraits. He gives due recognition to their way of thinking, esteems their culture and tries to get to the bottom of the laws which govern the societies in which they live. At the risk of his life he enters the areas where no foreigner dares tread, collects vessels and objects of daily life, accompanies hunters on their perilous undertakings or studies the colourfully dressed warriors on their swift steeds. Delacroix is one of those artists who recognize the vitality and forces hidden in these unknown nations. He depicted extreme varieties of bearing and gesture with complete sympathy and understanding.

The forms of behaviour of men in the desert are different to those of the European – this is an experience which is to affect his work to the end. Delacroix catches movements which are directly opposed to those of the classical Greek and Roman tradition. "If the art school insists on giving the young devotee of the muses the family of Priam and Atreus as his subject of study, then I am convinced it would be of much greater advantage to him if he were to enlist as a cabin boy on the next best ship sailing for the land of the Berbers than to continue to walk the classical soil of Rome. Rome is no longer in Rome," Delacroix remarks in one of his letters. Delacroix is thus one of the great synthesists among the artists of the nineteenth century; he draws on the untapped reserves of the tribes of North Africa in his pictures. And in so doing, he chronicles events and changes which burst the bounds of art.

Much less fortunate than the work of the painter and sculptor was the aggressive approach of the nineteenth century to matters of language. Great efforts were made on all sides to ensure the spread of the European languages. The encounter of the colonial administration with the cultures of the various subject lands gave rise to peculiar pidgin languages, a development which by no means furthered the creative talent of the peoples concerned. Political intervention served both the ends of the Christian faith and of economic interest; language was of greatest importance in the realm of religion. The humanitarian aims reflected in the slave trade are practically non-existent. They are not be brought into harmony with the missionaries' ideas and deeds. Language is the instrument either of force or of justification. It is precisely this which grants us an insight into the complex nature of the nineteenth century.

Islam was much better able to adapt itself to the attitudes of mind in the extra-European territories and it was able to directly integrate the religious needs of the people into its profession of faith. The slave trade survives as a frightful relic in the midst of nineteenth-century "humanitarian" Europe. No attempt to palliate or to clarify scientifically can mitigate the horrors of slavery.

The portrait of Jean-Baptiste Belley provides us with a direct insight into the situation which cannot be ignored. Belley, a former slave, added Mars to his Christian names. He was born in Senegal and died in Santo Domingo (the births and deaths of negroes were not registered). He was elected deputy to the

National Convention in the district on the island of Santo Domingo where he had settled as a planter. On 1st Prairial of the Year III he was deprived of his mandate by lot, whereupon he applied for a military mission and on 14th Floréal in the Year III was appointed commander of a battalion in the 16th infantry regiment. On 3rd Messidor in Year V he was made brigadier general and on the 25th of the same month he was named commander-in-chief of the gendarmerie on Santo Domingo. He accompanied General Leclerc, the commander of the expedition, with whom he also embarked. Promoted to divisional commander of the gendarmerie, he was imprudent enough to avail himself of the right of free speech. As a result he was cast into chains. His condition was so deplorable that even the Prefect of Brest was roused to sympathy; on 11th Messidor in the Year V, he enquired what compensation should be paid to Belley. The answer he received was: "There is no compensation for a negro that has been cast into chains." Thanks to the protection of Cambacérès he was freed and returned to Santo Domingo as a private person.

The importance of his portrait lies in the bearing and gesture the former slave assumes in front of a humanist bust and against a sweeping landscape. The picture shows us what possibilities were available to the nineteenth-century artist when presenting a man of great significance whose past would inevitably be incomprehensible to many of his fellow countrymen. The fantastic possibilities of adventurous antitheses are here combined; real facts do not have a part in creating the impression the picture makes. It is only in connection with post-classicist ideals that the warrior and champion is to be "immortalized," not on his own account but as a symbol of the colonial ideals of races other than his own. The neo-classical externals presented in this portrait show that the associations of the feudal portrait of earlier times still determine the convention. The painter is able to use artistic means to stress the contradictions: the white area around the neck and the white trousers stand in marked contrast to the dark skin and the striking face. Fear of the outlandish and strange, which should not be underestimated in nineteenth-century Europe, leads to prejudices and conventional judgments. This explains why the bearing and gestures of the black brigadier general are borrowed from the feudal portrait, within which he is "imprisoned," as it were. This dogmatic approach is absent from Theodor Géricault's unorthodox "Portrait of the Negro Joseph". Some of the important artists of the nineteenth century are just not prepared to succumb to the prejudices of their day, to subscribe to the cliché views of their contemporaries. Of this mould are the painters Theodor Géricault and Eugène Delacroix. They are opposed to stereotype conceptions; they are not prepared to generalize about foreign groups. The lasting effects of chinoiserie are still latently at work in the art of many, but Géricault and Delacroix call them into question once and for all. The Negro Joseph with the high forehead and the self-assured gaze is a deeper experience for Géricault than the representatives of his day whom he did not want to depict in their conventional guise. This insight brings painting to a technical perfection that is forward-looking in its handling of colour. The silken blackness of the Negro Joseph's skin is merged into the pronounced tones of the background. The light-coloured shirt contrasts with the finely differentiated presentation of the skin. For Géricault this picture is a confession of more than local significance.

The difference in the approach to this type of portrait is manifested in the lithography by Charles Bodmer (1809–1893) "Dog dance". The Indians of the Hidatsa tribe (Minitari) are here shown executing the dog dance in full war paint. This type of picture is legitimated by the numerous publications on the Indians. Robinson Crusoe had also been commented on and illustrated from an unending variety of viewpoints. The ethnological interest in the culture of the Indians stands in diametrical opposition to the destruction of the Indian reservations. Empty show was now the experience and in this sense these are but eighteenth-century reminiscences carried over into the nineteenth century. However, the possibilities of reproduction offered by printing meant that this was the view of the Indian say as continued in the Indian novels read by the young and was to remain the determining impression in the future, too. Nobility of character, energy and pluck, and complete mastery of the body were the characteristics which dominated the presentations in art as well.

During the expansionist period of the 1870's interest in extra-European peoples manifested itself in many other spheres, too. Souvenirs from foreign lands grew common in European homes. It became usual to arrange tiger skins and spearheads under palm trees. Mosque

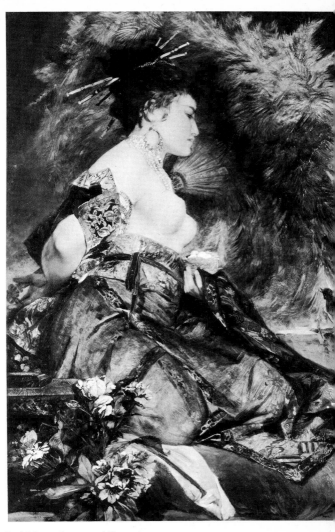

8 Makart, Japanese Woman

lamps embellished living rooms. Tents and their interior furnishings were erected in the mansions of English lords and of French and German nabobs. Hans Makart himself decorated his studio with Janissary swords and arrows of the Masai tribe of Africa. He draped Chinese court clothing and Japanese kimonos across the corners of his large studio. Buddhist alms bowls were arranged as trophies on the drums of South American tribes. The aim was always to pervade modern-style houses with medieval implements. Makart's Portrait of a Japanese Woman does not fall within the sphere of ethnology; there is more of the theatrical, of the stage set about it. It belongs rather to the whole ceremony of "make-believe" which found expression in his own liking for

masquerade at his parties and feasts. Makart was one of those European painters of the third quarter of the last century who knew nothing of cultural conflict, just as there was no such thing as social divisions for him. Everything that was there had the right to be there. This complex pluralism by which he was induced to regard everything as on one level led him to a universal viewpoint in art. The extra-European stimuli were also received in accordance with this principle and without prejudice. As a painter, Makart thus fulfilled a function in his day which documents pan-European interests. His colour notation is noticeably different from that of the oriental painters of the first half of the century. The direct relationships, the differentiated tonal variations Makart transposes for his part into the style of the old masters, which is not prepared to assimilate the impulses of extra-European cultures in such a way that they become part of the artistic means at the painter's disposal. It is another alienation process that commences at a time when the world exhibitions in Europe are putting on display the achievements of the different distant countries. Men had to realize that the organization and artistic energy of the peoples of the

7 Müller, Sphinx Visage

world were still not exhausted and that their great reserves of creative vitality could influence the European viewpoint.

Carl Leopold Müller (1834–1892) draws his inspiration from European oriental painting. His realistic approach as a portraitist he combines with an impressionist style that incorporates the sensation of inflowing light from all sides. Favourite subjects are caravans in a desert storm or colourful bazaars. What fascinates him about the North African is his behaviour, his composure. His picture is entitled "Sphinx face of today." Müller makes a real effort to understand the individual he is portraying and he uses corresponding artistic means. Only the head stands out in clear relief against the enveloping garments; the head alone attracts the attention of the viewer.

Paul Gauguin (1848–1903) goes a stage further in his mask of a Tahitan woman. The head is presented like a cultic object. Influenced by the Tikis, Gauguin depicts a head that reminds us of the ancestral skulls of the Hiva Oa islanders. The parts of the face are presented as if autonomous; they are ornamentalized just like the hair and blossoms. The simplified portrayal, confined to the essential traits, signposts the way that is to be taken. The encounter of the painters of the

Brücke with extra-European peoples also produced an elemental art which leaves its characteristic stamp on their portraits, too. Nolde, Schmidt-Rottluff, Heckel and Kirchner are filled with a remarkable sense of community. This leads them to portray groups, a tendency which can be traced through the work of all the Brücke artists. The journeys to the "earthly paradise" of the South Sea Islands gave these artists a general view of the inhabitants in their unspoilt natural surroundings. It is precisely this aspect which comes to the fore in the group pictures by Emil Nolde. Seen from the general viewpoint of the Brücke, the autostereotype of both groups is complementary. The picture which these artists have of the people of the South Seas corresponds partially to their self-portrait of their group. Of course, this group view is neither homogeneous nor lasting. This maximum of reciprocal understanding among these artists can be revised at any time. In the final analysis, the view of the extra-European which the artists of Europe have is heterogeneous. Life in a community, existence in the wild, simple ways of life, iridescent colour as a symbol of the paradisiacal world bears the mark of Expressionism which also formed Fauvism. The white eyes in Emil Nolde's group sparkle out of the darkness. These women of New Guinea, in their nakedness and with their fetishes, fascinate the artist, who thus receives new impulses from the way of life of the inhabitants of distant isles; in him there is thus resurrected what has been submerged by the academic approach of the nineteenth century.

Oskar Kokoschka, who grasped the fascinating figures of the Orient in a way similar to Slevogt, prefers to portray individuals. Like Leopold Carl Müller he sees a self-portrait in the portrait of a member of another race. He depicts the "Marabout of Temacin" as a magnate and representative of his people, a people who have now come to trade under the same conditions as the industrial magnates of Europe. The natural resources of the Near East and the high level of their cultures ensure that these peoples now appear in the pictures of European artists as equal partners, who nevertheless still appear in all their fine apparel and impressive splendour. The message these pictures convey is that the focal points of the world have shifted. Europe is no longer the economic and political centre of the world but one partner among many in the worldwide system of trade. Twentieth-century portraits

10 Gauguin, Tahitian

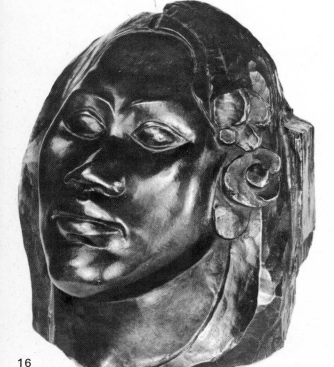

reveal that the Orient of today no longer corresponds to the Orient as conceived yesterday — a new world, one for all partners, is in process of creation.

Translation P. J. D.

1 *Elias Adam; Nautilus goblet;* silver, embossed, gilded, enchased; h - 35.6 cm; first half of 18th cent.; sig.: E. H.; Frankfurt, Mus. für Kunsthandwerk

2 *Johann Peter Melchior; manufacture: Höchst, Porzellanmanufaktur; Boy and Girl as Sultan and Sultaness;* porcelain; painted in colour, with gold setting; h - 18.5 cm (sultan), 17.6 cm (sultaness); c. 1770; Frankfurt, Mus. für Kunsthandwerk, Inv.-No. WMC 18; WMC 19

3 *The Chinese Emperor; manufacturer: Dammer; formed from the Höchst porcelain model;* earthen-ware, painted in colour; h - 41.4 cm; 1860–1878; Frankfurt, Mus. für Kunsthandwerk, Inv.-No. 7056

4 *Anne Louis Girodet-Trioson (Montargis 1767–1824 Paris); Jean Baptiste Belley;* oil, canvas; 158×111 cm; 1797; Versailles, Mus. National; plate

5 *Theodore Géricault (Rouen 1891–1824 Paris); Portrait of the Negro*

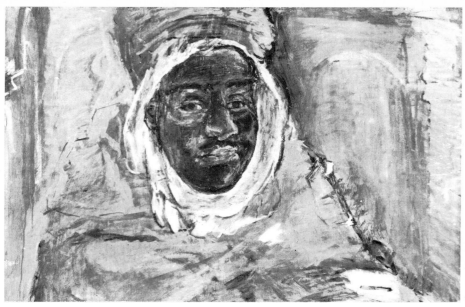

12 Kokoschka, Marabout (detail)

"Joseph;" oil, canvas; 46.5×38 cm; c. 1800; Winterthur, Hans Bühler Coll.; plate

6 *Eugène Delacroix (Charenton St. Maurice 1798–1863 Paris); Indian with Gurkha Kris;* oil, canvas; 40×32 cm; sig. bottom right: Eug. Delacroix; c. 1830; Zürich, Kunsthaus

11 Nolde, Women of New Guinea

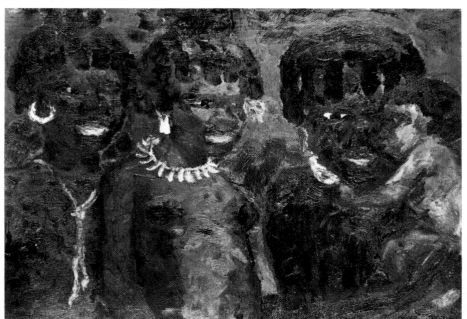

7 *Leopold Carl Müller (Dresden 1834–1892 Vienna); A Sphinx Visage of Today;* oil, canvas; 66.3×40 cm; sig. bottom left: Leopold Carl Müller; c. 1880; Vienna, Österreichische Gal. des XIX. und XX. Jahrhunderts; plate

8 *Hans Makart (Salzburg 1840–1884 Vienna); The Japanese Woman;* oil, wood; 142×92 cm; sig.: Hans Makart; 1875; Vienna, Ferdinand Pierer Coll.; plate

9 *Karl Bodmer (Riesbach 1809–1893 Barbizon); Pehriska-Ruhpa;* copper-engraving, water-colour; 43×59 cm; 1839–1841; Munich, Staatliches Mus. für Völkerkunde; plate

10 *Paul Gauguin (Paris 1848–1903 La Domenica); Mask of a Tahitian Woman;* bronze-casting by Valsuani (1959) from the original in Toa-wood; 25×20 cm; c. 1892; Paris, priv. coll.; plate

11 *Emil Nolde (Nolde, Schleswig 1867–1956 Seebüll); Women of New Guinea;* oil, sail-cloth; 73.5×100.5 cm; sig. bottom right: Emil Nolde; Seebüll, Nolde-Stiftung; plate

12 *Oskar Kokoschka (Pöchlarn 1886); The Marabout of Temacin;* oil, canvas; 97×130 cm; sig.: OK; 1928; Hamburg, priv. coll.; plate

Orient

Art and Sacral Drugs in the Orient

Rudolf Gelpke

In a brilliant study "Märchen und Traum" (Legend and Dream), Hannover, 1923, written more than half a century ago, the German Oriental scholar, Georg Jacob, formulated and substantiated certain views which were neither understood nor disproved. Unfortunately so; for Jacob's assertion that the actual source of the art of story-telling (and we may add, more or less that of every other art) of the Islamic Orient is the deliberately cultivated "conscious dream," is a key, which – correctly understood and employed – opens up the existential inner dimensions without which oriental works of art can only be misinterpreted. "The prostration of the will in favour of the fantasy characterizes the state of conscious dreaming" (Jacob). This concise phrase, which, in the cultural and psychological respect includes the most varied and often contradictory symptoms of "culture" in the East and West, entails the first of Jacob's perceptions interesting for us in this context; and the second derived directly from it, consists in the clear recognition of the very close interrelationship between artist and work of art on the one hand, and of the "various drugs exerting a powerful stimulating effect on the fantasy – above all hashish, thorn-apple, henbane, opium" – on the other hand.

Only after several decades had passed, in the nineteen-fifties, did the French graphic artist, author and student of drugs, Henri Michaux, arrive at the same conclusions independently of the German's research work and by a quite different approach, above all by subjecting himself to extensive experiments. He published his findings in several different versions, to my knowledge in greatest detail in his essay "Mécanisme des drogues" (1960). While Jacob laid emphasis upon literature, and within this, upon the spoken word of story-telling and so-called natural poetry, the Frenchman – as a primarily optically orientated artist – proceeds from his own hashish visions. The pronounced and recurrent Islamic – oriental character of such visions (minarets, domes, arabesques etc.) gave him the conviction, which he grew to advocate with increasing firmness, that hashish was responsible for the specific character of the Islamic architectural style, under the influence of which "the oriental, Persian and Arabic architects had visionarily perceived the refined forms and subsequently (in the outer reality) attempted to imitate them ..."

Not only does my own experience with drugs confirm this, but, several years ago, four artists and scholars– two Orientals, one European and one American–carried out a series of experiments with hashish and teonanacatl. The main object of the experiment was to clarify the "style differences" created by the specific effect of each drug.

Although it is not possible to go into detail here, it can be stated generally that (a) the Orientals felt "at home" and "integrated" under the influence of hashish; that (b) they showed pronounced alienation symptoms, felt "confused" and "lost" with the unfamiliar Indian drug, but when subsequently shown untitled illustrations of works of art dating from different epochs and civilizations, they immediately identified the Aztec works (seen for the first time) as conforming to the effect of the drug; and finally that (c) the Americans, who were familiar with Mexico and Indian art, experienced the mushroom as more "intimate" and hashish as "more exotic," while under the reversed preconditions the Europeans had the correspondingly opposite experience. It is by no means my wish to attempt to form "scientific proof" from such early, necessarily incomplete and more or less "illegal" experiments and personal experience. We have before us a whole huge continent of discovery and research that has not even been charted in outline. Our ignorance is two-sided. On the one hand, stubborn prejudice has prevented us from gaining access to an understanding of plant extracts, which, as sacral drugs fructified religion and art of extraEuropean high cultures in a similar manner and at similar times in the past (and partly in the present also) by making it possible for the so-called "metaphysical truths" to be experienced by the consciousness adapted for this purpose, thereby transforming mere belief into (inner) knowledge; also in that they inspired the artists among the initiates to reproduce the inner worldly (microcosmic) reality, whereby the style of their representations and not their realistic content "as such," which is absolute, also depends upon the chosen drug. On the other hand, our knowledge regarding the artists and styles of art is much more fragmentary, unprecise, contradictory and more hypothetical than the numerous, all too numerous art

volumes, catalogues and contradicting text commentaries wish to conceal. However, as far as the art of the Islamic Orient is concerned, of its intellectual-spiritual assumptions and background – not as established by western art historians but only by the initiated or from the often esoteric, largely still unpublished and unknown sources – the most important have either not yet been interpreted, or have been interpreted loosely and inaccurately. We turn to several "keywords" based upon still unpublished material collected during the last fifteen years. It should be said, however, that my insights only render the vision of oriental tradition whether communicated to me orally or in writing. In accordance with the specific character of Islam, which has been supranational from the very beginning and has always understood itself as a bridge-builder with western and eastern features, it has fused the inheritances of many cultures, peoples and races: old-oriental, Hellenistic and Jewish elements with the relics of the Great Persian Empire; African folklore and that of the Berbers with the administration or architecture of Christian, easternRome; Indian stories within a story, or the stories of the "Arabian Nights" compiled from three continents, with miniature painting adopted from the Chinese. Can one speak of Islamic art at all in that case? Certainly, for whenever and in whatever form we encounter works of art in the Islamic sphere, it seems to bear an invisible, but immutable and unmistakable seal. Whether it is the scroll enchasing a golden, turquoise or emerald green dome of a mosque; whether a gasel by Hafiz or Sheik Saadi; a sheet of the Koran in the archaic dignity of early Kufic writing, or a sample of Shekasteh writing of the Persian Quadarite period a thousand years earlier, which, in its lissom elegance, suggests a flight of herons soaring between gold-edged clouds; whether it is the portrait of a Mogul princess on the banks of the Ganges; the writ of an Ottoman sultan, which consists of twenty lines of magnificently conceived trifles around half a line of substance; whether it is the buoyant architecture of a Spanish Alhambra, or of the perfect symmetry of the Taj Mahal, or a carneole ring-stone minutely and masterfully engraved into a mini-cosmos of perfect harmony – in whatever form or material, with chisel, pen, or brush, these artists encircle a mysterious and hidden point, the invisible centre of a visible circle. But what point is this? It is the vision of paradise in the revelation of the Koran.

"They shall enter the gardens of Eden, which the Merciful has promised His servants in reward for their faith. His promise shall be fulfilled. There they shall hear no idle talk but only the voice of peace." (XIX, 61.)
"…they (the faithful) shall be decked with bracelets of gold and arrayed in garments of fine green silk and rich brocade…" (XVIII, 31 or 32.)
"…those on the right. Such are they that shall be brought near to their Lord in the gardens of delight; a whole multitude from the men of older, but only a few from the later generations. They shall recline on jewelled couches face to face, and there shall wait on them immortal youths with bowls and ewers and a cup of purest wine (that will neither pain their heads nor take away their reason); with fruits of their own choice and flesh of fowls that they relish. And theirs shall be the dark-eyed houris, chaste as hidden pearls; a guerdon for their deeds.
They shall hear no idle talk, no sinful speech, but only the greeting, 'Peace, Peace.'
Those on the right hand – happy shall be those on the right hand. They shall recline on couches raised on high in the shade of thornless sidrahs and clusters of talh; amidst gushing waters and abundant fruits, unforbidden, never-ending.
We (Allah) created the houris and made them virgins, loving companions of those on the right hand…" (LVI, 8, 11–38.)
"…the gardens of Eden, gardens watered by running streams, where they shall dwell for ever.
Allah is well pleased with them and they with Him…« (XCVIII, 8).
Just as the Islamic philosophers, scholars and Sufis have traditionally speculated upon the ideal picture of the perfect human being, it is the artist's ardent desire and highest aim to create an image of paradise. Both visions converge, fuse and become one in the Sufic mysterium of the wahdat al-wodschud (="unity of the existing"). This ultimate and hidden reality (as usual, rationalistically misunderstood in the West as "Pantheism") can only be experienced existentially, by inward communion, ecstasy, bursting open the ego, finding oneself; it can not be intellectually taught or learnt. Mystic and artist encounter each other in the whole sphere of the Islamic Orient (whereby the poet occupies an intermediary and mediatory position); then, for both, the external world of time and space is an "apparent world" and an "illusion," which conceals reality like a curtain or veil (pardeh, hedschâb). For this reason, Allah "knows" what man in

his blindness has to "believe;" the Koran contains the following, very important (perhaps the most important) words for the real artist:
"He (Allah) has the keys of all that is hidden: none knows them but he. He has knowledge of all that land and sea contain: every leaf that falls is known to Him.
It is He that makes you sleep like the dead by night, knowing what you have done by day, and then rouses you up to fulfil your alloted span of life. To Him you shall all return, and He will declare to you all that you have done…" (VI, 58/60.)
The fact that we are divided between a day and night-life, a Day-I and a Dream-Self – which can know nothing or practically nothing of one another – is the evident, permanent proof of our relative and transient existence. "The keys of all that is hidden" are in the hands of God, and "none knows them but he." Bu he can also reveal them to those whom he elects as his mediators and instruments. Thus, we read in the chapter III of the Koran, The Imrans:
"Nor will He reveal to you what is hidden. But He chooses those of his Apostles whom He will. Therefore have faith in Allah and his Apostle…" (III, 179.)
This is the common background against which both art and the role of the "soul drug" hashish and opium must be regarded and interpreted. This role is and must be ambivalent. The Sufi-sheik and founder of the order, Sheik Haydar (died 628/1051) ordered the hemp plant, called shâhdâneh ("King's seed") and zomorrod-giâh ("emerald plant") in Persian, to be sown around his grave, but before dying he made his adepts swear not to betray the mystery of the effect of hashischat al-foquarâ ("weed of the poor" and [or] "the Fakirs") to any outsider or unauthorized person. Indeed, one of the most frequent code names for hashish was – and still is – asrâr (=mysteries), which intimates both the mysteries of the inner life revealed by the drug and the exhortation to secrecy. Throughout the centuries, Sufis, poets and artists have repeatedly warned against betraying "the mysteries" to the profane outside world. It is thus spoken in riddles understood only by the initiated. For instance, as in the year 580 (= 1184 A.D.) the famous painter Jamâl Esfâhâni illustrated an authology of poets for the Seljuk sultan, Tugrul, the poet 'Abd ar-Razzâq dedicated a poem to him, which begins:
"O poet of the world of the soul in this world…" and ends with the words:
"In the ink of your noble script the ex-

19

quisite word flows on like the water of life in the darkness…"

First of all, we note that the painter Jamâl was also poet and calligrapher; the second probable and esoteric implication can only be divined if one knows that the legendary water of immortal life issues from a spring in absolute darkness hidden to human eyes, and that its guardian is the mysterious Chesr ("the green one") who, as the apostle of God, appears in the figure of a handsome double clothed in green to show the way to those who are lost and confused (both in an inner and outer sense). Chesr is also the "lord of the hemp;" his name is a secret term for hashish, which is frequently simply called Chasrâ ("the green"), and was also adopted into the French language in North Africa as "drogue verte;" moreover, in the Orient, the initiated call a hashish trip into the microcosm of the soul "to travel over the green dome."

Chesr in his double role as guardian of the spring of immortal life – in which the miniature painters of the Timurid and Safawid period (15–18th century) often depict him together with Alexander the Great – and as the apostle of transcendence, the embodiment of the innermost and indestructible self (of precisely that "Dream-Self" in contrast to the transitory "Day-I"), as the green guide of the confused and lost: this mythical figure simultaneously symbolizes the one thousand year old integration of Sufism and art in the Islamic East; a fusion so complete and harmonious that it can only be compared with Far Eastern Zen Buddhism. In the Orient there is no important artist (poet, painter, musician, calligrapher etc.) who, directly or indirectly, has not expressed his affiliation with the world of the esoteric and ecstatic, of the Sufi order and wandering Dervish in his life and work. On the other hand, not only were many of the great poets Sufis (Sheik Sanâ'i, Sheik Saadi, Sheik 'Attâr, Pir Jâmali, Jalâl ad-Din Rumi, Fachr ad-Din 'Erâqi, Ebn al'Arabi etc.), but every mystic was also at least a passive artist; for the means and methods of breaking out of the "prison of the ego" and closing the "outer senses" by ecstasy and inward communion, of waking the "inner senses" in order to make contact with the reality of the invisible, were largely those of art: for instance, "the hearing of music" (samâ), "dancing" (raqs), the "looking game" (Nazar-bâzi, the regarding of beauty in a person or a work of art to induce a state of trance), the recitation of verses or quotations from the Koran (half singing, half speaking), the "script illustration"

(chattâi = calligraphy) with simultaneous or subsequent meditation, and so forth. Even the famous "divine reflection" (zekr) is understood as inner painting, in that the daily, individual accretions of memories, emotions and affects are erased from the "page of the soul," which meditation in ecstasy then transforms into a reflecting picture of the absolute (this is also the esoteric sense of the negative and then positive binomial formula of the credo: La elaha ella'llah = "There is no god other than God (Allah)," which many Dervishes repeat in a specific rhythm of the body until they fall into a state of unconsciousness). The Sufis are thus soul painters; and the founder of one of the largest and most respected mystic orders, Sheik Bahâ' ad Din Band (= "painter") was named so because he had painted in himself the figure of Hagg (meaning both "truth" and "divinity"). As Sheik Haydar before him, he also recommended the members of his order, the "Naqschbandiyeh," to take hashish, and he frequently called the drug Waraq al-chiyâl (= "leaf of imagination"), because, by switching the consciousness to the frequency of conscious dreaming, it facilitated both an obliteration of the past with its self-oriented associations and memories, and a subsequent tuning of the soul to the wave length of the "eternal moment;" indeed, occasionally first making this possible. Thus, while the path of the Sufi "soul painter" leads from the outside to the inside, the task of the artist (painter, musician, architect, poet) is, the opposite: namely, to reveal the transcendent inner reality, which is invisible to the normal senses, in an external medium; but both, Sufi and artist (often one and the same person), meet and complement eachother in their knowledge of the "inner reality" and "apparent outer reality," for which reason they were often given the honorary title of "tongue of the invisible" or "mirror of the invisible."

In broad outline, this was and still is the background of Islamic art and whoever overlooks or ignores these prerequisites will necessarily misinterpret the meaning and character of oriental works of art irrespective of extensive "technical knowledge." The Persian scholar of oriental culture, Dr. 'Abdollah Râzi, has the following to say about Kamâl ad-Din Behzâd Harâti, a miniatur painter of genius of about the year 1500 A.D., the point of intersection of the declining Timurid and the developing Safawid styles: "His masterpieces are images of that which is hidden in the world of nature. They are shaped by the soul-code of

mysticism, and their message is the same as that of our great poets."

It is necessary to know that an elemental phenomenon of the change in consciousness produced by hashish (also by LSD and the psychedelic Indian drugs) is the animation of the so-called "anorganic nature": rocks and cliff awake from their rigid passivity, they shift and move, reveal faces and transmit messages into the universe which call to be decoded; a cloud, veins of wood, expanses of sand and snow, suddenly become as transparent as water with a multi-laminated inner life; but the figures and ornaments of a carpet or curtain created by human hand, also betray the secret of their vitality, and we understand what is revealed. However small the chessboard is, however limited the figures and squares, the combination possibilities are ultimately infinite.

From the insight into such experiences derives the Sufi's certainty that the "unity of existence" (wahdat al-wodschud) has penetrated into the soul, which, surprised and overcome, is freed from the ego with its fear of death and fear of living: and it is this certainty that has given its name to the most potent of all hemp drugs, the most penetrating and profound, namely the Dugh – e wadat (= "curdled milk of unity" consisting of hashish, a little safran and occasionally other ingredients added to curdled milk fermenting in the warmth of the sun). However, the depth of insight is offset by its danger. Pir Jamâli (died 879/1474), Sheik of an order and artist, and called "pole of the loving," is one of the profoundest of all the initiated. In one of his works which have been kept secret by other initiates for 500 years, he writes: "From the right appropriation (inner experience, events, results), paradise finds its right form and shape; and from barbarity and ignorance results hell … O dear friend! Whatever appears to be easy (in the journey through the cosmos of the soul), its mystery conceals the difficulties in itself. Be in harmony with your own truth (or [and] "divinity" = hagg) so that you do not suddenly push yourself into hell with your own hand; and as long as one has not shown you yourself, you do not know this…"

For the eastern esoterics, our knowledge of the possibilities and dangers of forms of energy within the "outer" sphere (dynamite, electricity, X-rays, atomic power) was and is their knowledge of the immense healing and destructive power of that "key to the invisible," the soul drug from hemp and opium. Only seldom do important artists break the

self-imposed rules of caution and secrecy in respect of this "key." An exception is to be found in the case of the incomparable "Gasel of Sams Tabrizi," which are neither poems nor works of art in the usual sense, since their creator, Jamâl ad Din Rumi (died 672/1273), a unique ecstatic between prophet and artist, composed them in an ego-freed trance, often dancing and singing, and – as he repeatedly assures us – in supertemporal union with his vanished master and beloved Sams ("Sun") as his veritable re-incarnation. Thus, Rumi's songs reveal, as though through a slit in a curtain, what the "keys to the invisible" meant to the esoterics in their so ambiguously cryptic inner world:
"When all, those above and those below, have drunk the water of Chesr,
Who remains in drudgery, lost in tears and sorrow?"
This is the same vision which, a century earlier (1164 A. D.), had induced the artist-romantics under the ruler of Alamut, the Grand Master of the Order of Assassins, Hassan II, to make the fateful proclamation of the dawning of paradise on earth; fateful because two fundamentally irreconcilable levels of reality were destined to collide: the inner, supratemporal, absolute level of the mystical ecstatic, and the outer, "political," relative level in time and space. This sacrifice of the esoteric principle implied the death sentence for the order, which was to be eventually carried out by the Mongols. A similar thing happened in the year 962/1555 A. D., when directly influenced by hashish visions, a group of so-called Qalandarân (wandering Dervishes comparable to the earlier mendicants or present-day hippies) proclaimed the Safawid ruler, Shah Tahmâsp I, as Mahdi, the twelfth and last Imam of the Shi'ites, who had disappeared in 941 A. D. and whose return, proclaimed as the "end of time," has been awaited ever since. When the hashish Qalandarân insisted upon the truth of their visions despite rejection by the Shah, court and priesthood, the Shah gave them the alternative of recanting their belief or of being clubbed to death. As this was of no avail, action was decided upon. However, while one visionary after another died under the club, the remainder carried off the Shah, whom they chose to ecexute as heretic rather than honour as Mahdi. None of the "wandering hashish scholars" (as the malignant court scribe grudgingly called them) recanted; and so finally the whole forty of them were "dispatched into the plains of nothingness…" This report, which is apparently

still unknown to western scholars (and whose truth and accuracy can not be doubted, since it comes from the official and pedantically accurate Safawid chronicle of the court scribe, Eskandar-Beg), is certainly a unique document of its kind: forty "good-for-nothing wandering Dervishes and Dervish-playing hashish vagabonds" sacrifice their lives, without exception and without conpunction, merely because they were not willing to give up their "corrupt belief" that the Shah – their executioner – was the Mahdi, the twelfth Imam who had returned from the "great concealment." Western scholars, M. G. S. Hodgson and others, have explained the use of hashish by the assassins (fedâ'-iyân) by suggesting that when the drug is taken habitually it has a debilitating effect; and whereas it can also produce momentary frenzy, it makes planning, perseverance, patience and resolution impossible. I feel that this view is sufficiently refuted by our Safawid record, or by a second much more detailed item in the same chronicle. In the year 988/1580, a wandering Dervish appeared in the Gilan mountains and assisted by a great physical resemblence, claimed to be Shah Esma'il II who had died three years earlier (probably from an overdose of opium). He mobilized thousands of madcap supporters, won several brilliant battles against the government troops, killed their generals, Rostam-Beg and Chalil-Chân, captured towns, and could only finally be overcome after a great deal of effort had been expended. This Qalandar, popular leader and pseudo shah – who remained nameless behind his double's mask – was also a hashish lover; in the jeering and abusive words of the court chronicler, a "fool" who, "in the celestial soaring of delirium gave perverse fantasies access to the castle of the mind," used "alien vagrants," boasted extravagantly, promised everything to everyone and seduced "those blockheads of the steppe" to leave "the path of common sense." Even after his death, there were numerous successors and imitators among the "hashish Qalandarân."
Altogether, our Safawid chronicle reveals how general the use of hashish and opium was in the sixteenth and seventeenth centuries. Both were eaten (the Indian habit of smoking narcotics first entered Asia after the discovery of America); and whereas the lower social groups of Dervishes and their artists used hashish, opium was exclusively and widely taken by the "great men of the sword and brush": for instance Shah Esmâ'il II (died

1577), the famous physician Hakim' Emad ad-Din, the last Lâr prince and great musician, Ebrâhim-Chân, and many others.
The greatest miniature painter of this century, the Persian Ostâd (master) Hosayn Behzâd recently died at the age of 75. He left about four hundred finished works, a number of which can be seen in European and American museums. His pictures have been exhibited with great success in the major cities of three continents (apart from India and Japan, the cities of Washington and New York, Paris and Brussels, Prague and Warsaw), and he received numerous international awards, testimonies and decorations. Eastern and western critics alike often referred to him as "the Picasso of the Orient;" and although he rejected this comparison, and did not require it, and although both artists are just as different as European and Asian painting, there are nevertheless several interesting parallels: both, the Persian and the Spaniard, are masterly technicians, who command perfectly all the artistic subtleties of their forerunners and every style of their cultural environment. This is demonstrated in Picasso by his very different consecutive "periods;" Behzâd on the other hand, has only one, his "own" style, which he constantly endeavoured to expand by means of integration. Another point of contact is Paris, for the emigrant Picasso his adopted country and platform of worldwide fame; for Behzâd, whose visit as a student was short but very important, the place of his encounter with "the art of the modern (western) world" as he himself wrote. Finally, Paris is the place where both artists found their mutual friend and admirer, the poet author, graphic artist, film designer and académicien, Jean Cocteau. Truly, a rare and curious chapter of history, in which within the magical magnetic field of Orient and Occident, three names have become worthy symbols of their countries.
Two of these three, Behzâd and Cocteau, were ardent smokers of opium; the latter wrote of his experience with this drug in an illustrated account sine ira et studio, which I believe to be one of the shrewdest and most just treatments of the poppy extract to have been written in an occidental language. It also reveals that Picasso was at least familiar with the odour, for Cocteau quotes him as saying: "Of all the odours in this world, that of opium is the least disagreeable."

Translation G. F. S.

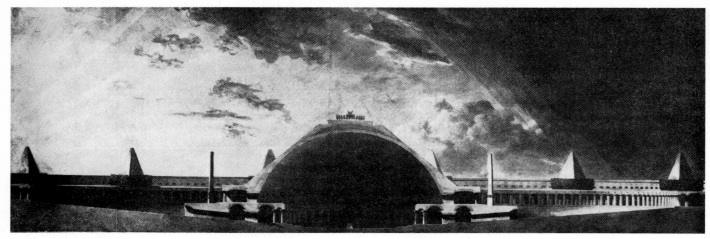

14 Fontaine, Tomb Monument

Egyptian Vogue

Following the initial interest shown in exotic motifs during the baroque period, the architects of the revolutionary era became the first to place an extra-European art — namely, that of Egypt — on an equal footing with the Greek-Roman tradition. The stereometric basic forms of sphere, pyramid and cube, which Claude Ledoux, Louis Boullée and Pierre Fontaine had proclaimed as the primitive forms of architecture, were now subjected to a more intensive confrontation with those of the Egyptian world of art. Their objective was block-like functionalism, their social task — to pull down the architectural hierarchy (porticus, projection, villa as symbol of ruling power). With their numerous designs for cemeteries and tombstones in pyramid form, the architects of the revolution prepared the way for the building styles of the Empire and of historicism. The pyramid thus became the current symbol of the everlasting monument, or eternity itself, and maintained this role into the twentieth century.

The objective of Napoleon's Egyptian expedition, in which over 120 scholars, technicians and artists participated, was not only to fulfil politico-economical objectives, but also to study and catalogue Egypt's monuments. The publication of the illustrated folio editions after 1809 laid the foundation stone for Egyptian styled tendencies in architecture and arts and crafts. H. L. Transl. G. F. S.

13 *Etienne-Louis Boullée (Paris 1728–1799), Cenotaph*; pen-and-ink drawing; wash; 39 × 61.3 cm; Paris, Bibliothèque Nationale, Cabinet des Estampes

14 *Pierre-François-Léonard Fontaine; Tomb Monument for the Ruler of a Great Empire*: detail; pen-and-ink drawing; 68.8 × 207.64 cm; 1785; Paris, École Nationale Supérieure des Beaux-Arts; plate

15 *After Friedrich Gilly; Design for a high stove*; pen, gray and black ink; 30 × 45.6 cm; c. 1800; Berlin, Staatliche Museen Preußischer Kulturbesitz, Kunstbibliothek

16 *August Stüler; New Museum, Inner Courtyard; from August Stüler, Bauwerke, Vol. I, 1862;* Berlin, Staatliche Museen Preußischer Kulturbesitz, Kunstbibliothek

17 *Description de l'Egypte ou Recueil des observations et des recherches qui ont été faites en Egypte pendant l'expedition de l'armée française, Vol. I, Paris, 1809, Vol. 4, Paris 1817;* Munich, Zentralinstitut für Kunstgeschichte, Bibliothek

18 *Johann Hoegl; Chest of drawers;* wood, partly gilded and painted; h - 131 cm, w - 200 cm, ⌀ - 86 cm; 1828; Salzburg, Erzabtei St. Peter

19 *Christopher Dresser (Glasgow 1834–1904 Mühlhausen) Silver cupboard;* black lacquered wood, bronze-green casing; h - 219 cm, w - 141 cm, ⌀ - 62 cm; c. 1880; Richmond, Stuart Durant

20 *France; Table obelisk;* bronze on white marble, porphyr and onyx base; h - 118 cm, end 18th cent.; Paris, Palais Beauharnais (German Embassy)

21 *France; Two Athletes;* blue marble; h - 175 cm; circa 1800; Paris, Mus. Marmottan

22 *France; Desk set;* gilded bronze; w - 28 cm; c. 1800; Paris, Mus. Marmottan

23 *France; Inkstand in form of a Canopic vase;* imit. basalt; 40 cm, c. 1800; Paris, Mus. Marmottan

24 *Thomire; Nubian-Women with Candlabra (pair);* bronze, gilded, with hieroglyphics; h - 122 cm; c. 1800; Paris, Palais Beauharnais (German Embassy)

25 *France; Girandoles (pair);* bronze, partly gilded on marble base; h - 82 cm; early 19th cent.; Vienna, Österreichisches Mus. für angewandte Kunst, Inv.-No. 25345/Br. 1139

26 *George Smith; Chair;* beech, gilded, painted in black; h - 87.5 cm, w - 65 cm, ⌀ - 68,8 cm; 1806; Brighton, Art Gall. and Mus. and the Royal Pavilion

27 *William Holman Hunt; Chair:* mahogany, sycamore with ebony and ivory; h - 83.4 cm, w - 47.5 cm, ⌀ - 48.5 cm; Birmingham, City Mus. and Art Gall.

28 *Albert Cheuret; Clock;* silvered; 17 × 38 cm; sig.: Albert Cheuret; circa 1900; Paris, Alain Lesieutre

The Orient and Nineteenth- and Twentieth-Century Architecture

Wolfgang Pehnt

Like the fine arts, the architecture of the nineteenth and twentieth centuries has the foregoing, eighteenth century to thank for the broadening of its horizon. The exotic settings of the novels then written and the books of travel and of engravings which were produced in the century intermediate to the Baroque and the Neo-Classic periods are completely in accord with the program of universal history which Voltaire gave such celebrated formulation to in his "Essai sur l'histoire générale et sur les mœurs et l'esprit des nations" (1756). One of the weighty reasons why a historiography based entirely on the Christian view of the world was in need of revision was that it completely neglected all the civilizations outside the Greco-Roman West. Preoccupation with Chinese, Indian or Islamic culture and civilization was, in the eyes of the Enlightenment, one of the hallmarks of the cosmopolite or citizen of the world.

However, the architectural follies which we come across everywhere in the landscape gardening of the eighteenth century, from Kew and the Désert de Retz to Drottningholm Palace and Wörlitz Castle, all stand in marked contrast to these high ideals. The Confucius houses, pagodas, mosques and Turkish kiosks provided, like the Gothic ruins and Greek temples, occasions for sentimental meditation and can be justifiably interpreted either as an illusionary escape from the realities of the industrial age just dawning or as evidence of incipient worldwide communication. At any rate they satisfied the practical need for small isolated buildings for intimate social gatherings and, at the same time, the psychological yearning for "variété" and "novelty". Kant provides a good summary in 1785: "The information which the new voyages have disseminated about the diversity of the human species has so far contributed more towards stimulating us to delve further than towards satisfying our thirst for knowledge."

The eighteenth-century architects and their patrons were so little troubled with doubts about antiquarian authenticity that terms like Chinese, Arabian and Gothic were interchangeable, in fact mere synonyms for anything alien and foreign. This utter ingenuousness in their handling of the exotic repertoire was no longer vouchsafed the architects of the following century. What had until then been the private "folie" of feudal landowners with large parks now began to concern the general public, whose interest had been awakened by the colonial acquisitions, international trade, ethnological expeditions and archaeological excavations. Consistency in the use of stylistic means became a criterium—even if disputed—by which the architecture especially of the first half of the nineteenth century could be judged. Faithfulness to one's model was opposed as a valid alternative to the eclectic approach, in the strictest sense of the term. The Eclectics were convinced that it was impossible to create entirely new architectural forms. Only by the appropriate selection, combination and ornamentation of available forms can "we, who know all the foreign creations of the past and the present," produce something stylistically new and original.

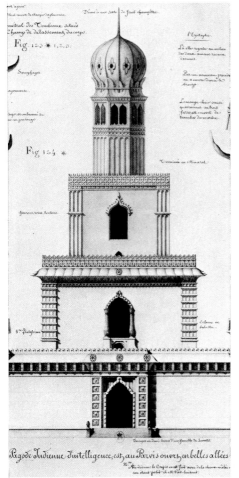

29 Lequeu, Indian Pagoda

A noteworthy achievement of the historical-minded nineteenth century consisted in welding the problematical wealth of new forms into an applicable language. An *architecture parlante* was also the declared aim of the so-called "revolutionary architects" (Boullée, Ledoux), although for them architecture was to "speak" through the very evocative power of the form or by the direct meaning it conveyed to the viewer. However, historical and geographical knowledge was a prerequisite to an understanding of the *architecture parlante* of the nineteenth century. It was not the form in itself which "spoke," but its origin. The horizon of ideas which was involved in each quotation from the historical repertoire was regarded as the product of a preliminary semantic enquiry. Certain architectural tasks involved certain styles.

Extra-European models were, understandably enough, more rarely followed than examples from the tradition of the West, but they did nevertheless differentiate and multiply the possible modes of expression. With the exception of Egyptian architecture, which early acquired a set value as a source and was used for edifices dedicated to the cult of the dead or—an evocation of the Egyptian theocracies—was employed to document the power of the state, the exotic products of the eighteenth century had mediated little more than the attraction of the outlandish. In the nineteenth century, on the other hand, an iconography developed which was legible to the cultured middle-class public, an iconography which could descend to detail without thereby becoming less intelligible. Thus, the Byzantine motifs in Léon Vaudoyer's Cathedral at Marseilles (1852–72), for example, were a clear allusion to the Levantine connections of the port. The choice of repertoire could convey even the most subtle thought-contents to the connoisseur. The oriental pavilions and castle projects of King Ludwig II of Bavaria and the Indian extravaganza, the Winter Garden which he had laid out (1867–71) under a steel and glass roof over the "Festsaalbau" of the Munich royal residence, are all connected with eastern ideas of purity and deliverance, with which the Monarch was preoccupied for very personal reasons.

"(It is) ... an undertaking doomed to failure to try and turn to account for our own age the content and forms of earlier architectural periods," Ludwig Mies van der Rohe maintained in 1924. But in direct contradiction to the wholehearted efforts of modern architects to cast off the very notion of style itself with the histori-

23

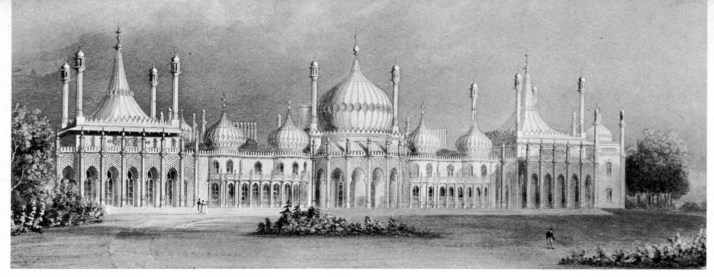

30 The Royal Pavilion

cal styles, even the avant-gardists cannot get along without some borrowing from the past. The fact that many twentieth-century architects regard themselves as revolutionary does not by any means signify that they have rejected all models; it only means that they have both sought and found new ones." Moreover, history

35 The Oriental Annual, View of Delhi

does not soil our hands; on the contrary, it fills them for us" (Le Corbusier, 1929). Non-European architecture—however, not so much its great and extravagant creations as far more its anonymous achievements—played an important role in the development of the new architecture.

The forms which the preoccupation with and the adoption of the extra-European took in the twentieth century are those which had evolved in the course of the

eighteenth: the appeal to actual or alleged parallels (the liana-bridges of the Pueblo Indians, for example, and modern suspension bridges; the ribbed framework of primitive dwellings say in Samoa and modern construction methods like that of Zollinger); influence on the grounds of comparable structural demands, functional needs or stylistic intentions (Mediterranean dwelling-habits and contemporary housing construction); the adoption of individual basic forms of construction

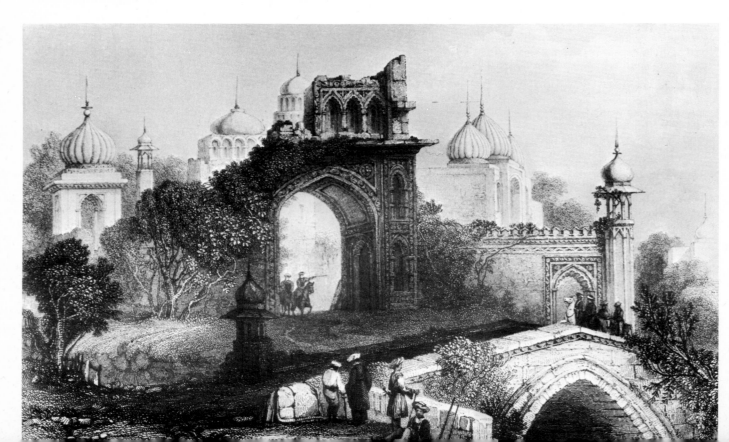

(Ziggurat, and stepped terrace-construction); the borrowing of—for the most part ornamental—details (e. g. early Mexican decorative elements by Frank Lloyd Wright).

At times of aesthetic crisis, twentieth-century architects have felt no qualms about adopting the classical procedure of Eclecticism: they make a compilation of what were once self-contained formal systems and then adapt them to the changed constructional and functional circumstances. When, around the year 1955, the prestige of what was known as the "International Style" was at a low ebb, a good number of architects decided to adopt methods that were not different from those of their predecessors in the 18th and 19th centuries. Edward D. Stone combined the layout of the classical temple with mashrabiya-type screen-walls and Minoru Yamasaki united Gothicizing façades with Islamic cupolas. Praise of eclecticism by a contemporary architect like the former art historian, Philip Johnson, sounds all the more suspicious and naive, because it is in no way bound up with considerations stemming from a philosophy of history or rooted in a spirit of aesthetic functionalism, in marked contrast to a number of the Eclectics of the nineteenth century: "There is only the feeling of a wonderful freedom of endless possibilities to investigate, of endless past years of historically great buildings to enjoy."

Translation J. P. D.

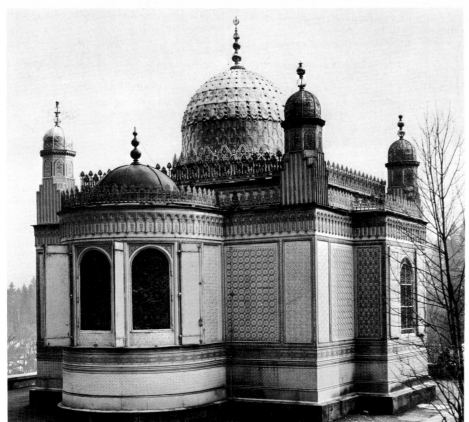

41 Diebitsch, Moorish Kiosk in Linderhof

Orientalizing Architecture

29 *Jean-Jacques Lequeu (Rouen 1757–1825?); Indian Pagoda;* drawing, pencil and watercolour; 44×29.5 cm; c. 1800; this is a perfect example of the stylistic pluralism typical of the nineteenth century; Paris, Bibliothèque Nationale, Cabinet des Estampes; plate

30 *John Nash (London 1893, lived at Wormingford, Colchester, Essex), Royal Pavilion, east view;* aquatint, 37.8×53.5 cm; 1826; Brighton, Art Gall. & Mus. and the Royal Pavilion; plate

31 *John Nash (after Augustus Pugin); Royal Pavilion, west view;* aquatint, 37.8×53.5 cm; 1826; Brighton, Art Gall. & Mus. and the Royal Pavilion

32 *John Nash (after Augustus Pugin); Royal Pavilion, music room;* aquatint,

37.8×53.5 cm; 1826; Brighton, Art Gall. & Mus. and the Royal Pavilion

33 *John Nash (after Augustus Pugin); Royal Pavilion, banqueting room;* aquatint, 37.8×53.5 cm; Brighton, Art Gall. & Mus. and the Royal Pavilion

34 *John Nash, "Views of His Majesty's Palace at Brighton," 1826; 35 aquatints (28 coloured) of the exterior and interior of the Royal Pavilion;* Brighton, Art Gall. & Mus. and the Royal Pavilion

35 *The Oriental Annual, London 1840, vol. 7; This is a collection of aquatints made by Thomas Daniell and his nephew, William, who went to India for ten years in 1784 to study and draw the monuments of art there;* Munich, Bayerische Staatsbibliothek; plate

36 *Northern India, Attack on an Enemy Castle; leaf from the Hamza Book;* Mogul miniature, tempera, water-colours; 63×78 cm; 1570–1579. Produced at the court of Akbar the Great; Vienna, Österreichisches Mus. für angewandte Kunst, Inv.-No. K. I. 8770/38

37 *Northern India, Kirke the Sorceress abducts Maelaek Mah, Leaf from the Hamza Book;* Mogul miniature, tempera, water-colours, 63×78 cm, 1570–1579; Vienna, Österreichisches Mus. für angewandte Kunst, Inv.-No. K. I. 8770/36

38 *Karl Friedrich Schinkel, Plan for Orianda Palace, 3rd edition, Berlin 1862;* Berlin, Staatliche Museen Preußischer Kulturbesitz, Kunstbibliothek

39 *Karl von Diebitsch (1819–1869); construction plan;* pen, water-colour, body colours; 50.1×70.3 cm; c. 1850; Berlin, Staatliche Museen Preußischer Kulturbesitz, Kunstbibliothek

40 *Karl von Diebitsch, construction plan;* pencil and pen, water-colour, body colours; 49×65.1 cm; c. 1850; Berlin, Staatliche Museen Preußischer Kulturbesitz, Kunstbibliothek

41 *Karl von Diebitsch; Moorish kiosk in the grounds of Linderhof Palace* (photograph); The "authenticity" of the kiosk is presumably the reason why King Ludwig II of Bavaria bought it in 1876; plate

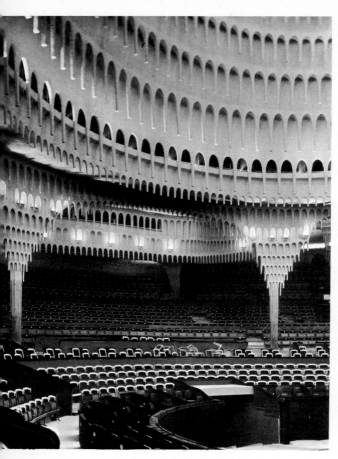

59 Poelzig, Berlin Theatre, Auditorium

42 *Heinrich Breling, Interior of the Moorish Kiosk in grounds of Linderhof Palace;* water-colour; 31 × 37.6 cm; sig.: Breling; 1881; Munich, Bayerische Verwaltung der Staatlichen Schlösser, Gärten und Seen, Inv.-No. 313 (WAF).

43 *Karl von Diebitsch; design for a stock exchange, Berlin, exterior;* pencil and water-colour, on paperboard; 68.4 × 80.7 cm; 1853; Berlin, Universitätsbibliothek, Technische Universität, Abt. Architekturplanslg.

44 *Karl von Diebitsch; design for a bathroom;* pencil and water-colour; 44.2 × 35.6 cm; c. 1850; Berlin, Staatliche Museen Preußischer Kulturbesitz, Kunstbibliothek

45 *Muyschel; design for a synagogue, view and plan, Motto: All men are brothers;* ink drawing on paperboard, grey wash; 44.6 × 34.6 cm; 1852; Berlin, Universitätsbibliothek, Technische Universität, Abt. Architekturplanslg.

46 *Wilhelm Stier; plan for the restoration of the Winter Palace at St Petersburg, façade overlooking the Neva;* pencil, water-colour, body-colours, on Ingresboard; 64 × 100 cm; 1838–1839; Berlin, Universitätsbibliothek, Technische Universität, Abt. Architekturplanslg.

47 *Karl von Diebitsch; design for a stock exchange, Berlin; interior;* pencil, water-colour, on paperboard; 56.1 × 53.2 cm; 1853; Berlin, Universitätsbibliothek, Technische Universität, Abt. Architekturplanslg.

48 *Ludwig von Zanth; Wilhelma Palace; Moorish Villa of His Majesty King William of Württemberg; 1855;* Stuttgart, Württembergische Landesbibliothek

49 *Ludwig von Zanth; Wilhelma Palace, Festsaal (*photograph); William I, King of Württemberg, commissioned Ludwig von Zanth to build Wilhelma Palace near Stuttgart in the years 1842–1846; the park grounds with the kiosks were completed in 1851

50 *Pascal Coste; "Architecture Arabe ou Monuments du Caire, Mesurés et Dessinés," 1818–1834;* Munich, Bayerische Staatsbibliothek

51 *Charles Texier, "Description de L'Arménie, la Perse, et la Mésopotamie", 2 vols, Paris 1842, 1852;* Munich, Bayerische Staatsbibliothek

52 *Vienna, Zacherlhaus* (photograph); the construction plans for this building, originally an insecticide factory, were submitted at Vienna in 1892; the tiled façade, central dome, and the two lateral towers were inspired by 17th-cent.; Persian architecture

53 *Owen Jones; "Plans, Elevations and Details of the Alhambra," 2 vols, London 1842, 1845;* Richmond, Stuart Durant

54 *K. Weigle, Moorish glass-roofed court in Graf-Eberhardsbad, Wildbad* (photograph); this copy of the inner courts of the Alhambra, Granada, was added to Nikolaus Thouret's Eberhardsbad (built 1840–1847) by K. Weigle in 1897

55 *Paris, Palais Beauharnais; Turkish Cabinet* (photograph) c. 1805; one of the earliest examples of oriental reception in interior decoration; the upper frieze with harem motifs is, however, in the classicistic Pompeian tradition

56 *Peter Herwegen; interior view of the royal house at Schachen;* gouache with gold; 48 × 64 cm; sig.: 18 PH 79; 1879; Munich, Bayerische Verwaltung der Staatlichen Schlösser, Gärten und Seen, Inv.-No. 558 (WAF)

57 *George Aitchison, Leighton House, Arab Hall, London* (photograph), c. 1879; this is a later edition to Frederic Leighton's house and combines elements of the Turkish Iznik style with Persian decoration; plate

58 *Antoni Gaudí (Reus 1852–1926 Barcelona); Casa Vicens, Barcelona* (photograph); the plans for the house date from 1878–1880; Moresque influence is evident in the tiling, the window arches and the loggia supports of the façade, and in the stalactite pendentives of the vestibule

59 *Hans Poelzig (Berlin 1869–1936); Großes Schauspielhaus in Berlin, auditorium, 1919;* stalactite pendentives heighten the cave-like effect; plate

Furnishings

60 *France, stool;* from the Turkish Cabinet of the Palais Beauharnais, refitted in the Empire style from 1803 onwards; h approx. 45 cm; Paris, Palais Beauharnais (German embassy)

61 *Bohemia, Mosque lamp;* h - 106 cm.; circa 1860; Vienna, Österreichisches Mus. für angewandte Kunst, Geymüller-Schlößl, Inv.-No. 37575/Sob. I. 310

62 *Carlo Bugatti; chair;* these chairs were first exhibited at the Turin exhibition of 1902 and combine North African elements with the floral tendencies of art nouveau; Paris, Alain Lesieutre

63 *Vienna; censing vessel;* ∅ - of base plate 88 cm; first half of 19th cent.; combination of Baroque elements with Islamic forms which is most characteristic of Ludwig II of Bavaria in the second half of the century; Vienna, Österreichisches Mus. für angewandte Kunst, Geymüller-Schlößl, Inv.-No. Lg. 1253

64 *Placido Zuloaga, censer;* iron, silver and gold inlay, tarnished; h - 23.5 cm; sig.: ZP; 1873; Berlin, Staatliche Museen Preußischer Kulturbesitz, Kunstgewerbemus., Inv.-No. 73.789 a, b, c

65 *Arabia and India; furnishings of an oriental room: Framed wall-screens –*

Arabia, 2nd half of 19th century; *Framed window grilles* — India, 2nd half of 19th century; Window — stucco tracery, coloured glass; Arabia, 2nd half of 19th century; Vienna, Österreichisches Mus. für angewandte Kunst

66 *Edgar Brandt; floor lamp;* gilt bronze and alabaster; h - 170 cm; sig.: E. Brandt; c. 1920; Paris, Alain Lesieutre

68 Royal seat at Schachen, censing stands

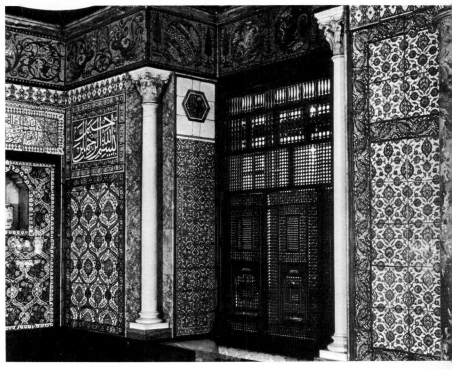

57 London, Leighton House

Furnishings from the royal seat at Schachen, built for King Ludwig II of Bavaria in 1870

67 *Two "winged" vases with peacock fantails;* gilt wood; brass, velvet, dyed ostrich and peacock feathers; h - 200 cm; c. 1870; Munich, Bayerische Verwaltung der Staatlichen Schlösser, Gärten und Seen, Inv.-No. Scha-V 2–3; 6–7

68 *Two censing stands;* gilt wood, some parts in brass; h - 177 cm; c. 1870; both this and the previous exhibit exemplify Ludwig II's stylistic pluralism; Munich, Bayerische Verwaltung der Staatlichen Schlösser, Gärten und Seen, Inv.-No. Scha-V 10–11; plate

69 *Two stools;* gilt wood, seats of brocade; 50×50×50 cm; c. 1870; Munich, Bayerische Verwaltung der Staatlichen Schlösser, Gärten und Seen, Inv.-No. Scha-M 40–41

70 *Two cushions;* in gold brocade, rear in red silk; 52×140 cm; c. 1870; Munich, Bayerische Verwaltung der Staatlichen Schlösser, Gärten und Seen, Inv.-No. Scha-M 16–17

71 *Lamp;* brass and glass; octagonal star suspended by long chains; h -

200 cm, ⌀ 100 cm; c. 1870; Munich, Bayerische Verwaltung der Staatlichen Schlösser, Gärten und Seen, Inv.-No. Scha-M 13

72 *Small table;* gilt wood, copper top, silver-plated; 77×74×74 cm; c. 1870; Munich, Bayerische Verwaltung der Staatlichen Schlösser, Gärten und Seen, Inv.-No. Scha-M 13

73 *Owen Jones, "The Grammar of Ornament," London 1856;* Richmond, Stuart Durant

74 *W. G. Aufley, "Outlines of Ornament in the Leading Styles selected from ancient and modern Works;" London 1881;* Richmond, Stuart Durant

75 *Jules Bourgoin, "Les Arts arabes, Architecture etc."; Paris 1873;* Richmond, Stuart Durant

76 *Jules Bourgoin, "Les Elements de L'Art arabe, Le Trait des Entrelacs," Paris 1879;* Richmond, Stuart Durant

77 *Christopher Dresser, "Studies in Design," London 1874–1876;* Richmond, Stuart Durant

78 *Owen Jones, Jules Goury, "The Alhambra," London 1836–1846;* Richmond, Stuart Durant

79 *Owen Jones, "Design for Tessellated Pavements," London 1841;* Richmond, Stuart Durant

80 *John Leighton, "Suggestions in Design," London* (c. 1880); Richmond, Stuart Durant

Stage Design

At the beginning of the 19th century many architects had the opportunity to realize the wildest flights of their architectural imagination in their work as stage designers. Thus Schinkel's interest in extra-European architecture did not find expression in his construction plans but in his stage sets. After Iffland's death, Schinkel received his first commissions (from 1816 on) from the new director general in Berlin, Karl Graf von Brühl. By 1832 he had designed 42 sets. His designs for the "Zauberflöte" are worthy of special mention for they incorporated his complex views on Egyptian architecture. He gave visionary realization to Persian and Mexican architecture in a similar way. From the 1820's on, Carl W. Gropius, who had at times collaborated with Schinkel, designed sets that showed Schinkel's decided influence. H. L.

81 *Karl Friedrich Schinkel, "Collection of Stage Designs," Potsdam 1849;* Berlin, Staatliche Museen Preußischer Kulturbesitz, Kunstbibliothek

82 *Wilhelm Hensel, "The Tableaux Vivants and Pantomimic Presentation in the Festival Production of Lalla Rookh," Berlin 1823;* Berlin, Staatliche Museen Preußischer Kulturbesitz, Kunstbibliothek

83 *Carl W. Gropius, "Stage Designs";* pencil, pen, body colours; 22.9 × 33.6 cm; c. 1820; Berlin, Staatliche Museen Preußischer Kulturbesitz, Kunstbibliothek

84 *Carl W. Gropius; "Stage Designs;"* pencil, pen, body colours; 20.9 × 33.6 cm; c. 1820; Berlin, Staatliche Museen Preußischer Kulturbesitz, Kunstbibliothek

85 *Carl W. Gropius, "Stage Designs,"* pencil, pen, body colours; 22.3 × 33.2 cm; c. 1820; Berlin, Staatliche Museen Preußischer Kulturbesitz, Kunstbibliothek

European Ceramics and their Islamic Prototypes

The Isnik-Copies by Théodore Deck and his Contemporaries

Horst Ludwig

An exhibition of Jugendstil ceramics in Tokyo in 1968 included 33 works by Théodore Deck. While these objects are also orientated to Japanese ceramics and point towards Jugendstil, the large selection of exhibits from his work does testify to his importance and to a new interest in his work. Rooted in the pluralistic style of the "Gründerzeit", his works represent connecting links between historicism and art nouveau. Characteristic of Deck is his endeavour not only to imitate the decoration of European and Asian ceramics and faience-ware, but particularly to follow closely the techniques of glazing and colour composition. His scrupulously exact scientific approach finds its counterpart in the glass-work of Ludwig Lobmeyr. Théodore Deck considered it an achievement that the formal and technical quality of his work matched that of Islamic ceramics.

Deck first studied under Hügelin in Strasbourg, where he concentrated upon sixteenth century French faience-ware. Afterwards he went to Feilner in Berlin and then to Madame Veuve Dumas in Paris, who was engaged in the production of porcelain stoves. With the support of his brother he opened a workshop for decorative faience-ware in 1856, which two years later was officially given the name "Atelier Deck." He collected ceramic-ware from all over the world and analyzed the chemical composition of Isnik ceramics. He arrived at a basic analysis which he used for his own work. He created the famous Deck-blue with an addition of potash, carbonate of soda and chalk. In 1861 he offered his first pieces to the public and soon attracted attention with them. He became a member of the workers' committee of the Sèvres Manufactory in 1875 and was appointed director in 1887. At the 1889 exhibition, his work was cooly received by critics and public alike, who rejected both his exact historicism and his scientific analyses. The ceramic-ware of Edmond Lachenal, one of Deck's collaborators, Emile Decoeur and Cantagalli shows certain similarities in style.

Before Deck noticed Chinese and Japanese ceramic work, he had been deeply involved with sixteenth century Isnik ceramics, which he took as prototypes for his own forms. He also frequently copied the naturalistic tulip, carnation, pomegranate and pumpkin flowers most regularly reproduced on the work created in the Isnik style. The centralized, axial-symmetrical arrangement, which is relatively rare in the Turkish prototypes, was specially favoured by Deck (cf. Cat. No. 80, 88). More seldom, he starts with the free-swinging tendrils and flowers, a common feature of Turkish ceramics (cf. Cat. No. 89). It is impossible to overlook his tendency towards the exemplary, which always reveals an inherent, strict symmetry. His colours are taken from the range displayed in his prototypes and show a tendency towards intensification. The monumental Alhambra vases finished in 1891 are a further example of the varied influence of Islam.

Translation G. F. S.

86 *Théodore Deck (Guebwiller 1823–1891 Paris);* plate; faience, underglaze painting on a whitish ground in axial-symmetrical arrangement; ⌀ 50.8 cm; sig. on underside: TH. Deck/A; c. 1875; modelled on the Iznik ceramics of the 16th and 17th centuries; Hamburg, Hans-Jörg Heuser Coll.; coloured plate

87 *Turkey (Iznik); plate;* faience, underglaze painting on a white ground; ⌀ - 28.8 cm; Berlin, Staatliche Museen Preußischer Kulturbesitz, Mus. für Islamische Kunst, Inv.-No. 87,512; plate

88 *Théodore Deck; plate;* faience, underglaze painting on a whitish ground

87 Iznik, plate ▼ 86 Deck, plate ▶

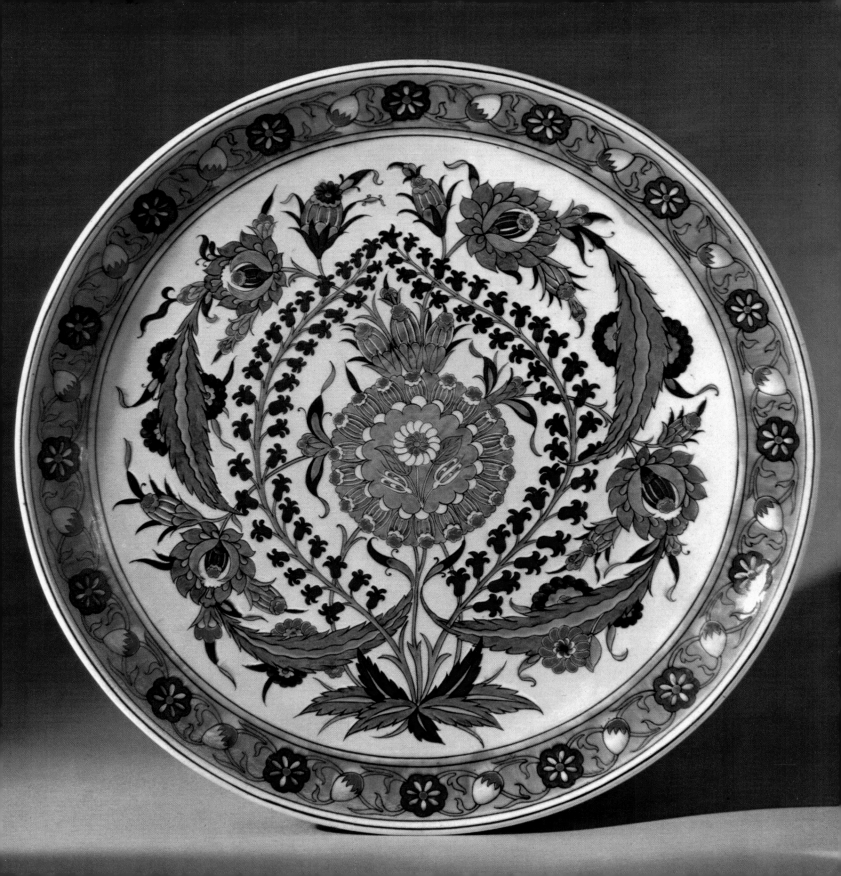

in axial-symmetrical arrangement; ∅ - 40 cm; sig. on underside: Th. Deck; 1865; London, Victoria & Albert Mus., Inv.-No. 226–1896

89 *Théodore Deck; plate;* faience, underglaze painting on turquoise-coloured ground with freely patterned floral ornamentation; ∅ - 29.5 cm; sig. on underside: Th. Deck/A; c. 1875; Hamburg, Hans-Jörg Heuser Coll.; plate

90 *Théodore Deck, vase;* faience, floral ornamentation in the Iznik style; h - 35 cm; sig.: THD; 1867; Berlin, Staatliche Museen Preußischer Kulturbesitz, Kunstgewerbemus.; Inv.-No. 67, 173

91 *Turkey (Iznik ?); plate;* faience, underglaze painting on yellowish ground; ∅ 28 cm; mid-16th century; Berlin, Staatliche Museen Preußischer Kulturbesitz, Mus. für Islamische Kunst, Inv.-No. I. 5370; plate

92 *Théodore Deck; plate;* pottery, enamelled and glazed; floral motifs on a blue ground; ∅ - 29.8 cm; sig. on underside: Th. Deck; c. 1870; a rare modification of the Iznik style; London, Bethnal Green Mus., Inv.-No. 699–1878

93 *Turkey (Iznik), jug;* faience, underglaze painting with royal blue pennate leaves, pomegranate blossom and vermilion tulips, green and turquoise leaves; h - 30 cm; 17th cent.; Nuremberg, Landesgewerbeanstalt Bayern, Gewerbemus., Inv.-No. 5829

94 *Istanbul (from the Piali-Basha Mosque); tiling of a niche;* 16 tiles in semi-faience, blossoms and foliage in

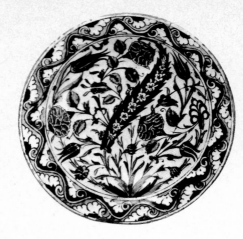

96 Iznik, plate

axial-symmetrical arrangement, the whole enclosed by a frieze; light and dark blue, green, red and black on a whitish ground; 70×143 cm; 1573–1574; Vienna, Österreichisches Mus. für angewandte Kunst, Inv.-No. Ke 3381

95 *Turkey (Iznik), plate;* faience, underglaze painting in tomato red, green and blue; ∅ - 35 cm; c. 1600; Frankfurt, Mus. für Kunsthandwerk, Inv.-No. 622

96 *Turkey (Iznik); plate;* faience, underglaze painting; ∅ - 33 cm; end of 17th century; Frankfurt, Mus. für Kunsthandwerk, Inv.-No. 3310; plate

97 *Cantagalli; plate;* earthenware, enamelled; pennate leaf with playfully treated tulips, carnations and other flowers; ∅ - 29.2 cm; 2nd half of 19th century; Iznik plates of this style were already being imitated by his European

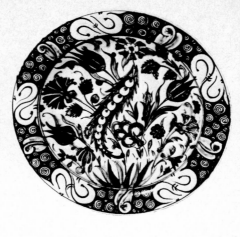

97 Cantagalli, plate

contemporaries; London, Victoria & Albert Mus., Inv.-No. Circ. 308–1892; plate

98 *Emile Decoeur; plate;* faience; ∅ 30 cm; sig.: company stamp and monogram; c. 1870; Paris, Alain Lesieutre; plate

99 *Emile Decoeur; plate;* faience; ∅ - 30.5 cm; sig.: company stamp and monogram; c. 1870; Paris, Alain Lesieutre

100 *Turkey (Iznik); plate;* faience, underglaze painting; ∅ - 29.5 cm; 17th cent.; Frankfurt, Mus. für Kunsthandwerk, Inv.-No. 624

101 *Turkey (Iznik); plate;* earthenware, engobe technique, underglaze painting; ∅ - 30.3 cm; end of 16th cent.; Düsseldorf, Hetjens-Mus., Inv.-No. 10375

102 *Edmond Lachenal; plate;* earthenware, glazed; carnation blossoms and buds arranged in a circle, bordered by stylized blossom ornamentation; ∅ - 33 cm; 1869; London, Bethnal Green Mus., Inv.-No. 501–1889

103 *England, six tiles;* earthenware, white ground glaze with floral decoration in an onion-shaped vase with flat foot; 61×41 cm; c. 1890; modelled on the building tiles of 16th and 17th century Turkey; London, Victoria & Albert Mus., Inv.-No. 361–1905

104 *Collinet et Cie, cornice section;* earthenware, overglaze decoration; 20×51 cm; modelled on Persian structural ceramic work of 16th and 18th cent.,

91 Iznik, plate

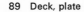

89 Deck, plate

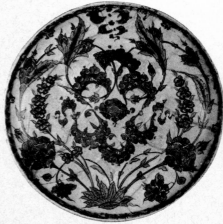

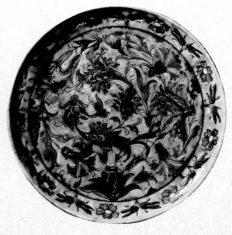

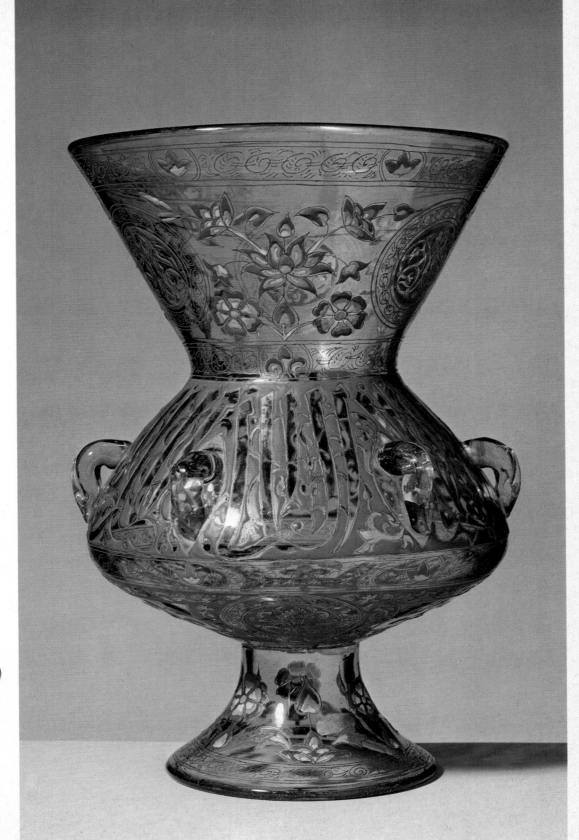

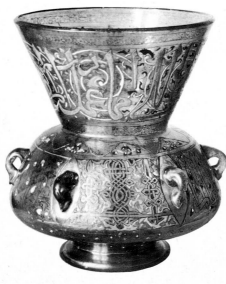

192 Syria/Egypt, Mosque lamp ▲

193 Brocard, vase ▶

esp. of Isfahan; Vienna, Österreichisches Mus. für angewandte Kunst, Inv.-No. 7734/Ke 1054

105 *Léon Pavillier, 8 sections of wall facing;* pottery, overglaze decoration; each 37.2×37.2 cm; 2nd half of 19th cent.; such rich foliage ornamentation is based on Persian models of 17th and 18th centuries; Vienna, Österreichisches Mus. für angewandte Kunst, Inv.-No. 9591/1540

106 *Collinet et Cie. cornice section;* earthenware, overglaze decoration in majolica colour; 24×54 cm; 2nd half of 19th century; Vienna, Österreichisches Mus. für angewandte Kunst, Inv.-No. 7733/Ke 1053

William de Morgan's Islamic and Oriental Sources

Roger Pinkham

William De Morgan is perhaps the most significant maker of "art pottery" in England during the last thirty years of the nineteenth century.

With regard to his importance as an user of oriental motifs De Morgan cannot legitimately be considered as a self-contained entity and independently of the arts and crafts movement to which he belonged, for when he began to work seriously at pottery in 1872 the exploitation of *orientalia* in the English decorative arts had already been established some time.

In common with the Syrian painters De Morgan used the same kind of flower and leaf forms on his decorative pots as are found on his tiles. However, his techniques are extended to include painting in lustre, a type of metallic glaze originally exploited during the thirteenth century in certain centres in Persia: Kashan, Rayy, and Gurrgan. But the colours of De Morgan's lustres owe more to the hues of Italian maiolica, in particular those of Deruta and Gubbio, rather than to Persia; there are no correlatives there for De Morgan's ruby-red and silver coloured lustres. In making his lustres De Morgan had no contemporary that he knew of to whom he could look for advice, thus his scientific knowledge was called on to provide an amazing repertoire of reducing agents for the critical moment in the firing process, other than the traditional wood fuel. Others included gases, vapours, and fuels such as coal, charcoal and oil. This kind

of experimentation was in the tradition of the arts and crafts workers in all their branches and must also have had much in common with the Persian and Egyptian potters and their tradition of experiment. De Morgan's discovery of the Syrian palette permanently changed his own, for he adopted the colours found there, and, of equal importance, the Syrian attitude to colour—a combination of discretion and parsimony—in his treatment of subjects painted in his naturalistic style. A large two-handled vase in the Victoria and Albert Museum that was bought from the Morris shop in London in 1887 is a case in point: it has as its subject galleys at sea painted in colours that are distinctively Syrian—with light and turquoise blue, sage green and purple predominating.

That the taste for Islamic styles established itself for many years may be judged from the fact that towards the end of De Morgan's career a number of English potteries made imitations of his work. Amongst these were the Della Robbia pottery of Birkenhead that made a coarser type of earthenware. A more refined type employing lustre had something in common with his own taste and high technical standards; this was the ware made by Pilkington's up to the early years of this century.

North of Syria is Turkey, a country to which De Morgan also looked for inspiration, and, in particular, to the Isnik wares dating from the sixteenth and seventeenth centuries. Although it is customary to find him looking for painterly subjects rather than for shapes, there are exceptions to this for he adopted some of the Isnik forms, in particular a type of dish with a depressed centre and with borders some two inches in width that allowed ample space for decorative painting. This was one of the kinds he had supplied ready made from Davis of Hanley during his years at Chelsea.

Another shape to be found later in his work is the long-necked bottle with an annular knop that is close to an Isnik type of the first half of the sixteenth century. The Turkish bottles are painted in underglaze blue; whilst De Morgan treated his either with enamels or with lustre colours, one of which he christened Khedive.

In some respects one might have expected the fuller flower painting of the early sixteenth century Isnik wares to have appealed more to a mid-nineteenth century artist in preference to the weaker and more strained Syrian variety, but on the whole little of the Isnik style of painting found its way into De Morgan's repertoire excepting the fanlike flower heads that

are to be seen on the high footrimmed bowls, and also the dishes. The interest Morris had in Icelandic sagas may be the source of De Morgan's interest in ships of all kinds found on his painted wares, but ships are also depicted on Isnik dishes and there can be no doubt that De Morgan saw these, too.

Turkish tiles were largely ignored by him as source material in spite of their attractive blues. However, the presence of the iron-red coloured enamel so prevalent on Turkish tilework may have struck him unfavourably as this colour is never found in his own work. Nor, in fact, is there much in the way of tiles in relief although much of this sort was made in Islam. The few relief tiles made by Halsey Ricardo, De Morgan's partner at Fulham (1888–1898), were probably imitated from the Kashan lustre tiles, and other Persian centres. But few seem to have been made, and one might assume that they were not well liked.

Closely dependent on Islamic ceramics are the Hispano-Moresque wares of the fifteenth century that are made in a strong middle-eastern spirit. De Morgan acknowledged his debt to these in his lecture to the Royal Society of Arts in 1892. He certainly looked closely at the lustres as well as adopting the form of the large charger dishes painted with fierce heraldic beasts. The latter probably gave him inspiration for the heavily built quadrupeds of his own found on his "rice dishes" in lustre.

On occasion De Morgan, who liked animal subjects exceedingly, reveals in his layout of dragons and swimming fish something of the Chinese manner to be found on certain *famille noire* vases of the K'ang-Hsi. He also adopted from the smae dynasty the turquoise-blue and flambé glazes that are found on porcelain vases.

107 *Persia (Kashan), bottle;* faience with copper-coloured lustre; h - 15.5 cm; 17th cent.; London, Victoria & Albert Mus., Inv.-No. 946–1876; plate

108 *William de Morgan, bowl;* gold lustre; ∅ - 29.5 cm; prior to 1899; Vienna, Österreichisches Mus. für angewandte Kunst, Inv.-No. 11,855/Ke 4094

109 *William de Morgan; vase;* earthenware, lustred; h – 21.5 cm; c. 1890; London, Victoria & Albert Mus., Inv.-No. C 265–1915

110 *William de Morgan, vase;* pottery, glazed and lustred; h - 25 cm; indistinct

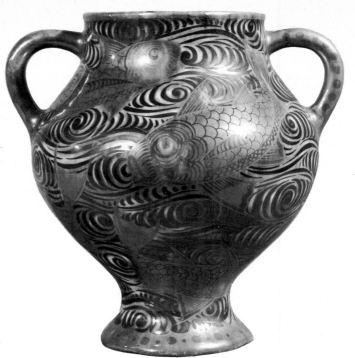

115 De Morgan, vase

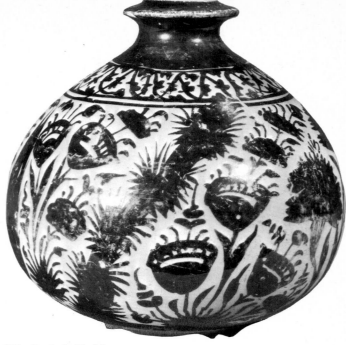

107 Persia, bottle faience

stamp on the underside: W de Morgan Sands E..., with letters 232 J. J. in paint; 1888–1898; Darmstadt, Hessisches Landesmus., Inv.-No. 65: C 367

111 *William de Morgan; shallow bowl;* pottery, whitish ground glaze, lustred; ⌀ - 36 cm; on the underside indistinct stamp; c. 1898; Darmstadt, Hessisches Landesmus., Inv.-No. Kg. 62:2

112 *William de Morgan, tiled frieze;* pottery, glazed; eight square tiles in axial, symmetrical arrangement; sevenfold repetition of same fish type in various positions; each tile 20.2×20.2 cm; on the underside: stamp De Morgan Merton Abbey; 1882–1888; Darmstadt, Hessisches Landesmus., Inv.-No. 64:19 a–h

113 *William de Morgan; two tiles;* earthenware, naturalistic palmette and freely positioned leaves on a white glaze; 15.5 cm; sig.: W de Morgan & Co. Sand's End Pottery, Fulham; c. 1890; de Morgan, in contrast to Théodore Deck, who sought his inspiration in Persian lustreware of the 13th century, here draws from the 16th century Iznik style; London, Victoria & Albert Mus., Inv.-No. C 136 and 154–1917.

114 *Persia (Kashan); spittoon;* faience with copper-red lustre; h - 12.7 cm;

17th cent.; London, Victoria & Albert Mus., Inv.-No. 959–1876; plate

115 *William de Morgan; vase;* earthenware, lustred; h - 19.5 cm; sig: W. de Morgan Fulham J. J.; c. 1900; London, Victoria & Albert Mus., Inv.-No. C. 417–1919; plate

116 *William de Morgan (London 1832–1917); two tiles;* earthenware, two stylized palmettes on a whitish ground, joined by an s-shaped frieze; 30.5×15.2 cm; sig.: D. M. 98; 1898; London, Victoria & Albert Mus., Inv.-No. C. 156 and C. 156 A–1917

117 *Persia; dish;* faience, lustred; h - 11 cm; 17th. cent.; London, Victoria & Albert Mus., Inv.-No. 2552–1876

118 *William de Morgan, vase;* earthenware, grey body; floral decoration in the Iznik style; in brown, dark blue and turquoise blue; h - 22 cm; sig: E. de Morgan-Fulham; c. 1890; Munich, Coll. Paul Tauchner

119 *William de Morgan; vase;* earthenware, lustred; h - 25 cm; c. 1890; London, Victoria & Albert Mus., Inv.-No. C. 191–1919

120 *William de Morgan; vase;* earthen-

ware, silver lustre; h - 25 cm; sig.: JJ; c. 1900; London, Victoria & Albert Mus., Inv.-No. 862–1905

121 *William de Morgan; dish;* earthenware, underglaze painting; ⌀ 25 cm; sig.: De Morgan I. & P. Fulham; c. 1890; London, Leighton House Art Gall. & Mus., Inv.-No. 2

122 *William de Morgan, Fred Passenger; vase;* earthenware, lustred; fish on blue ground; h - 25 cm; London, Victoria & Albert Mus., Inv.-No. C. 194–1919

123 *Iran; bottle;* faience, lustred; h - 31 cm; 17th cent. (silver plate on the neck: 18th cent.); Berlin, Staatliche Museen Preußischer Kulturbesitz, Mus. für Islamische Kunst, Inv.-No. I. 4215

124 *Persia; tiled composition (42 tiles) representing Dancers and Musicians;* faience, underglaze ornamentation; 175×150 cm; 18th cent.; Paris, Joseph Soustiel

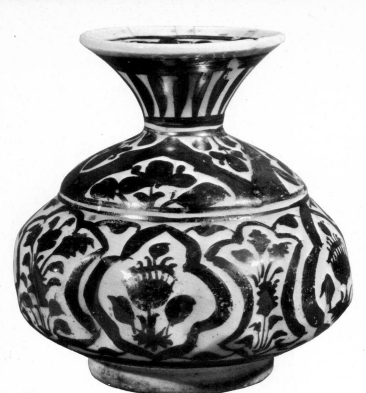

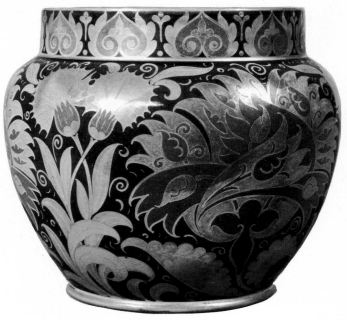

De-Morgan-Pottery and Successors

125 *Sands and Pottery, London; vase;* earthenware, underglaze painting; blossoms and plants in blue, green and purple on a white ground; h - 18.3 cm; sig.: Fulham stamp; c. 1890; this vase is one of the few examples of work from the De-Morgan Factory modelled on the Turkish Isnik style; London, Leighton House Art Gall. & Mus., Inv.-No. 42

126 *William de Morgan's Factory; plate;* earthenware, glazed; ⌀ - 42 cm; c.1900; London, Victoria & Albert Mus., Inv.-No. C. 424–1919

127 *Fred Passenger; vase;* earthenware, lustred; h - 19.5 cm; sig.: F. P.; c. 1895; London, Victoria & Albert Mus., Inv.-No. C. 4–1971; plate

128 *Fred Passenger, Bushey Heath Pottery, vase;* earthenware, copper and red lustre; h - 8.8 cm; sig.: F. P.; c. 1880; London, Leighton House Art Gall. & Mus.; Inv.-No. 61

129 *Fred Passenger; Bushey Heath Pottery; plate;* earthenware, blue-grey and copper lustre; ⌀ - 23.8 cm; sig.:

F. P.; c. 1920; London, Leighton House Art Gall. & Mus., Inv.-No. 10

130 *Fred Passenger; Bushey Heath Pottery; plate;* earthenware, underglaze painting; ⌀ - 31.9 cm; sig.: F. P.; c. 1920; London, Leighton House Art Gall. & Mus., Inv.-No. 8

131 *Fred Passenger; Bushey Heath Pottery; plate;* earthenware, red lustre; ⌀ - 35.6 cm; c. 1900; London, Leighton House Art Gall. & Mus., Inv.-No. 48

132 *Fred Passenger; Bushey Heath Pottery; plate;* earthenware, red and gold lustre; ⌀ - 28.8 cm; sig.: F. P.; 1879; London, Leighton House Art Gall. & Mus., Inv.-No. 15

133 *Fred Passenger; Bushey Heath Pottery; plate;* earthenware, lustred; ⌀ - 28.8 cm; sig.: F. P.; c. 1900; London, Leighton House Art Gall. & Mus., Inv.-No. 16

134 *Charles Passenger; vase;* earthenware, lustred, overglaze painting; h - 20 cm; sig.: 2581 P VII England; c. 1900; Darmstadt, Hessisches Landesmus., Inv.-No. Kg. 62:22

135 *William Rathbone; pot;* earthenware, red lustre; h - 11 cm; pre 1899; Vienna, Österreichisches Mus. für angewandte Kunst, Inv.-No. 11858/Ke 4097

136 *William Rathbone; vase;* earthenware, red lustre; h - 23.5 cm; pre 1899; Vienna, Österreichisches Mus. für angewandte Kunst, Inv.-No. 11856/Ke 4095

Paul Dresler

Dresler was a pupil of Debschitz and Kandinsky in Munich. His encounter with Persian and Chinese ceramic ware led him to study ceramics in Landshut from 1910. In 1913 he founded his own pottery, "Grootenburg," at Krefeld. Like Théodore Deck's, his work also shows the influence of Islamic motifs and techniques and especially of Chinese and Japanese (tea ceramic ware) forms. Whereas Deck looked for his inspiration mainly to the ware of Rhodes, the so-called Isnik style, Dresler favoured the abstract designs of Sultanabad faience of the 13th and 14th centuries and the blue glazed ceramic ware of the 18th century. Generally he used single motifs, like deer, birds or fish, which then occupy the centre of the plate. The edge is then decorated with floral or geometric orna-

mentation. Dresler's favourite colours were cobalt blue and turquoise, those given preference in his Persian models, too. Some of his works given monochrome treatment in one of these colours. H. L. Translation P. J. D.

137 *Persia; dish;* faience; at the centre a white hare with turquoise and dark blue foliage, surrounded by a geometric and floral frieze; around the edge stylized leaves in white, turquoise and blue; ∅ - 23.7 cm; 14th cent.; the majority of Paul Dresler's ceramic ware is indebted to this prototype of Sultanabad faience from the 13th and 14th centuries; Krefeld, Kaiser-Wilhelm-Mus., Inv.-No. 1918/19; plate

138 *Paul Dresler; dish;* earthenware, underglaze painting in enamel colours; ∅ - 24.7 cm; sig.: P. D.; pre 1930. Düsseldorf, Hetjens-Mus., Inv.-No. 1950/24; plate

139 *Paul Dresler (Siegen 1879–1950 Krefeld), plate;* pottery, engobe technique; ∅ - 35 cm; sig. on underside: P. D.; 1920; Krefeld, Kaiser-Wilhelm-Mus., Inv.-No. 1951/148

140 *Paul Dresler; bowl;* earthenware, underglaze painting in enamel colours; ∅ - 37 cm; sig.: P. D.; pre 1930; Düsseldorf, Hetjens-Mus., Inv.-No. 1949/9

141 *Paul Dresler; dish;* earthenware, underglaze painting in enamel colours; ∅ - 26.3 cm; stamped on base: Grootenburgmarke; pre 1930; Düsseldorf, Hetjens-Mus., Inv.-No. 1949/14

142 *Paul Dresler; plate;* pottery, engobe technique, grey-yellow body; ∅ - 33 cm; sig. on underside: P. D.; 1948; Krefeld, Kaiser-Wilhelm-Mus., Inv.-No. 1951/155

143 *Paul Dresler; plate;* pottery, engobe technique; ∅ - 24 cm; sig. on underside: P. D.; 1945; Krefeld, Kaiser-Wilhelm-Mus., Inv.-No. 1972/24

144 *Paul Dresler; plate;* pottery, engobe technique, yellow-white body; ∅ - 22 cm; sig. on underside: P. D.; 1944; Krefeld, Kaiser-Wilhelm-Mus., Inv.-No. 1951/165

145 *Persia; dish;* earthenware, engobe technique; ∅ - 29.6 cm; beg. of 17th cent.; Düsseldorf, Hetjens-Mus., Inv.-No. 12254

146 *Persia; dish;* faience; ∅ - 19 cm; 13th cent.; Düsseldorf, Hetjens-Mus., Inv.-No. 1955/22

147 *Persia; bowl;* faience, dark turquoise glaze; ∅ - 34.5 cm; 18th cent.; besides the animal and ornamental motifs of Sultanabad faience, Dresler also took over the black lined decoration under a turquoise glaze; Krefeld, Kaiser-Wilhelm-Mus., Inv.-No. 1910/77

148 *Paul Dresler; pot;* pottery, engobe technique; h - 7,8 cm; 1918; Krefeld, Kaiser-Wilhelm-Mus., Inv.-No. 1951/170

149 *Paul Dresler; dish;* pottery, engobe technique, reddish brown body; ∅ - 28.5 cm; sig. on underside: P. D.; 1922; Krefeld, Kaiser-Wilhelm-Mus., Inv.-No. 1951/150

150 *Paul Dresler; dish;* pottery, engobe technique; ∅ - 11.5 cm; sig. on underside: P. D.; 1920; Krefeld, Kaiser-Wilhelm-Mus., Inv.-No. 1972/23

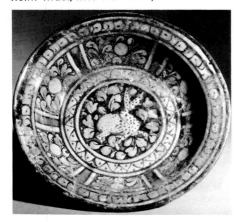

137 Persia, dish

138 Dresler, dish

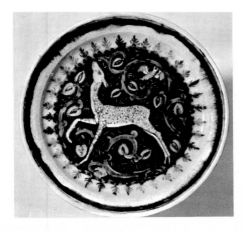

151 *Paul Dresler; pot;* pottery, engobe technique; h - 9 cm; sig. on underside: P. D.; 1915; Krefeld, Kaiser-Wilhelm-Mus., Inv.-No. 1951/168

152 *Paul Dresler; dish;* earthenware, glazed; ∅ - 13 cm; pre 1930; Düsseldorf, Hetjens-Mus., Inv.-No. 1950/27

153 *Edmond Lachenal (Paris 1853 – post 1930), vase;* earthenware, crackled, high glaze in Persian blue; h - 23 cm; sig. on base: Lachenal; c. 1900; Munich, Paul Tauchner Coll.

154 *Persia; dish;* pottery, glazed; ∅ - 20.5 cm; 11th/12th cent.; Vienna, Österreichisches Mus. für angewandte Kunst, Inv.-No. 37097/ke 9499

155 *Persian; dish;* pottery, glazed; ∅ - 20 cm; 12th cent.; Paris, Joseph Soustiel

Persian-Spanish Models and their Imitations

156 *Spain, bowl;* faience, cream-coloured glaze, copper lustre; ∅ - 38.7 cm; 17th cent.; Vienna, Österreichisches Mus. für angewandte Kunst, Inv.-No. Ke 511; plate

157 *Austria, plate;* faience, copper lustre; ∅ - 49.2 cm; 2nd half of 19th cent.; Moresque ceramics, in particular from Malaga and Valencia, which had found an extensive market throughout Europe, are here copied; Vienna, Österreichisches Mus. für angewandte Kunst, Inv.-No. HM 1677; plate

158 *Spain, bowl;* faience cream-coloured glaze, copper lustre; ∅ - 30 cm; 17th cent.; Vienna, Österreichisches Mus. für angewandte Kunst, Inv.-No. Ke 3015

159 *Spain, bowl;* faience, cream-coloured glaze, copper lustre; ∅ - 37 cm; 17th/18th cent.; Vienna, Österreichisches Mus. für angewandte Kunst, Inv.-No. Ke 3017

160 *Spain, Valencia, jug;* earthenware, lustred; h - 18.8 cm; 2nd half of 17th cent.; London, Victoria & Albert Mus., Inv.-No. 5–1907

161 *A. N. De Lint (Delft); decorative plate;* faience, lustred, red body; white glaze, cobalt-blue and turquoise overglaze painting, gold lustre; ∅ - 42.3 cm; prior to 1912; the Persian lustred ceramic ware of the 13th century and the Anda-

lusian work derived from it both served as models; Zürich, Kunstgewerbemus., Inv.-No. 7197

162 *A. N. De Lint; vase;* lustered faience, red body; white glaze, ornamental foliage in yellow on glaze painting, gold lustre; h - 21.3 cm; pre 1912; Zürich, Kunstgewerbemus., Inv.-No. 7181

163 *Iran, Gurgan; pot with spout;* pottery, glaze over white engobe and yellow lustre painting; h - 25 cm; 13th cent.; Frankfurt, Mus. für Kunsthandwerk, Inv.-No. 12393

164 *A. N. De Lint; decorative plate;* lustered faience, red body; red ground, green and grey overglaze decoration, gold lustre; ∅ - 23.6 cm; pre 1912; Moresque ceramic work stands model; Zürich, Kunstgewerbemus., Inv.-No. 7184

165 *Iran, Gurgan, dish;* pottery with gold and copper lustre; ∅ - 19.7 cm; c. 1200; Frankfurt, Mus. für Kunsthandwerk, Inv.-No. 12628

166 *Zslolnay, Hungary, dish;* earthenware with glazed decoration, lustred, crackled; Moresque ornamentation in red, white, yellow and olive; ∅ - 22.6 cm; c. 1895. Hamburg, Mus. für Kunst und Gewerbe, Inv.-No. 1896.341

Alhambra Vases

167 *Placido Zuloaga (1833–1910); pair of Alhambra Vases;* Iron, inlaid with gold and silver; h - 108 cm; sig.: Zuloaga, Eibar; 1869; Placido Zuloaga, son of Eusebio Zuloaga, gunsmith at the Spanish court, attracted attention with his exhibits at the Great Exhibition, London, in 1851; the inlay technique whereby threads of silver and gold are laid in the engraved or etched parts of a metal was reintroduced by Zuloaga to Central Europe; the two vases were executed for Alfred Morrison, a banker and patron of the arts, who lent his support especially to Owen Jones; London, Phillips & Harris

168 *Placido Zuloaga; vase;* iron, inlaid with silver and gold; large round medallions with Moresque ornamentation and palmettes, frieze; h - 35 cm; 1873; Berlin, Staatliche Museen Preußischer Kulturbesitz, Kunstgewerbemus., Inv.-No. 73791

169 *Placido Zuloaga; Alhambra vase;* bronze, silver and gold inlay; Moresque wavy ornamentation and calligraphic frieze; h - 105 cm; sig.: Guipuzgoa-Eibar 1880 Placido Zuloaga; the vase is a present from King Alphonse XII of Spain to Emperor Franz Joseph I of Austria-

Hungary; Vienna, Bundesslg. alter Stilmöbel, Inv.-No. TB 75; plate

170 *France, Voisin-Lieu; vase;* earthenware, brown glaze; wavy Moresque ornamentation covers the vase to the neck; h - 44.4 cm; c. 1850; London, Victoria & Albert Mus., Inv.-No. C. 3100–1846

171 *Théodore Deck, copy of an Alhambra vase;* faience; h - 109 cm; sig.: Th. Deck 1890; this vase is an exact copy of the Alhambra vase which is depicted in Owen Jones' publication on the Alhambra, 1842–1845; all of these huge vases are the products of the potteries at Malaga during the 14th century. Generally they are painted with floral and geometrical ornamentation and decorative inscriptions. If, by way of exception, animals are depicted, then they are strictly formalized; Vienna, Österreichisches Mus. für angewandte Kunst, Inv.-No. 9516/Ke 3702; plate

Metalwork

173 *Turkey; washing jug with stand;* chased copper, traces of gilding; h - (incl. stand) 44 cm; 19th cent.; Vienna, Österreichisches Mus. für angewandte Kunst, Inv.-No. Or 1671

156 Spain, bowl

157 Austria, plate

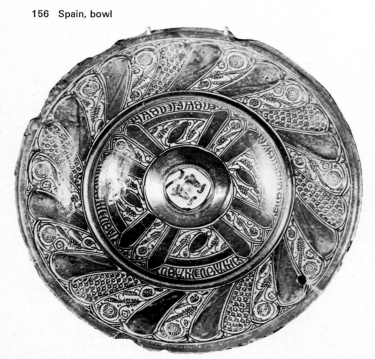

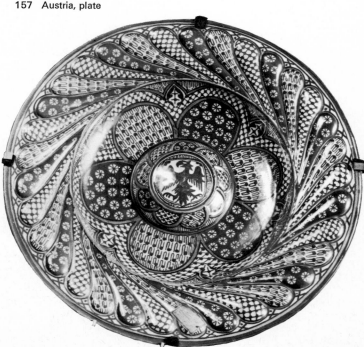

174 *Turkey, washing jug with stand;* brass, tinned and chased; h (incl. stand) - 45 cm; 1860–1870; Vienna, Öster- reichisches Mus. für angewandte Kunst, Inv.-No. Or 1670

175 *Marrel Frères; (Paris) jug and stand;* copper plate, engraved; h - 41 cm; 2nd half of 19th cent.; London, Victoria & Albert Mus., Inv.-No. 163 A and B-1851

176 *Bosnia and Herzegovina; vase;* copper, engraved and gilded; h - 16 cm; c. 1880; Paris, Musée des Arts Décoratifs, Inv.-No. 7316

177 *Bosnia and Herzegovina; jug;* copper, chased and gilt; h - 18 cm; c. 1880; Paris, Musée des Arts Décoratifs, Inv.-No. 7317

178 *Southern Russia; water jug;* tinned copper, engraved decoration; h - 41 cm; 2nd half 19th cent.; Vienna, Österreichisches Mus. für angewandte Kunst, Inv.-No. Ku 221

179 *Persia; water jug;* brass, silver inlay, engraved and chased; h - 41.5 cm; 18th/19th cent.; Vienna, Österreichisches Mus. für angewandte Kunst, Inv.-No. Me 391; plate

180 *Persia-Northern India; water jug;* cast brass, handle and spout soldered on, decoration engraved and dotted; h - 31 cm; 18th/19th cent.; Vienna, Öster- reichisches Mus. für angewandte Kunst, Inv.-No. Me 213

181 *India, bottle;* brass, inlaid; h - 39 cm; 2nd half of 19th cent.; Vienna, Österreichisches Mus. für angewandte Kunst, Inv.-No. Go 538

182 *Heckert, Petersdorf, Riesengebirge; phial with lid;* glass, gilt and flashed; h - 30 cm; 1882; Berlin, Staatliche Museen Preußischer Kulturbesitz, Kunstgewerbemus., Inv.-No. 06,167 a. b

183 *Louis Comfort Tiffany; jug;* silver, enamelled, foot of green glass, ivory; Moresque ornamentation with Baroque elements, 24 cm; sig.: Sterling Tiffany & Co; pre 1893; Berlin, Staatliche Museen Preußischer Kulturbesitz, Kunstgewerbemus., Inv.-No. 96,23

184 *Persia; candlestick;* brass, etched, asphalt inlay; on the foot scenes showing the parents turning out their daughter's lover; the Arabic of the inscriptions is not quite correct; probably for export; h - 42 cm; 1st half of 19th

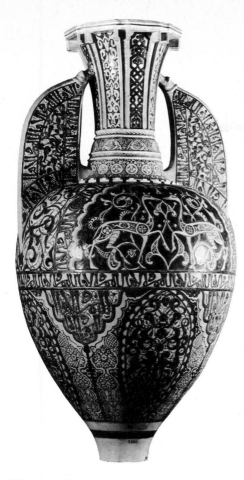

171 Deck, Alhambra vase

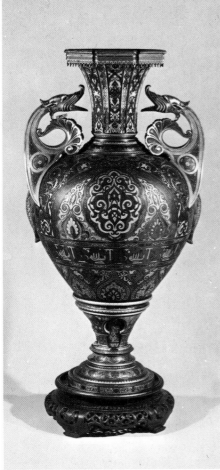

169 Zuloaga, Alhambra vase

cent.; Vienna, Österreichisches Mus. für angewandte Kunst, Inv.-No. Me 183

185 *Clément Massier (Vallauris 1845–1917 Golfe-Juan near Cannes); dish;* pottery, lustred bronze; bronze, silver and gold inlay; Moresque, vegetative ornamentation; ∅ - 22 cm; sig.: Clément Massier; end of 19th cent.; Vienna, Priv. Coll.

186 *François Barbédienne (St.-Martin-de-Fresny 1810–1892 Paris); vase;* bronze, cloisonné enamel; h - 38 cm; sig. on edge of foot: F. Barbédienne, Fondeur, Paris; Paris, Musée des Arts Décoratifs, Inv.-No. 19642

187 *Barbédienne; vase;* bronze, gilt, cloisonné enamel; Moresque ornamentation in green, blue, yellow, and red; h - 22 cm; sig.: Barbédienne; c. 1870; Vienna, Österreichisches Mus. für ange- wandte Kunst, Inv.-No. Em 14

188 *Barbédienne; beaker with stand;* bronze, gilt, cloisonné enamel; beaker h - 15.8 cm; ∅ - (stand) 28 cm; sig.: F. Barbédienne; c. 1870; Vienna, Öster- reichisches Mus. für angewandte Kunst, Inv.-No. Em. 13

189 *Barbédienne; casket;* bronze, gilt, cloisonné enamel; Moresque ornamen- tation in yellow, blue and green on a brown ground; l - 26.5 cm; sig.: Barbé- dienne; c. 1870; the Islamic influence is to be seen in the ornamentation, not in the form of the casket; Vienna, Öster- reichisches Mus. für angewandte Kunst, Inv.-No. Em 18

190 *Elkinton; dish with lid;* bronze, gilt, cloisonné enamel; blue and black Moresque ornamentation in enamel; h - 28 cm; 1873; this is influenced by Turkish vessels of the 16th cent.; Vienna, Österreichisches Mus. für ange- wandte Kunst, Inv.-No. Em 72

37

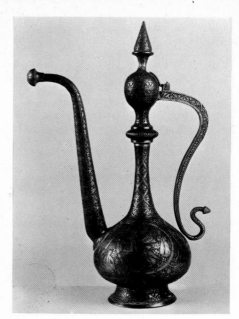

179 Persia, water jug

Islamic Glass

Wilhelm Hein

The Moslem artists had very good reasons for devoting their loving attention and their refined skills to the material glass, for in the sura entitled "Light" in the Koran (XXIV, 35) they read: "Allah is the light of the heavens and the earth. His light may be compared to a niche that enshrines a lamp, the lamp with glass of star-like brilliance..." Since the State was founded on the Koran and the traditions associated with it, the servants of the State – the clerks and copyists, the administrative officials – and, in the last analysis, the artists, too, had every cause to obey the behests of their sacred book and to orient themselves on its direct and indirect prescriptions. In our context, that meant imparting, accepting and executing commissions for all kinds of work in glass. From the Sunna the Mohammedans were also well aware of the Prophet's partiality for fragrant smells and aromas, and their religion taught them that in paradise, that most wondrous of gardens, they would dip their beakers in the River Cautar and drink their fill.

Stimulus enough, then, there certainly was. Glass, glass and more glass was produced, and every care was taken to adorn and beautify it to the full.

And since work in glass was recommended, it was employed not only for the ends directly mentioned but for profane pur-

poses, too. Mosque lamps of glass were adorned with particular artistry. Flowers, scent-bearers, were placed then as now in glass vases. The chemical industry required for its experiments tubes and flasks of all kinds. To hold and preserve the fragrant essences small bottles, phials, and balsam and aromatic containers of every shape, size and form were employed. Builders needed glass for windows and pieces of coloured glass for mosaics. In short, the production was as large and the use as varied as perhaps only we can appreciate today. The containers for the perfumes then marketed were treated as "packaging" and included in the price.

In daily use, eating and drinking vessels were made of glass, for as a material it possessed, as al-Ghuzuli assures us, wonderful properties: "A draught therefrom tastes better than from a vessel of precious stone, the face of one's friend is not lost sight of therein, and the hand bears it lightly... Vessels of glass release more fragrance than pots of earthenware, they do not rust and cannot be sullied through and through. When they are dirty, water alone cleanses them whenever and as often as they are washed in it. But if one drinks from them, one imbibes not just water but light and radiance as well."

Ever since man has engaged in the arts, he has striven to give permanence to what is fleeting and transitory. When writing of the mosaics of the Great Mosque at Damascus, the Persian writer Qazvini (died 1283 A. D.) has expressed this thought in words which we would advance as the definition par excellence of man's constant desire in regard to the work of his hands and would further ascribe as the special property, that of permanence, of the object of our study, glass. He says: "... Representations of animals, plants and various branches whose fruit we can gather with our eyes! And never are they assailed by the cares of real trees and fruit, for they remain while time runs its course, they can be enjoyed in all ages and in all seasons. They do not tantalize our thirst when no rain falls, and they do not wilt away with the passage of time..."

If there was a degree of dependence on Byzantium in the techniques and material employed, Islam soon achieved complete creative freedom in the form of the ornamentation. Certainly, in the east, the style of the great Sassanid epoch long played a decisive role. Thus, for instance, we find a wine bottle with the polished pattern of the late Sassanian style, although there can be no doubt that it is to be attributed to the ninth or tenth century.

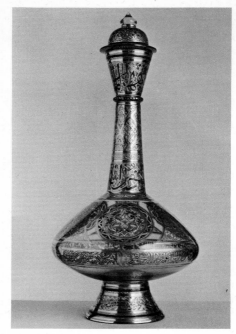

209 Lobmeyr, bottle

This means that the notions of the Magi, as the followers of Zoroaster were still called, survived at least externally in the ornamentation, before this cultural heritage was thoroughly Islamized. In the west, in contrast, the change took place with significantly greater abruptness. There the change of direction, or better the absorption of the past and its subordination to their own artistic ends, took place not merely by the choice of new thematic groups, or rather of new thematic groups based on the heritage of the past – whereby, of course, the tradition prohibiting the representation of living things probably played the biggest role in Islam – but also by the way in which the Moslem artists conceived and executed their decorative themes: motifs drawn from geometry, the plant world and Arabic script.

Translation P. J. D.

Syrian enamelled Glass and its Reception from about 1865 to Gallé

Mosque Lamps and their Imitation

191 *Syria (Aleppo), Mosque lamp;* glass, enamelled and gilt; h - 25.5 cm; c. 1300; probably the eulogistic inscrip-

tions on the neck and shoulder refer to Sultan Nasiraddin Muhammad, from whose madrasah and mausoleum, erected 1299–1304, in Cairo the lamp is said to come. Mosque lamps were generally made of enamelled and gilt glass, a technique which the Syrian glass-workers systematically developed in the 12th century. The lamps were suspended from the ceiling by chains attached to the fused-on eyes; oil and flame were in a filter-shaped container within. The decoration is ornamental and calligraphic. The inscriptions, either in the large Mameluke naskhi or in florid kufic, are drawn from the Koran or refer to the donor; Berlin, Staatliche Museen Preußischer Kulturbesitz, Mus. für Islamische Kunst, Inv.-No. I. 2296

192 *Syria / Egypt, Mosque lamp;* glass, enamelled and gilt; h - 28 cm; the Arabic inscription around the neck runs: "executed at the behest of his majesty, the lord, grand-duke of the king"; 14th cent.; cp. the small mosque lamps by Brocard; Vienna, Österreichisches Mus. für angewandte Kunst, Inv.-No. GI 3035; plate

193 *Joseph Brocard; vase in the form of a mosque lamp;* greenish glass, gilt and enamelled; Islamic script in blue enamel pigment on the body of the vase; h - 34.8 cm; sig. on the base: Paris 1867; like Lobmeyr, Brocard here takes Syrian mosque lamps around 1300 as his model; Vienna, Österreichisches Mus. für angewandte Kunst, Inv.-No. 7552/GI 553; coloured plate

194 *Joseph Brocard; vase in form of a mosque lamp;* glass, enamelled and gilt; h - 13.8 cm; sig. on the base: Brocard Paris 1873; Nürnberg, Gewerbemus. der Landesgewerbeanstalt Bayern, Inv.-No. G 1623/2

195 *Joseph Brocard; vase in form of a mosque lamp;* glass, enamelled, gilt; h - 13.8 cm; sig. on the base: Brocard Paris 1873; this form of vase with the bulging body is not inspired by Syrian mosque lamps, but rather by 14th-century Egyptian forms; Nürnberg, Gewerbemus. der Landesgewerbeanstalt Bayern, Inv.-No. G. 1623/1

196 *Joseph Brocard; vase in form of a mosque lamp;* deep-blue glass, enamelled and gilt; h - 27 cm; pre 1887; the usual form of the mosque lamp is not followed here: the Syrian model is followed in the calligraphic frieze, whereas the rest of the ornamentation is

Moresque and European; Paris, Musée des Arts Décoratifs, Inv.-No. 4129

197 *Théodore Deck; vase;* pottery, enamelled; in the form of a Syrian mosque lamp; h - 35.9 cm; c. 1870; 13th and 14th-century Syrian mosque lamps in enamelled glass were copied in the 1870's above all by Brocard and Lobmeyr; ceramic imitations, like this one here, are rare; London, Bethnal Green Mus., Inv.-No. 705 A–1869; plate

198 *Central Europe; vase in the form of a mosque lamp;* glass, enamelled and gilt; h - 23.5 cm.; c. 1880; Frankfurt, Knut Günther

Joseph Brocard

199 *Joseph Brocard; bottle;* glass, enamelled and gilt; h - 16.5 cm; sig.: Brocard; c. 1880; there is a bottle by Lobmeyr which is very similar to this: both are inspired by Syrian pilgrim's bottles of the 13th century; Charleroi, Chambon Coll.

200 *Joseph Brocard; bottle;* glass, enamelled and gilt; h - 30 cm; sig. on base: Brocard. F; pre 1884; Paris, Musée des Arts Décoratifs, Inv.-No. 369

201 *Joseph Brocard; goblet;* glass, enamelled and gilt; h - 26 cm; sig. on base: Brocard 1884; Paris, Musée des Arts Décoratifs, Inv.-No. 364

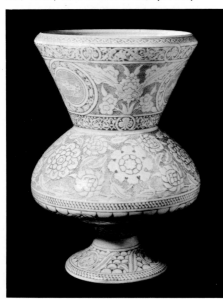

197 Deck, Vase in form of Mosque lamp

202 *Joseph Brocard; foot-bowl;* glass, enamelled and gilt; ⌀ - 27 cm; 1873; in a way similar to Lobmeyr's treatment of the plate, Brocard has used European and Islamic elements here, cp. Cat. no. 214; Vienna, Österreichisches Mus. für angewandte Kunst, Inv.-No. 1281/GI 1093

203 *Joseph Brocard; receptacle with lid;* glass, enamelled and gilt; h - 11 cm; sig.: Brocard; c. 1870; Paris, Priv. Coll.

204 *Joseph Brocard; dish;* glass, enamelled and gilt; h - 10 cm; sig.: Brocard; c. 1870; here Brocard adopts the form and decoration of Persian metal dishes which he translates into glass, cp. the brass dish from Vienna which is distinguished from this only in small details; Paris, Priv. Coll.; plate

205 *Persia, dish;* brass, etched, with inlaid asphalt; h - 12 cm . The inscriptions are not in quite correct Arabic. The six run: I am the weeper; I am the dew to him; I am the irrigation ditch; I am the all-pervading; I also bring relief; I offer cooling refreshment. 1st half of 19th cent.; Vienna, Österreichisches Mus. für angewandte Kunst, Inv.-No. Me 192; plate

Ludwig Lobmeyr

Like Brocard in Paris, Lobmeyr devotes his attentions, with the aid of a team of scholarly collaborators and experts, to reviving enamel painting and an authentic reproduction of the ornamentation. Even the Islamic scripts on his works are in most cases without the slightest mistake. His scientific interest is shown by the basic treatment of the subject he published with Ilg and Boeheim: "The glass industry, its history, present development and statistics," 1874. It was with his exhibits at the Vienna World Fair in 1873 that Lobmeyr first attracted attention. His orientalizing tendencies helped popularize the oriental fashion. Lobmeyr rarely copies exactly. For example, the enamelled glass beaker (Cat. no. 216) is easily recognizable as a work of the 19th century because of the complete regularity of the ornamentation. Islamic motifs are even modified and interspersed with European elements. The tendrils beneath the calix are Islamic. The spirit of the copyist is revealed more in the ogival, trefoil arabesques, whereas the impressive zigzag frieze beneath the mouth, the imitated fluting and the wide foot of the beaker betray Lobmeyr's

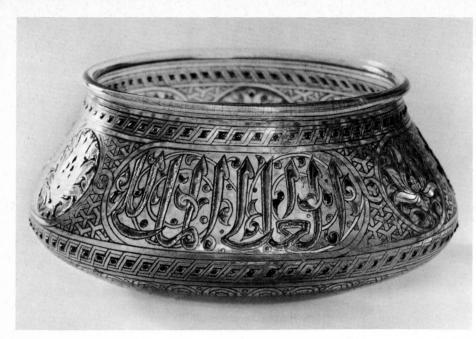

▲ 204 Brocard, dish ▼ 205 Persia, dish

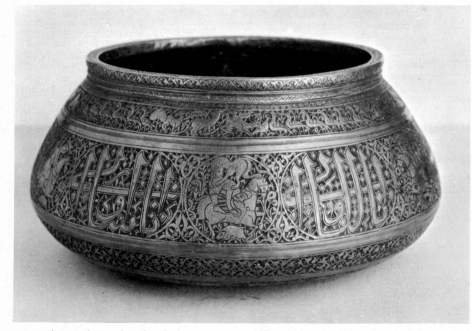

personal stylistic tendencies. Lobmeyr never used his skills to defraud. The quotations from the Koran are often translated on the foot of his vessels. Whereas on the mosque lamp by Brocard (Cat. no. 192) only the external form of Arabic script is imitated without conveying any meaning. Artists, schooled in Arabic, have collaborated in the production of other works, e. g. the plate by Lobmeyr (Cat. no. 214) on which the

calligraphic principles are carefully observed. On other objects, for example on the little bottle (Cat. no. 212), the copyist betrays himself in the way the tendrils overlap the writing, something which never happens on Islamic originals. H. L. Translation P. J. D.

206 *Syria; beaker;* glass, enamelled and gilt; h - 11 cm; 13th cent.; Lobmeyr and Brocard, in their adaptations and assim-

ilations, take Syrian beakers as their model; the cups of these are covered with ornamentation; Frankfurt, Mus. für Kunsthandwerk, Inv.-No. St 261

207 *Ludwig Lobmeyr (Vienna 1892–1918); phial with stopper;* glass, enamelled and gilt; h - 135 cm.; sig.: ILL 5; c. 1870; Vienna, Priv. Coll.

208 *Ludwig Lobmeyr; pair of beakers;* glass, enamelled and gilt; h - 11 cm; on the base the translation of the inscription: "Refresh thy soul through me"; 1875; the form of the glass is European; only the decorative motifs are Islamic; Vienna, Österreichisches Mus. für angewandte Kunst, Inv.-No. 27969/GI 2578

209 *Ludwig Lobmeyr, bottle;* glass, enamelled and gilt; h - 30.5 cm; the inscription is translated on the base: "The Kingdom belongs to God, the Only and Eternal One, the Omnipresent"; 1875; a copy of Syrian enamelled glassware of which only a few examples are extant; Vienna ,Österreichisches Mus. für angewandte Kunst, Inv.-No. 27964/GI 2573; plate

210 *Ludwig Lobmeyr; vase;* glass, enamelled and gilt; h - 26 cm; on the base the translation of the inscription: "Mohammed"; 1875; a Syrian pilgrim bottle, c. 1280, from the Cathedral and Diocesan Museum, Vienna, could have served as a model here; Vienna, Österreichisches Mus. für angewandte Kunst, Inv.-No. 27965/GI 2574

211 *Ludwig Lobmeyr; jug;* blue glass, enamelled; h - 23.7 cm.; 1873; the jug is part of the furnishings of an "Arab" room; Vienna, Österreichisches Mus. für angewandte Kunst, Inv.-No. 27962/GI 2571

212 *Ludwig Lobmeyr; bottle;* glass, enamelled and gilt; h - 16.8 cm; 1875; Vienna, Österreichisches Mus. für angewandte Kunst, Inv.-No. 27968/GI 2577

213 *Ludwig Lobmeyr; pair of bottles;* glass, enamelled and gilt; h - 30 cm; 1875; on the base the translation of the inscription: "Mohammed, O Defender"; Lobmeyr uses a European form with Islamic decoration; Vienna, Österreichisches Mus. für angewandte Kunst, Inv.-No. 27967/GI 2576

214 *Ludwig Lobmeyr, plate;* glass, enamelled and gilt; ∅ - 39 cm; translation of the inscription on the underside: "Prudence is man's most powerful sup-

port and integrity is his best quality." European and Islamic decorative motifs on a European form, cp. the plate by Brocard; Vienna, Österreichisches Mus. für angewandte Kunst, Inv.-No. 5128/GI 1430

215 *Ludwig Lobmeyr; beaker;* glass, enamelled and gilt; h - 18.7 cm; 1879; a 5-cm-high duplicate is in the Germ. National Museum at Nürnberg; they both borrow from a Near Eastern drinking beaker, c. 1300, which is generally without a foot, however, and has a filter-shaped cup; Vienna, Österreichisches Mus. für angewandte Kunst, Inv.-No. GI 1444/5156

216 *Ludwig Lobmeyr; design by Ludwig Lobmeyr; painting by Franz Schmoranz jr.; beaker;* glass, enamelled and gilt; h - 23 cm.; c. 1878/79; Nürnberg, Germanisches Nationalmus., Inv.-No. GI 494

217 *Ludwig Lobmeyr; phial;* light-blue glass, enamelled and gilt; h - 18 cm; c. 1875; this form has no Islamic prototype; Vienna, Österreichisches Mus. für angewandte Kunst, Inv.-No. 27963/GI 2572

Anonymous Glass

218 *French-Belgian; beaker;* glass, enamelled and gilt; h - 18.5 cm; end of 19th cent.; Syrian glass beaker from the 13th century served as a model; Liège, Musée du Verre, Inv.-No. E/35; plate

219 *Syria; beaker;* yellowish, fluted glass, enamelled and gilt; h - 31 cm; c. 1290; Munich, Bayerisches Nationalmus.; plate

220 *Germany; beaker;* glass, enamelled and gilt; h - 13.5 cm; end of 19th cent.; the vessel combines Far-Eastern elements, like the asymmetry of the ornamentation, with Islamic techniques (enamelling and gilding); a similar example is a rose-water sprinkler (Cat. no. 265) with its decoration in Chinese relief engraving; Liège, Musée du Verre, Inv.-No. E/180

221 *Germany; goblet;* glass, enamelled and gilt; h - 9.5 cm; end of 19th cent.; Liège, Musée du Verre, Inv.-No. E/96

222 *French-Belgian; Carafe;* glass, enamelled, gilt and iridescent; h - 22 cm;

end of 19th cent.; Liège, Musée du Verre, Inv.-No. E/181

223 *Fernand Thesmar; dish;* green glass, enamelled and gilt; h - 4,5 cm; c. 1890; Paris, Musée des Arts Décoratifs, Inv.-No. 5932

Glass from Russia

224 *Russia; tea service (three piece), a tea pot;* glass, enamelled and gilt; h - 23.6 cm; c. 1870; the Balkan countries and parts of Russia which were still in Ottoman hands at the beginning of the 19th century continued to use mixed forms of Islamic and domestic elements later; these works are thus distinguished from the oriental products of European historicism in that they are the fruit of a living Islamic tradition; Nuremberg, Gewerbemus. der Landesgewerbeanstalt Bayern; Inv.-No. G 7956/2

225 *Russia; tea service, b) plate;* glass, enamelled and gilt; ⌀ - 36.3 cm; c. 1870; Nuremberg, Gewerbemus. der Landesgewerbeanstalt Bayern, Inv.-No. G 7956/1

226 *Russia; tea service, c) tea cup;*

glass, enamelled and gilt; h - 4,2 cm.; c. 1870; Nuremberg, Gewerbemus. der Landesgewerbeanstalt Bayern, Inv.-No. G 7956/2

227 *Russia; beaker;* glass, enamelled and gilt; 1867; Vienna, Österreichisches Mus. für angewandte Kunst, Inv.-No. 8490/Gi 614

228 *Russia; jug;* glass, dark blue-green with silver painting; h - 41.7 cm; c. 1870; Nuremberg, Gewerbemus. der Landesgewerbeanstalt Bayern, Inv.-No. G 7957; plate

229 *Persia; jug;* glass, full of bubbles and somewhat striated; h - 23.3 cm; 17th/18th cent.; Nuremberg; Gewerbemus. der Landesgewerbeanstalt Bayern; Inv. No. G 7189

Emile Gallé

230 *Emile Gallé (Nancy 1846–1904); beaker;* glass, enamelled and gilt; h - 22.5 cm; sig. on base: Emile Gallé à Nancy; c. 1880; the depiction of figures in the quatrefoil is a borrowing from Indo-Persian miniatures; Liège, Musée du Verre, Inv.-No. E/67; plate

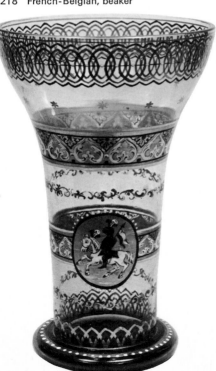

218 French-Belgian, beaker

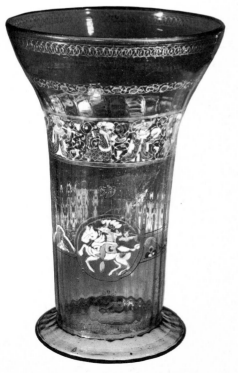

219 Syria, beaker

41

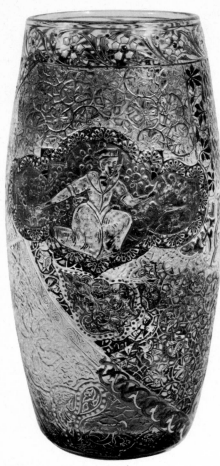

230 Gallé, beaker

231 *Emile Gallé, vase; glass*, etched, enamelled and gilt; h - 42.5 cm; sig.: Emile Gallé à Nancy; c. 1880; like the Liége vase, this one also shows the Islamic influence which is so noticeable in Gallé's early work; Frankfurt, Knut Günther

232 *Emile Gallé, dish;* glass, intaglio engraved, gilt; h - 8 cm; sig.: Gallé; c. 1880; fatamid intaglio-engraved glasses, such as the "Hedwigsbecher" served as Gallés model. He took over the gilding from Syrian glass work; Munich, Stadtmus., Inv.-No. K 70/100

233 *Emile Gallé, vase;* crystal, intaglio, enamelled and gilt; h - 7.5 cm; sig.: on the base: Gallé (mirror inverted), plus Persian inscription; c. 1895; after the Syrian enamelled glass work and mosque lamps, Gallé devoted his attentions to Fatamid intaglio-engraved glass which he combines with Syrian techniques; S. Germany, Priv. Coll.

234 *Emile Gallé, vase;* thick glass, sealed-in blue-green veins; cut, etched and enamelled; h - 8 cm; sig. E. Gallé, Nancy; 1889; Hamburg, Hans-Jörgen Heuser

Art Nouveau Lustre Glass and the Orient

Siegfried Wichmann

An important phenomenon, which occurred around 1900, is the lustre glazing of tiles, friezes, and pottery; even fashion, with its iridescent silk fabrics attempted to employ it as an eye-catching effect. The opal was the jewel of the day, and its glowing, reflecting and illuminating character was adapted in glasswork at the turn of the century to achieve an iridescent effect, an effect which even penetrated into the colour combinations of neo-impressionist painting. Ludwig Hevesi, the commentator of the Viennese secessionist style, wrote: "...the deep-blue cupboard in the pointellirist-room, which fits remarkably well into the colour scheme; and iridescing naturally above it is glass from Klostermühl, from the Tiffany's of Austria as we should like to call it. It makes a delightful effect and certainly has a future..."
Under the master-hand of the American, Louis Tiffany, lustreglazing reached its artistic culmination. From art nouveau, he developed a "glass epoch", and fantastic colour effects make his glass-ware a high-water mark in this field. The mat surface of the "Favrile Glases" shimmers like a rainbow. He discovered this technique in 1894, a technique which possesses a high refraction index due to the density of the surface. The lustres are combined with the surface in such a way that a style developed which became decisive for Tiffany's artistic aims. The Tiffany studio in New York and its entire production was subsequently influenced by the non-European centres of glasswork. Tiffany noticed Syrian glass and designed his own work from it. Syrian ceramics and lustreware also appear to have greatly influenced his glass-ware. Lustrepainting reached an important stage of development, above all during the Ayubid period (end of 12th to middle of 13th century), with its imposing lustred faience. The faience of the Raqqua was also probably decisive; it has the usual lead glaze which was originally opaque and could be made lightly iridescent by an addition of chemicals. "Almost all the Raqqua pieces excavated so far, reveal such decomposition effects, which can actually be quite attractive..." (Ernst Kühnel: "Islamische Kleinkunst, Braunschweig, 1963, p. 125.)
Syrian glass, too, which was also of central importance, especially for Tiffany's work, was evoked by means of sintering and transformation by alkaline treatment of the surface, by soil moisture and soil reagents. This transformation procedure, which was valued by artists around 1900 as a method of ageing and changing the structure of the surface, created extensive industries in America and Europe which devoted themselves to the technique of lustreglazing.
In the manufacture of "factory iris" the glowing molten glass is subjected to metallic vapours (tin salts etc.) before blowing in the iris drum. The painter's iris, also a frequently used technique, is produced by a thin application of the lustre colour on to the glass before firing.
Lustreglazing is particularly widely used in the Bohemian glass centres around Leipa, Kamnitz, Steinschönau, Haida, Adolphshütte and Klostermühl. The Lötz glassfactory was the main centre of this method of lustreglazing, but it was also employed by the English and American glassfactories of Joseph Locke, the New England Glass Company in Cambridge, Mass., Rainbow, Mother of Pearl, and the Washington Glass Company. The colourless and also coloured glazes are produced by an addition of silver chlorite or silver nitrate to the furnace in the form of smoke-producing substrates in tar or naphtalene compounds. The resulting reactions are prolonged by repeated smoking until the metallic substances are deposited on the surface like mother of pearl. The addition of cobalt, manganese, copper, iron, silver and bismuth also produces fantastically iridescent reflections that are independent of the light surounding the glass-ware, and cause the surface to appear extremely variable. The iridescent effect, which reached its culminating point during this period, is still influential today and has recently received new impetus in glass production from findings dating from the Old Orient.

Translation P. J. D.

235 *Persia; dish with handle;* glass, strongly iridescent; ∅ - 25 cm; c. 1400 A. D.; Vienna, Österreichisches Mus. für angewandte Kunst, Inv.-No. 37222/ Gl. 3236

236 *Central Europe; dish;* glass, lustred; ∅ - 15.8 cm; c. 1900; Düsseldorf, Kunstmus., Prof. Hentrich Coll.

237 *Central Europe; dish;* glass, lustred; ∅ - 16.4 cm; c. 1900; Düsseldorf, Kunstmus. Prof. Hentrich Coll., Inv.-No. P. 1970–69 (II 346)

238 *Persia, dish;* light green glass, iredescent; ∅ - 11.5 cm; 9th/10th cent.; Düsseldorf, Kunstmus., Prof. Hentrich Coll., Inv.-No. 1956–16

239 *Lötz, Austria (Max Ritter von Spaun); manufacture: Glasfabrik Klostermühle near Unterreichenstein, West Bohemia; vase;* glass, lustred; h - 13.2 cm; c. 1900; Vienna, Priv. Coll.

240 *Lötz Austria (Max Ritter von Spaun); manufacture: Glasfabrik*

240 Lötz, vase

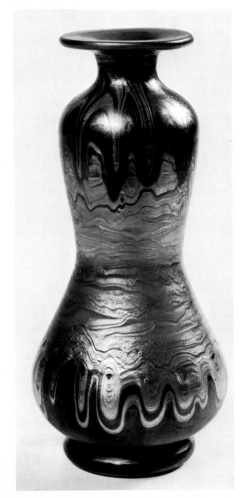

Klostermühle near Unterreichenstein, West Bohemia; vase; glass, lustred; h - 17.8 cm; sig.: Loetz Austria; c. 1900; Vienna, Priv. Coll.; plate

241 *Lötz Austria (Max Ritter von Spaun); manufacture: Glasfabrik Klostermühle near Unterreichenstein, West Bohemia; vase;* glass, lustred; h - 18 cm; c. 1900; Vienna, Priv. Coll.

242 *Lötz Austria (Max Ritter von Spaun); manufacture: Glasfabrik Klostermühle near Unterreichenstein, West Bohemia, vase;* glass, lustred; h - 10.5 cm; c. 1900; Vienna, Priv. Coll.

243 *Lötz Austria (Max Ritter von Spaun); manufacture: Glasfabrik Klostermühle near Unterreichenstein, West Bohemia; vase;* glass, lustred; h - 10.5 cm; c. 1900; Vienna, Priv. Coll.

244 *Lötz Austria (Max Ritter von Spaun); manufacture: Glasfabrik Klostermühle near Unterreichenstein, West Bohemia; vase;* glass, lustred; h - 10.5 cm; c. 1900; Vienna, Priv. Coll.

245 *Lötz Austria (Max Ritter von Spaun); manufacture: Glasfabrik Klostermühle near Unterreichenstein, West Bohemia; vase;* glass, lustred; h - 12.3 cm; c. 1900; Vienna, Priv. Coll.

246 *Amphora-Werke Riessner, Kessel-Stellmacher (Turn b. Teplitz, Bohemia), vase;* porcelain, lustred; h - 32.3 cm; sig.: trademark Amphora and Amphora Turn, red stamped trademark with amphora, the letters R St K and the words Turn Teplitz Bohemia Made in Austria and the punched-in numbers 5 and 580; c. 1900; Vienna, Priv. Coll.

247 *Lötz Austria (Max Ritter von Spaun); manufacture: Glasfabrik Klostermühle near Unterreichenstein, West Bohemia; vase;* glass, lustred; h - 13.6 cm; c. 1900; Vienna, Priv. Coll.

248 *Lötz Austria (Max Ritter von Spaun); manufacture: Glasfabrik Klostermühle near Unterreichenstein, West Bohemia; vase;* glass, lustred; h - 17.3 cm; c. 1900; Vienna, Priv. Coll.

The Rose-Water Sprinkler — its Role between East and West around the Year 1900

Siegfried Wichmann

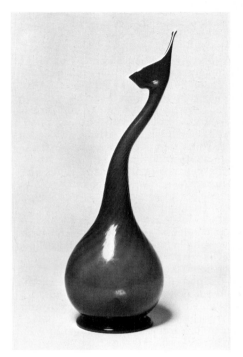

250 Persia, rose-water-sprinkler

A bizarre form of vessel to which insufficient attention has so far been devoted in the scientific study of oriental glassware is the rose-water sprinkler. In all likelihood it was primarily a product of Iran, although India and the Near East also contributed towards its evolution. During the eighteenth century it was mainly produced at Shiraz, perhaps in manufactures founded by Shah Abdâs. In his Survey of Persian Art, C. J. Lamm remarks: "... the rose-water sprinkler with the gracefully curving swan-like neck of ribbed glass became fashionable throughout the whole of Europe. The Persian manufactures did their best to keep pace with the demand and thus ensured the continuation of a tradition which had originated in the sixteenth century. This has undoubtedly contributed towards the difficulty we experience today in distinguishing the various stages in its development, in dating individual pieces exactly and in determining the precise date of origin of individual specimens..." This comment is drawn from the realm of specialized research and immediately underlines how

many questions the sprinkler raises which are still waiting to be solved. Here we should like to consider in greater detail above all the reference to the swan-like curve of the neck. On closer examination we see that the rose-water sprinkler is full-bellied in form with an s-shaped neck of varying width. Indeed, the eighteenth century Persian pieces produce the quite definite effect of a tense, aggressive poise. The peculiar-shaped mouth resembles gaping jaws, which accounts for the animal associations often evoked by the form of the vessel. The sprinklers are in blue-, green-, yellow- or amber-coloured glass, often very thin-blown, and ornamented with superimposed light-toned glass threads and ribbed bands. Occasionally small dabs of colour are added to the mass which produce the effect of iridescent scales on the neck. What we are here faced with is in fact no swan shape but, in all probability, a form owing its inspiration to the cobra poised for attack, a type which recurs again and again in Indian ornamentation and miniatures, for in India this snake enjoys almost divine veneration. When really roused, the cobra throws back its head in an s-shaped curve and dilates its neck into a broad hood; the wide-open jaws are then flattened to expose the poison fangs in the upper jaw. In this position, the upper jaw forms a flat, tapering furrow — in other words, it takes on the shape which is typical of the mouth of the rose-oil sprinkler. The few drops of neurotoxic venom from the fangs is enough to kill man or beast; its extremely rapid action fascinated the inhabitants of the Orient. Their fear and admiration mingle in the legends and tales concerning the cobra. The form of the sprinkler was thus well chosen, for, instead of the snake's poisonous venom, drops of the costly attar or otto of roses were emitted from the carefully designed neck and mouth of the vessel. The precious rose-oil was stored in the belly of the sprinkler which, when tilted, allowed the "tears of Allah" to run slowly down the curved neck to the mouth, where, carefully apportioned, it dripped out. Genuine oil of roses is one of the treasures of the Orient and was weighed out in gold. It nearly all came from Iran, from Shiraz itself, so that oil and containers were produced at the same place. Iran exported great quantities of rose-oil for centuries to India; Medinet-el-Fayum met the needs of all the wealthy sheiks and potentates of North Africa. In subtropical countries, attar of roses was highly esteemed for its medicinal and numerous other properties. Its fragrance filled the palaces of the Moghul emper-

ors. It soon enjoyed great renown with the inevitable result that clever imitations found their way on to the market. The unscrupulous trader produced the best fake rose oil from geranium oil, which has a similar smell; like rose-oil, it is colourless, or yellowish, greenish or brownish in colour. However, this substitute essential oil, which was obtained from the blossoms and leaves of the Pelargonium radula, only raised the price of real rose-oil still further. The fake oil also fetched a high price and was exported first and foremost from the Turkoman regions to India. Turkoman geranium oil is obtained from the grass Andropogoren pachnodes, a plant said to come from Mecca. Via Smyrna it reached Bombay, where it was traded. The oil was always sold in rose-oil sprinklers, which are still faked and traded in the Orient.

II.
This bizarre vessel of drawn glass which resembles the scaly skin of the cobra deeply impressed America's great artist in glass, Louis Comfort Tiffany. He produced rose-water sprinklers in favrile glass with an extremely effective iridescent surface. The fat-bellied form is extremely well adapted to the superimposition of coloured glass which, when the neck is drawn, produces a thread-like ornamentation on its slim contours. The result, especially in favrile glass, is a rich variety of colour effects. Favrile glass, invented by Tiffany in 1894, has an extremely high refractive index. Its surface seems denser and compacter than lustre glass which aims at the same effect. On account of its translucent fusibility, the colour combinations are extremely similar to the scaly brightness of the cobra's skin. Only if one has seen the cobra fighting its deadly enemy, the mongoose, in the Indian sun, will one be able to understand that only the iridescent scales of the snake can be compared with the work of man's hands, glass.
Tiffany's rose-water sprinklers are extremely elegant, decided in contour and concise in form, and technically perfect, too. The European glass centres, but especially the Bohemian workshops at Leipa, Kamnitz, Steinschönau, Haida, Adolphshütte and Klostermühle, soon produce sprinklers on the Tiffany model. In a very short time, it is especially the workshop of Loetz at Klostermühle which carries out experiments with resins — the result is a daring lustre, but the shape of the vessel takes on abstruse forms. Formal homogeneity is replaced by heterogeneity: the gaping, broad lips, the ecstatically curved neck and multicoloured iridescent surface are

given a wide variety of treatment. The Europeans, who have always been ready to adopt formal stimuli and then exaggerate them, developed the sprinkler form further and, by widening the mouth, tended to more floral effects. This process of reception can be studied in a comparative series. The glass is arbitrarily drawn and pressed. A change of form is initiated which leads to quite new associations. Just as the rose-oil sprinkler had been determined in its form by the tense power of the cobra, so now the floral element gains the upper hand. Final perfection is aspired after here, too. The mouth is extended until it takes on a languid goblet shape, a form to which Tiffany imparts a value all of its own.

Translation P. J. D.

249 *Persia; rose-water-sprinkler;* blue glass; h - 38.7 cm; 17th/18th cent.; Hamburg, Mus. für Kunst und Gewerbe, Inv.-No. 1892.530

250 *Persia; rose-water-sprinkler;* blue glass; h - 31.8 cm; c. 1800; Frankfurt, Mus. für Kunsthandwerk, Inv.-No. 786; plate

251 *French-Belgian; vase in form of a rose-water-sprinkler;* glass, amber coloured, gently iridescent; h - 26 cm; end of 19th cent.; Liège, Musée du Verre, Inv.-No. E/186

252 *Lötz Austria (Max Ritter von Spaun); manufacture: Glasfabrik Klostermühle near Unterreichenstein, West Bohemia; vase in the form of a rose-water-sprinkler;* glass, lustred; h - 28.5 cm; c. 1900; sig. Loetz; Vienna, Priv. Coll.

253 *Persia; rose-water-sprinkler;* glass, yellowish green, white and red spots; h - 22.1 cm; 17th/18th cent.; Munich, Staatliches Mus. für Völkerkunde, Inv.-No. 32–17–1

254 *Lötz Austria; manufacture: Glasfabrik Klostermühle (S. Bohemia, founded 1830); vase;* glass, green iridescent; h - 25.3 cm; c. 1900; Darmstadt, Hessisches Landesmus., Inv.-No. 63.C241

255 *Louis Comfort Tiffany (New York 1848–1933); vase in form of a rose-water-sprinkler;* glass, lustred; h -

257 Persia, rose-water-sprinkler
259 Tiffany, vase
261 Germany, vase
263 Tiffany, vase

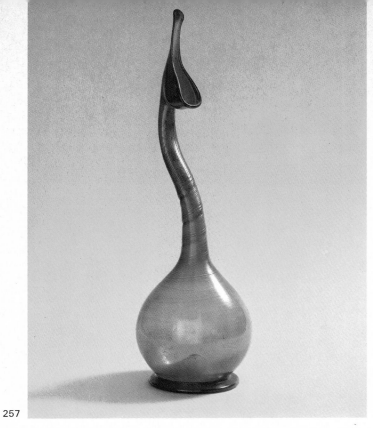

257

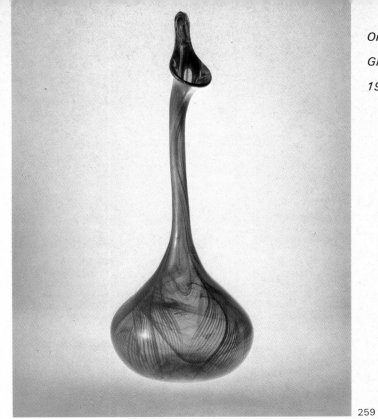

259

261

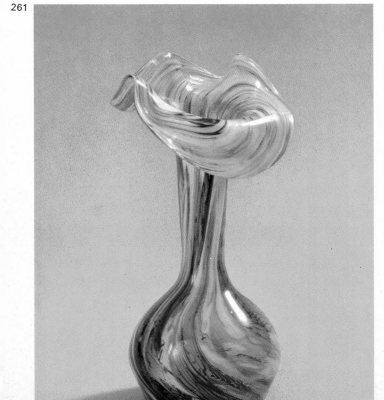

263

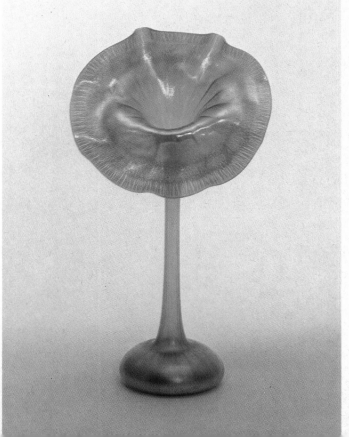

45

38.5 cm; c. 1900; sig. on base: workshop no. 01116; Vienna, Österreichisches Mus. für angewandte Kunst, Inv.-No. 11,488/GI. 1989

256 *Persia, rose-water-sprinkler;* blue glass; h - 45 cm; 19th cent.; Vienna, Österreichisches Mus. für angewandte Kunst, Inv.-No. 17,881/Or 1071

257 *Persia, rose-water-sprinkler;* blue glass; h - 35 cm; 18th/19th cent.; Düsseldorf, Kunstmus., Inv.-No. 12414; coloured plate

258 *Louis Comfort Tiffany, vase in form of a rose-water-sprinkler;* favrile glass, dominating colours blue and green; h - 29 cm; c. 1900; Frankfurt, Ferdinand Wolfgang Neess Coll.

259 *Louis Comfort Tiffany, vase in form of a rose-water-sprinkler;* favrile glass, yellowish green; h - 45.5 cm; sig.: X1402; c. 1900; Munich, Deutsche Bank AG; coloured plate

260 *Louis Comfort Tiffany, vase in form of a rose-water-sprinkler;* favrile glass; h - 27.5 cm ; sig.: L. C. T. M4368; c. 1900; S. Germany, Priv. Coll.

261 *Germany, two vases;* glass; h - 18.5 cm; 2nd half of 19th cent.; Düsseldorf, Kunstmus., Slg. Prof.Hentrich, Inv.-No. 11,330; II 331; coloured plate

262 *Lötz Austria, vase;* ruby glass, lustred; approx. h - 30 cm; c. 1900; the Persian rose-water-sprinkler is given a more vegetative interpretation and has a floral lobate mouth, instead of that of a cobra; Paris, Barlach Heuer Coll.

263 *Louis Comfort Tiffany, vase;* favrile glass; h - 44.5 cm; sig.: L. C. T. Y 3263; c. 1900; floral tendencies begin to transform the vessel entirely: the character of the rose-water-sprinkler almost disappears because of the strong lustering and the floral mouth. S. Germany, priv. coll.; coloured plate

264 *Louis Comfort Tiffany, vase;* favrile glass; h - 52 cm; sig.: L. C. Tiffany 1066 G; c. 1900; Düsseldorf, Kunstmus., Slg. Prof. Hentrich, Inv.-No. P. 1970–440

265 *Val St Lambert, vase;* glass, flashed; h - 49 cm; sig.: VsL; c. 1900; this vase is an example of the combination of Islamic and Chinese elements; the mouth reminds

one of the Persian rose-water-sprinkler, whereas it is executed in the Chinese relief technique of the 18th century; Munich, Stadtmus., Inv.-No. 70/94

Peacock Motifs

Horst Ludwig

The inclusion of representations of the peacock and especially its train and covert feathers among the arts and crafts of the oriental section is not without its problems. With equal justification, they could also be exhibited in the Chinese or Japanese section, for the peacock also appears there in the decorative arts. It was already known to the Greeks as the bird of the Hera and symbol of the firmament. It possessed a varied emblematic significance for western Christianity: it was the symbol of immortality, corrupt passion, as the radiance of virtue which is as self-illuminating the train of the peacock, and finally as the image of vanity. Originating from India and Java, it was introduced into other countries by the Israelites and Phoenicians. It is of central importance in the East as a sign of rank among Chinese officials, the emblem of the Persian monarchy (peacock throne) and as a symbol in Buddhist art. It is for this reason that we have chosen to treat it here. Over and above this, the peacock still evokes an aura of the exotic by virtue of its shimmering clothing of feathers, whereby the association of oriental pomp and fantasy arises automatically.

From the "Gründerzeit" onwards, the peacock found growing use in Europe as a motif in handicrafts and interior decoration. The peacock throne of Ludwig II in the Moorish Kiosk at the palace of Linderhof dating from 1877 is one of the most obvious receptions of Islamic form and symbolism. The pluralistic style of the period and the retrospective attitude of Ludwig II embodied in the identification with different epochs of world history, are recorded here in a Persian manner on equal terms with other styles of form. While this possessed an aristocratic, exclusive character at that time, a little later it found access to the salons of the upper middle class and the artists' studios of Markart and his contemporaries. In the same way as the potted palm, the stuffed peacock became a necessary requisite of an exotic panorama, by which means these families demonstrated their worldliness and edu-

cation. Franz von Seitz, for example, made a number of salons in which the peacock was included in the wings of the decorative stage. It became an emblem of social status like the Turkish smoking-rooms with their Islamic tables, tabourets, hookahs and rugs, which no better family could dispense with. About the year 1900, it was discovered by the potters and glassware artists of the Jugendstil movement. Plates by de Morgan, Fred Passenger and Gordon Forsyth show the peacock in varied pose. A number of vases by Juriaan Kok from the Rozenburg manufactory in the Hague depict it in all its colourful splendour. Pieces of jewelry, brooches and small flasks by Lalique, Wolfers and Feuillatre are precious variations of the peacock. Apart from the rose-water sprinkler which Louis Comfort Tiffany used for his guest-rooms, he made special use of the peacock's feathers in his vase decoration: sometimes stylized beyond recognition in combed-out form, sometimes as a covert feather in flowing, streaky form with lustre effect; but he also represented the whole bird complete with hanging train. The peacock motif was taken over from Tiffany by Ferdinand Poschinger and the Lötz company in Austria.

We encounter it again in book illustrations in the works of Melchior Lechter, Marcus Behmer, William Morris and other Jugendstil artists. Prominent is a Rubaiyat edition by Sangorski which shows a peacock in full display on the cover (see Cat. No. 288) with 21 covert feathers formed in opal and which, on the glossed and gilded leather, invokes impressions of former Persian splendour.

Translation G. F. S.

266 *Persia, peacock;* steel, silver and gold inlay; h - 63 cm; 18th/19th cent.; Munich, Staatliches Mus. für Völkerkunde, Inv.-No. 23–15–91

267 *France (?), Peacock with natural feathers;* bronze, gilt; h - 47 cm; c. 1870; Munich, Bayerische Verwaltung der Staatlichen Schlösser, Gärten und Seen, Inv.-No. LiP4

268 *Franz Seitz, design for a peacock throne;* gouache with gold; 51.5 × 39.5 cm; 1877/78; Munich, Bayerische Verwaltung der Staatlichen Schlösser, Gärten und Seen, Inv.-No. 2526b

269 *Theodor Kärner (Hohenberg 1885), peacock;* porcelain, underglaze painting

by Ludwig Carl Frenzel; h - 38.5 cm, w - 70 cm.; sig. on left of pedestal: T. Kärner; 1905; Berlin, Coll. Karl H. Bröhan

270 *Juriaan Kok (Rotterdam 1861–1919 Den Haag); produced by Haagsche Plateelbakkerij Rozenburg, Den Haag, vase with handles;* eggshell porcelain; on the front a peacock is depicted, on the rear crysanthemums in various tones of brown and green leaves; h - 12.4 cm; sig. on base: trademark, year, serial number and monogram JS; 1907; Darmstadt, Hessisches Landesmus., Inv.-No. 63:C292

271 *Juriaan Kok, produced by Haagsche Plateelbakkerij Rozenburg, Den Haag; vase;* eggshell porcelain; on the body of the vase peacock and birds of paradise in yellow, green and violet, between polychrome blossoms and buds; h - 28.5 cm; sig. on the base: trademark, year, serial number and monogram H; 1904; Darmstadt, Hessisches Landesmus., Inv.-No. Kg 63: C 290

272 *Juriaan Kok; produced by Haagsche Plateelbakkerij Rozenburg, Den Haag; vase with lid;* eggshell porcelain; peacock with three blossoms and buds in various tones of violet, with green

leaves and stems; h - 19.5 cm; sig. on the base: trademark, year, serial number and monogram JS; 1908; Darmstadt, Hessisches Landesmus., Inv.-No. Kg 63:c293

273 *Juriaan Kok; produced by Haagsche Plateelbakkerij Rozenburg, Den Haag; vase;* eggshell porcelain; front with birds of paradise in various tones of brown, yellow and blue on grey-green plant, the remaining three sides covered by floral fantasy and large rust-coloured blossom; h - 22 cm; sig. on base: trademark, year, serial number and monogram JMR; 1914; Darmstadt, Hessisches Landesmus., Inv.-No. Kg. 63: C 295

274 *René Jules Lalique (Ay 1860–1945 Paris); broach in the form of two peacocks facing each other; gold, enamelled,* saphires and opals; 2.2 × 6.5 cm; c. 1900; Paris, Michel Perinet

275 *René Jules Lalique, bracelet;* silver, appliquéd gold, opals, agate, peacock motifs; ∅ - 7 cm; c. 1900; Paris, Michel Perinet

276 *Philippe Wolfers (Brussles 1858–1929); oroach;* gold, enamel, diamonds, emerald, pearl; stylized peacock with widespread wings in light-blue encrusted enamel with en emerald and 38 diamonds; 8.5 × 4.2 cm; 1901; Darmstadt, Hessisches Landesmus., Inv.-No. Kg. 63: C 142

277 *Louis Comfort Tiffany (New York 1848–1933); window;* glass, leaded metal frames; a peacock sits in a rose bush with hanging train; enclosed by rose ornamentation almost in the form of a frieze; colours blue, green, and shades of yellow and red; 143.5 × 67.7 cm; c. 1900; Munich, Mus. Stuck-Villa

278 *Louis Comfort Tiffany; vase;* favrile glass, honey-coloured with stripes and six peacock feathers in lustrous green, violet and blue; h - 26 cm; c. 1900; sig. on base: L. C. T. E. 638 L C. Tiffany; Frankfurt, Mus. für Kunsthandwerk, Inv.-No. WME 638

279 *Louis Comfort Tiffany, vase;* favrile glass, combed peacock-feather ornamentation with striation; h - 17.7 cm; sig.: L. C. T.; c. 1900; Karlsruhe, Badisches Landesmus., Inv.-No. V. 4717

280 *Frederick Carder (1863–1963); vase;* flashed glass, lustred; on a white opaque ground, golden-lustred peacock feather pattern with superimposed

280 Carder, vase

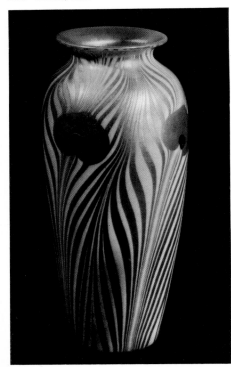

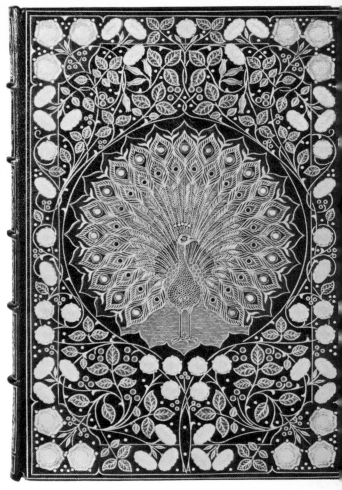

288 Sangorski, Rubaiyat

green "peacock eyes"; h - 23 cm; sig.: Aurene 294; adhesive label of the Steuben Glass Works, Corning N. Y.; 1903–1914; Frankfurt, Knut Günther; plate

281 *Eugène Feuillâtre (Dunkirk 1870–1916 Paris); vase;* silver, enamelled; the stopper is formed by the head and neck of the peacock, the body by the tail feathers; h - 12 cm; c. 1900; Paris, Michel Perinet

282 *Eugène Feuillâtre, ink-pot;* metal, blue enemel; stylized peacock-feather ornamentation; h - 5 cm; sig.: Feuillâtre; c. 1900; Paris, Alain Lesieutre

283 *Arte della Ceramica Firenze, vase;* pottery, glazed; whitish glaze with three peacocks in various shades of blue, green and yellow with red; h - 19.4 cm; sig. on the base: D A C F 227 R Firenze; post 1900; Darmstadt, Hessisches Landesmus., Inv.-No. Kg. 64: 190

47

284 *R. Fornaci, vase;* faience, reddish body; scale and peacock-feather motifs painted overglaze in brown, lustred red and shades of yellowish brown; h - 27 cm; pre 1910; Zürich, Kunstgewerbemus., Inv.-No. 7086

285 *Jean Durand, vase;* copper, chased; three peacock feathers in silver on a patinated ground; h - 39.5 cm; sig. on base: Jean Dunand; pre 1913; Paris, Musée des Arts Décoratifs, Inv.-No. 19140

286 *Clifton Junction; produced by Royal Lancastrian Pottery, ornamentation by Gordon Forsyth; plate;* earthenware, lustred; on the inner surface peacock in red and black lustred; ∅ - 48.2 cm; c. 1910; London, Victoria & Albert Mus., Inv.-No. C. 32–1964

287 *Ferdinand Freiherr von Poschinger; glass goblet;* colourless glass; stylized peacock ornamentation, brownish lustre; h - 23.2 cm; c. 1900; Karlsruhe, Badisches Landesmus., Inv.-No. 70/82

288 *A. Sangorski; Rubaiyat of Omar Khayyam;* book cover, pressed and gilded leather; at the centre peacock and wheel; 21 opals inset as "peacock eyes"; 20.4 × 14 cm; London 1903; Frankfurt, Mus. für Kunsthandwerk; plate

Oriental Textiles and European Fashion

Europe and the Oriental Carpet

289 *Persia, Isfahan; carpet;* "Tapis polonais," formerly in the imperial family; the pattern of the carpet represents a variation of a well-known cartoon of a continuous pattern of medallions joined be pairs of arabesque leaves; 135 × 200 cm; end of 17th cent.; Vienna, Österreichisches Mus. für angewandte Kunst, Inv.-No. 25480/T. 8326

290 *Ferdinand Sodoma; Ancient Persian Carpet after an Original in the Possession of the Supreme Court;* Copy, body colours with gold and silver on paper, 61 × 45 cm; c. 1870; this is a reproduction of a quarter of a "tapis polonais" which is today in the possession of the Österreichisches Mus. für angewandte Kunst and which was exhibited in the museum on loan from the court from 1865; Vienna, Österreichisches Mus. für angewandte Kunst, Bibl. Kunstbl. Slg. I, Inv.-No. 5547

291 *Turkey; prayer carpet;* wool fragment of a large prayer carpet with six scarlet, stepped niches; 329 × 128 cm; 17th cent.; the carpet was intended for use in the mosque; families or religious brotherhoods could kneel in parallel rows and pray; Berlin, Staatliche Museen Preußischer Kulturbesitz, Mus. für Islamische Kunst, Inv.-No. 25/61

292 *Persia; atlas;* 44 × 23 cm.; 14th cent.; Vienna, Österreichisches Mus. für angewandte Kunst, Inv-.No. 4097/T. 830; plate

309 Beechy, Thomas Hope

293 *Philipp Haas & Söhne, Vienna, atlas;* a faithful copy of the original in the Austrian Museum for Art and Industry; 19 × 60 cm; Vienna, Österreichisches Mus. für angewandte Kunst, Inv.-No. 3070/T.2607; plate

294 *K. K. Aerarial Wollenzeug-, Tuch-, und Teppichfabrik, Linz; carpet;* with the exception of the choice of colours, the carpet is a copy of a Caucasian pattern; 67 × 116 cm; 1837; Vienna, Österreichisches Mus. für angewandte Kunst, Inv.-No. TGM 29427

295 *Ferdinand Sodoma; Ancient Persian Carpet after an Original in the Possesession of the Supreme Court;* two copies in body colours with gold and silver on paper; each 92 × 61 cm; c. 1870; Somewhat more than a quarter of a "tapis polonais" from the former imperial collection; Vienna, Österreichisches Mus. für angewandte Kunst, Bibl. Kunstbl. Slg. I, Inv.-No. 5551 and 5551 A

296 *Ferdinand Sodoma; Ancient Persian Carpet after an Original in the Possession of the Supreme Court;* copy, body colours with gold and silver on paper, 91 × 61 cm; depicts part of a hunting carpet which was the first one to be exhibited at the Museum for Art and Industry in the year of its foundation 1864; Vienna, Österreichisches Mus. für angewandte Kunst, Bibl. Kunstbl. Slg. I, Inv.-No. 5543

297 *Ferdinand Sodoma; Ancient Persian Carpet after an Original in the Possession of the Supreme Court;* copy, body colours on paper, 62 × 45 cm; c. 1870; depicts part of a "tapis polonais" from the former imperial collection; Vienna, Österreichisches Mus. für angewandte Kunst, Bibl. Kunstbl. Slg. I, Inv.-No. 5549

298 *Seidenzeugfabrik Georg Griller, Vienna; three Patterns of "Rich Oriental Clothing Materials";* silk with gold brocading; 28 × 9 cm; 18 × 8 cm; 27 × 6 cm; 1820; Vienna, Österreichisches Mus. für angewandte Kunst, Inv.-No. TGM 23082

299 *Ziz- und Katunfabrik der Brüder Mayer, Vienna, Sample of various printed patterns;* cotton twill for searts and shawls, 108 × 43 cm; 1829; Vienna, Österreichisches Mus. für angewandte Kunst, Inv.-No. TGM 20009

300 *Silk cloth factory C. G. Hornbostel, Vienna; brown-red and rose foulard;* dress edging, copy of Bengalese pattern; 1829; Vienna, Österreichisches Mus. für angewandte Kunst, Inv.-No. TGM 23277

301 *Cotton printing factory Jaeger, Vienna; cloth sample;* cotton, print pattern for light coloured croisé cloth; 96 × 61 cm; Vienna. Österreichisches Mus. für angewandte Kunst, Inv.-No. TGM 20008

302 *Waistcoat manufacturer Carl Otto, Vienna; waistcoat;* sheep's wool and silk; 63 × 68 cm; 1893; Vienna, Österreichisches Mus. für angewandte Kunst, Inv.-No. TGM 22948

303 *Printing factory, Chazel in Vienna; shawl;* wool; 155 × 155 cm; 1845; Vienna, Österreichisches Mus. für angewandte Kunst, Inv.-No. TGM 19994

304 *Oriental cloth printer Nicolaus Lazarus, Vienna; oriental croisé cloth pattern;* cotton; 42 × 63 cm; 1829; Vienna Österreichisches Mus. für angewandte Kunst, Inv.-No. TGM 20015

305 *Philipp Haas and Sons, Vienna; silk fabric;* copy of original in Österreichisches Mus. für angewandte Kunst, pattern in yellow and instead of gold on red background; 55×38 cm; around 1870; Vienna, Österreichisches Mus. für angewandte Kunst, Inv.-No. 3074/T. 2611

306 *Silk cloth factory Joseph Giessauf, Vienna; two samples of poplin stamboul scallis on caftans;* poplin; 20×17 cm; 20×16 cm.; 1836; Vienna, Österreichisches Mus. für angewandte Kunst, Inv.-No. TGM 22401

307 *William Morris; design William Morris; manufactured by Morris & Co., London; wollen fabric "Isphahan";* 130×240 cm; end 19th cent.; Zürich, Kunstgewerbemus., Inv.-No. 6440

308 *William Morris (Walthamstow, 1834–1896, London); design: William Morris; manufactured by Morris & Co., London; silk fabric "Persian";* 70×94 cm; end 19th cent.; Zürich, Kunstgewerbemus., Inv.-No. 6445

European Fashion

309 *Sir William Beechy; Thomas Hope in Turkish Costume;* oil, canvas; 220.3×167.8 cm; 1798; London, The National Portrait Gall.; plate

310 *Carl von Sales, Portrait of the Authoress Caroline Pichler;* oil, canvas; 55×43 cm; 1818; Vienna, Historisches Mus.

311 *Anton Einsle (Vienna, 1801–1871); Lady in Turkish Costume in front of Mirror;* oil, canvas; 86×71 cm; sig. top right: Ant. Einsl. pinx. Vienna 831; 1831; Vienna, Österreichisches Mus. für angewandte Kunst, Geymüller-Schlößl; Inv.-No. 38357, Art. No. 302

Fashion Engravings

312 *Paris; Lady's dress in Indian style;* illustration from Theaterzeitung No. 147; 13×22 cm; 1833; Wien, Historisches Mus., Fashion Coll.

313 *Paris; Lady with oriental patterned cloth;* illustration from Petit Courrier des Dames, No. 2134; 19.5×28 cm; 1870; Vienna, Historisches Mus., Fashion Coll.

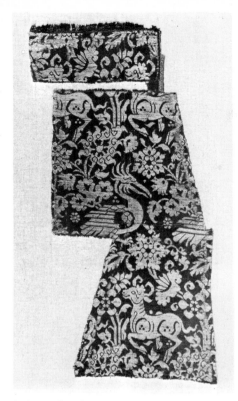

292 Persia, atlas

293 Vienna, atlas

314 *France; Lady with mantilla of oriental patterned cloth;* illustration from La Mode Illustrée, No. 2; 26×36 cm; 1870; Vienna, Historisches Mus., Fashion Coll.

315 *France; Lady with jacket in Tournure style with oriental pattern;* illustration from La Mode Illustrée No. 16; 26×36 cm; 1870; Vienna, Historisches Mus., Fashion Coll.

316 *Lady with mantlet of coloured Turkish cloth;* illustration from Illustrierte Frauen-Zeitung, No. 6; 28×38 cm; 1880; Vienna, Historisches Mus., Fashion Coll.

317 *France; Lady with oriental patterned cloth;* illustration from Pariser Moden, No. 47; 16×22 cm; 1847; Vienna, Historisches Mus., Fashion Coll.

318 *Paris; Lady with oriental patterned cloth:* illustration from Theaterzeitung No. 529; 14×22.5 cm; 1840; Vienna, Historisches Mus., Fashion Coll.

319 *Lady with mantilla of oriental patterned cloth;* illustration from Germania No. 14; 25×32.5 cm; 1871; Vienna, Historisches Mus., Fashion Coll.

320 *Lady with oriental patterned cloth;* illustration from Modebild No. 43; 22×29 cm; 1842; Vienna, Historisches Mus., Fashion Coll.

321 *Paris; Lady with coat of oriental patterned cloth and turban;* illustration from Theaterzeitung No. 175; 16×23.5 cm; 1833; Vienna, Historisches Mus., Fashion Coll.

322 *France; Boy with red fez;* illustration from Pariser Mode, No. 27; 16×23 cm; 1844; Vienna, Historisches Mus., Fashion Coll.

The Indian Shawl

323 *Kashmir; shawl;* loosely woven cotton with horizontal and longitudinal strips of silk; 180×350 cm; first half of 19th cent.; Zürich, Kunstgewerbemus., Inv.-No. 1955–16; plate

324 *Kashmir or Eastern Persia; shawl;* pure silk, embroidered with border; 134×304 cm; 19th cent.; Zürich, Kunstgewerbemus., Inv.-No. 1950–7

325 *Kashmir; shawl;* thin wool, natural colour; 180×345 cm; first half of 19th cent.; Munich, Stadtmus., Inv.-No. 59–485

326 *Scotland (?); shawl;* wool with border; 150×165 cm; second half of 19th cent.; Munich, Stadtmus., Inv.-No. S/59/7/6

327 *Scotland; shawl;* wool; 168×163 cm; 19th cent.; Munich, Stadtmus., Inv.-No. 32448

328 *Scotland, Paisley; shawl;* wollen fabric, embroidered with narrow border; 150×320 cm; middle 19th cent., imitation cashmere; Zürich, Kunstgewerbemus., Inv.-No. 13806

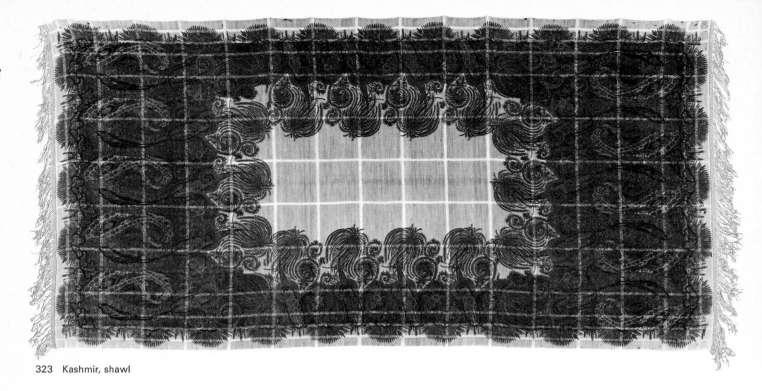

323 Kashmir, shawl

329 *Scotland, Paisley; shawl;* woolen fabric, embroidered; 142×314 cm; middle 19th cent., imitation cashmere, cf. Cat. no. 275; Zürich, Kunstgewerbe-mus., Inv.-No. 7834; plate

331 Austria, long cape

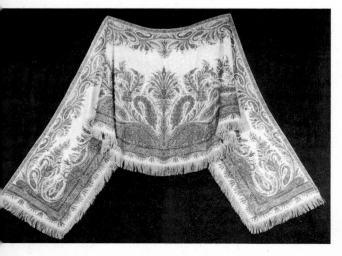

Robes and Accessories

330 *Austria; opera-cloak;* cashmere, woven pattern, coloured; c. 1888; Vienna, Historisches Mus., Fashion Coll., Inv.-No. 10532/1

331 *Austria; lady's long cape;* sheep's wool, Indian pattern; middle 19th cent.; Vienna, Historisches Mus., Fashion Coll., Inv.-No. 2743/1; plate

332 *Austria; two fez-caps;* black and red silk, gold embroidery designed from Turkish originals for home use; Vienna, Historisches Mus., Fashion Coll., Inv.-No. 6430/1; 6431/1

333 *Austria; lady's shoes;* embroidered red leather with pompon, no heel; first half of 19th cent.; Vienna, Historisches Mus., Fashion Coll., Inv.-No. 5075/2

334 *Austria; bashlik, lady's hood;* black cloth with coloured embroidery, silk fringe; 1870; Vienna, Historisches Mus., Fashion Coll., Inv.-No. 2807/1

335 *Austria; lady's dress;* muslin of wool, woven printed oriental pattern, white chiffon; c. 1840; Vienna, Historisches Mus., Fashion Coll., Inv.-No. 9281/2

336 *Austria; lady's shoes;* red Marocco leather, gold embossed, silk laces; first quarter of 19th cent.; Vienna, Historisches Mus., Fashion Coll., Inv.-No. 3459/2

337 *Austria; cape;* c. 1890; Vienna, Historisches Mus., Modesammlungen, Inv.-No. 1511/1

338 *Vienna, T. & L. Scharfetter; lady's jacket;* woven woolen fabric, pattern after Indian shawl combined with Turkish design; circa 1875; Vienna, Historisches Mus., Fashion Coll., Inv.-No. 2348/1

339 *Austria; lady's hat in Turban form;* white wool; 1968; Vienna, Historisches Mus., Fashion Coll., Inv.-No. 10886/1

340 *Germany; evening bag;* black satin, with sequins and Taj Mahal, embroidered in gold-thread; 16×10.5 cm; c. 1925; Munich, Stadtmus., Inv.-No. 1959/556C

341 *Russia; belt buckle;* enamelled silver, dagger clasp; 9×6.5 cm; c. 1900; Munich, Stadtmus., Inv.-No. 68/487

342 *Germany; belt;* metal thread on corded silk, copper-plated buckle with glass stones and filigree; buckle 10.5×7.4 cm; circa 1900; Munich, Stadtmus., Inv.-No. 57/215

Weapons and appurtenances

343 *Persia; helmet;* iron, copper, silver; engraved, chased, silver inlay; ∅ - 20.5 cm; 1787; Vienna, Österreichisches Mus. für angewandte Kunst, Inv.-No. Or 2996; plate

344 *Eugène Delacroix; Study of a turkish helmet;* oil, canvas; 48.6×27 cm; 1826; Paris, Mus. National du Louvre; plate

345 *Persia; shield;* iron, engraved, chased, silver inlay, frieze with Persian inscription; ∅ - 45.5 cm; 1787; belongs to No. 315; Vienna, Österreichisches Mus. für angewandte Kunst, Inv.-No. Or 3023

346 *Carl Goebel (Vienna 1824–1899); Seressaner Haram Pascha;* lithograph, coloured; 49.5×35.5 cm; sig. bottom right: Goebel 1848; Vienna, Heeresgeschichtliches Mus.

347 *Turkey; turban;* white muslin with two medals at front; ∅ - 18 cm; 18th cent.; Vienna, Heeresgeschichtliches Mus., Inv.-No. Rot 1278

348 *Russia; sword of honour with sheath;* damascus steel, velvet sheath; l - 98.2 cm; 1820; Solingen, Deutsches Klingenmus., Inv.-No. 1941.143

349 *Max Dinger; blade of sabre;* damascus steel; l - 96 cm; end of 19th cent.; Solingen, Deutsches Klingenmus., Inv.-No. DKM 100

350 *Solingen; infantry and cavalry sabre;* damascus steel, brass sheath; l - 103 cm; c. 1860; Solingen, Deutsches Klingenmus., Inv.-No. 1935. 180

Oriental Scenes

351 *Jean Léon Gérôme (Vesoul 1824–1904 Paris); Snake-charmer;* oil, canvas; 83.8×122.1 cm; sig.: J. L. Gérôme, c. 1870; Williamstown, Sterling Francine Clark Art Inst.

352 *Louis Comfort Tiffany (New York 1848–1933); Snake-charmer in Tangiers;* oil, canvas; 80×98 cm; sig.: Louis C. Tiffany; pre 1876; New York, Metropolitan Mus. of Art

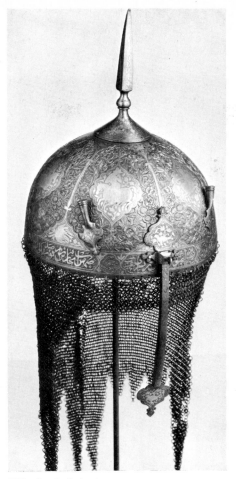

343 Persia, helmet

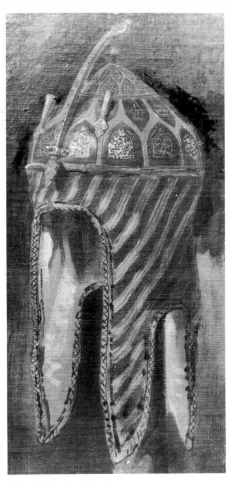

344 Delacroix, helmet

353 *Paul Ranson (Limoges 1862–1909 Paris); Snake-charmer;* oil, canvas; 72×91 cm; sig. top right: P. Ranson; c. 1890; Munich, Galleria del Levante

354 *Leopold Carl Müller (Dresden 1834–1892 Vienna); Marketplace at Gate of Cairo;* oil, canvas; 136×216.5 cm; sig. bottom right: Leopold Carl Müller 1878; Vienna, Österreichische Gal. des XIX. und XX. Jahrhunderts

355 *Frank Buchser (Feldbrunn near Solothurn 1828–1890); Market in Marocco;* oil, canvas; 62×110 cm; sig.: F. Buchser; 1850; Solothurn, Coll. of Gottfried-Keller-Stiftung in Solothurn, Mus.

356 *Hermann Kretschmer (Anklam, Pommern 1811–1890 Berlin); Bedouin;* oil, canvas; 193×166 cm; sig.: Kretschmer 1850; Vienna, priv. coll.

357 *Frank Buchser; Naked Slave-girl;* oil, canvas; 54×30 cm; 1880; prop. of Kunstverein Solothurn, deposited in Solothurn Mus.

358 *Karl Blechen (Kottbus 1798–1840); Interior View of Palm House on the Peacock Island;* oil, on paper, canvas; 64×56 cm; 1832–1834; Hamburg, Kunsthalle; plate

359 *Wintergarden of King Ludwig II, Munich;* photo; Munich, Residence; 1867

360 *Hans Makart (Salzburg 1840–1884 Vienna); Cleopatra;* oil, canvas; 189×506 cm; sig. bottom left: Hans Makart; 1875; Stuttgart, Staatsgal.

Treatment of Light and Colour in the Oriental Painting of the Nineteenth and Twentieth Centuries

Ernst Strauss

I.
From the viewpoint of their subject matter and motifs the Orient-inspired paintings of the nineteenth and twentieth centuries undoubtedly form a category apart. However, the main artistic problems with which these painters were confronted are exactly the same as those facing the whole of European painting during this same period. They are concerned primarily with the treatment of light and colour and arise from the gradual abandonment and transformation of the traditional chiaroscuro technique, from the demands made by outdoor painting and from the development to independent colour. These problems are all intimately connected. The various solutions found are the result of slow but sure transitions and still occupied the attentions of painters in the early years of this century.

By "traditional chiaroscuro" we understand the artistic means employed in painting from the late Middle Ages until the close of the eighteenth century. It was a method of treating light in a way which was "larger than life," as it were, a magnified version of man's everyday conception of "daylight." In chiraroscuro painting the subject depicted does not appear to be "illuminated," but the lights and the darks seem to be regarded as "primeval phenomena" and thus of equal standing and importance; in their diametric opposition or in their interpenetration, these two elements determined the physiognomy of the painting, utterly independently of the limitations placed by reality. They are, as it were, the factors imparting order, and to them all the other components of the picture — form, colour, line and pictorial content — are subordinated.

When the Baroque era comes to an end, this light-dark relationship is no longer of universal significance. Certain of its external characteristics, like the predominance of shadow in the composition of the picture, do indeed survive to a greater or lesser extent for nigh on a century, but it gradually loses its deeper, compositorial significance from the early years of the nineteenth century onwards. The mere fact of the reinterpretation of chiaroscuro effects as the light-dark contrasts occuring in nature, for example at dawn or twilight (cf. for instance Decamps' "La Caravane"), provides sufficient evidence of this process. With the coming of Romanticism the universal character of chiaroscuro disappears to the same extent as it seems to be *motivated* by the studies for the pictures, which are mainly drawn from the dark or nocturnal side of life, or as it is a means employed to give expression to the painter's own personal, inner vision.

All these transformations are particularly evident in the work of Delacroix. Delacroix dramatized the light-dark contrast, gave it prominence. In his work it is used to mediate the tragic and fateful, a "mystère douloureux" as well as a "mélancholie singulière" (Baudelaire). This primeval opposition between light and darkness creates in him — and to a lesser extent in many other painters of his day — tension, indeed menace; it is no longer reassuring and transfiguring as in all painting previous to him. Corresponding to this is a new "Romantic" palette, created by Delacroix. Perhaps its colours have less brilliance on the whole than those of its traditional forerunner, but this is more than compensated for by their greater range, their more passionate intensity and their greater warmth, three features which encourage the flowering of their poetic qualities, too. A latent tension between these colours and the darkness of his pictures dominates Delacroix's colour and light notation. This can be seen not just in the appearance of the individual colours but every bit as much in the texture of the dark areas. For his pictorial treatment of them betrays, even at times in his early works, his defi-

358 Blechen, Palm House on the Peacock Island

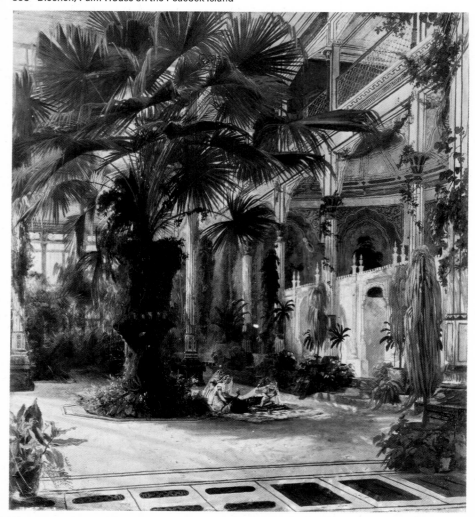

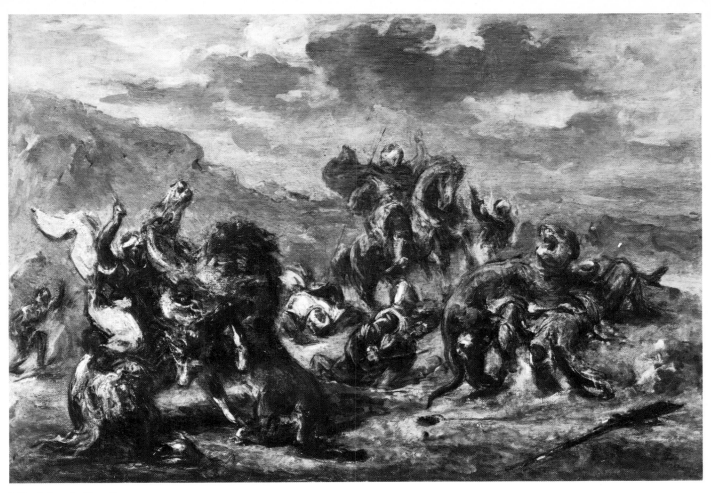

363 Delacroix, Lion Hunt

nite determination to go beyond, to sur-
mount once and for all the absolute lack
of colourfulness in the traditional hand-
ling of the darks and shades. It was one of
Delacroix's aims to "enlighten" the
traditional shadow in the picture with his
rich colours and thus establish a new
relationship between the former and the
light integrated in his colour.

II.

It is considerations such as these which
make clear the decisive significance of
Delacroix's journey to Africa for his
development as a painter. For, as we learn
from various references in his corre-
spondence and journal, in Marocco and
Algeria his vision was continually en-
riched by a new and profound ex-
perience of light, not in the sense of light
which in this intensity and profusion is
capable of being enhanced to the limits
of what is endurable but in its power of
dissolving and transilluminating all dark-

ness. This explains why during this
journey and from then on until his latest
works he was preoccupied with shadow
as with no other phenomenon. Obser-
vations like those he noted down on
February 21, 1832 already take us straight
to the central problem of his treatment of
light and colour: "The shadows, strongly
reflected, white in the shadows," "the
cast shadows of white objects with blue
reflections," "the cast shadow on the wall
with light yellow reflection." At first
these impressions are caught in the
watercolours made during the journey;
after his return they are elevated to one
of the guiding principles of his art. When
Delacroix remarks in the last year of his
life that the "true" local colour of an
object is always to be found near the
strongest light, that cast shadow on the
earth always appears violet, that every
reflection in a shadow has a green tint and
every edge of a shadow a violet tone,
then he is not just passing on his isolated

"observations of nature." No, such state-
ments are based far more on his lifelong
endeavours to transform the traditional
darks and shades into zones of reflected
brightness, into a *luminosity* of colour.
The results of his efforts here may justi-
fiably be regarded as the most significant
and momentous contribution to the
light-saturated painting of the nine-
teenth century.
The originality and extent of his innova-
tions are, it is true, less obvious in his
easel paintings than in his ceiling- and
wall-paintings. In the latter we have
perfect examples of the transformation of
the chiaroscuro of the old masters into a
colour notation based on medium lumi-
nosity. They also clarify the importance of
the "demi-teinte reflétée" for the colour
structure of the picture, that is of the
mean value between colour-intensifying
light and colour-debilitating darkness
which Delacroix is convinced should
dominate in a painting, since it alone is

53

370 Decamps, Caravan

capable of presenting the unfaked, "real" colour of the object and of giving it authenticity as a reflected colour. Thus his wall-paintings — most spectacularly the "Heliodorus" and "Jacob wrestles with the Angel" in the Chapelle des Anges, St-Sulpice, Paris — show just how decisive his "divisionist" technique of "*gradation*" (the division of a colour by means of grading it into degrees of luminosity) and of "*flochetage*" (the covering of a basic tone with parallel or criss-crossing hatching) was in achieving that dull-glistening reflected luminosity which he aspired after.

Certainly the same process can be observed in Delacroix's easel pictures, too. In them as well, especially in the larger-scale works, the consistent application of the divisionist method produces a drily gleaming, not seldom pastel surface effect. However, this effect arises spontaneously only in the light areas of the painting, whereas the lightening of the regions of shadow, which is produced with hatching or dabs of faint-coloured, mainly decidedly olive tones, is far less obvious in the overall effect and only goes to strengthen the main impression that Delacroix's works are conceived as "*dark grounded*." For in all areas of his pictures — and by no means just in the rear sections — the low-pitched colours of the object and their lightening reflections appear to have been "backgrounded" with darks and shades. It is as if they are able to defend themselves only with great effort against the superior might of a dark ground enveloping them; apart from which only the "real" colours —

thanks to their intensity — are able to maintain themselves against this ground.

III.

This distinction between the "reflected luminosity" and the "dark-grounded" nature of Delacroix's paintings as between two different formative principles in his work can of course only be made as an expedient, especially as it should be complemented by a reference to the comparatively pure colourfulness of the (here not included) studies for his paintings. Nevertheless, the distinction is useful because it enables us to determine more easily the various influences Delacroix exercised with his distinctive treatment of light and colour on the oriental painting of his own and later times.

That it was his "dark-grounded" works which at first exercised the stronger influence is most convincingly shown by the work of Adolphe Monticelli. Monticelli built on Delacroix's chromatism, but he condensed it, indeed radicalized it still further (for instance, in "Les Nomades"). In his œuvre the colours are reduced to their material origins; they are "kneaded," as it were, in impasto strokes, applied in furrowed patches or mosaic-like spots and then worked into an encrusted layer. It is the optical fusion of these elements with the ground which conjures up the concrete forms after the manner of a picture puzzle. The fairy-tale, exotic aspect of Monticelli's painting is the result of his extremely concentrated and violent colouring, in complete independence of the subject of the pic-

ture. The glittering and at the same time decorative lighting effect he achieves arises partly from the real light reflections on the "tips" of the impasto surface and partly from the deep-set hues drawn almost exclusively from the range of browns and blues and imbedded in extremely dark grounds in contrast to which they still have a kind of dull intensity. A luminosity which is based on reflected intensity, on the other hand, is not compatible with such a reduced chromatic system. — Stylistically Monticelli's glowing use of colour, so forward-looking and full of significance for the future in its abstraction, forms a link between Delacroix's colour notation and the early works of Cézanne and van Gogh.

The stylistic effects of Delacroix's luminarist innovations are of a different kind and more difficult to point to exactly in individual cases than those of his chiaroscuro. His innovations here were not taken to their logical conclusion immediately after his death but only over thirty years later when a school of out-and-out luminarist painting was founded (cf. in this respect Paul Signac's fundamental treatise "D'Eugène Delacroix au Néo-impressionisme," 1899). Nevertheless, his achievements in this field were recognized at a much earlier date — and this was no mere chance — by nobody less than one of the main representatives of oriental painting, Eugène Fromentin, for whom, two decades after Delacroix' Moroccan travels, North Africa was also to prove the source of impressions decisive for his development. Fromentin distinguished himself both as a first-rate painter and as a first-class writer, and was quite right in regarding his literary production as the necessary complement to his artistic creations. This is above all true of his two books based on his early accounts of his travels, "Un été dans le Sahara" (1856) and "Une année dans le Sahel" (1858) — valuable sources for a knowledge of views on light around the middle of the last century which have still hardly been tapped. In them we already find a passage which very appositely characterizes Delacroix's use of light in his pictures: "... Starting from the principle that the colours are deformed by the pronounced shades and lights and thus lose their richness and urgency, he (Delacroix) has conceived, even for his outdoor paintings, a type of Elysian, mild, moderate, regular light which I have called the light-dark of the open fields (le clair obscur des campagnes ouvertes). He has taken over from the Orient the vigorous blue of the sky, the shallow

shadow, the soft semitones... Often he takes pleasure in cold semi-luminosity, the real light of Veronese..." (Un été dans le Sahara).

Who can read these lines without immediately thinking of the murals in St-Sulpice? These observations are all the more remarkable when we recall that they cannot be based on a knowledge of Delacroix's main works which were most influenced by reflected light, since these were only just in process of creation during the 1850's. We also see from one of Fromentin's descriptions of light in the Sahara that his observations of nature also raised the basic problem of presenting light through colour which Delacroix was seeking to solve in his last work, incidentally with repeated reference to Veronese's technique, too:

"In contrast to what one sees in Europe, the ensemble of things presented to view here is formed in the shadow, which has a dark core and bright corners. It is Rembrandt in reverse, so to speak; nothing can be more mysterious! The shadow in this land of light is inexpressible; it is something dark and yet at the same time something transparent and coloured – like deep waters: they look dark, but as soon as the eye has penetrated them it is quite astonished to discover there is luminosity in them! One has only to think the sun away and this shadow is itself transformed into light..." (Un été dans le Sahara).

It is statements of this kind that make it clear what Fromentin understood by his "clair-obscur des campagnes ouvertes" – a characterization which fits his own pictures better than those of Delacroix. For their "bare" light is generally based on a cool, almost glassy reflective luminosity which serves as a background for dark zones and deeply shadowed, sharply delimited formal details. In addition to an enamel type of smooth "luminarist" coloration, Fromentin also shows a liking – often in one and the same picture – for a specifically "colouristic" technique, for example whenever he uses *grey* as an independent, fixed colour value, as a "dry" semitone or as a colour-levelling basic tone, in other words from completely different interpretative viewpoints. Such lack of conformity is basically to be traced to a conflicting view of the picture in which light has already emancipated itself to a large extent from its original chiaroscuro connections and is evidently beginning to reveal itself as the light of sun and day.

This decisive change had been completed in European painting by about the middle of the nineteenth century. The Orient-inspired painting is a particularly good and instructive example here because "by the nature of things" in this field the representation of the light of the sun in its most active form could not but become the most central problem to be solved. The novelty of the problem and the difficulties involved in its solution had already been recognized by Fromentin. Thus, he notices that nobody had ever thought that it could one day become one of the highest aims of painting to depict the profusion of the sun's light and brightness with the scant means at its disposal and he wonders why it is, unconsciously delineating van Gogh's later achievement, that no artist has so far ventured to tackle the "main obstacle, the sun" (le capital obstacle du soleil). As a painter he did not see himself capable of this and thus endeavoured to do it in words. His descriptions of the African atmosphere contain a whole number of instructive observations from the viewpoint of the history of painting, too. When he remarks for example (in "Une année dans le Sahel," that the Orient is "the land of the scorched earth surfaces under a blue sky so that the former are brighter than the latter, which at every moment produces pictures in reverse; no focal point, the light streams in from all sides; no mobile shadows, for the sky is cloudless...", then he is imparting visual impressions which, applied to pictorial art, are of decisive significance for the understanding of what was new in the outdoor painting of pre-Impressionist times. It is not merely that, in contrast to the landscape painting of previous epochs, the surface of the sky with its marked coloured treatment is of equal, if not greater, value than the fore- and middle-grounds of the picture; these latter are now exposed to the light and at precisely those points where the traditional chiaroscuro painting was accustomed to exclude this by darkening (preferably at the lateral and lower edges). These delimiting dark zones can now be dropped; the light portrayed now corresponds to that of "nature" in that it can penetrate from every direction, forming no focal point. Where the last traces of the traditional dark-grounded character have vanished, the picture appears bright-grounded instead. To the same degree in which the chiaroscuro light is transformed into sunlight, physical shadow gains in significance as a compositional element in the picture. We can go further and say that, on the basis of its contrastable sharpness, it is now recognized as the means par excellence for suggesting the full intensity of the "impacting" sun. Thus it was that oriental painting employed this in its most clearly expressed and most expressive form: as against-the-light shadow and especially cast shadow, often with conscious emphasis on its formal qualities; the precisely delimited

385 Signac, Constantinople

area of shadow which does not completely coincide with the object casting it but forcefully overlaps it almost as a detachable "figure" in its own right becomes practically a stylistic characteristic of early "sunlight painting" (for example Pasini "The Nile").

IV.
From the art historical viewpoint, the Orient-inspired painting does not appear to us today, taken as a whole, to be homogeneous enough to allow us to attribute to it an unmistakable style of its own with a consistent development. There can be no doubt that it produced its most characteristic achievements in the sixties and seventies of the last century; its "best" years therefore coincide with the period of pre- and early Impressionism. However, it has left no traces on the further development of Impressionism. The deeper reason for this is surely to be seen in the fact that, as the century progressed, the endeavours of the Impressionists and Post-Impressionists were so one-sidedly and exclusively concerned with the purely artistic solution of the problem of light for its own sake that any interest in its depiction based on considerations external to art, such as that of "locale," were just doomed to extinction. It is true that one of Monet's letters informs us how deeply he was impressed by the light and coloration of the Orient as he experienced it during his military service in Algeria in 1860–1862, but it is also clear that it was only much later that he grew aware of the fact that his future experiments were already contained in embryonic form in these early visual experiences. Furthermore, there is not a single "oriental painting" from his hand, just as there is not one from the brush of any of the other leading Impressionists or Post-Impressionists with the exception of Renoir and Signac. However, when Renoir painted in Algeria in 1881, he did not experience the light there as a new visual experience as did Delacroix or Fromentin, but only as the same light experienced on the Île de France although in incomparably greater intensity. It formed the subject matter of his painting both at home and abroad. When all is said and done, the North African light, in all its uniquenes, could only present him with a still greater incentive to apply the painting techniques he had evolved and already had been testing for years.
The same can also be said for the painting of Paul Signac three decades later: his picture of Constantinople harbour (1909) is not an exotic painting as

understood in the nineteenth century, but merely a work which is distinguished from all the other works of Signacs by the oriental motif, which is undoubtedly unusual for a Post-Impressionist and yet for all that still the product of the same vision of light. The presentation of this vision through a particular way of applying the paint, in complete independence of the motif, is the epoch-making innovation introduced by the Impressionists and their successors. Their achievement represents at the same time a decisive step on the way to the emancipation of colour as an artistic means of expression. For the Impressionists, by dissecting colour and applying it in dabs, inevitably severed its traditional links with the object and the firmly drawn line, and thus transformed it into a structural element in its own right. To a certain extent Delacroix had applied his paint in the same way and it is on his "Divisionism" that their technique is largely based. The big difference is that in Delacroix the dabs of paint are still entirely bound up with the object and have not yet combined to a chromatic patchwork which occupies the entire surface of the picture and which is intended in its vibrating overall optical effect to produce the illusion of daylight.
The exclusion of the dim colours of the earth from the colour scale so used, their systematization in the chromatic luminarism of Seurat and Signac, and finally the drawing together of the dabs of paint to surfaces of colour are the well-known stages on the way to colour as an absolute. Each new formal phenomenon is linked with an intensification and concentration of the light in the picture: the bright chromatic structures of early Impressionism are different from the colouristic surface structure of Matisse's painting. Matisse overcame the "obstacle du soleil" by renouncing any attempt at reproducing light (which he held to be impossible of attainment) and creating instead an *equivalent* for the light of the sun. This he did by extending pure, object-related colour to homogenous plain surfaces and then relating these to each other; he "organized" them so that, seen as a whole, they complemented each other to form an evenly dense, compact, "static" light of their own. That such a light could be used to suggest a definite physical light effect of extreme intensity is best seen in the works he made during two journeys to North Africa during the winters of 1911/12 and 1912/13, especially in his "Moroccan Tryptic" (Pushkin Museum, Moscow).
It is no mere chance that these paintings

were made during the very years which were to prove of the greatest significance for the history of the treatment of colour and light in European painting. For at same time Robert Delaunay was treating light for the first time in the history of painting as something abstract and autonomous; he raised light to the one and only subject of his pictures and freed it from any links with a concrete substratum, thus rendering it visible in its own pure existence and its own splendour. Delaunay, too, only had the normal colours at his disposal for the artistic realization of his vision of light but he employed them in a completely novel way, namely as a dynamic, vibrant and, at the same time, constructive element. Pure light was to result from the open interaction of forces released by the free development of colour. That Delaunay only completely attained this end in those decisive years before the outbreak of World War I by no means diminishes the greatness and significance of his achievement, even less so when we recall that it was bound up with epoch-making innovations in the field of colour and its aspects. What enabled Delaunay's colour to produce his special effect of light was its "prismatic" structure. The peculiarity of his coloration is based on the principle of the "fragmented surfaces" which suggest light as a colourful reflection and which in their seemingly "grounded" edges produce an overall effect of linear structures. However, these do not occupy the surface of the picture only two-dimensionally as in Matisse, but also penetrate them in depth too and thus open up a new dimension in which the *interior* of the ground is seemingly laid bare. What determines the composition as a whole is repeated in the appearance of the individual colours; their transparency — as a means of artistic expression an absolutely new phenomenon — is to be understood as a way of expressing the "interiorization" of the surface of the picture.
The radical change in the conception of the picture which is noticeable in Delaunay's painting around the year 1912 and is connected with the formal achievements of Cubism was not restricted to French painting. It was a change which was made, naturally under different preconditions at its starting-point, in the work of creative artists outside France who realized the inner relationship between Delaunay's vision and their own and, without in any way surrending an iota of their own originality, are indebted to him for decisive impulses which profited their own work. The great

achievement of August Macke, by far the most gifted colorist among the leading German modern masters, is to be seen, historically, in his objectifiying, as it were, the abstract prismatic light of Delaunay's creations by relating it to his own more respressentational vision and thus allowing it to merge into his own work and thus deepen its poetic content (Cat. no. 386). For Paul Klee it was a confirmation of his basic conviction that colour is something moving and creative of movement, a means of making light visible instead of depicting it (Cat. no. 455). It is above all the illumination of prismatic colour and its organization by means of a greatly simplified basic structure of large-scale geometric fields which have proved decisive for the art of the Swiss painter Moilliet (Cat. no. 445 ff.).

Macke, Klee and Moilliet are generally mentioned together since they went on what has become an almost legendary journey to Tunis in April 1914. And it is a fact that these bare two weeks of their stay in North Africa represent one of the high points in the history of early classical modernism. These three essentially different talents seem to have come close to a common new stylistic language which they had evolved independently of each other and in a completely individual use of Delaunay's vocabulary. It was the Tunisian journey which made clear to each of them definitively the path they were each to take: immediately after his return, in the short time that still remained to him, Macke concentrated and simplified his watercolours to pictures of the highest order; from that time on, the watercolour and the glass window became almost exclusively the medium of Moilliet's art; in Klee's work the "Wonder of Kairouan" produced the final breakthrough to pure colour as a means of artistic expression. We must add that the encounter with the Orient was to produce the deepest and most long-lasting effect in the art of Klee. This can be shown not only by his choice of themes in numerous instances but still more in the reminiscences of oriental forms that we come across in his work (mosaic structures, arabesques, the ad-infinitum repetition of pattern schemes, etc). Relationships of this kind had also proved fruitful for the art of Matisse, a fact confirmed by a number of his own words. And may not Macke also have been thinking of the hidden relationship of his own and contemporary art to that of the Orient, from the viewpoint of colour, when he once remarked: "Most recent pictures seem to me to be so organized that the sharp overall contrast

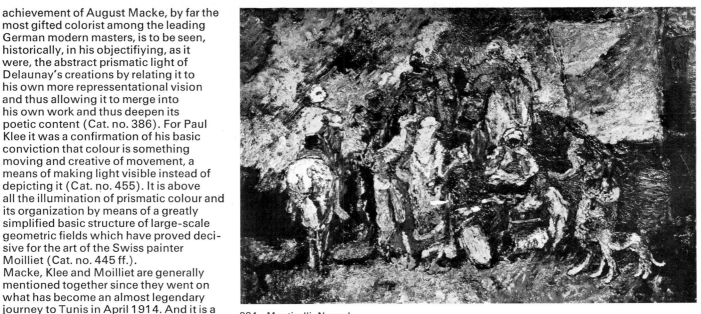

384 Monticelli, Nomads

of all the contrastive groups must be regarded as the compositional means, in contrast to the tranquil merger of more tranquil contrast groups in earlier pictures"?

Even the mere idea of a possible evaluation of impulses provided by the artistic methods of the Orient was entirely foreign to the "oriental painters" of the nineteenth century; sufficient for them was the natural experience of the oriental "scene," for the most part in connection with conceptions drawn from outside the field of art. In contrast, the Orient mediated the visual experience of its essential nature to the painters of modern art and at the same time a more or less deep insight into its artistic language.

Viewed in this way, the encounter of modern painting with the world of the Orient at various times has been no less significant for the history of art than the contact of the earlier painting of the European lands of the north with the art of Italy.

Translation P. J. D.

Action in the Hunting Compositions of Eugène Delacroix

Siegfried Wichmann

French painting of the July Monarchy took the consequences from the preceding revolutionary era; the culturally responsible classes, which had been intellectually or physically exiled during that period took an interest in the life of extra-European peoples. The artist concentrated on a reproduction of that which was direct and obviously characteristic. No rules, as in classicism, no strict dimensions were observed; the artist's own fantasy was given priority together with a new interest in the common aspects of everyday life, particularly in the life of foreign peoples.

Importance was not only attached to the content of objects, the event itself was considered elemental. Pictorial representation focused upon bold action and departed from the scheme of traditional prototypes. The turmoil of baroque battle pictures, the scandent arabesque of the mounted potentates, the hunting composition with the victor poised over the vanquished creature, were culminations of action scenes in the seventeenth and eighteenth centuries. The choice of the hunting scene as a motif is above all determined by feudal notions of power demonstration. The numerical superiority of the hunters enhanced by the pack of hounds, the perfection of regal hunting sports as a vast battue with nets, this is the climax of a rigid action cliché, which, as a "social diversion," performed a distinct role at European courts.

A number of nineteenth century artists became interested in big-game hunting as representing a fairer contest. The advocates of a new representation of motion and deportment were Théodore Géricault (1791–1827) and Eugène Delacroix,

whereby Delacroix is to receive our main attention here. Quite generally, it can be said that Géricault gives preference to the horse, which represents the central motif in his pictures. The high-bred Arab stallion, in typically sheer, unrestrained ecstatic movement, is the essence of Géricault's painting. The fiery rolling eyes, the distended nostrils, the finely curved crupper and haunches, are never repeated in accordance with a rigid scheme as in the work of earlier painters; it is fleeting action of the moment that is decisive. It is true that the baroque "horse portraits" are picturesque, but it is the "minimum motion" which Géricault perceives in a flash.

Delacroix proceeds from this conception; he admires Géricault's art but the distinctive feature is that posture and movement in his paintings, particularly in his hunting scenes, are led to a centering "axial acceleration" which dominates and signifies the picture. It is understandable that he includes colour in this acceleration since it supports horizontal and vertical movement, determines spatial gradations and culminates in the serpentine rotating motion. The temperature of the colour-light combinations are directly connected with the minimum movement and the mimic trace of the actors—they supplement eachother.

We shall not refer here to the frequently over-taxed triangular composition, the diagonal orientation or other systems that are much discussed in respect of the artist's academic compositional inclinations. It is decisive that Delacroix, as Géricault before him, does not submit to the repetition demanded by traditional European painting in the motional sequences. Through his concentrated typology and the cumulative motional sequences, the situation existing in the fight between man and beast always remains open; the elemental in both contestants is enhanced, equilibrium is guaranteed.

This impression is conveyed by the picture at the Louvre, "Chasse au Tigre". Rider and horse are caught in surprise by the wild leap of the tiger; fury and aggression are subject to the moment. Animal and animal are fused together in the form of a supporting pillar; the human being rises momentarily above the animal force of the action, but the outcome remains open. The horse rears up in the moment of reaction, the tiger becomes part of the serpentine movement, which envelops the entire tense body of the animal. The motional energy flows along the cropper and head of the horse, accumulates in the figure of the rider, who, having raised himself unsteadily from the saddle, stabs with his lance in falling. The painter cre-

ates the greatest contrast in the reaction of human being and animal. Dark and light are contrasted and juxtaposed. The rotational motion consists of opposite poles, which are elemental and illustrate the direct power of reaction.

Harmony and disharmony in the picture are based on the shifting of emphasis in the dynamic, rhythmic and space-forming variety of the composition. The minimum motion and expansive flourishes originate in Delacroix' work from the change in tension and relaxation, which was unknown to baroque artists in this degree of differentiation. Tension is created in his hunting and riding scenes by energy, an elemental input of power; relaxation by abatement, elimination of the partial motions. The rearing horse stands in the foreground like a "momental" monument, sculpture-like and supported statically by the tenacious wildcat. In this transfixed, but exceedingly animated motional situation, it harmonizes, unifies the experience of expectation and fulfilment for the observer. This enhanced creative conciseness alone determines the space in the picture. The hunters rushing to help in the middle distance and background only fulfil preparatory motions, as do the sinuous sprays of plants or jagged silhouettes of rock.

In addition to colour, line was also a means of design continually employed by the painter. Technically, Delacroix' drawings are exact and concentrated shorthand; they express the desired moment in the shortest formula. Delacroix' diary contains the following significant remark: "The first thing to be observed in drawing is the contrast of line. One must be clear about this before making a stroke" (Diary: p. 11).

The contour is premeditated even in the painting; reasoned, involuted movement conceived as an independent entity. The masses receive from the multiple lines that dynamic "charge" which makes the range of motion concrete. In Delacroix' paintings and drawings we recognize the way in which the pentimenti lead from one minimum motion to the next. This depiction of differentiated movements under consideration of the whole, makes a periodicity evident that compels one to participate in the sense of space-time experience. In 1843 Delacroix wrote in his diary: "There are lines that are colossal, particularly the regular serpentine lines. A line has no significance by itself. A second must be added to give it expression." The form of the line, therefore, possesses a power in its multiplication which traditional European painting did not know in this form. The outline of mo-

368 Schreyer, Mounted Arabs

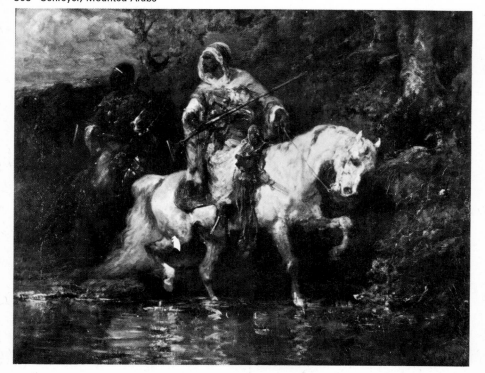

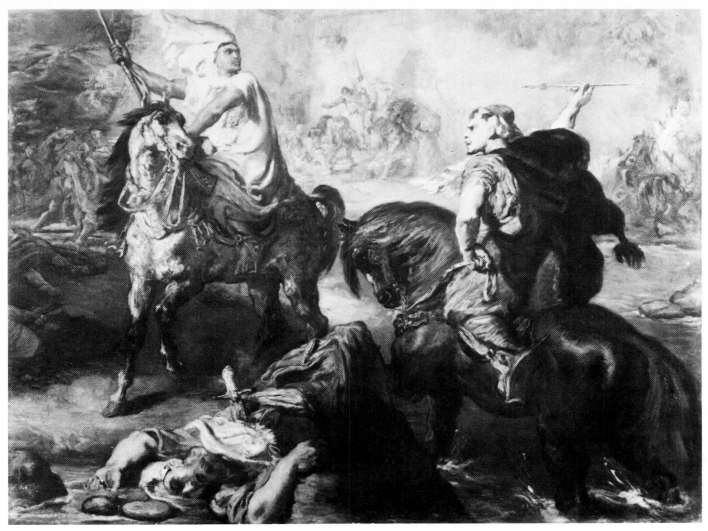

364 Chassériau, Arab Leader

tion conquers the configuration of space. Delacroix repeatedly allowed his fantasy to be stimulated by the English travel novel, but after 1844 he became more critical of Byron's work than previously. In this context he wrote: "The authors furnish their heroes with indomitable bravery. When they describe cowards, it seems as though the reader gains a false conception of the author's boldness. Byron's heroes are all braggarts, in the form of model figures, which one would vainly search for in nature" (Diary). Delacroix refers to the numerous lithographs and woodcuts devoted to oriental themes depicting bloody massacres and incredible hunting scenes. The exhalted gesture, the wildly theatrical posture were immediately desired as a form of entertainment and became popular with the masses. Delacroix wrote: "The slightest word which suggests emphasis, the smallest hint of diffuseness in the expression of feeling destroy the entire effect of these tendencies which otherwise occur so naturally" (Diary).

To the artist in North Africa, the life of its peoples and their daily activities appeared to be extremely natural. He showed an ethnological interest in his study of the dress, the living habits and customs. Like no other painter before him, he discovered the interconnection of specific motional sequences and also the extremes in their validity. The Berber and desert warrior, the wandering nomadic peoples and, above all, the hunters of every tribe, who themselves perform animal movements in the tracking of their prey, provide the painter with the swift reaction that he sought.

Delacroix thus not only became the painter of important motional scenes, but also one of the great representatives of human life who recognized that the oriental peoples had more to offer than the expansive lands that provided the main incentive for colonization by the European.

Translation G. F. S.

Hunt, Battle, Horsemen

361 *Théodore Géricault (Rouen 1791– 1824 Paris); Stalking Lion;* oil on paper, canvas; 24.5×29 cm; c. 1820; Winterthur, Hans Bühler Coll.

362 *Eugène Delacroix (Charenton-St Maurice 1798–1863 Paris); Tiger Hunt;* oil, canvas; 73.5×92.5 cm; sig. bottom right: Eug. Delacroix 1854; Paris, Mus. National du Louvre; coloured plate

363 *Eugéne Delacroix; Lion Hunt;* oil, canvas; 69.5×102.5 cm; c. 1860; Bremen, Kunsthalle; plate

364 *Théodore Chassériau (Santo Domingo 1819–1856 Paris); Arab Tribal Leader in Battle;* oil, canvas; 91×118 cm; sig.: Th. Chassériau 1852; Paris, Mus. National du Louvre; plate

365 *Alexandre-Gabriel Decamps (Paris 1803–1860 Fontainbleau); Oriental Riding Scene;* oil, cardboard; 32×40 cm; c. 1850; Munich, Baye-rische Staatsgemäldeslgn.

366 *Alexandre-Gabriel Decamps; Oriental Landscape with Troops;* oil, wood; 35×64 cm; sig. DC; Stockholm, National Mus.

367 *Adolf Schreyer (Frankfurt 1828–1899 Kronberg im Taunus); Arabian Horseman;* oil, canvas; 58×94 cm; sig. bottom right: Ad. Schreyer; c. 1865; Frankfurt, Adolf-und-Luisa-Haeuser Stiftung für Kunst- und Kulturpflege (on loan in Historisches Mus.)

368 *Adolf Schreyer; Mounted Arabs;* oil, canvas; 65×80 cm; sig. bottom right: Ad. Schreyer; c. 1865; Frankfurt, Dr. Hubert Schönwolf; plate

369 *Odilon Redon (Bordeaux 1840–1916 Paris); Lion Hunt (after Delacroix);* oil, canvas; 46×55 cm; sig. bottom right:

d'apres Delacroix, Odilon Redon; c. 1870; Bordeaux, Mus. des Beaux-Arts

370 *Alexandre-Gabriel Decamps; Caravan;* oil, canvas; 60.6×100 cm; pre 1880; Paris, Mus. National du Louvre; plate

Sculptures

371 *Antoine Louis Barye (Paris 1796–1875); Turkish Horse;* bronze casting; 30×31.5 cm; sig.: Barye; Paris, Alain Lesieutre

372 *Antoine Louis Barye; Horse attacked by Lion;* bronze casting; 40×29 cm; sig.: Barye; c. 1833; Paris, Alain Lesieutre; plate

373 *P. J. Mène; Mare with Arabian Saddle;* bronze casting; 27×45 cm; sig.: P. J. Mène 1855; Paris, Alain Lesieutre

374 *Emile Antoine Bourdelle (Montau-ban 1861–1929 Le Véninet near Paris); Sitting Maroccan;* bronze casting; 24×16 cm; 1924; Paris, Mus. Bourdelle

375 *Enzo Plazzotta; Falling Horse;* bronze casting; 20×16 cm; sig.: Plazzotta; Paris, Alain Lesieutre

Oriental Life, enlightening the Palette

376 *Johann Michael Wittmer (Murnau 1810–1880 Munich); At the sweet Waters of Asia;* oil, canvas; 81×118.5 cm; sig. bottom centre: longish inscription; c. 1835; Munich, Bayerische Staats-gemäldeslgn.

377 *Eugène Delacroix (Charenton-St. Maurice 1798–1863 Paris); Arab;* oil, canvas; 32×41 cm; sig. bottom right: Eug. Delacroix 1845; Rouen, Mus. des Beaux-Arts

378 *Carl Spitzweg (Munich 1808–1885); Turkish Café;* oil, canvas; 41.7× 52.7 cm; sig. bottom left: S (in rhombus) 1855–1860); Munich, Bayerische Staatsgemäldeslgn.; plate

379 *Tito Pellicciotti; Camels;* oil, canvas; 70.5×35.5 cm; c. 1890; Turin, Galleria Civica d'Arte Moderna

380 *Wassily Kandinsky (Moscow 1866–1944 Neuilly-sur-Seine); Carthage;*

372 Barye, Horse

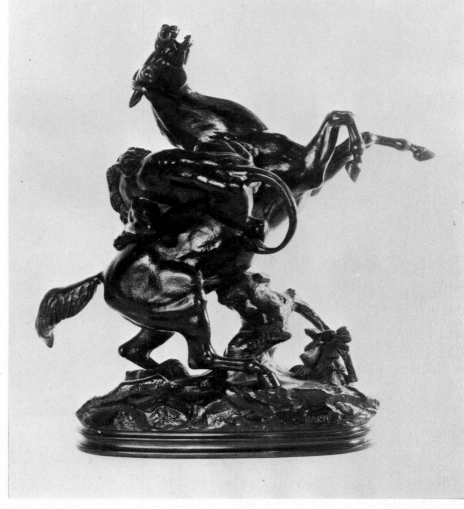

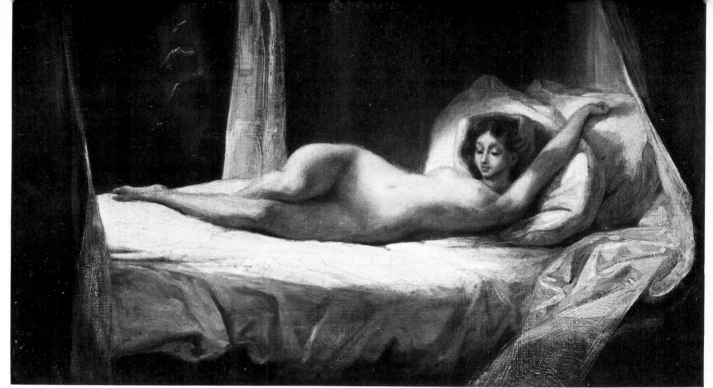

390 Delacroix,
Odalisque
(detail)

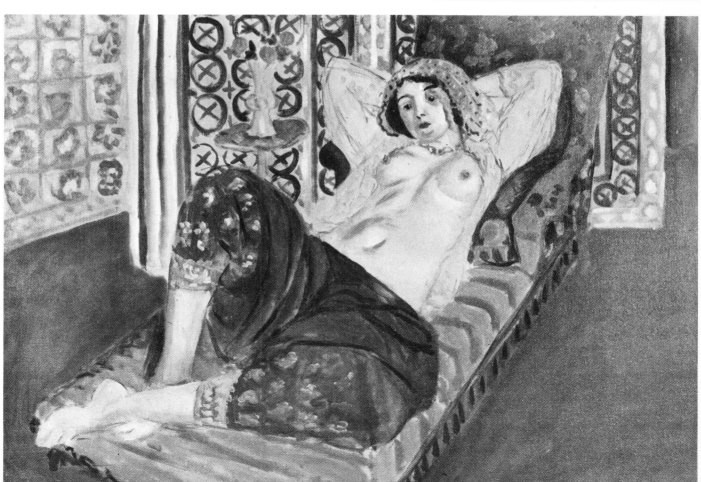

394 Matisse,
Odalisque

oil, canvas board; 23.6×32.8 cm; 1905;
Munich, Städtische Gal. im Lenbachhaus

381 *Charles Lapicque (Thieze, Rhone
1898, living in Paris); The Tiger of Ordos;*
oil, canvas; 130×97 cm; sig. bottom left:
Lapicque 61; 1961; Zürich, Dr. Peter
Nathan Coll.

382 *Alberto Pasini (Busseto near
Parma 1826–1899 Cavoretto near
Turin); Bazaar in Constantinople;* oil,
canvas; 35.5×27 cm; sig.: A. Pasini 1858;
Milan, Galleria d'Arte Moderna

383 *Alberto Pasini; The Nile;* oil, canvas;
23×39 cm; sig. bottom left: Pasini 1862;
Turin, Galleria Civica d'Arte Moderna

384 *Adolphe Monticelli (Marseille
1824–1886); Nomads;* oil, canvas;
44×64 cm; 1875–1878; Paris, Mus.
Bourdelle; plate

385 *Paul Signac (Paris 1863–1935);
Constantinople;* oil, canvas; 65×80 cm;
sig. bottom left: P. Signac 1909; Brussels,
Clive Morris Coll.; plate

386 *August Macke (Meschede,
Westphalia 1887–1914 Perthes, Cham-
pagne) Tunisian Landscape;* oil, canvas;
45×55 cm; sig.: Aug. Macke 1914;
Mannheim, Kunsthalle, coloured plate

Biblical Scenes

387 *Charles Théodore Frère (Paris
1814–1888); View onto Jerusalem;*
oil, canvas; 75×110.5 cm; sig. bottom
right: Th. Frère/Jerusalem. Terre Sainte;
1881; New York, Metropolitan Mus. of
Art

388 *Rudolphe Bresdin (Ingrande 1825–
1885 Sèvres); The Good Samaritan;*
lithograph; 56.5×44.3 cm; sig. bottom
left: Rudolphe Bresdin 1861; Hamburg,
Kunsthalle

389 *Gustave Moreau (Paris 1826–
1898); Dance of Salome for Herod;*
oil, canvas; 92×61 cm; 1876; Paris,
Mus. Gustave Moreau

Odalisques

Horst Ludwig

The word odalisque derives from the
Turkish odalyk, which originally referred
to a chamber-maid or lady's maid before it
was employed to denote the white
harem slave from the Sultan's palace in
Istanbul. The odalisques mainly came
from Caucasia and were declared free
after legalization of their children. In
European usage, the word is generally
employed for any depiction of harem
women includig oriental representations.
In the "Great Odalisque" painted by
Ingres in 1814, the recumbent female
nude is given an oriental interpretation.
The oriental mood is enhanced by requi-
sites such as the peacock fan and the
draping; the mode of representation and
painting technique are in the French
classicist style. As in the case of Géricault,
who discovered the themes and motifs of
Islam in the eighteen-twenties, the in-
fluence is limited to attributes and
themes. The composure of the odalisque
and the bold colour tends to draw the
erotic atmosphere of the harem more into
contrast with oriental reality rather than
to emphasize its presence. The tradition of
the Venetians, Giorgione and Tizian, with
their representations of Venus, is far more
significant for broad sections of odalisque
painting than the Orient itself. Delacroix'
odalisques, as well as his hunting scenes
and battling horsemen, congenially
paraphrase the vitality and vivid colour of
the Orient. "L'Odalisque couchée" of
1827 is the prelude to a large number of
larger and smaller-sized works which
deal with this theme. He dispenses with
detail in the area encompassing his
odalisques; it remains a dark field in
which the female nudes shimmer like
pearls on an oyster shell.
The Islamic world, which, virtually with-
out exception, signifies stimulation and
exoticism for the European, is always
interpreted in this sense by the painters of
the Orient. The elements of romance and
sex play a particular role in the odalisques
of "Gründerzeit" art in Germany. There is
also a picture by the Spaniard, Mariano
Fortuny, dating from 1861, with an
odalisque which is a perfect example of
this trend. At the back of the room a green
curtain is draped opulently over a chest;
the hookah and free wall surface are
brightly illuminated by the incoming rays
of light. A turbaned lute-player is ab-
sorbed in his music, while the odalisque
reclining on cushions and rugs, dreamily

presents her charms to the observer.
Matisse is the first painter in whom the
odalisque motif together with Islamic
forms achieve their full pictorial effect. He
fuses the overpatterning of the back-
ground, which links the surface areas as
in the Islamic carpet or miniature with the
figurative representations to form a new
pictorial unity. We also observe the con-
struction of the picture realized in additive
sequence of the surface areas. From 1920
onwards, the odalisque appears in many
variations in the work of Matisse, six
larger pictures of this genre being com-
pleted in 1922 alone.
The odalisque motif was taken up again
in contemporary art by Felix Labisse,
who represents the "Great Odalisque" by
Ingres and the "Turkish Bath" in a sur-
realistic context.

Translation G. F. S.

390 *Eugène Delacroix (Charenton-
St-Maurice 1798–1863 Paris); Odalis-
que;* oil, canvas; 24.5×32.5 cm; c.
1850; Zürich, Dr. Peter Nathan Coll.;
plate

391 *Eugène Delacroix; Women of
Algiers;* oil canvas; 27×21 cm; sig.
bottom left: Eug. Delacroix; 1847;
Rouen, Mus. des Beaux Arts

392 *Camille Corot (Paris 1796–1875);
Reclining Woman of Algiers;* oil, canvas;
40×60 cm; sig. bottom left: Corot;
c. 1871–1873; Amsterdam, Stedelijk
Mus., loan from Rijksmus., Amsterdam

393 *Ya Myhammad, Persia; Odalisque
Qajar;* oil, canvas; 147×88 cm; c.
1840; Paris, Joseph Soustiel Coll.

394 *Henri Matisse (Le Cateau 1869–
1954 Nice); Odalisque with Red
Trousers;* oil, canvas 67×84 cm; sig.
bottom right: Henri Matisse; 1922;
Paris, Mus. National d'Art Moderne;
plate

395 *Shiraz; Gehangir with Lover, Musi-
cians and Dancing-girl;* miniature; 31 ×
19 cm; 1547; Munich, Staatliches Mus.
für Völkerkunde, Inv.-No. Pree LI 297

396 *Persia; King Lohrasp on his Throne
surrounded by Musicians and Servants;*
miniature; 26×15.1 cm; end of 16th cent.;
Munich, Staatliches Mus. für Völker-
kunde, Inv.-No. Pree LI 326

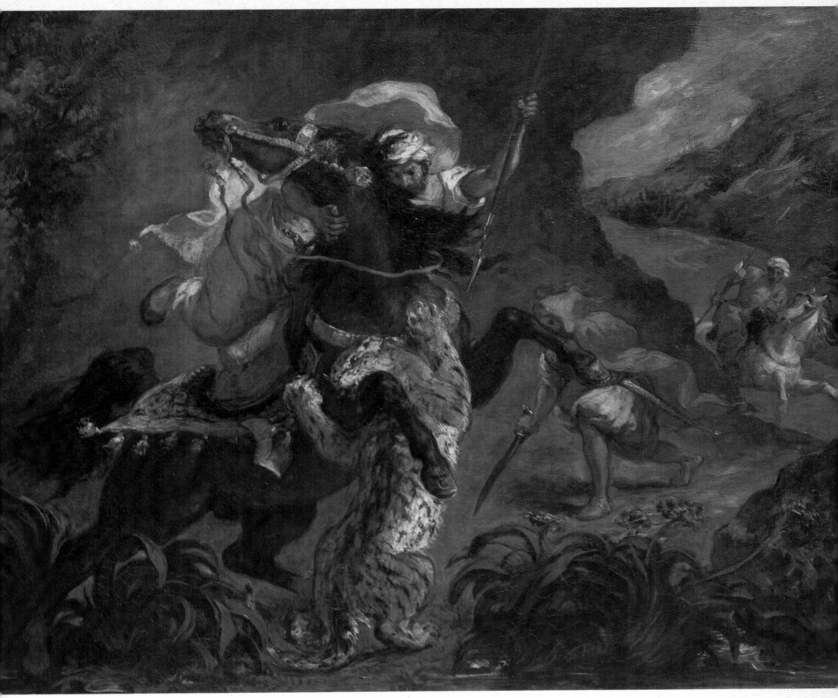

362 Delacroix, Tiger Hunt

Aspects of Oriental Ornamentation and Twentieth Century Art

Horst Ludwig

Islamic painting and ornamentation first began to have an extensive influence upon the European pictorial arts around 1900. While nineteenth century artists, such as Géricault, Delacroix, Chasseriau and Fromentin, were stimulated by the oriental landscape with its colour and light, to choose new pictorial motifs and to review light and colour instrumentation, the representational mode of the Islamic miniature scarcely found access to their picture world. It gained wider reception with the Jugendstil movement, and Persian miniatures were taken as models in the illustrations of Dulac, Schmied, Carré, Baudin, Lechter, Behmer etc. In contrast, style in panel-painting remained free of influences from the Orient; oriental ornamentation and calligraphy first made itself felt here with the beginning of the modern movement.

Sultan's Inscription

Klee, Insula Dulcamara (1938)

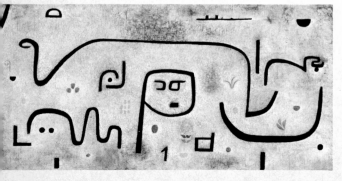

Matisse

From 1906 onwards, we find Islamic structures in Matisse, which are largely derived from the Persian miniature of the schools of Schiraz and Herat dating from the fifteenth and sixteenth centuries, as well as forms from Persian rugs and Maroccan textiles. The great exhibitions of Islamic art in Paris and Munich, and his journeys to Marocco in 1912 and 1913, deepened his relationship to Islamic form. One of the earliest works in which the laminar Islamic forms and North African textiles become constitutive elements is the painting "Nature morte au Tapis rouge" of 1906 in Grenoble. Even though the intense colours still reveal characteristic fauvist features and the resolved contures contain late-impressionist elements, the flat, asyndetic sequence in the left part of the picture, with the over-patterning of the background and the generous ornamental composition of the fabric in the right half, represent future variants of his new style.

The over-patterning of individual picture components with cross, star and rosette is a characteristic feature of the Persian carpet and Persian miniature before the second half of the fifteenth century. The principle of these miniatures is asyndetic, according to which space is divided into individual compartments, covered with single forms and — areally reduced — reassembled. This additive form of the unconnected sequence with equivalent components was replaced after about 1450 in the carpet by a subordinating system of medallions, arabesques and tendrils. The miniatures lose their purely ornamental construction, become open to the landscape and tend towards a dynamic mode of composition. Typical now is the encroachment of pictorial forms upon partly illusionary dimensions, which are thereby bound to the surface again. Matisse, who realized the rudiments of both principles in a still-life dating from 1906, generally employed them separately during the course of his development. "The Tablecloth" of 1908 at the Eremitage in Leningrad is a significant example of over-patterning orientated to the surface. The plasticity of the table is revoked by the large- dimensioned tendrils, which are continued over the wall. "The Still-life in Seville" (1911) and the "Figure décorative" (1927) continue this series.

The asyndetic picture construction, with its surface patterning as represented in early miniatures, is congenially paraphrased in Matisse. In the pictures "The

Family of the Painter" (1911) from Leningrad and "The Red Studio" (1911) from New York, the additive series and patterning is analogous to a miniature by Bihzâd from Herat (British Museum, 1494). The climax of this style is formed by the "Aubergines" (1911–1912) in Grenoble. The longitudinally extended background of the picture with the closely adjoined compartments, the tendrils and blue straw-flowers, as well as the views to the left and right of the screen, structurally resemble a miniature by Aboul-Ghazi with the portrait of the Sultan Hosain Mirza (1485). Matisse makes this resumé: "The Persian miniatures made me conscious of all the possibilities of my own mode of vision."

The odalisque motif, the white harem slave, allowed Matisse to continue the great tradition of French painting in the nineteenth century and after 1920 it appears in numerous variations. Six larger works of this genre were completed in 1922 alone. "As far as the odalisque is concerned, I have seen enough of them in Marocco; it was thus easy for me to recreate them in my pictures." Not all his odalisques reveal an Islamic influence (asyndetic composition or an over-patterning orientating to surface). The "Odalisque au Fauteuil turc" (1928) is conspicuous in that, apart from Islamic requisites such as the chair and vase, it has an ornamental pattern which can already be observed in the Leningrad "Tablecloth". The principle of additive surface arrangement is realized in the "Odalisque with Red Trousers" from 1922.

Psychedelic art and op-art

The rhythmic-ornamental character is a main feature of Islamic art. As Rudolf Gelpke and Henri Michaux have often emphasized, form constants of Islamic ornamentation are dependent upon a form of sensory experience which receives its impulses in a hallucinatory-creative state of mind. The basic medium of this ergotropic condition or tranquil meditation is the ornamental-rhythmic abstraction.

In no other world culture was ornamental abstraction so pronounced and intensively developed as in Islam. This tendency was certainly promoted by the prohibition of figures, which was of course restricted to Koran illustrations and mosque decoration. Psychomimetic or psychodysleptic drugs increase one's receptiveness for visual experiences, which rise from the depths of

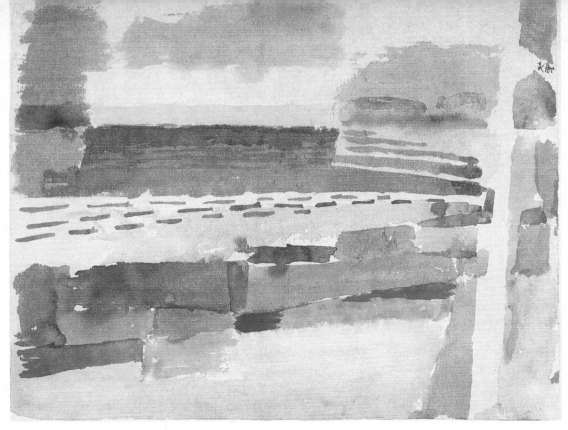

455 Klee, Beach near Tunis

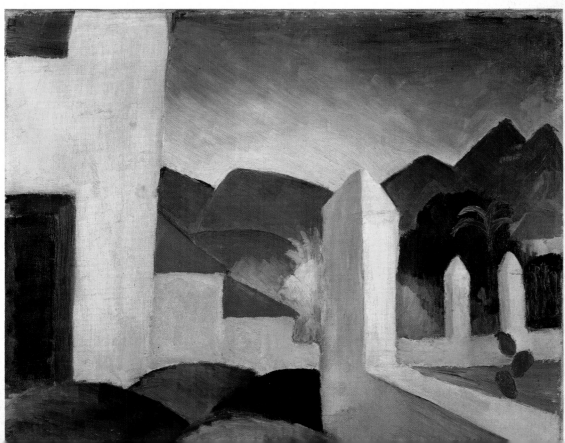

386 Macke, Tunisian Landscape

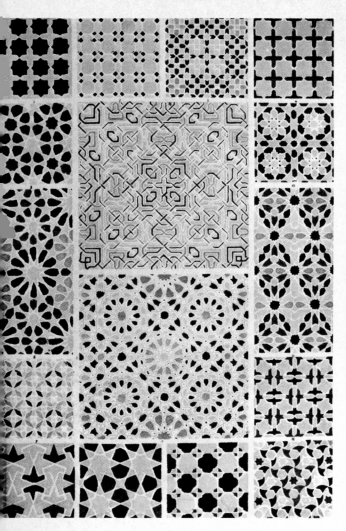

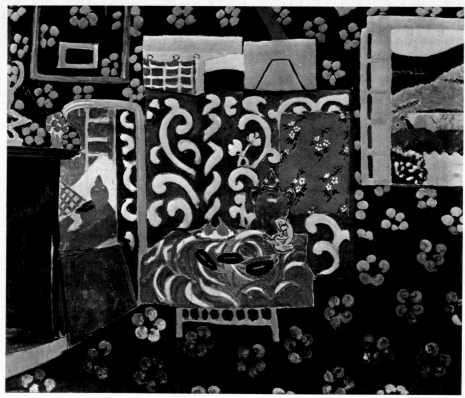

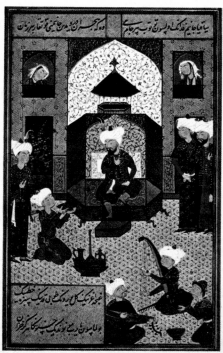

▲ Matisse, Aubergines (1911–12)

◄ Jones, Sample page from "Grammar of Ornament" (1856)

▼ Persian miniature, Aboul Ghazi (1485)

the soul and have only little in common with the world of natural phenomena. Access to this subconscious material is all the easier the more this inner reality is accepted and the external reality is neglected. The retreat from an apparent reality and optically perceptible world, and the opening of the imaginative dimension, eliminates the mimetic intention and pictorial structures originate, which do not endeavour to recreate the object but to create an image of the inner reality. There are two main trends within the hallucinatory sphere: the geometrization and the resolution of forms. In the first case, visual form constants such as the circle, triangle, square and polygon dominate. Common to both modes of experience is the inherent animation of the images in contrast to the static aspect of normal perception. The carpets of Kashan and Isfahan, or the Persian building ceramics are evidence of an outlook manifested in ornamental-rhythmical abstraction, which attempts to communicate the transcendental reality of inner reflection through the medium of the pictorial arts. We shall turn to geometrical building ceramics which show analogies to op-art in the next section. Here, we shall attempt to examine aspects of psychedelic art which are related to floral ornamentation (Persian carpets and building ceramics of about 1600).

Isaac Abrams, who first recognized his artistic talents after the experience of psychedelic drugs, which intensified his experiental capacity, began to paint in the nineteen-sixties. His trip-pictures are an energy flow of atomic vibration or vegetal, cellular dynamics. Apart from the psychedelic flora and fauna, his pictures constantly reveal form constants that are especially characteristic of the Kashan carpet dating from about 1600. The central medallions of these carpets have concentrically arranged shapes composed of abstract flowers, stars and tendrils which turn on their own axis and appear to simultaneously pulsate from the inside to the outside. There are a number of these concentric forms in Abrams' "Flying Leap" (1966), which rotate and pulsate on a blue background. Curved elements curl out between them

and divide the surface as in the Persian carpet. The picture "All Things are Part of one Thing", painted in the same year, demonstrates this scrolled ornamentation more clearly. When Abrams says that he orchestrates pulsating patterns which are an image of cosmic energy, he is describing a process also generated by Islamic ornament. His works do not exhibit merely a chance similarity with Islamic art. In his case, it is not an adoption of extra-European art, but an outlook which leads to analogous results.

The work of Allen Atwell, a New York artist who lived and studied in the East, is of quite a different category. Atwell orientates himself to Tibetan meditation diagrams, the mandalas, visual aids for tranquil meditation which record the unity of the world of Mahâyâna Buddhism in circles and squares. In the same way as rhythmical-ornamental abstractions, these magic symbol structures can be conceived as form constants which produce a meditative outlook. Atwell's mandalas are multilayered variations of Tibetan designs projecting cellular currents of vital energy instead of deities. There are works of Jacques Kaszemacher which lie at the border region between psychedelic art and op-art. Their pulsating, geometrical irrationalism suggests the constructive steam of Arabic art, while the surface-space problems and their visual effects remind one of op-art. It is only a seeming contradition to bring aspects of op-art, which works exclusively with rational means, into relation with the geometrization of Islamic art, in which the impulses are visionary. Although the generic prerequisites differ in this analogy, the objective is the same. A large part of Islamic art reveals itself to be op-art.

Victor Vasarely's work shows form constellations which, in their visual aggressiveness, are analogous to Islamic surface-space mysticism. A close affinity to Arabic art can be detected in his comments on his own work: "The idea of movement in the surface area has occupied me since childhood." Movement, rotating forms and pulsating vibration are characteristic of the oriental world of forms. The mosaics of the Alhambra in Granada, mosaic wall decoration in Marocco or faience-ware in Persia, are often laid out in such a way that the observer falls into a state of optical animation in which all stability is missing. In addition, the technique of creating optical illusion is frequently employed, whereby the elucidation of concave or convex forms is never resolved. Vasarely says the following about this

visual aporia which characterizes his work: "A spatial phenomenon originates on this surface and disappears again." This visual aporia is systematically developed in the works "Vaar", "Ond-dva" and "Meh-sin" (1970). When observing these pictures, one's perception is reactivated time and time again without it coming to a halt: areal, spatial, concave, convex. Perception remains insecured. Every glance at the picture starts again from zero.

The working with standardized elements, with molecular germ-cells, which comprise Vasarely's picture — the "unité plastique" — permits a final comparison. The wall decoration and glass windows of the Orient are composed of individual constructional elements, which are mostly geometrical basic forms in Vasarely's work. The square plastic unit, also employed by Vasarely for tiles and wall elements for the realization of a polychrome city, was already striven for in Islamic architecture centuries ago; in a civilization capable of communicating the multilayered structure of the ornament to the rest of the world. Vasarely himself wrote: "I recognized that the pure form colour was able to signify the world". Bridget Riley, an English artist, worked towards similar objectives as pursued by

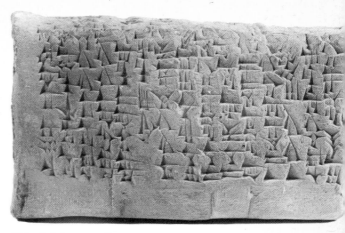

398 Babylon, cuneiform text

Vasarely. In contrast to Vasarely, however, polychromy plays a subordinate role in her work. The black-white contrast, the shifting and changing of black lines and surface structures in relation to one another, and the grey tones of the negative form are the constituitive elements of her compositions. The work "Blaze III" (1963) consists of spirally formed circles, which, due to the arrangement of the oblique lines, appear to rotate and evoke

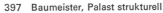

397 Baumeister, Palast strukturell

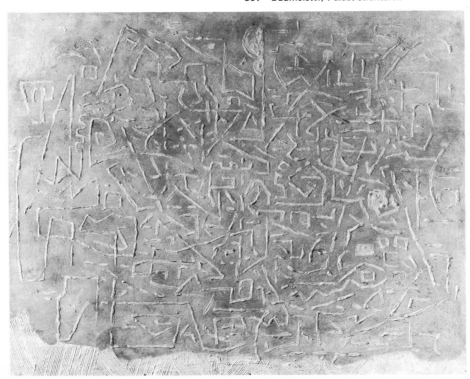

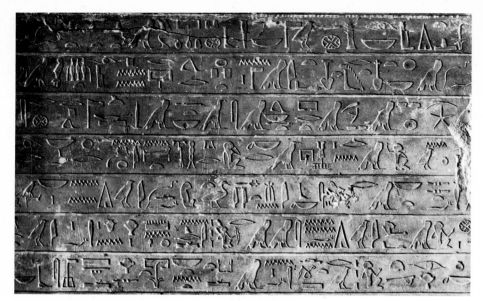

403 Egypt, hieroglyphics

402 Kandinsky, Zeichenreihen

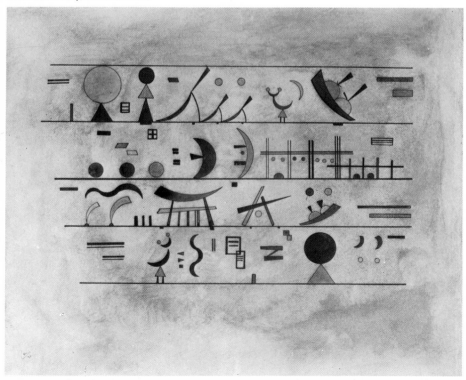

an obscure concave or convex form. A Persian dome over a tomb in Sangbast (dating from about 1000), or a Turkish dome of the Ulu Cami mosque in Eski Malatya (thirteenth century), reveal an analogous conception.

Cipher and calligraphy

In its endeavours to reach the primeval and its search for a mystical level of consciousness, the twentieth century has repeatedly tried to revert or approximate to ancient cultures and extra-European sources of form. The graphic character of old oriental, Egyptian and Islamic art was a source of inspiration for the abstractions and symbolism of painters such as Kandinsky, Klee and Baumeister. Baumeister's "Gilgamesch Series", begun in 1942, is a cycle depicting the Sumerian epos in seventy pictures. His interest in past cultures grew during the Nazi era, since when he has regularly visited the excavations in the vicinity of Stuttgart and the Schwäbische Alb. For Baumeister, the past as a source of cognition enabling him to return to the origin and essence of man, is also an obvious way of expanding his own consciousness. Baumeister says of earlier cultures: "These archeological prototypes can only provide the key to a steeper descent into a primeval and lost reflection on the nature of being." The style of the series is reminiscent of Hethitic rock reliefs and the tile frieze of the Inanna Temple; the spatula mastic technique with the relief-like modelling imparts an aura of antiquity to this cycle.

The picture "palast strukturell" of this series, done in 1942, has reduced all figurative elements to mere signs. They cover the picture surface in the manner of the calligraphic messages of the Sumerians, Babylonians or Assyrians, and draw us into their magic sphere. The ciphered character of old oriental cuneiform writing was recreated by Baumeister for his symbolic language.

Kandinsky was occupied in a similar way with the canon of Egyptian hieroglyphics. In contrast to Baumeister they are less intended to evoke associations with antiquity than to represent parallels to his concrete figurations originating after 1923. The hieroglyphics, which were developed about 3000 B. C. and can run in either vertical or horizontal lines, work with a stylized, graphic vocabulary placed in isolated juxtaposition. Hieroglyphic tones are to be found in Kandinsky from 1924 onwards. The picture "Verstummen" contains rectangular fields and

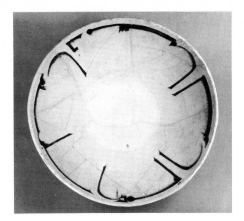

405　Turkestan, bowl

407　Persia, title-page

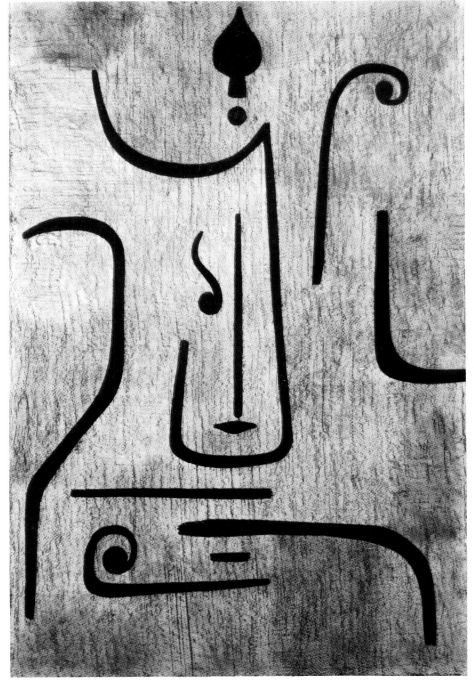

404　Klee, Erzengel

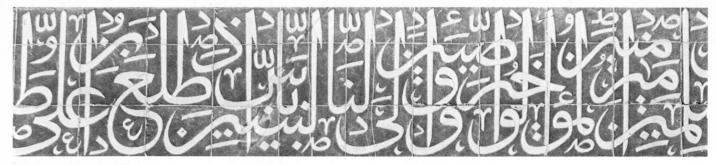

410 Isfahan, inscribed frieze

409 Weil-Heller, Dia-Object

oblique lines in the top half which are set
"hieroglyphically". Triangles suggest a
pyramid landscape in the bottom half.
His "Vertikalbau" was painted three years
later and contains large triangles on the
right-hand side together with a field
showing sacred signs. A journey to Egypt
in 1931 once more confronted Kandinsky
with the Egyptian picture world. The
picture "Zeichenreihen" originates from
this period and brings a series of forms in
four horizontal bands. There are also later
works by Kandinsky based upon the
development of Egyptian hieroglyphics.
We refer to those pictures which contain
their "message" in vertical or horizontal
sequence.
Paul Klee's encounter with the Islamic
and Egyptian world is complex and of
lasting effect. His journey to Tunis with
Louis Moilliet and August Macke in 1914
was a decisive light and colour experi-
ence, which, as in the case of Delacroix,
was not without its effect. Klee is thus
within the tradition of the French Orient
painters, all of whom rely upon their ex-
perience gained from the light and colour
of the Orient. Moreover, after his visit to
Egypt in 1928, his attention was caught
by Egyptian and Islamic art. The Egyptian
landscapes were painted at this time. The
formula-like hieroglyphics and the duct of
Islamic signs, however, first influence his
pictures in the years 1937 and 1938. As in
the case of Baumeister (and in contrast to
Kandinsky), Klee's ciphers and formulas
are abbreviations for factual things and at
the same archaic associative media. The
harmony between his pictorial scheme
and the ancient signs exists in causal
relationship with an orientation to the
past and a releasing of the subconscious.
The picture "Legende vom Nil" (1937)
integrates hieroglyphic characters with a
system of heavy inscriptional signs remi-
niscent of Islamic writing. After these and
other forerunners, they eventually appear
in a purer form in "Tempelfest" (1937)
and "Leichttrockenes Gedicht". The
analogy with Islamic script is most pro-
nounced in the works in 1938. The

painting "Insula Dulcamara" is covered with flowing black signs, in which even the diacritic points are not omitted. The Islamic Thuluth, the spirited variants of the Naski duct, which we encounter in most of the modern Islamic inscriptions, permits a direct comparison with this work. Particularly the large sultan inscriptions, which partly give the impression of framed pictures, have a striking resemblence to Paul Klee's inscriptional works which also include the "Erzengel" of 1938.

The aesthetic tension resulting from the combination of various forms of script, as for instance in the superposing of the Kufic, angular, vertical writing with Naskhi letters, was consciously employed by oriental calligraphers. This superposing of different types of ornament (pattern on pattern), in which two flat spatial layers can be observed, is a general characteristic of Islamic art. Dia-objects by Marie-Luise Weil-Heller conform to this principle in that the two levels are realized in two transparent plexiglass discs placed one behind the other. The curved signs at the intersection, together with the vivid colour (blue, turquoise, yellow) and the shining surface, give a structure similar to that found in Turkish inscriptions on building ceramics. The calligraphic element, which was always conceived as purely ornamental by Islamic artists, becomes in Weil-Heller's work a pure representation of intersection, spatial suggestion and movement.

Translation G. F. S.

397 *Willi Baumeister (Stuttgart 1889–1955); Palast strukturell;* oil on cardboard; 54 × 65 cm; sig. bottom right: Baumeister; c. 1942; Stuttgart, Margaret Baumeister; plate

398 *Babylon; tablet with cuneiform text;* clay; 9.5 × 5.7 cm; c. 1000 B. C.; Bremen, Übersee-Mus., Inv.-No. A 13117; plate

399 *Babylon; tablet with cuneiform text;* clay, 11 × 13.8 cm; c. 1000 B. C.; Bremen, Übersee-Mus. Inv.-No. 13121

400 *Babylon; tablet with cuneiform text;* clay; 11 × 6 cm; c. 1000 B. C.; Bremen, Übersee Mus.-Inv.-No. 13111

401 *Assyria; tablet with Kufic text;* clay; 13.5 × 7.6 cm; c. 1000 B. C. Munich, Staatliche Slg. Ägyptischer Kunst, Inv.-No. 1311

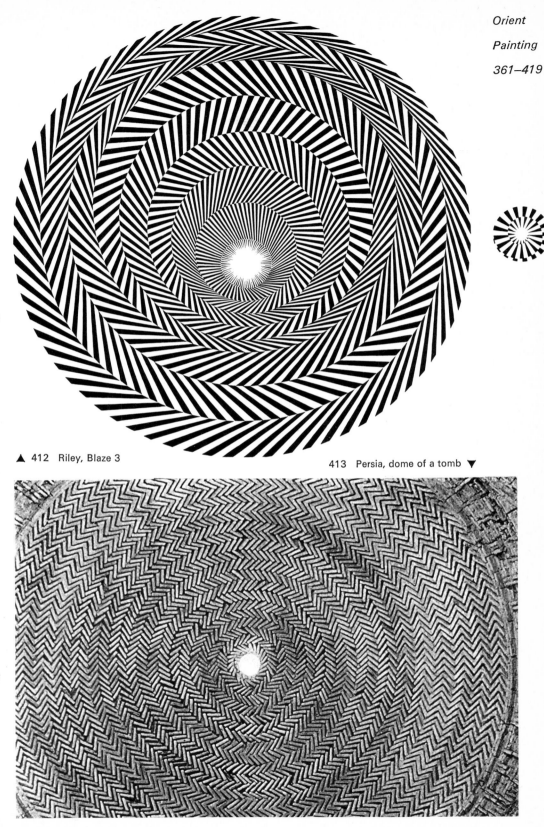

▲ 412 Riley, Blaze 3

413 Persia, dome of a tomb ▼

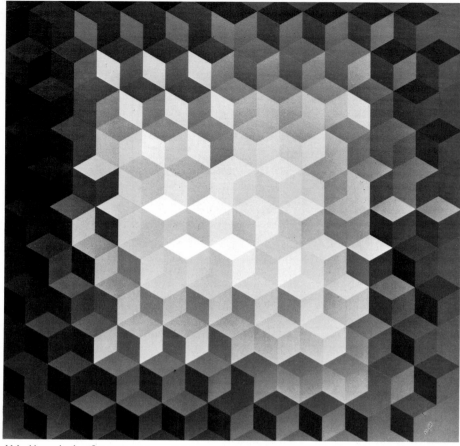

414 Vasarely, Ion 2

402 *Wassily Kandinsky (Moscow 1866–1944 Neuilly-sur-Seine); Zeichen-reihen;* water-colour and tempera on paper; 41.5×50.5 cm; sig. bottom left: K 31; 1931; Basel, Kunstmus., plate

Natanz, stalactite vault in mausoleum

403 *Abydos, Egypt; Memorial of Prince and General Sebeki* (Photo); c. 1970 B. C.; Munich, Staatliche Slg. Ägyptischer Kunst; plate

404 *Paul Klee (Münchenbuchsee near Bern 1879–1940 Muralto near Locarno); Erzengel;* oil, jute with cotton; 100× 65.5 cm.; sig. top right: Klee; 1938; Munich, Staatliche Gal. im Lenbachhaus; plate

405 *Turkestan; bowl;* glazed pottery; ∅ - 36 cm; 9–10th cent.; Berlin, Staatliche Museen Preußischer Kulturbesitz, Mus. für Islamische Kunst, Inv.-No. I. 26/60; plate

406 *Iran; bowl;* glazed pottery; ∅ - 27.3 cm; 10th cent.; Karlsruhe, Badisches Landesmus.

407 *Persia; titlepage;* 22.5×14.3 cm; 16th cent.; Munich, Staatliches Mus. für Völkerkunde, Inv.-No. Pree L I 302 b; plate

408 *Persia; titlepage;* 20×12.2 cm; 16th cent.; Munich, Staatliches Mus. für Völkerkunde, Inv.-No. Pree L I 302 a

409 *Marie Luise Weil-Heller (Worms 1919, lives in Munich); Dia-Object;* acryl lacquer on plexiglass, two sheets; 60×120 cm; sig. bottom right: Heller, 1970. Munich, priv. owned; plate

410 *Isfahan Masjid-i-Jami; inscribed frieze with Koran text, n.-w. Liwan* (photo); 1700/01; plate

411 *Turkey (Isnik); tile frieze (nine pieces) with inscription from Koran;* faience, underglaze painting; 40×240 cm; c. 1570; Paris, Joseph Soustiel Coll.

412 *Bridget Riley (London 1931), living in London); Blaze 3;* emulsion on hard-board; 94×94 cm; 1963; London, Rowan Gall.; plate

413 *Persia, Sangbast; dome of a tomb* (photo); c. 1,000 A.D., plate

414 *Victor Vasarely (Pecs, Hungary 1908, living in Annet-sur-Marne). Ion 2:* from the folio Hexagone; silk-screen; 68×67.5 cm; sig. bottom right-Vasarely; 1968; Munich, Gall. Heseler; plate

415 *Victor Vasarely; Ion 10:* from the folio Hexagone; silk-screen; 68×67.5 cm; sig. bottom right-Vasarely; 1968; Munich, Gall. Heseler

416 *Persia, Kharraquan; masonry of a tomb* (photo); 11th cent.

417 *Isaac Abrams (1935); Astral Mega;* oil, canvas; 104×104 cm; 1969; Zürich, Gal. Bischofsberger, coloured plate

418 *Allen Atwell; Triptychon;* acryl with gold leaf on canvas; 182×335 cm; 1971; New York, priv. coll.; coloured plate

419 *Tibet; Lamaitic Mandala;* tempera on cloth primed with chalk; 62.5×37 cm; 18th cent.; Munich, Staatliches Mus. für Völkerkunde, Slg. Preetorius, plate

Graphic Art

Horst Ludwig

The following compilation of water-colours, drawings and lithographs from the section oriental painting gives a brief survey — parallel to the oil paintings in the preceding room — of oriental pictorial motifs from the period of classicism up to the Macke's and Klee's visit to Tunis.

The object of this introduction is not to gauge the quality of graphic art against oil painting, but to present an informative survey of oriental painting using the material available.

The interest in the Orient can be compared, as a phenomenon, with the study of antiquity. It adapted to the historical-ethnological fervour of the nineteenth century and formed one facet of pluralistic style (above all in handicrafts and architecture). It soon gained a slightly polemical tone, however, in its rejection of antiquity and the traditional form of academic painting (Delacroix), and led to a renewal of the seventeenth and eighteenth century dispute between the representatives of defined corporeality and the advocates of a more scenic conception – between the followers of Poussin and those of Rubens. Delacroix' range of colours, however, which had changed fundamentally following his experience of the Orient, became a prerequisite for the new colourfulness of impressionism and pointillism, and consequently for modern painting. Paul Signac refers specifically to Delacroix and devotes a whole chapter to him in his account of his travels in the Orient (Paul Signac: Von Eugen Delacroix zum Neoimpressionismus, Krefeld, 1903, pp. 31–48).

The basis for a reception and understanding of these new light and colour problems was already prepared before 1830 by the growing interest in the Orient After 1827, decisive visits were made by Decamps (1827), Marilhat (1831), Delacroix (1832), Vernet (1834 ff.), Chassériau (1846) and Fromentin (1848 ff.).

German artists also gained contact with Turkish art as a result of Ludwig I's engagement in Greece (King Otto landed in Nauplia in 1833); representations of Turkish dress and Turkish life date from this time. The opening of the Suez canal in 1869 drew attention to Egypt (Lenbach, Markart). In contrast to France, orientalism in German art does not provide the same decisive impulse as in the period from Gros to Signac.

From the theatre decoration of Schinkel to the palaces of Ludwig II, it remains a form of backcloth, setting and imitation. An exception is the painting of Schreyer in which the colour of the Orient also finds its place as in France. Lenbach and Markart's journey to Cairo (1875–76) only influenced them as far as motifs were concerned.

The handwriting character of lithography was quickly adopted by French Orient painters for their North African scenes. Baron Gros and Horace Vernet were among the first painters to employ this technique. Gericault's lithographs, especially his lion, tiger and hunting scenes, represent the first highlight in this field. Delacroix' 104 lithographs embrace, as do his paintings, the entire range of romantic pictorial themes. Not until the twentieth century do works begin to reappear in which the oriental landscape enflames in a manner comparable with early French oriental painting. We refer

433 Persia, miniature ▶

432 Delacroix, Study after a Persian Miniature

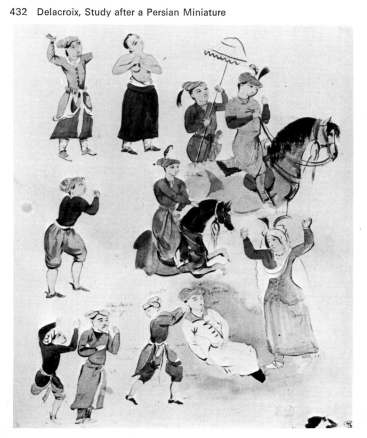

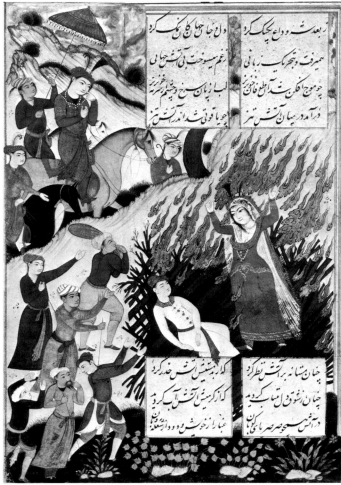

to the water-colours of Louis Moilliet, Paul Klee and August Macke who travelled together to Tunis in 1914 and visualized their experiences in a process of increasing abstraction and in their spectral colour. Translation G. F. S.

420 *Antoine Jean Baron Gros (Paris 1771–1835 Bas-Mendon); Mameluke Leader;* lithograph; 31.9×23.5 cm; 1817; Bremen, Kunsthalle

421 *Horace Vernet (Paris 1789–1863); Conrad rescues Guluare from the Fire;* lithograph; 24.3×17.4 cm; sig.: H.Vernet 1819; Bremen, Kunsthalle

422 *Théodore Géricault (Rouen 1791–1824 Paris); A Mameluke defends the wounded Trumpeter;* lithograph; 34.2×27.8 cm; 1818, Delteil 9; Bremen, Kunsthalle

423 *Théodore Géricault; Copy of a Persian Miniature;* pencil; 13.6×22.5 cm; c.1820; Bremen, Kunsthalle

424 *Théodore Géricault; Lion clawing Horse;* lithograph; 19.5×30 cm; 1820 Delteil 26; Winterthur, Hans Bühler Coll.; plate

425 *Théodore Géricault; Arab Horse;* lithograph; 17×33.5 cm; 1821; Delteil 37; Winterthur, Hans Bühler Coll.

426 *Théodore Géricault; Egyptian Mare;* lithograph; 17.8×23.5 cm; 1822; Delteil 57 II; Winterthur, Hans Bühler Coll.

427 *Théodore Géricault; Arab Horse;* lithograph; 18×23.2 cm; 1822; Delteil 56 II; Winterthur, Hans Bühler Coll.

428 *Théodore Géricault; Le Giaour;* after the poem by Lord Byron: water-colour; 21×24 cm; c.1822–1824; Winterthur, Hans Bühler Coll.

429 *Théodore Géricault; Le Giaour;* lithograph; 15×20.9 cm; 1823; Delteil 95 II; Winterthur, Hans Bühler Coll.

430 *Théodore Géricault; Horse being clawed by Lion;* lithograph; 19.5×24.2 cm; 1823; Delteil 67 I; Winterthur, Hans Bühler Coll.

431 *Eugène Delacroix (Charenton– St. Maurice 1798–1863 Paris); Women from Algiers;* lithograph 16×22 cm; sig.: Eug. Delacroix; 1833; Delteil 97 II; Bremen, Kunsthalle

432 *Eugène Delacroix (Charenton– St. Maurice 1798–1863 Paris); Study after a Persian Miniature;* water-colour; 23.5×18.8 cm; c.1823; Paris, Mus. National du Louvre, Cabinet des Dessins; plate

433 *Persia; miniature;* 24.7×14.5 cm ; 17th cent.; Paris, Bibliothèque Nationale; plate

434 *Eugène Delacroix; Algerian Jewess;* lithograph; 20.8×15.3 cm; sig.: Eug. Delacroix/1833; Bremen, Kunsthalle

435 *Eugène Delacroix; Lioness clawing Breast of Arab;* etching; 15×27 cm; sig.: Eug. Delacroix/ 1849; Bremen, Kunsthalle

437 *Théodore Chassériau (Samana, San Domingo 1819–1856 Paris); Interior of an Arab School in Istanbul;* pencil, wash and water-colour; 30.6× 36.7 cm; sig. bottom left: Constantine 1846; Paris, Mus. National du Louvre, Cabinet des Dessins

438 *Théodore Chassériau; An Arab mounting his Horse;* etching; 27.3×22.5 cm; sig.: Théodore Chassériau 1849; Bremen, Kunsthalle

439 *Théodore Chassériau; Algerian Woman;* pencil, wash and water-colour; 30.9×23.9 cm; sig. bottom right: Paris 16 mars 1857; Paris, Mus. National du Louvre, Cabinet des Dessins

440 *Théodore Chassériau; Rider with Horse;* pencil, wash and water-colour; 32.2×39.1 cm; sig. bottom left: Paris 16 mars 1857; Paris, Mus. National du Louvre, Cabinet des Dessins

441 *Adolf Schreyer (Frankfurt 1828– 1899 Kronberg im Taunus); Resting Bedouin with Horse;* gouache; 14.8×21 cm; sig. bottom left: Ad. Schreyer 59; 1859; Schweinfurt, Georg Schäfer Coll.

442 *Adolf Schreyer; Mounted Arabs;* pencil, crayon; 16.8×24 cm; Schweinfurt, Georg Schäfer Coll.

443 *Adolf Schreyer; Mounted Bedouin resting at Well;* pencil, crayon; 24×33.8 cm; sig. bottom right: A. S. 1879; Schweinfurt, Georg Schäfer Coll.

444 *Adolf Schreyer; Arab on Excursion;* pencil, crayon; 19.4×17 cm; Schweinfurt, Georg Schäfer Coll.

445 *Louis Moilliet (Bern 1880 living in La Tour-de-Peilz); Street Scene in Kairouan;* water-colour; 22.3×27.9 cm; sig.: Kairouan 1914. Moilliet; La Tour-de-Peilz, priv. coll., plate

446 *Louis Moilliet; Vineyard in Tunisia;* pencil, water-colour; 28.3×28.6 cm; sig.: L. Moilliet Tunisie 1920; La Tour-de-Peilz, priv. coll.

447 *Louis Moilliet; Médenine;* pencil, water-colour; 23.5×27.8 cm; sig.: Moilliet/Tunisie; Zürich, Gottfried-Keller-Stiftung; plate

424 Géricault, Lion clawing Horse

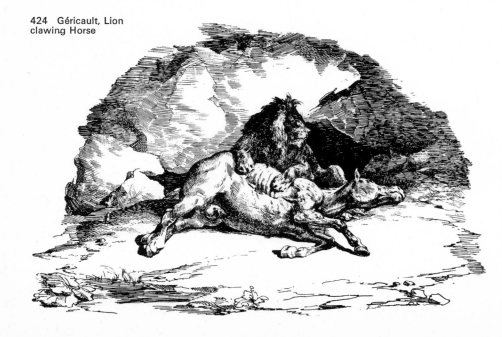

448 *Louis Moilliet; Street in Zarzis;* water-colour; 23.4×27.4 cm; sig.: L. Moilliet/1920, Tunisie; 1920–1926; La Tour-de-Peilz, priv. coll.

449 *Louis Moilliet; House-front in Tunis;* water-colour; 31.8×32.8 cm; 1921; La Tour-de-Peilz, priv. coll.

450 *Louis Moilliet; Saleh, Marocco;* water-colour 24×27.3 cm; sig.: Salé L. Moilliet 19 III 21; 1921; Zürich, Gottfried-Keller-Stiftung

451 *August Macke (Meschede, Sauerland 1887–1914 Champagne); Landscape at the Sea;* water-colour; 30.9×22.1 cm; 1914; Munich, Bayerische Staatsgemäldeslg., Neue Staatsgal.

452 *August Macke; Kairouan 1;* water-colour; 21.4×27 cm; Munich, Bayerische Staatsgemäldeslgn. Neue Staatsgal.; plate

453 *August Macke; Woman on Street in Tunis;* water-colour; 27×22.7 cm; 1914; Munich, Bayerische Staatsgemäldeslgn., Neue Staatsgal.; plate

454 *Paul Klee (Münchenbuchsee near Bern 1879–1940 Muralto near Locarno); Oriental Garden Landscape;* pen, water-colour and oil; 21.9×16.8 cm; sig. bottom right: Klee; 1924; Ulm, Städt. Slgn. für Kunst- und Kulturgeschichte

455 *Paul Klee; Beach St. Germain near Tunis;* water-colour; 21.8×27.1 cm; sig. top right: Klee; 1914; Ulm, Städt. Slgn. für Kunst- und Kulturgeschichte; coloured plate

Oriental Motifs in Book Publications

The confrontation with the Islamic world in Central Europe is not only restricted to the decorative arts, it can also be observed in literature and numerous illustrated works. Central themes are the travel journals, architectural views and the precise reproduction of buildings, illustrations, expecially the "Arabian Nights," paraphrases and translations. The rendering of oriental literature by the early romantics made a special contribution towards the initial reception of eastern poetry by European culture. The de luxe editions of Islamic architecture, Islamic ornamentation and Persian miniatures influenced the illustrators of the Jugend-

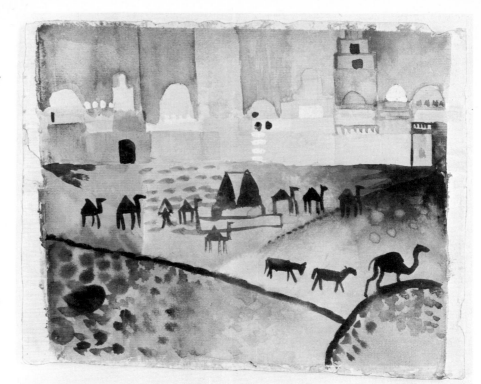

452 Macke, Kairouan 1

447 Moilliet, Médenine

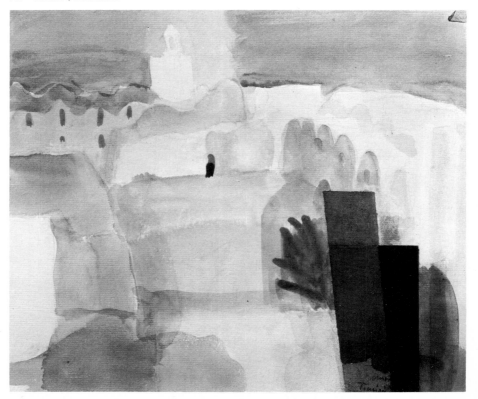

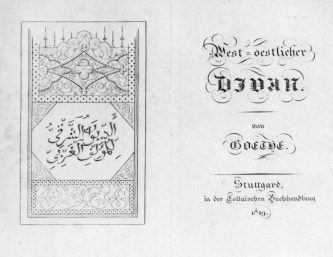

475 Goethe, binding to "Westöstlicher Diwan"

475 Goethe, title-page to "Westöstlicher Diwan"

stil movement. The following section presents a survey of these developments from Niebuhr's descriptions of travels through Arab countries up to Chagall's "Arabian Nights." H. L.; Transl. G. F. S.

456 *Adrien Dauzats (Bordeaux 1804–1868 Paris) ; Sinbad the Sailor; oil, canvas; 150×200 cm; c. 1865; Bordeaux, Mus. des Beaux-Arts*

457 *Carsten Niebuhr; Reisebeschreibungen nach Arabien und anderen um-*

477 Persian, elaborate binding

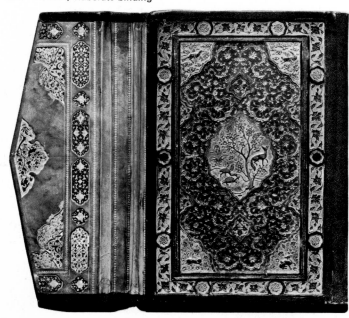

liegenden Ländern, 2 Vols., Copenhagen, 1774–1778; Munich, Bayerische Staatsbibliothek

458 *Vinvant Denon; Voyage dans la basse et la haute Egypte pendant les Campagnes du Général Bonaparte, Paris, 1802;* Munich, Bayerische Staatsbibliothek

459 *Laurent Adrèche; Histoire de l'Empereur Napoléon, Paris, 1859;* Munich, Bayerische Staatsbibliothek

460 *Thomas and William Daniell: A picturesque Voyage to India, London 1810;* Munich, Bayerische Staatsbibliothek

461 *The Oriental Annual, or Scenes in India, 7 Vols., 1834–1840;* Munich, Bayerische Staatsbibliothek

462 *Pückler-Muskau; Semilasso in Afrika, Part 1, Algeria, Stuttgart, 1836;* Munich, Bayerische Staatsbibliothek

463 *Amand von Schweiger-Lerchenfeld: Der Orient, Vienna, 1882;* Munich, Priv. Coll.

464 *Heinrich von Mayr; Genre-Bilder, gesammelt auf der orientalischen Reise Sr. Königl. Hoheit des Herrn Herzogs Maximilian in Bayern, Stuttgart 1846–1850;* Munich, Bayerische Staatsbibliothek

465 *Melchior Lechter; Tagebuch der Indischen Reise, Berlin, 1912;* Munich, Bayerische Staatsbibliothek

466 *Koran, Arabic script with lacquered binding and ornamented pages, 1712;* Munich, Bayerische Staatsbibliothek

467 *Koran, Arabic script, 1389;* Munich, Bayerische Staatsbibliothek

468 *David Friedrich Megerlin: Die türkische Bibel, oder des Korans allererste teutsche Übersetzung aus der arabischen Urschrift, Frankfurt, 1772;* Frankfurt, Freies Deutsches Hochstift

469 *Gustav Weil; Historisch-kritische Einleitung in den Koran, Bielefeld, 1844;* Munich, Bayerische Staatsbibliothek

470 *Friedrich Rückert; Der Koran, Frankfurt, 1888;* Munich, Bayerische Staatsbibliothek

471 *Pückler-Muskau; Semi Iasso in Afrika, 5. Teil, Stuttgart, 1836;* Munich, Bayerische Staatsbibliothek

472 *Gustav Weil; Geschichte der Chalifen, 1 Vo. Mannheim, 1846;* Munich, Bayerische Staatsbibliothek

473 *Joseph von Hammer-Purgstall; Rosenöl. Erstes Fläschchen, oder Sagen und Kunden des Morgenlandes, 2 Vols., Stuttgart, Tübingen, 1813;* Frankfurt, Freies Deutsches Hochstift

474 *Mohammed Schemsed-din Hafis; Der Diwan, Aus dem Persischen zum erstenmal ganz übersetzt von Joseph von Hammer, 2 Vols. Stuttgart, Tübingen, 1813;* Frankfurt, Freies Deutsches Hochstift*

475 *Johann Wolfgang von Goethe; Westöstlicher Diwan, Stuttgart, 1819;* Frankfurt, Freies Deutsches Hochstift; plate

476 *Friedrich Rückert; Östliche Rosen, Leipzig, 1822;* Munich, Bayerische Staatsbibliothek

477 *Persia; elaborate binding; 27 × 18 cm.; 16th cent.;* Offenbach, Deutsches Ledermus.; plate

478 *Marcus Behmer; Goethe, West-östlicher Diwan, 1910;* Munich, Bayerische Staatsbibliothek

479 *William Jones; Sacontala, or the Fatal Ring, an Indian Drama by Calidas, translated from the Original Sanscrit and Pracritt Calcutta, 1789;* Munich, Bayerische Staatsbibliothek

480 *Georg Forster; Sakontala oder der entscheidende Ring, ein indisches Schauspiel von Kalidas, Main, Leipzig, 1791;* Munich, Bayerische Staatsbibliothek

481 *Friedrich Schlegel; Über die Sprache und Weisheit der Indier, Heidelberg, 1808;* Munich, Bayerische Staatsbibliothek

482 *Lord Byron, The Giaour, London, 1814;* Munich, Bayerische Staatsbibliothek

483 *Victor Hugo: Les Orientales, Paris, 1829;* Munich, Bayerische Staatsbibliothek

484 *Alphonse Lamartine; Souvenirs, Impressions, Pensées et Paysages pendant un voyage en Orient, Vol.I., Brussel, 1836;* Munich, Bayerische Staatsbibliothek

Orient

Books

456—497

494 Gribble, Ruba'ijat, double-title by Marcus Behmer

IN·DEUTSCHE·VERSE·ÜBER TRAGEN·VON·G·D·GRIBBLE UND·ERSCHIENEN·IM·INSEL VERLAG·LEIPZIG·MDCDVII

RUBA'IJAT·DES OMAR·CHAJJÂM VON·NESCHAPUR

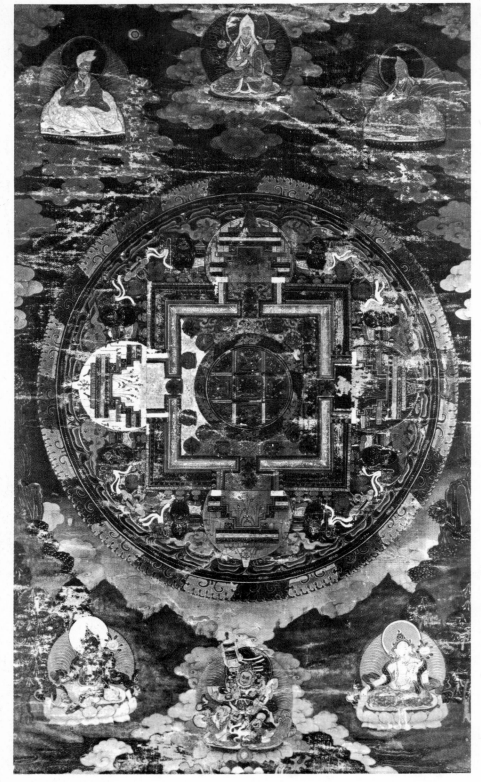

419 Tibet, Mandala

485 *Erzählungen aus Tausend und eine Nacht, Maghribin script of Arabic text; 18th cent.;* Munich, Bayerische Staatsbibliothek

486 *Antoine Galland; Les Mille et une Nuit, Lyon 1704–1708, 12 Vols, Vol. 5, 1705;* Munich, Bayerische Staatsbibliothek

487 *Firdusi, Shahname;* Persian national epos; circa 1000 A. D. (with numerous miniatures); 1496; Munich, Bayerische Staatsbibliothek

488 *Gustav Weil; Tausend und eine Nacht, Vol. 1, Stuttgart, 1872;* Munich, Bayerische Staatsbibliothek

489 *Richard F. Burton: Thousand Nights and a Night, Vol. I, 1906;* Munich, Bayerische Staatsbibliothek

490 *Felix Paul Greve; Die Erzählungen aus den Tausendundein Nächten, Vol. 1 & 12, Leipzig, 1908;* Munich, Bayerische Staatsbibliothek

491 *Max Slevogt: Sindbad der Seefahrer, Berlin, 1908;* Munich, Bayerische Staatsbibliothek

492 *Felix Paul Greve; Die Abenteuer Sindbad des Seefahrers, illustriert von Agnes Peters, 1913;* Munich, Bayerische Staatsbibliothek

493 *A. Sangorski, Rubáiyát of Omar Khayyam, London, c. 1900;* Frankfurt, Mus. für Kunsthandwerk

494 *G. D. Gribble; Omar Chjjâm von Neschapur: Ruba'ijat, double-title and initials by Marcus Behmer, Leipzig, 1907;* Munich, Bayerische Staatsbibliothek, plate

495 *Edmond Dulac; Rubáiyát de Omar Khayyam, Paris, 1910;* Munich, Bayerische Staatsbibliothek

496 *Edmund Dulac: Omar Khayyam, Die Sprüche der Weisheit, Munich, 1915;* Munich, Bayerische Staatsbibliothek

497 *Marc Chagall (1887 Witebsk); He went up to the couch and found a young lady ...;* Sheet 11 from: Four Tales from the Arabian Nights, lithograph; 43.5 × 33.0 cm; sig.: Marc Chagall; New York, 1948; Paris, Bibl. Nat.

418 Atwell, Triptychon

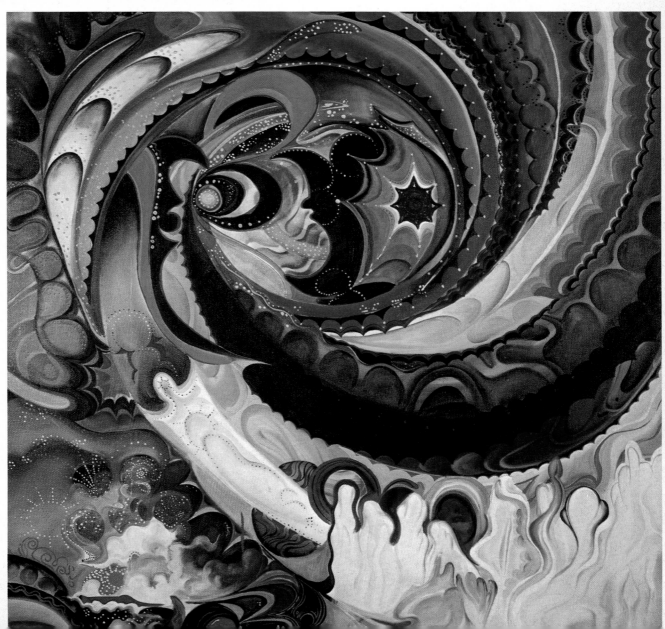

417 Abrams, Astral Mega

Orientalism in Music

Oriental Colouring in the Music of the Nineteenth Century

Ramón Pelinski

"There where you are not,
there is happiness." ("Der Wanderer")

The Eighteenth Century

For centuries European music had developed consistently within the socio-historical and politico-economical boundaries of Europe.
Occasional exoticisms, such as those which appear in opera and ballet from the beginning of the seventeenth century onwards, hardly leave their mark on music itself: they find their expression in stage decoration and costumes, lay no claim to ethnological exactitude, and are accepted form of social toying with the outlandish and foreign. It is within this framework that the "chinoiserie" and the "Turkish operas," which extend right into the nineteenth century, are to be seen. "Here the foreign element did not contradict but rather gave a new nuance to what was already possessed."

Nineteenth-Century Colonialism

A decisive change took place around 1800: economic and political interests forced European colonialism to extend its sway over every part of the globe. While the American people were struggling for their independence, almost the whole of Africa and Asia found itself under the domination of the European colonial powers. This meant on the one hand, material and cultural exploitation of the subject peoples, and racial extermination for some, whereas it brought, on the other hand, an influx of information, new experiences and stimulating impulses as a result of the travels among and the scientific expeditions to these manifold and diverse peoples. The ruthless exploitation and the romantic yearnings aroused lay bare the inherent contradiction in colonialism. Rousseau's idea of the naturally happy man still unspoilt by civilization and history ("l'homme naturel") or Herder's conviction that the arts are rooted in the soul of the people only stand in apparent contradiction to colonialism. We are much closer to the truth when we say that they provided colonialism with its justification: it was the tenets of humanism and the Enlightenment which caused the colonial powers to found ethnological museums in their capitals, encourage scientific studies of the colonies, and put on public display the attraction of the exotic in Europe even through the medium of the world fairs and exhibitions ("colonial exhibitions"). It was hoped in this way to gloss over the real nature of the colonial system. The yearning for the exotic is the subconscious mourning for what has been destroyed and at the same time the justification for colonial expansion. Apparently the destruction is even made good by the yearning. Alongside these romantic longings, Eurocentric, racist notions are also at work. "Blood and the colour of the skin are to remain indigenous, but the thoughts and feelings must become European." This will safeguard economic profit. Everything else — the cultural heritage of the colonized peoples — is to be preserved in the museums of Europe, scientifically investigated and, possibly, creatively evaluated, too.

One Common Musical Language

Around the year 1800, European music reaches its peak, despite all compositorial differences, in one common musical language. This is embodied above all in the work of the Viennese classical composers, Haydn, Mozart and Beethoven, and represents a coherent, unifying ideal of music which in its day was regarded as having universal validity. The system of the major and minor modes, the product of historical evolution, offered composers sufficient freedom to write in such a way that the intrinsic coherence of the system was in no way impugned. The self-contained system of classical Viennese music, in fact, allowed no inlet for the adoption of extra-European elements. The well-known reminiscences of Janissary music prove on closer examination to be a mere continuation of an eighteenth-century tradition, as is the case for example in the last movement of Beethoven's Ninth symphony, in which, however, the unexpected transition to the march form merely underlines one of the essential characteristics of German music, or again — as a passing tribute on a special occasion — the Turkish March and the Chorus of Dervishes from "The Ruins of Athens" composed for the opening of the German Theatre at Pest, Hungary. They are intended as a reminder of the remnants of Janissary music which still survived in Hungary.

The Dawn of Romanticism

It is not until we come to the music of

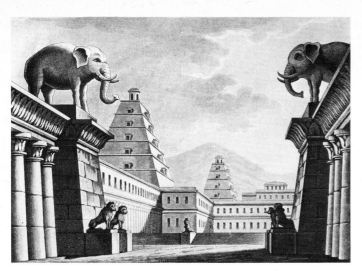

A Sanquirico, Piazza di Babilonia; stage design to G. Rossini's opera "Semiramide," 2nd act, 1823; Museo Teatrale alla Scala, Milan

Carl Maria von Weber that we find symptoms of later developments; in his compositions, Weber employed "genuine" Spanish, Russian, Arab, Turkish and Chinese melodies. His interest in the music of other peoples was aroused by his teacher, Abbé Vogler. Towards the close of the eighteenth century, Vogler travelled through Spain, North Africa and the Near East in order to collect songs. Back in Europe, he gave concerts with an extraordinary mixed programme: a prelude and fugue was followed by an African song; after a concerto for flute and bassoon, the Mohammedan confession of faith was played. Or he published collections of musical compositions like his "Polymelos or Characteristic Music of Divers Nations" (1806) in which he combined African and Chinese songs with Bavarian patriotism ("I am a Bavarian, a Bavarian am I")! The tendency which aimed at reviving the European folk-song comes at a time when the folk-song had been robbed of its natural setting by the industrialization which was just gathering momentum. And at the same time, too, expanding colonialism was creating the very conditions which would lead to the unremitting extermination of extra-European music.

The Folk-Song and Exoticism
The folk-song and exotic music both contribute towards a differentiation in the language of music. However, in the course of the nineteenth century, this process develops in various directions and leads to different consequences: the folk-song is elevated to the realm of serious music and thus encourages the growth of the national consciousness in many lands of Europe, whereas exoticism in music represents the first step on the way to a new universalization of the language of music.

Knowledge of Extra-European Music
Composers became acquainted with extra-European music during the nineteenth century through song-book collections, the occasional appearances of non-European musicians in Europe, and finally through journeys which some composers themselves undertook. That such contacts resulted in only an imperfect knowledge of extra-European music is to be explained not just by the external circumstances but by the nature of European music as well. What was idiosyncratic and alien in extra-European music was either filtered into the current European musical system through the "well-tempered" ears of the composers of the time or was simply ignored on account of the complexity of the difficulties involved in the process of integration. In their efforts to assimilate exotic elements, composers always came up against the extreme reglementation (Georgiades) of the European musical system.

Fictive Exoticism
Nevertheless, it is during the nineteenth century that the musical "platitudes" were coined which, without in any way shaking the foundations of European music, aimed at getting across a more fictive than real exoticism. They form a system of "signals" which, when presented, are intended to arouse in the listener a longing for the sunny lands of the Near East or of Asia – no one appears to have thought it necessary to come to real terms with the music of these regions. The aesthetic categories which cover these "signals" are "interesting", "out of the way", "picturesque", "local colouring" – all notions based, to a large extent at least, on the desire to escape from everyday life and take refuge in far-away places. The musical realization of these orientalizing "signals" takes the following form:

In the melody there is a descending movement through the various intervals which is embellished with fioriture, appoggiaturas and melismata: these are used to fill out the areas between the melodic "scaffolding"; in the melodic composition there is thus a real attempt to blur over the fixity of clearly defined notes so that the melody dissolves into pure ornamentation. Some scales are employed which are not usual in the European system of tonality: the so-called "Gypsy" scale – C, D, E flat, F sharp, G, A flat, B, C – and the related scale – G, A flat, B, C, D, E flat, F sharp, G (they correspond to the Indian scales Simhendramadhyama and Mayamala-vagaula in the râga-system "Melakarta"). Both these scales represent an enrichment of the composer's repertoire because of their peculiar interval structure – in both cases two augmented seconds and fourths, two consecutive semitones – melodic composition and harmony. For the orientalizing imagination of the composer they represent newly won freedom which the romantic spirit soon saw as a return to nature and spontaneity.

The rhythm is generally characterized by ballabile, ostinato-type formulas which form a monotonic background; dynamic rhythms acquire increased effectiveness through the syncopative shifting of the regular beat. It is particularly among the Russian composers that unusual measures (5/7, 7/4) and frequent changes in time occur. The superimposing of various measures and asymmetrical rhythms is rarely met with, on the other hand.

The sustained bass notes almost certainly symbolize the absence of functional chord combinations in extra-European music; they generally carry a chromatic, descending movement of the accompanying voices. The alternation between major and minor keys is also intended to produce an exotic effect – the tonal identity of a chord is thus placed in doubt. Where the instrumentation is concerned, there is a marked tendency to separate individual instruments from the orchestra as a whole, for example the flute or oboe with harp or tambourine accompaniment, cymbal, drums and

81

triangle for "Turkish" music.
The musical form is often characterized by a rhapsodic succession of melodies which are hardly subjected to further elaboration in the sense of variation or development.

Assimilation
By employing these means a type of music was created which, while remaining essentially European, did offer sufficient superficial colouring to conjure up a pseudo-oriental atmosphere in the imaginations of the composer and his audience. What was genuinely oriental was sought after, yet men remained satisfied with its shadow. It was the "foreground" effect which was assimilated, not the music in its essential, genuine character. The pseudo-oriental music of the nineteenth century was a forgery which helped pacify the colonial conscience of the European capitals. From the musical point of view, however, it marked the first, modest attempt to view European music as one system among many.

The Presentation of the Music
In the music sections of the exhibition, the main objective was to let the music speak for itself, let it be heard. This explains why the main stress was laid here on reproduction of the music. The arrangement is determined by both historical and geographical standpoints: historically it passes from the eighteenth century via Janissary music (Beethoven) to the occurrence of orientalism in the twentieth century (Debussy, Busoni, Richard Strauss, and others); geographically it ranges from China to the Near East.

Speaking in general, European composers have translated the oriental impulses they have received into a generalized orientalism. The examples of extra-European music which are here included in the exhibition programme were chosen not so much to draw parallels as far more to show just how wide the gulf is between the sources of the stimulus and the fictive exoticism of the response. Over earphones the visitor can hear instruments in their original and in their European context.
Stage-sets, photographs of scores and excerpts from ethnomusicological treatises will form part of the visual documentation.

Translation P. J. D.

Music Program

Near East

503 *Neyzen Ali Riza (Oh! You glorious Army); Janissary march with choir;* Turkish Radio and Television Company; Janissary Orchestra of the Military Museum, conducted by Cemal Cümbüs; plate

504 *Ludwig van Beethoven (Bonn 1770–1827 Vienna); Die Ruinen von Athen, op. 113, 1812: Türkischer Marsch;* His Masters Voice ALP 1596; Royal Philharmonic Orchestra, conducted by Sir Thomas Beecham

505 *Carl Maria von Weber (Eutin 1786–1826 London); Oberon, opera, 1826, Finale: "Horch, welch' Wunderklingen";* plate

506 *Music of the Mevlevi (Dervish): Ikinei Selâm (the second greeting);* BM 30 L 2019 (UNESCO Coll.); group of instrumentalists and singers, conducted by Halil Can and Sadettin Hepper

507 *Ludwig van Beethoven; Die Ruinen von Athen, op. 113, 1812; Chor der Derwische;* His Masters Voice ALP 1596; Royal Philharmonic Orchestra, conducted by Sir Thomas Beecham

508 *Hector Berlioz (Côte-Saint André 1803–1869 Paris); L'enfance du Christ; 1854; Cabbalistic processions and invocation of the prophets;* Vega 30 BVG 882; Orchestre du Concerts Colonne, conducted by Pierre Dervaux; plate

509 *Muezzin chants;* recorded Monika Touma, Turkey, 1968.

510 *Peter Cornelius (Mainz 1824–1874); Der Barbier von Bagdad, opera, 1858: Intermezzo, theme of Muezzin chant;* Bayerischer Rundfunk; Symphonie-Orchester des Bayerischen Rundfunks, conducted by Hans Gierster

511 *Charles Gounod (Paris 1818–1893); La Reine de Saba, opera, 1862: Rêverie arabe;* Südwestfunk; Grosses Südfunk-Orchester, conducted by Cedric Dumont

512 *Georges Bizet (Paris 1838–1875 Bougival); Djamileh, opera, 1872: Dance of an Almee with Choir;* Hessischer Rundfunk; Radio-Symphonie-Orchester des Hessischen Rundfunks, conducted by Paul Schmitz

503 Mehteran Bolügü Yürüyüsü, a Janissary band of today

513 *Camille Saint-Saëns (Paris 1835–1921 Algiers); Samson and Delilah, opera, 1877: Ballet;* HMV ALB L 14673; Royal Philharmonic Orchestra London, conducted by Sir Thomas Beecham; plate

514 *Guiseppe Verdi (Le Roncole 1813–1901 Milan); Aida, opera, first performed Cairo 1871; Great Temple Scene and 1. Finale;* Decca SXL 2167/09-B. Wiener Philharmoniker; Singverein der Gesellschaft der Musikfreunde; Priestess-Eugenia Raffi; Redamés – Carlo Bergonzi; Ramphis – Arnold van Mill; conducted by Herbert von Karajan

515 *Modest Mussorgskij (Karewo 1838–1881 St. Petersburg); Pictures at an Exhibition, 1874: Samuel Goldenberg and Schmuyle* (orchestrated by M. Ravel, 1922); DG 139010; Berliner Philharmoniker, conducted by Herbert von Karajan

516 *Rûy-i Irak Makaminda Taksim (Turkey);* BM 30 L 2019

517 *Nikolaj Rimskij-Korsakow (Tichwin 1844–1908 Ljubensk); Antar, symphonic suite 1897: IV movement, Arab melody;* Teldec, LXT/2982/A; Orchestre de la Suisse Romande, conducted by Ernest Ansermet; plate

518 *Pjotr I. Tschajkowskij (Wotkimsk 1840–1893 St. Petersburg); Nutcracker Suite, op. 71 a, 1892: Arabian dance;* DGG St 32814; Berliner Philharmoniker conducted by Herbert von Karajan

519 *Edvard Grieg (Bergen 1843–1907); Peer Gynt (1872), 2. Orchestral-Suite, op. 55, 1891: Arabian dance;* Eurodisc 78 015 KK; Great Radio Symphony Orchestra of the USSR, conducted by Genradi Roshdestwensky

520 *Michail Glinka (Nowo Spaskoje 1804–1857 Berlin); Ruslan and Ljudmilla, opera, 1837/42: III act, Choir of Persian Women;* Telefunken LSK 7036; Choir and Orchestra of the Bolschoi Theatre Moscow, conducted by Kyrill Kondraschin

521 *Modest Mussorgskij; Chowanschtschina, opera* (after 1872, unfinished): *Dance of the Persian Slaves;* Bayerischer Rundfunk; Münchner Philharmoniker, conducted by Christoph Stepp; cf. Cat. no. 515

522 *Variations in the mode of Chahâr-gah (Persia);* BM 301 2004, Unesco Collection; Ashgar Bahari, kamantché

505 above: Air turc, Published by Th. Shaw in "Voyages," La Haye, 1743

below: C. M. v. Weber, Horch, welch Wunderklingen, Finale of the opera Oberon; autograph

523 *Nikolaj Rimskij-Korsakow; Schéhérazade, Orchestral Suite, op. 35, 1888; II movement, The story of prince Kalender;* Philips St 839 599 VGY; Minneapolis Symphony Orchestra, conducted by Antal Dorati

524 *The mode Segâh (Persia);* BM 30 L 2005, Unesco Collection; Hossein Malek, santur

Central Asia

525 *Milij Balakirew (Nischnij Nowgorod 1837–1910 St. Petersburg); Islamej, oriental fantasy, 1868;* Eurodisc St 31867; Julius Catchen, piano; plate

526 *Michail Glinka (Nowo Spaskoje 1804–1857 Berlin); Ruslan and Ljudmilla, opera, 1837/42: Lesginka;* Telefunken LSK 7036; Bolschoi Theatre Orchestra Moscow, conducted by Kyrill Kondraschin

527 *Alexander Borodin (St. Petersburg 1833–1887); In Central Asia, symphonic sketches, 1890;* Decca SXL 2292; Orchestre de la Suisse Romande, conducted by Ernest Ansermet

528 *Alexander Borodin; Prince Igor, opera (after 1869, unfinished); II act Polovitzian dances;* Electrola SHZE 216; Philharmonia Orchestra London, conducted by Herbert von Karajan

India, Japan, China

529 *Bharata Natyam: "Krishna" (India);* Raga: Yamanklyan; Tala; Mishram (3+2+2 basic units); Bayerischer Rundfunk; Dieter Dreyer V.D.T., Bombay

530 *Nikolaj Rimskij-Korsakow (Tichwin 1844–1908 Ljubensk); Sadko, opera, 1867: Song of Indian merchant;* Electrola B. I. E. M./D.A. 1307; Benjamino Gigli, tenor

531 *Léo Delibes (St.-Germain-du-Val 1836–1891 Paris); Lakmé, opera 1883; Scene and legend of Pariah's daughter;* Decca SXL 21019 B; Joan Sutherland, soprano; Covent Garden Orchestra, conducted by Molinari Pradelli

83

532 *Sokyoku;"Rokudan no shirabe"
(Japan);* BM 30 L 2014; Unesco coll.

533 *Camille Saint-Saëns (Paris 1835–
1921 Algiers); The yellow Princess,
opera comique, 1872: Overture;* ARD-
Music – 3 – 1303; Rundfunkorchester
des Südwestfunks, conducted by
Emmerich Smola; plate

534 *Shansi Music (China);* BY
844. 935; recorded at a public concert in
Jennan

535 *Carl Maria von Weber (Eutin –
1786–1826 London); Turandot-
Overture,* 1809; BR; Das Fränkische
Landesorchester, conducted by Erich
Kloss; plate

536 *Pjotr I. Tschajkowskij (Wotkimsk
1840–1893 St. Petersburg); Nutcracker
suite, op. 71 a, 1892: Chinese dance;*
DGG St 32814; Berliner Philharmoniker,
conducted by Herbert von Karajan

537 *Flute solo in rastu-dh-Dhil mode
(Tunisia);* BM 30 L 2008; Salah el
Mahdi, flute.

508 H. Berlioz, L'enfance du Christ; autograph, Paris, B. N.

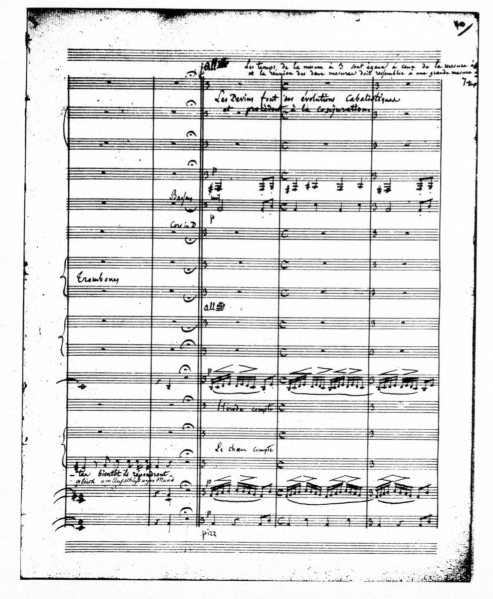

Orientalism around 1900

538 *Claude Debussy (St. Germain-en-
Laye 1862–1918 Paris); Six épigraphes
antiques, 1914: Pour l'Egyptienne;* WER
60008; Aloys and Alfons Kontarsky,
piano

539 *Maurice Ravel (Ciboure 1875–
1937 Paris); Two Hebraic melodies:
Kaddish, Eternal mystery;* Phonogram
839733 LY; Gérard Souzay, baritone;
Dalton Baldwin, piano

540 *Ferrucio Busoni (Empoli 1866–
1924 Berlin); Die Brautwahl,* Orchestral
Suite, op. 45, 1913: *No. IV Hebräisches
Stück;* Symphonie-Orchester des Nord-
deutschen Rundfunks, conducted by
Hans Schmidt-Isserstedt

541 *Richard Strauss (Munich 1864–
1949 Garmisch); Salome, opera, 1905:
Dance of Salome;* Decca 2863–64;
Wiener Philharmoniker, conducted by
Clemens Krauss

542 *Maurice Ravel (Ciboure 1875–
1937 Paris); Schéhérazade, 1903: Asie,
La flûte enchantée, indifferent;* Teldec
LXT 5031; Suzanne Danco, Sopran;
L'Orchestre de la Suisse Romande,
conducted by Ernest Ansermet

543 *Karol Szymanowski (Tymoszówka
1892–1937 Lausanne); Lieder des ver-
liebten Muezzins, op. 42, 1918: No. 2
"O Vielgeliebte", No. 6 "Vorbei, o
vorüber";* Bayerischer Rundfunk Nicolai
Gedda, tenor; Hans Altmann, piano

544 *Muezzin chant;* recording: Monika
Touma, Turkey, 1968

Headphone Program

545 *Music of the Near East*
a) *Turkey: muezzin chants;* Berlin;
private recording by Monika and Habib
Touma
b) *Turkey: music of the Mevlevi
("dancing Dervishes");* Bärenreiter-
Musicaphone BM 30 L 2019
c) *Iran: song of Saadi; accompaniment
by kamantché (string instrument);*
Golpaycgani (vocal); Ashgar Bahari,
(kamantché); Bärenreiter-Musicaphone
BM 30 L 2004 side B, No. 4
d) *Iran: mystic poem of Arâqi;* Zabihi
(vocal); Bärenreiter-Musicaphone BM
30 L 2005, side B, No. 4

e) *Turkey : Mehter music (Janissary):*
Old Army March, Prayer of the Janissary,
19th century march; BAM LD 363.

f) *Iran : solo for dombak* (drum); Bären-
reiter-Musicaphone BM 30 L2005, side
A, No. 1

g) *Turkey : Kanun solo (taksim);*
trapezium shaped zither; Klangdoku-
mente zur Musikwissenschaft; KM 0002
ST, side B, No. 5

h) *Turkey : Ud solo (Hicas taksim;)*
six-stringed lute; Klangdokumente zur
Musikwissenschaft; KM 0002 ST, side
A, No. 5

i) *Turkey : Ney solo (taksim);* flute;
Klangdokumente zur Musikwissenschaft
KM 0002 ST, side B, No. 1

j) *Iran : Nai solo (in the Batriyari mode);*
flute; Hussein khâne Yaveri (nai flute);
Bärenreiter-Musicaphone BM 30 L 2005,
side B, No. 5

k) *Turkey : tambur solo (taksim);* long-
necked lute; Klangdokumente zur
Musikwissenschaft; KM 0002 ST, side B,
No. 3

l) *Iran : Târ solo (in the Isphahan mode);*
large Iranian lute; Zarif (târ) Bärenreiter-
Musicaphone BM 30 L 2005, side B, No.3

m) *Iran : Santur solo (in the Segâh*
mode); dulcimer; Hussein Malek
(santur); Bärenreiter-Musicaphone
BM 30 L2005, side A, No. 2

Instruments

546 *Turkey :* Zurna (Janissary instru-
ment); shawm with seven front holes and
one at back; 1.—44.5 cm, 20th cent.;
Berlin, Mus. für Völkerkunde, Ethno-
musicological Section

547 *Turkey :* Davul (Janissary instru-
ment); two-skinned cylindrical drum;
⌀ 75 cm.; 20th cent.; Berlin, Mus. für
Völkerkunde, Ethnomusicological Section

548 *Turkey :* Turkish crescent
("Jingling Johnnie"; Janissary instru-
ment); Munich, Deutsches Mus., Music
Section

549 *Turkey :* def tambourine, one-
skinned frame drum with pair of jingles;
h - 6 cm., ⌀ - 23 cm.; 20th cent.; Berlin,
Mus. für Völkerkunde, Ethnomusicologi-
cal Section

550 *Ethiopia :* Sistrum; used in the
Abyssianian liturgy; 1—22 cm., w - 8 cm.;
Basel, Mus. für Völkerkunde and
Schweizerisches Mus. für Volkskunde

525 M. Balakirew,
Islamej; Ed. D. Rother,
1922

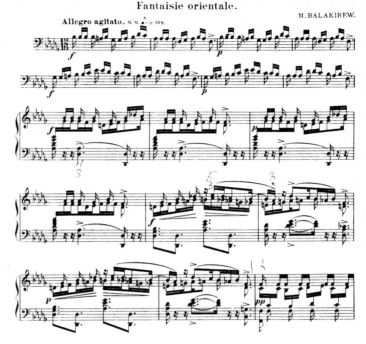

551 *Turkey : pair of finger cymbals;*

552 *China : pair of cymbals;* Basel,
Mus. für Völkerkunde and Schweize-
risches Mus. für Volkskunde

553 *China : pair of cymbals, "Po";*
⌀ 41.5 cm.; pre - 1900; Berlin, Musik-
instrumenten-Mus.

554 *China : Gong, "Lo";* ⌀ 42 cm.;
pre — 1900; Berlin, Musikinstrumenten-
Mus.

555 *Japan : gong, "Dora";* ⌀ 34.5 cm.;
pre 1900; Berlin, Musikinstrumenten-
Mus.

556 *Thailand : gong with hammer;*
h - 8 cm., ⌀ 54 cm.; Basel, Mus. für
Völkerkunde und Schweizerisches Mus.
für Volkskunde

Stage Designs

557 *Temple of Ptah, Aida (Verdi):*
1. act; 2. decoration painted by Hermann
Burghart, Vienna; Vienna, Theaterslg. der
Österreichischen Nationalbibliothek;
sig. HOpü 4.588

558 *Room of Amneris, Aida (Verdi):*
2. act; 1. decoration painted by Johann
Kautsky, Vienna; Vienna, Theaterslg. der
Österreichischen Nationalbibliothek;
sig. HOpÜ 4.580 Th

559 *Alhambra for Weber's Oberon,*
1829; water-colour, 30.7×44.4 cm,
painted by Simon Quaglio (1745–1878);
Munich, Theatermus.

560 *Turkish Courtyard for Weber's*
Oberon, 1881; water-colour 30.6×50.7
cm; Munich, Theatermus.

535 Chinese melody,
published by G. M. de
la Borde in "Essai sur
la musique ancienne
et moderne," vol. I,
Paris 1780

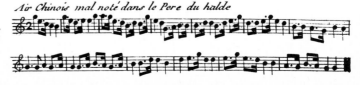

East and South-East Asia

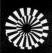

Chronological Survey of the Japanese Influence

Yujiro Shinoda

Prior to 1812, the first Japanese woodcuts are brought to Europe by Isaak Thyssen, head of the Dutch trading station on the island of Deshima near Nagasaki.

Around the year 1830 Philipp Franz von Siebold, doctor and naturalist, likewise lives for years on the island of Deshima as representative of the Dutch government. He was able to undertake some journeys to the interior of the island empire. His diaries relate his experiences and describe the country, for example the famous Tôkaidô Road along the south coast of Honshu which Ando Hiroshige depicted in a series of woodcuts around this same time.

Siebold's collection — more a cabinet of Japanese curiosities, which, however, did contain a number of kakemonos — was bequeathed to the museum at Leyden.

The response in Europe was small. It was in fact not until the Japanese ports were forcibly opened by Commodore Perry on 31 March 1854 that the necessary preconditions for intercontinental contacts were created.

In 1855 commercial treaties are concluded with Russia, America, Great Britain, and France and in 1856 with the Netherlands.

In 1856, Felix Braquemond, the French engraver, comes across a Japanese sketch book, one of Hokusai's "Manga" volumes, at his printer's, Delâtre's. In 1857 he is at last able to acquire the book (which he had at once wanted) from Lavieille. Taken aback by the surprising variety and multiplicity of the sketches, he shows them to his Paris artist friends.

In 1861 Captain Sherard Osborn publishes a series of Japanese landscapes at London in his "Japanese Fragments."

In 1862 contemporary art criticism gives a positive evaluation of Japanese art. The Goncourt brothers write on 10 January: "L'art japonais a des beautés comme l'art français" (Japanese art, like French art, also has its beauty).

In 1862 the Boutique Desoye is opened at 220 Rue de Rivoli. This is not, as has so far always been presumed, identical with the Porte Chinoise which probably already existed in the thirties. The "chinoise" in the name also makes one think quite involuntarily of the chinoiserie of the eighteenth century, which

would again suggest a much earlier date for its foundation.

In 1864, at the London exhibition, Sir Rutherford Alcock exhibits his collection of Japanese woodcuts, which were commented on in detail in John Leighton's essay "On Japanese Art, a Discourse."

In 1864 James McNeill Whistler paints his girl-friend Jo in a kimono and looking at a Japanese woodcut.

In 1865 Henri Fantin-Latour paints his picture "The Toast", which showed Whistler in a kimono. The painting is unfortunately no longer existent. The Salon at Paris exhibits Whistler's "La Princesse au Pays de la Porcelaine."

In 1866 Zacharie Astruc publishes a series of articles in the magazine "L'Etendard" entitled "L'Empire du Soleil Levant."

In 1867, at the Paris world exhibition, Japanese woodcuts are exhibited in Europe for the second time. The result is the Japanese fashion of the following century.

In 1868 the restoration of imperial rule in Japan means that the country is opened to Europe once and for all.

In 1871 Theodore Duret, publisher and art dealer, and Cernuschi visit Japan. They bring back with them, among other things, innumerable woodcuts.

In 1876 Claude Monet paints his wife Camille in a kimono. The painting, which he himself entitled "La Japonaise," enjoyed a success which can only be described as epoch-making. It was sold in those days for 2000 francs!

In 1880 Emile Guimet publishes his "Promenades Japonaises."

In 1883 the Georges Petit Gallery presents an exhibition of Japanese art from Parisian private collections. Monet, who has now moved from Argenteuil to take up his final home at Giverny, lays out a water garden there with Japanese bridge, water lilies and irises. Pictures from this last period (1899–1924) present this garden, mainly in the form of series of paintings.

In 1885 James McNeill Whistler delivers his famous "Ten O'Clock" lecture at London, Cambridge and Oxford.

In 1886–1888 Vincent van Gogh is at work in Paris. His serious study of Japanese woodcuts — mentioned in many of his letters written during the next two years — is best illustrated by his interpretations of Ando Hiroshige's "Ohashi — Bridge in Rain" and "Plum Branch in Blossom in the Kameido Garden" and Kesai Eisen's "Actors."

In 1887 there is an exhibition of Japanese woodcuts in the café "Le Tambourin,"

result of this journey are genre scenes whose subjects could be taken from the woodcuts of Utamaro or Chôki.
In 1900–1901 Emil Orlik embarks on an extended visit to Japan for purposes of study. The diaries of his travels contain numerous sketches depicting Japan at the turn of the century. Two papers, later published, on Japanese and Chinese printing techniques document Orlik's specific interest in the technical processes involved in the woodcut.

Translation P. J. D.

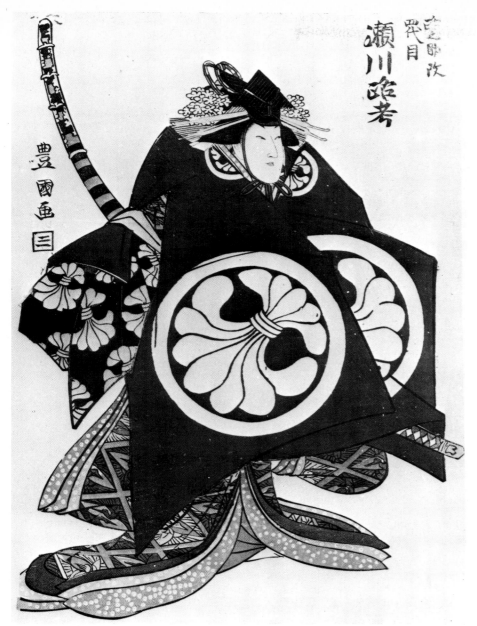

Japan, Kabuki Actor

Manual Techniques of Japanese and European Wood-engraving and the Artists of the Utagawa School

Siegfried Wichmann

Emil Orlik had closely studied the Ukiyo-e artists (painters of scenes from daily life) in Japan in order to learn their working techniques. Prior to about year 1900, there was little information to be found on Far-Eastern wood-engraving in Europe. Various printing media were used, such as ornamented writing paper and the decorative book sheets which were especially popular during the Tang period in China. Fan segments, hanging scrolls – a typical Far Eastern picture format – and folding screens were similarly decorated by means of the wood-engraving procedure. On the other hand, coloured wood-engraving was adapted to the specific nature of the printing paper, which was extremely resistant and tensile but still possessed that flexibility required particularly in relief-printing. A characteristic, secondary feature of the Far-Eastern wood-engraving is the seal, which often gives the gram-weight of the composition; name-stamp, Imprimatur (permission to print from the official censor) and the publisher's imprint, are also customary and are adapted to the composition of the engraving in versatile form. It was precisely this seal form, which was mostly executed in red colour on the wood-engraving, which influenced Europeans artists' in the design of their own signatures in the nineteenth century. The quality of the Japanese wood-engraving derives from the collaboration between the artist, the engraver, the printer and the publisher. The artist designed the drawing and artistic colour scheme. The execution of the wood-

in the Boulevard Clichy. The organizers are called Theo and Vincent van Gogh. In this same year, van Gogh paints his "Portrait of Père Tanguy" which shows the paint-seller from the Rue Clauzel, Montmartre, against a background of Japanese woodcuts.
In 1888 there is another exhibition of Japanese woodcuts, this time at Siegfried Bing's at 22 Rue de Provence.
In 1889–1891 Bing's "Le japon artistique" is published.

In 1890 there is an exhibition of Japanese woodcuts at the École des Beaux Arts. Mary Cassatt and Henry Rivière fall under their spell; they are particularly impressed by Japanese printing techniques. Under the influence of this experience Mary Cassatt produces her ten coloured etchings and Henri Rivière his coloured lithographies.
In 1893 Bing organizes an exhibition at Durand-Ruel's which includes works by Hiroshige and Utamaro.
In 1894–1895 George Henry, the painter of Scottish extraction, goes to Japan to recuperate from a serious illness. The

87

engraving itself depends upon the skill of the engraver, the printer and, above all, upon the financial investment of the publisher. The observer of such a wood-engraving must be aware that it required the collective skill of many talented and specialized artists, who, in constant collaboration with each other, regarded this one work of art as the beginning and end of a joint undertaking. This traditional artistic approach persisted into the later work of the Ukiyo-e masters. These painters came not only from every branch of handicrafts, many were of aristocratic descent or so well-known as to be feared by the Schogun. They constantly recorded the daily events of Japanese life in their pictures and, in the metropolitan city of Edo in particular, they made no small contribution to the reforms carried out in the nineteenth century. During the Tempo period, the novel gained popularizing elements, which it had never possessed, and achieved increasing influence in the numerous volumes of the "Gôkan" published annually with forty titles. A popular combination of historical tales and romances, the plots were determined by the most improbable situations. The later masters of wood-engraving made an appreciable contribution to the illustration of these works.

These brief references serve to indicate the close connection which existed between the artists and their social environment during the late Ukiyo-e period. Their work, which often focused upon everyday life and the daily personal habits of the common people, contrasted with the refined and coutly representations of traditional painting and was frowned upon in official circles. Nor have the main representatives of the late Ukiyo-e masters, Kuniyoshi, Kunisada and Hoshito received the attention they deserve in Europe, although the French Impressionists gained much of their inspiration from them. In 1961 Akijama Terukazu made the following brief comment on the "difficult problem" of the influence of Japanese wood-engraving upon impressionism in his book "Japanese Painting": "... we mention only that the 'artistic' sheets from the land of the rising sun, which enthused Manet, Monet, Degas, Whistler, van Gogh, Gauguin and many others, were actually faded flowers of nineteenth century Japan. The reproduction of woodcuts in many impressionist pictures (e. g. in the portrait of Emile Zola by Manet, and Père Tanguy by van Gogh) prove this ..." It is not entirely true that the artists named above admired only the late masters.

Van Gogh's letters show that the collector of Japanese art, Bling, possessed an excellent collection of prints and discussed them with artists to demonstrate the importance of the different periods of the Japanese wood-engraving. Van Gogh admired Hokusai just as much as the Utagawa school, which particularly appealed to his artistic sense and confirmed his own discovery of the intrinsic, autonomous value of colour. In his encounter with Japanese wood-engraving, it is not the quality of the print alone which is important to van Gogh; his bold decision to start from striking colours, for instance cobalt-blue in his portrait of Père Tanguy, was influenced by the work of the Ukiyo-e masters. The bright colour of Hokusai, Hiroshige, Kuniyoshi, Kunisada and Yoshitoshi was experienced as "beautiful" by virtue of the diaphanous brilliance it possessed against a light background; an effect lost to European painting. The characteristic style of the Utagawa school, the heir of Japan's wood-engraving tradition, is not to be underestimated as an influence upon early expressionism in Europe. The deployment of line favoured by this school, which together with the areal compartments led to the creation of different compositional planes, culminated in dynamic motional sequences. The artistic tension deriving from a natural sense of colours and a bold desire to intensify them, not only produced striking colour combinations, for example the red colour variations favoured up to Yoshito, the figures were imparted with that suspended buoyancy and autonomy in space which impressed every artist who came into contact with the work of the Utagawa school. A conscientious realism combined with an estranged use of striking colours, give the triptychs a spontaneity of expression, which illustrates the dramatic contours, not only by expressions of motion but also by ornamental sequences in the pattern-background system. The deliberate severity of the juxtaposed colours in the work of the Utagawa school makes itself felt to the observer and represents a new conception within the Ukiyo-e tradition. The intrinsic value of colour is often developed to a point where it becomes independent of the figure bearing it; it liberates itself and demands abstraction — a phenomenon which European artists were soon to notice. This is probably the most essential and significant contribution of this school of Japanese wood-engraving to European art.

Summary and translation G. F. S.

Vincent van Gogh's Search for the Serene Life in the Japanese Wood-Engraving

Hans Jaffé

The work of Vincent van Gogh marks a turning point in the development of japonaiserie in nineteenth century European art. The beginnings of japonaiserie in nineteenth century painting since the expedition of Commodore Perry in 1854 and the entry treaty of 1868, showed strong signs of an anecdotal employment of Japanese motifs: Japanese ceramic exports and wood-engravings appeared in European pictures, thus characterizing a new trend in taste which was stimulated by such exotic products. The japonaiserie, actively propagated by the Goncourt brothers, was a vogue which, in the late nineteen-sixties and seventies, gained particular access into works of the French artistic avantgarde. Edouard Manet's portrait of Emile Zola with the Japanese wood engraving and wall-screen, is the most important record of an epoch which embraced Japanese motifs within its cultural horizon in the same way as Egyptian themes and forms were included in the repertoire of European art following Napoleon's Egyptian expedition at the beginning of the century. Up to the middle of the nineteen-eighties, when the most decisive pictures of van Gogh were painted, japonaiserie was a form of exoticism in European art scarcely different from the other forms of this artistic vogue; the essential fact is that motifs of exotic origin are included in a composition whose principles and characteristic features belong entirely to the European tradition.

Vincent van Gogh changed the content of japonaiserie in the same way as Delacroix, whom he greatly admired, transformed the "orientalism" of the romantic period. In the three decisive "japonaiserie" works of van Gogh, a Japanese work of art is not only an additional motif, but also the starting point of the composition. Tralbaut (M. E. Tralbaut: Vincent van Gogh et les Japonaiseries in: M. E. Tralbaut; Vincent van Gogh & Charles de Groux de Kalmthoutse heide, les Japonaiseries, les femmes, P. Peré, Antwerp, 1953, pp. 135–146) has clearly demonstrated the transposition of the Japanese prototype using paper tracings from the van Gogh collection with squares on van Gogh's canvas, and shows how the three Japanese woodcuts — by Kesai Eisen and Hiroshige — form the basis of the entire

structure and compositions of the picture. A great change in the attitude towards the Japanese motif thus occurred, which is also important in van Gogh's own work. In a series of pictures dating from 1887, for example in the portrait of Père Tanguy, which F. Orton (F. Orton: Vincent's interest in Japanese prints, in: Vincent, bulletin of the Rijksmuseum Vincent van Gogh, No. 3, 1971, pp. 2–12) dates at September 1887, Japanese woodcuts still only provide background. In a similar manner to Manet's portrait of Zola, they are adapted in Tanguy's portrait as motifs for a different kind of composition, whereas they form the basis of the composition itself in the three "japonaiserie" works. Within the span of a few months then, van Gogh progressed from an "anecdotal" japonaiserie to a point where Japanese prototypes are employed. This no longer entailed a mere incidental inclusion of Japanese motifs in a composition of European origin, but rather an understanding of the principles and essential characteristics of Japanese composition.

The three japonaiserie compositions occupy such an important position in van Gogh's work and in modern art history, mainly because the first attempt is made by a European artist, not only to adopt the form of an extra-European work of art, but to appropriate its spirit. Tralbaut (M. E. Tralbaut: van Gogh's Japanisme, in: Mededelingen van de

654 Hiroshige, Bridge in Rain

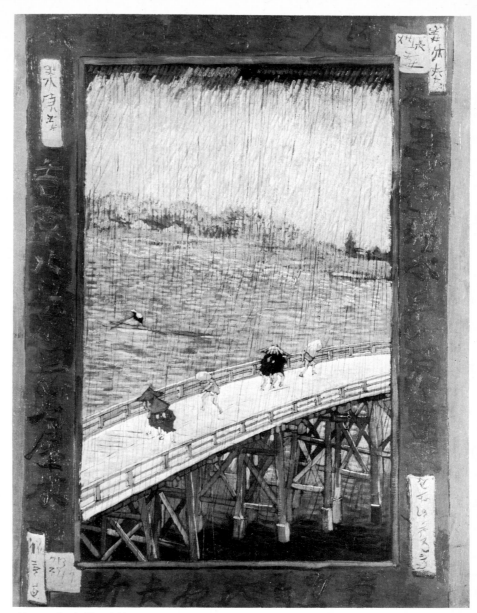

653 van Gogh, The Bridge

dienst voor Schone Kunsten der Gemeente's Gravenhage, symposium edition; Dienst voor Schone Kunsten, 1954, Yr. 9 No. 1–2, pp 6–40) already mentioned this fact in a lecture in 1951; one might add that these pictures also mark the prelude to a long series of works in which European artists discovered and absorbed the very essential elements of decorative art from other parts of the world, above all from the Far East, Africa and Polynesia.

What are the essential features of the three japonaiserie pictures which con-stitute van Gogh's own discovery and, therefore, also form the character of these works? In the very first instance we have the areal mode of composition, the conscious abandoning of depth: in the spirit of Far-Eastern principles of arrangement, the suggestion of space is not given by illusionary perspectives but by partitioning or superimposing planes, which leads the observer to integrate them himself. This principle of composition is closely related to the use of colour: the colour is areal, applied in clearly delineated patches and not, as

in the case of the Impressionists, reduced to the smallest colour unit, the brush stroke; nor is it applied in graduated tone units between light and dark in the manner of the Impressionists' predecessors, the Realists gathered around Coubert and the Barbizon school, who had guided van Gogh along his artistic path from the very beginning. On the contrary, colour is present in its entire vitality and appears distinctly in areal patches in the picture. Van Gogh's prototypes were not in fact paintings, but graphic art compositions – woodengravings – in which natural phenomena were restricted to their essential elements. He followed the prototypes closely and, with his friable brushstroke, he even went as far as to suggest the structure of the areas of colour on the crinkled paper – "crépons" as they are termed, after the "crêpe" paper on which they were printed.

The core of his innovations, however, is not represented by the characteristics of form, but by the new conception of space, or reality. It is a particular attitude towards reality; an attitude which van Gogh adopted quite early during his apprenticeship in Brabant, and which is reflected in his own description of his aims: "Tell him that my great desire is to learn to make such errors, such deviations, revisions, transformations of reality, that they become, well, lies, if you will, but truer than literary truth" (Letters No. 418). He did not discover this way of handling reality in Brabant, and certainly not from the Impressionists in Paris: his source of help is to be found in the Japanese woodengraving. In a letter from St. Rémy, he describes what he intends to achieve with a picture: "I am convinced that mother would understand this – for it is actually as easy as one of these rough woodcuts which one finds in country almanacs" (Letter No. 604). He writes in the same letter: "And then, it's good to work for people who do not know what that is: a picture" (Letter No. 604). The key to this conception of a work of art – and reality – lies in the significance of the japonaiserie works and the discovery of a new world-picture. Thus, van Gogh can also write: "Whatever one says, the most vulgar Japanese sheets coloured in flat colour tones, are, for the same reason, as admirable as Rubens and Veronese. I know quite well that it is not primitive art" (Letter No. 542). The Japanese woodcuts showed van Gogh the way to a new conception of reality. In the case of van Gogh, however, this conception is not limited to perception, to the picture of reality alone, he also sees the essential

aspects lying behind this picture. It seems certain that van Gogh left Paris for Arles in search of an equivalent for Japan. He wrote of his painting "View of Arles": "A small town surrounded by a completely verdant landscape in yellow and violet – you know, like a real Japanese dream" (Letter No. 487). And directly after his arrival in Arles, he wrote to his friend Emile Bernard: "Since I promised to write, I will begin by telling you that the region seems as beautiful as Japan through the clearness of the air and the gay effect of colour. The water forms patches of beautiful, emerald green and rich blue colours within the landscape, as we know them from the woodengravings. The pale orange sunsets make the earth appear blue. Magnificent yellow sun. But I have still not seen the region in its customary summer splendour. The local costume is pretty, and particularly on Sunday one sees very naive and harmonic colour combinations on the boulevard. They will certainly be all the more gay in summer" (Letter No. 2). What van Gogh sought in Japanese woodcuts and attempted to bring to new life in his own pictures, was not only a problem of painting, it was also a human problem. In the same way as Millet's work was his model for representing the toilsome gravity of the farmer, the "crépons" were his model in his search for serenity – a keyword in his work. A letter to his sister clearly describes what he wanted: "When one intensifies every colour, one regains peace and harmony. Then something similar happens as in Wagner's music, which although performed with a large orchestra, is no less intimate for that reason. One thus chooses sunny and colourful effects, and nothing can prevent me from thinking that later many painters will work in tropical countries. You can probably gain an impression of the changes in painting if you think of the Japanese representations which one sees everywhere – landscapes and figures. Theo and I have hundreds of Japanese prints" (W. 3). And a later letter distinctly shows that he found Japan, and the serene life, in Arles: "Theo has written that he sent you Japanese sheets. That is certainly the best means to gain an understanding of the direction which colourful and bright painting has currently taken. I don't need any Japanese sheets, for I always say that I am in Japan here. Thus, I only need to keep my eyes open and paint what makes an impression upon me" (W. 7). Van Gogh's aim, however, is to become more than a mere successor of Japanese

prototypes, not only in respect of colour but also with regard to line: "Hokusai provokes the same surprise, but he does this with his line, his drawing; when you write in your letter that the waves are claws and the boat is imprisoned in them, one feels this. Now, if one did not make the colour quite right and the drawing quite right, one could not convey this flow of emotion" (Letter No. 533). The Japanese woodcuts are a prototype for Vincent van Gogh – but a prototype for what? Without doubt, primarily for that love of natural things, for that consummation in nature which moves him to write to his brother: "Couldn't it be the case that when one loves something one sees it better and more rightly than when one does not love it?" (Letter No. 591). The art of the Far East gave van Gogh the possibility of realizing this conviction in his pictures.

Translation G. F. S.

The Far-Eastern "Dash-Dot-Line" in the Work of Vincent van Gogh

Siegfried Wichmann

Research has so far proved that van Gogh had closely studied the Japanese Ukiyo-e masters. He constantly refers to them in his letters. Furthermore, he records that his choice of colour was directly influenced by the late masters of Japanese wood-engraving. Van Gogh admired Hokusai and Hiroshige and perceived detail in nature in the same way. However, research has failed to investigate the individualistic style of this artist and to compare it with certain dash and dot forms employed in Japanese and Chinese painting. To gain a complete impression, it is not only necessary to examine the coloured woodcut, but also to equally consider the Chinese painting manuals and the sketch-books and teaching doctrines of the Japanese masters. The reader of treatises and text-books constantly encounters a dash-dot system, which is bound to the space and area of the picture, and related to the objects and their concreteness. This technique and method of design is illustrated in the 15 volumes of the Manga by Hokusai, but can also be identified in all the other "sketch-books" of Japanese artists. It is certain that van Gogh was familiar with Hokusai's Manga

Hokusai, from "Hundred Views of Fuji" (detail)

van Gogh, Washer-women (detail)

ing to orthogonal principles, but by a graduation of vertically ordered areas of dashes. This system can be identified especially in the dotting of van Gogh's drawings, and he also adopts the areal ordering principle more concisely than the prototype. He even pluralizes the individual dot-dash elements and creates from it the typical van Gogh dash line of the bamboo-pen drawing which also determines oil painting. Van Gogh's important achievement consists in his transferring this compositional medium into a brush technique divergent from that of the Pointillists, since it heightens that flowing character which increases the capacity for movement in things. The cypresses begin to writhe, the waves roll, and the clouds—although ornamentalized—are set in motion by the strokes of his line: every object lives in the consistency of the respective medium.

Van Gogh's affiliation with Japanese art was not only spontaneous, he also understood this art. He created a new style from this experience, which helped to shape fauvism and expressionism.

Summary and Translation G. F. S.

The Far-Eastern Pattern-Background Principle as Source of initial Attempts at Abstraction in Western Painting at the Close of the Nineteenth and Beginning of the Twentieth Centuries

Siegfried Wichmann

works, for the conformity with the dash-dot line is convincing. Hokusai works in certain areas of the picture surface with a pronounced dot system, which he applies where small structures, such as moss, shrubbery and small plants are to be found in the landscape. This concept derives from Chinese painting manuals, which assert that "the dotting of moss is an extremely difficult matter. In part consciously, and partly quite unintentionally, one must dot it in with a concentrated and composed frame of mind..."

It was intended to implant this systematic and partly contemplative technique in the subconscious by means of intensive practice. For Hokusai, it was a perfectly natural system to be employed even in the sphere of the landscape. But Hokusai also uses a vertical, short dash system in accordance with the Chinese painting manual; the same comma-line duct later mastered by van Gogh in his bamboo-pen drawings. The organizing system of these juxtaposed comma-like structures no longer arranges the landscape accord-

Important observations on this subject were made by the English painter and illustrator Walter Crane (1845–1915), who responded spontaneously to Japanese principles of design in his book "Line and Form" (1900). It is decisive that Crane speaks of a pattern-painting which leads to a unity between linear ornamentation and colour surface constructions. He describes the Japanese as also being "conscious decorators," and their "Kakemonos"—hanging scroll pictures of the Ukiyo-e period—as clear examples of pattern paintings in which the pattern motif is at least as pronounced as the graphic or figurative motif. In the following we shall discuss the elements

91

of the varied patterning and established ornamental forms of China and Japan which have influenced European artists. Decisive were the areally composed Japanese chrome woodcuts (Ukiyo-e) depicting a cross-section of everyday life: figurative representations whose colourfully patterned costumes determined the impression created by the respective composition. The focal point of the early and mature periods of Ukiyo-e art is formed by the human figure clothed in masterpieces of Japanese textile art. The most prominent are the lavishly ornamented samurai dress or court robes (kamishimo and suo), richly patterned Nô-garments and kimonos (kisode, furisode), robes with magnificently ornamented sashes (obi), and ornamented cloaks and coats (hô-uchikake, chihaya haori, kazugi). Through the medium of the Japanese coloured woodcut, European artists and craftsmen were drawn to these still-life "textile paintings," and received impulses which, from the aspect of patterning principles have not yet received the attention they deserve in art history.

A new vogue in Japanese silk in the eighteen-seventies, and japonaiserie in general, also helped to attract interest to the rich colours and distinctive forms of patterning: artists from Monet, Whistler, Toulouse-Lautrec, Breitner, Vuillard to Klimt, to name only a few, possessed fine examples of kimonos and also wore them. Later, at the turn of the century, the Vienna Secessionists were also struck by the direct connection between the "textile still-life" of the Japanese woodcut and silk art.

The essential principle of the Japanese system of patterning was already perceived by the Munich art historian, Friedrich Pecht, at the World Exhibition in Vienna in 1873. He not only correctly observed the duality of large and small ornaments, and the way in which they were broken down and integrated, he also noticed their irregular use as compositional media and the system or principle behind this. As an art scholar, he perceived in the striped and quadratic forms an example of those "ideals" which determine conceptions of form over a period of time.

The variety of Far-Eastern ornamental patterns is endless and deserves our special attention at this point. In the section "Oriental Fashion" the exhibition has so far shown pattern forms of the first half of the nineteenth century, which were directly copied on European metalwork, glass and ceramic-ware, and primarily textiles, from ornaments of the Near East and India. Even in painting and book-decoration, the ornamentation is varied and subject to rapport systems, which, following their own ordering principles, rhythmically merge into, and cover the surface in mosaic form. The varied system of Japanese ornamentation developed over the centuries, has been subject to standardization and, on occasion, reduced to schematic principles which offer themselves to the European artist as working formulas. The example we wish to consider here, the "pattern — background" principle, was first clearly perceived by European artists through the medium of Japanese wood-engraving and textile art in the second half of the nineteenth century and taken beyond the stage of pure reception. By "pattern and background" we understand a primary and secondary pattern, which presupposes an integration of both elements in advance. The effect of this system is subject to a mode of composition producing visual tension. The stylized elements in the heraldic forms of the large and small patterning principle, especially as found on the Japanese kimono, Nô-costume and Kabuki robes, deliberately negate the unity of the object in order to create tension and extreme dislocation within the static area occupied by the transfixed figure of the wearer of the costume. This characteristic form of ornamentation could derive from the clothes of the wandering Buddhist monks which were made up of odd remnants of donated material and thereby came to manifest the most irregular and assymetrical patterns. This effect is reproduced in the assymetrical patterning of later Japanese costume: often, only half of the garment is provided with a pattern; large ornamental forms seem to spread over the contours in the manner of a "wandering shadow." Important are the raised surface structures or elaborate embroideries and superimposed patch-work of varying consistencies, which can smooth or roughen, contour or integrate the surface and thereby impart movement to the fabric. The general effect created appeals equally to the optical and tactile senses. More important, however, is that this patterning principle totally disregards the shape of the wearer.

The costumes of the Japanese actors in the Nô and Kabuki are often consciously designed to veil the contours of the wearer; the costume retains its ornamental function, and in the manner of a symbol represents a typification or codification of certain social groups which have to embody specific modes of behaviour manifested in pose and gesture.

The individual decorative motifs of Japanese ornamentation, which stimulated groups of artists in Europe, can be arranged in three categories:
1. Geometrical — abstract motifs
2. Naturalistic motifs
3. Concrete objects
It is important that these things were observed with respect to their real formal aspect without disturbing their inherent significance. Cipher-like forms, which derive from naturalism, are always subject to stylizing elements of movement. Via the idea, intellectualization and sublimation are expressed in them and this is performed by way of empiricism to the direct outward form. These three groups can themselves be subdivided into three representational principles:
a) The "trellis" principle in infinite rapport
This particular principle was regularly developed to an astonishing degree in the field of textiles. The rapport which spreads over the picture surface, nevertheless orders, subdivides and gives it life, and the most varied natural phenomena are employed in its composition. The repetitive sequence is determined by a contemplative attitude to composition involving highly-developed techniques and a modulated manner of application. The motifs selected are floral, flowing, curving, and conform to their organic form.
b) The "framing" principle
This principle has a circumscribing function. Decorative borders, wave bands and patterned strips predominate, which demonstrate the universal character of ornamentation in Far-Eastern art and came to influence European art in the nineteenth century.
c) The centering principle
An important system here is that of the monos, a type of coat of arms with a traditional basic form. Generally, it is a circle in which any appropriate concrete object can be represented. The so-called mono-books contain countless examples of designs. Monos were widely used as ornamental forms and have played an essential role in Japanese textile designing. In Europe, they exerted an important influence upon the Viennese secessionist school. Silk art was a focal point of artistic thought in Japan: manufacture and use of the material was subject to the same creative process. Patterning was aslo a field of creative activity in which the Ukiyo-e masters came to participate and to design and paint their own patterns. The close contact between the woodcut and textile design is demonstrated by the fact that many Japanese painters came form the textile branch. In

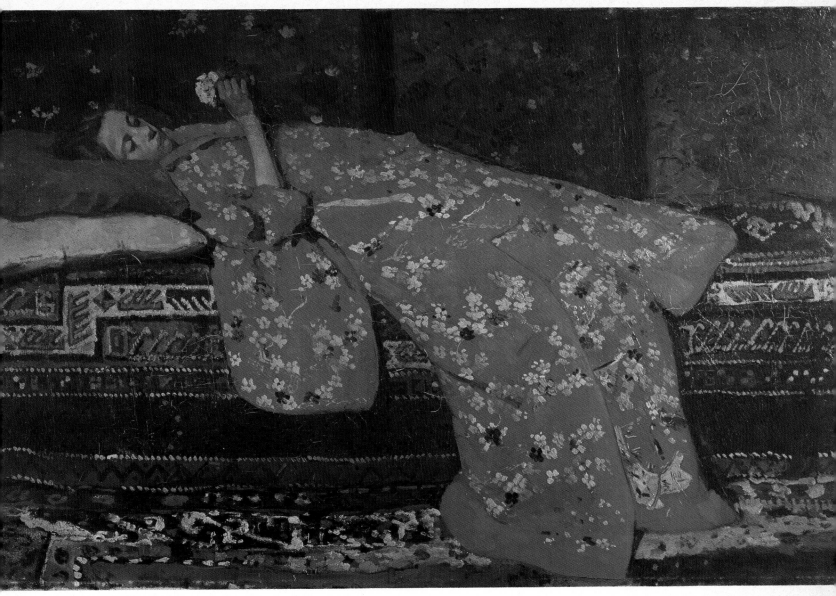

644 Breitner, The Red Kimono

this connection, it is important to refer to Japanese dyeing-stencils, a specialized field in which the work of Hishikawa Moronobu (1638–1714) in particular reveals a precise, graphic technique. There is scarcely any other form of black and white technique which is as striking and decoratively ornamental as this, as the representative selection contained in the exhibition demonstrates. The pattern-background principle is already visible in the stencil itself, which entails the above-mentioned principles a–c and ornaments them in great variation. In Europe, the Museum of Applied Art (Museum für angewandte Kunst) in Vienna began a collection of Japanese dyeing-stencils in the eighteen-sixties which soon contained thousands of exhibits, and by the turn of the century European graphic art had begun to receive impulses from them.

The role of the Ukiyo-e masters merits special consideration. We have already referred to their close affiliation with textile designing, and it is therefore not surprising that their wood-engravings, which were also devoted to depicting daily events, should focus upon costume in its typification. The Japanese manipulation of costume was quite generally cultivated and distinguished, and it was something which everyone understood. For instance, the courtesan draped the kimono in front of her body in a particular way; the reversed sash (obi) was a signal with which she attracted attention. The individualistic posture and movement of the women in sitting, standing or reclining, as represented in thousands of woodcuts, entailed a prescribed language of gesture which also determined movement of the garment. The culmination was reached in the theatrical sphere. The manipulation and movement of the fabric became an art form that expressed more

than the draped proportions of the body: the Kabuki actor was, in fact, an appendix to his costume. His task was to control the now autonomous mass of fabric and allow its intrinsic value to come into the play. In the lion dance, for example, the talent of the actor is measured against the mode of rotation of the voluminous fabric, which is draped around his body in such a way that he becomes an "abstract" object with its culmination in colourful movement. This was a popular motif in wood-engraving, especially among the late masters. The human body often appears to have been eliminated: the costume is the focal point; head, face and hands disappear entirely into the ornamented fabric. The ornament becomes larger, gains significance, and the colours more brilliant and determinant. In the woodcut, the "consumption" of the figure by the ornament points quite generally to a transcending of voluminous

919 Kunisada, Actors

918 Kunisada, Actor

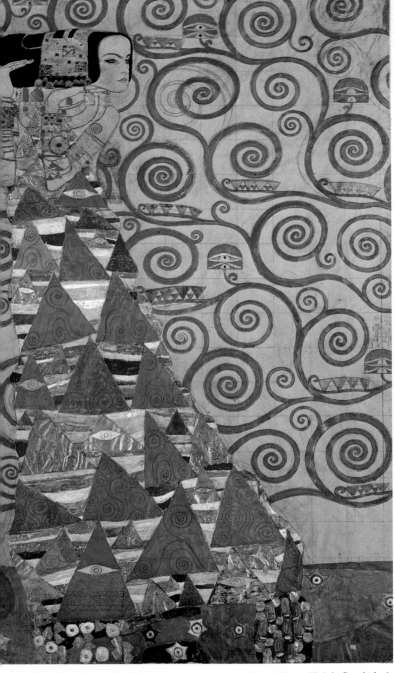

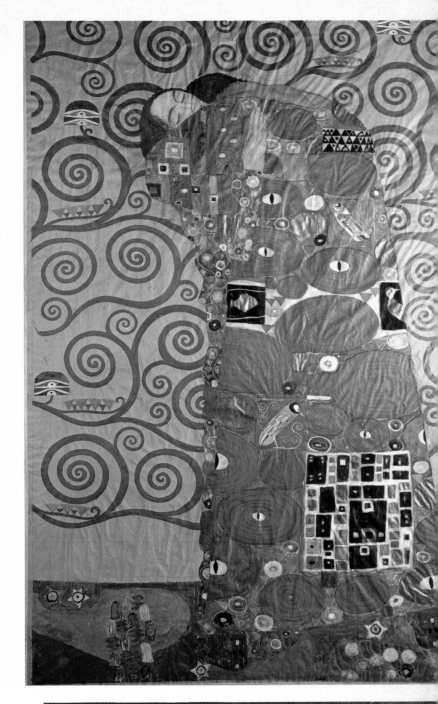

917 Klimt, Frieze (Palais Stoclet) ▲ 917 Klimt, Frieze (Palais Stoclet) ▶

942 Japan, Dyeing-Stencil ▶

contours of outward form. Under the
influence of the Ukiyo-e painters, Euro-
pean artists and craftsmen identified
themselves with the same objective.
Vincent van Gogh was familiar with the
Ukiyo-e woodcuts and admired their
ornamental power and unbroken colour.
We notice how the background of the
portrait is hung with Japanese prints —
a device employed more extensively in
his painting of the postman Roulin. "La
Bergeuse" contains the large, floral
wallpaper design which the Nabis later
developed into a pattern-background
system.
Monet also tends towards the large
ornament in his picture "La Japonaise":
fans cover the wall in the background,
and the red kimono of Madame Monet
has large patches of embroidery. The
Japanese compositional principle of
joining ornamented area to ornamented
area is also to be found in the graphic art
of Mary Cassat. This is well demonstrated
by comparing the "Woman writing
Letter" and the "Praying Actor" of Kuni-
sada I and Toykuni II.
The "trellis principle" of composition
is to be found in related form in the work
of the Nabis. A persistent theme is the
coloured network consisting of a mosaic
of small and large patterns, which
decorates the surface in the spirit of the
Japanese. Maurice Denis referred to the
intervals in the patterning as "harmonic
dissonance." Bonnard, Vuillard, and
their circle of friends, suggest an orna-
mentalized plane in their works. Direct
simplification is achieved by Bonnard,
the "Nabi Japonnard." Together with
Vuillard, he eliminates orthogonal space
employed in the illusory spatial effect
inherited from the Renaissance. In their
efforts to achieve simplification of things,
the European painters also favoured
patterned objects, above all ornamented
garments, in conformity with Japanese
wood-engraving. The figures in their
check, dotted or flowered robes, become
part of the wallpaper or curtain ornament;
the background absorbs the concrete
object.
In common with the Ukiyo-e masters, the
Nabis were also familiar with textiles.
Vuillard pictures are frequently carpet,
wallpaper or curtain still-lifes in which
the textile principle of the patterning
appears as the primary feature. The over-
patterning of the eighteen-nineties
corresponds closely to the Japanese
system.
The "framing "principle in the sense of
decorative borders, wave bands and

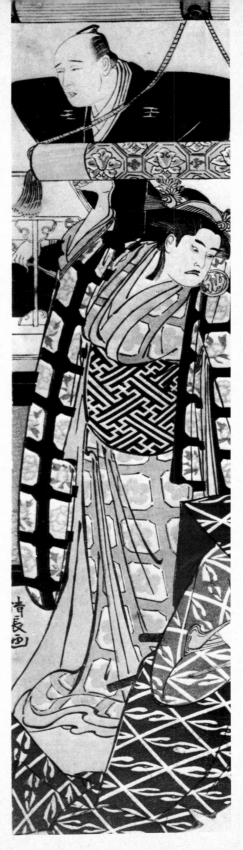

patterned strips, is largely to be found in
Europe in book illustration. Line finds
firmer application and appears schematiz-
ed as a guiding line — a dynamically
animated system of bands, in the sense of
calligraphic curvatures, becomes visible.
These principles of composition can be
observed in the periodicals "Japon
Aesthetique" (France) "The Yellow
Book" (England), and in "Pan" and
"Jugend" (Germany). The patterned
strip is expressed in autonomous and
varied form, however, in the work of
Vuillard, Vallotton and Maurice Denis.
In respect of its European reception, the
most decisive aspect of the third principle,
large pattern in front of small pattern in
the "mono" system, is the alternating
arrangement of ornament which raised
the Japanese pattern-background to an
interesting climax here. Referring to the
Japanese exhibits at the World Exhibition
in Vienna in 1873, Friedrich Pecht speaks
of "unbelievable brilliance of colours,"
"irregular harmony" and the "ornamental
improvization of mosaic patches of
colour."
The pattern-background principle was
intensified in the art of the Vienna
Secessionists, particularly in the work of
Gustav Klimt where the figures convey
a certain anonymity and ornament is
composed in a highly personal style.
Klimt possessed a rich collection of
Japanese kimonos and Nô-costumes,
and had studied the pattern-background
principle on his own collection of hanging
scroll pictures (kakemono). He could
perceive the "mono" principle in the
large heraldic ornaments, and he himself
represented the most varied concrete
objects in the "mono" systems in
ornamentalized or pluralized form. The
reserved simplicity of the sitting or
standing figures is set off by the opulent
splendour in gold-silver and varied
ornament reminiscient of the Japanese
shomenzuri, a special form of glossy print.
Klimt's ornamentations do not strive for
total abstraction. In accordance with his
Japanese prototypes they retain a large
degree of their concrete value and are
emphasized in the sense of simplifying
formulas. In this way, his work develops
that concentration of patterning which
culminates in system. Klimt employs
every patterning principle discussed in
this article and realizes them above all in
his frieze for the Palais Stoclet in
Brussels. We observe the "consumption"
of the figure by the ornament: only a
small part of each face is visible and the
rest of the body is cloaked by a kimono-
like garment, which reminds one of the
patch-work clothes of the Buddhist

Kiyonaga, Actors (detail) ▶

monks. The asymmetry of the large ornament, the "wandering" of the autonomous ornamental units over the picture, again emphasises integration within the surface. The motifs bind the compact ornament system together and expand in folding-screen sequence. The contours of every figure were united in a pattern-background principle. The Japanese woodcut and textile art provided abundant impulse for reception and analogy. The step was taken in one direction towards modern art in Europe.

Summary and Translation G. F. S.

The Japanese Motif

European Handicrafts and Japanese Motifs

561 *Félix Bracquemond (Paris 1833–1914); manufacture: Leboeuf, Milliet & Cie., at Creil and Monterau; plate;* earthenware; ⌀ 24.4 cm; sig. Paris; 1867; Hamburg, Heuser Coll.

562 *Felix Bracquemond; manufacture: Leboeuf, Milliet & Cie. at Creil and Monterau; plate;* earthenware, ⌀ 23.4 cm; sig. on bottom: stamp E. Rousseau; 1867; Hamburg; Heuser Coll.

563 *Felix Bracquemond; manufacture: Leboeuf, Milliet & Cie. at Creil and Monterau; seven plates;* earthenware, ⌀ 24.4 cm; sig. bottom: stamp E. Rousseau; 1869; London, Bethnal Green Mus.; Inv. No. 699–699 E and 699 H; plate

564 *Felix Bracquemond; manufacture: Leboeuf, Milliet & Cie. at Creil and Monterau; four plates;* earthenware, ⌀ 24.4 cm; sig. bottom: stamp E. Rousseau; 1867; Paris, Mme Henriod-Bracquemond

565 *Auguste Delaherche (Beauvais 1857–1940); ornamental plate with fleur de lis;* earthenware, ⌀ 31.8 cm; sig. bottom: stamp Auguste Delaherche 3446; c. 1895; Karlsruhe, Badisches Landesmus.; Inv.-No. 70/133

566 *Alf Wallander; manufacture: AB Rörstrand Porlinsfabriker, Stockholm; small plate;* porcelain, ⌀ 17.5 cm; sig. bottom: factory stamp; Berlin; Bröhan Coll.

567 *Denmark; manufacture: Royal Porcelain Manufactury Copenhagen; decoration Richter (1893–1847); wall plate;* porcelain, ⌀ 19.7 cm; sig. bottom: artist's and factory mark 1893–1897; Berlin, Bröhan Coll.

568 *V. S.; mounted vase;* glass, h - 21.5 cm; sig. bottom: stamp VS with sailing ship; c. 1900; Darmstadt, Hessisches Landesmus., Inv.-No. Kg 64 : 277

569 *China, Ch'ing Dynasty (1644–1912); vase;* porcelain, h - 43 cm; 18th cent.; Schloss Egg, Georg L. Hartl Coll.

570 *France; manufacture: Samson; vase;* porcelain, h - 51 cm; c. 1900;

Vienna, Österreichisches Mus. für angewandte Kunst; Inv.-No. 16467/Ke 4922

571 *Japan, Tokugawa period (1603–1868); vase with lid;* porcelain, h - 37.2 cm; 17th cent.; Vienna, Österreichisches Mus. für angewandte Kunst; Inv.-No. 17776/Or. 966

572 *France; manufacture: Samson, Paris; vase with lid;* porcelain, h - 31.5 cm; sig. bottom: mark Samson and Chantilly; c. 1900; Vienna, Österreichisches Mus. für angewandte Kunst; Inv.-No. 16465/Ke 4920

573 *Japan, Meiji period (1868–1912); bowl;* porcelain, ⌀ 23.5 cm; 19th cent.; Vienna, Österreichisches Mus. für angewandte Kunst; Inv.-No. LKH 307

574 *France; manufacture, Samson; plate;* porcelain, ⌀ 34 cm; c. 1900; Vienna, Österreichisches Mus. für angewandte Kunst; Inv.-No. 16459/Ke 4915

Hokusai, from "Manga"

563 Braquemond, plate

East and
South-East
Asia

The
Japanese
Motif

561–731

585 Japan, Box with Lid

580 Japan, Writing Casket

575 *France; manufacture: Legras & Co.; vase;* glass, h - 39.4 cm; sig. wall: Legras; c. 1900; Darmstadt, Hessisches Landesmus.; Inv.-No. Kg. 62 : 18 a

576 *China, Ch'ing Dynasty (1644–1912); vase with wooden lid;* porcelain, h - 15.7 cm; Vienna, Österreichisches Mus. für angewandte Kunst; Inv.-No. 30744/Ke 8197

577 *Muller Frères; manufacture: French Glass Factory Lunéville; vase with branches of wistarias;* crystal, h - 28.5 cm; sig.: Muller Fres. Luneville; c. 1910; Karlsruhe, Badisches Landesmus.; Inv.-No. 70/170

578 *Japan, Meiji period (1868–1912); lacquer designs on screen-like frame;* h - 98 cm., w - 64 cm; sig. base; 19th cent.; Vienna, Österreichisches Mus. für angewandte Kunst; Inv.-No. 20290/Or. 3480

579 *Hokkio Korin Doshû; tall casket;* wood, black lacquer, h 27.3 cm; w - 30 cm.; ⌀ 34.3 cm.; sig.: Hokkio Korin Doshû, Tokugawa period (1603–1868); 18th cent.; Vienna, Österreichisches Mus. für angewandte Kunst; Inv.-No. 36680/La 255;

580 *Japan, Meiji period (1868–1912); writing casket (Suzuribako);* wood, black lacquer, h - 23 cm, w - 21 cm; 19th cent.; Vienna, Österreichisches Mus. für angewandte Kunst; Inv.-No. 31740/La 195; plate

581 *Japan, late Tokugawa period (1765–1868); casket;* wood, golden lacquer, h - 18.5 cm, w - 15 cm; sig.: Jo-o; post 1817; Vienna, Österreichisches Mus. für angewandte Kunst; Inv.-No. 31738/La 183

582 *Japan, Meiji period (1868–1912); writing casket (Suzuribako);* wood, golden lacquer, h - 29 cm, b - 26 cm; 19th cent.; Vienna, Österreichisches Mus. für angewandte Kunst; Inv.-No. 31736/La 191

583 *Japan, Meiji period (1868–1912); casket;* wood, golden lacquer, h - 27.7 cm, w - 10.7 cm; 19th cent.; Vienna, Österreichisches Mus. für angewandte Kunst; Inv.-No. 19333/Or. 2523

584 *Japan, Meiji period (1868–1912); box with lid;* wood, coloured lacquer, h - 13 cm, w - 13 cm; 19th cent.; Vienna, Österreichisches Mus. für angewandte Kunst; Inv.-No. 20644/Or 3834

585 *Japan, Meiji period (1868–1912); box with lid;* wood, coloured lacquer, h - 13 cm, w - 10.3 cm; 19th cent.; Vienna, Österreichisches Mus. für angewandte Kunst; Inv.-No. 19297/Or 2487; acquisition of Österreichisches Handelsmus.; plate

586 *Japan, Meiji period (1868–1912); box with lid;* wood, golden lacquer, l - 13.2 cm, w - 12.2 cm; 19th cent.; Vienna, Österreichisches Mus. für angewandte Kunst; Inv.-No. 19253/Or 2443

587 *Japan, Tokugawa period (1603–1868); writing casket (Suzuribako);* wood, golden lacquer, h - 23.5 cm, w - 21.7 cm; 18th cent.; Vienna, Österreichisches Mus. für angewandte Kunst; Inv.-No. 29681/La 170

588 *Japan, late Tokugawa period (1765–1868); writing casket (Sazuribako);* wood, golden lacquer, h - 24 cm, w - 22.5 cm; Vienna, Österreichisches Mus. für angewandte Kunst; Inv.-No. 32100/La 232

589 *Japan, late Tokugawa period (1765–1868) or Meiji period (1868–1912); book with wood-engravings;* paper, 18 × 12 cm; 19th cent.; Copenhagen, Royal Porcelain Manufactory

590 *Arnold Krog (Frederikswerk 1856–1931 Tisvilde); manufacture: Royal Porcelain Manufactory, Copenhagen; plate;* porcelain, ⌀ 29.8 cm; sig.: AK; 1887; Copenhagen, Royal Porcelain Manufactory

591 *Japan, late Tokugawa period (1765–1868) or Meiji period (1868–1910); Duck in Water;* coloured woodcut, 32 × 38 cm; 19th cent.; Copenhagen, Royal Porcelain Manufactory

592 *C. F. Liisberg (1860–1909); manufacture: Royal Porcelain Manufactory, Copenhagen; vase;* h - 24.5 cm; sig. bottom: CLF; 1889; Copenhagen, Royal Porcelain Manufactory; Inv.-No. U : 87

593 *Arnold Krog; vase;* porcelain, h - 22 cm; sig. bottom: A. Krog; factory mark, Oct. 1886; Copenhagen, Danish Mus. for Arts and Crafts; Inv.-No. B 72/1910

594 *England: manufacture: Rockwood; Pottery; vase;* porcelain, h - 23.5 cm; pre 1900; Vienna, Österreichisches Mus. für angewandte Kunst; Inv.-No. 1221/Ke 4374

595–600 *James McNeill Whistler (Lowell, Massachusetts 1834–1903 London); drawings for the catalogue of the blue-white Nanking porcelain of Sir Henry Thompson's collection;* sepia on paper; c. 1876/77; Glasgow, Art Gall. and Mus. Kelvingrove

601 *China, Ming Dynasty (1368–1644); vase;* earthenware, h-43 cm; early 16th cent., Chia-ching period 1522–1566); Paris, Mus. Guimet; Inv.-No. 93130

602 *China, Ming Dynasty (1368–1644); vase;* h-28.5 cm; first half of 16th cent.; London, Victoria & Albert Mus., Inv.-No. C 941–1935

603 *China, Ming Dynasty (1368–1644); pot on wooden plate;* earthenware, h-15.3 cm; Vienna, Österreichisches Mus. für angewandte Kunst; Inv.-No. 31944/Ke 8729

604 *Auguste Delaherche; vase;* earthenware, h-25 cm; sig.: stamp; pre 1900; München, Paul Tauchner Coll.

605 *Auguste Delaherche; vase;* earthenware, h-27.5 cm; sig. floor: round name stamp and work No. 5971; 1890–1894; Hamburg, Heuser Coll.

606 *Max Laeuger (Lörrach, Baden 1864–1952); vase;* clay, h-35 cm; sig. floor: LM 224; Karlsruhe, Badisches Landesmus., Inv.-No. 70/70

607 *Max Laeuger; vase;* clay, h-23 cm; sig. floor: stamp MLK and B 37; 1897; Nuremberg, Gewerbemus. der Landesgewerbeanstalt Bayern; Inv.-No. 18337

608 *Max Laeuger; vase;* clay; h 29.5 cm; sig. floor: MLK (K = Kanden); pre 1903; Karlsruhe, Badisches Landesmus. Inv.-No. 68/12

609 *Edmond Lachenal (Paris 1855 until after 1930); vase;* clay; h 20.4 cm; sig. floor: Lachenal original; c. 1900; Darmstadt, Hessisches Landesmus. Inv.-No. Kg 1:7.

610 *China, Ch'ing Dynasty (1644–1912); vase;* porcelain with white glaze; h - 21.1 cm; Ch'ien-lung period (1736–1795); Vienna, Österreichisches Mus. für angewandte Kunst, Inv.-No. 31281/Ke. 8440

611 *Sweden; manufacture: AB Rörstrand Porslinsfabriker, Stockholm; vase;* porcelain; h - 21.6 cm; pre 1900; Vienna, Österreichisches Mus. für angewandte Kunst; Inv.-No. 12175/Ke 4335

612 *Sweden; manufacture: AB Rörstrand Porslinsfabriker, Stockholm; vase;* porcelain; h - 23.7 cm; Vienna, Österreichisches Mus. für angewandte Kunst, Inv.-No. 12177/Ke 4337

613 *Sweden; manufacture: AB Rörstrand Porslinsfabriker Stockholm; vase;* porcelain, h - 22.3 cm; Vienna; Österreichisches Mus. für angewandte Kunst, Inv.-No. 12176/Ke 4336

614 *Gunnar Wennerberg; vase;* fine English earthenware; h - 20,5 cm; c. 1896; Stockholm, National Mus., Inv.-No. N. M. 29/1897

614 a *Alf Wallander; manufacture: AB Rörstrands Porslinsfabriker, Stockholm; vase;* porcelain; h - 37 cm; 1896; Stockholm National Mus., Inv.-No. N. M. 13/1897

615 *Nils Lundström (Stockholm 1865–1960); manufacture: AB Rörstrand Porslinsfabriker, Stockholm; vase;* porcelain; h - 48 cm.; sig. floor: green mark of Rörstrand factory, 13516, NL; c. 1900; Darmstadt; Hessisches Landesmus., Inv.-No. Kg. 64–21

616 *China, Ch'ing Dynasty (1644–1912); incense vessel in blanc-de-chine;* porcelain, h - 7.6 cm; 18th cent.; Vienna; Österreichisches Mus. für angewandte Kunst; Inv.-Nr. 17540/Or. 730

617 *Denmark; manufacture: Porcelain Manufactury Bing & Gröndahl, Copenhagen; vase;* porcelain, h - 12 cm; pre 1900; Vienna, Österreichisches Mus. für angewandte Kunst, Inv.-No. 12593/Ke 4474

618 *China, Ch'ing Dynasty (1644–1912); brush glass;* glass, h - 11.2 cm; Nien-hao of the Ch'ien-lung period (1736–1795); Vienna, Österreichisches Mus. für angewandte Kunst, Inv.-No. 17846/Or. 1036

619 *China, Ch'ing Dynasty (1644–1912); vase;* earthenware – green; h - 20.9 cm; 19/20th cent; Nuremberg, Gewerbemus. der Landesgewerbeanstalt Bayern; Inv.-No. AE6

620 *Andrew Walford (Bournemouth 1942); vase;* light-coloured stoneware;

Europe, Pattern-Book

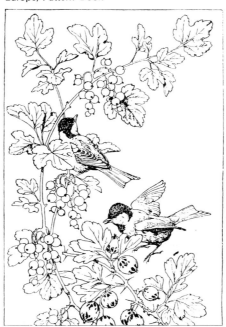

h - 17 cm; sig., covered by glaze; 1967; Hinang, Wolf; Coll. No. 079005

621 *Andrew Walford; four-coloured flask;* stoneware; h - 30.5 cm; Hamburg, Thiemann Coll.

622 *Japan, Tokugawa period (1603–1912); hand-box (tebako);* wood goldlacquer; h - 9.5 cm., l-22.2 cm, ⌀ 16.5 cm; sig. on lid: Nagata seal: Yûji (worked 1711–1736); probably 19th cent.; Hamburg; Mus. für Kunst und Gewerbe; no Inv.-No.

623 *Daum Frères (Auguste 1853–1909, Antonin 1864–1930); two goblets;* crystal; h - 24.8 cm; sig. foot: factory mark "Daum Nancy" and cross of Lorraine; c. 1900; Karlsruhe, Badisches Landesmus., Inv.-No. 70/134 ab

624 *Camille Moreau – Nélaton (Paris 1840–1897); vase;* faience; h - 32.7 cm; sig. wall: monogram and 83; floor: whole signature and date; 1833; Hamburg, Heuser Coll.

625 *Camille Moreau – Nélaton; wall plate;* faience; ⌀ 44 cm; sig. rim: monogram and 76; back: full signature; 1876; Hamburg, Heuser Coll.

626 *China or Japan; box with lid;* guri lacquer; ⌀ 6.5 cm; sig.: Chang-Ch'eng (14th cent.) but probably later (Japa-

Hokusai, from "Ukiyo Gafu"

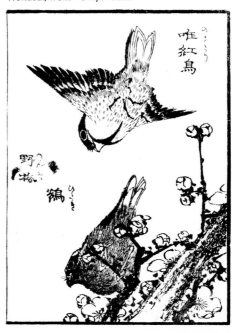

99

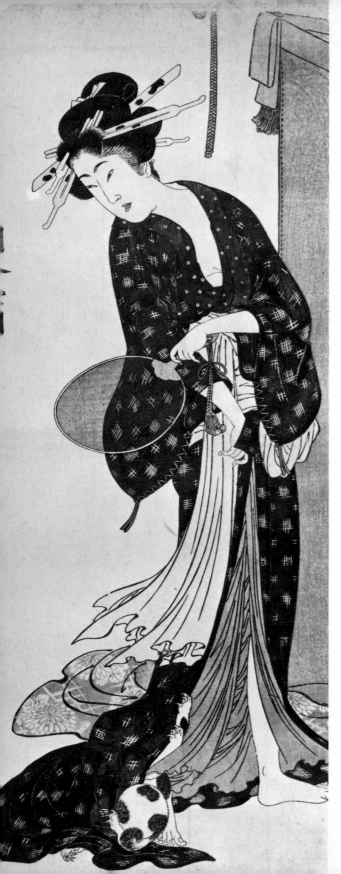

nese?) work; Hamburg, Mus, für Kunst und Gewerbe; Inv.-No. 1890.281

627 *Emile Gallé (Nancy 1846–1904); vase;* colourless glass; h-7 cm.; sig. floor: Gallé Modèle et décor déposés; Düsseldorf, Kunstmus., Prof. Hentrich Coll.

628 *Emile Gallé; vase;* colourless glass; h - 7 cm; sig. floor: Gallé Modèle et décor déposés; Munich, Stadtmus., Inv.-No. K 70–89

629 *Emile Gallé; vase;* colourless transparent glass; h - 15 cm; sig. floor: Gallé Modèle et décor déposés; c. 1898; Darmstadt, Hessisches Landesmus., Inv.-No. Kg 61 : 26

The Kimono

The great surprise of the World Exhibition in Paris in 1878 was the success of Far-Eastern art, especially that of Japan. Critics were quick to notice parallels between the influence of China upon artistic taste at the end of the seventeenth and beginning of the eighteenth centuries. Compared with China, however, Japan was to have an even greater penetrating effect in all fields of European decorative art which, starting from an interest in oriental fashion, focused upon the living habits of the people.
Not only were connoisseurs and collectors enthused by the paintings, sculptures and architecture, applied arts also received impulses which have remained effective up to the present day. Ladies' fashion, as an aspect of daily life, was dominated by the Japanese kimono and cloak until about the turn of the century; even the posture and deportment of the Parisian lady was imported from Japan. The flowing S-line, at first merely suggesting the lady's robe, was perfected by the turn of the century. In painting, the lady in kimono became a popular motif among the early and late impressionists: from Whistler's "La Princesse du Pays de la Porcelaine", to Monet's "La Japonaise" we can trace the influence of the Japanese wood-engraving in the figure's lightly bowed head, the gently curved back, and the flared hem of the dress. S. W.

Summary and Translation G. F. S.

◀ 633 Shigenobu, Courtesan (detail)

630 *Claude Monet (Paris 1840–1926 Giverny); Madame Monet in Kimono (La Japonaise);* oil, canvas; 231.5× 142 cm; sig. bottom left: Claude Monet 1876; cf. Cat. no. 632, 633; Boston, Mus. of Fine Arts; coloured plate

631* *James McNeill Whistler (Lowell, Mass. 1834–1903 London); Rose and Silver: La princesse du pays de la porcelaine;* oil, canvas; 199.9×116.1 cm; sig. top left: Whistler 1864; cf. Cat. no. 630, 631; Washington D. C.; Freer Gallery of Art; plate

632 *Torii Kiyomine (Tokyo 1788– 1868); The Courtesan Inaska from the Okamoto (Okamoto-ya uchi, Inaoka);* from the series "Songs of the Four Seasons," "Seiro shiki no uta"; coloured woodcut, ôban 39×26.2 cm; sig.: Kiyomine ga; imprint: Eiju (do) han (Nishimura-ya Yohachi, three tomoe under "yama"); c. 1810/20; Berlin, Mus. für Ostasiatische Kunst

633 *Yanagawa Shigenobu (Tokyo 1787–1832); The Courtesan Konami from the House Kurahashi;* from the series "Procession in Shinmachi in Osaka," "Osaka Shinmachi nerimono"; coloured woodcut, ôban 37.4×25.3 cm; sig.: Tot Yanagawa Shigenobu; first third of 19th cent; Berlin, Mus. für Ostasiatische Kunst; plate

634 *Eiryu (worked in Tokyo in seventeen-nineties); The Courtesan Tsukioka from Hyogoya walks with her two Kamuro Hagino and Kikuna;* from the series "The first Fashions of the Courtesans in the New Year," "Wakana no hatsumoyo"; coloured woodcut, ôban 37.1×24.4 cm; sig.: Eiryu zu; imprint: Nishimura – ya Yohachi (imprint with three tomoe under "jama"); Imprimatur stamp: Kiwame; c. 1790/1800; Berlin, Mus. für Ostasiatische Kunst

635 *Torii Kiyonaga (Tokyo 1752– 1815); The Courtesan Katsuasa with Servants;* coloured woodcut, ôban 32.2×23.1 cm; sig: Kiyonaga ga; c. 1800; cf Cat. no. 630, 631; Köln, Mus. für Ostasiatische Kunst

636 *Katsukawa Shunsho (Tokyo 1726– 1792); The Actor Nakamura Noshio (1757–1777) in the Role of a Pilgrim;* coloured woodcut, hoso-e 31.6× 14.4 cm; sig.: Shunsho ga; second half of 18th cent. Köln, Mus. für Ostasiatische Kunst

637 *James McNeill Whistler; Sketch for variations in carnation and gree : The Balcony;* water-colour on paper; 62.8×50 cm; c. 1864/65; Glasgow, University of Glasgow, Birnie Philip Bequest

638 *James McNeill Whistler; Study for the Balcony;* oil on wood, 61×48.2 cm; c. 1867/70; Glasgow, University of Glasgow, Birnie Philip Bequest

639 *Hosoda Eishi (Tokyo 1756–1829); Four refined Ladies;* coloured woodcut, ôban 36.7×24.7 cm; sig.: Eishi ga; imprint: Eijudo (Nishimura Yohachi); Imprimatur stamp: Kiwame; c. 1792; Regensburg, Franz Winzinger Coll.

640 *Alfred Stevens (Rotterdam 1823–1906 Amsterdam) The Japanese Parisian;* oil, canvas; 150×100 cm; sig. bottom right: A. Stevens; after 1885; Liège, Musée des Beaux-Arts;

641 *William Merritt Chase (Williamsport, Indiana 1849–1916 New York); Japanese Woodcut;* oil, canvas; 50×61 cm; after 1890; Munich, Bayerische Staatsgemäldeslgn.;

642 *George Henry (Ayrshire, Scotland 1859–1943 London) Japanese Woman with Fan;* oil, canvas; 61×40.6 cm; sig. left centre: George Henry/Tokyo 1894; Glasgow, Art Gall. and Mus.

643 *George Henry; Japanese Woman in a Garden;* oil, canvas; 76.2×63.5 cm; c. 1894; Glasgow, Art. Gall. and Mus.

644 *Georg Hendrik Breitner (Rotterdam 1857–1914 Amsterdam); The red Kimono;* oil, canvas; 50×76 cm; sig. bottom right: G. H. Breitner; c. 1893; Amsterdam, Stedelijk Mus.; coloured plate

645 *Georg Hendrik Breitner; The Japanese Kimono;* oil, canvas; 59×57 cm; sig. bottom left: G. H. Breitner; c. 1895; Amsterdam, Rijksmus.;

646 *Henri de Toulouse-Lautrec (Albi 1864–1901 Malromé, Gironde); Lily Grenier in Kimono;* oil, canvas; 54×45 cm; c. 1888; Dortu 302; New York, Mr. and Mrs. William S. Paley Coll.

647 *Félix-Edouard Vallotton (Lausanne 1865–1925 Paris) Young woman with Fan;* oil, canvas; 81×65 cm; sig. bottom left: F. V. 1912; Lausanne, priv. coll.

648 **Edouard Manet (Paris 1832–1883); Portrait of "Emile Zola";* oil, canvas; 146×114 cm; c. 1868; Jamot-Wildenstein 146; Paris, Jeu de Paume

649 *Paul Gauguin (Paris 1848–1903 Hivaoa, Marquesas); Still-life with Horse's head;* oil, canvas; 49×38 cm; sig. bottom right: Paul Gauguin; c. 1885; Wildenstein 183; Switzerland, priv. coll.

650* *Vincent van Gogh (Groot-Zundert 1853–1890 Auvers-sur-Oise); Japonaise: The Actor (copy after Kesai Yeisen: The Actor);* oil, canvas; 105×61 cm; Paris 1886–1888; De la Faille 373; Amsterdam, Rijksmus. Vincent van Gogh;

651 *Vincent van Gogh; Japonaiserie: The Tree (copy after Andô Hiroshige: Plum-branch in Blossom in the Kameido Garden);* oil, canvas; 55×46 cm; Paris 1886–1888; De la Faille 371; Amsterdam, Rijksmus. Vincent van Gogh; coloured plate

652 *Andô Hiroshige (Tokyo 1797–1858); Plum-branch in Blossom in the Kameido Garden;* from the series "Views of Famous Places in Edo," "Meisho Edo Hyakkei"; coloured woodcut, ôban 35×22.5 cm; sig.: Hiroshige ga; imprint: Uo (ya) Ei (kichi) Shituya Shinkoku; Imprimatur stamp: aratame; c. 1857; Köln, Mus. für Ostasiatische Kunst; coloured plate

653 *Vincent van Gogh; Japonaiserie: The Bridge (copy after Andô Hiroshige: The Ohashi Bridge in Rain);* oil, canvas; 55×46 cm; Paris 1886–1888; De la Faille 372; cf. Cat. no. 654; Amsterdam, Rijksmus. Vincent van Gogh; plate

654 *Andô Hiroshige; The Ohashi Bridge in Rain;* from the series "Views of Famous Places in Edo," "Meisho Edo hyakkei"; coloured woodcut, ôban 33.8×21.8 cm; sig:. Hiroshige ga; imprint: Shitaya Uoei; c. 1857; Vienna, Österreichisches Mus. für angewandte Kunst; plate

655 *Emil Orlik (Prague 1870–1932 Berlin); Fuji pilgrims;* coloured woodcut; 23.9×42 cm; sig. on plate, bottom right: Orlik; c. 1900; Regensburg, Ostdeutsche Gal.

656 *Emil Orlik; Sitting Japanese Woman viewed from behind;* page from a sketch-book; pencil on paper; 20.2×13 cm; c. 1900/01; Regensburg, Ostdeutsche Gal.

657 *Emil Orlik; Sitting Japanese Woman;* page from a sketch-book; pencil on paper; 20.2×13 cm; c. 1900/01; Regensburg, Ostdeutsche Gal.

658 *Emil Orlik; Japanese Woman drawing;* etching; 17.4×12.6 cm.; sig. bottom right: Orlik; c. 1900/01; Regensburg, Ostdeutsche Gal.

659 *Emil Orlik; The Designer;* coloured woodcut; 19.7×15.9 cm; c. 1900; Regensburg, Ostdeutsche Gal.

660 *Emil Orlik; The Wood-carver;* coloured woodcut; 19.5×16.2 cm; sig. bottom right: Orlik; c. 1900; Regensburg, Ostdeutsche Gal.

661 *Emil Orlik; The Printer;* coloured woodcut; 19.5×16.2 cm; sig. bottom right: Orlik/00; Regensburg, Ostdeutsche Gal.

662 *Emil Orlik; Japanese with Fan;* coloured woodcut; 16.4×13.2 cm; sig. bottom right: Emil Orlik/1901; Regensburg; Ostdeutsche Gal.

Movement as an Autonomous Element in Hokusai and in the Pastels and Drawings of Edgar Degas

Vincent van Gogh wrote to his brother Theo that the Japanese drew quickly due to their having simpler and more sensitive feelings. In this connection, it is important to know that painting handbooks were published in Japan under the title of "Examples of Fleeting Scenes." Van Gogh was referring to a specific phenomenon in the Japanese wood-engravings (Ukiyo-e); namely, the rejection of the constrained expression of movement which had appeared in posture and gesture in Europe after about 1870 in favour of a spontaneous registration of elementary movements, which demanded a rapid perception and corresponding stenographic technique from the artist. The rigid gesture, as representative of uniform movement, had not only extensively influenced portrait painting but also figurative composition in Europe and the United States of America. Viewed quite generally, a contradiction can be noted in nineteenth century figurative painting; the individualistic outward form is determined by uniform movements and posture. The transition to a new concep-

101

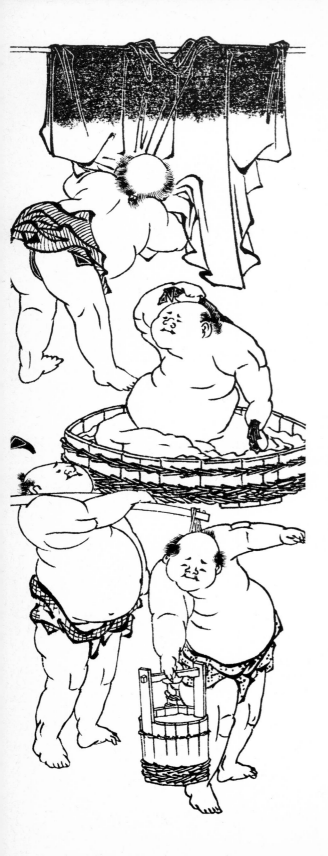

tion of posture and movement demanded a more personal level of communication with the subject, which in turn, presupposed that open-minded or less sophisticated approach to be found in the Japanese representative of folk art, Hokusai. Although he periodically lived in isolation, Hokusai studied his surroundings in great detail, especially the people as they performed their daily tasks, and represented them with great feeling for movement without any suggestion of monotony. Degas' ballet-dancers reveal many similarities with Hokusai's picture sequences. In Degas' "Dancers at Rehearsal with Double-bass in the Foreground" — an important exhibit — we observe the same spontaneous capture of movement, and the unusual posture of Hokusai's prototype is recorded even down to the position of the feet. S. W.

Summary and Translation G. F. S.

663 *Mary Cassatt (Allegheny, Penns. 1844–1926 Paris); The Bath;* coloured etching; 36.7 × 26.7 cm; c. 1891; Breeskin 143; cf. Cat. no. 664; Paris, Bibliothèque Nationale, Cabinet des Estampes

664 *Utagawa Kunisada (Tokyo 1786–1865); Mother and Child;* coloured woodcut, naga-e 67.5 × 22.3 cm; sig.: Kunisada aratame ni daime Tokoyuni ga; imprint Yamashiroya Kambei; c. 1842, 1847; Vienna, Österreichisches Mus. für angewandte Kunst; Exner Bequest

665 *Katsushika Hokusai (Tokyo 1760–1848); Mother and Child;* page from the Manga, Assorted Sketches, Vol. 12; woodcut, duotone print, facsimile; kôban 24 × 25 cm; Tokyo, Yujiro Shinoda

666 *Mary Cassatt; Young Woman Dressing;* coloured etching; 36.7 × 26.7 cm; c. 1891; Breeskin 148; Paris, Bibliothèque Nationale, Cabinet des Estampes

667 *Mary Cassatt; Young Woman at the Mirror;* coloured etching; 36.7 × 26.7 cm; c. 1891; Breeskin 152; Paris, Bibliothèque Nationale, Cabinet des Estampes; plate

668 *Chokosai Eisho (worked in Tokyo 1794–1800); Woman combing her Hair;* coloured woodcut, ôban 36.7 × 24.5 cm; sig.: Eisho ga; c. 1795–1800; Paris, Musée Guimet

669 *Katsushika Hokusai; Japanese Woman combing her Hair;* page from the

Manga, Assorted Sketches, Vol. 2; woodcut, duotone print, facsimile; kôban 24 × 25 cm; 1812–1875; Tokyo, Yujiro Shinoda;

670 *Katsushika Hokusai; Woman dressing her Hair;* page from the Manga, Assorted Sketches, Vol. 13; woodcut, duotone print, facsimile; kôban 24 × 25 cm; 1812–1875; Tokyo, Yujiro Shinoda

671 *Edgar Degas (Paris 1834–1917); Woman combing her Hair;* monotype;

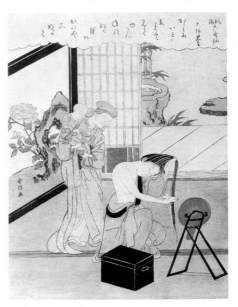

672 Harunobu, Woman combing her Hair

667 Cassatt, Woman at Mirror

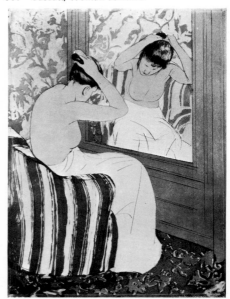

◀ Hokusai, from "Manga"

32×28 cm; c. 1880; Munich, Staatliche Graphische Slg.; plate

672 *Suzuki Harunobu (Tokyo 1725(?) –1770); Woman combing her Hair;* coloured woodcut, nishiki-e chûban; 29×21.7 cm; sig.: Harunobu ga; c. 1768; Regensburg, Franz Winzinger Coll.; plate

673 *Edgar Degas; After the Bath;* crayon on paper; 48×63 cm; sig. with inscrip. bottom left: à M. J. Stchoukine Degas; c. 1888–1892; cf. Cat. no. 674; Lemoisne 964; Munich, Bayer. Staatsgemäldeslgn.

674 *Kitagawa Utamaro (Tokyo 1753– 1806); Yamauba, with the small Kintoki on her Back, combing her Hair;* coloured woodcut, ôban 37.5×25.5 cm; sig.: Utamaro hitsu; imprint: Yohachi; Paris, Bibliothèque Nationale, Cabinet des Estampes, Resérve; plate

675 *Edgar Degas; Woman combing her Hair;* crayon on paper; 74.2×63.5 cm; sig. bottom right: Degas; c. 1895; study for "Les Baigneuses" Lemoisne 1072; London, Reid and Lefèvre; coloured plate

676 *Edgar Degas; After the Bath;* black chalk on paper, mounted on cardboard; 65.8×37 cm; sig. bottom left: estate stamp Lugt 658, rs.: Lugt 657; c. 1895; not with Lemoisne, cf. Lemoisne No. 1011; Wuppertal, Von-der-Heydt-Mus.

677 *Katsushika Hokusai; Japanese Woman washing Herself;* page from the Manga, Assorted Sketches, Vol. 11; woodcut, duotone print, facsimile; kôban 24×25 cm; 1812–1875; Tokyo, Yujiro Shinoda

678 *Katsushika Hokusai; A Man strokes the Column of a Temple Door;* page 4 from the picture -book "Hokusai shashin gafu"; coloured woodcut; 25.7×33.8 cm; imprint: Isuru-ya Kiemon, Toto, Tori – abura cho; date stamp: Bunsei 2 tsuchi-no-to u (second year, sixth sign of the almanac, zodiac hare = 1819); Berlin, Mus. für Ostasiatische Kunst

679 *Henri de Toulouse-Lautrec (Albi 1864–1901 Malromé); Woman with Water-can;* chromolithograph; 40×52 cm; sig. bottom right: stamp; c. 1896; cf. Cat. no. 690; Paris, Bibliothèque Nationale, Cabinet des Estampes

680 *Katsushika Hokusai; A Wrestler bending Down;* page from the Manga, Assorted Sketches, Vol. 3; woodcut, duotone print, facsimile; kôban 24×25 cm; 1812–1875; Tokyo Yujiro Shinoda

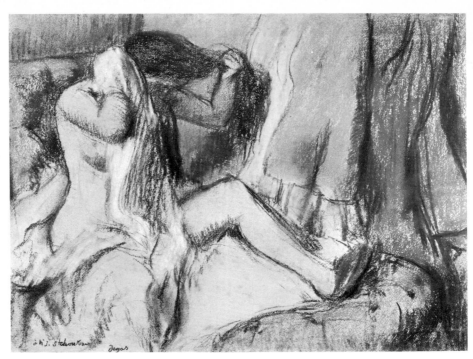

671 Degas, Woman combing her Hair

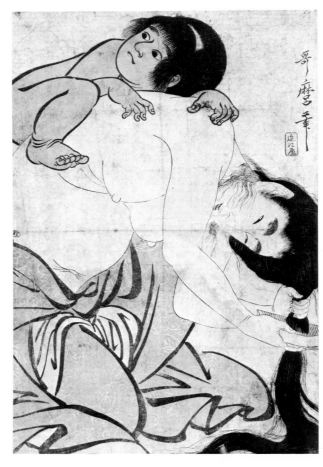

674 Utamaro, Yamauba with small Kintoki

East and
South-East
Asia

The
Japanese
Motif

561–731

Some Observations on the "Bridge" as a Motif in Far-Eastern and European Painting during the Nineteenth Century

Siegfried Wichmann

I.
The bridge is frequently employed as a motif in Chinese and Japanese art. The observer of the scroll also "wanders", as it were, over the bridge which, in the Kasagi-Mandara of the thirteenth century (Museum Yamato Bunkanan in Nara), leads on to the place of the sacred spirits. The landscape description commences from a bridge placed just above the lower picture margin in the work of Yosa Buson (1716–1738), Chikuhei-Hoin, "Visit to a Hermit in Bambushain" (privately owned, Ashiya, Japan). This motif is a focal point with regard to content and representation in Far-Eastern art. The long path through the landscape generally starts from a bridge. It is inevitable and clearly outlined in the Chinese painting manuals: "One must not be too sparing with bridges in a landscape painting; for, with their help, one can continue one's journey over places where the terrain is broken. By this means, one can induce people to enter into the beauties of the landscape.

Moreover, they offer the possibility of linking up the fine network of channels which give the picture its very breath of life, and they are thus an eminently suitable means of representation. Whether a stone or wooden bridge is required, depends upon what conforms best with the conditions of the terrain. One can not simply erect it arbitrarily." The bridge is also part of the geological structure of the landscape. It is a structure for connecting the footpath and the roadway.
The bridge, in the same way as the waterfall, was also represented in a sequence by Hokusai. This work is titled: "Wonderful Views of Famous Bridges in the Provinces" (Shôkoku meikyo Kiran). The Japanese are the best carpenters in the Far East. Since ancient times they have had a close affinity with wood, and their bridges were "wonderful" constructions to which people came not only to use but also to look at. They were, therefore, often depicted in chrome wood-engravings, due to the great interest in the artistic and constructional achievement of the bridge builder. The bridge could not be erected at any chosen point, even when the course of the river might appear favourable. Nor was it to give the effect of being positioned arbitrarily in the landscape; on the contrary, adjustment to the landscape was a prerequisite. The bridge constructed according to the best craftsmanship as a technical wonder in the middle of a beautiful landscape

became a special theme of the Ukiyo-e masters. Every type of bridge construction, from the girder bridge supported by columns, to the floating suspension bridge, was variously represented in chrome wood-engravings. The contrasting types of bridges are just as extreme in form as the round bridge of Chinese origin and the simple Japanese stone-slab bridge. The painters endeavoured render the technicalities of bridge construction clearly without disturbing the beauty of the landscape. The supporting frame of the large bridges was illustrated in the manner of a construction drawing. The spanning of the transverse beams over the supports, the depicted bracings and abutments became aesthetic elements in the woodcut.
The strut-frame bridges on their numerous stays, furnished with tie-beams, impart to the picture those vertical elements of composition that Hokusai liked to insert into his horizontal landscape. In near vision, the bridges are treated like large still-lifes. The piers, with their stiffening girders, are large ornaments in the picture creating "framed" views of the landscape, which are so unexpected as to let the bridge construction become a second viewing channel.
The bridge can also be composed in dominating series to fill the triptych-like surface of the picture. Utagawa Kuniyoshi (1798–1861) demonstrates this composition and construction in his

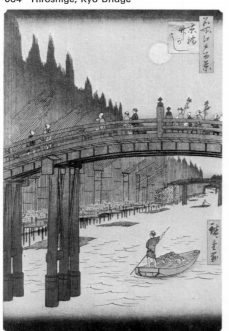

684 Hiroshige, Kyo Bridge

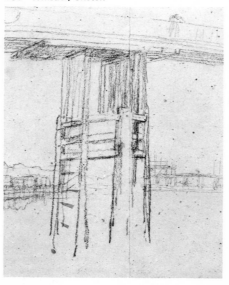

686 Whistler, Sketch

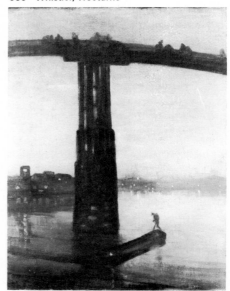

685 Whistler, Nocturne

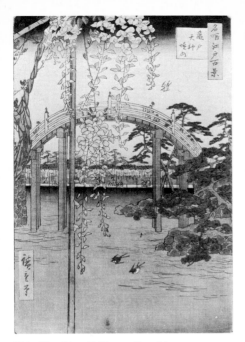

681 Hiroshige, Bridge at Kameido

682 Monet, Japanese Bridge ▶

East and
South-East
Asia

The
Japanese
Motif

561–731

radically conceived detail is perfect, the pier looms blue-black against the blue-green night sky. Western mood stimulus and "Far-Eastern ratio" are united. "The Japanese Painter of Chelsea" continued to study the bridge system of the Japanese and applied them to the bridges of London. He repeatedly drew and etched "The Broad Bridge" and "The Fall Bridge". Both sheets appeared in 1878. Whistler creates a new optical sequence in the bridge picture, which he adapts from Hokusai and Hiroshige. This is the dual *viewing channel*, which is first confined by the edges of the picture format, and secondly by the bridge – past the piers and into the distance. Important in this composition is the total opening of the landscape space, which in Hiroshige is frequently to one edge and in Whistler's main work, "Battersea Bridge," towards both edges of the picture. A part of the natural scenery conceivable out-side the edges of the picture, is illustrated here. What is *not* represented must also be seen, for the radical detail in the sense of Japanese art is always intended to be a *whole*.

Claude Monet (1840–1926) also belongs to the circle of great European bridge painters. He made quite an early discovery of the bridge as a highlight of the landscape in the work of Eugine Boudin, and closely studied Constable and Turner. The Japanese woodcuts with bridge representations provided new impulses, which were to persist for many years in his work. "Le Pont de Chemin de Fer à Argentueil" (Louvre), and "Le Pont de Seine Argenteuil" (Neue Pinakothek, Munich) are samples of the great bridge painting which he cultivated well into old age. When Monet moved to Giverny in 1883, the main motif is his garden, with the lily-pond and Japanese round-bridge. The Chinese painting manual

chrome woodengraving: "The Fight on the Gojo-Bridge". The round bridge cuts the picture space diagonally. The view from under the arch and between the piles out into the landscape, is a deliberately chosen opening. Minamoto Yoshitsune's fight is given the requisite dramatic effect through the massive bridge structure.

II.
The bridge is not a rare theme in European painting. It has been a popular motif throughout the centuries. This theme is heightened by the influence of the Ukiyo-e. Interest focuses on the detail-like character of the bridge and its closely observed construction; and it is the French Impressionists who combine the reflection of the supporting frame on the water with the vibrant, all-pervading light.

McNeill Whistler was directly influenced by Japanese chrome wood-engraving and its bridge representations. He studied Hokusai (1760–1849) and also Hiroshige (1797–1858). Hiroshige's famous woodcut, the "Bridge of Edo", from "100 Views of Famous Places in Edo" (1857), inspired Whistler, eight years later, to paint his "Old Battersea Bridge: Nocturne – Blue and Gold" (1865). The pier stands like a huge scalebeam in en hauteur format on the picture surface. The

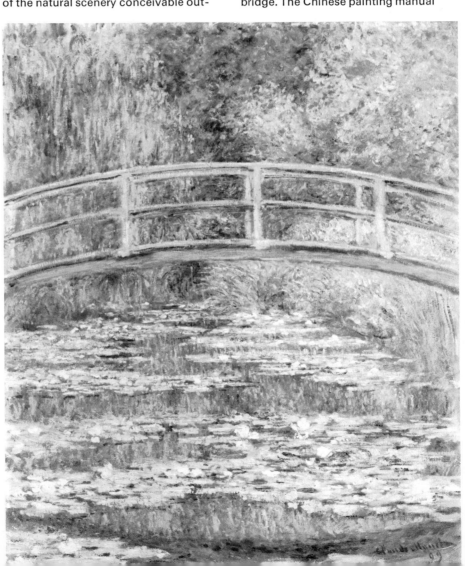

105

East and
South-East
Asia

The
Japanese
Motif

561–731

could virtually invoke this idyllic scene, which Monet so often painted. It recommends that the bridge should be placed where the terrain is broken: "By this means, one can induce people to enter into the beauties of the landscape."

Translation G. F. S.

681 *Ando Hiroshige (Tokyo 1797–1858); The Bridge at Kameido;* from the series "Views of Famous Places in Edo," "Meisho Edo hyakkei"; coloured woodcut, ôban 33.7 × 22 cm; sig.: Hiroshige hitsu; imprint: Shitaya Uoei; Imprimatur stamp: aratame; date stamp: seventh month 1856; Vienna, Österreichisches Mus. für angewandte Kunst, Exner Bequest; plate

682 *Claude Monet (Paris 1840–1926 Giverny); Japanese Bridge;* oil, canvas; 92.7 × 73.7 cm; sig. bottom right: Claude Monet 99; New York, Metropolitan Mus.; plate

683 *Claude Monet; Japanese Bridge;* oil, canvas; 87.5 × 91.8 cm; c. 1922; Greenwich, Mr. and Mrs. Walter Bareiss

684 *Andô Hiroshige; The Kyo-bridge (Kyobashi, Takegashi);* page 112 from the series "Views of Famous Places in Edo," "Meisho Edo Hyakkei"; coloured woodcut, ôban 35.3 × 24 cm; sig.: Hiroshige ga; imprint: Uoya Eikichi Shitaya; c. 1857; cf. Cat. no. 685; Vienna, Österreichisches Mus. für angewandte Kunst; plate

685* *James McNeill Whistler; Nocturne in Blue and Gold; Old Battersea Bridge;* oil, canvas; 68.3 × 51.1 cm; c. 1873/75; London, The Trustees of the Tate Gall.; plate

686 *James McNeill Whistler; Study for the Screen (Battersea Bridge with Moon);* charcoal, crayon and watercolour on paper; 26.7 × 35.5 cm; sig. right: stamp with butterfly; Buffalo, Albright Knox Art Gall.; plate

687 *Andô Hiroshige; Moon in Twilight over the Ryôgoku Bridge (Ryógoku no yoizuki);* from the series "Views of Famous Places in Edo," "Tôto meisho"; coloured woodcut; sig.: Ichiyusai Hiroshige ga; c. 1831; Berlin, Mus. für Ostasiatische Kunst

688 *James McNeill Whistler; High Bridge;* lithograph; 28.4 × 18.3 cm; c. 1878; Chicago, Art Institute

689 *James McNeill Whistler; Old Putney Bridge;* engraving; 20 × 29.8 cm; sig. in plate: stamp with butterfly; Kennedy IV; Berlin, Staatliche Museen Preußischer Kulturbesitz; Kupferstichkabinett

690 *James McNeill Whistler; Bridge;* lithograph; 50 × 28 cm; Berlin, Staatliche Museen Preußischer Kulturbesitz; Kupferstichkabinett

691 *Camille Pissarro (St Thomas, Antilles 1830–1903 Paris); Old Chelsea Bridge;* oil, canvas; 68.7 × 71.2 cm; sig. bottom left: C. Pissarro 1899; New York, priv. coll.

692 *Andô Hiroshige; The Nihon Bridge in snow (Nihonbashi setchu);* from the series "Famous Plades in Edo," "Tôto Meisho"; coloured woodcut, ôban 22.1 × 35.5 cm; sig.: Hiroshige; imprint: Kawa Sho; c. 1840/42; Berlin, Mus. für Ostasiatische Kunst;

693 *Andô Hiroshige; The Fuji from Ryôgoku;* from the series "36 Views of Fuji", "Fuji sanjurokkei"; coloured woodcut, ôban 34 × 22.2 cm; sig.: Hiroshige ga; imprint: Tsutuya Kichizo; date stamp: 1858 fourth month; Vienna, Österreichisches Mus. für angewandte Kunst, Exner Bequest

694 *Katsushika Hokusai (Tokyo 1760–1849); The Yahagi Bridge in the Province Mikawa at the Tôkaidô (Tôkaidô Okayaki Yahagi no Hashi);* from the series "Wonderful Views of Famous Bridges in the Provinces," "Shokoku meikiyo kiran"; coloured woodcut, ôban yoko-e; 24.9 × 37.1 cm; sig.: Zen Hokusai Iitsu hitsu; imprint: Eijudô; Imprimatur stamp: kiwame; 1828; Köln, Mus. für Ostasiatische Kunst

Rocks in the Sea, a Theme of Japanese and European Painters in the Nineteenth and Twentieth Centuries

Siegfried Wichmann

Armand Séguin, the chronicler of the artists of Pont-Aven wrote in the journal L'Occident (Paris, 1903): "The constant collision of the waves gives the rocks the form of strange monsters, which perhaps they once sheltered…" Chinese painting, and more prominently that of Japan, presents this motif in countless variations. For China, rocks in the sea were the symbol of longevity; for Japan, the emblem of steadfastness. Beings, who repeatedly achieved reincarnation by virtue of their good deeds, are represented on rocks above the sea. For the European, for Séguin, such rocks are an anthroposophic phenomenon; but he already regards the wave as an arabesque in the sense of Ogata Kôrin-Nami (creator of the Kôrin wave). Ogata Kôrin (1658–1716), one of Japan's greatest painters, gave the wave an individual rhythmic character, which helped to produce the wave-formed Jugendstil ornament in Europe. The wave also found a typical outward form in China. The rocks are always depicted in the sea; a motif to which a revolving arabesque is imparted by the rhythm of the waves. While the rocks are shaped by the waves, the rocks also change the waves' course of direction: the rocks determine the tide. Buddhist Japan also connects rocks with the deity Kuan-yin, who rests upon them. Not only do the rocks rise from the sea, Boddhi-Dharma himself, the founder of the Buddhist contemplative sect, reposes like a rock above the sea.

The Japanese Ukiyo-e masters have represented rocks in the sea in countless sequences; in the form of sharply pointed columns, massive piled-up crags, rounded domes or jagged formations, they rise toweringly from the sea. The rocks are developed according to specific systems as, for instance, prescribed in the Chinese painting handbook, "The Mustard-Seed Garden," with its instruction to impart them with life. In the artist's representations, the "living" mass of stone becomes a portrait and the individual form of its structure is accurately perceived. The more bizarre and aged the stone, the more worthy of representation it becomes in Far-Eastern art. The "rock portraits," as we should like to call them here, have also impressed European painters, above all in their dynamic relationship to the surface of the sea. Séquin wrote: "The crest of a wave forms a white arabesque upon the blue of the sea." This mutating arabesque is a frequently painted motif in European art; from Rivière via Gauguin to Monet. It represents a central theme in the work of Claude Monet, where it undergoes considerable variation in surface consistency. It is not without reason that the Bridgestone Museum in Tokyo has acquired Monet's "Rocks in the Sea," which is also included in the exhibition.

Summary and Translation G. F. S.

◀ Hokusai, from "Manga"

695 *Félix Bracquemond (Paris 1833–1914 Nevers); Rocks in the surf;* silk firescreen; 110×74 cm; Paris, Mme Henriod-Bracquemond, estate

696 *Suzuki Harunobu (Tokyo 1724(?)–1770); Rocks in the surf;* sheet from a sketch-book; woodcut, monotone print; 20.1×14 cm; Paris, Bibliothèque Nationale, Cabinet des Estampes, Réserve; plate

697 *Claude Monet (Paris 1840–1926 Giverny); Rough sea (Belle-île-en-Mer);* oil, canvas; 61×74 cm; sig. bottom left: Claude Monet; 1886; Tokyo, Bridgestone Mus. of Arts; coloured plate

698 *Andô Hiroshige (Tokyo 1797–1858); The gulf of Naruto in the straits between Shikoku and the island of Awaji (Awa Naruto no Fûkei);* coloured woodcut, three sheets, 3 ôban 37×17.5 cm; sig.: Hiroshige hitsu (seal); imprint: Tstaya; Imprimatur stamp: aratame; date stamp: zodiac snake, fourth month – 1857; Berlin, Mus. für Ostasiatische Kunst

699 *Claude Monet; The rocks of Belle-île-en-Mer;* oil, canvas; 65×81.5 cm; sig. bottom left: Claude Monet, 86; 1886; Paris, Jeu de Paume

700 *Andô Hiroshige; Bo-Ro-Wa (The Sword Rocks);* from the series "Famous Landscapes from more than 60 Provinces," "Rokujû-yoshû meisho zue"; coloured woodcut, ôban tate-e; 36.6×24 cm; sig.: Hiroshige hitsu; wood-carver; Horitake; imprint: Koshikei (Koshimura Heisuke); Imprimatur stamp: Aratame; date on title-page of series: Ansei 3 = autumn of the dragon year = 1856; Regensburg, Franz Winzinger Coll.

701 *Henri Rivière (Paris 1864–1951); Foaming waves, Tréboul (L'Écume après la vague);* page 4 from the series "La mer. Étude de vague"; coloured woodcut; 22.7×34.4 cm.; 1892; Paris, Bibliothèque Nationale, Cabinet des Estampes

702 *Hiroshige II (Shigenobu) (Tokyo 1826–1869); The Futami Bay in Ise;* from the series "Hundred Views of Famous Places in the Provinces", "Shôkuku meisho hyakkei"; published by Shitaya Uoei 1859–1861; coloured woodcut, ôban 33.1×22 cm; sig.: Hiroshige ga; collector's stamp; Vienna, Österreichisches Mus. für angewandte Kunst, Exner Bequest

703 *Henri Rivière; Breaking waves spraying in cascades (La vague vient de taper et retombe en cascade);* page 5 from the series "La mer. Étude de vague"; coloured woodcut; 23.4×34.7 cm.; 1892; Paris, Bibliothèque Nationale, Cabinet des Estampes

704 *Andô Hiroshige; The Takasuiwa Rocks in the Takinoura Bay in the Province of Noto;* from the series "Famous Landscapes from more than 60 Provinces", "Rokujû-yoshû meisho zue"; published by Koshimura-ya Heisuke 1853–1856; coloured woodcut, ôban 34.2×22.8 cm.; sig.: Hiroshige hitsu; wood-carver's stamp: Hôri Take (carved by Take [Yokokawa Takejiro]); date stamp: 1852, ninth month; collector's stamp; Vienna, Österreichisches Mus. für angewandte Kunst, Exner Bequest

705 *Katsushika Hokusai (Tokyo 1769–1849); Rocks in Whirlpool;* double page from the Manga, "Assorted Sketches," Vol. 2; woodcut, duotone print, facsimile; kôban 24×29.5 cm; 1812–1875; Tokyo, Yujiro Shinoda

706 *Henri Rivière; Breton landscape: Ar-Frich Ploumanac'h;* coloured woodcut; 22.4×34.4 cm; 1892; Paris, Bibliothèque Nationale, Cabinet des Estampes

707 *Andô Hiroshige; Night view of eight famous Places at Kanazawa in Musaski north of Yokohama;* page 2 (Moon) from the group "Snow, moon and cherry-blossoms", "Setsugekka"; coloured woodcut; three sheets, 3 ôban 36×75 cm; sig.: Hiroshige hitsu; seal: Ichiryusai; imprint: Tsuta-ya; Imprimatur stamp: Aratame; date stamp: zodiac, snake, fourth month – 1857; Berlin, Mus. für Ostasiatische Kunst

708 *Andô Hiroshige; The Island of Enoshima in Sagami, Entrance to Rock Cave;* from the series "Famous Landscapes from more than 60 Provinces", Rokujû–yoshô meisho zue"; coloured woodcut, ôban 34.3×22.2 cm.; sig.: Hiroshige hitsu; wood-carver's stamp: Hûri Take; imprint: Koshihei (Koshimura-ya Heisuke); date stamp: 1853, eighth month; collector's stamp; Vienna, Österreichisches Mus. für angewandte Kunst, Exner Bequest

709 *Andô Hiroshige; The Kannon Temple on the Rocks of Abumon in the Province of Bingo;* from the series "Famous Landscapes from more than 60 Provinces", "Rokujû–yoshû meisho zue"; published by Koshimura–ya Hei-

East and
South-East
Asia

The
Japanese
Motif

561–731

suke 1853–1856; coloured woodcut,
ôban 33.8 × 22.5 cm.; sig.: Hiroshige
hitsu; imprint and stamp; collector's
stamp; Vienna, Österreichisches Mus. für
angewandte Kunst, Exner Bequest

710 *Alfred Sisley (Paris 1839–1899
Moret-sur-Loing); Langland Bay,
Morning;* oil, canvas; 65 × 81.5 cm; sig.
bottom left: Sisley 97; 1897; Bern, Berner
Kunstmus.

711 *Andô Hiroshige; The Oyashirasu
Coast in Echigo;* from the series "Famous
Landscapes from more than 60 Pro-
vinces", "Rokujû – yoshû meisho zue";
coloured woodcut, ôban 34.4 × 22.8 cm;
sig.: Hiroshige; wood-carver's stamp:
Hôri Kosen (carved by Kosen); imprint:
Koshihei (Koshimura-ya Heisuke); date
stamp: 1853, ninth month; collector's
stamp; Vienna, Österreichisches Mus. für
angewandte Kunst

712 *Emile Gallé (Nancy 1846–1904);
vase;* h - 55.5 cm; sig. on foot of glass
vessel: Gallé; c. 1900; Paris, Jean-Claude
Brugnot

713 *China, Ch'ing Dynasty (1644–
1912) Rocks in the Sea;* porcelain bowl;
h - 7 cm, ∅ 15.5 cm; sig.: mark; K'ang hsi
period (1662–1722); Vienna, Öster-
reichisches Mus. für angewandte Kunst;
plate

714 *Japan; large writing-paper box
(Yatate);* lacquer 42.5 cm; Munich,
Völkerkundemus.; plate

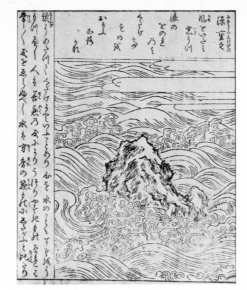

◄ 696 Harunobu, Rock

◄ 713 China, bowl

◄ 714 Japan, writing-paper box

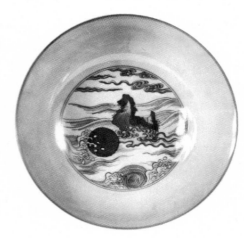

The plant, grass and insect instructions of
"The Mustard-seed Garden" have
remained a constant source of inspiration
for European artists up to the present day.
The most familiar were the four methods
for painting blossoming flowers:

"1. Fill pre-drawn contours with colour.
This style was established by Xu Xi during
the southern Tang period (936–975). At
that time, the flower painters mostly
began immediately with colours, Xu Xi
alone used ink to first outline branches,
leaves, buds and calyx, before filling the
contours with colour. He was a good
observer, and for this reason his pictures
were effective both in form and mood...

2. Stipples of colour without pre-drawn
contours. One does not outline the plant
with ink, but directly with colour. This
method was introduced by Teng Chang-
you in the early Shu period (907–925)...
He taught that one should paint directly
from nature with colour to allow the
floral pictures to appear life-like... This is
called "stipple painting"...
At the beginning of the northern Song
period (960–1127), Xu Chong-si (grand-
son of Xu Xi) painted two colours, one
over the other, without contours. This is
the so-called "boneless floral painting"...

3. Ink-stipple painting: one does not
paint with colour but applies ink in
stipples. This method was established by
Yin Zhong-rong at the beginning of the
Tang period (618–907). The black ink,
which is applied in different nuances
creates the illusion that flowers are
painted in many different colours. Later,
during the southern Tang period (936–
975), Lhong Yin applied ink in various
shades to suggest the depth in his floral
pictures...

4. Representation without ink-stipples
with blank spaces: one draws the outline
in broken lines, as if the brush does not
hold sufficient ink, and paints over
with white body-colour. This method
was established by Chen Chang towards
the end of the Tang period. This technique
was later developed by the monk Bu Bai
and Zhao Meng-jian in the southern
Song period (1126–1279). Zhao Meng-
jian in particular sketched narcissi, win-

The Lily and Iris as
European Picture Motifs
in the Ninetenth and Early
Twentieth Centuries

Siegfried Wichmann

Specialization in the different fields of the
visual arts was more advanced in the Far
East than in Europe. Important for our
context is that individual centers were
formed during different periods, which
recommended or demanded clearly
defined methods for floral painting.
The various schools formed at these
centres, developed instructions, which
were subsequently summarized and
compiled into concise drawing and paint-
ing manuals.

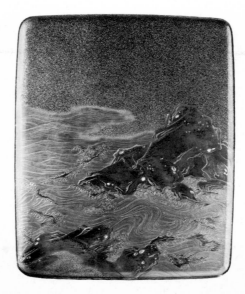

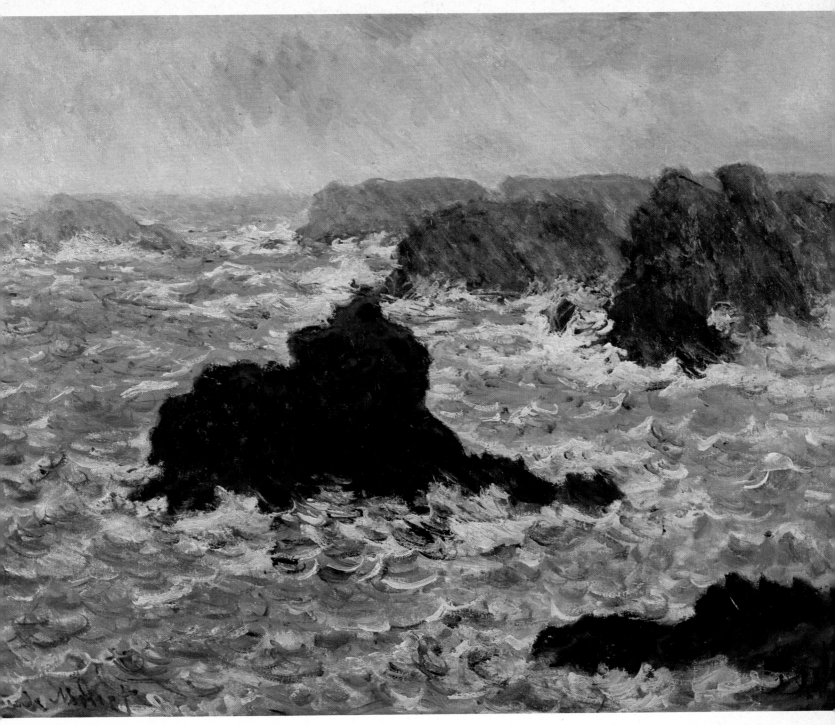

697 Monet, Belle-île-en-Mer

*East and
South-East
Asia*

*The
Japanese
Motif*

561–731

ter-plum blossoms, orchids, irises and bamboo with fine double brush strokes and left the intermediate space blank." (Ibid., p. 24.).

Important was the graphic language of the instructions and the precise knowledge of the group or species. Numerous painters of the Far East concentrated on one type of plant and reproduced that alone. Since the plants and flowers in China and Japan had iconographical significance, the artist often explained his loyalty to a particular plant. The monk Yue Yin of the Yuan period (1280–1267) said: "When light-hearted, I paint the orchid and iris; in anger, the bamboo." (Ibid., p. 19).

Japanese painters also concentrated for years on a single type of flower during the nineteenth century.

Rokuroku Kinzin compiled a series depicting the bindweed and lesser bindweed, which appeared in Osaka in 1816/17. The artist was not only concerned with botanical accuracy but also with the "behaviour" of the plant in its environment (Berlin, Museum für Ostasiatische Kunst, Kinzin Rokukoku, Collections of Bindweed and Lesser Bindweed, Osaka, 1816/17). There are numerous examples of "species painters" in China and Japan.

In the Far East, the iris was always conceived in the same way as the orchid, as a symbol of victory. The iris thus belongs to the group of the "four noble" plants: winter plum-blossom, bamboo, chrysanthemum and orchid (iris).

The iris, a very resistant growth, belongs to the family of iridaceous plants. It has a firmly anchored root-stock. The sturdy, rigid and frequently shortened stems are resistant and furnished with sword or lily-shaped bipartite leaves which are grouped around the stems. Above the leaves are the terminal, single or bunched flowers. The yellowish flowers were popularly regarded as a "victory plant" in Japan, and the "Mustard-Seed Garden" contains vivid descriptions of how the iris or orchid should be painted:

"The leaves are the main feature in a representation of the orchid (iris), and one should, therefore, begin with them. A brush-stroke conforming to one of the following types should first be applied: pin-head, rat's tail or grasshopper's body. The second leaf is given the form of a phoenix's eye. One then adds hanging leaves with the fourth and fifth stroke. Below them, one draws a short supporting leaf with a fish-head. The orchid (iris) leaves should be arranged in such a way that several reach upwards while others curve downwards. By this means

the whole picture gives a life-like impression. The leaves fall in all directions without crowding one another…
One must be able to distinguish the leaves of the spring and summer iris or lily (orchid): one must draw the leaves of the former fine and slender, and those of the latter more forcibly" (The Mustard-Seed Garden

Hokusai also repeatedly devotes his attention to the iris and lily. The iris and lily are rendered in the collections of the Edo period (around 1846), which the owner commissioned to be engraved from the originals of Hokusai (Anthology from the Edo period from originals by Hokusai, Regensburg, Collection Franz Winzinger). The sturdy, vigorous growth is convincingly represented by Hokusai according to a form of tracing system in both picture surfaces, which, however, simultaneously causes an optical partitioning. The right side shows a larger empty space than the left side. The left picture margin of the right side sharply overlaps the flowers and leaves, the left side is covered with the lancet-shaped leaves and the stem with flowers. Nevertheless, both parts of the picture belong together. The middle caesura is a decisive interval, which again strengthens the concentrated composition.

II.

The iris representations were received with great interest by European artists at the close of the nineteenth century and around 1900, and an attempt was made to produce them in accordance with the same technical prerequisites. Animated by the lily and iris representations of Hokusai and Hiroshige, Vincent van Gogh produced numerous pictorial compositions which demonstrated the vertical principal in the growth structure while taking the immediate detail into consideration. The grid-like bracing of the floral pictures does not convey the floral still life of the previous century, but entails the casual detail of a flower-bed or garden as presented in Japanese art. The iris and lily motifs were pursued further during the development of French impressionism until, finally, the graphic techniques of the Japanese began to exert an even stronger influence on the artistic work of Europeans.

Around 1900, these plants became the distinctive sign of the period in the Jugendstil movement. The iris and lily also served as Otto Eckmann's designs when he first began to consciously study Japanese woodcuts in Hamburg. An abundance of drawings, above all the well-known woodcut of the magazine

"Pan", derive from this encounter with Japanese art. In the introduction of 1897 to Otto Eckmann's "Neue Formen, dekorative Entwürfe für die Praxis" ("New Forms, decorative Designs for practical Usage") it is written: "We have rediscovered the way to nature via Japan. No longer does our present flourishing art rely upon past style, nor does it seek its motifs from the Renaissance or Rococo periods… Gratefully, we must remember Japan, whose wonderful art, with its rare combination of the freshness of nature with the finest decorative taste and greatest stylistic assurance, first demonstrated the right path and opened the eyes of those who were able to see."

Summary and Translation G. F. S.

715 *China (Ch'ing period 1644–1912); Peony;* from the collection of calligraphy and paintings from the Hall of Ten Bamboos, Book 1: miscellaneous; coloured woodcut; 25.5 cm × 18.7 cm; c. 1633; Vienna, Österreichisches Mus. für angewandte Kunst, Exner Bequest

716 *China (Ch'ing period 1644–1912); Peony;* from the painting manual "The Mustard-seed Garden," Vol. III, Book 1: "Grasses, Blossoms and Insects"; coloured woodcut; 27.1 × 32.2 cm; c. 1701; Vienna, Österreichisches Mus. für angewandte Kunst, Exner Bequest

717 *Pierre Bonnard (Fontenay-aux-Roses 1867–1947 Le Cannet); Snowballs;* oil, canvas; 40.6 × 32.4 cm; sig. bottom right: Bonnard; Dauberville 30; c. 1891; cf. Cat. no. 718; England, The Hon. P. Samuel

718 *Katsushika Hokusai (Tokyo 1760–1849); Peonies with Swallows;* from the series "Ten Large Flowers"; coloured

675 Degas, Woman combing her Hair ▶

Hokusai, from "Manga"

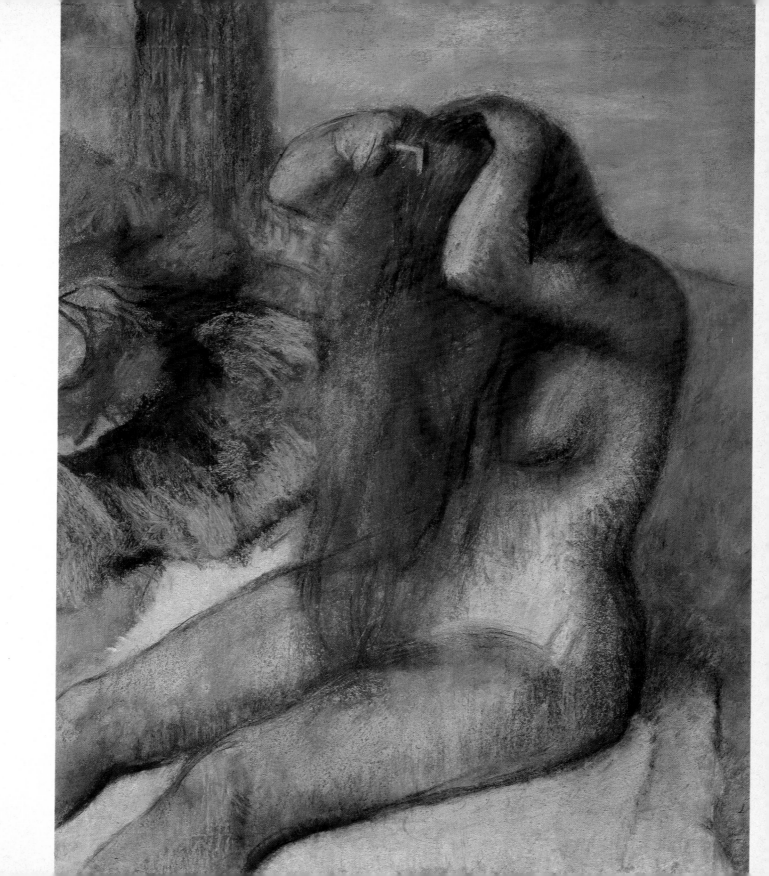

East and
South-East
Asia

The
Japanese
Motif

561–731

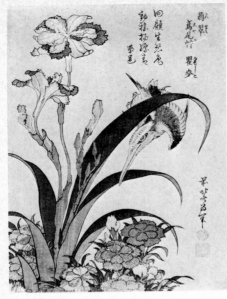

728 Hokusai, Kingfisher with Iris

woodcut, ôban yoko-e 25.9×37 cm; sig.:
Zen Hokusai litsu Hitsu; imprint:
Eijûdô; Imprimatur stamp: Kiwame; c.
1827/30; Köln, Mus. für Ostasiatische
Kunst

719 *Ernst H. Walther (Landsberg
a.d.W. 1858) Iris;* from a series of
designs for vignettes; pen and water-
colour; 28.5×9.2 cm; sig. bottom left:
E.W./H 96; Hamburg, Mus. für Kunst und
Gewerbe

723 Hondard, Iris (Europe)

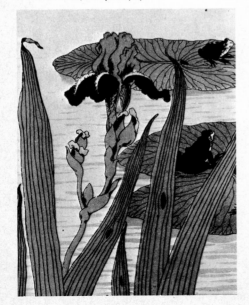

720 *Ernst H. Walther; Cyclamen;*
from a series of designs for vignettes;
pen and water-colour; 28×8.5 cm; sig.
and titled bottom right: E/H/W/
1895/C/Y/C/L/A/M/E/N, M/A/I/27;
Hamburg, Mus. für Kunst und Gewerbe

721 *Andô Hiroshige; Spider-fish
swimming between Egg-plants with
Blossoms and Fruit;* from the series
"Large Fish"; coloured woodcut, yoko-e
25.6×36.2 cm; sig.: Ichiryôsai Hiroshige
ga; imprint: Eijûdû; c. 1832–1834;
Vienna, Österreichisches Mus. für ange-
wandte Kunst, Exner Bequest

722 *Christian Hondard; Iris;* chromo-
lithograph; 25.8×40.0 cm; sig. top right:
stamp, bottom right: No. 40/Chr. Hon-
dard; c. 1895; Munich, priv. coll.

723 *Christian Hondard; Iris;* chromo-
lithograph; 22.7×32.5 cm; sig. bottom
right: Chr. Hondard; Obbach,
Georg Schäfer Coll.; plate

724 *Otto Eckmann (Hamburg 1865–
1902 Badenweiler); Iris;* coloured wood-
cut; 21.5×12.5 cm; sig. bottom left: OE;
c. 1895; Berlin, Staatliche Museen
Preußischer Kulturbesitz, Kupferstich-
kabinett

725 *Andô Hiroshige; Waterlilies in
Horikiri (Horikiri Hanashobu);* page 56
of the series "Views of Famous Places
in Edo", "Meisho Edo Hyakkei";
coloured woodcut, ôban 35×24 cm; sig.:
Hiroshige ga; imprint: Shitaya Uoei;
c. 1857; cf. Cat. no. 7; Köln, Mus. für
Ostasiatische Kunst

726 *Carl Thiemann (Karlsbad 1881–
1966 Dachau); Iris;* coloured woodcut;
30×19 cm; c. 1916; cf. Cat. no. 728;
Dachau, Kunstslg. der Stadt Dachau

727 *China (Ch'ing period 1644–1912);
Iris;* from the painting manual "The
Mustard-seed Garden," Vol. III, Book 1
"Grasses, Blossoms and Insects";
coloured woodcut; 27×32.2 cm; c. 1701;
Vienna, Österreichisches Mus. für ange-
wandte Kunst, Exner Bequest

728 *Katsushika Hokusai; Kingfisher
with Iris and Carnations;* from the series
"Small Flowers"; coloured woodcut,
chûban 25×18 cm; sig.: Zen Hokusai
litsu Hitsu; imprint: Eijûdô; Imprimatur
stamp: Kiwame; c. 1828; Vienna, Öster-
reichisches Mus. für angewandte Kunst;
plate

729 *Carl Thiemann; Iris;* coloured
woodcut; 60×39.5 cm; sig.: bottom left:
CT 61; cf. Cat. no. 728; Dachau,
Kunstslg. der Stadt Dachau

730 *Paul Ranson (Limoges 1864–1909
Paris); The Tiger;* lithograph; 38×26 cm;
sig.: bottom right: P. Ranson; c. 1895;
cf. Cat. no. 731; Paris, priv. coll.

731 *Katsushika Hokusai; The Tiger;*
page from the Manga, Assorted
Sketches, Vol. 9; woodcut, duotone
print; facsimile; kôban, 24×25 cm;
1812–1875; Tokyo, Yujiro Shinoda

Methods of Composition

The Diagonal as extreme Optical Line in the Japanese Wood-engraving and in European Painting and Graphic Art at the Close of the Nineteenth Century.

Using the extreme diagonal, which can
run from the bottom right to the top left
of the picture, or vice versa, the Ukiyo-e
masters often constructed extreme com-
positions to convey the sectional charac-
ter of the picture surface. This aspect of
Japanese painting, especially as em-
ployed by Hokusai and Hiroshige, exerted
a lasting influence on European painters
and graphic artists. Depending upon the
specific requirements, the Ukiyo-e
masters developed compartments and
special forms in order to differentiate the
diagonal motion as widely as possible.
Most frequently, the content of the pic-
ture is in a state of tension with the space,
which receives activated space-surface
relations through the diagonal. Line
composition can penetrate the depth of
the picture as "straight as an arrow," but it
can also escalate through diagonally
arranged objects that appear to become
smaller with increasing distance. By
employing successive planes of space, it
is possible to transcend the rigid con-
struction of diagonal movement and
achieve a continual gliding effect from
section to section. An alternation be-
tween confined and extensive space, be-
tween proximity and remoteness, prod-
uces a variable rhythm in the pictorial
sequence of the diagonals. The Ukiyo-e
masters understood how to integrate
every object, including those which did
not move, within the picture in such a

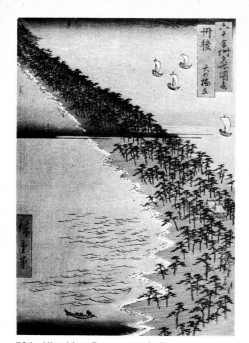

734 Hiroshige, Promontory in Tango

735 Kirchner, November

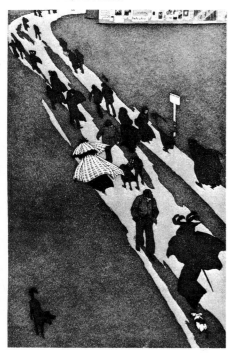

way that the eye is led on in a continuous movement, and no optical divisions are created during the arrow-like penetration of the depth of the picture by sharp sections or rigid borders.
The importance of this diagonal principle for European art is demonstrated by the

work of van Gogh and Vuillard; the Neo-Impressionists, Signac, Seurat, Cross, Rysselberghe; and these Japanese methods of composition have even remained binding for expressionist printed art. S. W.

Summary and Translation G. F. S.

732 *Andô Hiroshige (Tokyo 1797–1858); Sudden Rain in Shôno (Tôkaidô gojôsan tsugi no uchi: Shono-Haku-u);* sheet 46 from the series "The Fifty-three Stations of the Tôkaidô", "Tôkaidô Gojusan Tsugi"; coloured woodcut, ôban yoko-e 22.3×34.7 cm; sig. bottom left: Hiroshige ga; Vienna, Österreichisches Mus. für angewandte Kunst; plate

733 *Henri Rivière (Paris 1864–1951); Funeral under Umbrellas;* etching; 21.5× 17.7 cm; c. 1895; cf. Cat. no. 732; Paris, Bibliothèque Nationale, Cabinet des Estampes; plate

734 *Andô Hiroshige; Ama-no Hashidate in the Province of Tango;* from the series "Famous Landscapes from more than 60 Provinces", "Rokujû-yoshû meisho zue"; coloured woodcut, ôban tata-e 36.6×24 cm; sig.: Hiroshige hitsu; wood. carver's stamp: Horitake; imprint: Koshihei (Koshimura Heisuke); Imprimatur stamp: Aratame; Regensburg, Franz Winzinger Coll.; plate

735 *Eugen Kirchner (Halle 1865); November;* etching; 31×19 cm; c. 1896; Obbach, Georg Schäfer Coll.; plate

736 *Henri de Toulouse-Lautrec (Albi 1864–1901 Malromé) The Theory of an Elephant; Two Elephants in Line approaching Pagoda;* pencil on paper; 23.2×36.1 cm; sig. bottom left: stamp; c. 1896; Albi, Mus. Toulouse-Lautrec

737 *Edouard Vuillard (Cuiseaux 1868–1940 La Baule); The Street;* from the series "Paysages et Interieurs"; chromolithograph; 31×41 cm; 1899; Roger-Marx 34; Munich, Staatliche Graphische Slg.

738 *Andô Hiroshige; Street Scene at Nihonbashi;* from the series "Views of famous Places in Edo," "Meisho Edo hyakkei"; coloured woodcut, ôban 33.2×22.2 cm; sig.: Hiroshige ga; imprint: Shitaya Uoei; date stamp: eighth month; Vienna; Österreichisches Mus. für angewandte Kunst, Exner Bequest

739 *Hiroshige II (Tokyo 1826–1869) Gion Festival (Gion-e);* from the series "Merry Pictures of sightworthy Places in Edo"; "Edo meisho doke zukushi"; coloured woodcut, ôban 37.1×24.8 cm; sig.: Hiroshige ga; wood-carver's stamp: Kane; imprint: Tsujika-ya Bun (suke), Yokohama-cho-sanchome; Imprimatur stamp: Aratame; date stamp: zodiac, sheep, sixth month (1859); Berlin, Mus. für Ostasiatische Kunst

740 *Edouard Vuillard; The Tuileries;* chromolithograph; 28×43 cm; sig.: bottom right: E. Vuillard; c. 1896; Roger-Marx 29; Paris, Bibliothèque Nationale, Cabinet des Estampes

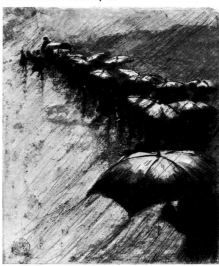

733 Rivière, Funeral

732 Hiroshige, Rain in Shôno (detail)

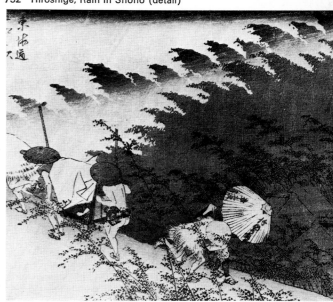

East and
South-East
Asia

Methods of
Composition

732–1037

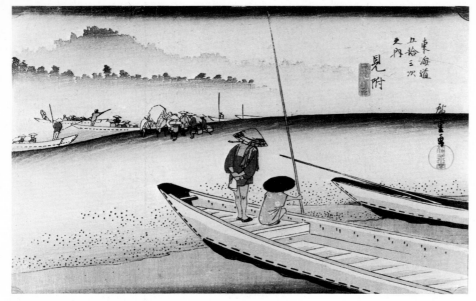

745 Hiroshige, Station Mitsuke

741 *Andô Hiroshige; Nippon Dam in Yoshiwara (Yoshiwara Nikon tsutsumi);* from the series "Famous Views of Edo", "Meisho Edo Hyakkei", coloured woodcut, ôban 37.5×25 cm; sig.: Hiroshige ga; imprint: Shitaya Uoei; c. 1857; Düsseldorf, Willibald Netto Coll.

742 *Edgar Degas (Paris 1834–1917); Dancers at Rehearsal;* oil, canvas; 39×89.5 cm; sig. bottom left: Degas; c. 1887; Lemoisne 900; cf. Cat. no. 743;

New York, Metropolitan Mus.; coloured plate

743 *Katsushika Hokusai (Tokyo 1760–1848); Peasant bending down;* page from the Manga, Assorted Sketches, Vol. 9; woodcut, duotone print, facsimile; kôban 24×25 cm; 1812–1813; Tokyo, Yujiro Shinoda; plate

744 *Henri Rivière (Paris 1864–1951) Fishing-boats leaving Harbour;* sheet 39

744 Rivière, Fishing-boats

from "Breton Landscapes"; coloured woodcut; 23×35 cm; sig. bottom left: Henri Rivière; c. 1893; Paris, Bibliothèque des Estampes; plate

745 *Andô Hiroshige; Station Mitsuke, picture of the Tenryu River (Mitsuke Tenryugawa no zu);* sheet 29 from the series "Tôkaidô Gojûsan," "The Fifty-three Stations of Tôkaidô"; coloured woodcut, ôban 25×36.5 cm; sig.: Hiroshige ga; imprint: Hôeidô; Imprimatur stamp: Kiwame; c. 1837; Cologne, Mus. für Ostasiatische Kunst; plate

746 *Carl Thiemann (Karlsbad 1881–1966 Dachau); Wild Swans over the Dachau Moorland;* coloured woodcut; 26.3×41.5 cm; c. 1837; Dachau 1837; Dachau, Kunstslg. der Stadt Dachau

747 *Katsushika Hokusai; Birds;* from the book "Ippitsu gafu," coloured woodcut; 21.8×16.5 cm; c. 1823; Cologne, Mus. für Ostasiatische Kunst

748 *Alfred Sisley (Paris 1839–1899 Moret); English Coast;* oil, canvas; 53×64.5 cm; sig. bottom right: Sisley 97; 1897; Hanover, Niedersächsische Landesgal.

749 *Andô Hiroshige; The Autumn Moon over Ishiyama (Ishiyama no shugetsu);* from the series "The Eight Views of Omi", "Omi hakkei no uchi"; coloured woodcut, ôban 22.4×34.4 cm; sig.: Hiroshige ga; imprint: Hôeidô; c. 1835; Berlin, Mus. für Ostasiatische Kunst

750 *Carl Thiemann; By the Stream;* coloured woodcut; 28×28.5 cm; sig. bottom right: CT 1907; Dachau, Kunstslg. der Stadt Dachau

751 *Andô Hiroshige; Numazu under Full-moon (Numazu Kikure);* sheet 13 from the series "The Fifty-Three Stations of Tôkaidô," "Tôkaidô Gojûsan Tsugi"; coloured woodcut, ôban yoko-e 23.9×36.8 cm; sig.: Hiroshige ga; imprint: Hôeidô; Imprimatur stamp: Kikami; c. 1833–1834; Regensburg, Franz Winzinger Coll.

752 *Carl Thiemann; Calender sheet "July";* coloured woodcut; 7×16 cm; c. 1906; Dachau, Kunstslg. der Stadt Dachau

753 *Paul Signac (Paris 1863–1935); Rough Sea;* oil, canvas; 66×82 cm; sig. bottom left: 91; 1891; London, priv. coll.

114

754 *Andô Hiroshige; Return of Fishing-boats to Yabase (Yabase no kihan);* from the series "The Eight Views of Ômi," "Ômi hakkei no uchi"; coloured woodcut, ôban 22.5 × 35.7 cm; sig.: Hiroshige ga; imprint: Eisendô; c. 1835; Berlin, Mus. für Ostasiatische Kunst

"Trellis-work" within the Landscape of the Japanese Wood-Engraving and Nineteenth Century Western Art

"The feeling for systematic arrangement in the Japanese coloured woodcut impressed me from the first moment. The

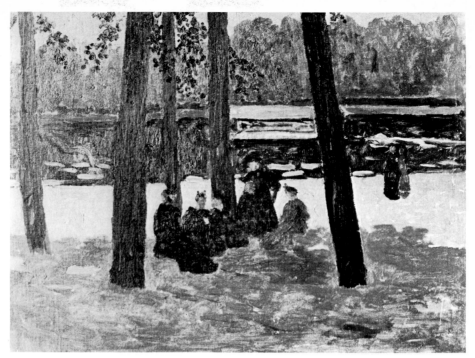

◄ 762 Denis, Beeches of Kerduel

761 Vuillard, Women under Trees ▲

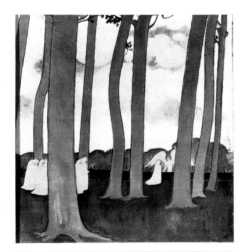

horizontals always stand in an interesting relationship to the verticals. Copious surface-space relations are thought out by the Japanese painter... He may even develop a trellis-work in the form of posts or trees arranged in the foreground, middle-distance or background..." This quotation is taken from a letter written around the year 1912 by Emil Orlik to Julius Kurth; both were important collectors of Ukiyo-e works. Orlik is regarded as the reviver of coloured wood-engraving in Germany. He visited Japan in 1901–1902, and again in 1911 and 1921. We are indebted to him for practical investigations into the techniques of Japanese wood-engraving.

Orlik speaks of a "trellis-work," an important phenomenon to which one section of the exhibition is devoted. This technique of sectioning the picture surface gained special importance among the Ukiyo-e artists, who employed it to separate the front stage from the plan of the landscape behind it, and to promote a spatially combined view with often quite surprising optical sequences. The lineal graduation in the sense of trellis-work was favoured in Japan by the straight, post-like stature of the trees. The vertical bamboo forests or cedar woods, with their upright trunks and

shafts, convey to the artist precisely that vista which he created in his landscapes. This "trellis-system" was already adopted in Europe in the eighteen-sixties and seventies: Rivière deploys his tree formations in the manner of Hokusai and forms a trellis-work to produce a second spatial zone behind them. After the Pont-Aven school had been founded, the principle was tested anew in conjunction with the cloissoné technique by Bernard, Gauguin and Denis. Soon afterwards, this reduction procedure found even wider acceptance among European painters – notably Vuillard – who, animated by Japanese wood-engraving, differentiated the trellis-work principle even further. S. W.

Summary and Translation G. F. S.

755 *Katsushika Hokusai (Tokyo 1760–1849); The Fuji seen from Hodogaya;* from the series "Thirty-six Views of Fuji," "Fugaku sanjurokkei"; coloured woodcut, ôban yoko-e 24.7 × 36.5 cm; sig.: Zen Hokusai Iitsu hitsu; imprint: Eijudô; c. 1825–1832; Vienna, Österreichisches Mus. für angewandte Kunst, Exner Bequest; plate

756 *Henry Rivière (Paris 1864–1951); Twilight;* from the series "Pictures of Nature", "Les Aspects de la Nature";

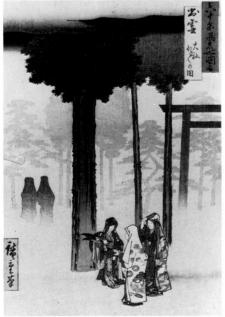

◄ 760 Hiroshige, Shinto Temple

115

*East and
South-East
Asia*

*Methods of
Composition*

732–1037

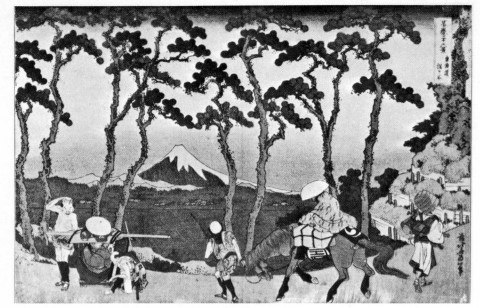

755 Hokusai, Fuji seen from Hodogaya

756 Rivière, Twilight

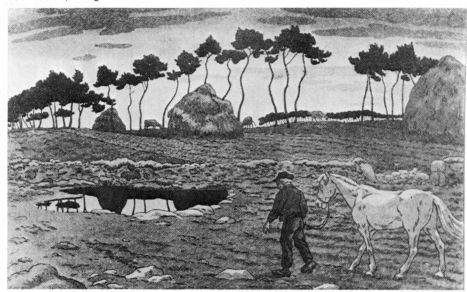

chromolithograph; 44×28 cm; c. 1894; Paris, Bibliothèque Nationale, Cabinet des Estampes; plate

757 *Carl Thiemann (Karlsbad 1881– 1966 Dachau); Pine-trees at Grunewaldsee;* coloured woodcut; 29× 38.5 cm; c. 1908; Dachau, Kunstslg. der Stadt Dachau

758 *Felix Vallotton (Lausanne 1865– 1925 Paris); Group of Trees;* oil, canvas;

170×73 cm; sig. bottom left: F. Vallotton 1922 (stamp); Lausanne, Gal. Vallotton.

759 *Edouard Vuillard (Cuiseaux 1868– 1940 La Baule); Two Schoolboys;* limewater-colour, canvas; 212×96 cm; c. 1894; Brussels, Musées Royaux des Beaux-Arts de Belgique

760 *Andô Hiroshige (Tokyo 1796– 1858); Oyashiro, Shinto Temple in Mist, Izumo Province (Izumo Oyashiro);*

sheet 42 from the series "Famous Landscapes from more than 60 Provinces," "Rokujû-yoshû Meisho zue"; coloured woodcut, ôban tata-e 34.5×23 cm, c. 1853–1856; Vienna, Österreichisches Mus. für angewandte Kunst, Exner Bequest; plate

761 *Edouard Vuillard; Women under Trees;* oil, canvas; 31×40 cm; c. 1894; Paris, priv. coll.; plate

762 *Maurice Denis (Granville 1870– 1943 St. Germain-en-Laye); The Beeches of Kerduel;* oil, canvas; 45× 42 cm; sig. bottom right: MAUD 99; St.-Germain-en-Laye; priv. coll.; plate

763 *Andô Hiroshige; View of the Kanda – Myojin Temple at Dawn (Kanda – Myojin akebono no kai);* from the series "Views of Famous Places in Edo," "Meisho Edo Hyakkei"; coloured woodcut, ôban 37×25.5 cm; sig.: Hiroshige ga; imprint: Shitaya Uoei; c. 1857; Düsseldorf, Willibald Netto Coll.

764 *Maurice Denis; Regatta in a Breton Harbour;* oil, cardboard; 44×54 cm; c. 1897; Paris, priv. coll.

765 *Andô Hiroshige; View of Harbour at Night;* from the series "Fashionable Genji Novel," "Furyu Genji"; coloured woodcut, ôban 33.7×32.8 cm; sig.: Hiroshige hitsu; woodcarver's stamp: Horitake; imprint: Aratame and Kiwame; date stamp: 1853, eleventh month; cf. Cat. no. 764; Vienna, Österreichisches Mus. für angewandte Kunst, Exner Bequest

766 *Edgar Degas; "The Artist in his Studio";* oil, canvas; 41×27 cm; c. 1873; Lisbon, Gulbenkian Coll.

767 *Katsushika Hokusai; Japanese standing by sitting Japanese Woman;* page from the Manga, Assorted Sketches, Vol. 9; woodcut, duotone print, facsimile; kôban 24×25 cm; 1812–1875; Tokyo, Yujiro Shinoda

The Detail and Asymmetrical Composition in Far-Eastern and Western Painting in the Nineteenth and Twentieth Centuries

The asymmetrical detail is given a determining function in Japanese coloured wood-engraving. The optical opening presented to the observer is frequently

East and
South-East
Asia

Methods of
Composition

732–1037

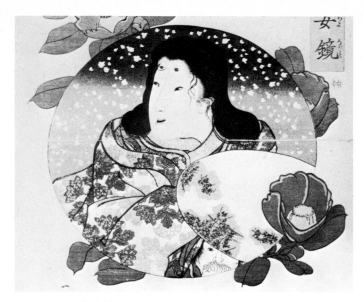

774 Kuniyoshi, Tokiwa-Gozen

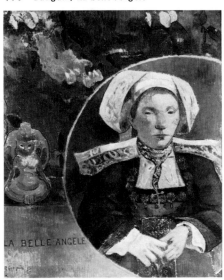

773 Vuillard, The Negligé

only perceived by chance and conceived at extremely close range. The painter experiences the object only in part, but closer and more directly. Certain illusions of a sudden entering into the picture, of sweeping by, are convincingly conveyed in their fleeting motional sequence by a close-up of a torso-like figure. The Chinese painting manuals attempt to transform the accidental nature of the object with abbreviating clarity into a transfixed

and abiding momentary phenomenon, which causes the observer to complete his impression of the object for himself. The Far-Eastern observer is, however, familiar with the essential character of the object in question. The iconographical significance is determined by form and content. The flower, animal, cloud or wave, to name only a few examples, are transfixed graphically and rendered in cipher form, so that completion of the

thing represented is a matter of experience and the collective consciousness of the observer.
The Japanese coloured woodcut takes "life" from the extreme detail. The asymmetrical overlapping in the composition conveys an abridgement of concrete form; the dynamics of the detail correspond to the content. As the Japanese woodcut became known in Europe, this method of design gained "expressive"

771 Kuniyoshi, The Hero

772 Hiroshige, Hill

770 Gauguin, La belle Angèle

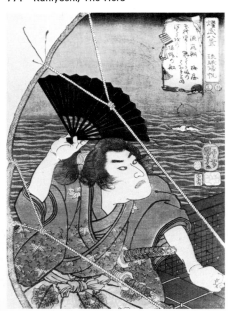

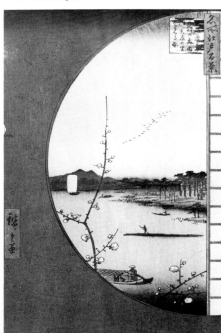

East and
South-East
Asia

Methods of
Composition

732–1037

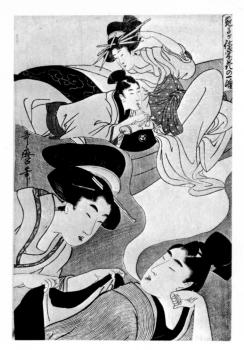

779 Utamaro, A Youth's Dream

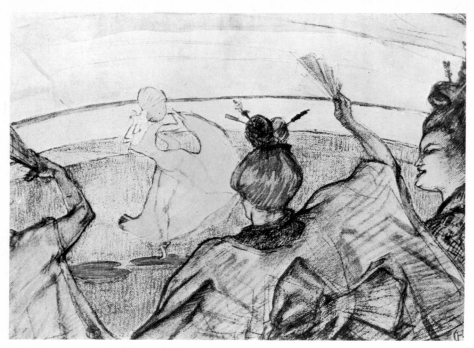

Toulouse-Lautrec, At the Circus: Ballet

overtones, for there was scarcely any artist of the nineteenth and twentieth centuries who had not dealt with it. It would be possible to write a history of art of this period from the aspect of the optical opening and the asymmetrical figure detail. This tendency can be observed among the French Impressionists, who treat it individualistically and in rich variation. With this system, the Japanese coloured woodcut has exerted a direct and formative influence upon European principles of composition. S. W.

Summary and Translation G. F. S.

768 *Paul Gauguin (Paris 1848–1903 Hivaoa); Vision after the Sermon: Jacob's Struggle with the Angel;* oil, canvas; 73×92 cm; sig. bottom left: P. Gauguin 1888; Wildenstein 245; cf. Cat. no. 769; Edinburgh, Nat. Gall. of Scotland

769 *Katsushika Hokusai (Tokyo 1760– 1848); Two Wrestlers;* Detail from the Manga, Assorted Sketches, Vol. 3; woodcut, duotone print, facsimile; kôban 24×25 cm; 1812–1875; Tokyo, Yujiro Shinoda

770 *Paul Gauguin; La belle Angèle (Portrait of Mme Satre);* oil, canvas; 92×72 cm; titled and sig. bottom left: La belle Angèle/P. Gauguin 89; Wildenstein 315; Paris, Jeu de Paume; plate

771 *Utagawa Kuniyoshi (Tokyo 1798– 1861); The Hero Tametomo sails Home from the Ryûkû Islands,* "Ryûkû kihan"; from the series "Eight heroic Pictures," "Yobu hakkei"; coloured woodcut, ôban 36.9×25 cm; sig.: Ichiyusai Kuniyoshi ga; c. 1852; cf. Cat. no. 770*; Cologne, Mus. für Ostasiatische Kunst; plate

772 *Ando Hiroshige (Tokyo 1797– 1858); View of the Hill of Sekija from Masaki;* from the series "Views of Famous Places in Edo", "Meisho Edo, Hyakkei"; coloured woodcut, ôban 33.3×22,2 cm; sig.: Hiroshige ga; imprint: Shitaya Uoei; Imprimatur stamp: Aratame; date stamp: 1857 eighth

804 Denis, Mother and Child

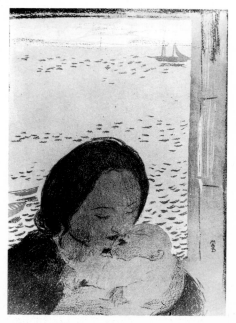

805 Utamaro, Mother and Child

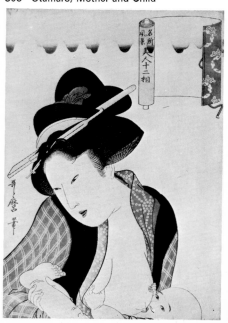

month; Vienna, Österreichisches Mus. für angewandte Kunst, Exner Bequest; plate

773 *Edouard Vuillard (Cuiseaux 1868–1940 La Baule); The Negligé (Deshabille ovale);* oil, cardboard; 25×25 cm (oval); sig. bottom right: studio stamp; c. 1891/92, cf. Cat. no. 774, 775; Paris, priv. coll.; plate

774 *Utagawa Kuniyoshi; The beautiful Tokiwa-Gozen;* from the series "Mirror of Wise and Brave Women," "Kunyu fujo Kagami"; coloured woodcut, ôban 37×24 cm; sig.: Ichiyusai Kuniyoshi; imprint: Buneidô; c. 1843; Düsseldorf, Willibald Netto Coll.; plate

775 *Utagawa Kuniyoshi; The strong Woman O Kane from Omi (Omi no O Kane jo);* from the series "Mirror of Wise and Brave Women", "Kenyu fujo Kagami"; coloured woodcut, ôban 36×25 cm; sig.: Chôôrô Kuniyoshi ga; imprint: Buneidô; c. 1843; Düsseldorf, Willibald Netto Coll.

776 *Paul Gauguin; Leda;* design for a plate; zincograph, ∅ 20.5 cm; title and sig. on inner rim: honi soit qui mal y pense/P. G. O.; title bottom centre: Projet d'asiet en 89; 1889; Guerin I; Berlin, Staatliche Museen, Preussischer Kulturbesitz, Kupferstichkabinett

777 *Edgar Degas; The Washer-women;* charcoal, paper; 30×45 cm; title bottom right: Les blanchisseuses; c. 1876–1878; not in Lemoisne, draft to Lemoisne 410; Brussels; Clive Morris

778 *Emile Bernard (Lille 1868–1941 Paris); Breton Women in Meadow;* oil, canvas; 74×92 cm; title bottom left: E. Bernard 1888; St-Germain-en-Laye, priv. coll.

779 *Kitagawa Utamaro (Tokyo 1753–1806); Dream of a Youth;* from the series "To see a Picture of Happiness in Sleep," "Mirg na toku eiga no issui"; coloured woodcut, ôban 37.8×24.3 cm; sig.: Utamaro hitsu; c. 1800–1806; Berlin, Mus. für Ostasiatische Kunst; plate

780 *Emile Bernard; Washer-women;* from the series "Bretonneries"; zincograph, water-colour; 25.5×32 cm; sig. bottom left: E. Bernard; c. 1889; Mannheim, Städt. Kunsthalle

781 *Emile Bernard; Breton Woman in Meadow;* from the series "Bretonneries"; zincograph, water-colour; 23×29 cm; sig. on plate: E. Bernard 89; 1889; Mannheim, Städt. Kunsthalle

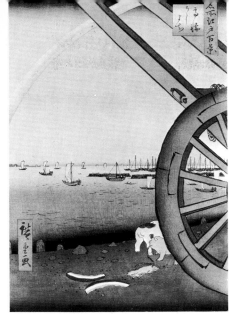

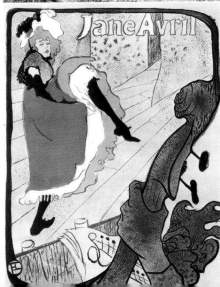

782 *Eishosai Choki; The most beautiful Niwaka Games in the Green Houses (Seiro niwaka zensei asobi);* coloured woodcut, ôban 37.6×25.1 cm; sig.: Choki ga; imprint: Tsura-ya Kiemon; c. 1790/1800; Berlin, Mus. für Ostasiatische Kunst

783 *Paul Gauguin; Breton Women in front of a Fence;* zincograph; 16,2×21.6 cm; sig. bottom left: P. Gauguin; c. 1889; Guérin 4; Paris, Bibliothèque Nationale, Cabinet des Estampes

784 *Paul Gauguin; Human Misery (Misères Humaines);* zincograph; 28.5×23 cm; sig. bottom right: P. Gauguin 89; 1889; Guérin 5; Berlin, Staatliche Museen Preussischer Kulturbesitz, Kupferstichkabinett

785 *Rekisentai Eiri (worked in Tokyo in the seventeen-nineties until the beginning of the 19th cent.); Two Girls;* coloured woodcut, ôban 38.6×25.9 cm; sig.: Rekisentai Eiri ga; imprint: Echigo-ya Chohachi; c. 1780–1800; Berlin, Mus. für Ostasiatische Kunst

786 *Utagawa Toyokuni (Tokyo 1769–1825); Half-length Portrait of two Actors;* coloured woodcut, ôban 37.9×25.5 cm; sig.: Toyokuni ga; late seventeen-nineties; Berlin, Mus. für Ostasiatische Kunst

787 *Paul Gauguin; Washer-women;* zincograph; 21.3×26.3 cm; sig. bottom right: P. Gauguin; c. 1889; Guérin 6; Paris, Bibliothèque Nationale, Cabinet des Estampes

788 *Paul Gauguin; The Drama of the Sea, Brittany;* zincograph, 16.9×22.7 cm; sig. and title bottom left: 89 Paul/Gauguin les drames de la mer Bretagne 1889; Guérin 7; Paris, Bibliothèque Nationale, Cabinet des Estampes

789 *Emile Bernard; At Corman's;* chromolithograph; 20×23.5 cm; c. 1886; Paris, Bibliothèque Nationale, Cabinet des Estampes

790 *Maurice Denis (Granville 1870–1943 St-Germain-en-Laye) Evening;* oil, canvas; 47×55 cm; sig. bottom right: MD; c. 1894; Douai, Musée de Douai

◀ 808 Hiroshige, Waggon-Wheel

◀ 807 Seurat, Harbour of Honfleur

◀ 947 Toulouse-Lautrec, Jane Avril

119

East and
South-East
Asia

Methods of
Composition

732–1037

791 *Utagawa Kuniyoshi; Mother and Child;* from the series "Sankai medetai zuye"; coloured woodcut; Cologne, Mus. für Ostasiatische Kunst

792 *Edouard Vuillard; The Siesta;* from the series "L'Estampe Originale"; 1893; chromolithograph; 28 × 21 cm; Munich, Staatliche Graphische Slg.

793 *Edouard Vuillard; The Dressmaker;* from the "Album de la Revue Blanche"; 1895; chromolithograph; 26 × 16 cm; Roger-Marx 13; Paris, Bibliothèque Nationale, Cabinet des Estampes

794 *Pierre Bonnard (Fontenay-aux-Roses 1867–1947 Le Cannet); Family Scene;* from the series "L'Estampes Originale III, 1893"; chromolithograph; 31 × 17.7 cm; sig.: Bonnard 93 Roger-Marx 4; Munich. Staatliche Graphische Slg.

809 Hiroshige, Beuten Temple

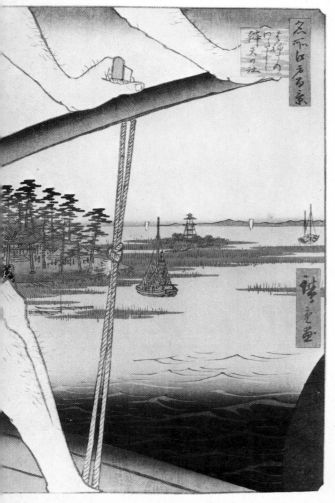

795 *Pupil of Toyokuni; The Actors Iwai Kumesaburo (1776–1847) and Onoe Matsusuke (1745–1815);* coloured woodcut, ôban 36.9 × 24 cm; imprint: Yamashiro-ya Tokei; c. 1804; Berlin, Mus. für Ostasiatische Kunst

796 *Pierre Bonnard; Family Scene II;* from the series "L'Estampe Originale"; 1892; sig. top right: 1892/Bonnard; chromolithograph; 21 × 26 cm; Roger-Marx 2; Paris, Bibliothèque Nationale, Cabinet des Estampes

797 *Ker Xavier Roussel (Chène 1867–1944 L'Etang-la-Ville); The Training of a Dog;* chromolithograph; 32.5 × 19 cm; sig.: stamp K. X. Roussel; c. 1893; Bremen, Kunsthalle

800 *Kitagawa Utamaro; The Courtesan Akashi from the Tama-ya-House;* from the series "The classical Poetess Ono no Komachi represented seven Times by Beauties of the Amusement Quarter", "Seiro nana Komachi"; coloured woodcut, ôban 37 × 22.3 cm; sig.: Shomei Utamaro hitsu; imprint: not legible; c. 1794; Vienna, Österreichisches Mus. für angewandte Kunst, Exner Bequest

801 *Kitagawa Utamaro; The Courtesan Takigawa from the Ogi-Ya-House;* from the series "The classical Poetess Ono no Komachi represented seven Times by Beauties of the Amusement Centre," "Seiro Naua Komachi"; coloured woodcut, ôban 37.5 × 24.5 cm; sig.: Shomei Utamaro hitsu; imprint: Izumiya; c. 1794; Vienna, Österreichisches Mus. für angewandte Kunst, Exner Bequest

802 *Emile Bernard; The Fountains;* zincograph, water-colour; 19.6 × 32.3 cm; c. 1892; Basel, Öffentliche Kunstslg.

803 *Kitagawa Utamaro; The Courtesans Tsukazu and Tsushima from the Ogi-ya;* coloured woodcut, ôban 37.3 × 24.9 cm; sig. Tsutaya Jusaburo; c. 1801; Regensburg, Franz Winzinger Coll.

804 *Maurice Denis; Mother and Child at the Seaside (Maternité devant la mer);* chromolithograph; 34.7 × 25.1 cm; c. 1900; Cailler 120; Obbach, Georg Schäfer Coll.; plate

805 *Kitagawa Utamaro; Woman feeding her Child;* from the series "Twelve Pictures of beautiful Girls compared with famous Series," "Meisho fukei bijn juniso"; coloured woodcut, ôban 38.7 × 25,9 cm; sig.: Utamaro hitsu; c. 1804; cf. Cat. no. 804; Berlin, Mus. für Ostasiatische Kunst; plate

806 *Maurice Denis; Girl's Head (Les Attitudes sont faciles et chastes);* page two from the series "Amour"; chromolithograph; 38.5 × 27.5 cm; c. 806; Paris, Bibliothèque Nationale, Cabinet des Estampes

807 *Georges Seurat (Paris 1859–1891); The Harbour of Honfleur;* oil, canvas; 79.5 × 63 cm; sig. bottom right: Seurat; c. 1886; cf. Cat. no. 808, 809; Otterlo, Rijksmus. Kröller-Müller; plate

808 *Andô Hiroshige; Waggon-wheel on Beach (Takanawa Ushimachi);* page 110 from the series "Views of Famous Places in Edo," "Meisho Edo Hyakkei"; coloured woodcut, ôban 35.3 × 24 cm; sig.: Hiroshige ga; imprint: Uoya Eikichi Shitaya; c. 1857; Cologne, Mus. für Ostasiatische Kunst; plate

809 *Andô Hiroshige; Beuten Temple (Haneda-no-Watashi);* page 105 from the series "Views of Famous Places in Edo", "Meisho Edo Hyakkei"; coloured woodcut, ôban 35.3 × 24 cm; sig.: Hiroshige ga; imprint: Uoya Eikichi Shitaya; c. 1858; Cologne, Mus. für Ostasiatische Kunst; plate

810 *Edouard Manet (Paris 1832–1883); Child in Flowers, The Son Hochedé in Montgeron;* oil, canvas; 60 × 97 cm; sig. bottom right: Manet; c. 1875; Jamot-Wildenstein 253; Paris, Durand-Ruel et Cie

Observations on the Fan Segment as "Testing Ground" of Composition for European Painters in the second half of the Nineteenth Century.

Far-Eastern art has not only supplied European painters with motifs, it has also decisively influenced the format and the graphic aspects of their works. The extreme types of format correspond to the extreme compositions, which were above all promoted by the coloured woodcut and standing screen, and form a unity with them. One specific format within this series is the semicircular fan segment, which became a testing ground of composition for European artists in the last quarter of the nineteenth century. As we know it today, the folding fan consists of a series of long, slender segments connected by a band, or of thin sticks on to which a broad sheet of material is glued.

This semicircular sheet was provided with the most varied form of decoration by artists of the Far East.

Fan composition also featured regularly among European artists, who applied the most varied methods to it. Mostly they attempted to conceive the fan segment as an extreme optical opening into the space of the picture. The sharply defined range of vision of impressionism, which favoured the detail. attempted to represent its momentary character, particularly as movement. In contrast to early nineteenth century fan painting of the Barbizon school, and especially Munich painting, which favoured depictions conveying a certain atmosphere, the French Impressionists chose the extreme intersection of land-

scape and figure. Pissarro deliberately cuts into groups of figures in the foreground, and the section which then reveals itself reproduces the proximity of the landscape situation in miniature form. However, the fan paintings of Pissarro, the old master of impressionism, also reveal that same asymmetry employed later by Toulouse-Lautrec in his compositions. After the turn of the century, fan painting was developed to an astonishing degree in European art by Oskar Kokoschka. We refer to the three folding fans painted for Alma Mahler. Kokoschka follows the old fan-painting principle but also transcends it by extending parts of the picture area, or the figure, over the segments. Nevertheless, he adapts the high-angled figure to the segments, so that a vertical effect is given on the opened fan and the expressionistic effect in the grouping of the slender figures becomes even more pronounced, more expressive, when the fan is closed. The colourfulness, set off by the red and black lacquer of the sticks, sets an example for fan painting in the early twentieth century. S. W.

Summary and Translation G. F. S.

J11 Japan,
Fan with Geisha

J13 Japan,
Fan with Cherry
Blossom

J10 *Utagawa Kuniyoshi (Tokyo 1797–1861); Kyumon Ryu;* fan; the robber Kymon Ry from the Chinese novel Suikoden; Tokyo, National Mus.

J11 *Utagawa Toyokuni (Tokyo 1769–1825); A Geisha;* fan; ink and colour on paper; Tokyo, National Mus.; plate

J12 *Tsurusawa Tansaku (+ 1797); the Landscape of Amanohashidate;* fan; Tokyo, National Mus.

J13 *Tosa Mitsuyoshi; Cherry Blossom and Moon;* fan; painted on gold; Tokyo, National Mus.; plate

J14 *Nagsawa Rosetsu (1755–1799); Sparrow on rock;* fan; Tokyo, National Mus.

J15 *Tani Buncho (1764–1840); Dolls and Venus Molluscs;* fan; Tokyo, National Mus.

J16 *Tachihara Kyoshi (1785–1840); Chrysanthemums;* fan; Tokyo, National Mus.

811 *Edgar Degas (Paris 1834–1917); Dancers resting in the Wings;* fan picture; gouache on silk, cardboard, lightly ornamented with gold; 31 × 61 cm; sig. top left: Degas; c. 1879; Lemoisne 556; Bern, Kornfeld und Klipstein; plate

812 *Giuseppe de Nittis (Barletta 1846–1884 St.-Germain-en-Laye) Vine Leaves;* fan picture; tempera on silk; 26 × 52 cm; sig. bottom right: De Nittis; post 1880; kindly pointed out by Christine Farese-Sperken; Barletta, Gall. de Nittis

813 *Giuseppe de Nittis; Notturno;* fan picture; tempera on silk; 26 × 53 cm; kindly pointed out by Christine Farese-Sperken; Barletta, Gall. de Nittis

814 *Giuseppe de Nittis; Chrysanthems and Bamboo;* fan picture; tempera on silk; 25 × 49 cm; sig. right of centre: à la Princesse Mathilde/De Nittis; post 1880; kindly pointed out by Christine Farese-Sperken; Barletta, Gall. de Nittis

815 *Giuseppe de Nittis; Nature; fan picture;* tempera on silk; 28 × 55 cm.; sig.

East and
South-East
Asia

Methods of
Composition

732–1037

bottom right: G. De Nittis; after 1880;
kindly pointed out by Christine Farese-
Sperken; Barletta, Gall. de Nittis

816 *Chikki Nakabayashi (1816–1867);
Pine-tree Branches and Cherryblossoms;*
fan segment; ink on paper edged with
gold-leaf; 20.5 × 45 cm; sig.: Nakabaya-
shi; Regensburg, Franz Winzinger Coll.

817 *Camille Pissarro (Saint Thomas,
Antilles 1830–1903 Paris);* fan picture;
Hamburg, priv. coll.

818 *Berthe Morisot (Bourges 1841–
1895 Paris); Tree in Bougival;* fan pic-
ture, gouache on silk; ∅ 54 cm; c. 1884;
Bataille-Wildenstein 701; Neuilly-sur-
Seine, priv. coll.

819 *Joshun; Sparrow;* fan picture; ink
and water-colour on paper; 22.5 × 48 cm;
sig.: Joshun hitsu; Regensburg, Franz
Winzinger Coll.

820 *Unknown master; Shepherd-boy
playing Flute on Water-buffalo;* fan
segment, ink with gold dust on paper;
21 × 42.6 cm; Regensburg, Franz Winzin-
ger Coll.

821 *Henri de Toulouse-Lautrec (Albi
1846–1901 Malromé); In the Circus
Fernando;* fan picture; brush and ink on
paper; 21 × 66 cm; sig. bottom left: HTL;
c. 1888; Dorty 3055; cf. Cat. no. 822;
Bern, Kornfeld & Klipstein; plate

822 *Seiko; Monkey with its Master;* fan
segment; water-colour and ink on paper;
16.3 × 46 cm; sig. left: Seiko; cf. Cat. no.
821; Berlin, Mus. für Ostasiatische Kunst;
plate

823 *Camille Pissarro; Harvest;* fan pic-
ture; gouache on silk; 25 × 56 cm; sig.
bottom left: C. Pissarro; c. 1894; Bern,
Kornfeld & Klipstein

824 *Unknown master of the Tosa
school; Three Gentlemen in Costume of
Heian Period under Pine-trees;* fan
segment; gouache and gold-leaf on paper;
23.5 × 47.5 cm; 17/18th cent.; Regens-
burg, Franz Winzinger Coll.

825 *Jean-Louis Forain (Reims 1852–
1931 Paris); The Dancer;* fan picture;
water-colour on paper, mounted on
cardboard; 38 × 77 cm; sig. bottom right:
forain; c. 1900; Bern, Kornfeld & Klip-
stein

826 *Oskar Kokoschka (Pöchlarn, Donau
1886 – living in Salzburg); Second Fan*

822 Seiko, Monkey with Master

821 Toulouse-Lautrec, In the Circus Fernando

811 Degas, Dancers

829 Bonnard, Street Scene ▶

for Alma Mahler; fan picture; ink and body-colour on swan's skin, mounted on ivory or horn sticks; ∅ 21.5 cm; Vienna 1913; Hamburg, Mus. für Kunst und Gewerbe

827 *Oskar Kokoschka; Fourth Fan for Alma Mahler;* fan picture, ink and body-colour on swan's skin, mounted on ivory or horn sticks; ∅ 21.5 cm; on permanent loan from "Stiftung zur Förderung der Hamburgischen Kunstslg."; Vienna 1913; Hamburg, Mus. für Kunst und Gewerbe

828 *Oskar Kokoschka; Fifth Fan for Alma Mahler;* fan picture; ink and body colour on swan's skin, mounted on ivory or horn sticks, ∅ 21.5 cm; on permanent loan from "Stiftung zur Förderung der Hamburgischen Kunstslg."; Vienna 1914; Hamburg, Mus. für Kunst und Gewerbe

Folding Screens (Nyôbu) and their European Successors in the Nineteenth and Twentieth Centuries

In the second half of the nineteenth century, the folding screen and draught screen had become indispensable requisites in the living rooms and boudoirs of Europe, and above all in the artists' studios. There was scarcely an artist who did not possess a folding screen for subdividing his spacious studio. But the screen possessed additional significance in the life and work of the artist in the nineteenth, and to some degree, in the twentieth century. It presented him with the possibility of new artistic composition in close connection with its function as a piece of furniture. The opportunity of attempting a representation of space and time on a surface which is movable, whereby the individual surface components could be adjusted towards or away from one another by virtue of their hinges, added a new aspect to European painting. We know that Monet acquired folding screens, and that the folding and draught screens were a popular motif in impressionism and post-impressionism. Whistler repeatedly used the screen as centre-ground to break up the space of the picture. The Nabis, Pierre Bonnard, Edouard Vuillard, Maurice Denis, Odilon Redon, all painted screens and designed them from Far-Eastern prototypes. The methods of painting and, above all, of composition, are subject to various conditions. The range of the form of composition is wide, and provides the European artist in particular with a latitude that causes them to combine Far-Eastern influence with European tradition. It is possible to maintain that screen painting at the end of the nine-

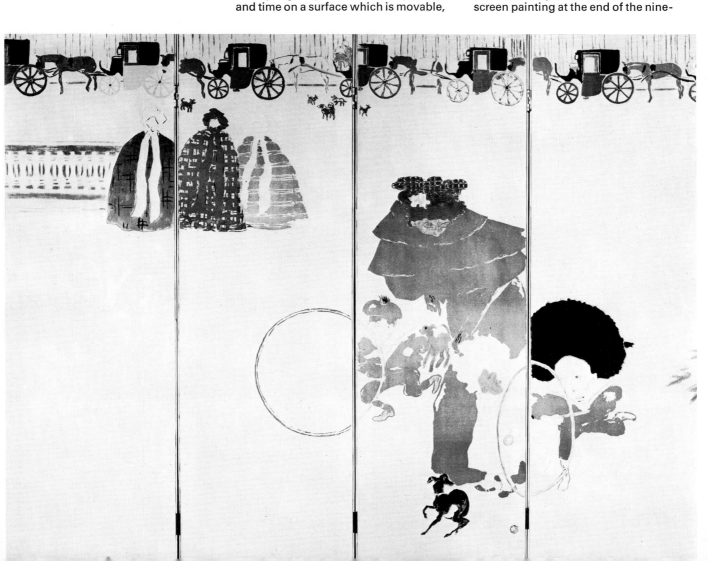

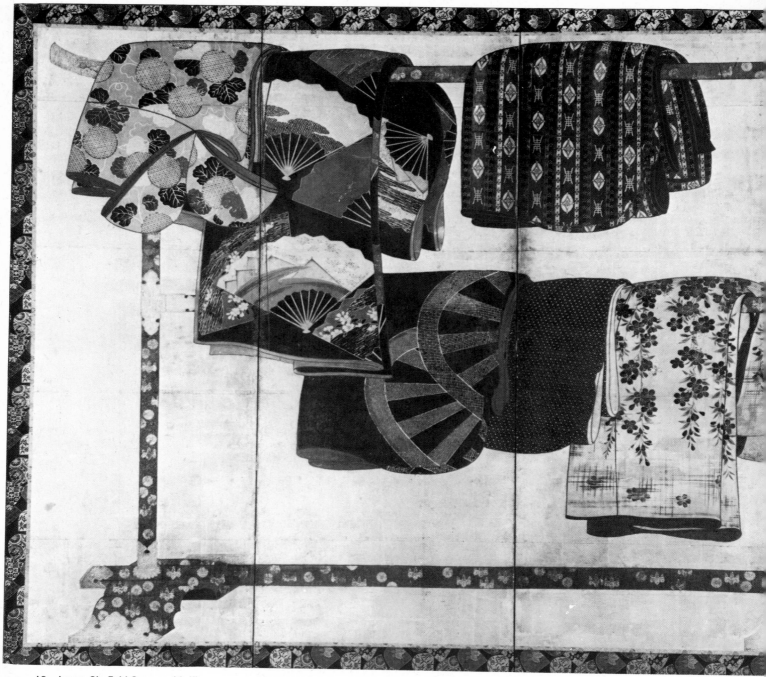

J3　Japan, Six-Fold Screen with Kimonos

teenth century entailed for the European
painter a most important encounter, and
that it was above all the system and
character of the Japanese folding screen
which continued to influence artists into
the twentieth century. An example of this
later influence is Chagall, who chose the

folding screen as a picture format. He
covers the surface with his floating figures
with a nonchalant disregard for real space
and the traditional perspective procedures
of the Renaissance. Chagall has a direct
contact with the phenomena of his
natural surroundings, which greatly
transcends their concrete attributes. S. W.

Summary and Translation G. F. S

J1　*Isshi Bunshu (Kyoto 1608–1645);
Sixteen Rakan;* ink on paper; 373×
173 cm; grotesque representation of the
first sixteen disciples of Buddha; Tokyo,
Idemitsu Mus.

J2　*Sengai Gibon (Mino 1750–1837);
Gasan (poem inscription and ink paint-
ing);* two-fold screen; ink on paper;
162×149.5 cm; Tokyo, Eisei-Bunko

124

J 3 *Tagasode Byobu; Clothes-stand with Kimonos;* pair of six-fold screens; ink on paper; 162×149.5 cm; 17th cent.; Tokyo, Idemitsu Mus.; plate

J 4 *Japan; Life of the Populace at Edo (Edo Fuzokuzu);* two-fold screen; 378× 130 cm; 17th/18th cent.; Tokyo, Idemitsu Mus.

J 5 *Unknown Master of the Miyagawa School; Varieties of Conversation (Yukyozu);* two-fold screen; ink and watercolour on paper; 143×143 cm; 18th cent.; Tokyo, Idemitsu Mus.

829 *Pierre Bonnard; Street-Scene;* four part screen; published by Molines, 1899, 110 copies, 40 mounted, chromolithograph; 147×186 cm; c. 1899, after a draft of 1892; Roger – Marx 47; Hamburg, Mus. für Kunst und Gewerbe, on permanent loan from the "Stiftung zur Förderung der Hamburgischen Kunstslg."; plate

830 *Ker Xavier Roussel (Lorry-lès-Metz 1867–1899 Etang-la-Ville); design for a screen;* ink, paper 29×43 cm; c. 1895; Paris, priv. coll.

125

*East and
South-East
Asia*

*Methods of
Composition*

732–1037

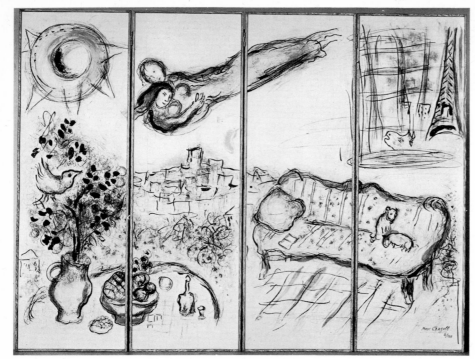

835 Chagal, Screen

831 *Katsukawa Shunshô (Tokyo 1747–
1800); The Actors Nakamura Riko
(1742–1786), Onoe Matsuke I (1745–
1815), Nakamura Nakazo I (1736–
1790), Ichikawa Danjuro V (1741–
1806), Sawamura Sojuro III (1753–
1801);* coloured woodcut, five sheets,
hoso-e 32–32.5 × 14.8 –15 cm; each sig.:
Shunshô ga; c. 1782; Berlin, Mus. für
Ostasiatische Kunst

832 *Pupil of Toyokuni;* The Actors
Ichikawa Ebijurô and Ichikawa Danjurô;
coloured woodcut, ôban 38 × 25 cm;
sig.: Toyokuni ga; eighteen-thirties;
Berlin, Mus. für Ostasiatische Kunst

833 *Ker Xavier Roussel; design for a
screen;* ink paper; 13.5 × 21 cm; c. 1900;
Paris, priv. coll.

834 *Maurice Denis (Granville 1870–
1943) Saint-Germain-en-Laye; Screen
with Doves;* oil, canvas,; each section
164 × 54 cm; c. 1904; Saint-Germain-en-
Laye, priv. coll.

835 *Marc Chagall (Witebsk 1887, living
in Vence); Screen;* chromolithographs
mounted in wooden frames; 147 × 191
cm; sig. bottom right: Marc Chagall/4/
100; 100 copies mounted as screens;
c. 1964; Hamburg, Mus. für Kunst und
Gewerbe; plate

The "en hauteur" Format in the Nineteenth and Early Twentieth Centuries under the Influence of Japanese Prototypes

The extreme format also determined the
overall impression conveyed by the pic-
ture in Far-Eastern painting. The Kaki-
mono is a roll-formed picture, which
makes the figure and landscape depend-
ent upon this format. The figure is
represented in erect posture and the
landscape composed of towering layers
of geological masses. This principle of
en hauteur composition gained increasing
influence in European decorative art at
the end of the nineteenth century. The
Art Nouveau and Jugendstil period was
almost exclusively determined by the
en hauteur format, and special tenden-
cies in art, such as the poster, are still
partly influenced by it. Of course, this
vertical format was not entirely unknown
to European art of past centuries: it was
employed in altar decoration and per-
formed a special function as wall decora-
tion in European mannerism and baroque
art as well as in eighteenth century wall-
panelling. But, under the influence of
Far-Eastern prototypes, it was treated
from a new aspect. The dimensions of the
en hauteur format are laid down quite
strictly in the Japanese woodcut: the

Kakimono measures 57 × 30 cm., the
Hoso-e (Hoso-ban) 32 × 15 cm., the
large Tanzaku 36 × 18 cm, and the very
slender Tanzaku 36 × 11.5 cm. The upright
format is generally referred to as Tata-e
and featured as a "testing ground" of
small dimensioned space for depicting
figures, objects and landscape in con-
centrated form.
The interest of European artists, who
were already familiar with these types of
composition, focused primarily upon the
picture format and the technical means
of mastering it. They ultimately produced
a virtually new form of picture composed
upon different principles. Instead of the
direction of movement being recorded
from right to left, rhythmically accumu-
lating elements of momentum rising from
the bottom to the top of the picture be-
came the rule; and the feeling for land-
scape — so prominent in the Far-Eastern
artist — is conveyed in towering layers of
rock mass.
The extreme en hauteur format reached its
culminating point in the circle of artists
gathered around the Nabis, Bonnard,
Vuillard, and Denis, all of whom employ-
ed it to portray the human figure and
landscape themes. Gustav Klimt had also
closely studied the Japanese system of
composition and frequently applied it in
his work. S. W.

Summary and Translation G. F. S.

J 17 *Suio Eiboku (1716–1789);Daruma
with a Shoe in his Hand;* kakemono (hang-
ing painting); ink on paper; 44 × 200 cm;
according to legend, Sung Yün met the
dead Daruma who was carrying a shoe in
his hand, a symbol of the invalidity of time
concepts in Zen Buddhism; Tokyo, Eisei-
Bunko

J 18 *Suio Eiboku; Jiz as Saviour of all
Beings (Rokudjiz);* kakemono; ink on
paper; 66.3 × 115 cm; Tokyo, Eisei-
Bunko

J 19 *Sengai Gibon (Mino 1750–1837);
Fuji;* kakemono; ink on paper; 59 ×
128 cm; Tokyo, Idemitsu Mus.

J 20 *Sengai; Daruma as a Woman;
persiflage on the founder of Zen;* kake-
mono; ink on paper; 30 × 168 cm; Tokyo,
Idemitsu Mus.

J 21 *Takuan Shoho (1573–1645); Poet
on horseback (Bahaishishi Gasan);*
kakemono; ink on paper; 34 × 142.5 cm;
inscribed with poem and seal; Tokyo,
Eisei-Bunko

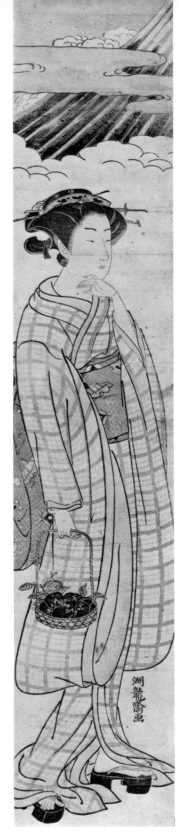

J 22 *Ishi; Red Daruma in circle (Shu Daruma);* kakemono; ink and watercolours on paper; 44.7×111 cm; sig.: seal; Tokyo, Eisei-Bunko

J 23 *Hakuin; Self-portrait;* kakemono; ink on paper; 48.5×195 cm; inscribed 1746; Tokyo, Eisei-Bunko; plate p. 148

836 *Claude Monet (Paris 1840–1926 Giverny); Japanese Lilies;* oil, canvas; 119.5×37 cm; sig. bottom right: Claude Monet; c. 1883/84; Paris, Gal. Durand-Ruel et Cie.; coloured plate

837 *Maurice Denis (Grandville 1870–1943 Saint-Germain-en-Laye); Portrait of Madame Ranson with Cat;* oil, canvas; 89×45 cm; sig.: MAUD; c. 1882; cf. Cat. no. 840–843; Saint-Germain-en-Laye, priv. coll.

838 *Maurice Denis; Portrait of Madame Ranson in Green;* oil, canvas 124×42 cm; sig. bottom right: Mau. denis 93; c. 1891; cf. Cat. no. 840–843; Paris, priv. coll.

839 *Nishimura Shigenaga (Tokyo c. 1697–1756); The Actor Sanogawa Ichimatsu I;* woodcut, hand-coloured; Kakemono-e 69.4×16.5 cm; sig.: Senkwado Nishimura Shigenaga hitsu; imprint: Urokogata-ya; c. 1743; Regensburg, Franz Winzinger Coll.

840 *Ishikawa Toyonobu (Tokyo 1711–1785); Girl with Straw-hat;* woodcut, hand-coloured; Kakemono-e 66×16.5 cm; sig.: Tanjodo Ishikawa Shuha Toyonobu; imprint: Urokogata-ya Hammoto; c. 1742; Regensburg, Franz Winzinger Coll.

841 *Isoda Koryusai (Tokyo, worked between 1765–1784); Girl with a Basket of Kaki Fruit in Front of Fuji;* coloured woodcut, hashira-e 67.5×11.5 cm; sig.: Koryusai ga; second half of 18th cent.; Cologne, Mus. für Ostasiatische Kunst; plate

842 *Kikugawa Eizan (Tokyo 1781–1867); Courtesan as Pilgrim with Flute and Twilled Hat;* coloured woodcut, raised printing; hashira-e 73×24,8 cm; sig.: Kikugawa Eizan hitsu; first half of 19th cent.; Cologne, Mus. für Ostasiatische Kunst

843 *Torii Kiyomitsu (Tokyo 1735–1785); The Actor Segawa Kikunojo II as Shizaka Gogu, Favourite of Yoshizume;*

Benizuri-e, hashira-e in old Kakemono-e frame 69.8×10 cm; sig.: Torii Kiyomitsu ga; imprint: Yama (Mammaoto kohei, Maru-ya); c. 1760; Regensburg, Franz Winzinger Coll.

844 *Gustav Klimt (Vienna 1862–1918); Judith II (Salome);* oil, canvas; 17.8× 46 cm; sig. bottom left: Gustav Klimt 1909 Dobai 160; Venice, Galleria d'Arte Moderna, Ca' Pesaro; coloured plate

845 *Kitagawa Utamaro (Tokyo 1753–1806); The Girl Yaoya Oshichi with the Lover Kichisaburo who attempts to remove the Sash held by the Girl;* coloured woodcut, hashira-e 62.6×13.8 cm; sig.: Utamaro hitsu; c. 1798; Regensburg, Franz Winzinger Coll.

846 *Maurice Denis; The Chosen Virgin (La Damoiselle Elue);* frontispiece to the work by Dante Gabriel Rosetti, set to music by Claude Debussy; chromolithograph; 29.5×11.3 cm; c. 1892 Cailler 30; Saint-Germain-en-Laye, priv. coll.

847 *Isoda Koryusai; Girl with Lantern on Stick;* coloured woodcut, naga-e 68.5× 12.4 cm; sig.: Koryusai zu; c. 1860–1870; Vienna, Österreichisches Mus. für angewandte Kunst, Exner Bequest

848 *Unknown Ukiyo-e-Master: Girl behind half-closed Sliding-door,* hanging scroll, ink and colour on paper; 130× 38 cm; first half of 19th cent.; Cologne, Mus. für Ostasiatische Kunst; plate

849–853 *Paul Klee (Münchenbuchsee 1879–1940 Lugano); Aare landscapes without titles;* oil, canvas 144×48 cm; c. 1900; Bern, priv. coll.

841 Koryusai, Girl

East and
South-East
Asia

Methods of
Composition

732–1037

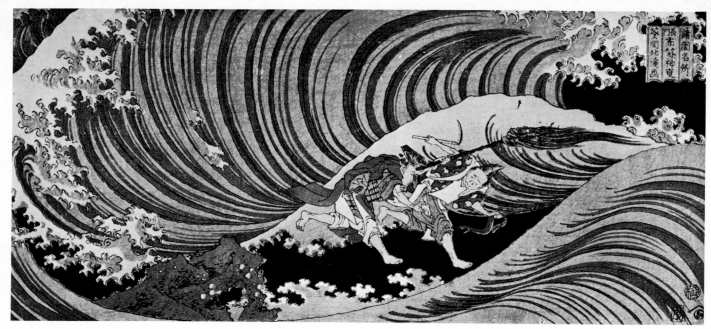

Hokkei, Mekari Festival in the Province of Nagato

854 Lacombe, Wave ▶

The "Wave" as Picture and Ornamental Form in Japanese Art and its Influence on European Art in the Nineteenth and early Twentieth Centuries

Siegfried Wichmann

I.

The incarnation of natural phenomena was developed in Japanese art into a perfect system. The concentration on single things in nature was designed to thoroughly explore the object in question, which was, as it were, approached from all sides. Only thus was it possible for a stylizing of the species according to typological prerequisites to be developed into a ciphered painting tenet which, at a single glance and employing extremely reduced form, could state everything about the content of the object in question. A great motif of Far-Eastern art, especially of Japanese art, was the wave, and the diversity of its undulation was developed to a drastic and impressive unity. Whole generations of painters have devoted attention to the undulating movements of the wave. The Japanese developed the most differentiated feeling for the rhythmical sequence of the wave movements, with their counteracting gravitation, with the rising and falling of the crest. After prolonged observations, painters endeavoured to depict the centre of agitation and the ensuing subsidence of the wave. In these paintings, we also recognize the circular shaped furrows which connect directly with the trough of the wave elevation in front. It is only the outward form of the water surface that advances, not the water itself. This scientific perception can be traced through the wave representations of the Chinese and Japanese down to Hokusai. The totality of all the wave rings issuing from the same agitation point forms a wave system; and this wave system, which the Japanese represent on their scrolls, screens, and utensils, on their textiles, and especially in chrome wood-engraving, is a motif that has repeatedly been taken up by art, particularly in Europe. The Chinese painting instructions strictly lay down the rules determining the artistical means. Wave representation, the wave motif, was subject to clear guiding principles, which were followed by artists time and time again throughout the centuries. The most detailed evidence of the river wave and the ocean billow is to be found in the "Mustard-Seed Garden", where it is written: "The mountains often have strange peaks, and water, too. When the moon hangs so grandly over the sea, the crests prance like white horses. With a light breeze, there are scarcely any waves. At such times, large rivers, oceans and small lakes are as smooth as mirrors. Wu-Dao-xuan, also named Wu Dao-zi (eighth century painter of the Tang period, 618–907), painted water in such a way that, when looking at the picture, one seemed to hear the whispering of the night. But he could reproduce the wind-whipped waves just as well."

Ogaka Kôrin (1658–1716) was certainly also familiar with these instructions. He is regarded as Japan's painter with the greatest talent for decoration. One of his main works is the wave screen in the Metropolitan Museum in New York. He painted the surging ocean with transparent colour and body-colour on gold paper. This powerful brush technique, which he had adopted in the Kâno school, determined his decorative, ornamentalizing approach: gold for the background, white for the foam of the waves, and a thickly applied, ominous blue that sharply sets off the waves.

More important is the pair of screens "Plum Trees at a Watercourse" in the Atami Museum in Shiznola-ken. The ornamentalized waves illustrated here went down in Japanese art history as Kôrin-Nami, Kôrin's waves. "They have been tirelessly reproduced by artists up to the present day as designs on lacquer, ceramics and textiles". The Kôrin wave also found a great response in Europe. The wave band style in art nouveau and Jugendstil is derived directly from this wave system.

East and
South-East
Asia

Methods of
Composition

732–1037

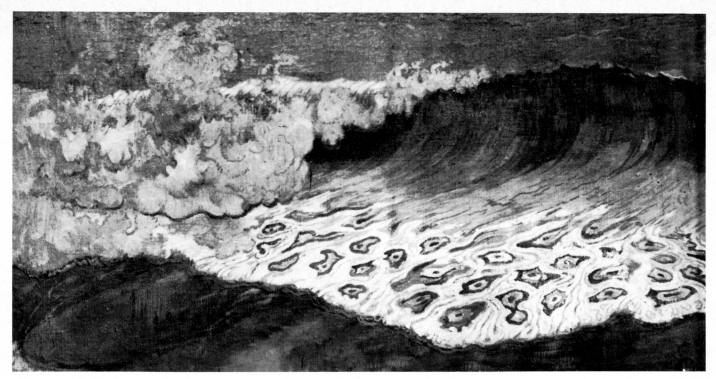

II.
Hokusai has also handed down an impressive representation of the wave systems in his comb booklet now in the National Library in Tokyo. (Cat. No. 7/334). It stands as a prototype of an attempt at transposition, which represents an important theme using a small everyday object. Nothing was unimportant for Hokusai or the preceding and following generations of artists. They could detect the great cosmic order of nature concentrated in the smallest area or the most "unworthy" object. Thus, in the comb booklet he shows us how the agitated sea, with mixed breakers, surges along from different directions. He still demonstrated the rolling sea, the horizontally rising and falling walls of waves; similarly, the gigantic rhythmical waves in a sharp wind direction, or the ruffled surface of the sea. He then proceeds further to depict the heaving mass of water in which boats are sinking; the towering mountains of waves, the curling of their long tongues. From these observations he develops the typical "frozen" wave crests, which then undergo stylization to become what may already be described as pure surface ornament. These wave elevations are ultimately modified to pure ornament and decorate the back of a semicircular

ornamental comb: an example of nature, rhythmically changed and transformed to ornament.
The famous wave of Hokusai entered into folklore not only due to its masterly representation but also because this imposing theme was comprehended equally well by people of many different nations. It can be proved that this woodcut exerted a powerful influence on wave representation in all following generations of painters, and the exhibition contains several representative examples to demonstrate this. It was considered very important to also show this principle of decoration on the daily utensils as well as in painting itself. The so-called large wave-band is an old motif; in the form of a consecutive wave it belongs to the pure geometric transformation of the Mäander-line, which was rounded off. The line of the large wave-band separates the spaces painted — often in blue on gold — in the flat ornament, and it is particularly suitable as a garment border in Japanese textile design. It also covers entire surface elements and belongs just as much to sword ornamentation or to vase decoration. It is also a popular decorative element on bowls and plates.
In contrast to the general ornamental effect of the large wave-band, the Japa-

nese developed an undulating wave system based upon amorphous guidelines, the Kôrin Nami, which takes ordered possession of the surface area and, with a flailing or rhythmically gliding motion, decorates the lacquered boxes, the writing cabinets and inros. The wave-band system is subjected to greater abstraction in so far as it conforms to the intentions of the artist, whereby naturalistic floral elements are transformed in their organic vitality into arabesque. The wave-band motif gains an eminent decorative function in Japanese art. The intrinsic ornamental value is also combined here with the ornamentalized nature to form a harmony.

III.
The cipher-like formula of the wave was enhanced in Europe — especially in art nouveau and Jugendstil — by stylizing elements of movement. It was possible to derive the rhythmical Jugendstil-line from the wave systems of Eastern Asia; for that specific decorative idea was also illustrated here in order to achieve the optical effect in an empirical manner. It was adopted in every European country around 1900, and its pronounced schematized aspect came to symbolize line during this period. Dynamically stimulated, it gained calligraphic impor-

129

East and
South-East
Asia

Methods of
Composition

732–1037

742 Degas, Dancers at Rehearsal

743 Hokusai, from "Manga" ▶

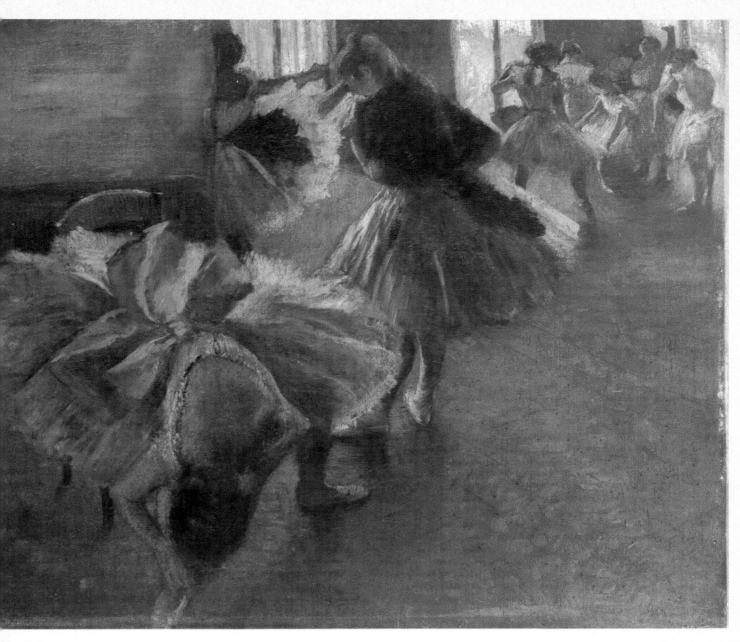

East and
South-East
Asia

Methods of
Composition

732–1037

East and
South-East
Asia

Methods of
Composition

732–1037

tance in the field of book decoration. It is abstracted as an "absolute line" in long flourishing curvatures, which possess maximum power of flowing movement. Walter Crane is conscious of the painting instructions for the wave when he writes: "When the moon hangs so splendidly over the sea, the wave crests prance along like white horses." In contrast, Aubrey Beardsley develops the same calligraphic, abstracting wave-band rhythm that was adopted by von Eckmann and the illustrators of the magazine Pan. Hermann Obrist, who helped to prepare the way for modern art, treated the swirling wave system scientifically. He adds the following programmatic comment to a "Wave Composition": "The surging of breakers against unyielding cliffs. The torrential impact, the seething and the subsiding. It is driven, primitive power! ... The life of the wave gushes forth."

The fact that Hermann Obrist conceived the wave as a living organism is revealed by these words and by his other written works. This concept also conforms with the Japanese model. The extent to which the surging wave system played an important role as large ornament in the

twentieth century, is demonstrated by Wes Wilson's placard "Birds", which illustrates in extreme analogy the monumental abstraction of the surging wave system.

Translatation G. F. S.

854 Georges Lacombe (Versailles 1868–1916 Alencon); Surging Wave (Marine bleue. Effet de vagues, Camaret); oil, canvas; 49×65 cm; sig. bottom right: GL; 1892; Rennes, Musée de Rennes; plate

855 Hans Schmidthals (Kreuznach 1878–1964 München); Composition in Blue; oil, canvas; 131.5×79.5 cm; c. 1900; München, Bayerische Staatsgemäldesammlung; plate

856 Andô Hiroshige; The Whirlpool of Naruto in the Province Awa; from the series "Famous Landscapes from more than 60 Provinces," "Rokujû yoshu meisho zue"; coloured woodcut, ôban yoko-e 33.6×22.5 cm; sig: Hiroshige hitsu; imprint: Koshihei (Koshimura-ya Heisuke); collector's stamp; 1853–1856; Vienna, Österreichisches Mus. für angewandte Kunst, Exner Bequest; plate

857 Henri Jossot (Dijon 1866–1951 Sidi-Bou-Said, Tunisia); The Rower (Le Rameur); woodcut, monochrome print 37×32 cm; sig. bottom right: Jossot; Munich, priv. coll.

858 Arnold Emil Krog; manufacture: Royal Porcelain Manufactory København; Wave and Flying Swans; plate, porcelain, underglaze painting; ⌀ 20 cm;

1887; Copenhagen. Das dänische Mus. für Kunst und Gewerbe

859 Arnold Emil Krog (Frederiksvaerk, Dänemark 1856–1913 Tilsvilde); manufacture: Royal Porcelain Manufactury København; Sea and Seagulls; vase, hard-glazed porcelain, underglaze painting; h - 36 cm; 1888; Copenhagen, Royal Porcelain Manufactory

860 Japan; vase (Pitong), porcelain, cylindrical, white with waves and birds; h - 22 cm; Paris, Musée Cernuschi, Inv. No. 3119

861 Ernest Chaplet (Paris 1835–1905 Choisyle); vase with wave decoration; earthenware; h- 21 cm; sig. at bottom: stamp Rosenkranz; 19th cent.; Copenhagen, Das dänische Mus. für Kunst und Gewerbe, Inv. No. A10/1906

862 Erich Heckel (Döbeln, Saxony 1883–1970 Radolfzell, Lake Constance); Breakers; woodcut 36.7×26.9 cm; sig. bottom left: Ostende 15, sig. bottom right: Erich Heckel; 1915; Essen, Mus. Folkwang

863 Erich Heckel; Cascading Waves; woodcut, 36.7×28.5 cm; sig. bottom right: Erich Heckel; 1918; Essen, Mus. Folkwang

864 Erich Heckel; Wave (After the Storm); oil, canvas; 99×66 cm; sig. bottom left: Erich Heckel, on the back: Erich Heckel "Wave" 1918; Krefeld, priv. coll.

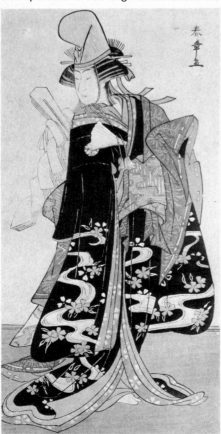

▲ 871 Rozenburg, plate

◄ 872 Shunsho, Actor

Bradley, Skirt ▶

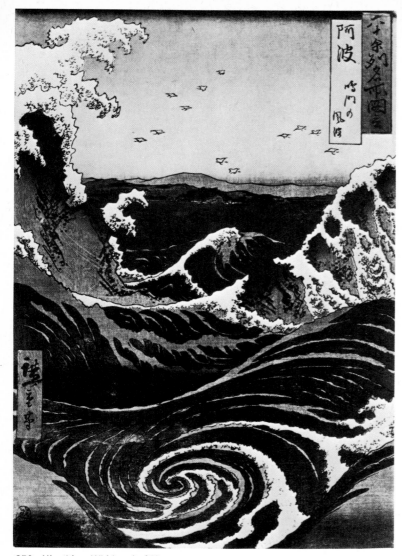

856 Hiroshige, Whirlpool of Naruto

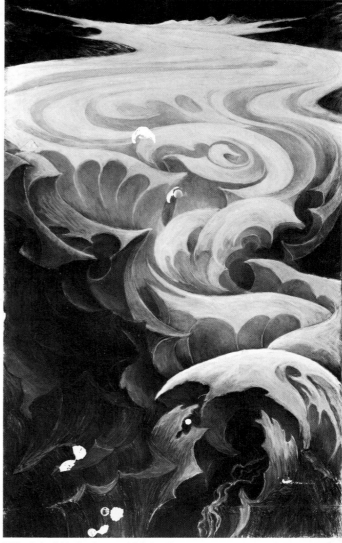

855 Schmidthals, Composition in Blue

865 *Japan; brush beaker; ivory;* h - 13.2, ⌀ 7.4×5.6 cm; Vienna, Öster- reichisches Mus. für angewandte Kunst

866 *Katshushika Hokusai; "The Wave" (Fuji seen through a Wave trough at Kanagawa), (Kanagawa oki namiura); from the series "Thirty-six Views of Fuji," "Fugaku sanjûrokkei";* published by Eijudô (Nishimura-ya Yohachi) between 1823 and 1832; coloured woodcut, ôban yoko-e 25.3×38.2 cm; sig.: Hokusai aratame litsu hitsu; Vienna, Österreichisches Mus. für angewandte Kunst, Exner Bequest; plate

867 *Katsushika Hokusai; The Great*

Wave; double page from Vol. II of "Hundred Views of Fuji," "Fugaku Hyakkei"; woodcut, duochrome print 26.2×22.5 cm; colophon containing: Zen Hokusai I-itsu aratame Sichi-je-go- rei Gateyorojin manji nitsu; publisher: Nishimura Yohachi; date: Tempo six = 1835 (first ed.); Regensburg, Franz Winzinger Coll.; plate

868 *Clément Massier (c. 1845–1917 Golfe-Juan); vase with wave decora- tion;* clay, lustre glaze; h - 22.8 cm; sig. on floor: C. M. Golfe Juan (A. M.); c. 1900; Darmstadt, Hessisches Landes- mus.

869 *Andô Hiroshige; The Great Wave*

at the Shore of Satta-Sunshu in the Province Sagami; page 24 from the series "Thirtysix Views of Fuji," "Fuji Sanju Rokkei"; coloured woodcut, ôban tate-e 34×23.8 cm; sig: Hiroshige ga; wood carver's stamp: Horicho; imprint: Tsutaja Kichizo (Koyeido); Imprimatur stamp: Aratame; date stamp: Year of the Horse, fourth month = 1858; Regensburg, Franz Winzinger Coll.

870 *Andô Hiroshige; Fuji seen from Satta in the Bay of Suruga;* from the series "Thirty-six Views of Fuji," "Fuji sanjurôkkei"; published by Tsutaya; coloured woodcut, ôban 33.5×21.7 cm; sig: Hiroshige ga; collector's stamp; date stamp: 1858, fourth month: Vienna,

133

East and
South-East
Asia

Methods of
Composition

732–1037

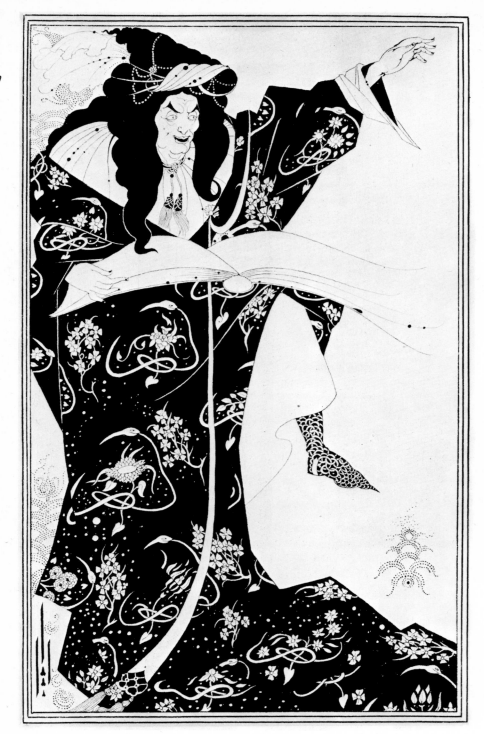

Österreichisches Mus. für angewandte
Kunst, Exner Bequest

871 *Haagsche Plateelbakkerij, Rozen-*
burg, The Hague; flat bowl with fish and
wave rim; clay, ⌀ 38 cm; sig. under-

neath: manufactory stamp and date;
Darmstadt, Hessisches Landesmus.;
plate

872 *Katsukawa Shunshô (1726–1792*
Tokyo); The Actor Nakamura Denkuro

in the Costume of a Court Lady; coloured
woodcut, h- 31 × 14.1 cm; sig: Shunshô
ga; c. 1775; Regensburg, Franz Win-
zinger Coll.; plate

873 *Isoda Koryûsai (worked 1766–*
1788); The Courtesan Sugatano from
the Yotsume-House leaving with her
Shinzo and two Kamuro; from the
series "Fashionable Clothes in new
Patterns as fresh as young Leaves,"
"Hinagata Wakana no hatsu moyo";
coloured woodcut, ôban 36.7 × 25.6 cm;
sig: Koriusai ga; imprint: Nishimura
Yochahi (Eijûdô); c. 1778/79; Regens-
burg, Franz Winzinger Coll.

874 *Walter Crane (1845–1915); The*
Horses of Neptune; oil, canvas;
86 × 215 cm; sig. bottom left: Walter
Crane/1892; Munich, Bayerische
Staatsgemäldesln.

The Silhouette Style in Europe and the Japanese Woodcut

After the Japanese coloured woodcut
became known in Europe, painters –
above all the French Impressionists –
chose dark patches of colour, which
contrast in sharp outline with the
light colour of the background. They not only
began to use numerous Japanese motifs
(as proved in the section on Japonaiserie
motifs), but Manet's circle in particular
soon started to construct their figurative
representations in the socle-like manner
of the Japanese woodcut, to contrast it
in dark colour with the background and,
finally, to employ the silhouette tech-
nique. Typical, sharply delineated colour
areas were produced by brush in the style
of the Japanese prototype. It is interesting
to note that, in this way, graphic elements
and their corresponding forms were
absorbed into European oil painting.
Certain masters of the Ukiyo-e were spec-
ially favoured by European painters; for
example Katagawa Utamaro (1753–1806)
whose geishas, tea-house scenes, and
amorous couples became famous. Those
woodcuts were of decisive importance
for the so-called silhouette style which
were furnished with a lacquer-like shim-
mer in the dark areas of the composition;
these were often polished and used with
striking effect for the rich black hair of the

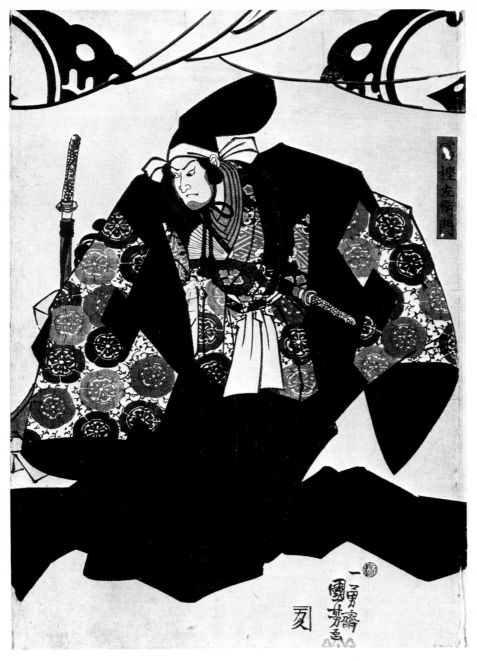

East and
South-East
Asia

Methods of
Composition

732–1037

from colour and detached as homogeneous black; colour can become autonomous as a flat, coloured silhouette.
S. W.

Summary and Translation G. F. S.

875 *Edgar Degas (Paris 1834–1917);
In the Louvre; Painting (Mary Cassatt);*
etching; 30.2×12.7 cm; sig. back, bottom right: studio stamp; c. 1876; Ulm, Städtisches Mus.

876 *Katsushika Hokusai (Tokyo 1760–1848); Japanese Women Standing;*
page from the Manga, Assorted Sketches, Vol. 9; woodcut, duotone, facsimile; kôban 24×25 cm; 1812–1875; Tokyo, Yujiro Shinoda

877 *Pierre Bonnard (Fontenay-aux-Roses 1867–1947 Le Cannet); Women with Umbrella;* from the Album de la Revue Blanche; chromolithograph; 22×14 cm; c. 1895; Roger-Marx 35; Bremen, Kunsthalle; plate

878 *Torii Kiyonaga (Tokyo 1752–1815); The Actors Ichikawa Yaozô III (1747–1818), Ichikawa Monnosuke II (1743–1794) and Nakamura Hikotarô (?),* coloured woodcut; ôban 37.7×25.8 cm; sig: Kiyonaga ga; imprint: Eji (dô) han; c. 1784; Berlin, Mus. für Ostasiatische Kunst; plate

879 *Edouard Vuillard (Cuiseaux 1868–1940 La Baule); Marthe Mellot;* oil, canvas; 26.5×9.5 cm; c. 1892; Paris, priv. coll.

880 *Edouard Vuillard; Ker Xavier reading Newspaper;* oil, cardboard; 23×28 cm; sig. bottom right: studio stamp; c. 1894; Paris, priv. coll.

881 *Utagawa Toyokuni (Tokyo 1769–1825); The Actors Sawamura Sôjûrô III (1753–1801) and Segawa Kikunojô III (1750–1810);* coloured woodcut, ôban 38,4×25.6 cm; sig: Toyokuni ga; imprint: Nishimura-ya Yohachi; Imprimatur stamp: Kiwame; c. 1798; Berlin, Mus. für Ostasiatische Kunst

882 *Utagawa Kuniyoshi (Tokyo 1798–1861); Kanjincho, Document authorizing Receipt of Donations for charitable Purposes;* coloured woodcut, centre part of triptych, ôban 36.1×24.5 cm; sig. Ichiyusai Kuniyoshi ga; imprint: Man Kyû; c. 1853; Berlin, Mus. für Ostasiatische Kunst

geishas and courtesans. The shadow, which the Impressionists employed for its colour value rather than its dark effect, had spatial functions and imparted that volume to figures which was eventually consumed by the brightness of the light in post-impressionism. The Pont-Aven artists rejected this tendency and committed themselves to contoured or detached, uniform areas of colour – the colour silhouette – which creates no illusions of depth.

Edouard Vuillard employs the black patches of colour in arabesque variations Pierre Bonnard produces bizarre silhouettes in the manner of Hokusai. Degas who was also a great admirer of Japanese art, creates dynamically structured silhouettes from the homogenous, contoured black, whereas Toulouse-Lautrec concentrates upon a precise registration of outline, which similarly leads to the areal form. The silhouette style thus becomes dualistic: shadow is withdrawn

East and
South-East
Asia

Methods of
Composition

732–1037

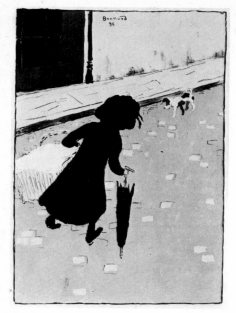

889 Bonnard, Washerwoman

883 *Edouard Vuillard; Portrait of
Women with Green Hat;* oil, cardboard;
21 × 16 cm; sig: studio stamp; c. 1891;
Paris, priv. coll.

884 *Keisai Eisen (Tokyo 1790–1848);
Courtesan;* from the series "Eight
Views of favourite Things of Today,"
"Tôsei kôbutsu hakkei"; coloured wood-
cut, ôban 38.5 × 26.4 cm; sig: Keisai
Eisen ga; Vienna, Österreichisches Mus.
für angewandte Kunst

885 *Gustav Klimt (Baumgarten 1862–
1918 Wien); The Black Feather-hat;*
oil, canvas; 79 × 63 cm; sig. bottom
right: Gustav Klimt/1910 Dobai 168;
Graz, priv. coll.

886 *Katsushika Hokusai; Surimono:
Peasant-girl;* coloured woodcut;
21.4 × 18.4 cm; sig: Hokusai ga; Zurich,
Boller Coll.

887 *Silhouettes of Actors; Illustrations
from an Actor's Book;* woodcut, fac-
simile; 9.9 × 7.5 cm; Zurich, Boller Coll.

888 *Edouard Vuillard; The two Sisters-
in-Law;* from the series "Landscapes
and Interiors," "Paysages et Interieurs";
chromolithograph; 28 × 35.5 cm;
c. 1899; Roger-Marx 43; Munich,
Staatliche Graphische Slg.

889 *Pierre Bonnard; The little Washer-
woman;* from the album "Peintres-
Graveurs"; chromolithograph; 30 × 19 cm;
sig. top centre: Bonnard/96; c. 1896/97;
Roger-Marx 38; Paris, Bibliothèque
Nationale, Cabinet des Estampes; plate

890 *Utagawa Toyokuni; The Actor
Ichikawa Yaozô III (1747–1818);*
coloured woodcut, hoso-e 29.6 × 14.1 cm
sig: Toyokuni ga; imprint: Yamada;
c. 1800; Berlin, Mus. für Ostasiatische
Kunst

891 *Egon Schiele (Tulln an der Donau
1890–1918 Vienna); Gerta Schiele;* oil,
canvas; 140.4 × 140 cm; c. 1909;
Kallir 89; Graz, Viktor Fogarassy

892 *Aubrey Beardsley (Brighton
1872–1898 Mentone); Virgilius the
Sorcerer;* frontispiece to "The wonder-
ful Story of Virgilius the Sorcerer in
Rome"; publ. by David Nutt; brush and
ink on paper; 22.8 × 13.8 cm; sig. bottom
left: monogram stamp; c. 1893; Chicago,
Art Institute; plate

893 *Utagawa Kuniyoshi; Document
authorizing Receipt of Donations for
charitable Purposes (Kanjincho);*
coloured woodcut; triptych, each ôban
35.8–36.1 × 23.9–24.5 cm; sig. (on
each sheet): Ichiyusai Kuniyoshi ga;
imprint: Man Kyû; Imprimatur stamp:
Muramatsu; c. 1843–1846; Berlin, Mus.
für Ostasiatische Kunst; plate

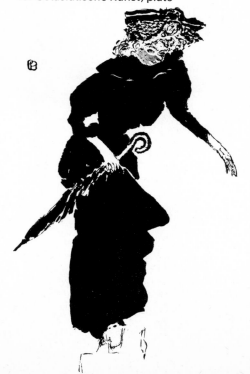

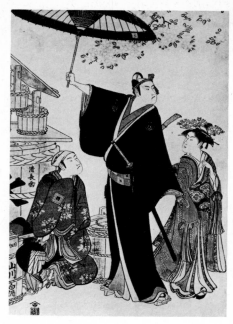

878 Kiyonaga, Actors

The Far Eastern Pattern-Background Principle as Source of initial Attempts at Abstraction in Western Painting at the Close of the Nineteenth and the Beginning of the Twentieth Centuries

Siegfried Wichmann

Ornamental patterning is the central
theme of Far Eastern art. In the course of
the development beginning with the
Asuka Nara period (552–794) and lasting
until the Momojama Edo period (1559 to
1876), the ornamental pattern principle
underwent persisting transformation to
reveal varied outward forms. In the field
of Japanese silk, the ornament system
gained increasing clarity. By the concept
pattern and background we understand a
relation to the rapport system and large
heraldic designs which can be trans-
formed. Large design in front of small
design, and vice versa, is a frequently
employed device; equivalent patterns
also appear, whereby the background
patterning takes on the function of pro-
viding a trellis-work and the super-
imposed ornamental form orders the areal
components. There is always a separation
between the foundation and primary
patterns, which makes one or the
other ornament system autonomous. The
unity of the surface component achieved
in this way, corresponded also to the

877 Bonnard, Woman with Umbrella ▶

material which, by virtue of its technical treatment, gave structures that similarly conformed closely to the pattern-background principle. This is demonstrated in the Kinran, a brocade of gold-thread, or the Donsu, a particularly lustrous silk damask. There is also the Chirimen, a crêpe-like material with its inherently vibrating surface, and Kaiki, a silk fabric resembling taft. Wool, velvet and cotton were also designed according to the versatile pattern-background principle. In summary, it can be said that the "two level technique" of pattern and background enjoyed countless possibilities presented by the structure of the silk fabric foundation, which not only enriched and influenced the art of silk designing, but extended to every Japanese art form. Silk thus became the principal material in every sphere of life. It was the privilege of the ruling classes, but at the same time it found expression in the common people in the so-called Kosode fashion, which ultimately gave the kimono dress its present form. It was inevitable, therefore, that the illustrators of popular life in Japan, the Ukiyo-e artists, not only represented everyday scenes, but had a constant affiliation to a sort of still-life which depicts the rich Japanese art of ornamentation and stands as a critical record up to the present day. The ornaments on the kimonos represented in the thousands of coloured woodcuts are not only portrayals, these jewels of textile designing are at the same time inventions of the artists, for a large number of the Ukiyo-e artists came from textile handicrafts and were thus quite familiar with the tradition of silk designing.

An important factor is the form of the garment in Japan; it envelops the body and gives it a bizarre shape in so far as the basic posture of the figure is emphasized. The kimono fits closely at the back while concealing the upper arm, breast, trunk and legs; only the head projects from the "textile pedestal," often together with the hands. The sweep of the back gives the kimono – and the figure only secondarily – that harmonic line which was frequently compared with the Japanese willow-tree. This form of dress, which receives a certain emphasis in its bizarre silhouette, is understandable, for posture and deportment of the wearer were often codified; namely, the court festivities, the assemblies, the class-consciousness of specific feudal classes, and the actors or courtesans adopted forms of posture and deportment indicative of their status. Posture was subject to a scheme of extremely variable gestures, which could be transformed into deport-

ment. The mimic trace in the features, similarly a form of behaviour, was tuned to it and, together with other forms, reached its apotheosis in the Japanese theatre. This code of posture and deportment is a century-old tradition perpetuated in the Nô plays. Combined with a highly developed idiom of language, an extremely stylized angularity of gesture, this play-acting has become the essence of abstracted norms of movement, which are similarly transmitted to the costume as to the rhythm of the stride and to an adjustment of all motional sequences to horizontal and vertical principles. Nô is thus an all-embracing work of art of the first order. Silk as ornamental art forms given motion in ornamental gestures, even language and the rhythmic-musical backing, fuse into a single centre of posture and gesture, which is geometrically orientated by the form and lay-out of the Nô stage.

The popular theatre Kabuki, however, brings more pronounced motional transitions; the geometry, the horizontal and the vertical remain, but are refined. Rotating movement finds its place and becomes most impressive. The silk and Kabuki costumes play an extremely important role here. The weight of the costume worn by the actor can exceed fifty pounds and represents the most significant aspect of the play, as well as the quality of the actor. In the movements of the silk fabric he sinks into total anonymity which in the Nô play had already been created by the use of masks. The masses of silk material set into swirling motion during the lion dance symbolize the transfiguration; the figure becomes secondary as do the physical proportions.

The primary importance of costume fabric and the secondary repression of the bodily shape were a deliberate and extended development of an artistic form which has been recorded in countless illustrations by the Ukiyo-e artists. The woodcut represents the figure of a famous actor in numerous prints. The illustrated costumes were repeated in the foreground so that the heads of the figures could be replaced; an indication of how secondary the physical and figurative element had become, as Julius Kurth has demonstrated. The priority given to costume naturally meant that the patterning principle was also given prominence and applied here in stenographic form. Certain abstracting elements were based on this concept, as the elimination of the figurative elements in favour of ornamental focal points quite vividly illustrates.

When the coloured woodcuts, especially those of the late Japanese Ukiyo-e masters, came to Europe, it was primarily the French artists who discovered the principle described above. They perceived the object involved emotionally and thereby introduced the pattern-background principle into European painting. The degree to which it has influenced surface composition in Europe is demonstrated by certain compositional forms of the French Impressionists, who no longer attempted to attain depth but employed the stage closer to the foreground as the plane of their pictures in order to achieve wall patterning by means of surrounding objects. This principle was applied in rich variation from Manet, Monet and van Gogh to the Nabis. Gustav Klimt and the Viennese Secessionists, Liberty style and the Glasgow school – all took over this concept. Klimt, the collector of Japanese Nô and kimono dress, experienced this most intimately and adopted it as his principle of design.

The exhibition contains examples of the Japanese art of textile designing in the section "Pattern – Background". Dyeing stencils and the important kimono and Nô cloak demonstrate the different periods and illustrate the observations made above.

Summary and Translation G. F. S.

Silk, Kimono and Nô costume – Symbols of Japanese Culture

Silk weaving and dress-making gained increased importance in Japan during the Monoyamo-Edo period (1569–1867). During this period of extended peace, the art of silk designing reached a perfection which combined the accumulated experience of preceding ages. Silk clothes were no longer the privilege of the ruling classes; the kimono and obi became a form of national dress characterized by varied individual and traditional aristocratic forms. The Okiyo-e masters created kimono still-life compositions which influenced this period and record its diversity. All of Japan's handicraft techniques are combined in the art of silk designing. The Nô and Kabuki costumes testify to the artistic freedom and élan of the designer. The trend was to create large ornamental designs spreading over the shoulder or down the back of the garment. The kambun patterns not only fascinated the Ukiyo-e artists, they also attracted the attention of painters in

*East and
South-East
Asia*

*Methods of
Composition*

732–1037

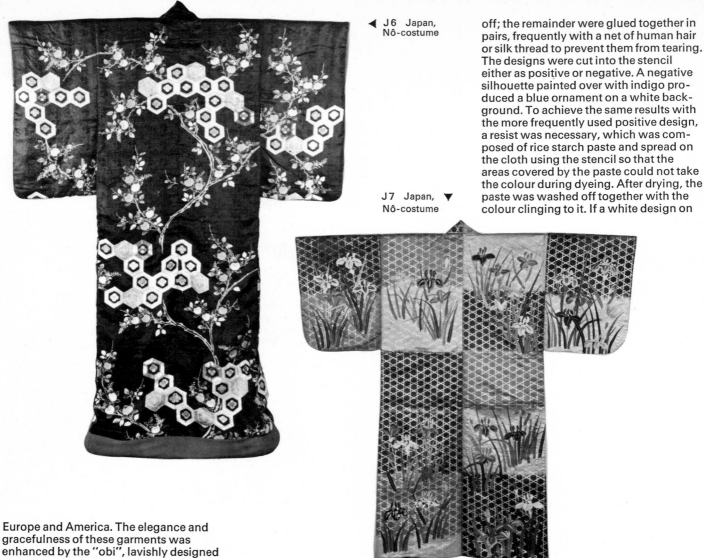

◀ J6 Japan,
Nô-costume

J7 Japan, ▼
Nô-costume

off; the remainder were glued together in
pairs, frequently with a net of human hair
or silk thread to prevent them from tearing.
The designs were cut into the stencil
either as positive or negative. A negative
silhouette painted over with indigo pro-
duced a blue ornament on a white back-
ground. To achieve the same results with
the more frequently used positive design,
a resist was necessary, which was com-
posed of rice starch paste and spread on
the cloth using the stencil so that the
areas covered by the paste could not take
the colour during dyeing. After drying, the
paste was washed off together with the
colour clinging to it. If a white design on

Europe and America. The elegance and
gracefulness of these garments was
enhanced by the "obi", lavishly designed
sashes, which still command high prices,
for they reveal the social status and taste
of the wearer.
The history of Japanese silk designing has
been treated in numerous publications.
However, the pattern-background prin-
ciple embodied in the alternation be-
tween small and large designs, the proc-
ess of abstraction and its influence on
Western art has not been investigated by
research workers. The Japanese silk
garment in the form of kimono and Nô-
dress has been included in the exhibition
to demonstrate how influential its pat-
terns have been in the West. The veiling
of the human figure with this precious
material to hide the contours of the body,
represents the starting point for attempts
at abstraction. S. W.

Japanese Dyeing Stencils (Katagami) and European Monochrome Graphic Art around 1900

Siegfried Wichmann

The material for the stencils was gained
from the bast of the paper produced from
the mulberry-tree, which had been
waterproofed with the juice of unripe
fermented Kai fruit and oil. To prepare the
stencil, the design was first cut out of a
wad of sixteen sheets. The bottom and
the top sheet with the design were peeled

a blue background was required, the
resist method had to be used with a
negative design.
The stencils were used in the dyeing of
cotton and silk cloths for the general
public. They were cheaper than woven
silks or embroidered fabrics and were
supplied in many different patterns:
simple "blue prints," coloured materials
dyed with a variety of stencils or by the
resist process, which allowed several
manufacturing stages, as well as mate-
rials in which the areas covered by the
stencils, were painted or embroidered
after dyeing.
The dyeing stencils of the Meiji-period
(1868–1912) are characterized by their

East and
South-East
Asia

Methods of
Composition

732–1037

concise cut, and they take their ornamental form from the whole world of nature. Floral patterns predominated and were grouped together in harmonic sequence. The system of dyeing stencils can be varied in different ways. Everything is contained in the ornamental form, from the geometric ornament up to the faithfully accurate reproduction of the object. The shape of the dyeing stencils is generally rectangular, which can be kept narrower or wider. The cutting technique continued to improve during the course of the development, so that the web-like ornament was permeated by enchasing individual forms. This graceful rapport was generally interrupted by large ornaments asymmetrically or symmetrically opposed, or symmetrical.

Large, one-dimensional ornaments were also quite customary in dyeing stencils. We find concrete surface patterns, for which the chessboard background was often employed contrasted with extreme landscape representations with spatial relationships. Cranes standing in reedy waters, swimming carp and irises in water, are frequent motifs.

A central motif is bamboo, which appeared in numerous variations, often as the familiar trellis-work. Basically, forms were employed which already tend towards the "abstract." The Japanese dyeing stencils have remained an extremely stimulating and, for European artists, a much desired requisite for their designs. Felix Vallotton, Otto Eckmann, Gustav Klimt, Marcus Behmer, Adolf Böhm, Zülow, Emil Orlik, and other artists were all familiar with the dyeing stencils.

Summary and Translation G. F. S.

J 6 *Japan, Karaori (mid Edo Period); Nô-costume;* brocade, ground in light-blue and golden chessboard pattern, arabesque type of design; 143×153 cm; 18th cent.; Tokyo, National Mus.; plate

J 7 *Japan (late Edo Period); Nô-costume;* nuihaku (embroidery and precious-metal overlay), satin; iris (embroidered) on a bamboo basket pattern of applied gold leaf on an alternating red, light-blue and dark-blue ground; 150×150 cm; 19th cent.; Tokyo, National Mus.; plate

J 8 *Japan (Edo Period); Kosode;* white satin, lined, design of cabins and oak leaves, partly embroidered, partly dyed; 138×149 cm; 18th cent.; Tokyo, National Mus.

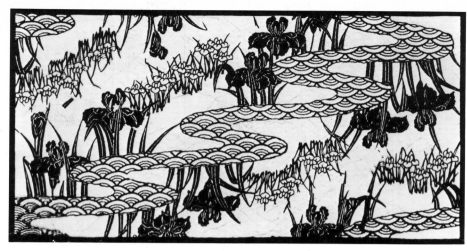

942 Japan, Dyeing Stencil

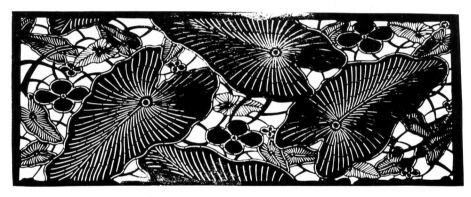

942 Japan, Dyeing Stencil

Böhm, Landscape

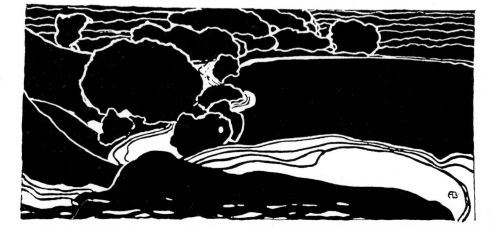

East and
South-East
Asia

Methods of
Composition

732–1037

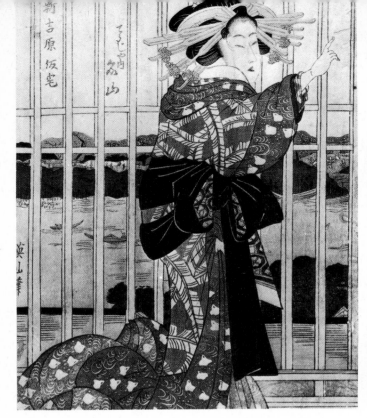

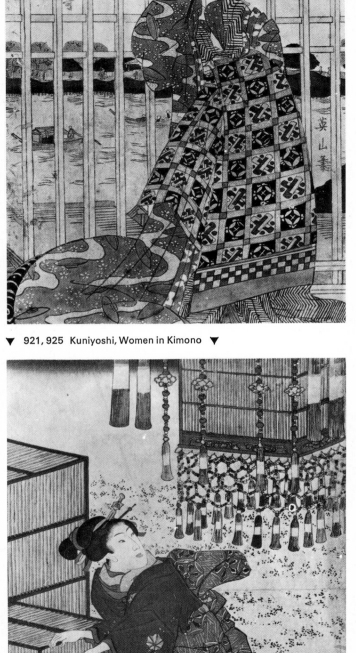

▲ Eisen, Courtesans ▲

▼ 921, 925 Kuniyoshi, Women in Kimono ▼

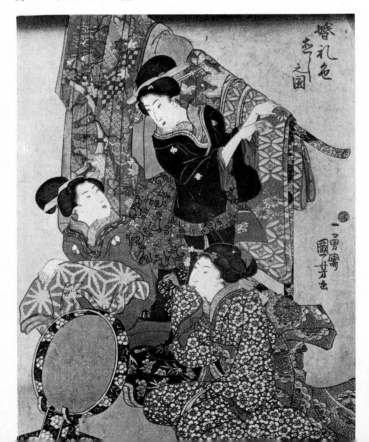

J9 *Japan (Edo Period); Uchikake;* satin, lined, oranges and tortoise-shell pattern on grey-blue ground; 124 × 160 cm.; 19th cent.; Tokyo, National Mus.

894 *Pierre Bonnard (Fontenay-aux-Roses 1867–1947 Le Cannet); Le Queen of Joy (Reine de Joie);* chromolithograph; 19 × 26 cm; c. 1892 Roger-Marx 3; Paris, Bibliothèque Nationale, Cabinet des Estampes

895 *Edouard Vuillard (Cuiseaux 1868–1910 La Baule); Interior with pink Wall-paper;* from the series "Landscapes and Interiors," "Paysages et Interieurs"; chromolithograph; 34 × 27 cm; c. 1899; Roger-Marx 36; Munich, Staatliche Graphische Slg.

896 *Edouard Vuillard; Interior with pink Wall-paper II;* from the series "Landscapes and Interiors," "Paysages et Interieurs"; chromolithograph; 34 × 27 cm; c. 1899; Roger-Marx 37; Munich, Staatliche Graphische Slg.

897 *Edouard Vuillard; Interior with pink Wall-paper III;* from the series "Landscapes and Interiors," "Paysages et Interieurs"; chromolithograph 34 × 27 cm; c. 1899; Roger-Marx 38; Munich, Staatliche Graphische Slg.

898 *Edouard Vuillard; Interior with Screen;* chromolithograph; 25 × 31 cm; c. 1895; Roger-Marx 8; Paris, Bibliothèque Nationale, Cabinet des Estampes

899 *Edouard Vuillard; At the Theatre;* oil, cardboard; 49 × 39 cm; sig. bottom right: E. Vuillard; c. 1899/1900; Zurich, Bührle Coll.

900 *Katsukawa Shuncho (Tokyo, worked 1770–1795); Theatrical Scene from "Sembonza-kura, Hikinuki Shiranu-mo no tana,"* coloured woodcut; ôban 37.3 × 25 cm; sig: Toto Shuncho ga; imprint: Daikando, Fushimiya Zenroku; c. 1787; Hamburg, Mus. für Kunst und Gewerbe

901 *Mary Cassatt; The Fitting;* coloured etching; 37,7 × 25,7 cm; sig. bottom right: Mary Cassatt; c. 1891; Breeskin 147; Paris, Bibliothèque Nationale, Cabinet des Estampes

902 *Mary Cassatt (Allegheny, Pennsylvania 1844–1926 Paris) The Letter;* coloured etching; 34.5 × 22.8 cm; c. 1891; Breeskin; Paris, Bibliothèque Nationale, Cabinet des Estampes; plate

903 *Utagawa Kunisada, called Toyokuni III after 1844 (Tokyo 1786–1864); The Female Impersonator Onoe Kikujiro as the Servant O Hatsu in the Play "Kagamiyama Gonichi no ishibumi";* coloured woodcut, ôban 36.5 × 25 cm; sig: Toyokuni ga; c. 1855; Düsseldorf, Willibald Netto Coll.

904 *Utagawa Kunisada; Japanese Lady in Chequered Kimono;* from the series "Striped Fabric in the Latest Fashion," "Atsura ori Tosei shima" coloured wood-

Japan, Kabuki Actor

cut, ôban 35.5 × 26 cm; sig: Oju Toyokuni ga; c. 1845/46 Düsseldorf, Willibald Netto Coll.; plate

905 *Edouard Vuillard; The Seamstress;* gouache on paper; 51 × 48 cm; c. 1892–1895; San Francisco, Mrs. Hans Popper

906 *Japan; Nô-costume;* embroidered silk inlaid with gold leaf (Nuihaku-technique); 160 × 85 cm; Tokugawa-period (1603–1868); Vienna, Österreichisches Mus. für angewandte Kunst; plate

907 *Japan; Nô-costume; Stockholm;* silk, embroidered, c. 200 × 150 cm; *Ostasiatiska Museet;* plate

908 *Japan; textile pattern with leaf and flower ornamentation;* cotton and silk; 44 × 29.3 cm; 18/19th cent.; Stockholm, Ostasiatiska Museet

909 *Japan; textile pattern with ornament in form of a pine-tree branch;* cotton and silk; 40 × 29.5 cm; 18/19th cent.; Stockholm, Ostasiatiska Museet

910 *Japan; textile pattern with geometrical leaf, blossom and tendril pattern;* cotton and silk; 41 × 28,5 cm; 19th cent.; Stockholm, Ostasiatiska Museet

911 *Japan; pattern-book with 119 samples of fabric;* 39 × 40.5 cm; Meiji-Period (1868–1912); present of the

Japan, Nô-costume (detail)

Japanese Commission to the Vienna World Exhibition 1873; Vienna, Österreichisches Mus. für angewandte Kunst

912 *Gustav Klimt (Baumgarten 1862–1918); Lady with Fan;* oil, canvas; 100 × 100 cm; c. 1917/18; Dobai 203; Vienna, Dr. Rudolf Leopold Coll.

913 *Kitagawa Utamaro (Kowagoe 1753–1806 Tokyo); Youth in Court Dress with High Cap dancing behind a Girl;* coloured woodcut, ôban 38.2 × 25.5 cm; sig: Utamaro hitsu; imprint: Omiya; c. 1800; Regensburg, Franz Winzinger Coll.

914 *Utagawa Kuniyoshi (Tokyo 1798–1861); Tennichibo and Mrs. Akoya in the Play Kotoba no Hana Momiji Sakagi;* coloured woodcut, ôban 35.6 × 25 cm; c. 1849; Cologne, Mus. für Ostasiatische Kunst

East and
South-East
Asia

Methods of
Composition

732–1037

◀ 902 Cassatt, The Letter

904 Kunisada, Mother with Child ▶

915 *Utagawa Kuniyoshi; Girl fastening Belt from the series "Stories of Prince Genji";* coloured woodcut, ôban 37 × 25 cm; c. 1851; Cologne, Mus. für Ostasiatische Kunst

916 *Torii Kiyonobu I (Osaka, c. 1664–1729 Tokyo); Actor as Fan Vendor;* woodcut, hand-coloured, hoso-e 31.7 × 15.7 cm; sig: Torii Kiyomasu zu; imprint: Iga-ya Kanyemon; c. 1726; Vienna, Österreichisches Mus. für angewandte Kunst, Exner Bequest

917 *Gustav Klimt; Working designs for Stoclet frieze:* Tree of Life, The Fulfilment, The Anticipation, Tree of Life; tempera, water-colour, gold colour, silver-bronze, chalk, pencil; 194 × 121 cm; c. 1905–1909 Dobai 152; zinc white, gold leaf, silver leaf on paper; Vienna, Österreichisches Mus. für angewandte Kunst; coloured plate

918 *Utagawa Kunisada; The Actor Onoe Tamizô (1799–1886);* coloured woodcut, right half of triptych, ôban 36.2 × 24.7 cm; sig: Gototei Kunisada ga; imprint: ivy with dot inderneath treble "yama"; Imprimatur stamp: Kiwame; c. 1841–1843; Berlin, Mus. für Ostasiatische Kunst; plate

919 *Utagawa Kunisada; Four Actors;* coloured woodcut, two sheets; ôban 36 × 24.4–24.8 cm; sig: Toyokuni ga; imprint: Hori Takichi Imprimatur; stamp with date: 1858 sixth month; Vienna, Österreichisches Mus. für angewandte Kunst; plate

920 *Torii Kiyonaga (Tokyo 1752–1815); In front of the Podest with the Joruri-Singers and the Shamisen-Actor, three Actors in Pose;* coloured woodcut, ôban 38 × 26 cm; sig: Kiyoanga ga; imprint: Eijudo; c. 1784; Regensburg, Franz Winzinger Coll.

921 *Utagawa Kuniyoshi; Three Ladies looking at bridal Robes;* coloured woodcut with relief printing, ôban 36 × 24 cm; sig: Ichiyusai Kuniyoshi ga; imprint: Izumi-ya Ichibei; c. 1842–1846; Vienna, Österreichisches Mus. für angewandte Kunst; plate

922 *Utagawa Kunisada; Genji-e;* coloured woodcut, triptych, each ôban 35.5–35.6 × 24.5–24.6 cm; sig on each sheet: Toyokuni ga; imprint on each sheet: Izutsu-ya; Imprimatur stamp on each sheet: Fuku, Muramatsu; ca. 1849–1854; Vienna, Österreichisches Mus. für angewandte Kunst

923 *Utagawa Kunisada; Sekiya from the series "Genji Roman," "Genji monogatari";* coloured woodcut, centre piece of a triptych, ôban 36 × 24.5 cm; sig: Kochoro Kunisada ga; c. 1842; Düsseldorf, Willibald Netto Coll.

924 *Utagawa Kuniyoshi; The only Woman among the 108 Thieves (Ichijosei Ko-sanjo);* from the series "The 108 Heroes of the Suikoden-Novel," "Tsuzoku Suikoden goketsu hyakuhachi-nin ichinin"; coloured woodcut, ôban 36.5 × 24.5 cm; sig: Ichiyusai Kuniyoshi ga; c. 1828; Düsseldorf, Willibald Netto Coll.

925 *Utagawa Kunisada; Prince Genji's visit to a House of Courtesans (Genji no kimi kagai yuran);* coloured woodcut, triptych, ôban 35.7–35.8 × 24.7–24.9 cm; sig. on each sheet: kakai (altered to) Toyokuni ga on the left and center sheet: keshiki monjin Utagawa Kunitoki hitsu; imprint on each sheet: Mori(ta) Ji(hei), Ba(Kurocho); Imprimatur stamp with date: Aratame, zodiak, monkey, fifth month; c. 1860; Berlin, Mus. für Ostasiatische Kunst; plate

926 *Utagawa Kunisada; Refined Amusements of beautiful Girls after latest Fashion (Tôsei bijin fûryû asobi);* coloured woodcut, triptych, ôban each 35.3–35.5 × 24.5–24.6 cm; sig. on right sheet: Ichiyôsai, Kôchôrô Toyokuni ga

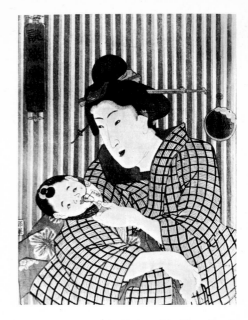

on centre sheet, ôju Kokuteiska Toyokuni ga on left sheet; imprint on each sheet: Maru (Ya) Kiyo(jiro)han, Shiba shimmei mae; Imprimatur stamp on each sheet: Kinugasa, Yoshimura; c. 1849; Berlin, Mus. für Ostasiatische Kunst

927 *Utagawa Kunisada; The Actors Matsumoto Koshirô V (1764–1838), Ichikawa Ebizo V (1791–1859) and Onoe Kikugoro III (1784–1849) in the kurumabiki-scene of the Play Sugawara Denju Tenarai Kagami;* coloured woodcut, triptych, each 34.7 × 25–25.5 cm; sig. on each sheet: Gototei Kunisada ga; imprint: Tsuru(ya) Ki(emon) han, Toriabura-chô; Imprimatur stamp on each sheet: Kiwame; c. 1835; Berlin, Mus. für Ostasiatische Kunst

928 *Utagawa Kuniyoshi; Scenes from the fashionable Isemonogatari (Imayo Isemonogatari);* coloured woodcut, triptych, each ôban 36.2–36.5 × 25–25.5 cm; sig.: Ichiûysai Kuniyoshi ga; imprint: Kazusaya Iwazo; c. 1847–1852; Vienna, Österreichisches Mus. für angewandte Kunst

929 *Utagawa Kuniyoshi; Three Actors;* coloured woodcut, triptych, each ôban 36.2–35.7 × 25.5–25 cm; sig.: Ichiyusai Kuniyoshi ga; imprint: Wakasaya Yoichi; c. 1847–1852; Vienna, Österreichisches Mus. für angewandte Kunst

930 *Utagawa Kuniyoshi; The Actor Saitôtarô saemon;* coloured woodcut, ôban 36 × 25.4 cm; sig.: Ichiyûsai Kuniyoshi ga; imprint: Iba-ya Sensaburô; c.

1847–1852; Vienna, Österreichisches Mus. für angewandte Kunst

931 *Utagawa Kunisada; Courtesan dressing;* coloured woodcut relief printing, ôban 38.7×26.3 cm; sig: Gototei Kunisada ga; Imprint: Idzutsu-y; Imprimatur stamp: Kiwame; c. 1820–1833; Vienna, Österreichisches Mus. für angewandte Kunst

932 *Utagawa Kunisada; The Courtesan Matsushima from the Sano-ya-house, walking with two Kamuro;* coloured woodcut, relief printing, ôban 38.8×25.9 cm; sig.: Gototei Kunisada ga; imprint: Eijudô; c. 1820–1823; Vienna, Österreichisches Mus. für angewandte Kunst

933 *Utagawa Kunisada; A Scene from the fashionable Genji-novel (Fûryû Azuma Genji);* coloured woodcut, ôban 35×24.3 cm; sig.: Toyokuni ga; imprint: Maru-ya Jinpachi; Imprimatur stamp: Aratame; date stamp: beginning of the year 1854; Vienna, Österreichisches Mus. für angewandte Kunst

934 *Utagawa Kunisada; Courtesan and two Kamuro in the Amusement Quarter of Edo;* coloured woodcut with relief printing, ôban 35.8×25 cm; sig.: Toyokuni ga; imprint: Yamamoto-ya Heikichi; c. 1842–1847; Vienna, Österreichisches Mus. für angewandte Kunst

935 *Utagawa Kunisada; Night Scene: Gentleman with two Ladies on a Bridge;* coloured woodcut, ôban 35.2–36×24.5–25 cm; sig.: Ichiûsai Toyokuni ga; Centre sheet sig.: Kôchôrô Toyokuni ga; imprint: Fujiokaya Keijirô; c. 1847–1852; Vienna, Österreichisches Mus. für angewandte Kunst

936 *Keisai Eisen (Tokyo 1790–1848); Courtesan with Shamisen;* from the series "Eicht Views of famous Beauties from the Yoshiwara", "Yoshiwara hakkei"; coloured woodcut, ôban 38.5×26 cm; sig.: Keisai Eisen ga; imprint: Tsutaya Kihizô, Imprimatur stamp: Kiwame; Vienna, Österreichisches Mus. für angewandte Kunst

937 *Keisai Eisen; The Courtesan Tokiwazu from the Ebi-ya-house;* coloured woodcut, ôban 38×26 cm; sig.: Keisai Eisen ga; imprint: Yezakiya; Imprimatur stamp: Kiwame; Vienna, Österreichisches Mus. für angewandte Kunst

938 *Keisai Eisen; Visit to the Myôken-Temple, during a Temple Festival of Today*

(Imayo ennichi môde); coloured woodcut, ôban 37.5×25.2 cm; sig.: Keisai Eisen ga; Imprimatur stamp: Kiwame; Vienna, Österreichisches Mus. für angewandte Kunst

939 *Utagawa Toyokuni (Tokyo 1769–1825); Scene with the Actors Osagawa Tsuneo II (1763–1808) and Ichikawa Danz O III (1745–1808);* coloured woodcut with relief printing, ôban 37×25 cm; sig.: Toyokuni ga; imprint: Eijudô; c. 1804–1808; Vienna, Österreichisches Mus. für angewandte Kunst, Exner Bequest

940 *Utagawa Toyokuni; Scene with the Actors Segawa Tokô (1783–1813) and Sawamura Tanosuke II (1785–1817) in Female Roles;* coloured woodcut, relief printing, ôban 39×26 cm; sig.: Toyokuni ga; two imprints: Xamashirôyo Tôkei; Imprimatur stamp: Kiwame; Vienna, Österreichisches Mus. für angewandte Kunst

941 *Shikimaro (worked first thirty years of 19th cent.); Poetess;* from the series "Poetesses à la Mode," "Imayo onna kasen"; coloured woodcut, relief printing, ôban 38.4×26 cm; sig.: Shikimaro ga; imprint: Eijudô; Imprimatur stamp: Kiwame; first third of 19th cent., Vienna; Österreichisches Mus. für angewandte Kunst, Exner Bequest

942 *Japan; Dyeing-stencils with chrysanthemums, lozenge, wistaria, leaf-tendrils, flying cranes, fir-branches, chestnut-branches, cherry-blossom, bamboo, peony-blossom, swimming carp, cranes, water-birds, straw-flower designs, maple-leaves, pomegranate branches, yew-branches, iris;* paper, 22.2–31.2×40.5–41.5 cm and 42–43.3×58.6–63.8 cm; Meiji-Period (1868–1912); Vienna, Österreichisches Mus. für angewandte Kunst; plates

943 *Japan; plait-work pattern with various geometrical patterns; straw or wooden trellis;* 33.5–41×25.2×27.6 cm or 136–137.5×55–55.5 cm, or 60.8–65.7×41.6–45.5 cm; Meiji-period (1868–1912); acquired at Vienna World Exhibition 1873; Vienna, Österreichisches Mus. für angewandte Kunst

Influences of Japanese Sumi Ink Painting on European Modern Art

Chisaburoh F. Yamada

East and South-East Asia

Methods of Composition

732–1037

I.

It is now well known that Japanese *ukiyo-e* prints exercised various kinds of influence on European artists of the second half of the nineteenth century. However, not much has been written about the influence of Japanese *sumi* ink paintings on European modern art. My assignment here is to study this question.

When a large number of Japanese *ukiyo-e* prints began appearing in Europe in the 1860's, Japanese paintings were also imported, and attracted the attention of the Western art world. In 1864 Whistler had already painted his *La princesse du pays de la porcelaine* placing the figure before a Japanese screen with flowers painted in a decorative style of the Korin school. In the same year he painted another girl in *kimono* in *Caprice in Purple and Gold*, seated before a Japanese gold screen. He was probably the first Occidental painter who was greatly influenced not only by Japanese prints but also by Japanese paintings. Whistler may well have received inspiration for expressing the lyrical mood and sentiment in his Nocturne series by dimly representing objects against the hazy background of subtly gradated tones of dark colours from such *ukiyo-e* prints as Hiroshige's *Night Rain at Karasaki* and *Shower at Ohashi*. On the other hand, Whistler must have studied Japanese paintings, especially *sumi* ink paintings, in certain questions of arrangement, as when placing a tree top above the lower edge of a painting and opening the background into wide river or sea scapes. Such a composition, which is unprecedented in European painting, can often be found in Japanese painting, although not in prints. The tree top against the ocean backdrop in *Symphony in Grey and Green: the Ocean* in the Frick Collection, which Denys Sutton dates c. 1868–7, may have been inspired by some Japanese polychrome paintings in the style of the Shijo School. Howewer, there are several paintings dating from the 1870's which, I think, must be regarded as a result of the impact of Japanese *sumi* ink paintings, especially *sumi* ink wash paintings. The dreamy *Nocturne in Blue and Silver: Cremorne Light*, painted in 1872 and now in the Tate Gallery, Lon-

**East and
South-East
Asia**

**Methods of
Composition**

732–1037

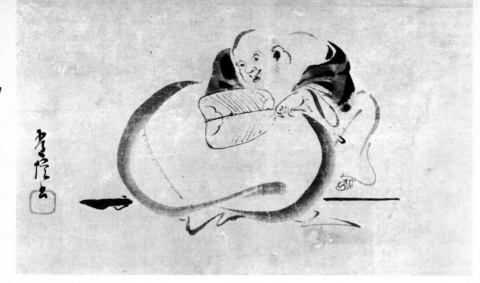

▲ Japan, Ink-painting

947 Toulouse-Lautrec, Jane Avril ▼

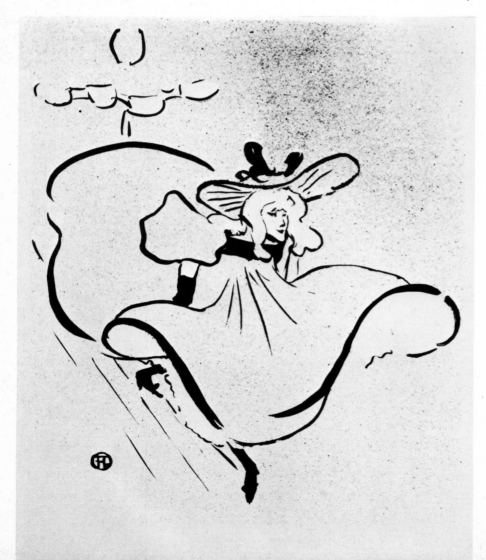

don, provides us with a good example. A small boat in the middle ground rendered with a few streaks of faint colour and the wind-swayed leaves executed with a few lively brush strokes just above the lower edge of the painting can come only from his study of Japanese ink wash paintings. The same is true of the representation of a long, low boat and faint figure in the foreground of the *Nocturne in Blue and Green: Chelsea*, painted in 1871, in the collection of Miss Alexander. These examples show that what Whistler learned from Japanese paintings was their evocative representation, and not necessarily the Japanese brush stroke. Although it is true that he imitated rather successfully a certain type of brush work taken from Japanese *sumi* painting in the *Cremorne Light* to represent the swaying movement of the leaves, this was really secondary to the painting. Whistler would not have been able to understand fully the intrinsic nature of the brush strokes in Japanese *sumi* paintings; the time was too early for that. Besides, Japanese brush strokes can not be imitated effectively when using oil pigments on canvas.

II.
The expressive nature of Japanese brushwork can be achieved only by the use of the pliable Chinese or Japanese brushes, *sumi* ink and the Chinese or Japanese absorbent papers. The latter two materials interact with each other marvellously. The brush holds back the black liquid allowing a painter to control the amount of *sumi* ink to be released. It can even retain ink of two different shades, so that in one stroke one can draw a broad line of different shades and of varying width. By changing the angles at which the brush is held and controlling the pressure with which the brush is applied to the paper and the speed at which it is moved, one can execute various types of strokes ranging from bold to subtle, from powerful to delicate.
Taking advantage of these special advantages of the Japanese brush, *sumi* ink and paper, and using the technical skill in brushwork trained in calligraphy, Chinese and Japanese painters developed a special style of monochrome painting in *sumi* ink wash, called *suiboku-ga* in Japanese, in which they represented their mental image of the subject matter through lively brushwork. The lines drawn with a brush in *suiboku* painting have a

Left: 836 Monet, Japanese Lilies ▶
Centre: 848 Ukiyo-e Master, Girl ▶
Right: 844 Klimt, Judith II ▶

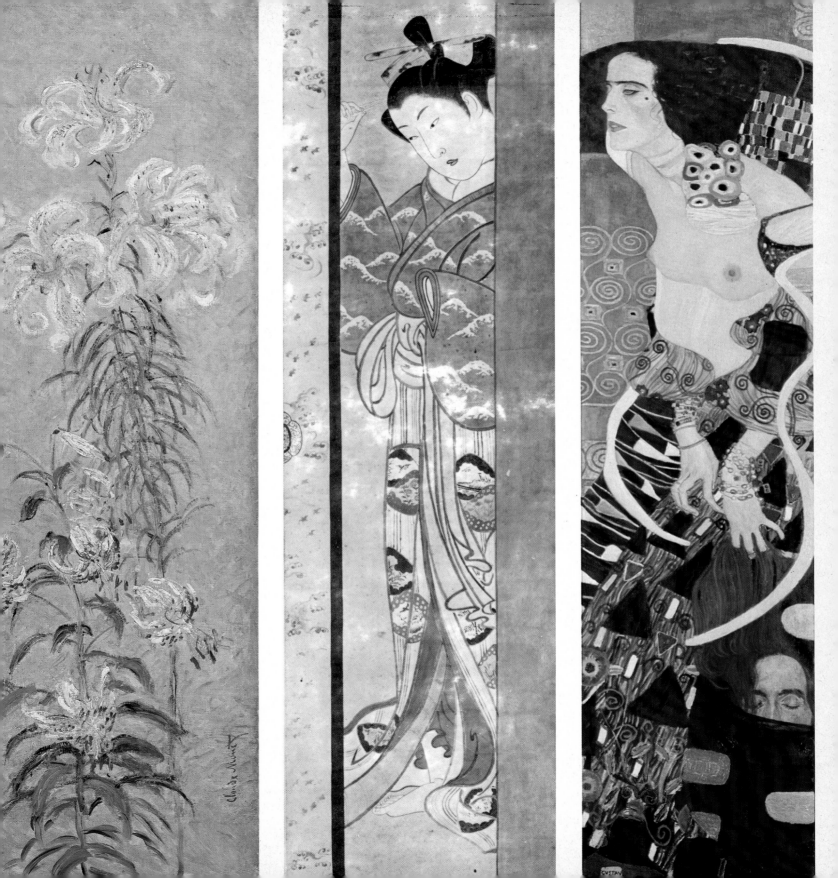

*East and
South-East*

*Asia
Methods of
Composition*

732–1037

different character from lines in the European tradition. The brush strokes in *suiboku-ga*, or ink wash painting, represent much more than the visual form of an object, as they can communicate the painter's feeling directly and vividly. The expressive brush strokes executed in various tones ranging from intensive black to subtle grey represent planes and three-dimensional masses without representing cast shadows of nature, rather than showing the mere outlines of the object. They also suggest texture, weight, movement, and even colour, thereby revealing the intrinsic beauty of the subject matter. This is especially true in the case of *haboku* painting, a particularly subjective branch of *suiboku* in which the subject matter is suggested with a minimum number of brush strokes. *Haboku* first appeared in China in the late T'ang Dynasty and further developed during the Five Dynasties and Sung periods under the strong influence of Zen Buddhism. It was introduced into Japan in the fourteenth century, and much later, painters in the eighteenth century adapted the brush technique of *haboku* to their sketchy polychrome paintings. This style of brushwork in colour is called *tsuketate*.

In the late 18th and 19th centuries, many Japanese painters and amateurs interpreted their poetic sentiment through sketchy paintings which we call *haiga*, done either in *suiboku* or *tsuketate*. The *haiga* was originally a painting done alongside a *haiku* poem as a kind of illustration of its mood and idea. However, *Haiga* may also be a completely independent, abbreviated painting or drawing which reflects a poetic feeling similar to a *haiku* in its compact, symbolic form. Quite a few *haiga* and similarly abbreviated style paintings found their way to Europe in the late 19th century, and we begin to feel their penetration into the western art tradition from that time on. Toulouse Lautrec's ink brush drawing of a fisher and another man in a boat, which Jedlicka found in the collection of Tapié de Céleyran and illustrated in his book on Lautrec as a "bestimmter Beweis dafür, daß sich Lautrec mit der Art der japanischen Pinselführung beschäftigt hat" seems to have been copied directly from *haiga*. Jedlicka found two more similar drawings by Lautrec in the same collection, and according to Tapié de Céleyran there had been many similar drawings by Lautrec which have been lost. He also reported that in the same collection were found a Japanese ink-stone *(suzuri)*, a *sumi* stick and Japanese brushes which Lautrec had ordered especially from Japan.

Lautrec was probably the first European painter to fully understand the real artistic meaning of the power of the brush in *suiboku* paintings. The Impressionists had appreciated the *ukiyo-e* prints, and apparently Japanese polychrome paintings, too. They possibly even enjoyed the simple *haiga*, but if so, only as witty and clever sketches. They were not especially drawn to the special character of line and the play of the brush. Manet might have been an exception in understanding the Japanese brush stroke. Anne Coffin Hanson is probably correct in her comment in the catalogue of the Manet Exhibition held in Philadelphia and Chicago in 1966/67: "Certainly his illustrations for Le Corbeau were influenced by Japanese brush drawings such as the painted crows included in Duret's and Gonse's publications."

I also suspect there is some influence of Japanese ink painting in some of his drawings and even in some of his paintings. However, in the case of the Corbeau, there is no such brush stroke with the expressive power that Lautrec drew in imitation of the Japanese stroke. Although Degas learned so much from Japanese prints for his compositions and the pose of his figures, the lines which he used so effectively seem to stem from the European tradition. By contrast the linear element of van Gogh's paintings after 1888 seems to have come from his study of Japanese prints. However, his strong painterly lines do not show any of the characteristics of the flowing Japanese brush strokes which we see in Japanese paintings or brush drawings.

In order to paint in the style of Japanese *suiboku-ga* with expressive brush strokes, the painter must have crystallized the image in his mind before taking up his brush. Once he puts brush to paper, he draws out the image created in his mind's eye, built up only after concentrated study of the subject matter. He does not proceed to paint by looking from subject matter to canvas as did the painters of the European tradition, and this opposite approach taken by the Japanese painter was contradictory to the principle of the Impressionists. It was also opposed to the

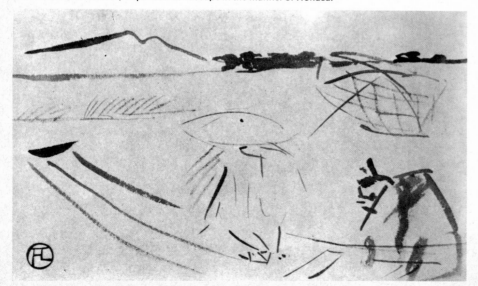

944 Toulouse-Lautrec, Japanese Landscape in the manner of Hokusai

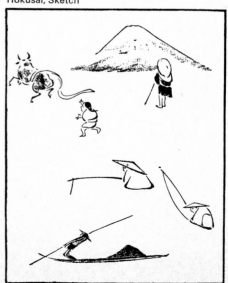

Hokusai, Sketch

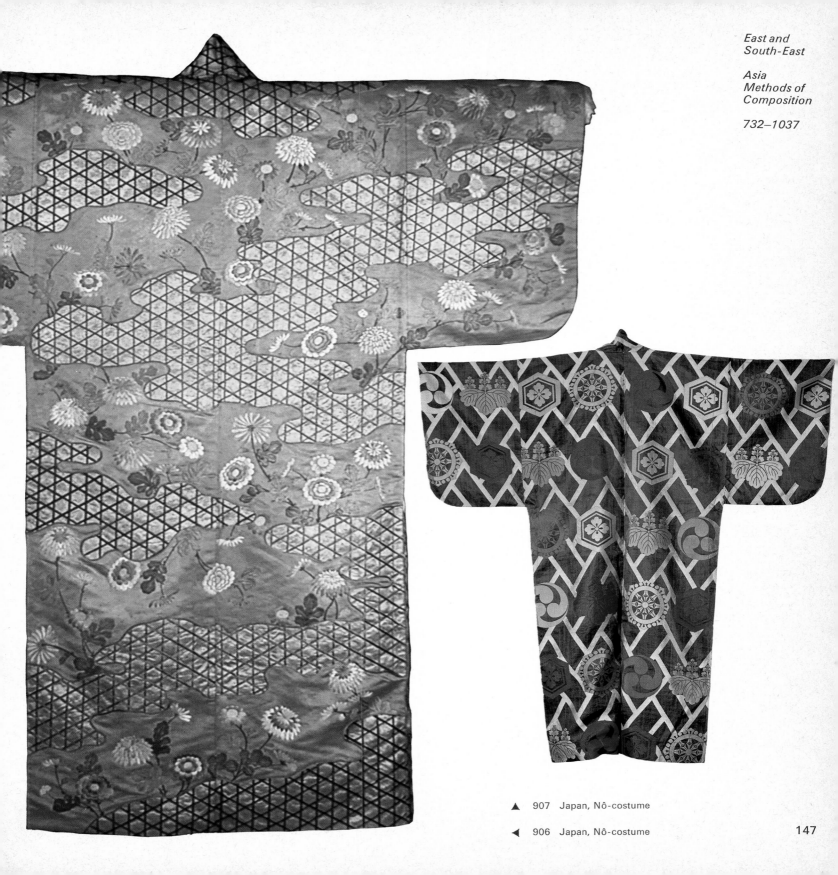

East and
South-East

Asia
Methods of
Composition

732–1037

▲ 907 Japan, Nô-costume

◄ 906 Japan, Nô-costume

147

*East and
South-East*

*Asia
Methods of
Composition*

732–1037

artistic attitude of the so-called Post-Impressionists. Stronger subjectivism in art developed in Europe after 1890 with Lautrec's generation born in the 1860's. Apart from the brush sketches which Lautrec copied freely from Japanese paintings or drawings such as the one mentioned above by Jedlicka, a simple brush drawing representing a scene at the Circus Fernando, dating from 1888, is an early example of his adaptation of Japanese brushwork. In this piece one can easily recognize the Japanese origin of his line, in the way he has trained his brush strokes to evoke lively figures through sparing use of lively lines. His monotype *Conversation* dating from 1899, now in a German private collection, demonstrates how well he had mastered the element of brushwork in Japanese *suiboku* painting for his own artistic use. Lautrec applied his knowledge of line to his lithographs to great advantage. In the lithograph of *Jane Avril*, from the series *Café Concert*, 1893 (Delteil No. 28), he completes the whirling movement of the dancing girl with just a few swinging lines outlining her fluttering skirt. In *Paula Brebion* from the same series (Delteil No. 30), he succeeds in depicting the charm of a *chansonniere* through a minimum of sensitive lines in which so much is implied. Her whole feature and personality emerge from this simple line drawing. His famous poster, *Mary Milton*, made in 1895 is another good example. Lautrec also applied this secret of expressive line learned from Japanese *suiboku* painting to his oil paintings. We cannot be sure about the origin of the graphic lines he used in many of his oils; however, there are a number of his paintings with lively, bold lines in which the influence of the Japanese brush stroke is clearly visible. The nude in the *Femme qui tire son bas* painted in 1894, now owned by the Louvre, is a good example. From the lesson drawn from the Japanese brushwork, he developed a more personal style of expressive and sensitive lines, which we see in his last great work *L'Amiral "Viau"* in the Chateaubriand Collection. This is the masterpiece in which the great tradition of Japanese *suiboku* painting is so wonderfully merged into the art of the West, opening up new horizons of expression.

After Lautrec, the expressive line drawn with a brush became a common stylistic technique among European painters. It is now difficult, and perhaps impossible to tell whether Rouault's only inspiration for his bold, powerful lines was from the lead outlines of Gothic stained glass windows, or whether he also learned

from Lautrec's use of line. In the case of his gouaches, watercolours and graphic works, one is tempted to suspect a strong Lautrec influence. He more likely learned from both, and possibly also from Japanese paintings as well, since we know that he admired both Japanese paintings and prints. Of course, even after Lautrec, there appeared a number of painters who did learn directly from Japanese *sumi* painting. The fact remains, however, that after Lautrec, the innate nature of line

in Western painting changed and gained an extra dimension from its contact with Japanese works.

944 *Henri de Toulouse-Lautrec; Japanese landscape in the manner of Hokusai;* ink and brush on paper 12.5 × 20.5 cm; sig. bottom right: monogram; c. 1894 Dortu 3.525; Exhib. Cat. Paris 1951, Musée de l'Orangerie, Lautrec, Cinquantaine, Cat. No. 134; Exhib. Cat. Paris 1959, Musée Jacquemart-André, Toulouse-Lautrec; Exhib. Cat. Tokyo 1968 and 1969; Exhib. Cat Kyoto and Tokyo, Cat. No. 68; priv. coll.; plate

945 *Saigyo Hosshi (1119–1190) Wandering Monk;* ink on paper; sig. bottom left; Tokyo, Idemitsu Coll.

946 *Henri de Toulouse-Lautrec; May Milton;* poster; lithograph 78.5 × 59.6 cm; c. 1895; Paris, Bibliothèque Nationale, Cabinet des Estampes

947 *Henri de Toulouse-Lautrec; Jane Avril;* poster; lithograph; 78 × 60 cm; c. 1896; Paris, Bibliothèque Nationale, Cabinet des Estampes; plate

948 *Henri de Toulouse-Lautrec; May Belfort;* poster; lithograph 78.8 × 60 cm; c. 1895; Paris, Bibliothèque Nationale Cabinet des Estampes

949 *Henri de Toulouse-Lautrec; illustration for "Histoires Naturelles" by Jules Renard;* lithograph; c. 23 × 18 cm; published 1900 by Floury; Paris, Bibliothèque Nationale, Cabinet des Estampes

950 *Henri de Toulouse-Lautrec; The Japanese Divan (Le Divan Japonais);* poster, lithograph; 79.5 × 59.5 cm; c. 1892; Paris, Bibliothèque Nationale, Cabinet des Estampes

951 *Pierre Bonnard (Foutenay-aux-Roses 1867–1947 Le Cannat); illustrations to "Histoires Naturelles" by Jules Renard;* lithograph; c. 23 × 18 cm; published by Flammarion; Paris, Bibliothèque Nationale

952 *Katsushika Hokusai (Tokyo 1760–1848); Ducks from the Book "Ippitsu gafu";* coloured woodcut; 21.8 × 16.5 cm; c. 1823; Cologne, Mus. für Ostasiatische Kunst

953 *Katsushika Hokusai; Frogs and Tortoises;* from the Book "Ippitsu gafu"; coloured woodcut; 21.8 × 16.5 cm; c. 1823; Cologne, Mus. für Ostasiatische Kunst

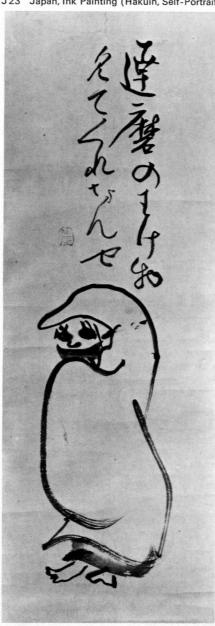

J 23 Japan, Ink Painting (Hakuin, Self-Portrait),

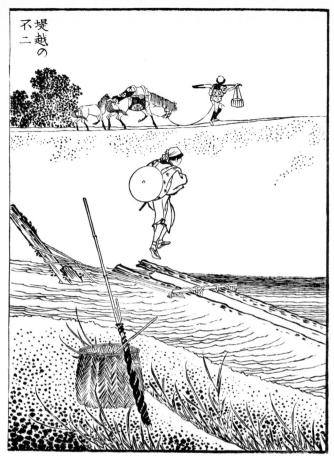

974 Hokusai, from "Hundred Views"

957 van Gogh, Park

Far-Eastern „Dash-Dot-Line" Duct in the Work of van Gogh

The inception of a decisive transformation can be observed in van Gogh's work during 1887/88. He began to examine Japanese and Chinese painting techniques and employed them in various forms in his work. The artist thereby goes through the same experience of Far-Eastern reception already made in Europe in respect of motif composition, partition and the beauty of diaphanous surface colour. He wrote to his brother Theo: "The exhibition of Japanese prints, which I gave in the "Tamburin," has had quite an influence upon Anquentin and Bernard..." Moreover, van Gogh recognized the specific artistic techniques in Japanese art which were important for his own work. The surface colours of Bernard, Anquentin and Cassat are thus intended to appear only secondarily in

van Gogh's work; he combines the bright colour surface with the brush stroke to achieve extreme unity. This is not performed in the sense of the optical mixture of the Neo-Impressionists; under the influence of Japanese-Chinese painting, van Gogh develops via the bamboo-pen rhythmic pigment structures that express more than only colour suggestions. He creates the motional sequences and currents in nature, and also in the posture and movement of every mobile object, in an individualistic manner. The painter constructs a point and comma stroke system for himself, and we note how he uses it symmetrically always under the influence of Far-Eastern techniques. In this learning process, van Gogh pursues a sure and steady path; above all, he observes the drawing and engraving techniques of the Japanese and thus, indirectly, also those of their tutors – the Chinese. S. W.

Summary and Translation G. F. S.

954 *Vincent van Gogh; View on to Arles;* oil, canvas; 54×65.5 cm; May 1888; De La Faille 409; Amsterdam, Rijksmus. Vincent van Gogh

955 *Vincent van Gogh; La Crau seen from Montmajour;* crayon, pen and bamboo-pen on paper; 48×60 cm; sig. and titled bottom left: Vincent; May 1888; De La Faille 1420; Amsterdam. Rijksmus. Vincent van Gogh

956 *Vincent van Gogh; Thistle Garden;* ink on paper; 24.5×32 cm; October 1888; De la Faille 1466; Amsterdam, Rijksmus. Vincent van Gogh

957 *Vincent van Gogh; In a public Garden;* pen and ink on paper; 32× 24 cm; Arles 1888; De la Faille 1477; Amsterdam, Rijksmus. Vincent van Gogh; plate

958 *Vincent van Gogh; The Sower on the Field;* on paper; 24×32 cm; June

149

East and
South-East
Asia

Methods of
Composition

732–1037

1888; De la Faille 1441; Amsterdam; Rijksmus. Vincent van Gogh

959 *Vincent van Gogh; Rhône Bridge;* pen on paper; 24×31 cm; summer 1888; De la Faille 1507; Amsterdam, Rijksmus. Vincent van Gogh

960 *Vincent van Gogh; Corner in a Park;* pencil and crayon on paper; 30×20.5 cm; Saint-Rémy 1889; De la Faille 1571; Amsterdam, Rijksmus. Vincent van Gogh

962 *Vincent van Gogh; Two Pines;*

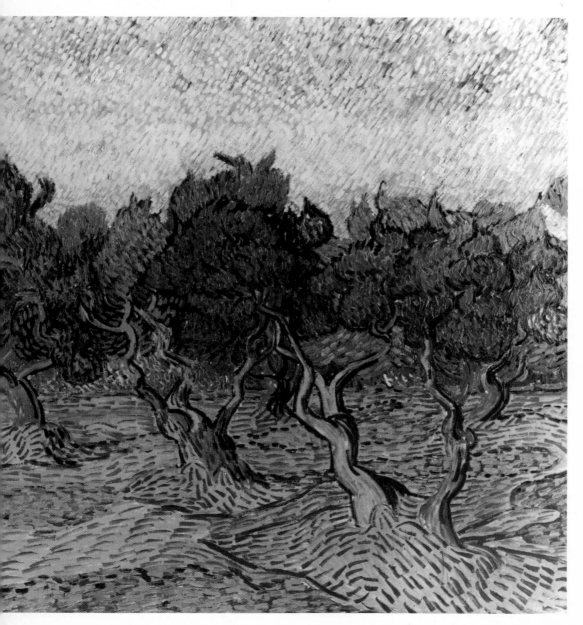

pencil on paper; 30×20.5 cm; Saint-Rémy 1889; De la Faille 1579; Amsterdam, Rijksmus. Vincent van Gogh

963 *Katsushika Hokusai (Tokyo 1760–1849); Fuji seen from South, Fishing Boats in Foreground;* page 4 from Vol. 1 of "The Hundred Views of Fuji," "Fugaku hyakkei"; woodcut; 18.2×25 cm; sig.: Gakyô Rôjin-manji; c. 1834; Vienna, Österreichisches Mus. für angewandte Kunst, Exner Bequest

964 *Katsushika Hokusai; Fuji over Rice-Fields; top right, a Chapel of the*

tutelary God Inari of the Rice Farmers; page 30 from the Vol. 1 of "The Hundred Views of Fuji," "Fugaku hyakkei"; woodcut; 18.3×25.1 cm; sig.: Gakyô Rôjin-manji; c. 1834; Vienna, Österreichisches Mus. für angewandte Kunst, Exner Bequest

965 *Katsushika Hokusai; A Procession of Pilgrims at the Festival "Opening" of the Fuji; Descent of the Pilgrims through the steep lava Fields of the Volcano;* pages 5 and 6 from Vol. 1 of "The Hundred Views of Fuji," "Fugaku hyakkei"; woodcut; 18.4×12.5 cm; sig.: Gakyô Rôjin-manji; c. 1834; Vienna, Österreichisches Mus. für angewandte Kunst, Exner Bequest

966 *Katsushika Hokusai; View of Fuji seen from a Cave; two Woodcutters in Foreground – Fuji between two Bales of Rice;* pages 17 and 31 from Vol. 1 of "The Hundred Views of Fuji," "Fugaku hyakkei"; woodcut; 18×12.2 cm; sig.: Gakyô Rôjin-manji; c. 1834; Vienna, Österreichisches Mus. für angewandte Kunst, Exner Bequest

967 *Katsushika Hokusai; View of Fuji from the East over the Gulf of Tokyo; harbour Scene in Foreground;* page 27 from Vol. 3 of "The Hundred Views of Fuji," "Fugaku hyakkei"; woodcut; 18.2×25 cm; sig.: Gakyô Rôjin-manji; c. 1834; Vienna, Österreichisches Mus. für angewandte Kunst, Exner Bequest

968 *Katsushika Hokusai; Two Priests and a Layman in front of Entrance to a Temple; in Background, Fuji, in Foreground, a Farmer and two Peasants;* pages 16 and 17 from Vol. 3 of "The Hundred Views of Fuji," 'Fugaku hyakkai"; woodcut; 18.2×12.5 cm; sig.: Gakyô Rôjin- manji; c. 1834; Vienna, Österreichisches Mus. für angewandte Kunst, Exner Bequest

969 *Katsushika Hokusai; Fuji in Mist; two Farmers in Foreground; Fuji seen through Opening in Wall; three Figures in Foreground;* pages 33 and 34 from Vol. 3 of "The Hundred Views of Fuji," "Fugaku hyakkei"; woodcut; 18× 12.5 cm; sig.: Gakyô Rôjin-manji; Vienna, Österreichisches Mus. für ange-wandte Kunst, Exner Bequest

970 *Katsushika Hokusai; View of Fuji through Bamboo Wood;* page 3 from

976 van Gogh, Olive Trees (detail)

Vol. 2 of "The Hundred Views of Fuji,"
"Fugaku hyakkei"; woodcut; 18.2 ×
25 cm; sig.: Gakyô Rôjin-manji; c. 1835;
Vienna, Österreichisches Mus. für ange-
wandte Kunst, Exner Bequest

971 *Katsushika Hokusai; View of Fuji
through Portal over Moor of Musashino
in Province Sagami;* pages 31 and 32
from Vol. 3 of "The Hundred Views of
Fuji," "Fugaku hyakkei"; woodcut;
18×12,4 cm; sig.: Gakyô Rôjin-manji;
Vienna, Österreichisches Mus. für ange-
wandte Kunst, Exner Bequest

972 *Katsushika Hokusai; Huts in a
Village;* page 34 from Vol. 3 of "The
Hundred Views of Fuji," "Fugaku
hyakkei"; woodcut; 18×12.4 cm; sig.:
Gakyô Rôjin-manji; c. 1834; Regens-
burg, Franz Winzinger Coll.

973 *Katsushika Hokusai; Farmers and
Porters in front of Fuji;* page 46 from
Vol. 2 of "The Hundred Views of Fuji,"
"Fugaku hyakkei"; woodcut; 18×
12.4 cm; sig.: Gakyô Rôjin-manji;
c. 1834; Regensburg, Franz Winzinger
Coll.

974 *Katsushika Hokusai; Porters on a
Shore Road, in background Fuji;* page 13
from Vol. 3 of "The Hundred Views of
Fuji," "Fugaku hyakkei"; woodcut;
18×12.4 cm; sig.: Gakyô Rôjin-manji;
c. 1834; Regensburg, Franz Winzinger
Coll.; plate

975 *Katsushika Hokusai; Two old Men;*
page 9 from Vol. 3 of "The Hundred
Views of Fuji," "Fugaku hyakkei"; wood-
cut; 18×12.4 cm; sig.: Gakyô Rôjin-
manji; c. 1834; Regensburg, Franz
Winzinger Coll.

976 *Vincent van Gogh; Olive Trees on
red Earth;* oil, canvas; 73×92.5 cm;
Saint-Rémy 1890; De la Faille 707;
Amsterdam, Rijksmus. Vincent van Gogh;
plate

European Symbolism around 1900 and the Influence of Hokusai's Spectres

The Japanese spectral cult, which
dominated everyday life and, as the
central theme of the Kabuki folk theatre,
found its climax in the Nô play, became
well-known in Europe from the woodcut,
especially from Hokusai's engravings in
the Manga series. The courage to deform
the figure, which Hokusai could well
develop to the point of grotesqueness,
shows that the cultic, bizarre and folklore
components constituted a unity. Much
of what was profound and existential
excited the European, notably Odilon
Redon, who would seem to have found a
confirmation of his own inclinations in
the work of Hokusai. Certainly, he was
also influenced by Goya, but the con-
firmation was supplied by Hokusai.
Although we only touch upon his rela-
tionship to Far-Eastern art here, it
suffices to bring the symbolistic–
surrealistic elements of his graphic art
into perspective. The characteristic
feature of these sheets is the dream-like,
spectral element already encountered
in Hokusai. His so-called "Noirs," with
their specialized blacked-in space,
contrast with the accuracy of concrete
representation but harmonize with the
darkness of their significance.
Hokusai transforms the human being
into an alienated organism focusing upon
the grotesque, the fiendish, but without
becoming abstract. Here, we discover
a linking point for Alfred Kubin, who
had studied the Japanese and especially
Hokusai, but also received impulses from
Rops, Redon, Ensor, Munch and Goya.
In 1903, Kubin appeared before the
public with a portfolio published by
Hans von Weber – an event of outstand-
ing importance. In the same way as
Edvard Munch, who struggled with the
hardship of his environment, Kubin was
susceptible to dark and mysterious
views of life. His style changed in 1911.
The "Sansara" portfolio reveals a thin-
lined calligraphy; the fantastic and
weird depiction moves out of the real
and into the unreal sphere and shows
a tendency towards abstraction. Both
Redon and Kubin demonstrate that,
in its modern development, European art
received decisive impulses from the
content and themes of the Japanese
woodcut shortly before the turn of the
century. S. W.

Summary and Translation G. F. S.

977 *Odilon Redon (Bordeaux 1840–
1916 Paris); Limbes;* page 4 from the
series of 10 sheets "Dans le Rêve";
lithograph; 30.7×22.3 cm; sig. bottom
left: Odilon Redon; 1879; Mellerio 30;
Bremen, Kunsthalle

978* *Odilon Redon; The Cyclops;* oil,
wood; 64×51 cm; c. 1900; Otterlo, Mus.
Kröller-Müller; plate

992 Redon, Fabulous Being

979 *Alfred Kubin (Leitmeritz, Bohemia
1877–1959 Castle of Zwickledt near
Wernstein, Upper Austria); Horror;* ink
(pen), wash, on cadastre paper; 27.3×
27.3 cm (margin); 32.5×30.8 cm (sheet);
sig. bottom right: Kubin; sig. bottom
centre: Horror; 1900–1903; Landshut,
Karl Russ Coll.; plate

980 *Alfred Kubin; Parade;* ink (pen),
wash, on cadastre paper; 20.3×17.3 cm
(margin), 38.7×31.8 cm (sheet); sig.

Hokusai,
from "Manga"

East and
South-East
Asia

Methods of
Composition

732–1037

◄◄ 1010 Hokusai, Fantastic Picture

◄ 1007 Kubin, Dispute

987 *Utagawa Kuniyoshi (Katsushika near Tokyo 1786–1865); Otome, The Fox Spirit;* from "Japanese and Chinese Stories in Imitation of the Genji-Novel, Chapter 'Otome'"; coloured woodcut, ôban 37 × 23.8 cm; sig.: Ochiyûsai Kuniyoshi ga; engraver's stamp: Shô Ji; imprint: Ise (-ya); Imprimatur stamp: Aratame; date stamp: zodiac, hare, seventh month = 1855; Berlin, Mus. für Ostasiatische Kunst

988 *Alfred Kubin; The Ocean Spirit;* paste colour on paper; 30 × 36 cm; Salzburg, Gall. Welz

989 *Odilon Redon; The Siren (La sirène sortit des flots, vêtue de dards);* page 4 of a series of eight sheets "Les Origines"; lithograph; 30 × 23.5 cm; 1883; Mellerio 48; Paris, Bibliothèque Nationale, Cabinet des Estampes

990 *Odilon Redon; White female Body with Skull (C'est une tête de mort, avec une couronne de roses, elle domine un torse de femme d'une blancheur nacrée);* page six of a series of ten sheets "Saint Antoine"; lithograph; 29.6 × 21.3 cm; 1888; Mellerio 89; Paris, Bibliothèque Nationale, Cabinet des Estampes

991 *Odilon Redon; Fabulous Beast (Une femme tournée vers la gauche et pourtant sur la tête une toque ornée de plumes. Son long corps mince rejette le buste en arrièrre faisant saillir la poitrine en une courbe gracieuse de ligne);* lithograph; 26 × 24 cm; 1900; Mellerio 188; Paris, Bibliothèque Nationale, Cabinet des Estampes

992 *Odilon Redon; Fabulous Being (Ensuite paraît un être singulier ayant une tête d'homme sur un corps de poisson);* page five of a series of ten sheets "Tentation de Saint-Antoine," text by Gustave Flaubert; lithograph; 27.5 × 17 cm; 1888; Mellerio 88; Paris, Bibliothèque Nationale, Cabinet des Estampes; plate

993 *Utagawa Kunisada (1785–1865 Tokyo); The Actor Matsumoto Kôshirô V. in the Part of a female Magigian Nikki Danjô from the Drama "Date Kurabe Okuni Kabuki";* coloured woodcut, ôban 37.8 × 25.5 cm; sig. Ichiyûsa Kunisada ga; imprint: Eijûdô; Imprimatur stamp: Kiwame; date stamp: 1812;

bottom right: Kubin; 1897; Linz, Oberösterreichisches Landesmus.

981 *Odilon Redon; The Dream fulfils itself in Death (La Rêve s'achève par la mort);* illustrations to "Le Jure" by Edmond Piccard, Brussels 1886; lithograph; 23.8 × 18.7 cm; sig. top right: Odilon Redon; 1887; Mellerio 81; Paris, Bibliothèque Nationale, Cabinet des Estampes

982 *Odilon Redon; Apparition (Je vis dessus le contour vaporeux d'une forme humaine);* illustration to "La Maison Hantée," text by Bulwer-Lytton, Paris 1896, Edition Clot; lithograph; 25.3 × 18.1 cm; 1896; Mellerio 161; Paris, Bibliothèque Nationale, Cabinet des Estampes

983 *Katsushika Hokusai (Tokyo 1760–1849); The murdered Kasané appears*

before her Husband; page from the "Manga," Assorted Sketches, Vol. 10; woodcut, duotone print, facsimile; kôban 23.8 × 15 cm; 1812–1875; Tokyo, Yujiro Shinoda; plate

984 *Utagawa Kuniyoshi (Tokyo 1798–1861); Minamoto Raiko and the Eearth Spider;* from the series "Local and Chinese Parallels to the Genji-Novel"; coloured woodcut, ôban 39 × 26 cm; 1855; Düsseldorf, Willibald Netto Coll.

985 *Utagawa Kuniyoshi; Kite-flying in the first Month;* from the series "The five Festivals," coloured woodcut, center part of a triptych; 1845; Düsseldorf, Willibald Netto Coll.

986 *Alfred Kubin; Furies;* illustration to "Adventure of a Drawing-pen" by Alfred Kubin, München 1941; München, Bayerische Staatsbibliothek

152

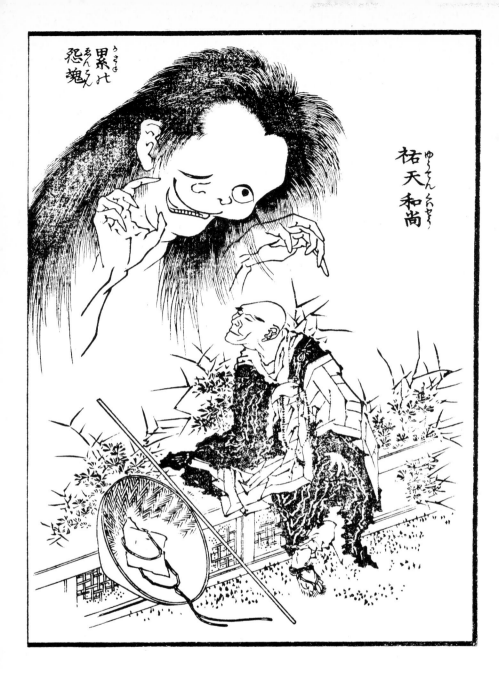

東京怨魂

拓天和尚

East and
South-East
Asia

Methods of
Composition

732–1037

▲ 978 Redon, Cyclops

◄ 983 Hokusai, Kasané

997 *Katsushika Hokusai; Evocation of
Spirits;* page from the "Manga," Assorted
Sketches, Vol. 10; woodcut, duotone
print, facsimile, kôban 24×14.5 cm;
1812–1875; Tokyo, Yujiro Shinoda

979 Kubin, Horror (detail)

Münster, Theodore Scheiwe Coll.

994 *Andô Hiroshige (Tokyo 1797–
1858); Flying Japanese Woman (Ejiri);*
page 29 from the series: "The Fifty-three
Stations Tôkaidô," "Tôkaidô Gojûsan
Tsugi"; coloured woodcut; 35.8×23.4
cm; sig.: Hiroshige ga (poem); c. 1844–
1846; Cologne, Mus. für Ostasiatische
Kunst

995 *Utagawa Kunisada; The Actor
Onoe Matsusuke II as Ghost of the Cour-*
tesan from "Kasanegafuchi"; coloured
woodcut; ôban 38×25.5 cm; sig.:
Gogotei Kunisada ga; imprint: Izumi ichi;
1820–1930; Vienna, Österreichisches
Mus. für angewandte Kunst, Exner
Bequest

996 *Katsushika Hokusai; Encounter
with a Spirit;* page from the "Manga,"
Assorted Sketches, Vol. 5; woodcut,
duotone print, facsimile, kôban 24×
14.5 cm; 1812–1875; Tokyo, Yujiro
Shinoda

East and
South-East
Asia

Methods of
Composition

732–1037

998 *Odilon Redon; Swamp Flower (La fleur de Marcécage, une Tète humaine et triste); page 2 of a series of six sheets "Hommage à Goya" lithograph; 27.5× 20.5 cm; sig. bottom left: Odilon Redon 1885; Mellerio 55; Paris, Bibliothèque Nationale, Cabinet des Estampes

999 *Odilon Redon; Swamp Flower;* charcoal on paper; 40.5×33 cm; 1885; Chicago, Art Institute

1000 *Odilon Redon; Primordial Being (Il y eut peut-être une vision première essayée dans la fleur); page 2 of a series of eight sheets "Les Origines"; lithograph; 21.3×20 cm; 1883; Mellerio 46; Paris, Bibliothèque Nationale, Cabinet des Estampes

1001 *Katsushika Hokusai; The Plate Spirit of the Okiku; one of the five published spectral pictures from the series "Hundred Tales," "Hyaku mono-gatari";* printed 1830 by Tsuruya; colour-ed woodcut; chûban 25×18.7 cm; sig.: Zen Hokusai hitsu; Vienna, Österreichi-sches Mus. für angewandte Kunst, Exner Bequest

1002 *Katsushika Hokusai; Kohada Koheiji's Skull appears before his Mur-derer, the Lover of his Wife, as a Ghost at the burning Mosquito-net;* from the series "Hundred Tales," "Hyaku Mono-gatari"; coloured woodcut, chûban 25.2×19 cm; sig.: Zen Hokusai hitsu; imprint: Tsuru (-ya) Ki(emon) ha; c. 1837; Berlin, Mus. für Ostasiatische Kunst

1003 *Odilon Redon; Cyclops (Le polype difformé flottait sur les rivages, sorte de cyclope souriant et hideux); page 3 from a series of eight sheets "Les Origines"; lithograph; 21.3×20 cm; 1883; Mellerio 47; Paris, Bibliothèque Nationale, Cabi-net des Estampes; plate

1004 *Katsushika Hokusai; The Lantern Spirit of the O-Iwa; one of the five published Spectral-Pictures;* from the series "Hundred Tales," "Hyaku mono-gatari"; printed 1830 by Tsuruya; colour-ed woodcut, chûban 24×18 cm; sig: Zen Hokusai hitsu; Vienna, Österreichisches

1004 Hokusai, Lantern Spirit

1003 Redon, Cyclops

Mus. für angewandte Kunst, Exner Bequest; plate

1005 *Alfred Kubin; A Dream comes to us every Night;* ink (pen and brush) washed and sprayed on cadastre paper, 26.3× 23.5 cm (margin), 39.3×31.8 cm (sheet); sig. bottom centre: Kubin and bottom right: A Kubin; 1900–1903; Vienna, Graphische Slg. Albertina

1006 *Katsushika Hokusai; Flying Spirit;* Page from the "Manga", Assorted Sketches, Vol. 3; woodcut, duotone print, facsimile; kôban 24×14.5 cm; 1812–1875; Tokyo, Yujiro Shinoda

1007 *Alfred Kubin; Animated Dispute;* ink (pen) on cadastre paper; 23.2×15.5 cm (margin); 31.5×19.5 cm (sheet); sig. bottom right: Kubin; c. 1912; Linz, Ober-österreichisches Landesmus.; plate

1008 *Alfred Kubin; Struggle for the Corpse of Patroclus;* ink (pen), water colour on cadastre paper 22.8×32.1 cm (margin); 31.7×39.7 cm (sheet); c. 1915; Vienna, Graphische Slg. Alber-tina

1009 *Katsushika Hokusai; Apparitions of Ghosts;double page from the "Manga" Assorted Sketches; Vol. 12; woodcut, duotone print facsimile; kôban 24× 14.5 cm; 1812–1875; Tokyo, Yujiro Shinoda

1010 *Katsushika Hokusai; Fantastic Picture;* double page from the "Manga" Assorted Sketches, Vol. 12; woodcut, duotone print, facsimile; Kôban 24× 14.5 cm; 1812–1875; Tokyo, Yujiro Shinoda; plate

"Abstractions" in Landscape-Representations of Japanese Chrome Wood-Engraving

Siegfried Wichmann

I.
"As elsewhere in Far-Eastern art, a certain measure of 'abstraction' not only does not impair concreteness, it can even inten-sify it in that it is sublimated to a higher aesthetic form" (Dietrich Sickel: Emaki, Munich, 1959, p. 52).
It is a striking fact that the late Ukiyo-e masters favour the chance occurrences of nature in their strictly stylized land-scapes. Hokusai and Hiroshige select the sensations in the sequence of a land-scape in order to transform the effect of reality into ciphered, individual pictorial events: incipient rainstorms, wind and cold, the ocean with gigantic waves, crashing waterfalls, darkened chasms, nocturnal light effects, jagged rocks in the sea. The stranger the phenomenon the bolder the interpretation becomes. The concrete element in the descriptions of nature is enhanced and the embodied contradictions, which lead to the creative tension, possess a decorative melodic character that strangely affected and stimulated European artists at the turn of the century. Hokusai's waterfalls are fantastical sensations of natural phenom-ena, which culminate in interlaced orna-mental systems. The Ukiyo-e masters worked according to an artistic principle that followed the formal character of every natural event.
The waterfalls are giant frozen crystals, but still motivated; the rectilinear system prevails in many representations but can

be transformed into numerous streamlets within a huge network of channels. The curved element then becomes the extreme of the rectilinear. There are, however, countless interposed form characters which continually surprise the observer. The waterfalls can assume a digital shape or, evoking the outward shape of a conch shell, spiral into a turbulent vortex, always ready to transmute into larger ornament: elegant and bizarre, the effect of reality is concentrated to a degree which nineteenth century European painters had not yet perceived.

Hokusai's wave is an example of this non-naturalistic conception, which develops functions in its linear construction that allude to the dynamic character of the natural event.

Strict and informal, placid and violent, weird and simple, these are the characteristics of natural entities in Japan. Above all, it is the simple things that are conspicuous: the smoothly contoured bamboo forest, the tall and slender cedar, the straighted ridge of hills, the symmetrically sloped Fuji, everything seems reduced to the observer — nature itself provides the stylizing. Banks of mist in the rain draw in the perimeter of the natural region, the haze reduces the volume of concrete things to a shadowy surface; when the natural events become more violent, action pervades the landscape. Tracts of rain cut across the picture surface dia-

gonally like a trellis-work, the waves of the ocean surge forward like a leaden swell. The colours of the sky appear to be graded in chromatic intensity, the colours of earthly things can be reproduced in conformity with all their intrinsic value. The aesthetic value of the colours is allocated congruently to the stylizing intrinsic value, so that the vivid colour frequently appears to be independent of whatever bears it. The pronounced colour accents are set against a rich tone variation which Hokusai allocates evenly to the near and distant spaces.

In its intensity, however, this colour value reveals a tendency to overcome imitative realism. Codification of form and "expressive" colourfulness are artistic means characteristic of the avantgarde of European art. Vincent van Gogh recognizes for himself the colour value of the distant colours in a landscape when he writes to his brother Theo:

"But the country here in Arles appears to be flat. I saw a wonderfully red terrain planted with vines, with mountains of the most delicate violet as background. And the landscape under snow, with the white mountain peaks against a sky just as luminous as the snow — it was like the winter landscape of the Japanese" (Fritz Erpel: Vincent van Gogh, Sämtliche Briefe vol. 4, letter 469, p. 14).

The school of Pont Aven also discovered the "abstract" form and colour concept

of the Ukiyo-e masters. Van Gogh again comments to Theo:

"The exhibition of Japan prints which I gave in the 'Tambourin' has had quite an influence on Anquentin and Bernard ... The part that I took so much trouble with for the second exhibition in the hall on the Boulevard de Clichy, causes me less regret ... Without the Japan prints, your rooms would not be what they are" (Ibid., pp. 94–95).

II.
The Japanese woodcut possesses a great capacity of variation, the techniques were greatly differentiated, so that the surroundings to be depicted could be represented in the most splendid transformation. The Shomenzuri, a form of glossy print, transmitted reflexes of the local distribution of light, which European painters had not yet seen in this form. The same applies to prints with gold, silver or copper powder (Kingin zuri). Concrete things were alienated from their environment through printing with mica and brought into an autonomous, seemingly isolated sphere. In addition there were the superb relief printings (Karazuri, Kimekomi), which set the surface in gentle movement with shadow formations. Remote from all naturalistic imitation, these techniques lead into the sphere of "abstraction" without changing the outward shape of the concrete object.

1033 Kunisada, Actor in Thunderstorm

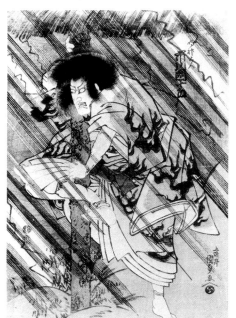

1032 Nolde, Storm

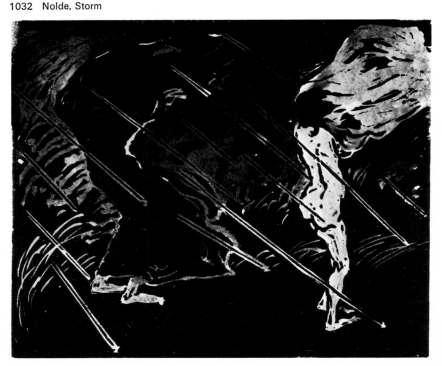

East and
South-East
Asia

*Methods of
Composition*

732–1037

There is a type of picture in Japan called the Bunjin-Cia, the symbolistic landscape. It is the quintessence of "real" nature, which becomes apparent, but must not necessarily be as it appears. It has many different facets. The sky does not have to be blue and trees need not be green. This perception is probably the most decisive made by European painters and it repeatedly appears in van Gogh's letters: "This evening I observed a wonderful and very strange effect. A large heavily loaded coal barge on the Rhône tied to the quay. Seen from above, it was shiny and moist, for there had been a really heavy shower of rain; the water was a cloudy, pearly gray and whitish yellow, the sky a lilac colour with orange streaks in the west, the town was violet. Small, dusty, blue and white labourers came and went as they unloaded the freight — a pure Hokusai" (Ibid., letter no. 516).

Translation G. F. S.

The "Waterfall" — a Japanese Motif and its Adaptation by European Art in the Nineteenth and Twentieth Centuries

Siegfried Wichmann

The waterfall is a central motif of Far-Eastern art. "The Nachi-Waterfall" ranks among the main works of the Kamakura period in the fourteenth century. This picture, painted on silk and measuring 161×69 cm, is in the Nezu museum in Tokyo. The numerous reproductions of the work, which is almost monochrome in its colour effect, do not convey its full significance, for it is more than pure landscape painting, it is representative of Japan's most important cult pictures. Influenced by the deep reverence for nature, the landscape becomes a mirror of divine powers. The steep, en hauteur format depicts, in extremely differentiated colour representation, the axially cascading stream according to a strictly ordered spectrum. "The bright stream", as the waterfall was also called, is at the very centre of nature — it is motive power but power controlled and it monumentally dominates the rocky architecture. This dynamic impression, which cascading water has made upon the Japanese up to the present day, has resulted in a wealth of waterfall representations in Japan of

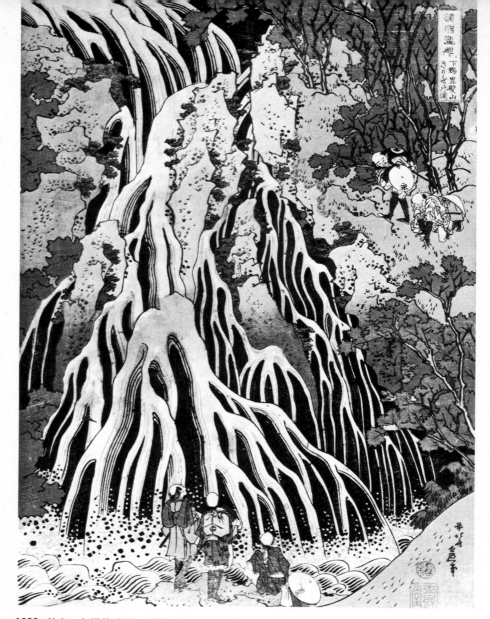

1029 Hokusai, Kirifuri Waterfall

great cultural and art historical importance. It may be mentioned here that in the scrolls (emaki), the waterfall has repeatedly featured as a point where, in the course of its "optical journey", the eye stops and lingers: it is similar to a view-point at which the Japanese was always prepared to experience and revere the beauty of natural phenomena.
In the emaki "Ippon-shonin-eden", scroll II, a late thirteenth century work, Ippon makes a pilgrimage to the Kumao-shinto shrines in the province of kig (in middle Japan), where the 120 metre high Nachi waterfall discharges its surging torrent and is venerated as a sacred being. These observations refer to the old tradition of waterfall representations, which continued into the nineteenth century and subsequently reached a renewed aesthetic climax in the series "Tour of the Waterfalls in the Province" (Shôkoku Taki meguri) by Katsushika Hokusai. The representational limits of the waterfall were clearly demarked: painting instructions such as those in the "Mustard-Seed Garden" define the ordering principle as follows.
The different methods of painting waterfalls: "Rocks are the 'bones' of the moun-

tain. Waterfalls are the 'bones' of the rock. It is said that water has a soft quality. How, then, can it be described as 'bone'? But water can hollow out mountains and split rocks. Its power is infinitely great. For this reason, the painter Jiao Gang (seventeenth century) thought that water was a 'bone'. A small rill and minute drops can become a huge river, a sea. Every drop is the blood and marrow of the world. A bone without marrow is not capable of living. Thus, a mountain receives its 'bones' through the water. The old masters painted waterfalls with extreme care; it is reported that they needed five days to paint a waterfall. Waterfalls can be represented in many different ways. The picture by Huang Gong-wang (1269–1354), for example, shows a waterfall in its entire length that has dug its bed in a green mountain. Where it falls steeply, it gives the effect of 'bone'. There are also the following modes of representation: waterfall between widely dispersed rocks, waterfall interrupted by clouds, three-part waterfall, fine waterfall, large waterfall, waterfall at end of valley, waterfall on steep cliffs, waterfall partly hidden by cliffs, two connecting waterfalls, etc." Hokusai has closely observed the painting instructions in his sequence of eight waterfall studies. Moreover, he has created an even greater differentiation in content, form and colour. Hokusai's waterfall representations are natural scenes, which are each adjusted to their interest-value as a spectacle. His interest in the natural phenomenon waterfall is not imitative, not idyllic, not pantheistic, but participatory in the Buddhist sense with respect to the event; it is a religious, metaphysical conception. Hokusai's deep intimacy with the diverse cycles of movement in waterfalls caused by their geological structure, and his knowledge of meteorological weather cycles, leads him to set cipher-like norms, which convey more than the verism is able to impart.

Hokusai's waterfalls become "abstract" woven textures furnishing the picture surface with an intricate trellis-work, or they stand like great, frozen organ-pipes between wings of towering rock.
When they carve through the rock like strips of silver, they look like the 'bones' of its geological structure. The waterfalls gush from rocky peaks into interconnecting valleys, which give an "ornamentalized" effect.
The waterfalls drop behind silhouetted masses of rock and flow in numerous channels into the valley. It is a manysided representation which Hokusai, follow-

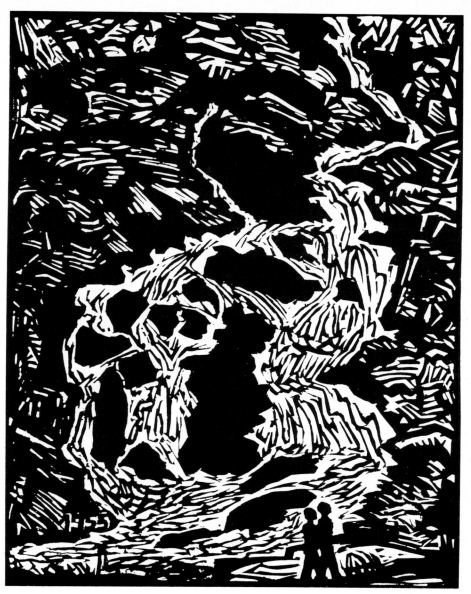

1028 Heckel, Waterfall

ing the accepted rules and inspired by his own fantasy, was able to give. It was precisely this many-sided depiction of a single natural phenomenon which inspired European painters in the second half of the nineteenth century, and more conspicuously around 1900, to adopt waterfall representation in the sense of Hokusai's chrome wood-engravings. All contradicting elements join together in Hokusai's magnified vision of reality. The material value of the waterfall and its surroundings appear autonomous; they are ornamentalized in an increasingly concrete form to the point of transpar-

ency. The waterfall can be represented as a bright surface or as a virtually "self-luminous" ribbon. All contradicting elements combine in a magnified effect of reality which, at a minimum eye distance, captures the natural event in the manner of a lense concentration within the wide-angle scheme. The singular and the plural, emptiness and fulness, depth and proximity, form a unity.
Water, as a multilayered and fluidly-vibrant reflecting medium, spurred impressionism on to a richer selection of subjects. Controlled water current in the shape of the waterfall or fountain, were

157

East and
South-East
Asia

Methods of
Composition

732–1037

given new form in the neo-impressionism of Signac, Cross and Rysselberghe. The artists of the art nouveau and Jugendstil, however, were inspired by the waterfall as represented in Japanese woodcuts. The fountain of Adolph Chudant stands as a bright strip of light in the composition, which is wholly attuned to the sensation of the rising and falling water. In Hans Schmidthals, who has a small collection of Japanese woodcuts, the waterfall cascades in ornamentalized form into the valley, and erupts into a delta-like system. It was possibly he who drew the attention of his friend Henry Obrist to the reverence for nature in Japan.

Obrist, who was specially interested in the systems of natural phenomena and wanted to create a practicable art on the basis of scientific principles, assorted works up to increasingly ciphered and extremely stylized forms in which the waterfall, the wave and the vortex gain central importance.

He calls for a programme according to which the "divine super-powers" are to be represented in the natural sphere. The diction and subjects of Obrist's written works remind one of the painting instructions in Chinese-Japanese art. In Obrist's designs, burning lava often exudes from the rock crevices instead of a waterfall; and when he experiences a waterfall in the mountains, then he draws it in mechanistic association: "Torrent in Riva – unprecedented violence, water from the explosion of a steam-engine, leak in the hull of ship, observed somewhere in the mountains."

Translation G. F. S.

1011 * *Paul Gauguin (Paris 1848–1903 Hivaoa, Marquesas Islands); At the Precipice (Au-dessus du Gouffre);* oil, canvas; 73×60 cm; sig. bottom left: P. Gauguin 88; Paris, Musée des Arts Décoratifs

1012 *Shotei Hokuju (Hokushu) (worked between 1805–1830 in Osaka); The Monkey-bridge in the Province Kai;* coloured woodcut, ôban 26×37.9 cm; sig.: Shôtei-Hokuju ga; imprint: Kiwame and Eikyûdô; London, Victoria & Albert Mus.

1013 *George Lacombe (Versailles 1868–1916 Alencon); The Green Wave (La Vague Verte à Camaret, Bretagne);* tempera, canvas 100×72 cm; sig. on back of canvas: Lacombe, also monogram and

studio stamp; c. 1896; Paris, Mora Lacombe

1014 *Andô Hiroshige; Mountain Gorge with Moon;* from the series "28 Views of the Moon," "Tsuki nijûhakkei"; coloured woodcut, reproduction, large Tanzaku; 37.2×16.5 cm; sig. Hiroshige hitsu Ichiryusai-Stamp; imprint: Yakurindô; 1832; Vienna, Österreichisches Mus. für angewandte Kunst, Legat R. Lieben

1015 *Henri Rivière (Paris 1864–1951); Wave surging on the Rocks and cascading in Spray (Vague frappant le rocher et retombant en arceau. Pointe de Lude Douarnenez);* page 7 of the series: "The Sea. Wave Studies," "La mer. Etude de vague"; coloured woodcut; 22.2× 35.4 cm; 1892; Paris, Bibliothèque Nationale, Cabinet des Estampes

1016 *Georges Lacombe; The Yellow Sea at Camaret;* tempera, canvas 61× 82 cm; sig. bottom right: G. L., on the back: G. L. and studio Lacombe; 1892; Brest, Musée Municipal de Brest

1017 *Andô Hiroshige; The Utsuno-Mountain in Okabe;* from the series "The Fifty-three Stations of Tôkaidô", "Tôkaidôgojûsan tsugi no uchi"; coloured woodcut, ôban yoko-e 22×35 cm; sig: Hiroshige ga; imprint: Hôeidô; collector's stamp; 1832–1834; Vienna, Österreichisches Mus. für angewandte Kunst, Exner Bequest

1018 *Gustave Moreau (Paris 1826–1898); Sketch D'ebauche;* oil, cardboard; 66×31.3 cm; Paris, Musée National Gustave Moreau

1019 *Katsushika Hokusai; The Waterfall of Ono on the Kisokaidô;* from the series of eight sheets "Tour of Waterfalls in the Provinces," "Shokoku taki meguri"; coloured woodcut, ôban 36.3×25.3 cm; sig: Zen Hokusai litsu hitsu (painted by litsu, earlier Hokusai); imprint: Eijûdô (Nishimura-ya Yohachi); Imprimatur stamp: Kiwame; c. 1828/29; Vienna, Österreichisches Mus. für angewandte Kunst, Exner Bequest

1020 *Jean Adolph Chudant (Besancon 1860); Cascading Water;* oil, canvas 175×80 cm; München, Bayerische Staatsgemäldesln.

1021 *Keisai Eisen (1790–1848 Tokyo); The Urami-Waterfall (Uramiga-taki);* from the series "Famous Places in the Mountains of Nikkô," "Nikkôsan meisho no uchi"; coloured woodcut, ôban 37×

24.5 cm; sig: Keisai Eisen utsusu, seal: Ippitsu; imprint: Yamamoto (-ya Heikichi) Imprimatur stamp: Watari; 1846–1847; Berlin, Mus. für Ostasiatische Kunst

1022 *Andô Hiroshige; The Urami-Waterfall in Shimotsuke at the Mountain Nikkô;* from the series "Famous Landscapes from more than 60 Provinces," "Rokujû-yoshû meisho zue"; coloured woodcut, ôban 34.3×22.8 cm; sig: Hiroshige hitsu; engraver's stamp: Hôri Take (carved by Take [Yokokawa Takejiro]); imprint: Koshihei (Koshimura-ya Heisuke); collector's stamp; date stamp: 1853, eighth month; Vienna, Österreichisches Mus. für angewandte Kunst, Exner Bequest

1023 *Hans Schmidthals (Kreuznach 1878–1964 Munich); Glacier Stream;* oil, canvas, 122×75 cm; c. 1902; München, Städt. Gal. im Lenbachhaus

1024 *Katsushika Hokusai; The Rôben-Waterfall near Syama in the Province Sagami (Sôshû = Oagami) (Oyama Rôben no taki);* from the series of eight sheets "Tour of Waterfalls in the Provinces," "Shokoku taki meguri"; coloured woodcut, ôban 36.9×25.5 cm; sig: Zen Hokusai Jitsu hitsu; imprint: Eijûdô; c. 1830; Berlin, Mus. für Ostasiatische Kunst

1025 *Erich Heckel (Döbeln, Saxony 1883–1970 Radolfzell, Lake Constance); Large Glacier Landscape;* woodcut 54.7× 53.3 cm; sig. bottom left: Large Glacier Landscape, sig. bottom right: Heckel 59; 1959; Essen, Mus. Folkwang

1026 *Keisai Eisen and Andô Hiroshige; The Inakawa-Bridge in Nojiri on the Kisokaidô;* from the series "The 69 Post-Stations along the Mountain Road between Edo and Kyoto," "Kisokaidô rokujûkutsugi"; coloured woodcut, ôban yoko-e 22×34.4 cm; imprint: Takeuchi Hôeidô; collector's stamp; c. 1840; Vienna, Österreichisches Mus. für angewandte Kunst, Exner Bequest

1027 *Andô Hiroshige; The Gôkei-River in Bitchu;* from the series "Famous Landscapes from more than 60 Provinces," "Rokuju-yoshu meisho zue"; coloured woodcut, ôban 33.8×22.5 cm; sig: Hiroshige hitsu; imprint: Koshihei (Koshimura-ya Heisuke); collector's stamp: January 1854; Vienna, Österreichisches Mus. für angewandte Kunst, Exner Bequest

1028 *Erich Heckel; 24. Calendar: Water-*

fall 1954; woodcut; 17.2×13 cm; sig. bottom right: Erich Heckel; Essen, Mus. Folkwang; plate

1029 *Katsushika Hokusai; The Kirifuri-Waterfall near Kurokamiyama in the Province Shimotsuke (Shimotsuke Kurokamiyama Kirifuri no taki);* from a series of eight sheets "Tour of the Waterfalls in the Provinces," "Shokoku taki meguri"; coloured woodcut, ôban 36.9×25.5 cm; sig: Zen Hokusai Jitsu hitsu; imprint: Eijudô; c. 1830; Berlin, Mus. für Ostasiatische Kunst; plate

1030 *Ernst Ludwig Kirchner (Aschaffenburg 1880–1938 Davos); Fields and Meadows;* woodcut; 10.5×14.8 cm; Campione, Kirchner Legacy

1032 *Emil Nolde (Nolde near Tondern, Nordschleswig 1867–1956 Seebüll); Storm;* page 7 from the series "Ten Woodcuts 1906," woodcut, water-colour; 15.5×19 cm; 1906; Schiefler No. 12/II; Seebüll, Nolde Foundation; plate

1033 *Gototei Kunisada I (Toyokuni III after 1844) (1785–1865 Tokyo); The Actor Idukawa Danjuro VII as Shirobei in a Thunderstorm in the Play "Edo no hana wakayagi soga";* coloured woodcut, ôban 37.5×25.5 cm; sig: Gogotei Kunisada ga; imprint: Yeijudo; Imprimatur stamp: Kiwame; c. 1818 (?); Regensburg, Franz Winzinger Coll.; plate

1034 *Ernst Ludwig Kirchner; Elbe Crossing in Rain;* Etching, Legacy Print; 18× 33 cm; 1908; Karlsruhe, Kunsthalle

1035 *Katsushika Hokusai; Fuji in the Rain;* double page from the "Manga", Assorted Sketches, Vol. 7; woodcut, duotone print, facsimile, Kôban 24× 14.5 cm; Tokyo, Yujiro Shinoda

1036 *Ernst Ludwig Kirchner; Davos Landscape in the Rain II;* woodcut; 36.9× 50 cm; 1935; Campione, Kirchner Legacy

1037 *Utagawa Toyokuni II (Toyoshige) (1777–1835? Tokyo); Evening Rain on the Oyama Mountain, View of Ascent to the Fudô Relics in the Province Kikuzen (Oyama Yaû, Rikuzen Fudô Choju nô);* coloured woodcut, ôban yoko-e 36× 24 cm; sig: Toyokuni ga Stamp Utagawa; imprint: Iseya Rihei; Imprimatur stamp: Kiwame; London, Victoria & Albert Mus.

The Ornamental Hair-Comb and European Art around the Year 1900

With but very rare exceptions, the Japanese portraitists of actors and courtesans (oiran) or of ideal feminine beauty devoted great care and attention to the hair and its embellishment in their treatment of their subjects. Famous masters of the woodcut technique from Hishikawa Moronobu to Utagawa Kuniyoshi have all depicted the hair-comb and hair-pin with a scrupulous eye for detail.

The comb was executed in a rich variety of forms and, like its inseparable adjunct, the hair-pin, was both treated and worn as a work of art; together the two formed a magnificent and bizarre accompaniment to the thick, jet-black hair of the Japanese woman. Generally, the comb is square in shape with the upper edge gently rounded off, although Okumura Masanobu (1686–1764) also depicts combs of extreme beauty with a straight upper edge. (Okumura Masanobu, "Girl with Looking-Glass in her Hand", Berlin, Museum für Ostasiatische Kunst, Inv-. Nos. 6000–05, 87 [the painter also depicts a wedge-shaped hair-pin].) The exposed area of the comb can also have a pronounced quadrantal or semicircular shape, so that it both contrasts and harmonizes with the oval of the face. The ivory and tortoise-shell carvers never ran short of ideas for the decoration of the

sides and top of the comb: sea monsters and fish, flowers and blossoms, birds – in short, nature in all its rich variety – appear on both back and front of the comb. Such pieces are distinguished by their costly open-work carving and the inlaid tortoise-shell and stones. A great number of combs were also executed in lacquer and continue the great tradition of the Japanese lacquer artists. They are mainly in black lacquer, although red is also fairly common. No less an artist than Hokusai produced a small booklet of designs for ornamental combs with the wave as their motif.

The ornamental comb was not just worn by the Japanese woman as a fashionable accessory but as a mark of distinction and social rank, too; it spoke a language all of its own. The refined courtesan, for example, wore a number of combs of magnificent workmanship and in such a way that her abundance of beautiful hair vied with the excellence of the accessory. The combs were often chosen to match a kimono or the light colour of the facial make-up, so that here the elements of contrast and harmony were influenced by fashion. (Cf. Isoda Koryusa, [...] "Girl with Cat," Berlin, Museum für Ostasiatische Kunst, Inv.-Nos. 60025–05, 415.) Again, as we can see on many of the woodcuts, the comb was not just worn for aesthetic reasons, but for very practical, domestic reasons, too: it was meant to prevent strands of hair falling down over the face.

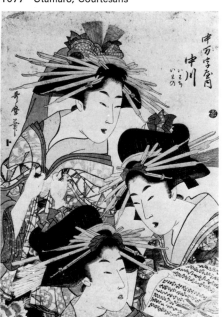

1077 Utamaro, Courtesans

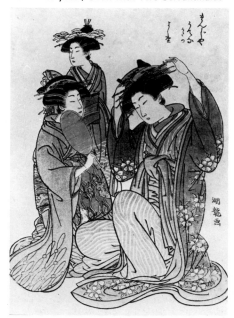

1076 Koryusai, Oiran with Two Servantmaids

East and
South-East
Asia

Arts and
Crafts

1038–1111

With the comb went the "kogai" or hair-pin. It likewise developed from an object with a particular practical function into an article of fashion which was a mark of distinction or rank, too. Its basic form is that of a needle some eight to twelve inches long with a knob at the top end. The knob is generally wrought in gold, silver or copper and carved plastically (sphere, precious stone, nosegay, twigs, etc.). Little bells or other pendants in the form of an amulet were also attached to the hair-pin.

The Japanese still hold the hair-comb and -pin in high esteem. And from the 1870's onwards, the ornamental hair-comb came into prominence in Europe, too, especially when extremely high coiffures were all the fashion, so that great European goldsmiths and craftsmen also produced magnificent examples of this accessory. The hair-pin appeared in Europe as the hat-pin which took on the same extraordinary and bizarre forms. S. W.

Summary and Translation P. J. D.

J 33 *Japan (late Edo Period); Combs with carp, grasses and insects, peacock and peony, dragon-flies, oak and cherry blossom, flowers, swallow;* tortoise-shell, ivory, lacquer, mother of pearl, copper, gold, coral beads; 19th cent.; Tokyo, National Mus.

J 34 *Japan (late Edo Period); Hair-pins (Kogai) with butterfly and bird, autumn plants;* lacquer (kawarinuri), tortoise-shell, ivory; 18th/19th cent.; Tokyo, National Mus.

J 35 *Japan (late Edo Period) Ornamental pins with plum-tree blossom, butterfly and almond tree, cherry blossom, oak, compass needle with ornamental pendants;* tortoise-shell, lacquer, copper, silver, gold; 19th cent.; Tokyo, National Mus.

1038 *Japan, Meiji Period (1868–1912); Comb with dragon riding the waves;* wood; 4.5×11.8 cm; 2nd half of 19th cent.; Vienna, Österreichisches Mus. für angewandte Kunst; plate

1039 *Japan, Meiji Period (1868–1912); Comb with wild ducks in flight;* wood with red and gold lacquer; 5.2×11.2 cm; 2nd half of 19th cent.; Vienna, Österreichisches Mus. für angewandte Kunst

1040 *Japan, Meiji Period (1868–1912); Comb with blossoms and pine needles;*

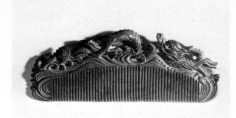

1038 Japan, Comb with Dragon

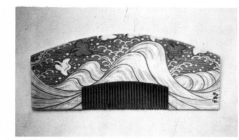

1055 Japan, Comb with Waves

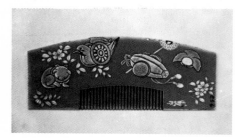

1050 Japan, Comb with Fan

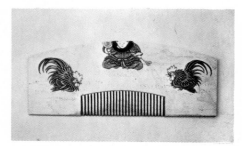

1049 Japan, Comb with Gamecocks

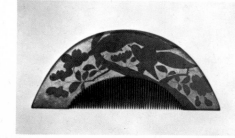

1041 Japan, Comb with Birds

wood with gold, silver and coloured lacquer; 4.5×12 cm; 2nd half of 19th cent.; Vienna, Österreichisches Mus. für angewandte Kunst

1041 *Japan, Meiji Period (1868–1912); Comb with birds and twigs in blossom;* wood with red lacquer and gold hiramakiye; 5.6×12.7 cm; late 19th cent.; Cologne, Mus. für Ostasiatische Kunst; plate

1042 *Japan, Meiji Period (1868–1912); Comb with bushes in blossom on the front, hares on the rear;* wood with dusted lacquer in gold and silver; 7.5×13.7 cm; sig.: Fûsetsusai; 2nd half of 19th cent.; Vienna, Österreichisches Mus. für angewandte Kunst

1043 *Japan, Meiji Period (1868–1912); Comb with Chrysanthemums;* wood with gold lacquer and mother of pearl; 4.5×11.3 cm; 2nd half of 19th cent.; Vienna, Österreichisches Mus. für angewandte Kunst

1044 *Japan, Meiji Period (1868–1912); Comb with fan and plant motifs;* wood, gold lacquer; 4.6×11.7 cm; 2nd half of 19th cent.; Vienna, Österreichisches Mus. für angewandte Kunst

1045 *Japan, Meiji Period (1868–1912); Comb with blossom and butterflies;* ivory with gold and silver lacquer; 4.4×10.5 cm; sig.: Yanagawa; 2nd half of 19th cent.; Vienna, Österreichisches Mus. für angewandte Kunst, Exner Bequest

1046 *Japan, Meiji Period (1868–1912); Comb with twig in blossom;* wood with gold lacquer, on the rear carved ivory; 5.1×13 cm; 2nd half of 19th cent.; Vienna, Österreichisches Mus. für angewandte Kunst

1047 *Japan, Meiji Period (1868–1912); Comb with foliage and blossom, fan motifs with chrysanthemums;* wood with gold and silver lacquer; 5.6×11.3 cm; inscribed: Tsuta; 2nd half of 19th cent.; Vienna, Österreichisches Mus. für angewandte Kunst

1048 *Japan, Meiji Period (1868–1912); Comb with lobster;* ivory with red lacquer in relief; 4.4×16.5 cm; 2nd half of 19th cent.; Cologne, Mus. für Ostasiatische Kunst

1049 *Japan, Meiji Period (1868–1912); Comb with two gamecocks, judge and blossoms;* ivory with gold hiramakiye; 4.3×10.5 cm.; 2nd half of 19th cent.;

Cologne, Mus. für Ostasiatische Kunst; plate

1050 *Japan, Meiji Period (1868–1912); Comb with fan, musical instruments, autumn blossom and grasses;* wood with gold lacquer in hiramakiye; 4.7×11.5 cm; 2nd half of 19th cent.; Cologne, Mus. für Ostasiatische Kunst; plate

1051 *Japan, Meiji Period (1868–1912); Comb with cherry-tree;* wood with gold lacquer, gold and silver hiramakiye; 6.8×16.3 cm; 2nd half of 19th cent.; Cologne, Mus. für Ostasiatische Kunst

1052 *Japan, Meiji Period (1868–1912); Comb with plum-tree in blossom and birds;* wood, gold and silver lacquer; 8×12 cm; 2nd half of 19th cent.; Vienna, Österreichisches Mus. für angewandte Kunst

1053 *Japan, Meiji Period (1868–1912); Comb with waves, cliffs and birds in flight;* wood, gold and silver lacquer with inlaid malachite and coral; 4.5×10 cm; 2nd half of 19th cent.; Vienna, Österreichisches Mus. für angewandte Kunst

1054 *Japan, Meiji Period (1868–1912); Comb with rocks, waves and birds;* ivory with gold lacquer; 3.5×9.1 cm; Vienna, Österreichisches Mus. für angewandte Kunst

1055 *Japan, Meiji Period (1868–1912); Comb with Chidori birds above waves;* ivory, engraved, in part coloured, gold lacquer; 4.6×11 cm; late 19th cent.; Cologne, Mus. für Ostasiatische Kunst, plate

1056 *Japan, Meiji Period (1868–1912); Comb with swallows and butterflies;* wood; 4×18 cm; 2nd half of 19th cent.; Vienna, Österreichisches Mus. für angewandte Kunst

1057 *Japan, Meiji Period (1868–1912); Comb with insects and frog;* wood, gold overlay, silver lacquer, mother of pearl; 6.8×13.4 cm; 2nd half of 19th cent.; Vienna, Österreichisches Mus. für angewandte Kunst

1058 *Japan, Meiji Period (1868–1912); Comb with cherry blossom and butterflies;* gold lacquer with hiramakiye decoration and mother-of-pearl inlay; mid 19th cent.; Cologne, Mus. für Ostasiatische Kunst

1059 *Japan, Meiji Period (1868–1912); Comb with butterflies and plants;* wood

1083 Lalique, Comb with Cock

and gold lacquer; 4.5×11.3 cm; 2nd half of 19th cent.; Vienna, Österreichisches Mus. für angewandte Kunst

1060 *Unknown; Ornamental comb;* horn, nickle silver, imitation gems; 4.0×6.7 cm; c. 1906; Pforzheim, Schmuckmus.

1061 *Unknown; Ornamental comb with blossom motif in centre;* tortoise-shell, silver, imitation gems; 6.1×9.5 cm; c. 1906; Pforzheim, Schmuckmus.

1062 *Loeb & Co. (Providence, USA); Ornamental comb with geometrical frieze;* ivory, turquoises and imitation gems; 6.1×10 cm; Pforzheim, Schmuckmus.

1063 *Vever & Co., Paris; Ornamental comb with mistletoe;* horn, partly gilt, pearls; 8×9.5 cm; c. 1900; Darmstadt, Hessisches Landesmus.

1064 *Georg Kleemann; Ornamental comb with dragon-fly;* gold, precious stones, pearls, email 'à jour; 4 cm; Pforzheim c. 1905; Pforzheim, Schmuckmus.

1065 *Georg Kleemann; Ornamental comb with butterfly;* gold, enamel,

stained agate, pearls, diamonds, tortoise-shell; 8.4×7.5 cm; Pforzheim 1902; Pforzheim, Schmuckmus.

1066 *F. Zerrenner & Co.; Ornamental comb;* 9.8×6.6 cm; Pforzheim 1900; Pforzheim, Schmuckmus.

1067 *F. Zerrenner & Co.; Ornamental comb with abstract leaves;* gold, turquoise, pearls, horn; 5 cm; Pforzheim 1903; Pforzheim, Schmuckmus.

1068 *F. Zerrenner & Co.; Ornamental comb;* gold, pearls, horn; 7 cm; Pforzheim 1903; Pforzheim, Schmuckmus.

1069 *René Lalique (Ay, Marne 1860–1945); Ornamental comb with Peacock motif;* horn, partially gold overlay, opals; 18.5×7.3 cm; sig.: Lalique; c. 1898; Paris, Musée des Arts Décoratifs

1070 *Lucas von Cranach; Ornamental comb with abstract blossom motif;* horn, enamel, brilliants, emeralds, rubies, drop pearls; 14.2×7.5 cm; c. 1900; S. Germany, priv. owned

1071 *Georges Fouquet (Paris 1862–1957); Ornamental comb with abstract wave ornamentation;* horn, enamel, opals; 18×8.1 cm; c. 1905; S. Germany, priv. owned

1072 *Kikugawa Eizan (Tokyo 1787–1867); Woman at her Toilette;* polychrome woodcut with blind blocking; ôban 38.2×25 cm; sig.: Kikugawa Eizan hitsu; imprint: Kiwame; Vienna, Österreichisches Mus. für angewandte Kunst, Exner Bequest

1073 *Katsushika Hokusai (Tokyo 1760–1849); Girl Shamisen Player;* polychrome woodcut with blind blocking; chûban 21.4×18.3 cm; sig.: Hokusai ga; inscribed: Somewhat inebriated at the New Year, playing the shamisen; Vienna, Österreichisches Mus. für angewandte Kunst, Exner Bequest

1074 *Utagawa Kunisada (Tokyo 1786–1865); The Courtesan Nakagawa from the Nakamanji-ya House;* polychrome woodcut with minimum blind blocking; naga-e 77.5×24.7 cm; sig.: Kunisada Kôchôrô ga; imprint: Maruya Seijirô; imprimatur stamp: Kiwame; 1930's; Vienna, Österreichisches Mus. für angewandte Kunst, Exner Bequest

1075 *Kesai Eisen (Tokyo 1790–1848); Courtesan with Kamuro;* polychrome

East and
South-East
Asia

Arts and
Crafts

1038–1111

woodprint with blind blocking; ôban
38×25.8 cm; sig.: Keisai Eisen hitsu;
imprint: Yesakiya; imprimatur: stamp
Kiwame; Vienna, Österreichisches Mus.
für angewandte Kunst

1076 Isoda Koryusai (fl. c.1766–1788);
Oiran at her Toilette from the Manji-ya
House with two Servantmaids; poly-
chrome woodprint with blind blocking;
ôban 32.2×22.2 cm; sig.: Koryusai ga;
Vienna, Österreichisches Mus. für ange-
wandte Kunst, Exner Bequest; plate

1077 Kitagawa Utamaro (Kawagoe
1753–1806 Tokyo); The Courtesan
Nakagawa from the Nkamanji-ya House
with her Servantmaids Iwachi and Iwano;
polychrome woodprint, ôban 37.7×
26 cm; sig.: Utamaro hitsu; imprint:
YamaguchiyaTobei; imprimatur stamp:
Kiwame; post 1790; Vienna, Österreichi-
sches Mus. für angewandte Kunst,
Exner Bequest; plate

1078 China, Ch'ing Dynasty (1644–
1912); Hair-pin with bat, fish, leaves and
blossoms; silver, gilt, glass pearls, enamel;
25.5 cm; 19th century; Vienna, Öster-
reichisches Mus. für angewandte Kunst;
plate

1079 Lucien Gaillard (Paris 1862–
1933); Ornamental comb with flower
cluster; horn, gold, diamonds; 13.5×
11 cm; Paris c. 1903; Pforzheim,
Schmuckmus.; plate

1080 René Lalique; Ornamental comb
with twigs of blossom; horn, gold, pearls
and tourmalines; c. 1900; London, John
Jesse Gallery

1081 Ornamental comb with two flower
clusters; horn, pearls, 15 cm; 1900;
Frankfurt, Kunstgewerbemus.

1082 Lucien Gaillard; Ornamental comb
with flower cluster; horn and pearls;
15.5×11.1 cm; sig.: L. Caillard; c. 1905;
S. Germany, priv. owned

1083 René Lalique; Ornamental comb
with cock; horn, enamel, gold, ame-
thyst; 15.5×9 cm; c. 1898; Lisbon,
Calouste Gulbenkian Foundation; plate

1084 China, Ch'ing Dynasty (1644–

1092	Japan, Hair-Pin	◄
1078	China, Hair-Pin	►
1079	Caillard, Ornamental Comb	►
1080	Lalique, Ornamental Comb	►
1097	Foy, Hat-Pin	►

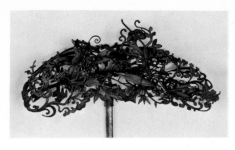

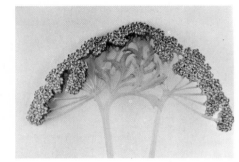

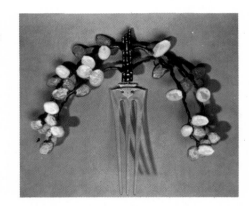

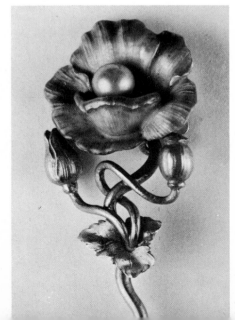

1912); Hair-pin with crab, insects and
flowers; silver pin, filigreed in gilt silver,
kingfisher feathers, coloured glass stones
and glass pearls; 20×11 cm; 19th cent.;
Vienna, Österreichisches Mus. für ange-
wandte Kunst

1085 Kitagawa Utamaro; Courtesan
from the Daimonji-ya House; from the
series "Beauty Competition in the Amuse-
ment Area Hokkaku zensai kisoi"; poly-
chrome woodprint with blind blocking;
ôban 37.5×25.4 cm; sig.: Utamaro hitsu;
1890's; Vienna, Österreichisches Mus.
für angewandte Kunst, Exner, Bequest

1086 China, Ch'ing Dynasty (1644–
1912); Hair-pin with flower vase against
a floral ground with bird; silver pin, fili-
greed in gilt silver and kingfisher feath-
ers; 17×14.5 cm; 19th cent.; Vienna,
Österreichisches Mus. für angewandte
Kunst

1087 China, Ch'ing Dynasty (1644–
1912); Hair-pin with plant and insect
motifs; silver pin, filigreed in gilt silver and
kingfisher feathers; 15.5×14 cm; 19th
cent.; Vienna, Österreichisches Mus. für
angewandte Kunst

1088 China, Ch'ing Dynasty (1644–
1912); Hair-pin with blossom and foli-
age motifs; silver pin, filigreed in gilt
silver, kingfisher feathers, glass pearls and
coloured glass stones; 9×11.5 cm; 19th
cent.; Vienna, Österreichisches Mus. für
angewandte Kunst

1089 Japan, Meiji Period (1868–1912);
Hair-pin with vine leaves; silver, partially
gilt, coral beads; 17 cm; 2nd half of 19th
cent.; Vienna, Österreichisches Mus. für
angewandte Kunst

1090 Japan, Meiji Period (1868–1912);
Hair-pin in form of a small tree with seven
branches in blossom; silver, partially gilt,
coral beads; 25 cm; 2nd half of 19th
cent.; Vienna, Österreichisches Mus. für
angewandte Kunst

1091 China, Ch'ing Dynasty (1644–
1912); Hair-pin with blossoms, leaves
and a bat; silver pin, filigreed in gilt cop-
per, glass pearls, kingfisher feathers and
coloured glass stones; 14×7 cm; 19th
cent.; Vienna, Österreichisches Mus. für
angewandte Kunst

1092 Japan, Meiji Period (1868–1912);
Hair-pin with twigs in blossom; silver,
gilt; 18.5 cm; 19th cent.; Vienna, Öster-
reichisches Mus. für angewandte Kunst;
plate

1093 *China, Ch'ing Dynasty (1644–1912); Hair-pin with two fish and floral motifs;* silver pin, filigreed in silver gilt and kingfisher feathers; 21.5 cm; 19th cent.; Vienna, Österreichisches Mus. für angewandte Kunst

1094 *China, Ch'ing Dynasty (1644–1912); Hair-pin with candelabrum of blossoms;* silver pin, filigreed in silver gilt, kingfisher feathers and glass pearls; 18 cm; 19th cent.; Vienna, Österreichisches Mus. für angewandte Kunst

1095 *Japan, Meiji Period (1868–1912); Hair-pin in form of a lanceolate leaf with lotus blossom;* silver, gilt, mother of pearl; 20 cm; 2nd half of 19th cent.; Vienna, Österreichisches Mus. für angewandte Kunst

1096 *René Lalique; Hat-pin with blossoms;* gold, enamel, email à jour; 4 cm; Paris c. 1900; Pforzheim, Schmuckmus.

1097 *Réné Foy; Hat-pin with blossoms;* gold, enamel, email à jour, pearl; 3,4 cm; Paris 1900; Pforzheim, Schmuckmus.; plate

1098 *Réné Foy; Hat-pin with flower cluster;* gold, enamel, email à jour, pearl; 4,5 cm.; Paris 1900; Pforzheim, Schmuckmus.

1099 *F. Zerrenner & Co.; Hat-pin with buds and blossom;* gold, pearl, enamel; h of knob 3.2 cm; Pforzheim c. 1900; Pforzheim Schmuckmus.

1100 *France; Hat-pin;* gold, enamel, email à jour; 3 cm; Paris 1899; Pforzheim, Schmuckmus.

1101 *Georg Kleemann; Hat-pin with stylized mistletoe;* gold, pearls, enamel; h of knob 4.5 cm; Pforzheim 1904/5; Pforzheim, Schmuckmus.

1102 *Atelier Beaudouin; Hat-pin;* gold, pearl, enamel; h of knob 4.4 cm; Paris 1901; Pforzheim, Schmuckmus.

1103 *George Kleemann; Hat-pin;* gold, gems, pearl, email à jour; 4 cm; Pforzheim 1902; Pforzheim, Schmuckmus.

1104 *J. Müller-Salem; Hat-pin;* silver, turquoise, lapis; 5 cm; Pforzheim 1902; Pforzheim Schmuckmus.

1105 *Henri Vever (Paris 1854–1942); Hat-pin with female figure;* gold; 7 cm; Paris 1901; Pforzheim, Schmuckmus.

1106 *George Kleemann; manufacture:*

1106 *F. Zerrenner & Co.; Ornamental comb with beetle;* gold, precious stones, pearl shell, email à jour; 6.5 cm; Pforzheim 1903; Pforzheim, Schmuckmus.

1107 *Levinger, Bissinger & Co.; Hat-pin with stylized insects;* silver, gilt, stained agate, glass stones; 5.1 (h of knob) × 2.3 cm; Pforzheim 1905; Pforzheim, Schmuckmus.

1108 *Unknown; Hat-pin in form of a lantern;* silver, cornelian cabochon; 3.4 cm (h of knob); pre 1908; Pforzheim, Schmuckmus.

1109 *K. J. Bauer; Hat-pin with cylindrical knob;* silver, amazonite cabochon; 2 cm (⌀ knob); Munich 1906; Pforzheim, Schmuckmus.

1110 *Georg Kleemann; Hat-pin with geometric knob;* silver, enamel; 3.7 (h of knob) × 2.9 cm; Pforzheim 1904; Pforzheim, Schmuckmus.

1111 *Gablonz; Hat-pin;* horn with bronze knob; 14.5 cm; c. 1903; Vienna, Österreichisches Mus. für angewandte Kunst

Java and the „Nieuwe Kunst"

Joop M. Joosten

In 1898 Julius Meier-Graefe published an article on the new movement in Dutch handicrafts in the journal "Dekoratieve Kunst" (Decorative Art), which be had founded and edited with his friend Henry van de Velde. This article was the first of a series published under the title "The New Ornament," in which the author set out to study the development of modern art from the aspect of its characteristic ornaments in those European countries which were relevant. Graefe was already convinced of the outcome: the investigations would undeniably lead to Egypt, India, Java, China, Japan and the Congo. These extra-European countries were the source of the new art. A matter of chance? certainly not! "One can not be so naive as to imagine a fleeting dilettantism in these oriental tendencies; it is more profound than that, one can only be of the clear conviction that the new ornament, if it comes from anywhere, it can only come from this movement, which has progressed far from its sources..." There is reason to believe that these exotic im-

pulses did not just appear from nowhere, but that they were felt in those countries which had been most intimately involved with their colonies. The colonies are of direct and decisive importance for England and Holland; it is almost 300 years since the East-Indian trading companies were founded, from which English and Dutch state property was derived, and the Sunda Islands have been in possession of the Dutch for just as long. Since then there has been a "mingling of blood" (Meier-Graefe). This was not without its consequences: "The colonies gorge themselves on the mother country. They swallow not only intelligence, soldiers and money, they also consume the artistic traditions." Meier-Graefe experienced this fully during a study tour of Holland. The furnishing of the art studios he visited was significant: "Where (in England) one is accustomed to see a 'Spring' by Botticelli hanging on the wall, here we find a piece of cloth, one of those old batik fabrics which the Javanese had decorated with an astonishing sense of colour and are now costly rarities; and the photographs are not of early Italian madonnas, but of Persian ornaments, old sculptures from Indian temples, Egyptian sculptures — in short, things which are treated as ethnographic curiosities in the rest of Europe."
He encountered similar objects in the Dutch museums. However, when he discusses the work of artists such as Th. Colenbrander, Jan Toorop, J. Thorn Prikker, G. W. Dijsselhof, C. A. Lion Cachet, K. P. C. de Bazel, M. L. Lauweriks, he achieves nothing more than the general characterizations of „exotic," "Oriental," "Persian," "Chinese," "Javanese" (Dijsselhof), "Egyptian" (Jan Toorop). In Meier-Graefe's book "History of Modern Art" (1904), we find the same ideas restricted to the sole Indonesian — Javanese element mentioned, namely batik art. "The Dutch artist batiked everything. Not only was this technique adopted for every possible material, but the characteristic cellular aspect of the method was copied graphically where the actual technique could not be applied... The same Holland, whose national obstinacy had successfully resisted the infiltration of the most powerful European movements during the seventeenth century, and had refused to adopt the common language of the world, the Renaissance, is now ready to capitulate to the culture of the Sunda Islands." Meier-Graefe was not in entertaining such misgivings about the sources of the "nieuwe" art in Holland. Dr. Deneken, curator of the Kaiser Wil-

163

helm Museum and a great expert on developments in handicrafts at that time, wrote in the catalogue for the "Dutch East-Indian Art Exhibition" organized in 1906 at his museum: "The Dutch Art Exhibition at the Kaiser Wilhelm Museum in 1903 clearly shows that the decorative arts in Holland have been affected by influences from the East-Indian colonies. Many of Jan Toorops' pictures, the carpets and faience-ware of Colenbrander, the work of Thor Prikkers, the printed fabrics of Duco Cropp, the book make-up and parchment batiks of Lion Cachet, Dijsselhof and Nieuwenhuis, and the batiked materials of Chris Lebau, all show the most conspicuous traces of a close study of Indian art and ornamentation."

When the discussion turns to movements in art at the end of the last century, one can search Dutch literature in vain for similar decisive statements on origin, influence and affinity. On the contrary, Jan Veth, painter and critic, who experienced the revival of Dutch handicraft from the inside, and gave an account of much of what he saw in extremely well-reasoned critical articles, called Meier-Graefe's view of decorative art "a blind generalization," or even "nonsense."

The art historian Willem Vogelsang, who wrote regularly on modern art, gives perhaps the best defence from the Dutch standpoint in his reply to Schäfer, the German critic: "The old self-assured, scholarly phrases concerning Javanese influences are being repeated for the umpteenth time and scarcely convey a good impression of his knowledge of Indian art forms. The exotic sound of the word "batik," together with the fact of Toorop's Javanese origin, have contributed to the German's prejudiced opinion that this ethnographical ornamentation must be included in a consideration of Dutch art."

In the last, very detailed work on the revival of handicrafts and architecture in Holland around the year 1900, Louis Gans' "Nieuwe Kunst, de Nederlandse bijdrage tot de Art Nouveau," published in 1906, the sole extra-European source named is Japan, whereby Gans proves that the French turned to this source before the Dutch.

The fact that one critic accords special importance to Indonesian art for the revival of Dutch handicrafts prior to 1900, and another denies or ignores it, suggests that the problems involved go deeper than the mere question of whether one was not prepared, or able, to recognize these derived forms. On the one side, one

proceeds from the proposition often heard at that time, that European culture had lost its vitality and could only be rescued by unspoilt and primitive cultures. Other critics, who denied or chose to ignore these sources, were themselves influenced by colonial conditions in the eighteen-forties and fifties. The Dutch belonged to a self-assured Europe in the process of an unremitting, industrial economic development, the Indonesians to a world lagging further and further behind in this development. This relationship was full of contradictions. On the one hand, there was a widening cleft between the omniscient rulers and a native population which, due to its different cultural background, was often a thing of mystery; on the other hand, mutual economic dependency increased. It became more and more necessary for Holland to exploit Indonesia to make up for her own lack of raw materials and keep up with European economic competition. After the middle of the nineteenth century, the attention of the Dutch was increasingly drawn to the economic possibilities offered by Indonesia to public as well as to private enterprise. By means of reports and publications, school instruction and museum exhibitions, the Dutch were clearly informed about the possibilities of exploiting Indonesia's natural resources, such as minerals, ore, agricultural produce (coffee, sugar, rice), and the potentialities of Indonesian industry. In 1865 the Koloniaal Museum was founded in Haarlem; the zoological society, Natura Artis Magistra, opened the Ethnographical Museum in Amsterdam; the Indonesian Collection was founded for instructional purposes in 1864 in Delft, and in 1878 the Museum voor Land- en Volkenkunde was established in Rotterdam. These institutions not only gave information on economic possibilities, but also on the "curiosities" of nature religion, customs and habits. The reasons for this were purely practical. To be successful, the aspiring colonist had to respect the cultural and social conditions in Indonesia. Knowledge of such things was thus an absolute necessity.

Whereas practical instruction was the primary task of the above museums, the Rijks Ethnografisch Museum founded in 1864 in Leyden, now the Rijksmuseum voor Volkenkunde, emphasized pure scientific research, as pursued at the University of Leyden with regard to Indonesian law, old-Indonesian language and oriental languages in general. But work progressed only very slowly here.

Indonesia was a practical economic problem for Holland. There was scarcely room for an objective, positive assessment of Indonesian art and culture, which did not mean, however, that the Dutch Government's economic policy with respect to a commercial and industrial exploitation of Indonesia was unanimously approved. Voices were soon to be heard in Holland which spoke for the interests of the Indonesians and criticized the negative aspects of Dutch economic policy. Douwes Dekker's book "Mac Havelaar," written under the pseudonym Multatuli in 1860, sharply criticized the policy of the Dutch Government.

It was not until the end of the nineteenth century that the importance of Indonesian art and culture began to be discussed, primarily by those Dutchmen who, invited to the colonies by the Government, trade and industry, became full of enthusiasm for what they had observed and experienced from a position of comfortable detachment. They returned to the mother-country loaded with products of Indonesian art and handicrafts.

In 1892 the society "Oost en West" was founded with the objective of arranging exhibitions, lectures and publications to provide the Dutch population with information both on the East and West Indies. This was occasioned by an exhibition of women's handicrafts in the summer of 1898 in the Hague, in which several wives of ex-colonists demonstrated the skill of the Indonesian women. Interest had also been furthered in the summer of 1883 by the imposing Indonesian department of the International Exhibition for the Promotion of Colonial and Export Trade organized by the virtually completed Rijksmuseum.

The fact that artists were no more familiar with Indonesian art and culture, and were no less prejudiced, is demonstrated by an article written by J. R. de Kruyff, curator of the Rijksschool voor Kunstnijverheid (Imperial Academy of Handicrafts) founded in 1881 as part of the Rijksmuseum in Amsterdam. De Kruyff played a leading part in the movement to revive handicrafts, which had also begun to flourish in Holland. In his article "At the Amsterdam Exhibition" he wrote that, with its Oriental designs, this exhibition was of benefit for Holland in the sphere of decorative art. According to de Kruyff, these designs could serve in many respects as a guiding line and lead to a termination of the fruitless struggle to maintain Gothic and Renaissance traditions by enabling the European artist to find himself once more, not by

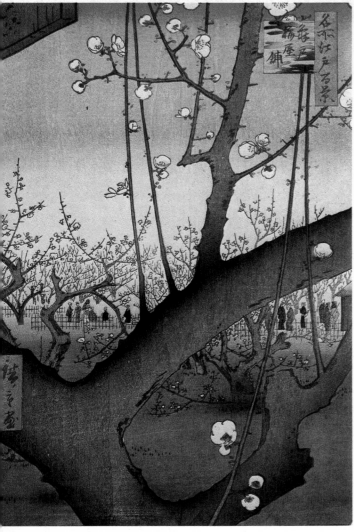

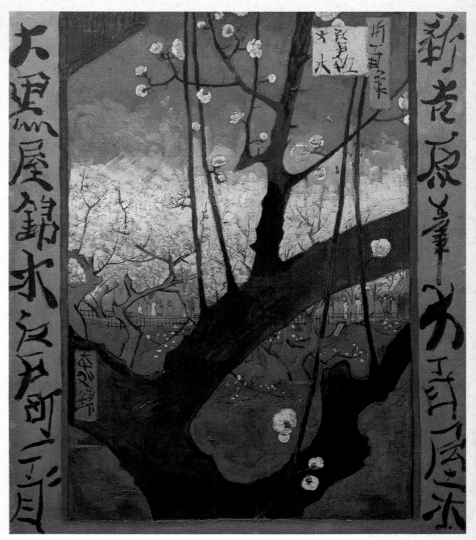

52 Hiroshige, Blossoming Plum-Tree

651 van Gogh, Blossoming Plum-Tree

East and
South-East
Asia

Java and
Nieuwe
Kunst

1112–1148

imitation but by analysis. If we examine what de Kruyff meant by oriental designs, we discover that they were the latest creations from Turkey, Persia, British East India (Hindustan); i. e. objects of Islamic origin. He regarded these as more important than exhibits from China and Japan. He brusquely disqualified the Indonesian exhibits from his list of prototypes.

This mention of de Kruyff's views is justified by the fact that Theo Nieuwenhuis and G. W. Dijsselhof were among his first pupils, who, with Lion Cachet, formed the avantgarde in Dutch handicrafts after 1890. The notes contained in the report of a journey made by the two friends from May 1888 to June 1889, during which they visited the most important European museums – Berlin, Dresden, Vienna, Munich and Paris – conform with the views of their teacher. The appeal made by van Eeden and many others for the protection and promotion of Indonesian handicrafts was primarily in favour of batik. The dangers threatening this flourishing branch of Indonesian handicraft were very easy to demonstrate. After the Dutch cotton industry had taken over the manufacture of cotton fabrics from the Indonesians, there was the danger that Indonesian batik work would be ruined by cheaper, industrial dyeing processes. The first artist to employ the batik technique in Holland was C. A. Lion Cachet. In August 1892, he surprised the art world at a small exhibition at E. J. van Visselingh's gallery in Amsterdam with two designs for an honorary diploma, which the Niederlandse Maatschappij tot Bevordering der Geneeskunst (Dutch Society for the Promotion of Medicine) wished to conform on the physiologist J. B. Molenschott in honour of his seventieth birthday. The design was not selected, but it was bought by Jan Veth, and is now only known from a blurred reproduction made in 1896. The striking feature of Lion Cachet's design was its unusual forms: bird, leaf and flower motives resolved in assymmetrical composition and intertwined. Jan Veth described the work as "half Chaldaic, half Javanese," distinguished by a margin of "oriental characters." Did the terms "Chaldaic" and "Javanese" refer only to the centrepiece with the text? It is difficult to recognize "Chaldaic" or "Javanese" form elements in the ornamentation. And what is meant by "oriental"? Does Veth possibly mean Japanese? As far as form is concerned, other batiks of Cachet from this period show a marked Japanese influence. Cachet's batik samples were

soon copied by his friends Dijsselhof and Nieuwenhuis. The Japanese influence upon the batik works produced by Dijsselhof some years later cannot be disputed. Whereas Cachet soon went his own way in respect of his choice of forms, the work of Dijsselhof and Nieuwenhuis in the following years still shows frequent traces of a Japanese influence.

The influence of Japan in Dutch art is not surprising. Characteristic is that it was not an immediate influence. Japan was no closed world to the Dutch. From 1641 to the opening of Japan in 1854, Holland was the only European country with access to Japan, via a settlement on the island of Decima. Holland already had the first Japanese museum in Europe before 1854. This was a collection in a public museum at Leyden comprising Japanese ethnic art, and included an important collection of woodcuts acquired by the great Japanese specialist Ph. Fr. von Siebold between 1823–1830 on Decima. This collection was already opened to the public in Siebold's house in 1837. At an even earlier date, King Wilhelm I had bought up further important Japanese collections from legacies, which also contained woodcuts. These were also accomodated as public collections, initially in the Mauritshuis in the Hague, and after 1883 in the Rijks Ethnografisch Museum in Leyden. Discussions of Japanese art, prior to about 1890, always refer to objects of applied arts (bronzes, lacquer work, etc.), and more seldom to drawings, but never to wood-engravings. This first changed as French literary circles began to develop an interest in them (L. Gonze, S. Bing).

The influence of Japanese art becomes evident in the work of Jan Toorop in the second half of 1891, and somewhat earlier in Dijsselhof's drawings of fish and other aquatic creatures. One gains the impression that Toorop was especially influenced by lacquered products. In 1899 a more conspicuous influence of Japanese wood-engraving is recognizable in the work of the Symbolist Johan Thorn Prikker. Prikker interpreted the Japanese woodcut in a late medieval manner.

We can not impute that the work of Cachet, Dijsselhof and Nieuwenhuis imitated Javanese batik or Javanese art in general, or that they were inspired by it. There are also great technical and functional differences. Nor do we gain the impression that these three artists had very much knowledge of Javanese batik techniques. They were dependent upon

their own experiments both with respect to dyes and to production. They used a brush and treated only one side of the cloth. The basic difference was functional; whereas the native batik was used exclusively for clothing, the work of Cachet, Dijsselhof and Nieuwenhuis was intended for wall or furniture fabrics. Cachet's first batik experiments on parchment for book bindings date from 1897.

Thorn Prikker became familiar with batik art at the end of 1896. As far as we know, the possibilities of batik were pointed out to him in Brussels by his friend Henry van de Velde. Perhaps the latter had himself seen batik for the first time at the World Exhibition in Antwerp in 1894, where much attention was devoted to it in the section on the Dutch colonies. This is not at all unlikely; we do know that van de Velde was always interested in new discoveries.

Prikker turned to batik art with great enthusiasm, but knew little of Javanese batik apart from the general principle of paring. He used aniline dyes, designed his own accessories to facilitate production, and favoured velvet as his working material. His batik was designed for cushions, curtains, tablecloths, bedcovers and the like. His work deviated not only technically and functionally from Javanese batik, the ornamentation was also different. It soon gained worldwide repute through the internationally orientated Hague art dealing business "Arts and Crafts," with which he was closely connected, and through the great interest shown in his work by van de Velde and Julius Meier-Graefe. About the year 1900, "Arts and Crafts" changed over to a large-scale manufacture of Prikker's batik designs, which impaired the artistic quality, and Prikker subsequently withdrew his services. A younger artist, Chris Lebeau, a pupil of J. R. de Kruyff at the School of Arts and Crafts in Amsterdam, followed his example.

Due to the activity of "Arts and Crafts" – especially during the World Exhibition in Paris in 1900 – batik became a vogue-article of the international Jugendstil-Art Nouveau movement.

Upon the coronation of Queen Wilhelmina, a national exhibition of women's handicrafts was organized, in which a selection of batik patterns was shown to convince the visitors of the high quality of Indonesian handicrafts. As mentioned above, these patterns had been collected by the wives of previous Dutch colonists. Indonesian batik workers from Solo gave regular demonstrations and information

at the exhibition. In the very same year, the Koloniaal Museum in Haarlem organized a splendid exhibition of Javanese batik, too.

In February 1900, Herman J. Baanders, the young collaborator of Chris Lebeau, held a very technical lecture on the production and importance of Javanese batik intended to initiate Dutch artists into original Javanese batik art. The lecture was published as a magazine article and widely distributed as a reprint. All this induced the Koloniaal Museum in Haarlem to undertake a systematic study of batik techniques for the benefit of Dutch artists, in order to help them with reliable dyestuffs, accessories and the correct processes. In this connection, Baanders was invited to the laboratory at Haarlem in September 1900, where he worked until April 1901. Detailed reports of the results were published in many languages and sent to every interested person. Experiments were also performed in the museum's own batik studio. The results were shown in 1904 at the large exhibition of Indonesian batik, the third of a series organized by the society "Oost en West" in the Hague, and wholly dedicated to art and handicrafts from Indonesia. Visitors were given a pamphlet on the Haarlem investigations. In 1902 the museum published a contribution for the International Exhibition of Modern Decorative Arts in Turin, which was shown together with a collection of Indonesian batik organized with other products of Indonesian handicraft by the society "Oost en West."

At the end of the year 1900, Chris Lebeau, who had shown great interest in the investigations at the Koloniaal Museum, came to Haarlem. In Haarlem, he found not only a well-installed laboratory, with every technical facility, but also several of the most important innovators in Dutch handicrafts. Also living in Haarlem were the graphic artist J. Veldheer and the book-binder J. B. Smits, who had been working together with the progressive book-binder J. Y. Loebèr jr. Two young architects were also connected with the school of handicrafts: K. P. C. de Bazel and M. L. Lauweriks, who, following in the footsteps of Dijsselhof, had formulated a number of well-conceived principles on graphic design and architecture, which, as theosophical thinkers, they had based upon construction and geometry. They shaped the trend of the "nieuwe" art in Holland at the turn of the century. We should also mention the goldsmith Frans Zwollo and the graphic designer Herman Jana. Characteristic of the Haarlem school of handicrafts was the attention devoted to plants and flowers as the basic graphic elements of ornamentation. It was the capable Duco Crop (died 1900) who had translated this interest for ornament design and composition into long years of practice. Furthermore, it was, of course, advantageous that the Haarlem school of handicrafts had the Koloniaal Museum and a museum of handicrafts. Lebeau exploited the possibilities offered in Haarlem to make a series of designs for cushion-covers commissioned by the furniture shop "Het Binnenhuis" run by Jacob van den Bosch in Amsterdam. They were made on cloth and parchment. Although Lebeau's decorative art is distinguished fundamentally from Indonesian art by the manner in which the various motifs and ornaments are combined in a single compact composition, they do induce us to look for similarities. The first similarity is to be found in his use of colours, which are sometimes the same as those used in batik. We also observe that the character of the lines and stipples derives from the same technique. The similarity of concept, however, is the most important feature: the extreme care with which the motifs and ornaments are selected and arranged in position. Lebeau performed batik-work until 1906/07, and his influence spread beyond the borders of Holland. His most famous pupil was Bertha Bake and many of the above-mentioned Haarlem artists found work in Germany.

In 1904 J. A. Loebèr jr. was appointed teacher at the school of handicrafts in Elberfeld, where he directed the interest of many pupils towards batik art. In autumn 1905, he organized an exhibition of Indonesian handicrafts in the municipal museum comprising many objects from Holland. After 1900 he was more pre-occupied than anyone else with Indonesian art, as his batik clearly shows. An inheritance from an uncle, who had lived for many years in Indonesia, first as a teacher and later as a school inspector, enabled him to collect Indonesian ethnographic art. He published a great number of articles on Indonesian handicrafts and especially on ornamentation. M. L. Lauweriks was engaged as a teacher at the academy in Düsseldorf, where, among other things, he taught batik techniques. In 1906 J. B. Smits was appointed lecturer at the school of handicrafts in Zürich; his director, the Belgian Jules de Praetere had also turned to batik. Johan Thorn Prikker worked in Krefeld. The intensive confrontation of the Dutch public with Indonesian art and culture left ist traces in many expressions of

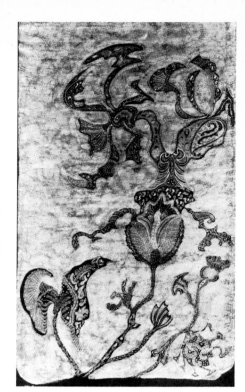

1115 Wegerijf-Gravesteyn, Tapestry

Dutch art and culture after 1900, especially during the Art Deco period between 1900 and 1930.

Translation G. F. S.

1112 Java, Batik

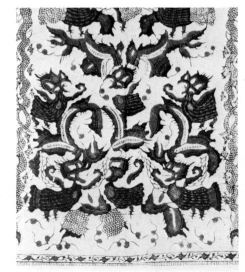

East and
South-East
Asia

Java and
Nieuwe
Kunst

1112–1148

Javanese Batiks and their Influence on the Textiles, Book Covers and Ceramics of the "Nieuwe Kunst"

Commercial relations have existed between Holland and Indonesia since the seventeenth century. The new interest in the arts and crafts of the colony was demonstrated by the foundation of museums at home, such as the Koloniaal Museum in Haarlem opened in 1865, the Tropics Museum in Amsterdam, and the Museum voor Land- en Volkenkund founded in 1878. It was only towards the end of the nineteenth century, however, that Indonesian art moved into the foreground, particularly due to those Dutchmen who had travelled through Indonesia and returned with numerous examples of Javanese arts and crafts. In 1899 they founded the society "Oost en West" for the purpose of providing the Dutch public with information through exhibitions, publications and lectures. In 1898, the wives of ex-colonists showed batiks, one of Java's oldest art forms, at an exhibition in the Hague. Fringed and bordered cotton fabrics were carefully prepared so that they were not too soft or permeable for the subsequent treatment with wax. The women and girls then drew in the patterns by hand or with the help of stencils and stamps. Those areas which were to remain free of colour were prepared with a coating of melted wax applied with a copper spoon. The actual dyeing process was performed cold, and different regions of Java maintained their favourite colours up to the middle of the nineteenth century, above all those from vegetable dyes: indigo blue and brown in central Java, and Mengkudu red in the coastal areas. After drying, the wax was removed and reapplied for the next dyeing process. In this way, parts of the pattern or the whole pattern, finally appeared in the original colour of the cloth, a broken white. The dye was then rendered fast by treatment with a special agent. Javanese batiks are almost always wholly covered with patterns. Graphic skill and a distinct sense of colour and form combine to make animal and plant motifs into virtually abstract ornaments, which bear their own names: "Sawat," "Semen," "Tejblokkan," "Grinsing," and "Parang" – the oblique spiral ribbons in indigo and brown reserved for princely families. Initially, it was this technique which was taken over by Dutch artists, from whom it then spread to other countries,

above all Germany. Thorn-Prikker took the technique with him to the textile engineering school at Krefeld, Loebèr to Elberfeld. Batik clothing with patterns of most different origin enjoyed a vogue in European society around 1900, after it had been introduced at court by Crown Princess Cecilia herself.

Over and above this, the finely chased and decoratively clear ornaments themselves came to gain influence in Holland. The leading artists of the nieuwe art movement Coelenbrander, Lebeau, Lion Cachet and Dijsselhof, used the artistic contribution of batik to revive Dutch art and crafts and at the same time produce their own modifications. The original patterns were not simply copied, however, but Tjeblokkan or Grinsing, for instance, served to supply details for new combinations and compositions in which the exotic element was combined with the tradition of Dutch lace or historical scenes. Lion Cachet employed batik techniques for the folding screen or book-bindings in parchment, thereby creating new, harder and smoother forms. Similarly, Thorn-Prikker and Loebèr adapted the wax procedure to the cooler European climate; Jan Toroop and T. Nieuwenhuis developed a type of lacquer batik, and de Bazel enriched Dutch book ornamentation with an abundance of frontpapers, margins and vignettes which were directly inspired by batik designs. Colenbrander and J. Kok entwined the patterns on Rozenburg porcelain with the liana work of Art Nouveau. A. S.

Translation G. F. S.

1112 *Indonesia, Java; Cloth with pattern of fanciful birds and flowers* (Semen motif); batik on cotton; 100×200 cm; late 19th cent.; Rotterdam, Mus. voor Land en Volkenkunde; plate

1113 *Indonesia, Java; hip cloth (sarong), central part (kapala) with (European-influenced) floral pattern, side parts (badan) with Bird and Plant Pattern (Semen and Sawat motif);* batik on cotton; approx. 100×200 cm; late 19th cent.; Rotterdam, Mus. voor Land en Volkenkunde

1114 *Indonesia, Java, Jogjakarta; hip cloth (sarong), middle part (kapala), side parts (badan) with blossom and foliage motifs;* batik on cotton; approx. 100×200 cm; late 19th cent.; Rotterdam, Mus. voor Land en Volkenkunde

1115 *Agatha Wegerijf-Gravesteyn (Nlissingen 1867); Tapestry with fanciful plant;* batik on velvet; 192×95 cm; c. 1900; Den Haag, Gemeentemus.; plate

1116 *Theodorus Colenbrander (Doesburg 1841–1930 Laag-Keppel); manufacture, Haagsche Plateelbakkerij Rozenburg; Plate with plant-like fanciful decoration;* pottery; polychrome painted; dull glaze; ⌀ 27.7 cm; c. 1891; Darmstadt, Hessisches Landesmus.

1117 *Juriaan Kok (Rotterdam 1861–1919 Den Haag); manufacture, Haagsche Plateelbakkerij Rozenburg; Vase with turtles;* semior egg-shell porcelain; polychrome painted; h 23.5 cm; sig.: trademark, date, series number and monogram RS (R. Sterken); c. 1901; Darmstadt, Hessisches Landesmus.

1118 *Juriaan Kok; manufacture, Haagsche Plateelbakkerij Rozenburg; Vase with fanciful foliage decoration;* semi- or egg-shell porcelain; polychrome painted; h 15 cm; sig.: trademark, date, series number and monogram RS (R. Sterken); c. 1902; Darmstadt, Hessisches Landesmus.

1119 *Theodorus Colenbrander; manufacture, Haagsche Plateelbakkerij Rozenburg; covered vase with fanciful decoration;* pottery, polychrome painted; h 30.5 cm; sig.: trademark, date; c. 1885; Darmstadt, Hessisches Landesmus.

1120 *Indonesia, Java, Cheribon; hip cloth (sarong), middle part (kapala) with two rows of triangular tumpal pattern, side parts (badan) with Chinese-influenced floral ornamentation;* batik on cotton; 100×200 cm; late 19th cent.; Rotterdam, Mus. voor Land en Volkenkunde

1121 *Indonesia, Java, Semarang; hip cloth (sarong), middle part (kapala) with two rows of triangular tumpal pattern and adjacent narrow edging (papan), side parts (badan) with foliage and bird pattern;* batik on cotton; 100×200 cm; late 19th cent.; Rotterdam, Mus. voor Land en Volkenkunde

1122 *Gerrit Willem Dijsselhof (Zwollerkerspel 1866–1924 Bloemendaal); three-fold screen with decoration of fanciful birds (guinea-fowl and peacocks) and willows;* oak, batik on silk; 200×246 cm; c. 1894; Amsterdam, Stedelijk Mus.

1123 *Indonesia, Java, Semarang; hip cloth (sarong), middle part (kapala) with two rows triangular tumpal pattern, side parts (badan) with bird and plant pattern; batik on cotton; 100×200 cm; late 19th cent.; Leyden, Rijksmus.*

1124 *Indonesia, Java, Solo-Vallei; open hip cloth (Kain pandjang) with stylized bird and blossom motif (Tjeplokkan motif); batik on cotton, 266×106 cm; late 19th cent.; Amsterdam, Tropical Mus.; plate*

1125 *Indonesia, Java, Semarang; hip cloth (sarong), middle part (kapala) with two rows of triangular tumpal pattern with adjacent narrow edging (papan), side parts with stylized blossom motif (Djlamprang motif in nitik technique); batik on cotton; 100×200 cm; late 19th cent.; Rotterdam, Mus. voor Land en Volkenkunde*

1126 *Chris Lebeau (Amsterdam 1878–1945 Dachau); cushion cover with fanciful pattern (monkeys); batik on cloth; 63×62 cm; sig. bottom centre: Chris Lebeau/1904; Amsterdam, Tropical Mus.*

1127 *Chris Lebeau; chair upholstery with stylized blossom ornamentation; batik on velvet; 53×54 cm; c. 1900; Zürich, Kunstgewerbemus.; plate*

1128 *Chris Lebeau; cushion with stylized blossom ornamentation; batik on linen; 54×54 cm; c. 1900; Zürich, Kunstgewerbemus.*

1129 *Chris Lebeau; wrap with stylized blossom ornamentation; batik on silk; 88×84 cm; c. 1900; Zürich, Kunstgewerbemus.*

1130 *Chris Lebeau; chair cushion with stylized blossom ornamentation; batik on silk; 98×91 cm; Amsterdam, Stedelijk Mus.*

1131 *Chris Lebeau; wrap with stylized rosette ornamentation; batik on silk; 73×69 cm; c. 1900; Zürich, Kunstgewerbemus.*

1132 *Indonesia, Java, Jogjakarta; cloth with stylized blossom ornamentation (Tjeplokkan motif); batik on cotton; 100×200 cm; late 19th cent.; Amsterdam, Ethnographical Mus.*

1133 *Indonesia, Java, Semarang; hip cloth (sarong), middle part (kapala) with two rows of triangular tumpal pat-*

tern with adjacent narrow edging (papan), side parts (badan) with geometric pattern (Lambae motif); batik on cotton; 100×200 cm; late 19th cent.; Rotterdam, Mus. voor Land en Volkenkunde

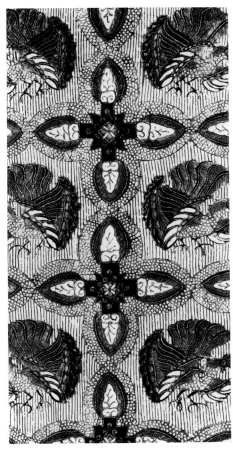

1124 Java, Hip Cloth

1127 Lebeau, Chair Upholstery

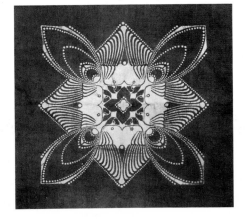

1134 *Chris Lebeau; three-fold screen; wood, batik on parchment; 203×201 cm; c. 1903; Amsterdam, Stedelijk Mus.*

1135 *Indonesia, Java, Jogjakarta; hip cloth (sarong), middle part (kapala) with two rows of triangular tumpal pattern with adjacent narrow edging (papan), side parts with oblique, spiral curvilinear ornamentation (Parang motif); batik on cotton; late 19th cent.; Amsterdam, Tropical Mus.*

1136 *Indonesia, Java, Surakarta; hip cloth (sarong), middle part (kapala) with two rows of triangular tumpal pattern with adjacent narrow edging (papan), side parts (badan) with fanciful faunal ornamentation (Sawat motif); batik on cotton; 100×200 cm; late 19th cent.; Rotterdam, Mus. voor Land en Volkenkunde*

1137 *Chris Lebeau; Book cover; batik on parchment; 40×30 cm; c. 1900; 's Gravenhage, Rijksmus.*

1138 *Johan Thorn Prikker (Den Haag 1868–1932 Keulen); Book cover; batik on linen; 27×42 cm; c. 1899; Amsterdam, Tropical Institute*

1139 *J. de Wilde; Tapestry with swans; batik on cambric; 71×46.5 cm; c. 1904; Amsterdam, Tropical Institute*

1140 *Indonesia, Java, Semarang; Cloth with orchid-type pattern ornamentation; batik on cotton; 100×200 cm.; late 19th cent.; Rotterdam, Mus. voor Land en Volkenkunde*

1141 *Johan Thorn Prikker; cushion cover with swirling ornamentation; batik on velvet; 48.5×46 cm; c. 1899; Amsterdam, Tropical Institute*

1142 *Indonesia, Java, Jogjakarta; hip (sarong), middle part (kapala) with two rows of triangular tumpal pattern with adjacent narrow borders (papan), side parts (badan) with bird motifs (Sawat motif); batik on cotton; approx. 100×200 cm; late 19th cent.; Rotterdam, Mus. voor Land en Volkenkunde*

1143 *Indonesia, Java, prob. Surakarta; cloth with oblique, spiral-type of curvilinear ornamentation, with birds (variant of Parang motif); batik on cotton; 100×200 cm; late 19th cent.; Rotterdam, Mus. voor Land en Volkenkunde*

1144 *Indonesia, Java, Tuban; cloth with oblique, spiral-type curvilinear orna-*

mentation (classical Parang motif); batik
on cotton; approx. 100×200 cm; late
19th cent.; Rotterdam, Mus. voor Land
en Volkenkunde

1145 *Carel Adolph Lion Cachet (Am-
sterdam 1864–1945 Vreeland); geo-
metric floral pattern on cover of exhibi-
tion catalogue "Portretten en Voorwer-
pen, betrekking hebbende op het Huis
van Oranje Nassau" (Amsterdam, Rijks-
museum, 9 Aug.–31 Oct. 1898); batik
on parchment; 21×16.5 cm; Amsterdam,
Stedelijk Mus.*

1146 *Chris Lebeau; stylized plant motif
on cover to Louis Couperu's "De Stille
Kracht"; batik on velvet; 21×16 cm;
c. 1900; Amsterdam, Stedelijk Mus.*

1147 *Indonesia, Java, prob. Surakarta;
cloth with encircling ornamental border
(Semen motif); batik on cotton; approx.
100×200 cm; late 19th cent.; Rotterdam,
Mus. voor Land en Volkenkunde*

1148 *Chris Lebeau; Curtaining; cambric
with pattern; 97×83 cm; c. 1900; Zürich,
Kunstgewerbemus.*

Japan's Contribution to Modern Western Architecture

Clay Lancaster

The Japanese influence upon Western
culture during the last one hundred years
is analogous to the Chinese influence
preceding it. The Chinese imprint was
manifested especially in Italian painting
after the return of the Polos from Cathay,
at the end of the thirteenth century,
through the introduction of slant-eyed
madonnas, a bolder rendering of the
human form, and the development of
landscape. The Chinese became promi-
nent again in the eighteenth century as
the decorative style known as chinoiserie—
throughout Europe and in America — and
a little afterward in the type of garden
called jardin anglo-chinois, the informal,
rustic landscape or English park. China
began to decline as a world force about
the middle of the nineteenth century; and
Japan broke its isolation of several
hundred years and engaged in inter-
national intercourse after signing a treaty
of friendship and commerce with the
United States in 1854. The Occident then
turned from the old and focused upon a
new source of inspiration in the Far East —

Japan. On the whole, the Japanese
influence was more widespread, more
vital and penetrating than the Chinese
had been. In Europe the Nipponese was
felt most strongly in the fields of interior
design, or applied arts, and in easel
painting and prints, whereas in practical
America it encompassed the entire range
of building, including the garden
setting.
Attention should be called to the
shortening of the distance between
Japan and the Western World during
their period of communication, as
compared with that earlier to neigh-
bouring China. The Island Empire was
directly across the ocean from the
currently developing Pacific coast of the
United States; and the opening of the
Suez Canal in 1869 reduced by one-third
the old route from Europe to the Far East
around the Cape of Good Hope. With
China out of the picture and Japan
active, it was inevitable that the rich
artistic heritage of the mikado's domain
would be taken to the hearts of the
Westerners aware of the deadliness of
contemporary industrialization. The
Japanese vogue divides naturally into
three phases. The first has to do with
Europe and England up to World War I.
The second deals with a similar period in
America. And the third embraces the
scene on both sides of the Atlantic
succeeding World War I and persisting
down to the present day.

*I. The Japanese Influence Upon European
and English Architecture From the 1860s
to 1915*
The well known indebtedness of
Impressionist painting to Japanese art is
beyond the scope of this article, but the
early uses of Japanese-inspired decora-
tion were intimately related to the first
pictorial essays. After Commodore Perry
succeeded in getting the Japanese to
endorse a trade agreement with the
United States in 1854, it was ratified by
an official Japanese mission sent to
America in 1860. Two years later, the first
Nippon art display ventured to the West
in the Japanese Court at the English
International Exhibition, followed by
another at the Paris Exposition of 1867.
The influence was immediate, as within
the year of the London show (1862), the
young architect and designer, Edward
William Godwin, remodeled for his own
occupancy a large Georgian house at
21 Portland Square in Bristol, in which
interior walls were treated as plain
background for hanging framed Japanese
prints. At the height of the Victorian
period, such restraint was considered

very daring. The trend evolved in God-
win's work, and in 1874 his London
drawing room was laid with matting on
the floor and in the dadoes, above which
the walls were white. He created wall-
papers for Jeffrey and Company, and
furniture for William Watt. The 1877
catalog of the latter company, entitled Art
Furniture Designed by Edward W. God-
win, shows strong Japanese feeling in an
entrance hall depicted as the frontispiece
(presumably representing that in God-
win's own house) and many of the
pieces made by the concern. The
items referred to were characterized as
"Anglo-Japanese" in style.
In the 1860s Godwin designed The
White House in Chelsea for James Abbott
McNeill Whistler, an American who had
gone to Paris to study art in 1853, and
afterward made his home in England.
The name reflects that of William Morris'
home in Kent, The Red House, and was,
through no coincidence, the same as that
of the President of the United States.
Whistler, like Godwin, espoused Far
Eastern influence directly after the
Japanese Court displayed in London. His
canvases, Caprice in Purple and Gold,
No. 2: The Golden Screen and Rose and
Silver: The Princess from the Land of
Porcelain, painted in 1864, have for
subjects models clothed in kimono and
holding, or otherwise related to,
Japanese accessoires. The second was
purchased by the wealthy Liverpool
shipowner, Frederick R. Leyland, for his
large London town house, called The
Mansion. Leyland commissioned the
architect Richard Norman Shaw to
remodel it, and Whistler was called in to
enrich the panels of the staircase, which
he did in pink and white imitation of
Japanese lacquer floral patterns. The
Rose and Silver "Princess" became the
center of interest in the dining room,
decorated by Shaw's assistant, Henry
Jeckyll, who had been using Japanese
ideas independently. The walls of the
room were covered by shelves bedecked
with blue-and-white porcelain. The
effect did not please Whistler, and, in
1876–77, the artist himself altered the
decor to a scheme of gold and bluegreen,
thus producing the Peacock Room, now
installed in the Freer Gallery in
Washington.
The break with tradition of the designs of
Godwin and Shaw-Jeckyll-Whistler
foreshadowed the main premise of Art
Nouveau, which took its name from the
shop of S. Bing at 22 Rue de Provence,
Paris. The establishment was designed by
Henry van de Velde, who fostered much
furniture and many influential buildings

throughout Belgium and Germany, including the Lounge of the Dresden Exposition of 1897 and polygonal Central Hall of the Dresden Exposition of 1906. Prior to establishing himself in the French capital in 1895, Bing had been a dealer in Oriental art, specializing in Japanese, at Hamburg. He often referred to the Eastern objects in discussing the principles underlying the design of the contemporary things for sale in his shop, summarized as adaptability to purpose, harmony in line (form) and colour, an honest use of materials, and reserve in ornament. Not all Art Nouveau adhered to such rationalism but was motivated by an emotional dynamism characterized by the whiplash line. The stairhall in Victor Horta's Tassel House in Brussels (1893) is a good example. The calligraphic treatment surges from the iron railing and structural members onto the decorated wall and floor, and it is reminiscent of the Eytreme East "grassscript", executed with a flowing brush, though this manner of writing shows more freedom and spontaneity.

Art Nouveau was primarily an applied-arts and interior style, and usually when it determined the outside of a building it remained decorative. The Atelier Elvira (1897–98), Munich, designed by Auguste Endell, is a case in point. The openings are quite subservient to the relief motif that overspreads the facade. An abstraction, it is Eastern in inspiration a dragon's wing, a cloud, mist and waves, a nelumbium or lotus that emerges from watery depths. It is, of course, many times enlarged from its Japanese archetype. The inner staircase in The Atelier Elvira was as non-conforming and stylized as Horta's in the Tassel house, only here the character of the line is more quiet and organic, like slender roots, derived from a delicate Japanese naturesilhouette stencil.

The dynamic and organic character of Art Nouveau, around the turn of the century, gave way to a new secession that was primarily geometric and hence more adaptable to building forms. Josef Hoffmann was an Austrian, who worked far beyond the confines of his own country. His Palais Stoclet (1905) in Brussels has the purity and serenity of the eighth-century ceremonial palace at Kyoto, the Shishinden (Purple-Dragon Hall), and like it set in a sanded courtyard with minimum, stylized planting. The clean-cut planes, pierced only where necessary and accruing interest through height variations, is somewhat like a Japanese room turned inside-out. The interior of the building was articulated by

standard-width units (though not determined by module floor mats-tatami), and it had lantern-shaped hanging lighting fixtures. The Palais Stoclet, lacking overhanging roofs of a Nippon villa, was given the crowning device of a figure embellished tower, a Western touch signifying completeness but looking superfluous according to the Eastern precept of simplicity.

Almost as severe, though more beholden to traditional architectural features outside–such as the monumental entrance, fenestration bays, the roofed pavilion system, and a consciousness of structural masonry–was the architecture of Charles Rennie Mackintosh, exemplified in his Art School (1898–99) and library wing (1907–09), Glasgow. The timbering inside (especially int he library) is totally without order members, and, except for being a bit self-conscious of milled lumber, is Japanese in the lightness of construction. Mackintosh houses have, naturally, a more human scale and appeal. The hall of Windy Hill (1899–1901), Kilmacholm, has a livable formality because of a forthright sequence of elements: windows, doors, fireplace, and the furniture that is plain without being stark. A horizontal plank insert, not so high as the doors, is like a Shaker peg rail, and the regular beams overhead are mindful of basic construction, enlivened at intervals by coupled cubic chandeliers. The tapered square pots flanking the fireplace rise to an overhang, more to focus attention on this feature than to serve any utilitarian purpose. The hall has taken the spirit of a Japanese room without any attempt at imitation, and in this accrues much credit to its planner. The great scale and forbidding aspect of a Japanese castle are manifested in the south facade of the Model Factory, Werkbund Exhibition (1914), Cologne, by Walter Gropius and Adolph Meyer. The striped wall (vertical rather than horizontal) is pierced by narrow, porter-like windows, and the main entrace has abandoned all Western ostentation and descended inconspicuously to ground level. The wall is capped by projecting coping-cornices, and it is flanked by a graceful innovation of convex glass and steel, spiral-staircase turrets, of bird-cage lightness. Above the corners of the solid mass hover the roofs of lookout pavilions, here of industrial recreational rather than feudal military intent. The first two stories of the court side of this building are dissolved into fenestration, because of which it has been called the most advanced piece of architecture built before the war. The feature and distinction

remind us of Shogun Yoshimitsu's Kinkaku (Golden Pvailion) near Kyoto, in its flexibility the world's first modern building, constructed at the end of the fourteenth century.

The examples by English, Belgian, German, Austrian and Scottish architects here shown give only a slight indication of the total amount of inspiration derived from Japan in Europe and the British Isles during the complex period constituting the second half of Queen Victoria's reign and period of Edward VII. In the exhibition may be seen more ample material. During the time span considered were laid the foundations for the architecture of the post-war or contemporary period, which is the subject of Part Three of this essay.

II. The Japanese Influence Upon American Architecture From 1876 to 1915
Just as the beginning of the Japanese vogue in Europe is traceable to the imported display at the English International Exhibition of 1862, so the imprint of Japanese architecture was established in various parts of the United States because of the foreign entries at successive world's fairs. The first of official sanction was the *Centennial Exhibition* at Philadelphia in 1876. Japan sent parts and assembly crews for erecting two buildings, a two-storied dwelling and single-storied bazaar with adjacent garden. A number of American Eastern-art collections began with purchases from the bazaar. Town houses became cluttered with them, and the background decor often was made sympathetic in style. Seldom, however, did it capture, the feeling of the original.

On the other hand, small summer houses in the Appalachian Mountains and along the Atlantic seacoast were more successful. In 1878, Bassett Jones of New York designed a summer retreat for U. S. Grant, Jr., at Asbury Park, New Jersey. Although a small building, it contained four rooms on each of two floors. The gable-on-hip roof is a typical Japanese irimoya, and the doubledecker porch is without any suggestion of western orders; holding to plain posts, lattices and authentic apron boards to the railings. Double glazed doors open onto the lower veranda. The one visible chimney is banished to the back of the house as an inappropriate element. However, there are sash windows and clapboards, and the stairway pavilion has a decorated "Queen Anne" gable, which are very much Occidental.

About five years later, Bruce Price planned about forty "boxes" at Tuxedo Park,

in the Catskills, with strong Japanese overtones. The Addison Canmack house, for instance, had reduplicated irimoya roofs, delicate half-timber second stories on bolder lower walls, and an entrance porch similar to that on the Centennial Japanese dwelling.

The Jones and Price essays were built before the publication of Edward Morse's Japanese Homes and Their Surroundings, Cambridge, 1885–86, containing over three-hundred drawings of every aspect of the island dwellings, a veritable design source book used by subsequent generations of architects and still unequalled for the scope of its coverage.

After the Philadelphia fair the next major American attraction was the World's Columbian Exposition at Chicago in 1893. The Japanese again sent a building, a villa based upon the mid-eleventh-century Hoo-do, or Phoenix Hall, near Kyoto, adjudged the first major monument to show the native architectural genius. The Chicago version had light-weight timber construction, deep roof overhangs, and a stress on horizontal lines. Frank Lloyd Wright began to practice independently during the year of the fair and, soon was using Japanese borrowings in his designs. In 1900 he produced two attractive homes in the neighboring B. Harley Bradley and Warren Hickox residences in Kankakee, Illinois. The latter is smaller and more Japanese in scale. The three principal (living, dining and music) rooms open into each other, the center most (living room) is accessible to a terrace, the equivalent of the garden off the main room in a Japanese house. Long, low lines and projecting eaves that thrust outward at the gable peaks (a feature of Shinto temples) characterize the exteriors, with banks of windows, and exposed timbers more delicate than in English black-and-white houses.

The Hoo-den (as the Japanese exhibition building was called) at the Columbian Exposition remained intact after the fair, and its influence was felt far afield. The Minneapolis firm of William Gray Purcell, George Grant Elmslie and George Feick conceived the "Bungalow on the Point" (a spectacular promontory) at Woods Hole on the Massachusetts coast in 1912. This, the Bradley house on the Crane estate, was given the spread-wing-and-body shape of the original Hoo-do. Its central chimney, shingle sides, over-hangs and banded casement windows were seventeenth century New England, but its openness, especially the semi-circular living room, was contemporary. Its peninsula setting is reminiscent

of the islet site of its prototype. The California Midwinter Exposition at San Francisco, held early in 1894, was small compared to the Columbian celebration, yet it included a "Japanese Village", which was a garden containing a bazaar, theatre, two-story gateway, residence and tea shelter. The compound was the gift of the first dealer in Nippon art in America, George Turner Marsh, a native Australian. The oldest existing Japanese garden in America, it and its structures had as much of an influence upon the California bungalow and its landscaping as the Phoenix Hall on the work of the Chicago School. The brothers, Charles Sumner and Henry Mather Greene initiated an office at Pasadena in 1894, and within a decade they made use of the Japanese style in the Arturo Bandini bungalow. Its plan was that of a ranch house, being low and U-shaped, but the construction was quite otherwise than that of the thick adobe-walled rancho. The Bandini house had batten-board walls, exposed rafters, an airy gallery around the inner side, and deep overhanging eaves. The system was adapted to larger Greene and Greene houses. One of the finest is David B. Gamble's retirement home (1908) on Westmoreland Place. It is three-storied yet maintains a horizontality, with low-pitched roofs hovering over verandas and sleeping porches, bands of windows, spreading terraces with broad stairs, and keying in with the planting. In some of the Greene brothers' houses (such as the R. R. Blacker house, Pasadena), Japanese gardeners were put in charge of the landscaping. Exposed timbers of these houses were subtly shaped and handfinished, and the interior furnishings were specially designed, the woods given a natural polish, a personal service rendered by the architects. California bungalow planners were more numerous than members of the east coast or Chicago School, and their work spanned the continent. During its heyday in America, as often as not, the low house with wide eaves was called not just "bungalow" alone, but "California bungalow". California became known as "bungalow land".

The greatest of the international fairs in the United States, up to that time, was the Louisiana Purchase Exposition held at Saint Louis in 1904, commemorating the centennial of Thomas Jefferson's 825,000-square-mile acquisition from the French. Japan sent its third important official exhibit, consisting of six major buildings and several minor, implanted in a garden setting. Standing by the

watercourse was a replica of the Kinkaku (Golden Pavilion—late fourteenth century), mentioned at the close of Part One above. At the southwest corner was the long Bazaar. The Main Pavilion, on the east side, was a diminished version of the ceremonial hall at Kyoto, the Shishin-den, compared earlier to the Palais Stoclet. Nearby was the little Bellevue, made for and shown at the Osaka Exhibition two years previously. Across from these, on the Trail, was the five-room Commissioners' Office. These last three buildings, together with the primary gateway, at the northwest corner, were given to the eminent scientist, Dr. Jokichi Takamini, who had them moved and reerected as a villa on his estate, Sho-fu-den (Pine-Maple Lodge), below Monticello, New York. As reassembled, the main pavilion housed a living hall, parlor and dining room, with kitchen and extra chambers in a new attached service ell. The Bellevue became a reception room, and the Commissioners' Office became a bedroom wing, connected by an open passerelle to the larger structure. The villa presided over a 1,500-acre farm, on which out buildings were fashioned in the Japanese manner. The Catskill site gave an appropriate setting for the group.

Other neighboring Japanesque estates, in varying degrees of authenticity, were: the large Alexander Tison summerhouse, Grey Lodge (1901), near Denning; the Frank Seaman guest farm, Yama-no-uchi (Home in the Mountains 1907), near Napanoche; the two-acre hill-and-water garden, called Raku-bo-yen (Happy Mother Garden 1913), in Clemson Park, Middletown; and the contemporary tea-house garden at the Scofield residence in Tuxedo Park. The last was laid out by Takeo Shiota, a Japanese gardener, who had come to the United States in 1907. His masterwork was the Japanese landscape in the Brooklyn Botanic Garden, opened in 1915. It was built around the existing feature of a tiny lake, which Shiota embellished with a tori (water gate), island near the artificial cascade, and a viewing pavilion built over the water. A shrine, several bridges, covered resting bench, imported stone lanterns, and realistic metal cranes were other picturesque touches. The garden is considered the finest of its kind in America.

It is appropriate that the United States, which engaged Japan in foreign intercourse, should have been much influenced by the Island Empire in such an important field as architecture, and

that it should have been so widespread. We have been able to touch only upon a few early examples in Part Two, and a few of more recent date will follow.

III. The Japanese Influence Upon European and American Architecture From 1915 to the Present

The traumatic shock of World War I stimulated repercussions seeking the rational approach to architecture as well as other areas of creative endeavor. The resulting functionalism, as in the Dutch Stijl or Neo-plasticism, Russian Constructivism, German Bauhaus, and French Purisme and Cubism resorted to stark geometric forms, conscious of interpenetrating planes in space, the use of new structural materials, contrasts in opacity and transparency, interesting new combinations of line, color and texture, a furtherance of ideas conceived and expressed before the war in the Werkbund movement, of which Gropius and Meyer's Model Factory (1914) is exemplary . Gropius became one of the leaders of the later Bauhaus, designing the building for the school when it moved from Weimar to Dessau in 1926. In Bauhaus teaching, the machine replaced the humanities. Charles Edouard Jeanneret, better known as Le Corbusier, developed his own brand of the new space-materials concept, his designs depending upon effects made possible by the slender pillar, independence of skeleton and wall, allowing for freedom of plan as well as facade, and incorporating a roof garden. His Villa Savoie (1928–30) at Poissy, France, embodies all of these principles. Enclosed living areas were connected to open terraces by clear glass walls that could be curtained. Partitions could be moved around the supports for plan variations. Except for the uncompromising boxiness of the forms and highly processed steel and concrete materials, the essence of Le Corbusier's architecture is inherent in Shogun Yoshimitsu's Kinkaku (1395), referred to twice before. The Kinkaku had skeletal construction with complete flexibility of room arrangement in the first two stories, by virtue of sliding screens—solid fusuma separating interiors and light-admitting shoji enveloping the suites. The third story was a meditation hall, rather than roof garden, offering spiritual and intellectual rather than physical recreation.

The architecture based upon geometry intervening the two world wars constituted the International Style. Frank Lloyd Wright employed it, as in his imaginative house built in 1936 on Bear Run, Pennsylvania, for Edgar J. Kaufmann. Called Falling Water, the design surpassed the obvious functionalism of the Villa Savoie through elimination of arbitrary post supports, attaining a hovering quality through stress on horizontals (the Japanese line of purity and unity), and keying in with the landscape by combining natural stone walls, superbly laid, with concrete planes. The ravine with stream and waterfall was a site such as the nature-loving people of the Far East would select. The stairs descending to the water is a motif taken from the sixteenth-century Hiunkaku (Flying Cloud Pavilion), at Kyoto, which one reached by rowboat and entered through sliding panels in the floor.

The western-states architect Harwell Hamilton Harris epitomized his regard for Japanese architecture through the construction of his own home (1935) in Fellowship Park, Los Angeles. The building is derived from structures in Nippon in form, construction, materials, plan and scale. Built on a hillside, the openness permits full impact of the spectacular view. Two-thirds of the twelve-by-thirty, six-foot building is devoted to the living room, which is provided with three sets of sliding outer screens—clear glass, translucent plastics and fly screens. The balance is partitioned into a bath and dressing space, kitchen, and utilities closet.

More derived than literal, the Rockefeller Guest House on East 53rd Street, New York City, designed by Philip Johnson and built in 1950, presents a plain brick wall to the street, masking the front entry, kitchen and stairs to the servant's quarters above. Back of these is the living room, fronting a terrace and pool, with stepping stones leading to the guest chamber and bath opposite. A graceful maple tree grows from a drum in the water, with ivy on the wall behind. Soft light filters through a white glass canopy over the terrace, giving the effect derived from rice-paper shoji. In 1956, the American sculptor Isamu Noguchi (whose father was Japanese) was recommended by architect Marcel Breuer to design a garden for the Unesco Headquarters being built in Paris. The space, adjacent to three buildings, was known as the Patio des Délégués. Noguchi divided it into two areas, a high and geometric terrace (consistent with the architecture), and an organically planned lower garden often referred to as the Jardin Japonais. Undulating elements of stone paving, ground with planting, and water crossed by stepping stones are interwoven, and enhanced by eroded rocks—amounting to 88 tons—selected by the designer and shipped from Japan. An elevated walk or "garden viewing veranda", crossing the lower section, has been compared by Noguchi to the hanamachi (flower path) in a Japanese theatre. Three gardeners and a shipment of maples and cherry tree saplings, dwarf bamboo and camellia came from Yamato to lend their authentic savor to the scheme. The project took two years to complete, Noguchi making two trips from New York to Paris, and two from Paris to Japan.

It hardly would be appropriate to close even this brief statement, touching only a few of the highlights of Japanese influence upon Western architecture during the last century, without mention of the foremost parallels between the tall commercial buidings of our modern cities and prototypes in Japan. The skyscraper has a skeletal structural system of modular units, the outer covering nonweight-bearing. Except for elevator shafts and conveniences at its core, each story has a flexible arrangement. For at least the last two decades, the casing generally has been the glass wall, a maximum of window and minimum grid of supporting members. The eye moves over the unvarigated rectangles easily, as over the shoji, or window wall, in a Japanese house. The high-rise is as of shoji removed, greatly enlarged, and set up as cubic forms soaring upward from the canyon streets of the metropolis. Japan was the first nation to develop an aesthetically pleasing, democratic architecture, adaptable to changing activities of the day, integral with nature, a structural counterpart of their other plebeian art from, the color woodblock print. It was inevitable that these two developments would attract the attention of Western society of the mid-nineteenth century, as it had just come abreast of this stage in its evolutionary march. The Japanese offered the West a great stride forward. The genius that conceived the Kinkaku laid the foundations for architecture on the other side of the Earth after a five-century lapse. Japan emerged from its isolation at the time its culture would be most generally appreciated, like a larva at the precise moment it is to assume the form of a winged adult, ready for flight. As the culture of Greece passed to and shaped that of Rome, so that of Nippon became transplanted to and flourished in Europe and America throughout the past century. Its affect perseveres today and shows every indication of continuing for some time to come.

Notes on the Influence of Japanese Architecture in Europe and North America

The functional interchangeability of individual rooms and entire sections of the dwelling, the standardization of components by employing modular systems and separating load-bearing from non-load-bearing structures has been practised in Japan since the sixth century. The theoretical and practical work of Walter Gropius, Frank Lloyd Wright, Ludwig Mies van der Rohe, Bruno Taut and others involved analogous developments to the Japanese, i. e. use of materials and construction methods were related. This facilitated the appreciation and the reception of Japan's rich architectural traditions. Frank Lloyd and Bruno Taut were the first to draw attention to and themselves employ the principle of the "open groundplan" with its flexible conception and standardized components. In many cases Japanese architecture merely led to decorative imitation, especially in many houses on the west coast of the USA. H. F.

The essential characteristics of Japanese construction methods are:
Standardization of room sizes and components
Modular groundplan
Standardized construction methods and wall surfaces
Internal and external variability, flexibility, extensibility and interchangeability
Use of materials in natural state. Built-in furniture, cupboards and shelves, maximum utilization of space, surface impression
Practical design, clarity of construction
Intimate linking of nature, house and garden
Highly-developed woodworking techniques, close connection between construction and design
Gable, mansard and gambrel (Joinoya) roofs as important architectural elements
Garden types

Translation P. J. D.

1149 Mies van der Rohe, House ▶

1151 Mies van der Rohe, Crown Hall ▶

1153 Mindeldal, Dwelling House ▶

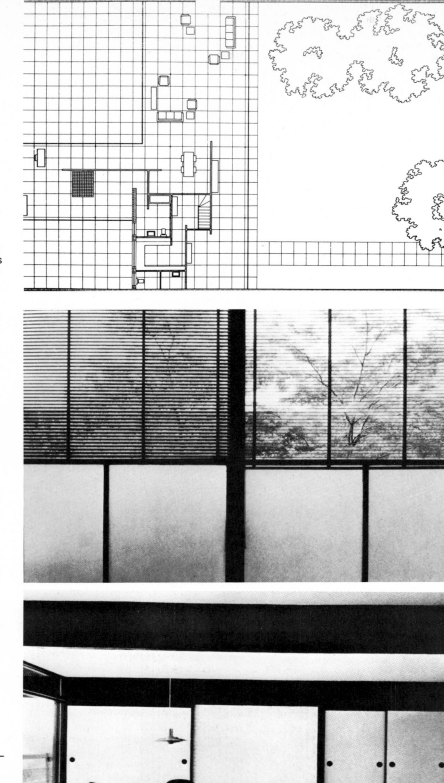

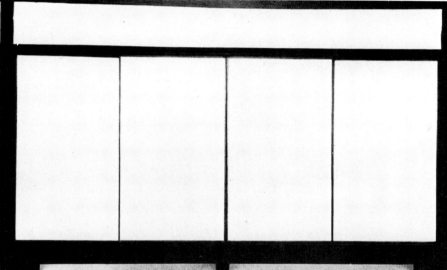

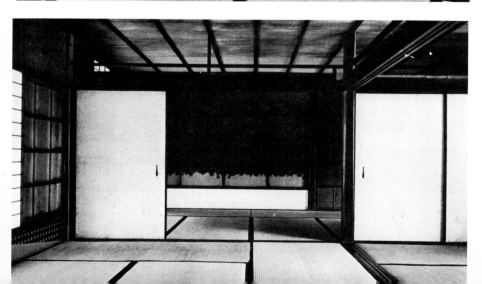

1149 *Ludwig Mies van der Rohe (Aachen 1886–1969 Chicago); Project, House with Garden Court;* "modular system of groundplan"; photo: W. Blaser; plate

1150 *Type of Japanese Dwelling-House;* "modular system of ground-plan"; photo: H. Engel; plate

1151 *Ludwig Mies van der Rohe; Crown Hall Chicago 1952–1956;* "surface distribution"; photo: W. Blaser; plate

1152 *Katsura, New Palace, Kyoto;* 16th cent.; "surface distribution"; photo: Gropius, Tange; plate

1153 *Lars Mindeldal (Svendberg); Dwelling House in Denmark 1968;* "sliding walls"; photo: H. Nissen; plate

1154 *Katsura, new Palace, Kyoto;* 16th century; "sliding walls"; photo: Gropius, Tange; plate

1155 *Richard Neutra (Vienna 1892–1970 Los Angeles); Lake View Residence USA 1957;* "House and Garden"; photo: Shulman; plate

1156 *Katsura, new Palace; Kyoto;* 16th century; "House and Garden"; photo: Gropius, Tange; plate

1157 *R. M. Schindler, USA; Project for a detached house, Los Angeles 1938;* "Roofs"; photo: D. Gebhard; plate

1158 *View of Japanese Dwelling Houses;* "Roofs"; Otto von Kotzebue; plate

1159 *Design: Harald Roth, B.R.D.; made by Meisterschule für Schreiner Vertrieb: Casa-Möbel GmbH; Mandarin table;* constructed in solid wood; ⌀ 80 cm, h 43 and 62 cm, w 154 cm; 1960

East and South-East Asia

Architecture

1149–1160

◀ 1150 Japan, Dwelling House
◀ 1152 Japan, Katsura Palace
◀ 1154 Japan, Katsura Palace

1160 *Urasenke XV. Sohitsu Sen, Kyoto; Japanese Tea House "Kanshoan" and Japanese Garden on an island in the Eisbach, English Gardens, opposite Haus der Kunst, Munich; 1971/72.* The Teahouse and Garden was built for the Olympic Games specially for the exhibition "World Cultures and Modern Art" by the head of a family that has been famous for centuries for its cultivation of the Tea Ceremony. The whole was prefabricated in the workshops of the Urasenke family in the spring of this year and then erected by five Japanese carpenters within a period of two months. Not a single nail was used on the entire structure. The island on which the Tea House stands and the river bank opposite have been transformed into a Japanese garden. In the years to come the Tea Ceremony will be carried out under the supervision of a member of the Urasenke family.

Historically the Tea Ceremony can be traced back to an ancient custom of the Zen priests who drank tea to keep awake for their nocturnal exercises. The ritual was described in the thirteenth-century booklet on the "Healing Influence of Tea" by the monk Eisan. After the ceremony had been transformed almost into a purely social event by the profane fourteenth century, Sen-no Rikyu restored the rite in the sixteenth century to its ancient simplicity. The Tea Ceremony is still performed today according to the rite of Sen-no Rikyu; plates

Translation: P. J. D.

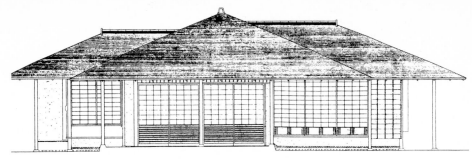

1160 Urasenka, Tea House

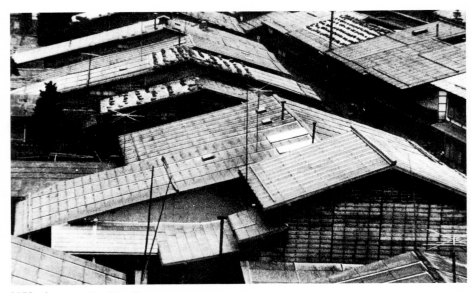

1158 Japanese Dwelling House

1156 Japan, Katsura Palace

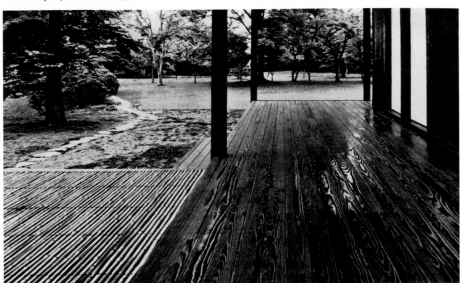

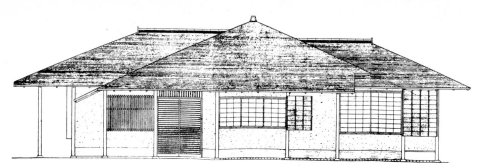

1160 Urasenke, Tea House

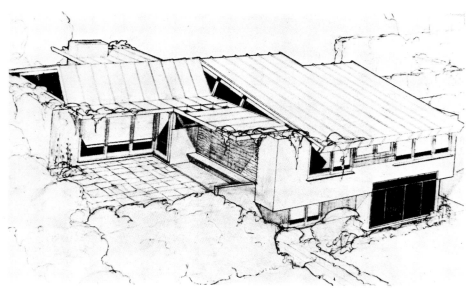

1157 Schindler, Detached House

1155 Neutra, Lake View Residence

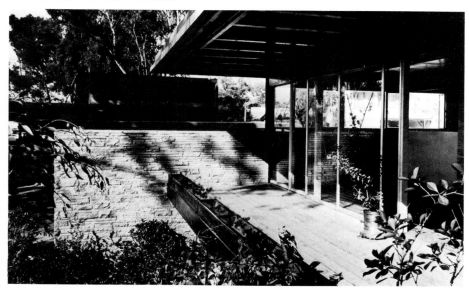

The Oriental Influence on the Decorative Arts in France and England

Elizabeth Aslin

East and
South-East
Asia

Ceramics
and Glass

1161–1587

"L'Orient est le berceau du genre humain." This is the opening phrase of a small book on ornament written by the Frenchman, Adalbert de Beaumont, in 1853, some years before the enthusiasm for Oriental and particularly Japanese art is generally assumed to have taken root in Europe. In fact it is to the personal enthusiasm of the little-known de Beaumont, described in contemporary accounts as an amateur of the arts and a traveller of discerning taste, that much of the taste and esteem for the Orient in both France and England can be directly attributed. It was this taste which was the most important single external influence on the European decorative and applied arts in the second half of the nineteenth century. The influence falls into clearly defined phases in both France and England: in the eighteen fifties and sixties it was a matter for individual collectors and enthusiasts; in the seventies the fashion was in full swing amongst informed people, manufacturers were producing high class "oriental" objects in quantity and in England interior decoration and furniture were based on what were believed to be Japanese principles. By the eighteen eighties what had been an art movement had become a fashionable mania and many a household on both sides of the Channel had its complement of Japanese fans and parasols. Asymmetry of form and ornament had spread to pottery, porcelain, silver and furniture.

It was this asymmetry which was the hallmark of orientally inspired design even if European design motifs were used. "Japanese art has taught the advantages of asymmetrical arrangements so that one need not always have pairs" or opposites, wrote an anonymous author in an English trade periodical and Philippe Burty, the French art critic and collector wrote, "Les Japonais mieux qu'aucun ancien peuple ont trouvé le secret du charme absolu dans l'irrégulier." The extravagant claims made for Japanese art by Burty in his published writings of the 1860's make it possible to appreciate the infectious enthusiasm that spread amongst artists and designers of the time. He claimed that their bronzes proved the Japanese "to be the most intelligent of all modellers" and writing of

177

East and
South-East
Asia

Ceramics
and Glass

1161–1587

Hokusai colour prints he said that they included "sketches of every sort, rivalling Watteau in their grace, Daumier in their energy, the fantastic terror of Goya and the spirited animation of Delacroix."
One of the most curious aspects of any stylistic influence and one of the most difficult to establish and define is the social climate in which such a cultural transplant or graft is succesful. This is particularly marked in the case of the impact of Japan on European art in the nineteenth century. After about 1862 the climate was clearly propitious for rapid growth in both France and England and to some extent in other countries, too, although in fact Japanese objects had been available earlier without arousing any real interest, however.
It has long been assumed that Japanese objects were first seen in Paris and London in the mid-eighteen fifties, mainly on the basis of a variety of stories of merchandise arriving wrapped in Japanese prints. This is said to be the origin of Felix Braquemond's interest and also that of the English designer, E. W. Godwin, who in the late 50's and early 60's was living in the port of Bristol, which had a thriving trade with the East. These casual discoveries were followed by the exhibition of the arts of Japan at the International Exhibition in London in 1862 when the first British Minister to Japan, Sir Rutherford Alcock, showed his personal collection of lacquer, bronze and porcelain. Certainly this exhibition made a considerable impact on the informed visitor as an art of relative simplicity and restraint in the midst of High Victorian elaborations, as did a similar though larger display at the Paris Universal Exhibition of 1867. However, this was not really the beginning of the story. Even during the centuries when Japan was closed to the rest of the world, there was a small volume of trade through the Dutch and Chinese who had limited trading rights at Nagasaki. As a result of this, when the forerunner of the present Victoria and Albert Museum was established in London in 1852, two thirds of its small collection of "Furniture and Upholstery etc" was either japanned or papier mâché, and nearly all the pieces were directly ascribed to Japan or China. Two years later, in 1854, an exhibition of Japanese applied art and colour prints was held in London, and a number of bronzes, pieces of lacquer and of porcelain were bought for the Museum collections. Though this was the first direct importation from Japan to England it would appear from contemporary press comments to have made little impact on

the public which was to be seized by the Japanese mania as if by revelation some twenty years later. One newspaper account did suggest that an exhibition would be attractive to the public "from the interest recently excited by the United States Expedition to Japan" and of course it was Commodore Perry's expedition of 1853 which made such a display possible.
From 1853 until 1858 when both the British and the Americans enjoyed the advantages of a limited commercial treaty with Japan, there was intermittent contact with the country itself. Thus, representatives of the British Navy and some civilians were continuously resident at Yedo (Tokyo) for six months in 1857, becoming fairly well acquainted with daily life and its accompanying arts.
It is this period of negotiation in Japan, no doubt, which explains the presence in Europe of the colour prints seen by both Braquemond and Whistler in Paris in 1856 and a series of roller printed cottons with designs taken directly from such prints which were produced and marketed by a Manchester firm in 1858, fully four years before the normally accepted date for the introduction of Japanese goods into England.
One of the unexpected aspects of the English enthusiasm for Japanese art was that it was closely related to the ideas associated with William Morris and with the Arts and Crafts movement. One of the initiators of Japanism in England was a staunch medievalist, the architect William Burges, amongst whose private papers are preserved some of the first Japanese prints collected in England and all dating from the early 1850's. These include some of the usual single figure prints and several sheets of rather crudely executed popular prints of children's games, some badges and figures of Europeans, as well as book wrappers, one of which is a repeating pattern of what came to be known as Whistler's butterfly. The combination of Burges' enthusiasm for 13th century French architecture and nineteenth century Japan, if superficially curious, is nevertheless easily explained. It was not primarily the form of Gothic architecture and furniture which attracted Burges but a romanticized view of the feudal conditions which produced it, in contrast to the industrial conditions of the nineteenth century. And it was the same with Japanese art, too. "If the visitor wishes to see the real Middle Ages," wrote Burges of the 1862 International Exhibition, "he must visit the Japanese Court, for at the present day the arts of the Middle Ages

have deserted Europe and are only to be found in the East. Here in England we can get medieval objects manufactured for us with pain and difficulty but in Egypt, Syria and Japan you can buy them in the bazaars."
A small and discerning group of French collectors and artists had already been introduced to these arts of the bazaars of the Middle and Far East by a handsome volume of etchings "Recueil de dessins pour L'Art et L'Industrie" published by Adalbert de Beaumont and Eugène Victor Collinot in 1859. This material was later known to a much wider public, as it formed the basis of the handsome series of volumes of colour lithographs collectively called "Encyclopédie des Arts Decoratifs de L'Orient" published in Paris between 1871 and 1883. The original album was a limited edition of designs drawn from objects and places seen by de Beaumont in his travels and included Chinese, Japanese, Persian and Turkish architecture, ornament and ceramics. The sketches include street scenes, gardens and landscapes as well as detailed studies of individual pieces of glass and pottery. It is these studies that provided the source of both form and decoration for many of the pieces made by Collinot and de Beaumont in their own pottery, which they had established in the late 1850's at Boulogne-sur-Seine. In addition a number of the plates provided the inspiration for Théodore Deck's oriental ceramics and for the Persian-type enamelled glass of Joseph Brocard. For example, one of the pieces shown by Brocard at the Paris Exhibition of 1867 was in fact not an original design but an exact reproduction of plate 196 of the "Recueil de dessins" and a number of such pieces occurred throughout his glass-making career. On the other hand, Théodore Deck used ornamental details from de Beaumont's work and applied them to his own forms with his own pottery technique. Philippe Burty recorded that it was Adalbert de Beaumont, returning from his travels not only with innumerable designs but also with "precious scraps of that enthusiasm which kindles all it draws near," who first urged Deck to imitate Oriental forms and glazes and that it was Deck in his turn who inspired Félix Braquemond to work on ceramics.
The famous Japanese service with decoration designed by Braquemond based on Hokusai's Manga was commissioned from him by Eugène Rousseau in 1866 and was made by Leboeuf and Millet for the Paris Exhibition of 1867. Rousseau was himself a glass

*East and
South-East
Asia*

*Ceramics
and Glass*

1161–1587

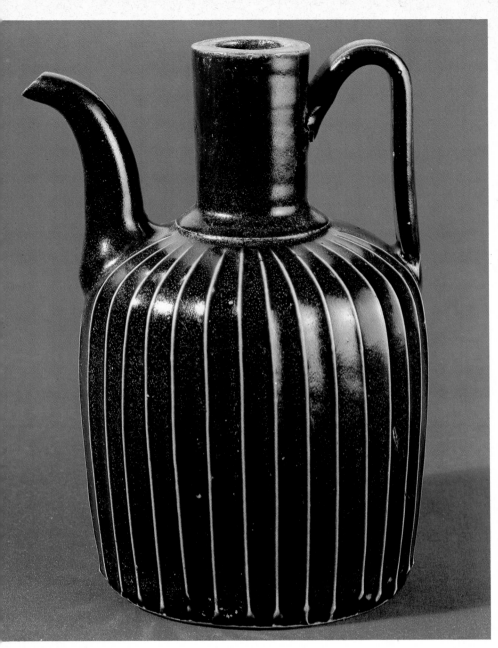

1393 China, Jug

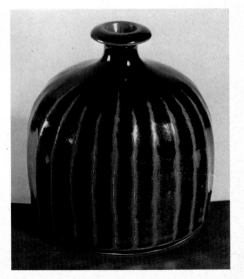

1394 Kerstan, Vase

179

East and
South-East
Asia

Ceramics
and Glass

1161–1587

artist of distinction as well as a pottery decorator and showed some of his own Japanese-influenced glass at the same exhibition. These were subtly tinted vessels with limpid, watery, asymmetrical decoration engraved and applied. The Braquemond Japanese service demonstrates the extreme to which the enthusiasm for asymmetry and randomness could be carried with success. Braquemond produced a series of boldly drawn and deeply bitten etchings based on his studies of the Hokusai originals. The sheets of prints were then cut up and the motifs transfer-printed at random on plates and dishes dependent on the whim of the decorator. Similarly the colours were also applied according to the caprice of the individual ceramic worker, possibly Rousseau in the first instance. However the common denominator remained Braquemond's drawings: "le service obtint ainsi une variété et une fixité," as Philippe Burty wrote.

Once the virtues of Oriental art had been appreciated, the influence spread with remarkable rapidity both in England and in France and in two distinct forms.

Quite apart from Japanese goods retailed in an ever growing number of specialist shops in Paris and London, objects were produced by designers and manufacturers which were in some instances virtually reproductions of their prototypes. Other designers worked in what they believed to be an Oriental manner. Thus an English service, made by Minton's in 1870 and decorated with the flora and fauna of the English countryside, can be counted as Japanese by virtue of the random disposition of decorative motifs. The designer W. S. Coleman, who began his professional life as a naturalist, was clearly influenced by the Braquemond service, which was shown in London soon after its Paris appearance. Probably the most attractive form of Japanese design in England and one that was well within the reach of the general public was that for pottery and porcelain commercially produced in quantity. Around 1880 almost every maker of tablewares registered at least one "Japanese" design with the Patent Office in London. The keynote of the designs was an asymmetrical arrangement of fans, birds, sunflowers and almost anything remotely oriental, within the framework of the circular plate. Another feature of this type of design was the practice of running a band of design obliquely across a circular plate or the cutting up of the whole pattern area by such bands meeting at acute angles. Occasionally the printed decoration

included a European figure or landscape subject but always set in a fan-or box-shape placed off centre in the design, thus indicating the oriental sympathies of the designer. Some of the earliest complete services were made by Wedgwood. One dating from 1873 is unusual in using direct careful reproduction of a series of Japanese prints of scenes on the Tokaido. Another of Wedgwood's early services was first made in 1879 and was called "Sparrow and Bamboo." Except that the body was of Wedgwood's usual cream earthenware, the service was quite unlike the firm's normal production. Jugs and other vessels were straight-sided and angular, and the decoration was a combination of relief moulding and transfer printing. The bamboo of the title was used as the motif for the handles of the various jugs and cups, and the surface decoration was of fans moulded in relief with a printed fan superimposed. In between the fans were sparrows and a type of kingfisher perched on boughs of plum blossom. While many designs of this kind on pottery were merely self-consciously asymmetrical and different from the conventional production, some of the more restrained examples were most attractive with painted or modelled decoration of very high quality. Possibly the most successful were relief-decorated stoneware jugs made by firms, who keeping up with the fashion in this form of popular art, substituted for their usual narrative or commemorative subjects, storks or plum blossom applied seemingly at random. Some makers occasionally made objects more nearly in imitation of oriental forms, such as the small teapots and vases produced by the Worcester Royal Porcelain Works. Generally speaking in pottery and porcelain there was no real attempt to imitate oriental techniques though the search for glazes and colours as brilliant as those of China, Japan and the Middle East became in some instances almost obsessive and was so much a part of the Parisian scene in the middle of the century that Flaubert includes it as part of the setting of "Sentimental Education." Amongst his other artistic activities, the central character Arnoux, "searched for the copper red of the Chinese" and "tried his hand at majolica, faïence, Etruscan and Oriental china."

It was in the field of metalwork of all kinds that serious attempts were made at the actual reproduction of oriental prototypes and techniques. In England one firm, Hukin and Heath of Sheffield, supplemented the genuine pieces of oriental metalwork available to collectors

through such dealers as Liberty and Co., by producing reproductions of actual Japanese and Persian bronzes and vessels by the electrotype process. Also around 1870, the old established firm of Elkington of Birmingham made cloisonné enamel vases and other small decorative pieces, virtually indistinguishable from their Japanese models except that in every case the maker's name was painted or impressed on the underside of the article. Despite these modest successes a writer in the English periodical "The Art Journal" in 1872, recorded somewhat despairingly that "we cannot reproduce the beautiful lacquer which the Japanese artists apply alike to wood, to metal and to porcelain" and continued that "much of their finer metalwork remains a perfect enigma to our most intelligent workmen."

In France, however, the making of artistic bronzes of high quality was a well established industry and as such had been the envy of the rest of Europe since the early 1840's. The leading maker in this art industry was Ferdinand Barbedienne and as early as the International Exhibition held in Paris in 1855 he showed bronze vases and ornaments, theoretically modern Greek in form, but with applied natural ornament of distinctly oriental flavour. Thus he exhibited a bronze amphora but with swallows skimming across the surface. At this time there was no attempt at oriental techniques. At the London Exhibition of 1862 Barbedienne showed a number of pieces described stylistically as Greek or Byzantine but using somewhat oriental techniques; by 1867 Japan was the predominant influence in his exhibit. It was reported of this display that "the most remarkable enamelled works both in size, elaboration of design, harmony of effect and perfection of execution and finish are to be found in the collection exhibited by F. Barbedienne. In these objects a new development of the decorative art of Europe is illustrated. Based on Oriental taste and modes of production they rival the enamels of the East alike in design and execution." At the same exhibition, Christofle of Paris introduced a range of small domestic pieces of cloisonné enamel said to be made in imitation of Chinese work. These were less obviously oriental in design but Christofle employed two designers, MM. Tard and Reiber, who were amongst the small group of enthusiasts centred round de Beaumont, Braquemond and Deck. Other manufacturers followed this example and in 1868 a tastefully produced little book on enamels was published by

East and
South-East
Asia

Ceramics
and Glass

1161–1587

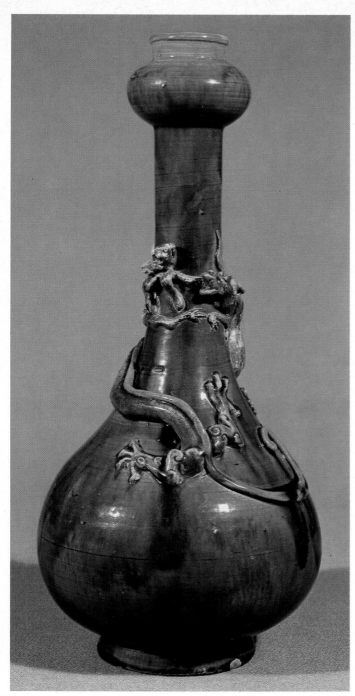

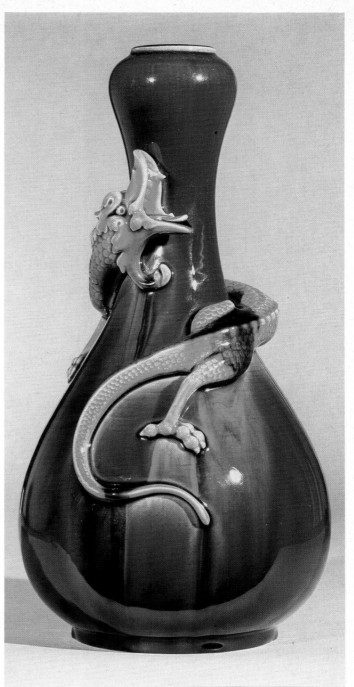

1176 China, Vase

1177 Deck, Vase

East and
South-East
Asia

Ceramics
and Glass

1161–1587

a jeweller named Martz who, trading in the Rue de la Paix, Paris, was sufficiently in touch with the new movement to employ Philippe Burty to write the text. In this book Burty suggested that the idea of the direct imitation of Japanese cloisonné for jewellery and small decorative pieces dated from the 1867 Exhibition.

Barbedienne's work was not limited to enamel. His experiments led amongst other work to brilliant imitations of Japanese lacquer usually mounted in bronze. Christofle, principally a silversmith, produced in addition bronze vessels damascened with precious metals of the highest quality, initially in oriental form but later the technique was used for pieces of conventional European design. Other lesser known firms of French metalworkers made vessels of all kinds engraved and embossed, simulating Persian or Turkish models, and perfected the most elaborate techniques involving carved jade inlaid with precious and semi-precious stones.

The other trades in which oriental designs and techniques were imitated in France and in England were those of textiles and wallpapers. High quality woven silks were produced in quantities in the 1870's and early 80's, with names like "Nagasaki" and "Yedo," and using small repeating motifs based on Japanese badges and other similar small motifs. While metalwork, textiles and ceramics tended to cater for the demand for high quality luxury goods, it was the cheapness of paper products that commended them to manufacturers. In the mid 1870's Japanese embossed and gilt leather paper was first imported into England as a decorative and cheap wall covering and Japanese paper curtains appeared on the market at "fabulously low prices." The British Government instituted an enquiry into oriental methods of paper manufacture and soon similarly cheap goods were available in England and in France, where the wallpaper industry took up both these techniques and Japanese design.

By the time of the Paris Universal Exhibition of 1878 the Japanese mania knew no limits. "There has been such a rage for Japanese design of late that we are tolerably well acquainted with it. From the highest to the lowest, from the Worcester Royal Porcelain Works to Parisian children's fans we have had imitations of Japanese style" wrote an anonymous English author in the Society of Arts Journal. At the same time Ernest Chesneau, himself an oriental enthusiast, wrote with some scorn of a proposed

Japanese ballet at the Opera in Paris, of the Japanese influence on fashion and concluded "ce n'est plus une mode, c'est de l'engouement, c'est de la folie."

J 36 *Japan, Edo Period (1603–1868); plate;* porcelain with enamel pigments; pine, bamboo, plum-tree blossom and birds after the manner of Kakiemon ware; ⌀ 22 cm; 18th cent.; Tokyo, Idemitsu Mus.

J 37 *Germany; manufacture: Königl. Sächsische Porzellanmanufaktur Meissen; plate with plant and bird decoration;* porcelain; ⌀ 23.5 cm; 18th cent.; Tokyo, Idemitsu Mus.

J 38 *Japan, Edo Period (1603–1868); Plate with a scene from a tale by Shiba Onko;* porcelain; ⌀ 23.5 cm; 18th cent.; Tokyo, Idemitsu Mus.

J 39 *England; manufacture: Chercy; plate;* porcelain; ⌀ 23.8 cm; 18th cent.; Tokyo, Idemitsu Mus.

J 40 *China, Ch'ing Dynasty (1644–1912); plate;* porcelain; ⌀ 37 cm; early 18th cent.; reign of K'ang Hsi (1662–1722); Tokyo, Idemitsu Mus.

J 41 *England; manufacture: Royal Worcester; plate;* porcelain; ⌀ 55.5 cm; 18th cent.; Tokyo, Idemitsu Mus.

J 42 *China, Ming (1358–1644) or early Ch'ing Dynasty (1644–1912); Rice-Wine Bottle (Tokuri);* porcelain with blue underglaze painting; h 25.5 cm; 17th cent.; Tokyo, Idemitsu Mus.

J 43 *Japan, Edo Period (1603–1868); Vase;* porcelain, Ko-Imari; h 28 cm; 17th/18th cent.; Tokyo, Idemitsu Mus.

J 44 *Holland; Vase;* Delft porcelain; h 30 cm; 17th cent.; Tokyo, Idemitsu Mus.

J 45 *Holland; Vessel; Delft porcelain;* h 13 cm; 17th cent.; Tokyo, Idemitsu Mus.

J 46 *Japan, Edo Period (1603–1868); Water container (mizusashi);* porcelain, Ko-Imari with underglaze decoration; h 14 cm; 17th cent.; Tokyo, Idemitsu Mus.

The Influence of the Far East on British Pottery in the Nineteenth and Twentieth Century

Hugh Wakefield

The nineteenth century saw the beginning of a distinction between factory and studio wares which is characteristic of modern ceramics. The factory wares have come to be based on quantity production and the convenience of manufacture. The studio wares are based on the skill and perception of the individual artist potter. Both owe a large part of their history in the Western world to the influence of the Far East, but in the case of the studio wares the debt is particularly heavy since the Far Eastern influence has affected the whole attitude of the Western artist towards the possibilities of the ceramic medium.

In the early decades of the nineteenth century, Far-Eastern styles were not lacking among the variety of wares produced in the British factories. "Japan" patterns based on Japanese export Imari wares were popular, until they were largely superseded in the second quarter of the century by a revival of Rococo and, later, of Classical styles. The more decisive phase of Far-Eastern influence, however, belongs to the latter part of the century. A new interest in the Far East was developing in the 1860's, symbolized by the Japanese display at the London International Exhibition of 1862, and in the 1870's and 1880's this was manifested in the field of industrial ceramics by a predominant fashion for the use of a variety of Japanese motifs. Factories such as those of Worcester, Minton, Wedgwood, Pinder Bourne and Brownfield produced many wares decorated with the fashionably "quaint" Japanese figures and patterns. Such wares exercised an appeal which, in spite of its superficiality, was long-lasting and in its final effect of considerable consequence. The Japanese style was followed in some quarters by the Third Rococo of the 1890's, but in general it was an important contributory factor to the Art Nouveau and the styles of the twentieth century. The Japanese style meant the freeing of decoration from the formalities of border patterns and symmetrically arranged motifs; it meant freedom to leave a ground surface unadorned; and it meant eventually the freeing of form from many ingrained classical conventions.

But although the British factories were quick to take up the Japanese style, British artists concerned with ceramics were at first relatively slow to appreciate the more subtle qualities of Far-Eastern work. The Arts and Crafts movement, initiated by William Morris, tended at first to look for medieval precedents, and the one outstanding potter of Morris' circle, William De Morgan, derived his inspiration mainly from the Near East. The pioneer artists from the Lambeth School of Art in London, who decorated unique pieces at the Doulton pottery in the 1870's, were working either in salt-glazed stoneware or in a painted earthenware which they called, somewhat inaccurately, "faience." In both cases the media were essentially European. The Martin brothers, also working in the London district, were similarly concerned with salt-glazed stoneware and did not come to use Japanese-inspired motifs or forms until the mid 1880's.

Many of the "art potteries," however, which sprang up in England in the later nineteenth and early twentieth centuries were taking part in a general movement of taste towards the appreciation of Far-Eastern forms and glazes. The interest in Far-Eastern forms manifested itself in a sense of freedom from classical preconceptions rather than in deliberate imitation. Similarly the interest in glazes implied little more than the use of glaze colour and texture as a principal means of decoration. An art pottery which attracted a good deal of attention in the years around 1800 was that of Linthorpe near Middlesborough, where the manager Henry Tooth was devising decorative glazes for the quixotic forms of the free-lance designer Christopher Dresser. A similar combination of decorative glazes on Dresser's forms appeared in the 1890's in the products of William Ault's pottery at Swadlincote. Sir Edmond Elton's "Elton Ware," produced over a long period from the 1880s until 1920, may be said equally to express a generalised influence from the Far East with its asymmetrical floral patterns and its strongly coloured glazes.

The culmination of this interest in emulating the effects of Far-Eastern glazes and forms came with the first decades of the twentieth century. Following on the first phase of modern influence from the Far East, which had been mainly a matter of Japanese-style patterning on industrial wares, this second phase involved mainly the emulation of the fine Ch'ing monochrome glazed wares which had long been well known in Europe. Several distinguished

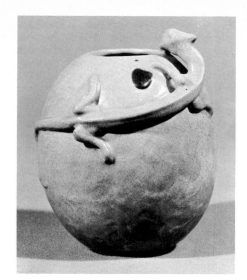

1165 China, Vase

British potters who were in effect the leaders of art potteries need to be mentioned in this context. Bernard Moore's work at Stoke-on-Trent included individual porcelain pieces with fine high-fired glazes. The brothers William and Joseph Burton, in charge of the Pilkington factory near Manchester, inspired the production of a remarkable variety of scientifically determined glazes and glaze effects in 1904 and the following years. William Howson Taylor, working in his Ruskin Pottery from 1898 until 1935, was similarly concerned with wares which were freely conceived but of obvious Chinese inspiration, decorated for the most part solely with elaborate glaze effects. Some others who may be considered individual potters were experimenting with stoneware in the Chinese manner, such as W. B. Dalton at the Camberwell School of Arts and Crafts and George Cox at the Mortlake pottery, London; but the artist potters in England can scarcely be said to have aspired to the same degree of conscious artistry in this mode as was practised by their French counterparts.

A third phase in the modern influence of Far-Eastern ceramics arose from the re-discovery, in the early twentieth century, of Chinese Sung and Korean Koryo dynasty wares and their interpretation in terms of the traditional pottery of Japan. Among the British potters of the 1920s and 1930s this fresh wave of influence from the Far East implied a new attitude of mind, which stressed the qualities of the material rather than the individual's originality of expression. Artist potters came thus to

be preoccupied by the integrity of their ceramic ideals with little regard to contemporary development in the fine arts or industrial design. The artist potter became wholly and personally responsible for every process in the production of his pots, from the provision of his clay to the building and firing of his kiln.

This change of attitude was formulated in the work and writings of Bernard Leach. Born in the Far East, educated as an artist in England, apprenticed to the potter's craft in Japan, Leach was almost uniquely capable of transmitting to the Western world a profound understanding of the Far-Eastern art. The surviving Japanese connoisseurship, of "raku" ware especially, gave a key to the full appreciation of the medieval Chinese and Korean wares. In 1920 Bernard Leach arrived in England accompanied by the young Japanese potter, Shoji Hamada, and together they set up a pottery at St Ives in Cornwall, where they proceeded to experiment partly in the making of Japanese style stoneware with brush-work or wax-resist decoration and partly in a revival of the old indigenous English style of slipware. They used natural local materials for their clays and glazes, and these, with their characteristic impurities, gave a quality to their ceramics which fitted well with the outlook of the British Arts and Crafts movement. Hamada subsequently returned to Japan, where he became a leader of a parallel revival of craft pottery, and to this day a close relationship in style and outlook has persisted between certain of the Japanese and British potters. Bernard Leach's personal influence resulted not only from his success as a potter but also from his willingness to take pupils and, later, from the popularity of his book, "A Potter's Book," first published in 1940. Among his best known pupils were Michael Cardew, who specialised at first in the use of slip-ware, and Katherine Pleydell-Bouverie, who made a systematic study of the use on stoneware of various wood-ash glazes. Bernard Leach's influence in Britain was complemented by that of William Staite Murray, a vigorous potter who had caught the spirit of Hamada's work from an exhibition in the early 1920's. From 1925 until the second world war Staite Murray was head of the pottery school in the Royal College of Art in London and was the teacher of such potters as Henry Hammond and the late Sam Haile.

A style of British artist pottery was thus established in the 1920s and 1930s

East and
South-East
Asia

Ceramics
and Glass

1161–1587

which was based on a combination of indigenous and Far Eastern elements. Its particular significance is that its borrowings were not merely of ceramic forms and decoration but also of a mental attitude which tended in an un-European manner to place the craft above the individual potter.

The Importance of the Far East for the Renaissance in French Ceramic Art towards the Close of the Nineteenth Century

Florence and Jean-Pierre Camard

China

The renewal of French ceramic art during the Empire (1804–1815) which continued under the Restoration (1815–1830) was succeeded by decades of stagnation. The artistic spirit waned and died and was replaced by an all-consuming interest in technical perfection. Progress in the chemical industry meant that the ceramic artist had new and even more refined metallic oxides at his disposal. Ancient and modern pottery methods were published in books intelligible to the general public. The artist potter was thus stimulated to intensify his experiments still further and thus throw light on the secrets of the past. The industrial age, apotheosized by the world fairs and exhibitions, showers technical progress with honors; the inventor is rewarded with patents, medals and a variety of prizes. The first generation of ceramists – 1840 to 1860 – rescued their art from anonymity; however, they exemplify the historical eclecticism which at this time is so apparent in architecture and painting as well. They reveal the confusion of a world on the threshold of modern times and finding comfort in the examples of the past.

From 1870, Asia begins to supplant Renaissance ceramics and Turkish faience in man's mind. The reason is to be sought in the development of international relations and the intervention of European lands – above all France and England – which compel China and Japan to abandon their isolation and to trade with the West.

When Théodore Deck began to interest himself for China, he was without a doubt the best-known ceramist of his day both for his eclecticism and for his

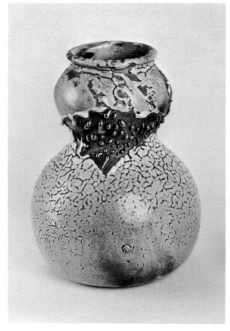

1262 Carriès, Vase

mastery of the techniques of his craft. After he had attained fame with his imitations of the faience ware of the French and Italian Renaissance, he set himself the task of reaching the heights of the faience of sixteenth-century Turkey. In contrast, the Chinese influence helps him to find a style of his own: mainly inspired by the fine Chinese decoration, he gives his own interpretation to the naturalistic motifs and scenes of Ch'ing porcelain. Himself an outstanding chemist and colourist, he attempted to realize his dream of translating the attraction of painting into the language of ceramic art. He used all the technical means at his disposal to arrive at an even more intense effect in his ornamentation. His importance lies not just in the great variety of his experiments but also in his efforts to pass on his discoveries to others.

Ernest Chaplet (1835–1909) also occupies a position apart among those who contributed decisively towards the renewal of ceramic art during the second half of the nineteenth century. He turned his attention first to faience (up to 1880), then to pottery (1881–1887) and finally to porcelain on which he expends all his creative powers until 1904. In contrast to Deck, his approach to his Chinese models is not quite so eclectic but far more purposive and selective.

In 1904 Ernest Chaplet was forced to give up his art for he had fallen prey to

the great hazard of his profession: he had gone blind. To ensure that it would be impossible for anyone to misinterpret his work, the result of his creative experiments, he burnt all his files and notes. Nevertheless, the spirit which had inspired him was to live on, for at this time the young ceramist Emile Decoeur had just abandoned the purely decorative.

Emile Decoeur (1876–1953) was an autodidact and the most remarkable successor to the Chinese-inspired potters. At first it looks as though he is stepping into the shoes of Deck and Chaplet. However, Decoeur sets himself far too high a standard to be satisfied with a hybrid technique. The Japanese influence is replaced by a lasting admiration for pottery and Sung porcelain, which is beginning to gather admirers in Europe. From 1912 onwards Decoeur turns his back on the decorative rhetoric of his early years and now strives after a subtle harmony between enamel pigments and the vase form, a development which is also to be seen in his porcelain work.

From 1880 to 1950 many French artists find their most valuable source of inspiration in Chinese ceramic art. Where the most outstanding of them are concerned, this admiration does not detract either from their creative productivity nor from their desire to reach the same heights as their Chinese masters.

Japan

Up until the world exhibition of 1867 when the pottery selected by the Prince of Satsuma was exhibited for the first time, European collectors had become acquainted only with "kakemono," the porcelain which had been imported by Dutch trading companies as early as the seventeenth century and had been imitated at St. Cloud and Meissen since the eighteenth.

Few visitors to the exhibition appreciated the finer points of what they saw. Few realized the importance of Zen Buddhism and the cha-no-yu for the intellectual and artistic life of Japan. And perhaps fewer still knew what an important part the cha-no-yu masters had played in the development of the extraordinary wealth of forms. In fact, the best pieces bear the names of these venerable "Chajin": "Shino" from Seto, a grey crackleware, with sketched-in decoration, often under a thick white glaze; "Oribe" with indistinct overglaze colours; "Ki Seto," a yellowish body with carefully conceived crackled effects; "Raku," brown and black with a thick, treacly glaze. Jean Carriès was no more

able to give a theoretical foundation for his emotional response than his contemporaries. Yet he was to be the one who was to ensure a new lease of life for Japanese earthenware in Europe. Jean Carriès (1855–1894), in spite of the tuberculosis that was wrecking his health, threw, glazed and fired thousands of pieces destroying all those he felt left room for improvement and thus discovered for himself, in the hard school of practice, all the techniques of the Japanese potter. He enthusiastically tried to emulate the best of their work and yet a number of points betray the personal touch of the artist. Since he was not only a potter of genius but a sculptor of note, too, he was able to lay a different stress and make new demands on the work of the ceramist.

Translation P. J. D.

German Ceramics from the Art Nouveau to the Bauhaus Period

Heinz Spielmann

A report submitted in 1878 to the Prussian Minister for Commerce, Trade and Public Works, Maybach, by a conference of experts called to investigate the conditions prevailing in the Royal Porcelain Factory in Berlin and make proposals for reform contains the following brief statement: "Dr. Seger, whose previous investigations into the pottery industry have received wide recognition, has, since April 1st of this year, been head of the experimental institute of chemical engineering, whose tasks are made clear in the program presented to the commission." Hermann Seger, born in 1839 in Gnesen, qualified analytical chemist, editor of ceramics journals and teacher at the academy of handicrafts in Berlin, drew up his own working program on becoming head of the institute. The tasks mentioned by the commission corresponded to Seger's own ideas. His objective was to scientifically examine the empirical working methods of the potters and ceramic technologists which still predominated and to practically adapt the result to the requirements of workshops and industry. The main beneficiary of this program was the Berlin Porcelain Factory, which was still able to compete with the factories at Sèvres and Copenhagen with their own methodically developed innovations. Over

and above this, however, the technical and aesthetic aspects of Seger's working methods gave German ceramics a specific character which persists today. The systematic preparation of the clay mass and the glazes, the risk-reducing firing procedures and control of temperatures according to physio-chemical laws, became absolute prerequisites for all European potters. Seger introduced a tradition in Germany within which impulses from the Far East, scientific technology, modern workshop operations and co-operation with industry, find their place. His inventions include a protecting case of baked fire-proof clay for fine ceramic-ware technically called a "saggar," an anglicized version of his name; the development of oriental forms of glazing and the preparation of a new porcelain mass. In order to determine how to manufacture this new porcelain, Seger investigated fragments of Japanese porcelain and discovered about the year 1880 that compared with the "hard porcelain" used in Europe, and also in the Berlin factory, this included higher proportions of quartz and feldspat and a lower kaolin content. He developed a "soft porcelain" based on these findings, which had the great advantage of a 200° to 250° lower baking temperature. Apart from the possibility offered by this low temperature of 1250 – 1300° C of employing new procedures for underglaze painting, Seger had thereby created the prerequisite for the burning of coloured glazes previously regarded as the monopoly of Far-Eastern ceramics. The first glaze of this type was the much called-for "ox-blood" or "sang-de-bœuf," a glaze containing copper from which the oxygen is removed during the so-called "reduction burning," whereby the verdigris coloured oxide is transformed into a brilliant red produced by the copper molecules. From 1884 onwards, Seger was able to produce this red methodically and to create varied graphic and colour effects, partly in vividly flaming forms. With this new glazing process, the porcelain factory at Berlin overtook its competitors in Sèvres and Copenhagen. Seger also succeeded in recreating a third form of glaze orientated to Far-Eastern prototypes, the craquelée, which arises from methodically produced tension in the glaze coating. He had to share the fame of this discovery, however, with his colleagues at the National Manufactory at Sèvres and the Royal Manufactory at Copenhagen.
After the elapse of about one century, Seger's orientation to Chinese glazes appears to represent a new stage in the

imitation and inspiration of Chinese ceramic ware, which followed the orientation of China fashion to decorative painting and ornamental designs. The Chinese design, which can also be detected in the form of several vessels from the series of Seger porcelain, was pushed into the background, where it remained for some time, by the new interest in Japan.
The enthusiasm for Japan caught Germany at a later date than France and England; in ceramics it eventually produced more concrete results than in painting, graphic art, textile or furniture design. The designs conceived by Otto Eckmann (1865–1902) in the Japanese manner, could have been executed by good craftsmen in other materials apart from ceramics. The first ceramic vessels with Japanese styled motifs to do justice to the material came from Max Laeuger (1864–1952), and they were produced at a time when he was artistic director of the pottery factory at Kandern (1895–1913). From a technical point of view, Laeuger's products are nothing more than work in the pottery tradition of folk art. This tradition of folk-art handicraft was used by Laeuger to serve the purposes of a Japanese styled form of decoration. This procedure was not an isolated case; the school of textile art at Scherrebek, with its techniques and designs, was a parallel case. Laeuger soon combined the impulses from folk art and japonaiserie in a novel manner. Between 1895 and 1897/98 he primarily employed ornaments and floral motifs reminiscent of the decorational schemes of southernGerman folk art. From 1898 onwards, however, he turned more and more to Japanese styled floral forms, which evoke (especially his plate patterns) compositions of Japanese painting, whereas the decoration of vases and jugs frequently appears to have been inspired by Japanese dyeing stencils. Towards 1900 the latter type of form become very prominent in Laeuger's ceramic work.
At the same time, Johann Julius Scharvogel (1854–1938) achieved a position of eminence with earthenware vessels coated with fluxive liquid glazes in the manner of Japanese ceramic tea ware. Scharvogel had gained industrial experience in the ceramic works of Villeroy and Boch, Mettlach, and had certainly become acquainted with the earlier work of the French potters Delaherche, Chaplet and Carriés before he founded his own workshop in Munich. After several attempts at underglaze painting he concentrated on experiments with high temperature-fired liquid glazes, which can

East and South-East Asia

Ceramics and Glass

1161–1587

185

East and
South-East
Asia

Ceramics
and Glass

1161–1587

still be seen in test samples and superb vessels preserved from that time. Scharvogel's best work, simply formed and enhanced merely by the glaze flux, is closer to much of the work of contemporary potters than that of his fellow artists. Unfortunately, Scharvogel's productive phase was terminated by his appointment to the Archducal Ceramics Manufactory at Darmstadt in 1906; the influence of the Viennese secessionist style in general and his collaboration with the graphic artist and interior designer Paul Haustein in particular, led Scharvogel to produce work which, from today's perspective, appears artistically less convincing and more conventional than his earlier pieces.

The Mutz workshop in Altona exerted a far-reaching influence with high temperature fired free-glazed ceramic vessels. Not only are we more familiar with the development of this skilled North German workshop than other workshops of the Jugendstil movement in Germany, Richard Mutz's notes also tell us in detail from where the Japanese influences came and what resistance had to be overcome before the new forms could establish themselves in Europe.

Justus Brinckmann, director of the Museum of Arts and Crafts (Museum für Kunst und Gewerbe) in Hamburg, started an extensive collection of Japanese Raku ceramics and stoneware in the middle of the eighteen-nineties. These and other pieces collected earlier, inspired a number of amateur enthusiasts, who founded the "Verein der Kunstfreunde" (Association of Art Lovers) and also busied themselves with ceramic ware. The young Richard Mutz (1872–1931) became acquainted with the mediocre endeavours of this group of dilettantes; he also heard Brinckmann's lectures on Japanese ceramics in 1898 and studied the collection in the museum (as well as the first earthenware vessels of French potters and the Danish potter Herman Kähler). Against the will of his father, who ran a conventional pottery works and had little understanding for his son's inclinations, Richard Mutz began to make experiments with earthenware, the first of which, however, were not entirely satisfactory. Nonetheless, he won the second prize for his work at the Paris Exhibition of 1900. Three years later, after he had mastered the technical difficulties and, together with his friend Ernst Barlach, had set out upon an artistically promising path, his relations with his father came to a rupture. Richard Mutz went to Berlin. The success of the family workshop with the Japanese

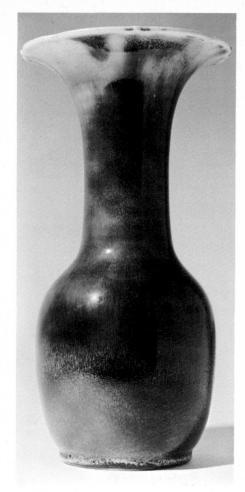

1449 Seger, Vase

styled products, which Richard Mutz had introduced, was so great that although other workshops began to compete with similar articles, the production of Japanese styled pieces could be continued until 1921.

World War I interrupted the continuity of development in German ceramics, because both the master workmen of the newly founded workshops and the pupils at the technical and handicrafts schools belonged to the generation of younger men which fought the war. An illustration of what the war signified is given by the Hamburg workshop Gerstenkorn and Meimerstorf, which had attracted attention with the magnificent achievements of Jan Bontjes van Beck in the field of glazed stoneware which were still admired two decades later.

Shortly after the end of the war, when the younger generation of German potters began to found their own workshops, the

economic and historical-artistic prerequisites were no longer the same as before 1914. In the same way as the young Bernard Leach in England, German potters of the generation born in the eighteen-eighties and nineties were more fascinated by Chinese ceramic work than Japanese Raku ceramics. Above all, the earthenware of the Sung period and the monochrome decorated porcelain of the Ming and Kang-shi period had become the supreme models. These periods of Chinese ceramic work have retained their power of fascination for modern potters throughout Europe. The first potter to establish his own workshop, which, in the changed situation after World War I, was to be of great importance for future developments, was Gusso Reuss, born in 1885. After completing his studies, which he had begun in 1908, he travelled through Europe, America, India Australia, Japan and China. In the Far East he systematically studied Chinese stoneware and the monochrome glazed porcelain of the Sung and Kang-shi periods. The studio founded in 1924 at Schöngeising near Munich and retained until 1962, one year before his death, resembled a laboratory. Reuss began his experiments with reduction glazes, which he fired in a coal furnace. At the time of his first exhibition in 1927, he was in a position to produce any chosen copperglaze. This assurance and the wide range of variety of his glaze colours earned Reuss a reputation which spread to America. He took as his aim and standard the Chinese copper glazes and, to a lesser extent, crystal glazes of an older type. Reuss scarcely tried to develop his own types of glaze, nor was he interested in new forms. But it is his achievement that, following Seger's experiments, he imparted to German ceramic work a more informal approach to older procedures and provided the aesthetic and technical impulses for more controllable work. Methodical aspects can also be found in the work of other German potters during the inter-war years; they were, however, orientated to form on the one hand, and to didactic objectives on the other. The ideal of a strict, ornament-free, functionally based form which widely predominated during the nineteen-twenties and was most purely expressed in the Bauhaus, necessarily increased the admiration for Chinese earthenware. The alert observer of contemporary tendencies and connoisseur of ceramics, Max Sauerlandt, constantly refers to the fascination which China, and especially the strict forms of Chinese ceramics, held for potters in the nineteen-twenties in his re-

ports of visits to museum and his travels during these years. This tendency reached its first climax shortly before 1930. Many variations of China's influence are revealed in modern ceramics of this period. They range from external imitation of colour and form as in the Oranienburg workshops at Körting, or the Hael workshops at Velten, through the more formal but technically still unsatisfying work of Douglas Hill in Berlin, whose low-fired vessels have the appearance of earthenware, to the aesthetically and technically excellent earthen-ware pieces of Auguste Papendiek (1879–1950). The creamwhite, sea-green and delicate blue glazed work of this potter from Bremen, which is now underestimated and difficult to come across, shows more detailed knowledge and understanding of early Chinese ceramic art than comparable work of her contemporaries. Nevertheless, they can be clearly recognized as products of the second quarter of this century. Despite their small dimensions, the gentle assuredness of these bowls and vases maintains itself against the largely programmatically presented models of her male colleagues.

This programmatic element is exemplified in the work of the Bauhaus. The fact that it did not adopt an ideological character — at least not during the Weimar period — was due to Otto Lindig (1895–1964). He had studied under van de Velde at the school of handicrafts at Weimar and, after an interruption caused by World War I, finished his studies in the sculpture course just as Gropius transformed the Weimar school into the Bauhaus. Gerhard Marcks proposed Lindig as head of the ceramics school which was established at Dornburg an der Saale and remained there when the Bauhaus was transferred to Dessau. As a private institution, this workshop survived the Nazi era with Lindig as head until 1947, when he transferred it to Hamburg where he taught for a further 13 years. Lindig's conception of ceramic art remained constant for years. It was a conception characterized by functional simplicity of form rather than refinement of the glazes. Here, the orientation to Chinese ceramics is more of an implicit premise than a competing endeavour to achieve something similar or equal. Lindig's ceramic work is shaped by an approach which was also not impaired by his contact with industrial modelling.

A comparison of the best achievements of German ceramic work in the nineteen-thirties reveals that a specific style of a generation of artists was realized here and not so much the individual style of one

prominent artist. This can be observed in the stonewere vessels of Paul Dresler (1872–1950), in the most convincing manner as a style orientated to the modelling of the hollow shape and to the limiting contour, rather than weight, volume and mass of the material, or to a pronounced colourfulness of the glaze. In terms of a mode of perception, it is a style in which contour is perceived more optically than tactilely. This still flourishes in the work of Hubert Griemert (born 1905) who as teacher in Halle and Höhr-Grenzhausen has transmitted this style to a younger generation.

Translation G. F. S.

Asia and Europe Meet in Contemporary German Ceramic Ware

Mariela D. Siepmann

This exhibition is attempting to show to what extent East Asia proved to be the prime instructor not only for German ceramic ware, but for that of the entire Western world. The set-up of the exhibition alone will make it perfectly evident to the visitor how the development of influences from abroad led to independent results within modern ceramic ware. Since this didactic point of view is of primary importance to this presentation, it necessarily follows that several examples of modern ceramic ware are directly compared to one or more prototypes which were exemplary for a certain form or a special glazing process. If comparison were limited to just one or two objects, the purpose and basic idea of this undertaking would be lost. The intensity and general effect of the ceramic-maker's occupation with foreign influences can only be convincingly documented if several objects are compared. Not until the visitor sees, for example, the diverse presentations of early Chinese glazing revealed in contemporary ceramic ware, can he judge what great impetus the investigation of this glazing process had on the development of German ceramic ware.

Jan Bontjes van Beek, Richard Bampi and Walter Popp, whose work was strongly influenced by the spirit of Eastern Asia, can be mentioned as the main agents of the East Asian art of ceramic-making. Jan Bontjes van Beek (1899–1969), who set up his first atelier

in 1922, came to grips with East Asian ceramic ware early in his career. The entire extent of his questing research was directed toward rediscovering early Chinese glazing techniques. He named the glazes he discovered after the Chinese prototypes, which enhanced the association with Chinese glazes even more. Like generations before him, he was occupied with the so-called "ox-blood" glaze which the Chinese called "lang-yao". He did not, however, blaze any new trails with these tests, but still kept completely within traditional boundaries. A personal characteristic revealed itself in his preoccupation with the glazes of the Sung period (960–1279), probably the most brilliant age of Chinese ceramic ware. Of these early glazes he was particularly anxious to discover the secrets of the "ting-yao," the "chien-yao" and the so-called "oil-spot" glazes, a variation of the Chinese "chien-yao" called temmoku by the Japanese and referred to as "Hasenfell" in Germany. In contrast to Bontjes van Beek, who made East Asian ceramic ware his model early in his career, Richard Bampi (1896–1965), who set up his atelier in 1927 in Kandern in the southern Black Forest region, stumbled across the path of constant questing research into the East Asian art of pottery-making rather late in his career. This artist, who strived to capture the effect of fire in glowing colours, attempted to achieve brighter and brighter glazes. It was inevitable that he discover the high-glazed stoneware of East Asia. He also let the Chinese guide the development of his glazes. He used a peach pink reminiscent of the "peach-bloom" of the Ch'ien-lung period (1736–1795) and managed to produce the "apple-green" of the same Period whose bright colour decorates many of his vessels.

Walter Popp (1913), an artist who gave many new twists to shape design and the development of new glazing processes for German ceramic ware while employed by the Academy in Kassel, can be called the third major agent of East Asian ceramic ware. His instructor was Bernard Leach, the great master of English pottery, who can be considered the great inspiration for Western ceramic ware. Walter Popp is one of those artists who were inspired by Leach to acquire the skill and techniques of Far Eastern glazing processes. His profound knowledge of East Asian ceramics and the techniques involved did not allow him to stagnate, but gave him impetus to research further.

The progress which German ceramic ware made in the last few decades was

*East and
South-East
Asia*

*Ceramics
and Glass*

1161–1587

possible only because artists were guided by the mother country of stoneware, by East Asia. Its firing techniques had to be mastered before further experimentation in the complicated field of preparing glazes could even be attempted. First and foremost, we are indebted to East Asia for its stoneware body, without which further development could not even be considered. The procedure of stopping the glaze just above the base of the vessel and thus juxtaposing the beauty of the body with the beauty of the glaze was also an old practice of East Asian potters which we learned from them. However, before the base of the vessel could be left bare of glaze, the art of ceramics had to be able to produce a vitrified body by a high-temperature (around 2308° F.) firing. We are again indebted to the East Asians for this process.

As with Walter Popp, Margarete Schott's (1911) work was also greatly influenced by her knowledge of East Asian ceramics. It is true that she was mainly interested in glazes as early as her years at the School of Handicrafts in Darmstadt; however, the decisive drive came from a coincidence. A book written by the great English ceramicist Bernard Leach gave her work new direction and brought her closer to realizing her true interests. She spontaneously decided to seek further tools of her trade in England. Harry C. Davis introduced her to work with high-fired stoneware and to the reoxidizing glazing technique which was still practically unknown in Germany. She was also responsible for helping Karl Scheid (1929) at the beginning of his career. She advised him also to gain insight into the new world of ceramic ware stimulated by the Far East through Harry C. Davis.

The work of Albrecht Hohlt (1928–1960), characterized by great concentration, love of research and great insight, was inspired by this first encounter with Chinese ceramic ware at an exhibition of East Asian art in Cologne. He was 21 at the time. The over-powering relevation he made was his recognition that reoxidizing glazes were "his" form of expression. China's ceramic ware fired by reoxidation process remained his absolute ideal in ceramic ware. "With no other firing technique is the elementary force of the fire, the mastery of it, the singular, secretive and unique element of each individual vessel so intensive and convincing to its admirer as with this one." (Exhibition catalogue, Albrecht Hohlt's Ceramic Ware, Kunstgewerbemuseum Zurich 1963.)
When Görge Hohlt (1930) took over the

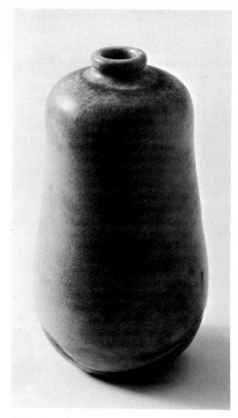

1270 Bontjes van Beek, Vase

atelier in 1965, which until that time had been run jointly by his father Otto and his brother Albrecht Hohlt, he began producing completely independent creations. The use of glazes as a means of surface design was also of central importance to the work of Horst Kerstan (1941), Richard Bampi's only gifted student and heir to his atelier. He preferred using dark glazes, a porous, lustrous Hasenfell glaze, a black-brown mixed with rust-red ribbed with mustard-colored ingredients, coal black "gold dust" glaze.
Whereas the success of old East Asian glazes depended almost completely on positive coincidence at the turn of the century, contemporary ceramicists have since learned to master the necessary chemical and other techniques. The tendency to let decoration slip farther and farther into the background behind colored glazes is very characteristic of contemporary German ceramic ware. It is also this trend that emphasizes to what extent German ceramicists have followed East Asian pottery traditions.

Translation Cecily E. Gardner

The Dragon as a Decorative Motif in Far-Eastern and European Pottery around the Year 1900

"May our sons and grandsons safeguard and use this precious oblation vessel for tens of thousands of years." Inscriptions such as these show the value attached to the products of the potter's art. They were treated as cultic objects with an influence far beyond regional borders and with the power of uniting generations.
They thus tell us about the way people lived and the course history took. And it is a fact that there are areas of the civilizations of the Far East that we can only elucidate and understand with the help of the forms the pottery took, with the help of those forms in fact which are often enough at the roots of innumerable European vessels. Their influence is felt in so many respects even today. If in the exhibition "World Cultures and Modern Art" this department is treated with particular care, then this is to be explained by the fact that only here the presentation of contrasted pairs and series is completely convincing. The encounter of the peoples of the world took place first of all on the basis of ceramic art. If the systematic presentation in the exhibition shows convincingly the influence of Asia, Africa and Amerindia in the realms of painting and sculpture, here in the pottery section the reception is all prevailing and has determined so great a part of the form and decoration for thousands of years right up to the present day.
This section in which the pottery of East and West is presented contrastively is only intended to provide a stimulus; so inexhaustible is the interaction that the treatment cannot be exhaustive. The plastic overlays on vessels come first in the section: they are intended to provide the uninitiated with an overall view. However, priority is given to Chinese forms which have, via Japan, exercised a decisive influence on European pottery. In describing individual vessels, the decoration is often the prime consideration. The dragon motif is here of particular significance. The very form of the animal — its long tail, its claws, the fantastic head, its wide-open jaws, its long tongue — predestined it as a decorative motif. And vessels thus ornamented could hardly escape the notice of the western artist because of their bizarre form. Very soon French, English and German potters were trying to grasp the real significance of this form and then to assimilate it.

French ceramists reached the heights here around the year 1900. In them we can recognize the Far-Eastern influence, but at the same time we see that they managed to attain an independent, personal style of their own. Of course, the floral tendencies so typical of art nouveau and the Jugendstil more than met them half way in their attempts to absorb the dragon motif. During this period it led artists to seek their decorative inspiration in other members of the zoological realm, too. The iconographical significance of the dragon is misunderstood and we find it being transformed into salamanders, snakes and various forms of amphibians on art nouveau glassware. S.W.

Summary and Translation P. J. D.

1161 *China, Ch'ing Dynasty (1644–1912); Vase;* porcelain; h - 30.9 cm; 19th cent.; Nuremberg, Gewerbemus. der Landesgewerbeanstalt Bayern, Inv.-No. 8887/1

1162 *Germany; manufacture: Königl. Porzellanmanufaktur Berlin; Vase;* porcelain; blue-violet and red glaze; h - 24 cm; pre 1888; Vienna, Österreichisches Mus. für angewandte Kunst, Inv.-No. 8663/Ke. 3550; plate

1163 *Japan, late Tokugawa Period (1765–1868); Dragon;* bronze; l - 44 cm; Vienna, Österreichisches Mus. für angewandte Kunst, Inv. No. 20495/r. 3685

1164 *China, Ming Dynasty (1368–1644) or Ch'ing Dynasty (1644–1912); vase;* bronze, gilt, cast with dragon relief; h - 28.5 cm; sig. on neck: mark Hsüan Te (Ta Ming); close of 16th/18th cent.; Berlin, Staatliche Museen Preußischer Kulturbesitz, Kunstgewerbemus., Inv.-No. 84, 1318

1165 *China, Yüan Dynasty (1280–1367); vase;* earthenware, brown body with thick, crackled, lavender-blue glaze with two red spots; h - 16.2 cm; London, Victoria & Albert Mus., Inv.-No. 1190–1903; plate

1166 *China, Ch'ing Dynasty (1644–1912); pot;* Kuang-tung earthenware with spotted glaze varying from a milky blue to brown violet; h - 20.7 cm; 17th cent.; Vienna, Österreichisches Mus. für angewandte Kunst, Inv.-No. 32231/Ke. 8845

1167 *Japan, Tokugawa Period (1603–*

1868); vase; earthenware with light-blue mottled glaze; h - 23 cm; 18th cent.; Vienna, Österreichisches Mus. für angewandte Kunst, Inv.-No. 30727/Ke. 8180

1168 *Japan, late Tokugawa Period (1765–1868) to Meiji Period (1868–1912); vase;* pottery, grey-green overflow glaze on black-brown basic glaze; h - 26.8 cm; 3rd quarter of 19th cent.; Vienna, Österreichisches Mus. für angewandte Kunst, Inv.-No. 30892/Ke. 8345; plate

1169 *Edmond Lachenal (Paris 1855–post 1930); vase;* earthenware, white body with yellow overflow glaze; h - 29 cm; sig. on base: Lachenal; c. 1900; Munich, Paul Tachner Coll.; plate

1170 *England; manufacture: Pellat & Wood, London; jug;* faience, blue glazed; h - 302 cm; sig. on base: crown, circle with wreath-shaped band (stamp); c. 1873; Nuremberg, Gewerbemus. der Landesgewerbeanstalt Bayern, Inv.-No. FA 2125

1171 *Edmond Lachenal; bottle with handles;* earthenware; h - 18.5 cm; pre 1900; Vienna, Österreichisches Mus. für angewandte Kunst, Inv.-No. 12207/Ke. 4367

1172 *China, Ch'ing Dynasty (1644–1912); vase in bottle form;* porcelain with light celadon glaze; h - 25.5 cm;

Nien-hao "K'ang Hsi"; prob. Tao Kuang Period (1821–1850); London, Victoria & Albert Mus., Inv.-No. C. 892–1936

1173 *China, Ch'ing Dynasty; long-necked vase;* porcelain with blossom in red enamel pigment; h - 22.5 cm; K'ang Hsi reign (1669–1722); Pommersfelden, Gräflich Schönbornsche Slg.

1174 *Japan, Late Tokugawa (1765–1868) or Meiji Period (1868–1912); bottle;* bronze; h - 21 cm; 18th/19th cent.; Paris, Mus. Cernuschi, Inv.-No. 2250

1175 *China, Ch'ing Dynasty (1644–1912); vase;* porcelain "blanc de Chine" from Te-hua; 1700–1725; Stockholm, Östasiatiska Mus., Inv.-No. NM 95/1944

1176 *China, Ming Dynasty (1368–1644); vase;* porcelain with tricolour decoration on biscuit in green, partially mottled with body visible; h - 41.3 cm; 16th/17th cent.; London, Victoria & Albert Mus., Inv.-No. 728–1883; plate

1177 *Thédore Deck (Gebweiler, Alsace 1823–1891 Paris); vase;* with dragon; earthenware; h - 36.9 cm; sig. on base: stamp Th. Deck; c. 1875; Hamburg, Heuser Coll.; plate

1178 *China, Ch'ing Dynasty (1644–1912); vase;* earthenware with green

1168 Japan, Vase

1169 Lachenal, Vase (France)

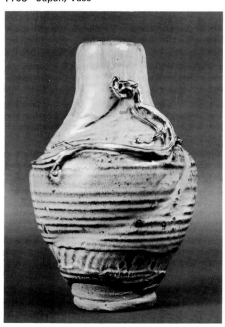

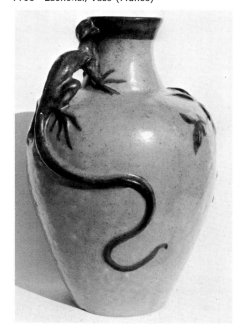

*East and
South-East
Asia*

*Ceramics
and Glass*

1161–1587

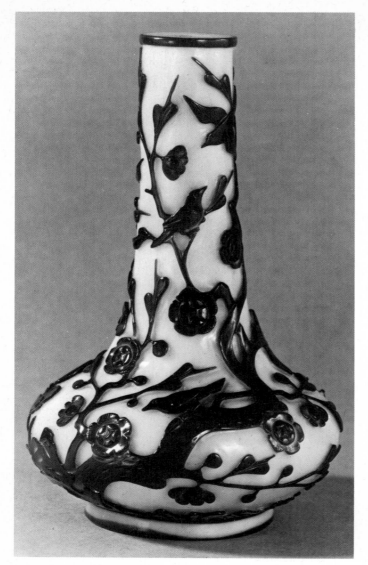

1209 China,
Glass Vase

lead glaze; h - 28.8 cm; K'ang Hsi
Period (*1662–1722*); Vienna, Öster-
reichisches Mus. für angewandte
Kunst, Inv.-No. 31234/Ke. 8393

1179 *England; vase;* earthenware;
h - 33 cm; c. 1865–1870; London,
Victoria & Albert Mus., Inv.-No. 1219–
1872

1180 *China, Ch'ing Dynasty (1644–
1912); long-necked vase;* porcelain
with milky-green celadon glaze, inter-
spersed with black spots; h - 31 cm;
Nien hao "Ta Ts'ung Ch'ien-lung";
Paris, Mus. Cernuschi, Inv.-No. 3556

1181 *China, Ming Dynasty (1368–
1644); vase on wooden base;* earthen-
ware in tricolour decoration on biscuit

in turquoise and aubergine; h - 36.5 cm;
Vienna, Österreichisches Mus. für ange-
wandte Kunst, Inv.-No. 31941/Ke. 8726

1182 *China, Ch'ing Dynasty (1644–
1912); double vase;* jade; h - 20.5 cm;
18th cent.; Vienna, Österreichisches
Mus. für angewandte Kunst, Inv.-No.
37729/Pl. 849

Far-Eastern Vessels of Semi-precious Stone and Their Influence on European Glass-ware around 1900

Two artists are most influential in the
field of French glasswork around
1900: Emil Gallé and François
Eugène Rousseau. The first developed
plant motifs to a decorative element in
relief; the second preferred a combination
of translucid mass with a lively surface.
Gallé's work can be divided into four
periods. First, the costly relief-engraved

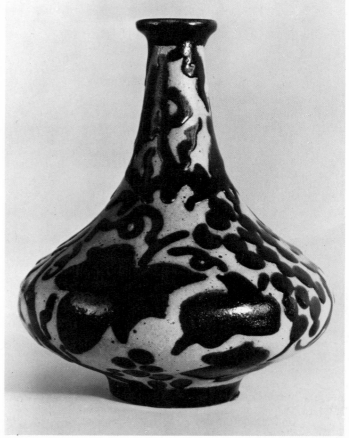

1210 Rumèbe, Vase

work where the impressions in the flashed glass are cut to the surface of the opaque, transparent or crystal-clear glass. By leaving his floral decoration in various glass layers against a transparent body he raised the "gravure à la roue" to the masterly style of his early period. To the second period, where he tried to combine the creative possibilities with those of his first years, belong his inlaid glassware. Mother of pearl, metal foil and semiprecious stones are flashed on to the glass. The third, most extensive period was that of "Gallé gravure à l'acid." His engraving technique is now combined with etching. Those areas of the glass surface not covered with wax are etched and then finished off with the wheel. An interesting, intermediate form found among his glassware is that of the translucent vases, mainly in green glass, with enamel-pigment decoration. How much the glasswork of the years around the turn of the century was influenced by the jade-carving techniques of China has still not been sufficiently studied to allow definite conclusions. However, in all probability it would be possible to establish quite definite and decisive relationships. In magnificent assimilated and analogous forms the glassworkers of France around 1900 create veritable masterpieces which are highly reminiscent of jade carving. The opaque effect, typical of nephrite, jadeite or genuine jade, can hardly be attained; the light refracted by the carved semiprecious stone is mild and almost luminous. In the Far East a religious and mystical power of healing was attributed to jade; it was a stone embodying divine power. Other stones, like agate, lapis lazuli, serpentine and rock-crystal, were also experimented with by European artists in glass. The carving takes the Far-Eastern counterpart as its model but is severely stylized. Clouded glass is worked until the effect of jade is obtained. Rousseau tried to enliven the surface of his ware from within, as it were. Under the influence of Far-Eastern carving in semiprecious stones, he had developed new techniques which enabled him to produce sculptural effects with his hollow ware.

S.W.

Summary and Translation P. J. D.

1183 *China, Ch'ing Dynasty (1644–1912); covered vase;* lapis lazuli, carved and open work, decorated with lions at play, birds and cherry tree in blossom, on the lid two birds with twig; h - 20 cm; 19th cent.; Vienna, Öster-

reichisches Mus. für angewandte Kunst, Inv.-No. 31010/Pl. 591

1184 *China, Ch'ing Dynasty (1644–1912); covered vase on wooden base;* steatite; h - 15.5 cm; 18th/19th cent.; Vienna, Österreichisches Mus. für angewandte Kunst, Inv.-No. 31006/Pl. 587

1185 *Emile Gallé (Nancy 1864–1904); vase;* glass; h - 32 cm; sig. on body: Emile Gallé; 1900; Frankfurt, Ferd. Wolfg. Neess Coll.

1186 *Daum Fréres (Auguste 1853–1909, Antonin 1864–1930); vase;* clear glass, the mass with red-green mottled staining, etched and carved; h - 49 cm; sig. on base: Daum Nancy; Frankfurt, Ferd. Wolfg. Neess Coll.

1187 *Emile Gallé, vase;* opaque glass; Frankfurt, Ferd. Wolfg. Neess Coll.

1188 *China, Ch'ing Dynasty (1644–1912); vase;* rhinestone in form of a tree stump with plastically overlaid twigs and leaves; h - 14 cm; 19th cent.; Paris, Mus. Cernuschi, Inv.-No. 7530

1189 *François Eugène Rousseau (Paris 1827–1891); manufacture: Verreri Appert, Clichy; vase;* white crystal with sealed oxides, red, brown, green; h - 17.2 cm; 1878–1885; S. Germany, priv. owned; plate

1190 *China, Ch'ing Dynasty (1644–1912); covered vase;* rhinestone; h - 15 cm; Ch'ien-lung Period (1736–1795); Vienna, Österreichisches Mus. für angewandte Kunst, Inv.-No. 31787/Pl. 752; plate

1191 *Emile Gallé; vase;* honey-coloured glass; h - 12 cm; sig. and inscribed on base: E. Gallé alla Japonica fecit Nancy No. 225; on body: E G with Cross of Loraine; 1884–1889; Frankfurt, Knut Günther Coll.

1192 *Ernest Leveillé (Paris); vase;* amethyst-coloured flashed glass; h - 9.5 cm; sig. on base: E. Leveillé Paris; c. 1890; Frankfurt, Knut Günther Coll.

1193 *Ernest Leveillé; vase;* clear glass, stained aubergine colour in the mass; h - 16 cm; Frankfurt, Ferd. Wolfg. Neess Coll.

1194 *China, Ch'ing Dynasty (1644–1912); vase in form of a tree stump;* jade; 18.5 cm; London, Victoria & Albert Mus., Inv.-No. C 1910–1910

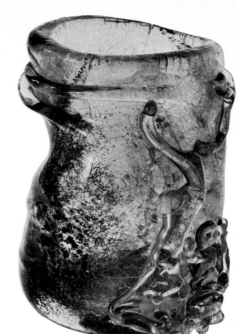

1189 Rousseau, Vase

1190 China, Covered Vase

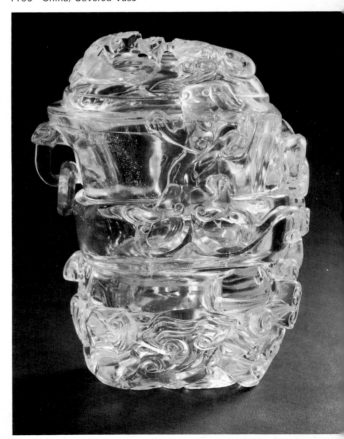

East and
South-East
Asia

Ceramics
and Glass

1161–1587

1195 *Eugène Rousseau (Paris 1827–1891); vase;* opaque glass coloured as green jade with red fused-on glass, partially shaped as leaves; h - 15 cm; pre 1887 (?); Paris, Mus. des Arts Décoratifs, Inv.-No. 627

1196 *China, Ming Dynasty (1368–1644); beaker;* rhinoceros horn in the form of a large lotus leaf surrounded by lotus plants with blossom and leaves; h - 19.5 cm; 17th cent.; Vienna, Österreichisches Mus. für angewandte Kunst, Inv.-No. 31003/Pl. 584; plate

1197 *China, Ch'ing Dynasty (1644–1912); offertory vessel in the form of an open flower-calix;* rhinoceros horn; h - (without pedestal) 13.5 cm; 18th/19th cent.; Berlin, Staatliche Museen Preußischer Kulturbesitz, Kunstgewerbemus., Inv.-No. 84, 1211 a+; coloured plate

1198 *China, Ch'ing Dynasty (1644–1912); offertory vessel;* steatite, light-grey stone with violet-grey grain; h - 12.4 cm; early 18th cent.; Schloß Pommersfelden, Gräflich Schönbornsche Slg.

1199 *Emile Gallé; vase in the form of an offertory bowl;* glass; h - 14 cm; sig. on body: Gallé; Frankfurt, Ferd. Wolfg. Neess Coll.; coloured plate

1200 *Emile Gallé; vase with sea-horses;* cast glass; h - 18 cm; sig. and inscribed on body; Gallé Étude: Frankfurt, Ferd. Wolfg. Neess Coll.; plate

1201 *China, Ch'ing Dynasty (1644–1912); snuff bottle;* h-6.5 cm; 18th/19th cent.; Berlin, Staatliche Museen Preußischer Kulturbesitz, Kunstgewerbemus., Inv.-No. 84, 1175

1202 *China, Ch'ing Dynasty (1644–1912); snuff bottle;* agate, light grey, mottled brown; h-5.5 cm; 18th/19th cent.; Berlin, Staatliche Museen Preußischer Kulturbesitz, Kunstgewerbemus., Inv.-No. 84, 1172

1203 *China, Ch'ing Dynasty (1644–1912); snuff bottle;* agate, light, carved decoration; h-5.5 cm; 18th/19th cent.; Berlin, Staatliche Museen Preußischer Kulturbesitz, Kunstgewerbemus., Inv.-No. 79, 1892

1204 *China, Ch'ing Dynasty (1644–1912); snuff bottle;* white glass with blue flashed decoration; h-7.7 cm; 18th/19th cent.; Vienna, Österreichisches Mus. für angewandte Kunst, Inv.-No. 38356/Gl. 3310

1205 *Emile Gallé (Nancy 1846–1904); vase;* opaque glass; h-10 cm; sig. on body: Gallé; c. 1900; Hinang, Wolf Coll., No. 018760

1206 *China, Ch'ing Dynasty (1644–1912); snuff bottle;* white frosted glass with red flashed ornamentation, stylized dragon with pearl; h-6.3 cm; Ch'ien-lung Period (1736–1795); Vienna, Österreichisches Mus. für angewandte Kunst, Inv.-No. 31380/Gl. 3063

1207 *China, Ch'ing Dynasty (1644–1912); snuff bottle;* jasper with alabaster stopper; h-6.8 cm; 18th cent.; Vienna, Österreichisches Mus. für angewandte Kunst, Inv.-No. 31542/Pl. 634

1208 *China, Ch'ing Dynasty (1644–1912); snuff bottle;* amber; h-8.2 cm; 18th cent.; Vienna, Österreichisches Mus. für angewandte Kunst, Inv.-No. 31540/Pl. 632

1209 *China, Ch'ing Dynasty (1644–1912); vase;* white opal glass with lotus tree in blue flashing, carved; h-21 cm; end 18th/beg. 19th cent.; Düsseldorf, Kunstmus., Inv.-No. P 1971-11; plate

1210 *Fernand Rumèbe (1875–1952); vase;* earthenware, grey-white glaze; h-27.5 cm; sig. on base: F. Rumèbe 115; Paris, Alain Lesieutre Coll.; plate

1211 *China, Ch'ing Dynasty (1644–1912); vase;* frosted glass, polished red flashing, with flowers and butterfly, bats in clouds on neck; h-19.5 cm; sig. on the base: mark Ch'ien-lung; Ch'ien-lung Period (1736–1795); Berlin, Staatliche Museen Preußischer Kulturbesitz, Kunstgewerbemus., Inv.-No. 79, 1583

1212 *China, Ch'ing Dynasty (1644–1912); vase;* turquoise-blue opaque glass with flowers and butterflies on red flashing; h-24 cm; sig. on base: mark Ch'ien-lung; Ch'ien-lung Period (1736–1795); Berlin, Staatliche Museen Preußischer Kulturbesitz, Kunstgewerbemus., Inv.-No. 79, 1569

1213 *China, Ch'ing Dynasty (1644–1912); vase in form of bottle;* red mottled frosted glass; h 14.5 cm; sig. on base: mark Ch'ien-lung; Ch'ien-lung Period (1736–1795); Berlin, Staatliche Museen Preußischer Kulturbesitz, Kunstgewerbemus., Inv.-No. 79, 1576

1214 *China, Ch'ing Dynasty (1644–1912); small long-necked vase;* white opaque glass, relief engraved in blue, light green and red; h-16 cm; 19th cent.; Stockholm, Östasiatiska Mus., no Inv.-No.

1215 *Emile Gallé; cylindrical vase;* green glass with brown flashing; h-35 cm; sig. on body: E. Gallé, Les grands feuillages chargés de brume et de secret; Düsseldorf, Kunstmus., Prof. Hentrich Coll.

1216 *E. Michel; vase with ornamental water-lilies;* yellow, thick-walled glass with black crackling and yellowish mottled, green and brown flashing; h 25.5 cm; sig. on base: E. Michel; Düsseldorf, Kunstmus., Prof. Hentrich Coll.

1217 *Emile Gallé; vase with iris blossom;* glass, flashed in dark green and violet; h-22.7 cm; sig. on body: Emile Gallé fecit 1897–98; Nürnberg, Gewerbemus. der Landesgewerbeanstalt Bayern, Inv.-No. G 8412

1218 *France; manufacture: Legras & Co. vase;* glass with wistaria branches in carved covering; h-20 cm; Düsseldorf, Kunstmus., Prof. Hentrich Coll., Inv.-No. P 1970-271

1219 *China, Ch'ing Dynasty (1644–1912); vase;* white glass, black relief engraving; h-15.2 cm; sig.: base mark of Ch'ien-lung Period (1736–1795); Vienna, Österreichisches Mus. für angewandte Kunst., Inv.-No. 31051/Gl. 3044

1220 *Fernand Rumèbe; vase;* earthenware, ocher-coloured glaze, ornamentation in light relief; h-28 cm; sig. on base: F. Rumèbe/Piece-No. 115; c. 1910; Munich, Paul Tauchner Coll., Inv.-No. 472

1221 *China, Ch'ing Dynasty (1644–1912); chalice-shaped bowl;* white frosted glass with red decoration, relief engraving; h-17 cm; Nien hao of Ch'ien-lung Period (1736–1795); Vienna, Österreichisches Mus. für angewandte Kunst, Inv.-No. 31603/Gl. 3069

1222 *China, Ch'ing Dynasty (1644–1912); brush bowl;* frosted glass with red relief engraving, lotus twig with blossom and birds; h-8.7 cm; Ch'ien-lung Period (1735–1795); Stockholm, Östasiatiska Mus.

1223 *Emile Gallé, beaker-shaped vase;* frosted glass, reddish brown flashing, etched and polished; h-7.5 cm; sig. under base: Emile Gallé (with blossom); post 1890; Düsseldorf, Kunstmus., Prof. Hentrich Coll.

1224 *Emile Gallé, (Nancy 1864–1904); cylindrical vase;* glass with gourd ornamentation in carved covering; h-20 cm; Düsseldorf, Kunstmus. Prof. Hentrich Coll., Inv.-No. P.1970-182

The Pedestalled Vessel in the Far East and Europe

During the Art Nouveau and Jugendstil period, glass vessels are often provided with bizarre pedestals. Artists in glass, particularly of the school of Nancy, see the vessel as forming a unity with its base. There were weighty reasons for the combination of vase or bowl with raised bases. The vessel is thus placed on a level of its own as a work of art which is unique and superior to the rest of a series. The experience of a lifetime and the situation of the moment imparted exaggerated significance to the individual piece. The cutting on the wheel, the random or chance firing, the forming of the glass on the blowpipe, or when cutting or engraving, are all subject to the unpredictible. The form and colour of a vessel are the result of technical knowledge and factors over which the artist has control. This rarity, this uniqueness of a piece often generates the desire for special presentation or display. The vase or bowl is thus raised above the ordinary, the common utensils of everyday life. There can be no doubt that this special form of presentation on a base or pedestal has its own particular history which still remains to be written. There are no exhaustive or specialized treatments of the matter in the literature of art history. However, the pedestals of the Far-Eastern vessels and their later adoption by western art presumably stand in direct connection with the furnishings of the Far-Eastern temple interior. There the statues and sacred vessels used in the cult stand on pedestals to which loving care was devoted. The pedestals were richly carved; or they were inlaid with wood, gems or mother of pearl; or overlaid with metal with open-work ornamental bands and chased relief. Painted decoration often emphasized the importance of the pedestal, too. Black or red lacquer in profuse splendour with gold and silver overlay elevated the pedestal to a work of art in its own right. The alms bowl was also provided with a fine pedestal since it was regarded, as its history shows, as an object worthy of veneration. The musical instruments in

the form of large alms bowls inside Buddhist monasteries also look like enormous pedestalled bowls and it was these which probably exercised the greatest influence, so that in the end the outstanding vase or bowl without its elevation above the ordinary by means of a pedestal was utterly unthinkable. With the passage of time, pedestal motifs, like that of the lotus, were developed to perfection.

The western artists in pottery and glass, particularly around 1900, see the unity of vessel and pedestal, so that understanding of the meaning and objective of the pedestal was soon widespread. The school of Nancy, above all Emile Gallé and the Daum brothers in their early work, and likewise François Eugène Rousseau, that inspiring force in the realm of French glass, look to the pedestal to provide a worthy setting for their fantastic compositions in glass. Around 1900, the pedestal is regarded as forming a creative unity with the vessel or accords the latter its fitting presentation. Rousseau placed the finest products of his craft on pedestals; Gallé designs vase or bowl with its pedestal, so that the latter becomes part of the former and the two become inseparable in thought. The pedestal becomes an important design element due to the harmony of height and breadth, of volume and surface. It is given the same or similar or matching treatment. Soon there are numerous companies in France and Germany which are exclusively engaged in the production of pedestals for vessels of glass, pottery or porcelain.

The selection of exhibits tries to document the significance of the pedestal and provide the visitor with a good cross-section of the forms it assumes during its process of development. The phenomenon of the pedestal is presented for the first time in a group – it is inconceivable as an art form without the encounter with Far-Eastern art. S.W.

Summary and Translation P. J. D.

1225 *China, Ch'ing Dynasty (1644–1912); vase on wooden base;* opaque glass, turquoise blue, with carved red flashing; h-(without base) 15.5 cm; sig. on body: Ch'ien-lung Mark; Ch'ien-lung reign (1736–1795); Berlin, Staatliche Museen Preußischer Kulturbesitz, Kunstgewerbemus., Inv.-No. 84, 1141 a + b

1226 *China, Ming Dynasty (1367–1644); vase with elephant handles;* porcelain with tricolour decoration on bis-

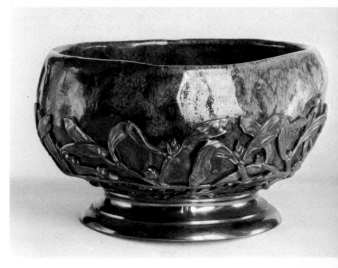

1235 France, Beaker

1237 Deck, Beaker

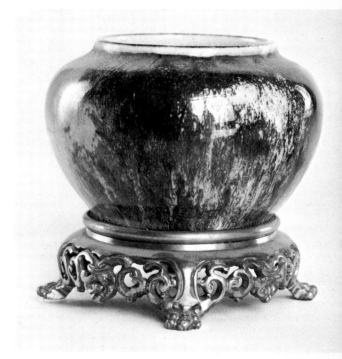

cuit; h-28.5 cm; early 16th cent.; London, Victoria & Albert Mus., Inv.-No. C 107-1929

1227 *Théodore Deck (Gebweiler, Alsace, 1823–1891 Paris); vase on bronze base;* faience with underglaze pigments; h-(with base) 23.3 cm; sig. on base: stamp Th. Deck; c. 1875; Hamburg, Heuser Coll.

193

East and
South-East
Asia

Ceramics
and Glass

1161–1587

1228 *Emile Gallé (Nancy 1846–1904); covered vase in pagoda shape;* colourless glass; h-26.8 cm; sig. under foot: Emile Gallé 1892; S. Germany, priv. owned

1229 *Emile Gallé; vase in goblet form;* brownish-yellow flashed glass; h-22.6 cm; sig. on body: Gallé; S. Germany, priv. owned

1230 *China, T'ang Dynasty (618–906); vase in form of a long-necked bottle;* pottery; h-13.2 cm; Vienna, Österreichisches Mus. für angewandte Kunst, Inv.-No. 32296/Ke. 8910

1231 *Emile Gallé, onion-shaped vase;* clear glass, mass stained honey-coloured to red-brown; h-13 cm; sig. on body: Gallé; Munich, priv. owned

1232 *Emile Gallé; covered vase on base;* blue-violet tinted opaque glass with overlaid decoration; h-35 cm; sig. on rim: Afrikana, on body inscription from Victor Hugo; pre 1900; Paris, Mus. des Arts Décoratifs, Inv.-No. 27982

1233 *Emile Gallé; pedestalled long-necked vase;* glass; h-approx. 45 cm; sig. on body: Gallé; Frankfurt, Ferd. Wolfg. Neess Coll.

1234 *Emile Gallé; vase on bronze foot;* clear glass; h-30 cm; sig. on body and foot: Gallé; 1898–1899; Frankfurt, Ferd. Wolfg. Neess Coll.

1235 *China (French mounting); beaker;* earthenware, metal foot and mounting by Guerchet; h 7.5 cm; pre 1898; Paris, Mus. des Arts Décoratifs, Inv.-No. 8717; plate

1236 *China, Sung Dynasty (960–1279) ?; small bowl on wooden base;* porcelain; h-(with base) 7.8 cm; Sung Period (960–1279) or later; Berlin, Staatliche Museen Preußischer Kulturbesitz, Kunstgewerbemus., Inv.-No. 07,31 a+b

1237 *Théodore Deck; beaker on metal base;* porcelain; h - 9.5 cm; pre 1884; Paris, Mus. des Arts Décoratifs, Inv.-No. 394; plate

1238 *China, Ming Dynasty (1368–1644); beaker on wooden base;* porcelain; h - base 10.2 cm; sig. on base: blue mark of Hsüan-tê; Hsüan-te Reign (1426–1435) or later; Berlin, Staatliche Museen Preußischer Kulturbesitz, Kunstgewerbemus., Inv.-No. 00, 568 a+b

1239 *Germany; manufacture: Königl. Porzellanmanufaktur Berlin; model: Schröder; foot bowl;* Seger porcelain; ⌀ 17.6 cm; sig. on base: sceptre mark, SgrP and M; 1918; Berlin, Staatliche Museen Preußischer Kulturbesitz, Kunstgewerbemus., Inv.-No. 64.4

1240 *Auguste Delaherche (Beauvais 1857–1940 Armentières); Filter bowl with silver foot;* earthenware; ⌀ 17.3 cm; sig. on base: Auguste Delaherche 2371, on the mounting: Cardeilhac and Stamp; Berlin, Staatliche Museen Preußischer Kulturbesitz, Kunstgewerbemus., Inv.-No. 00,612

The Adaption of Plant Forms under the Influence of Far-Eastern Pottery

One of the important influences on the vessels designed during the Art Nouveau and Jugendstil period is to be seen in the adaption of plant forms and shapes. Impressed by Haeckel's research into the artistic forms in nature, European artists come to the conclusion that it is precisely in this field that they will receive their most fruitful stimuli in designing new elemental forms.
Hermann Obrist, active in the applied arts and sculpture, wanted to create a new codex of forms based on this idea. He took the forms of nature to demonstrate in his writings a whole program for the fine arts which was to affect the art of the twentieth century. It is an undeniable fact that the heterogeneous forms in nature discovered for oneself and viewed with new eyes have exercised an influence on the design of vessels, an influence which just cannot be disregarded. The twists and turns, the folds and bends, the hanging fruit and the sprouting vegetation have all been reproduced by the artists in pottery and glass. Conventional forms, on to which those of organic nature are grafted as it were, are thus completely alienated and transformed. We see clearly that the mouth of the traditional vessel is caught up in a process of transmutation under the influence of these floral impulses and finally loses its specific formal characteristics.
Gourds and pomegranates in innumerable variations have Far-Eastern vessel forms as their models. The bottle gourd, the prototype par excellence throughout

Asia (in the form of the calabash), stands model for many artists in Europe, whereby naturalistic, almost completely realistic features are reproduced. The woody rind of the original takes on an almost unique decorative value. The European reception reduces the form of the fruit to the essentials. The bottle-gourd in the double form is also the result of Far-Eastern influence. Emil Gallé and Daum also bring the changes in the onion shape or pomegranate form. The utensils are placed on wooden pedestals or are assimilated to Japanese types by the decorative motifs. S.W.

Summary and Translation P. J. D.

1241 *China, Ch'ing Dynasty (1644–1912); vase;* copper, enamel, partly gilt; h - 38.4 cm; 18th cent.; Nuremberg, Gewerbemus. der Landesgewerbeanstalt Bayern, Inv.-No. Chi 3918

1242 *Emile Gallé; phial in double-gourd form;* white clear glass with red, carved flashing; h - 20 cm; Paris, Alain Lesieutre

1243 *France; Manufactur Nationale de Porcelaine, Sèvres, (Bottle), C. F. Heisse, Copenhagen (Mounting); bottle with silver mounting;* porcelain; h - 19.8 cm; sig. on base: S. 94 (Bottle), Arms of Copenhagen, 925s, Crown, Michelsen, 10, Firm's Trademark, C. F. Heisse (mounting); pre 1900; Darmstadt, Hessisches Landesmus., Inv.-No. Kg 65:16

1244 *France; Manufacture Nationale de Porcelaine, Sèvres; vase in double-gourd form;* mounting by Majorelle, Nancy; porcelain; h - 22.5 cm; sig. on base: firm's mark; pre 1900; Paris, Mus. des Arts Décoratifs, Inv.-No. 40307

1245 *Bernard Moore (Longton ? c. 1850–post 1915); double-gourd vase with silver mounting;* porcelain with underglaze painting; h - (without mounting) 19.3 cm; sig.: B. M., 1069 (Piece-No.); c. 1880; Karlsruhe, Badisches Landesmus., Inv.-No. 70/117

1246 *China, Ch'ing Dynasty (1644–1912); vase in tripartite double-gourd form;* porcelain with "sang-de-bœuf" glaze, partially badly discoloured; h - 20 cm; K'ang-hsi reign (1662–1722); Vienna, Österreichisches Mus. für angewandte Kunst, Inv.-No. 17464/Or. 650; plate

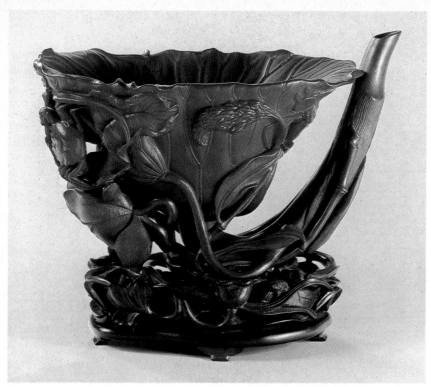

East and
South-East
Asia

Ceramics
and Glass

1161–1587

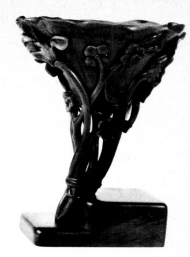

1196 China, Offertory Vessel

◀ 1197 China, Offertory Vessel

1199 Gallé, Vase ▶

1200 Gallé, Vase

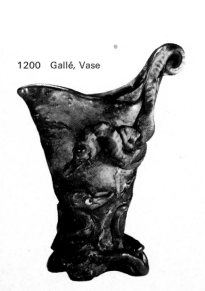

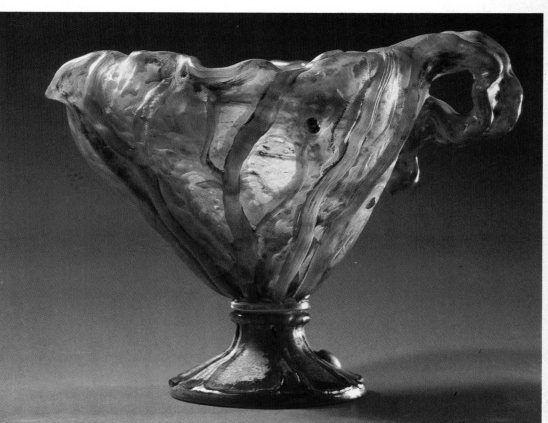

East and
South-East
Asia

Ceramics
and Glass

1161–1587

1247 *Germany; manufacture: Königl. Porzellanmanufaktur Berlin; Vase in form of double-gourd;* Seger porcelain with sang-de-bœuf glaze, badly discoloured around the rims; h - 21 cm; sig. on base: SP, sceptre mark, G 19; Munich Stadtmus., Inv.-No. 52/325; plate

1248 *Johann Julius Scharvogel (Mainz 1854–1938 Munich); vase in form* of double-gourd; earthenware; h - 12.8 cm; on base: stamp, monogram SKM; c. 1910–1920; Hamburg, Heuser Coll.

1249 *Japan; gourd bottle;* wood; h - 23 cm; Vienna, Mus. für Völkerkunde, Inv.-No. 145830

1250 *Japan; gourd bottle;* wood; h - approx. 23 cm; Vienna, Mus. für Völkerkunde, Inv.-No. 148517

1251 *Japan; gourd bottle with plated strap;* wood; h - 16.5 cm; Vienna, Mus. für Völkerkunde, Inv.-No. 129134

1252 *China, Ch'ing Dynasty (1644–1912); vase in double-gourd form;* porcelain with porous, brown-black glaze; h - 18.2 cm; 18th cent.; Vienna, Österreichisches Mus. für angewandte Kunst, Inv.-No. 32209/Ke. 8823

1253 *Japan; vase in double-gourd form;* earthenware; h - 13 cm; 19th cent.; Paris, Mus. Cernuschi, Inv.-No. 2955

1254 *Japan; gourd bottle;* earthenware, seto-yaki, with rustbrown glaze, brown spots and pronounced overflow; h - 18.7 cm; London, Victoria & Albert Mus., Inv.-No. C 624–1923

1255 *Jean Carriès (Lyon 1855–1894 Paris); double-gourd vase;* earthenware; h - 21 cm; sig. on base: Jean Carriès; Paris, Alain Lesieutre

1256 *Emile Grittel (1870–1953); vase in double-gourd form;* earthenware; h - 17.5 cm; sig. on base: E. G.; Paris, Alain Lesieutre

1257 *Alexandre Bigot (Mer, Loire-et-Cher 1862–1927 Paris); vase in form of double gourd;* earthenware, grey body with green crystal glaze interspersed with brown; sig. on base: Alexandre Bigot; c. 1907; Paris, Mus. des Arts Décoratifs, Inv.-No. 13949

1258 *Paul Jeanneney (Strasbourg 1861–1920 St-Amand-en-Puysaye);*

vase in double-gourd form; earthenware; h - 13 cm; sig. on base: Jeanneney and two further marks; c. 1895–1900; Hamburg, Heuser Coll.

1259 *Ingeborg Zenker (Hanover 1926); double-gourd vase;* earthenware; h - 17 cm; sig. on base: Zenker; c. 1960; Deidesheim, Mus. für moderne Keramik

1260 *Jean Carriès; vase;* earthenware; h - 21 cm; sig. on base: JC; Paris, priv. owned

1261 *Paul Jeanneney; vase;* earthenware; h - 13 cm; sig. on base: Jeanney; pre 1900; Paris, Mus. des Art Décoratifs, Inv.-No. 9342

1262 *Jean Carriès; vase;* earthenware, brown body with grey "snakeskin" glaze on dark-brown engobe; partially gold glazed with marked drop formation; h-19 cm; sig. on base: Jean Carriès; pre 1892; Paris, Mus. des Arts Décoratifs, Inv.-No. 7263; plate

1263 *Jean Carriès; vase;* earthenware; h - 13.5 cm; sig. on base: J. C., 10 (piece no.); Paris, Alain Lesieutre

1264 *Jean Carriès; vase;* earthenware; h - 17 cm; sig. on base: Jean Carriès, 1676; Paris, Alain Lesieutre

1265 *Jean Carriès; vase;* earthenware; h - 19 cm; sig. on base: Jean Carriès; Paris, Alain Lesieutre

1266 *Horst Kerstan (Frankfurt-on-Main 1941; lives at Kandern, S. Black Forest); vase* in double-gourd form; earthenware, light body, thrown, twice glazed, iridescent black-brown basic glaze with dull blue and yellow-mottled overflow glazes; h - 21.8 cm; sig. on base: Kérstan 69 1969; Hamburg, Heuser Coll.

1267 *Japan, late Tokugawa Period (1765–1868); cylindrical bottle vase;* earthenware, inuyama-yaki, oak twigs and fruit tree in blossom in red, green and brown enamel pigments; h - 21.5 cm; post 1835; Vienna, Österreichisches Mus. für angewandte Kunst, Inv.-Nr. 17708/Or. 898

1268 *Jean Carriès; bottle vase in barrel shape;* earthenware, grey body with ocher-coloured, reddish-brown glaze and white overflow glazing with

snakeskin effect; h - 20 cm; sig. on base: J. Carriès; c. 1890; Munich, Paul Tauchner Coll.

1269 *Japan, Late Tokugawa Period (1765–1868); rice-wine bottle (tokuri), tamba-yaki;* earthenware with mottled, metallic iridescent glaze in red-brown and black, mouth with silver edging; h - 16.8 cm; early 19th cent.; Hamburg, Mus. für Kunst und Gewerbe, Inv.-No. 1894.39

1270 *Jan Bontjes van Beek (Velje Jütland 1899–1969 Berlin); case;* earthenware; h - 20 cm; c. 1942; Zürich, Kunstgewerbemus., Inv.-No. 11038; plate

1271 *Japan, Tokugawa Period (1603–1868); rice-wine bottle (tokuri), Tamba-yaki;* earthenware with brownish-yellow glaze; h - 19 cm; Paris, Mus. Cernuschi, Inv.-No. 2732

1272 *Erika Yvonne Barlogie (1941); vase in cylinder form;* earthenware, thrown, grey body with grey-blue glaze, red-brown brush decoration; h-17 cm; sig. on base: artist's mark; 1965; Hinang, Wolf Coll., No. 267001

1273 *Japan, Tokugawa Period (1603–1868); rice-wine bottle (tokuri);* earthenware with iridescent, violet-grey and olive-green flamed glaze, form of an aubergine; h - 18 cm; sig.: Umebayashi; 19th cent.; Hamburg, Mus. für Kunst und Gewerbe, Inv.-No. 1900.220

1274 *Japan, Tokugawa Period (1603–1868); rice-wine bottle (tokuri), Seto-yaki;* earthenware with brown, milky-white and ocher-coloured flamed glaze, pear-shaped with three concave depressions in body; 19th cent.; Hamburg, Mus. für Kunst und Gewerbe, Inv.-No. 1890.220

1275 *Daum Frères (Auguste 1853–1909, Antonin 1864-1930); gourd-shaped vase;* bubbly glas, golden green and orange brown, stained in the mass; h - 24 cm; sig. on the body; Daum/Nancy and Cross of Lorraine; Munich, priv. owned

1276 *Daum Frères; gourd-shaped vase;* stained in the mass, green, brown, yellow, turquoise glass, stem with yellow-green inlaid threads; h - 19 cm; sig. on the body; Daum/Nancy and Cross of Lorraine; Munich, priv. owned

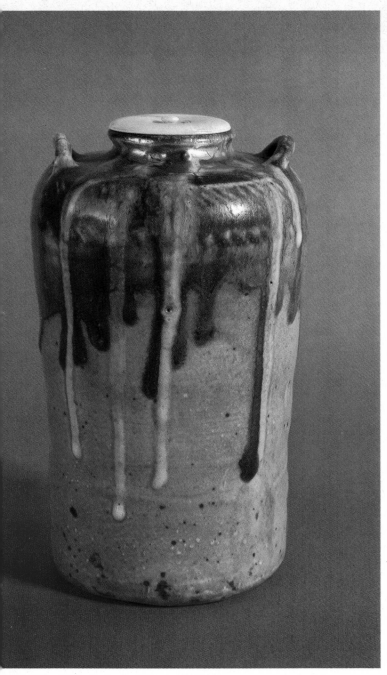

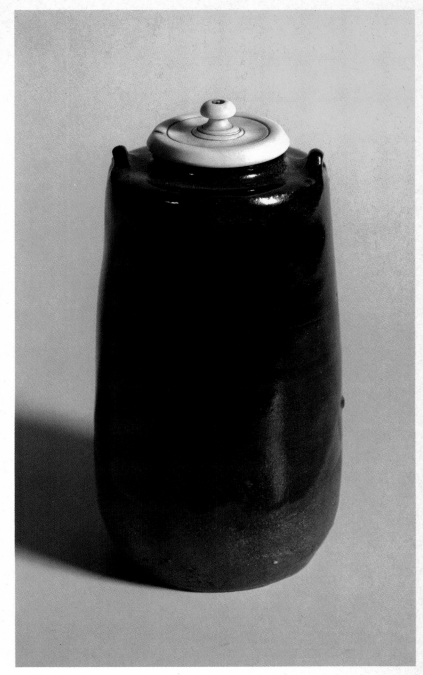

1523 Hoentschel, Covered Container

1522 Japan, Tea Container

1527/1532/1533 Japan, Tea Containers ▶

East and
South-East
Asia

Ceramics
and Glass

1161–1587

1277 *Japan, late Tokugawa Period (1765–1868) or Meiji Period (1868–1912); bipartite censor;* bronze; h - 17.5 cm; sig.: imitation Hsüan-te mark (1426–1435); 19th cent.; Vienna, Österreichisches Mus. für angewandte Kunst, Inv.-No. 11029/Br. 782

1278 *Japan; calabash (hyôtan);* wood; silk chord and wooden stopper; h - 13 cm; Vienna, Mus. für Völkerkunde, Inv.-No. 112462

1279 *Alexandre Bigot; pear-shaped vase;* earthenware; h - 12.7 cm; sig. on base; Abigoz; c. 1900; Darmstadt, Hessisches Landesmus., Lg 5, No. 2

1280 *Emile Grittel (1870–1953); pear;* earthenware; h - 15.5 cm; sig. on base: E. G. and G; Paris, Alain Lesieutre

1281 *Emile Grittel; pear;* earthenware; h - 13 cm; sig. on base: E. G. and G; Paris, Alain Lesieutre

1282 *Horst Kerstan (Frankfurt 1941; lives at Kandern, S. Black Forest); pear-shaped vase;* earthenware; h - 13 cm; sig.: on base: Kerstan; 1968; Hinang, Wolf Coll., No. 647039

1283 *Japan; box with lid (hako);* red-brown patinated copper alloy; h - 10.5 cm; Vienna, Mus. für Völkerkunde, Inv.-No. 34686; plate

1284 *Georges Hoentschel (Paris 1855–1915); apple;* earthenware; brown body with yellowish-brown glaze; h - 7 cm; sig. on base: stamp G. H.; pre 1902; Paris, Mus. des Arts Décoratifs, Inv.-No. 10208; plate

1285 *Nils Ivan Joakim Count Barck (Malmö 1863–c. 1930 St. Amand-en-Puysage); covered container in form of a paprika (pepper);* earthenware; h - 9.5 cm, ⌀ 11 cm; sig. and inscribed on base: N de B and firing no. 6; c. 1900; Hamburg, Heuser Coll.

1286 *Alexandre Bigot (Mer, Loir-et-Cher 1862–1927 Paris); butter dish with base and lid in form of a blossom;* earthenware, mounted in "gallia metal," in part gilt; h - 6.5 cm, ⌀ base 18.5 cm; sig. on base: A. Bigot 349, Gallia metal 4247; pre 1900; Berlin, Staatliche Museen Preußischer Kulturbesitz, Kunstgewerbemus., Inv.-No. 00,620

1287 *China, Ch'ing Dynasty (1644–1912); vase in form of gourd;* porcelain with celadon glaze; h - 13.2 cm; 18th cent.; Vienna, Österreichisches Mus. für angewandte Kunst, Inv.-No. 32293/Ke. 8907

1288 *Japan, Tokugawa Period (1603–1868); gourd bottle;* earthenware, Seto-yaki; h - 34 cm; 17th/18th cent.; Karlsruhe, Badisches Landesmus., Inv.-No. A 10100

1289 *Emile Adrien Dalpayrat (Limoges 1844–1910); vase in form of gourd;* earthenware; h - 20.5 cm; sig. on base: Dalpayrat stamp, pomegranate; pre 1908; Paris, Mus. des Arts Décoratifs, Inv.-No. 15224

1290 *Ruth Koppenhöfer (Heilbronn 1922); gourd vase;* earthenware; h - 18.5 cm; sig. on base: R K; 1970; Deidesheim, Mus. für moderne Keramik

1291 *Taxile Doat; bottle in form of gourd;* porcelain; h - 18 cm; pre 1900; Vienna, Österreichisches Mus. für angewandte Kunst, Inv.-No. 12429/Ke. 4468

1292 *Japan; gourd bottle;* wood, on round base, body of vessel in form of gherkin; h - 40 cm; Vienna, Mus. für Völkerkunde, Inv.-No. 145831

1293 *Jean Carriès (Lyon 1854–1894 Paris); vase in form of gherkin;* earthenware; h - 20 cm; sig. on base: Jean Carriès; Paris, Alain Lesieutre

1294 *China, Ch'ing Dynasty (1644–1912); vase in form of a cluster of bamboo;* porcelain with light celadon glaze, discoloured at the trims; h - 21 cm; 19th cent.; London, Victoria & Albert Mus., Inv.-No. 7228–1861

1295 *Frederick Carder (Corning 1863–*

1963); manufacture; Steuben Glass Works; vase; flashed glass, silvery green-blue lustre; h - 15.5 cm; sig. on base: Aurene 2744; post 1903; Frankfurt, Knut Günther

1296 *Loetz Austria; narrow-necked vase in the form of a tree stump;* thick-walled, lustred flashed glass; h - 29.5 cm; Düsseldorf, Kunstmus. Prof. Hentrich Coll.

Overflow Glazes

1297 *Japan, Tokugawa Period (1603–1868); bottle-vase;* earthenware with dark-grey glaze and white overflow; h - 22 cm; 18th cent.; Stockholm, Ostasiatiska Mus., Inv.-No. NM 143/1932

1298 *Japan, late Tokugawa Period (1765–1868); bottle-vase;* earthenware, amamori ware; h - 24 cm; 18th cent.; London, Victoria & Albert Mus., Inv.-No. 580–1877; plate

1299 *Japan, late Tokugawa Period (1795–1868); bottle-vase;* earthenware with black and white glaze; h - 22.5 cm; 18th/19th cent.; Paris, Mus. Cernuschi, Inv.-No. 2832

1300 *Andrew Walford (Bournemouth 1942); vase;* earthenware, reddish discoloration, light-brown body, thrown, olive-green glaze with iron dissociation; h - 21 cm; sig. on body; W; 1967; Hinang, Wolf Coll. No., 167006

1301 *China, T'ang Dynasty (618–906); pot with handles;* earthenware with dark-blue overflow glaze; h - 18.5 cm; Vienna, Österreichisches Mus. für angewandte Kunst, Inv.-No. 31290/Ke. 8448

1284 Hoentschel, Apple

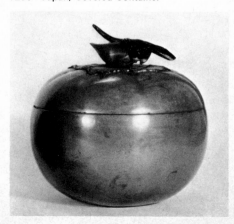
1283 Japan, Covered Container

East and
South-East
Asia

Ceramics
and Glass

1161–1587

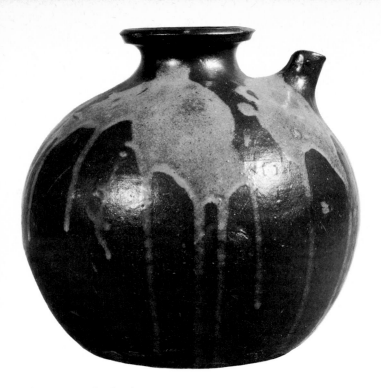

1309 Japan, Wine Bottle

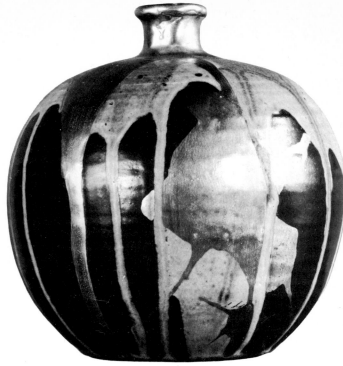

1310 Carriès, Vase

1302 *Auguste Delaherche (Beauvais 1857–1940 Armentières); vase;* porcelain; h-18 cm; sig. on base: A. D. 874.9; Paris, priv. owned

1303 *Auguste Delaherche; vase;* porcelain; h-13 cm; sig. on base: A. D. and green mark (artist's signature in green); pre 1902; Paris, Mus. des Arts Décoratifs, Inv.-No. 10285

1304 *Jean Pointu (1843–1925); vase;* earthenware; h-28 cm; sig. on base: Jean Pointu; Munich, Paul Tauchner Coll.

1305 *Paul Jeanneney (Strassburg 1861–1920 Amand-en-Puysage); vase;* earthenware; h-16 cm; sig. on base: Jeanneney; c. 1900; Munich, Paul Tauchner Coll.

1306 *Japan, Meiji Period (1868–1912); vase;* earthenware with brown-black glaze; h-12.8 cm; 19th cent.; Vienna, Österreichisches Mus. für angewandte Kunst, Inv.-No. HM 1842

1307 *Paul Jeanneney; vase in pouch form;* earthenware; h-10.5 cm; sig. on the base: Jeanneney and further sign; c. 1890–1900; Hamburg, Heuser Coll.

1308 *Japan, late Tokugawa Period (1765–1868); rice-wine bottle, bizen-yaki, Imbe;* reddish brown earthenware with pitted overflow glaze in grey-yellow, in form of a gourd bottle; h-15 cm; sig.: "Man" of the potter Mori Kishirô; 18th cent.; Hamburg, Mus. für Kunst und Gewerbe, Inv.-No. 1901.66

1309 *Japan, late Tokugawa Period (1765–1868) or Meiji Period (1868–1912); wine bottle from Province of South Kyushu;* earthenware, red-brown body with iridescent, brown glaze and pronounced overflowings in white; h-19.5 cm; 19th cent.; strong Korean influence; London, Victoria & Albert Mus., Inv.-No. C. 47-1936; plate

1310 *Jean Carriès (Lyon 1854–1894 Paris); vase;* earthenware, grey body with brown basic glaze and overflowings in cream-white and gold; h-20 cm; sig. on base: Jean Carriès; Paris, Alain Lesieutre; plate

1311 *Jean Carriès; vase;* earthenware; h-20.5 cm; sig. on base: Jean Carriès; Paris, Alain Lesieutre

1312 *Jean Carriès; vase;* earthenware; h-23 cm; sig. on base: Jean Carriès 27;

Paris, Mus. des Arts Décoratifs, Inv.-No. 7262

1313 *Japan, Tokugawa Period (1603–1868); tea bowl (chawan);* earthenware raku-yaki repaired with gold lacquer; ∅ 9 cm; 17th cent.; Munich, Prof. Kurt Martin

1314 *Horst Kerstan (Frankfurt 1941); deep bowl;* earthenware, fired body with iridescent black glaze and gold painting; ∅ 11.5 cm; sig. on base: Kerstan 21.5.68; 1968; Hamburg, Thiemann Coll.

1315 *S. W. Alexander Haussmann; dish;* earthenware; ∅ 13 cm; sig.: stamp; c. 1961; Zürich, Kunstgewerbemus., Inv.-No. 1962–3

1316 *Japan, Mishiwa, late Tokugawa Period (1765–1868); bowl;* earthenware, raku ware, black glazed; ∅ 11.5 cm; 18th/19th cent.; Paris, Mus. Cernuschi, Inv.-No. 3412

1317 *Wilhelm G. Albouts (Krefeld 1897–1971 Frankfurt); deep bowl;* earthenware, thrown, light-grey body, iridescent, black-brown glaze with dull beige brushwork decoration; ∅ 10.5 cm; sig. on base: stamp; c. 1965; Deides-

199

East and
South-East
Asia

Ceramics
and Glass

1161–1587

heim, Mus. für moderne Keramik

1318 *Korea, Li Dynasty (1392–1910);
tea bowl (chawan) Kyongsang (?);*
earthenware, totoya type, fine red body
with thin, transparent, grey-tinted glaze
and old gold-lacquer repair spots;
Ø 15 cm; Berlin, Mus. für Ostasiatische
Kunst, Inv.-No. 429

Mottled Glazes

1319 *Japan, late Tokugawa Period
(1765–1868) or Meiji Period (1868–
1912); vase;* earthenware with light-
blue glaze, mottled on the shoulder;
h-18 cm; 18th/19th cent.; Paris, Mus.
Cernuschi, Inv.-No. 2789

1320 *Peter Lakotta (Marburg 1933);
vase;* earthenware, thrown, beige-grey
body, dull black glaze with pitted iri-
descent red – socalled "lava" or "tiger" –
glaze; h-15 cm; sig. on base: scratched
sign; c. 1956; Deidesheim, Mus. für
moderne Keramik

1321 *Kurt Ohnsorg (Sigmundsherberg
1927–1970 Gmunden); vase;* fired pot-
tery with "pheasant" glaze; h-13.3 cm;
1955; Vienna, priv. owned

1322 *Jan Bontjes van Beek; vase;* fine
earthenware with glacier blue to violet
glaze, partially mottled; h-23 cm; 1965;
Hamburg, Thiemann Coll.

1323 *Japan, Tokugawa Period (1603–
1868); tea bowl (chawan);* earthen-
ware, raku-yaki, with mottled glaze;
17th cent.; Munich, Staatliches Mus.
für Völkerkunde

1324 *Barbara Stehr (Weetzen, Hanover
1936); vase;* earthenware with white,
black mottled glaze; h-12 cm; 1965;
Hamburg, Thiemann Coll.

1325 *Horst Kerstan (Frankfurt 1941)
deep bowl;* earthenware, fired whitish
body with brown, dark-pitted glaze
("lava"); Ø 13.7 cm; sig. on base: HK;
1969; Hamburg, Thiemann Coll.

1326 *Horst Kerstan; deep bowl;* fine
earthenware; Ø 14.5 cm; sig. on base:
HK stamp Kerstan/Kandern 1967;
Hamburg, Thiemann Coll.

1327 *Konrad Quillmann (Berlin 1936);
deep bowl;* earthenware; Ø 12.2 cm;
sig. on base: R 69; 1969; Hamburg,
Thiemann Coll.

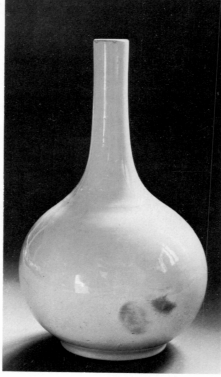

1329 China, Long-Necked Bottle

The White Porcelain of the Sung Period

Mariela D. Siepmann

The white porcelain of the Sung dynasty
known as "ting-yao," one of the most
highly valued wares of the Northern
Sung period, was brought to perfection
towards the end of the eleventh and
during the first quarter of the twelfth
century. "Ko ku yao lun," porcelain fired
during the chengho (1111–1117) and
hsüan-ho (1119–1125), is regarded as
the most outstanding "ting-yao" ware.
It is said that, after the Tartar invasion
forced the transfer of the Sung court to
the south (1126/27), the production of
the white porcelain was discontinued.
However, tradition has it that "ting-yao"
was manufactured in the south after this
date, as the potters also fled southwards
when the Tartars appeared on the scene.
There is no evidence to support this
tradition.
Since "ting-yao" porcelain was essen-
tially for everyday use, there are very few
vases represented among it, although
the type known as "mei-p'ing" is
occasionally met with. Of the vases

termed "ting" only a very small number is
actual Ting ware; the majority should
rather be assigned to the Tz'u Chou ware.
The bronze forms, too (cp. Cat. no.1328),
which we come across from time to time
are likewise not to be numbered among
the products of classical "ting yao", but
were produced at a later date when Ting
ware was being imitated.

The thin Ting ware can be quite smooth
or covered with decoration that is carved
(chin hua or hsiu hua), incised (tiao hua
or hua hua) or pressed out in moulds (yin
hua). The decorative repertoire is
extremely rich and varied but consists
essentially of forms drawn from the realm
of flora and fauna. Among the flowers
depicted, the lotus and the peony, the
symbols of wealth and prosperity, are
most frequently given the preference.
Among the birds, it is the wild duck and
the mandarin duck which are most often
represented. The floral motifs sometimes
appear individually in an arabesque type
of arrangement, but they are very often
combined with animal motifs.
A further characteristic of Ting ware is the
ivory-white tint of the translucent glaze
which is generally not crackled and is
applied directly on the body. Where the
pieces are fired upside down so that the
base and sides are glazed but the rims
unglazed, these latter are often covered
with a metal band. Since the glaze of
"tin-yao" ware is particularly thin, air
bubbles are often formed at those points
where it has been applied more thickly:
in this case the glaze runs down the
vessel in thin streaks until it ends in
whitish-grey drops which the Chinese
very poetically regard as tears.
The great attraction of "ting-yao" ware
has not passed unnoticed by the ceramic
artists of the twentieth century. Jan
Bontjes van Beek made a particular study
of the glaze of Ting ware and very
creatively endeavoured to imitate the
tranquil harmony and the gentle irides-
cence so typical of it.

Summary and Translation P. J. D.

1328 *China, Yuan-Dynasty (1276–
1367); vase;* porcelain, "tou-ting" type,
white glaze; h-32 cm; 13th/14th cent.;
Paris, Mus. Guimet, Inv.-No. G 1087

1329 *China, Ming Dynasty (1368–
1644); long-necked vase;* porcelain,
white glaze with yellow-violet fired
coloration as artistic effect; on the base:
mark; prob. 15th cent.; Zürich, Kunst-
gewerbemus., Inv.-No. 1955–55; plate

1330 *China, Ch'ing Dynasty (1644–1912); vase;* porcelain with crackled, cream-coloured "blanc-de-chine" glaze; h-21.4 cm; 18th cent.; Vienna, Österreichisches Mus. für angewandte Kunst, Inv.-No. 17524//r. 714

1331 *Edouard Chapallaz; vase in bottle form;* earthenware; h-43 cm; signed; 1954; Zürich, Kunstgewerbemus., 1955-141

1332 *Auguste Delaherche (Beauvais 1857–1940 Beauvais); vase;* porcelain; h-20 cm; sig. on base: A D; c. 1904; Munich, Paul Tauchner Coll.

1333 *Stephan Erdös (Bohemia 1906–1956 Tittmoning); vase;* earthenware; h-16.9 cm; sig. on base: S E M; pre 1956; Nuremberg, Gewerbemus. der Landesgewerbeanstalt Bayern, Inv.-No. St 11083

1334 *Jan Bontjes van Beek (Vejle, Jütland 1899–1969 Berlin); bowl;* fine earthenware; ⌀ 25.5 cm; 1966; Hamburg, Thiemann Coll.

1335 *China, Sung Dynasty (960–1279); bowl in form of a lotus blossom;* porcelain with white-yellow and grey-green glaze; ⌀ 18 cm; 12th cent.; perhaps also Korea; Schloß Pommersfelden, Gräflich Schönbornsche Slg.

1336 *Stig Lindberg; Manufaktur Gustafsberg, Stockholm; bowl;* porcelain; ⌀ 13.6 cm; Vienna, Österreichisches Mus. für angewandte Kunst, Inv.-No. 37164/Ke. 9512

1337 *Albrecht Hohlt (Freiburg in Breisgau 1928–1960 Munich); bowl;* porcelain; ⌀ 11.7 cm; sig. on base: Hohlt stamp; Munich, priv. owned

1338 *Ursula Scheid (Freiburg in Breisgau 1932); bowl;* porcelain; ⌀ 16 cm; sig. on base: Scheid 71; 1971; Deidesheim, Mus. für moderne Keramik

Celadon Ware and its Renaissance in Contemporary Ceramic Art

Mariela D. Siepmann

In ceramic terminology celadon is used to designate a large group of porcelain or semi-porcelain ware characterized by a monochrome green, felspathic glaze which appears in a whole range of finely diversified tints.

The earliest product of this type is the "Yüeh-yao" which was potted in the extensive Chekiang province in the third century of our era. The artistic climax was reached during the period of the Five Dynasties (907–960). The reputation which this ware enjoyed at home and abroad is witnessed to by the extensive export to the rest of the then known world. The most famous celadon is that of Lung-ch'üan. The products of the potteries there are distinguished by their unsurpassed purity and the inimitable translucent, jade-coloured glaze. European celadon owes its origin to these early products of the Chinese potter's art. The large, stoutly built vases and bowls produced at Lung-ch'üan during the Yüan dynasty (1260–1368) were destined to an ever increasing extent for export – the first examples of this pottery appear in France at the beginning of the seventeenth century. In a stage production during this same century of Honoré d'Urfé's romance "L'Astrée", the shepherd Céladon apparently wore a bluish green costume; because of this he gave his name to Chinese glazes of this colour in Europe.

Celadon was potted for centuries and its almost legendary fame accounts for the fact that magical properties were attributed to it in some regions. Thus, during the Middle Ages, it was maintained in the Near East that celadon dishes would change their colour if they contained poison, which accounts for their popularity in those days. However, in the last analysis, the wonders attributed to celadon ware are merely the expression of the extraordinary fascination which outstanding examples must have exercised in the past and still do at the present. Contemporary potters show a lively interest in pottery of the Sung dynasty, for it makes high demands not only on the potter's artistic sense but also on his mastery of the techniques of his trade. It is no wonder then when quite a considerable number of present-day ceramists have ventured to experiment with celadon. In the celadon vases and bowls produced by contemporary potters we have documented, on the one hand, the intensive preoccupation of modern ceramists with the pottery and porcelain of the Far East; on the other hand, we are also faced here with objects which, in their high artistic standard, are worthy to stand alongside the creations of ancient China.

Summary and Translation P. J. D.

1339 *Korea, Yi Dynasty (1392–1910); bottle;* earthenware with strongly crackled celadon glaze, underglaze in ocher brown and some cobalt blue; h-14.5 cm; Österreichisches Mus. für angewandte Kunst, Inv.-No. 17479/Or. 669

1340 *China, Ch'ing Dynasty (1644–1912); vase;* porcelain; h-47.4 cm; 18th cent.; Vienna, Österreichisches Mus. für angewandte Kunst, Inv.-No. 30606/Ke. 8061

1341 *Ursula Scheid (Freiburg in Breisgau 1932, lives at Düdelsheim, Upper Hessia); vase;* porcelain; h-10.7 cm; sig. on base: stamp UD with inscribed Scheid 67; 1967; Hamburg, Thiemann Coll.

1298 Japan, Vase

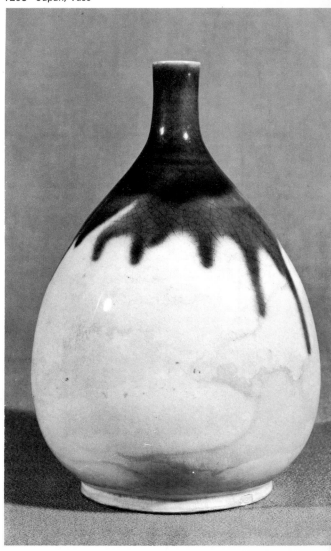

East and
South-East
Asia

Ceramics
and Glass

1161–1587

1342 *Volker Ellwanger (Baden-Baden 1933, lives at Berne); vase;* earthenware; h-14.5 cm; sig. on base: E. KB (Kunstgewerbeschule Bern) 71; 1971; Hamburg, Thiemann Coll.

1343 *Henri Simmen (born 1880); lobar vase;* earthenware, ebony lid with ivory knob; h-20.5 cm; sig. on base: H. SIM; post 1900; Munich, Paul Tauchner Coll.

1344 *Archibald Ganslmayr (Bardenberg, near Aachen 1943); cylindrical vase;* fine earthenware; h-24.2 cm; sig. on base: Ganselmayr stamp and AG, 71/10; 1971; Hamburg, Thiemann Coll.

1345 *China, Sung Dynasty (960–1279); bowl;* earthenware; ⌀ 19.5 cm; late Sung Period, 13th cent.; northern celadon ware in type; Zürich, Kunstgewerbemus., Inv.-No. 10899

1346 *China, Sung Dynasty (960–1279); bowl;* earthenware; ⌀ 17.5 cm; Schloß Pommersfelden, Gräflich Schönbornsche Slg.

1347 *China, Sung Dynasty (960–1279); dish;* earthenware; ⌀ 17 cm; Schloß Pommersfelden, Gräflich Schönbornsche Slg.

1348 *Korea, Koryo Dynasty (918–1292); bowl;* fine earthenware with engraved decoration under a bluish and blue-tinted, finely flawed celadon glaze with overflow effects; on lower part, gold-dust effect; ⌀ 19.5 cm; 11th/12th cent.; London, Victoria & Albert Mus., Inv.-No. C. 155-1926

1349 *Albrecht Hohlt (Munich 1928–1960 Freiburg in Breisgau); bowl;* fine earthenware; ⌀ 16.7 cm; sig. on base: Hohlt stamp; 1958; Hamburg, Thiemann Coll.

1350 *Görge Hohlt (Munich 1930, lives at Katzbach, Upper Bavaria); bowl;* porcelain; ⌀ 16.5 cm; sig. on base: cat on curved line and GH; 1968; Hamburg, Thiemann Coll.

1351 *Albrecht Hohlt; bowl;* porcelain; ⌀ 15.8 cm; sig. on base: Hohlt stamp; Munich, priv. owned

1352 *Fance Franck; bowl;* earthenware; ⌀ 31 cm; 1971; Henri et Nicole de Clermont-Tonnerre

1353 *Albrecht Hohlt; bowl;* fine earthenware; ⌀ 16.7 cm; sig. on base: Hohlt stamp; 1958; Hamburg, Thiemann Coll.

1354 *Daniel de Montmollin (St. Aubin, Neufchâtel, Switzerland 1921); bowl;* earthenware; ⌀ 17.6 cm; sig. on base: TZ (= Taizé); 1966; Hamburg, Thiemann Coll.

1355 *Karl Scheid (Lengfeld, Odenwald 1929); deep bowl;* porcelain; ⌀ 11 cm; sig. on base: HH stamp (= Hosset House) with inscribed Scheid 67; 1967; Hamburg, Thiemann Coll.

1356 *China, Ch'ing Dynasty (1644–1912); Pi-tong;* porcelain with celadon glaze; h-11.5 cm; 18th/19th cent.; Paris, Mus. Cernuschi, Inv.-No. 4275

1357 *Korea, Koryo Dynasty (918–1392); small dish;* earthenware with grey-green celadon glaze; ⌀ 11.2 cm; 13th/14th cent.; Vienna, Österreichisches Mus. für angewandte Kunst, Inv.-No. 30876/Ke. 8329

1358 *Bernard Leach (Hongkong 1887, lives at St. Ives, Cornwall); vase;* earthenware with semi-matt, grey-green celadon glaze which leaves the lower part of the body exposed; h-19.2 cm; sig. on lower part of wall: atelier stamp of St. Ives Pottery, in a square the stamp BL, England; c. 1959; Hamburg, Thiemann Coll.

1359 *Bernard Leach; dish;* earthenware; h-7 cm; 1963; Paris, Fance Franck Coll.

1360 *Bernard Leach; dish;* earthenware; ⌀ 17 cm; 1963; Paris, Mme Edith Ardagh

1361 *Mike Dodd (Sutton, Sussex 1943, lives at Watlington, Sussex); bowl;* earthenware; ⌀ 15.5 cm; 1970; Hamburg, Thiemann Coll.

1362 *China, Sung Dynasty (960–1279); bowl;* earthenware, lung-chüan-yao; ⌀ 16.4 cm; Stockholm, Johannes Hellner Coll.

1363 *Bernard Leach; bowl;* porcelain, with light celadon glaze; ⌀ 24.5 cm; 1963; Paris, Mme Philippe Daudy

"Chien-yao" and its Rediscovery in Modern Ceramic Art

Mariela D. Siepmann

This ware was potted in Chien-an, later in Chien-yang, in the north of the Province of Fukien and takes the form mainly of tapering bowls. It is a dark ferruginous stoneware covered with a thick treacly glaze whose ground varies from brownish to purplish black in colour. The metallic reflections it gives off in the light are to be traced to the silvery sheen of the brown which is either speckled or streaked. The sources compare this glaze with the brown lines of the fur of the hare or the mottled effect of the breast feathers of the partridge. As is generally the case with most flux glazes, the glaze is thicker at the bottom and in most examples leaves the lower part of the wall of the vessel and its base uncovered. In almost all examples the rim is protected by a metal band (cp. Cat. no. 1366). The bowls and vessels of this type are more usually known by their Japanese designation "temmoku". Modern ceramists have been greatly influenced by this stoneware and have been stimulated by it to develop new methods of glazing. Their starting point was always the classical temmoku, but they have attained to new and frequently startling variations on this form.

References from the tenth and eleventh centuries inform us that temmoku tea bowls were in great favour for the tea-testing competitions, for their colour showed up the least trace of the tea dust and their structure both kept the tea warm and made the bowls easy to handle. Temmoku bowls were also used for the Japanese tea ceremony. Ancient and modern Japanese imitations of "chien-yao" are thus extremely common and confusingly well done, especially those examples from the potteries at Seto.

In addition to the "chien-yao" from Fukien, there are a whole number of related kinds extremely difficult to localize; thus, from Yung-ho Chên, Province of Kiangsi, also stem bowls with temmoku glazing in a variety of tones. On the inside, dabs of a different colour to that of the glaze can be made out and are often interpreted as the forms of birds, flowers or leaves. Such bowls are very rare in European collections.

A much more common variety, this time from the north, is the so-called Honan temmoku. This stoneware is not quite so heavily built; the colours of its glaze are

not as intense as those of Fukien temmoku. The basic colour varies from beige to dark brown and rust. Free floral decoration is often sketchily suggested against this ground. In a more or less abstract form, this latter technique is met with again in modern pottery.

Also from the north is the temmoku variant which seems to be strewn with oil spots. This "oil spot" and the "gold dust" glaze reoccurs in the work of modern ceramists. A further type of Honan temmoku is characterized by ribs or ridges which cover the body of the vessel. Its attraction lies in the contrast between white and black, since the glaze, which is mainly in a lustrous dark brownish black, turns whitish along the vertical ribs.

Summary and Translation P.J.D.

1364 *China, Sung Dynasty (960–1279); bowl;* earthenware, chien-yao with brown-black "hare-fur" (temmoku) glaze; ⌀ 12.4 cm; Vienna, Österreichisches Mus. für angewandte Kunst, Inv.-No. 31844/Ke. 8629

1365 *China, Sung Dynasty (960–1279); bowl;* earthenware, brownish body with black iridescent glaze over green-brown engobe, partially running, towards the rim discoloured, lower part of wall and foot unglazed; ⌀ 12.5 cm; Stockholm, Östasiatiska Mus., Inv.-No. NM 122/1920

1366 *China, Sung Dynasty (960–1279); bowl;* chien-yao earthenware, silver band round rim; ⌀ 11.9 cm; Vienna, Österreichisches Mus. für angewandte Kunst, Inv.-No. 27061/Ke. 6808

1367 *China, Sung Dynasty (960–1279); tea bowl (chawan), chien yao;* dark earthenware with iridescent "hare-fur" glaze, silver band on rim; ⌀ 12.7 cm; Hamburg, Mus. für Kunst und Gewerbe, Inv.-No. 1905.30

1368 *Henry Hammond (Croydon, Surrey 1914); bowl;* earthenware; ⌀ 13.7 cm; sig. on base: HH stamp in square; 1959; Hamburg, Thiemann Coll.

1369 *Karl Hentschel (Dessau 1884–1959 Tittmoning, Upper Bavaria); bowl;* earthenware; ⌀ 17 cm; sig. on base: stamp; c. 1955; Deidesheim, Mus. für moderne Keramik

1370 *Albrecht Hohlt (Freiburg in Breisgau 1928–1960 Munich); bowl;* por-

celain; ⌀ 17.7 cm; sig. on base: Hohlt stamp; Munich, priv. owned

1371 *Albrecht Hohlt; shallow bowl;* earthenware; ⌀ 23 cm; sig. on base: Hohlt stamp; 1958; Hamburg, Thiemann Coll.

1372 *China, Sung Dynasty (960–1279); bowl;* earthenware with black glaze and ferruginous brown spots; ⌀ 12 cm; Copenhagen, Danish Mus. for Art and Crafts, Inv.-No. 40/1949

1373 *Karl Scheid (Lengfeld, Odenwald 1929, lives at Düdelsheim, Upper Hessia); deep bowl;* earthenware, light body, thrown, with glossy black temmoku glaze with rust-red painted decoration; h-8.5, ⌀ 9.5 cm; sig. on base: HH; 1965; Hinang, Wolf Coll., No. 129028

1374 *Karl Scheid; square beaker;* earthenware; h-11 cm; sig. on base: HH; 1966; Hinang, Wolf Coll., No. 277048

1375 *Margarete Schott (Berlin-Charlottenburg 1911, lives at Darmstadt);*

1390 Leach, Vase

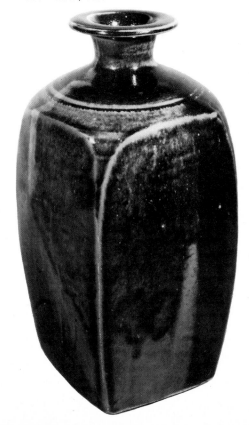

large bowl; fine earthenware, greyish white body with glossy black-brown temmoku glaze and encircling rust-red rings; ⌀ 21 cm; 1965; Hamburg, Thiemann Coll.

1376 *Fance Franck; shallow bowl;* earthenware, thrown, with rust-red and brown-black "gold-dust" glaze; ⌀ 21 cm; 1971; Paris, Marcel Altemeyer

1377 *China, Sung Dynasty (960–1279); pot;* earthenware with brown-black glaze and ferruginous brown spots; h-21.5 cm; northern Sung Period (960–1122); London, Victoria & Albert Mus., Inv.-No. C. 38-1965

1378 *China, Sung Dynasty (960–1279); spherical vase;* earthenware; h-21 cm; Copenhagen, Danish Mus. for Art and Crafts, Inv.-No. 89/1949

1379 *China, Sung Dynasty (960–1279); vase,* heart-shaped and short-necked; earthenware, honan type; h-18.5 cm; Zürich, Kunstgewerbemus., Inv.-No. 11027

1380 *Görge Hohlt (Munich 1930, lives at Katzbach, Upper Bavaria); pot;* earthenware, silvery and brown-mottled, glossy black temmoku glaze; h-18.2 cm; sig. on base: stamp of cat on wavy line (= Katzbach) and GH 69; 1969; Hamburg, Heuser Coll.

1381 *Andrew Walford (Bournemouth 1942, lives in S. Africa); vase in form of pot;* earthenware, matt-gloss, rust-brown reduction glaze with black slip and waxed relief; h-16 cm; sig. on wall; W; 1966; Hinang, Wolf Coll., No. 043004

1382 *Walter Popp (Bunzlau, Silesia, 1913); vase;* earthenware; h-38 cm; sig. on base: WP 62; 1962; Deidesheim, Mus. für moderne Keramik

1383 *Paul Barron (1917); bottle;* earthenware; h-22.3 cm; sig. on base: stamp; 1970; Hamburg, Thiemann Coll.

1384 *Karl Scheid (Lengfeld, Odenwald, 1929, lives at Düdelsheim, Upper Hessia); bottle;* earthenware; h-20.5 cm; sig. on base: HH; 1965; Hinang, Wolf Coll., No. 061012

1385 *China, Ch'ing Dynasty (1644–1912); vase;* porcelain with black "gold-dust" glaze; h-40.5 cm; 18th/19th cent.; Paris, Mus. Cernuschi, Inv.-No. 3482

1386 *China, Yuan Dynasty (1279–1368); vase;* earthenware, "honan ware";

East and
South-East
Asia

Ceramics
and Glass

1161–1587

h-19.4 cm; 13th/14th cent.; Vienna, Österreichisches Mus. für angewandte Kunst, Inv.-No. 30 765/Ke. 8218

1387 *China, Ch'ing Dynasty (1644–1912); vase;* porcelain with glossy black-brown glaze; h-45 cm; 18th/19th cent.; Paris, Mus. Cernuschi, Inv.-No. 3486

1388 *Auguste Delaherche (Beauvais 1857–1940 Armentières); vase;* earthenware; h-24.8 cm; sig. on base: Aug. Delaherche 2996; c. 1920; Hamburg, Heuser Coll.

1389 *Robert Wallace Martin (London 1873–1914); bottle vase;* stoneware; h-10.3 cm; sig. on base: 2-1909/Martin Bros/London and Southall; 1909; London, Victoria & Albert Mus., Inv.-No. C. 484-1919

1390 *Bernard Leach (Hongkong 1887, lives at St. Ives, Cornwall); quadrilateral bottle-vase;* earthenware; h-33 cm; 1963; Paris, Fance Franck Coll.; plate

1391 *Japan, late Tokugawa Period (1765–1868); long-necked bottle;* earthenware with brown glaze, yellow speckling in parts, white scriptoral decoration Ishii-chô and Sakuji-machi; h-27.5 cm; 19th cent.; Vienna, Österreichisches Mus. für angewandte Kunst, Inv.-No. 30 893/Ke. 8346

1392 *Bernard Leach; long-necked vase;* earthenware; h-40 cm; c. 1962; Zürich, Kunstgewerbemus., Inv.-No. 1964-46

1393 *China, Sung Dynasty (960–1279); jug;* earthenware, grey body, black-brown glaze with discoloured ribs and rim; h-23.2 cm; northern Sung Period (960–1126); Stockholm, Johannes Hellner Coll.; plate

1394 *Horst Kerstan (Frankfurt 1941); vase;* fine earthenware; h-16 cm; sig. on base: Kerstan 1968; Hamburg, Thiemann Coll.

1395 *Bernard Leach (Hongkong 1887, lives at St. Ives, Cornwall); onion-shaped vase;* earthenware; h-19 cm; 1963; Paris Mme Dominique Schulmann

1396 *Bernard Leach; vase;* earthenware; h-36 cm; c. 1959; London, Victoria & Albert Mus., Inv.-No. Circ. 129-1950; plate

1397 *Margarete Schott (Berlin-Charlottenburg 1911, lives at Darmstadt); bowl;* earthenware; ∅ 14 cm; sig. above foot ring: stamp; c. 1967; Deidesheim, Mus. für moderne Keramik; plate

1398 *Bernard Leach; large pot with lid;* earthenware; h-19.5 cm; 1963; Paris, priv. owned.

1399 *China, Sung Dynasty (960–1279); bowl;* earthenware, chien-yao, with black-brown temmoku glaze, partially lightly iridescent oil-spot effect, lower part of wall unglazed; ∅ 10.2 cm; Stockholm, Johannes Hellner Coll.

1400 *Jan Bontjes van Beek (Veile,*

Jütland 1899–1969 Berlin); high tubular vase; fine earthenware; h-66 cm; sig. on base: J. B. B.; 1962; Nuremberg, Gewerbemus. der Landesgewerbeanstalt Bayern, Inv.-No. St 10962

1401 *Jan Bontjes van Beek; bowl;* fine earthenware; ∅ 18.4 cm; sig. on base: JBvB; 1966; Hamburg, Thiemann Coll.

1402 *Barbara Stehr (Weetzen, near Hanover, 1936); plate;* earthenware; ∅ 31 cm; sig. on base: engraved sign; c. 1968; Deidesheim, Mus. für moderne Keramik

1403 *Heidi Kippenberg (Berlin 1941); deep bowl;* earthenware; ∅ 8.5 cm; sig. on base: HK; 1969; Deidesheim, Mus. für moderne Keramik

The Lavender-Coloured Glazes of the Sung Dynasty

Mariela D. Siepmann

The name of another famous Sung stoneware, the "chün-yao", is derived from its place of manufacture, Chün-chou in the Province of Honan. It has so far not been possible to establish exactly when this ware was first manufactured, but it is generally presumed that production began during the second quarter of the tenth century. "Chün-yao" was potted in a comparatively large area of Honan and appears in a whole series of forms which allow of exact definition.

The body of the Kuang-tung stoneware is harder than that from Yi-hsing which points to its having been fired at a higher temperature. The kilns at Kuang-tung go back to the T'ang dynasty (618–907). The characteristic colour of Kuang-tung stoneware is lavender blue which is sometimes streaked or mottled with green; occasionally we come across an opaque white on a brown ground or green threaded with black, blue and grey. A greater or less marked superficial similarity to the polychrome "chün-yao" of the north is more noticeable here than in the Yi-hsing ware. The glaze is generally opaque and does not possess the translucence characteristic of northern chün ware. Its surface often has a peculiar dull silken shimmer; only rarely do we find pieces with the same silky sheen as the products of Canton and Yi-hsing. Typical of Yi-hsing ware is the suppressed luster which combines the opalescent brilliance of the chün ware

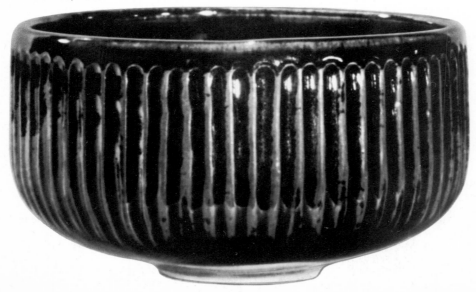

1397 Schott, Bowl

East and
South-East
Asia

Ceramics
and Glass

1161–1587

of the north with the silky sheen of the Canton glazes.

The great attraction of the "chün-yao" potted in the north is the wonderful shimmer effect of its lavender-blue copper glaze, which is one of the characteristics by which classical Sung ware can be recognized. The lavender blue of the glaze was enthusiastically designated by the Chinese "blue of the heavens"; modern collectors generally refer to it as "clair-de-lune". Particularly fine pieces can completely captivate the viewer with the splendour of its opalescent glaze, which can appear in a variety of tints ranging from an intense bluish violet to an irridiscent light blue. Occasionally protean changes produced by the firing cause the splashed or mottled effects of rich blue, red and violet. The harmonious interplay of colours in this "chün-yao" stoneware reaches its highest point where ancient gold lacquering vies with the wondrous nuances of this whole range of blue tones. Here one can appreciate why such pieces enjoy such favour among connoisseurs and collectors. One can also understand why it is that modern ceramists esteem these products of the Sung dynasty so highly.

Summary and Translation P. J. D.

1404 *China, Sung Dynasty (960–1279); bowl;* porcelain, ying-ch'ing-yao, with pale blue glaze; ∅ 18.2 cm; Vienna, Österreichisches Mus. für angewandte Kunst, Inv.-No. 27 062/Ke. 6809

1405 *China, Sung Dynasty (960–1279); bowl, ch'ing-pai, in form of lotus blossom;* porcelain with pale blue glaze; ∅ 17.5 cm; Stockholm, Johannes Hellner Coll.

1406 *Görge Hohlt (Munich 1930); bowl;* earthenware; ∅ 17.7 cm; sig. on foot ring: cat on wavy line, GH 71; 1971; Hamburg, Thiemann Coll.

1407 *Christine Atmer de Reig (Hamburg 1935, atelier at Hubbelrath, near Düsseldorf); bowl;* soft porcelain (1280°–1300° C); ∅ 11.5 cm; sig. on base: engraving sign; 1970; Hamburg, Thiemann Coll.

1408 *China, Sung Dynasty (960–1279); small bowl;* earthenware, kiun ware; ∅ 10.5 cm; 10th/13th cent.; Paris, Mus. Guimet, Inv.-No. Ma 721

1409 *China, Sung Dynasty (960–1279); shallow bowl;* porcelain, kiun ware, Japanese gold lacquer; ∅ 18 cm; southern Sung Period (1122–1279); Paris, Mus. Cernuschi, Inv.-No. 8353

1410 *China, Sung Dynasty (960–1279); bowl;* earthenware, chün-yao; ∅ 18.5 cm; London, Victoria & Albert Mus., Inv.-No. 46-1883

1412 *China, Yüan Dynasty (1280–1368); bowl;* earthenware, chün-yao; ∅ 20.3 cm; Stockholm, Östasiatiska Mus., Inv.-No. ÖM 6/66

1413 *China, Sung Dynasty (960–1279); bowl;* earthenware, chün-yao; ∅ 15.5 cm; late Sung Period, 13th cent.; Zürich, Kunstgewerbemus., Inv.-No. 10901

1414 *Horst Kerstan (Frankfurt 1941); bowl;* fine earthenware; ∅ 15.7 cm; sig. on base: Kerstan 1967; stamp KK (= Kerstan Kandern) in circle; 1967; Hamburg, Thiemann Coll.

The Monochrome Glazes of the Ch'ing Dynasty (1644–1912) and Their Influence on Ceramic Art of the Nineteenth and Twentieth Centuries

Mariela D. Siepmann

At the beginning of the Ch'ing Dynasty, epoch-making discoveries were made with regard to glazing techniques. Until then, the Chinese had mastered to perfection the art of underglaze painting in cobalt blue or copper red. Now they directed their attentions to the production of monochrome glazes. One can without exaggeration speak of a new era in the history of Chinese pottery and porcelain, even if, from this time on, too, recourse was often had to old forms, styles and colours.

The great technical problem which the Chinese potter had to solve before he could produce monochrome glazes was how to master the reduction as opposed to the oxidation process. In the reduction process metallic colours are converted almost without exception into their complementaries. Thus, for example, whereas copper oxide is green, reduced or deoxidized copper is red, whereas titanic oxide is yellow, after reduction titanium is an intense blue.

Here we see how artistic conceptions

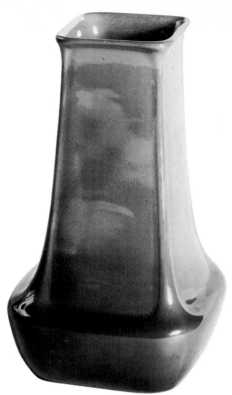

1425 England, Vase

have to go hand in hand with technical perfection. The mastery of the reduction process, which has been attained by a number of modern ceramists, must be numbered among the exceptional achievements of contemporary ceramic art.

Ox-blood or sang-de-bœuf glaze
Most important among the monochrome glazes of the Ch'ing dynasty is the K'ang Hsi glaze known as sang de bœuf. This glaze which was first attained (perfected) around the year 1700 is one fired at a very high temperature. It is a glaze obtained from copper oxide which flows during firing and is known by the Chinese as "lang-yao". The especial characteristic of the finished glazed vessel is a deep, variegated red colour threaded by a fine crackle. The mouth rim is generally white, though it can occasionally, but only seldom, be of a pale green colouring. The glaze of the base can be white or green, occasionally leather-coloured. Characteristic of classical pieces of the K'ang Hsi period is the purity of the red tone; admixtures, say of grey of blue, are regarded as undesirable attendant phenomena.
Another achievement of the K'ang Hsi potters is the glaze known as "peach bloom", a fairly rare variety of the ox-

205

East and
South-East
Asia

Ceramics
and Glass

1161–1587

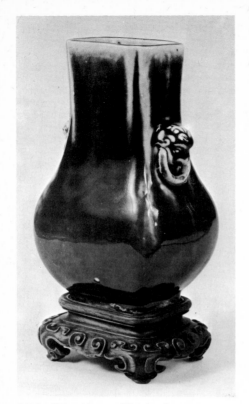

1420 China, Vase on Wooden Base

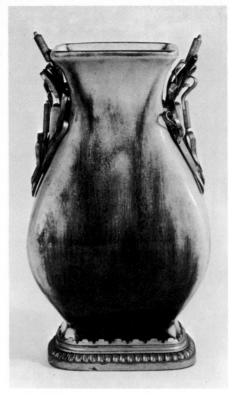

1421 Chaplet, Vase

blood class of glazes. It ranges from a pale brownish red to the red of ripe apples, and is at times flecked with green. Its particular characteristic is a gentle, soft shimmer.

The artist potters of the second half of the nineteenth century started their glazing experiments with the monochrome glazes of eighteenth century China, particularly those under the Emperor Ch'ien Lung, in view. However, ceramists of this and the last century have been stimulated not just by the sang-de-bœuf but also by the "peach-bloom" glazes. These demand complete mastery of firing techniques. Art nouveau ceramists turned their attentions to these glazes, it is true, but the concern of modern ceramists with them has been every bit as intense.

Summary and Translation P. J. D.

1415 *W. Staite Murray (London 1881); bowl;* earthenware; ⌀ 13.8 cm; sig. on base: stamp M, D 5; pre 1924; London, Victoria & Albert Mus., Inv.-No. C 1455-1924

1416 *Jan Bontjes van Beek (Vejle, Jütland 1899–1969 Berlin); bowl;* fine

earthenware; ⌀ 15.3 cm; 1964; Hamburg, Thiemann Coll.

1417 *China, Ch'ing Dynasty (1644–1912); vase;* porcelain with flamed reddish violet glaze, rims very discoloured; h-29.5 cm; Nien hao "Ta Ts-ing Ch'ien-lung"; Paris, Mus. Cernuschi, Inv.-No. 2615

1418 *Ernest Chaplet (Paris 1838–1909 Choisy-le-Roi); vase;* porcelain with flamed reddish violet glaze; h-31 cm; sig. on base: rosary as stamp; pre 1911; Paris, Mus. des Arts Décoratifs, Inv.-No. 18218

1419 *Ernest Chaplet; vase;* porcelain; h-25.5 cm; sig. on base: rosary as stamp; pre 1910; Paris, Mus. des Arts Décoratifs, Inv.-No. 167970; plate

1420 *China, Ch'ing Dynasty (1644–1912); vase on wooden base;* porcelain with "ox blood" glaze; h-18.4 cm; K'ang Hsi reign (1662–1722); Vienna, Österreichisches Mus. für angewandte Kunst, Inv.-No. 17461/Or. 651; plate

1421 *Ernest Chaplet; vase on metal pedestal;* porcelain; h-17 cm; Paris, Alain Lesieutre; plate

1422 *China, Ch'ing Dynasty (1644–1912); quadrilateral vase;* porcelain; h-31.5 cm; K'ang Hasi reign (1662–1722); Vienna, Österreichisches Mus. für angewandte Kunst, Inv.-No. 447//r. 637

1423 *Ernest Chaplet; quadrilateral vase;* porcelain; h-31 cm; sig. on base: rosary as stamp; c. 1890; Hamburg, Heuser Coll.

1424 *Ernest Chaplet; quadrilateral vase;* porcelain; h-40 cm; sig. on base: rosary as stamp A 1 1890; two large firing cracks in base, inside; Hamburg, Heuser Coll.

1425 *England; manufacture: Royal Doulton, Burslem; quadrilateral vase;* earthenware; h-18 cm; sig. on base: stamp England and 2853; 1905–1913; London, Victoria & Albert Mus., Inv.-No. Circ. 187-1958; plate

1426 *China, Ch'ing Dynasty (1644–1912); tall vase;* porcelain with sang-de-bœuf glaze; h-39.1 cm; K'ang Hsi reign (1662–1772); Berlin, Mus. für Ostasiatische Kunst, Inv.-No. 1962-9

1427 *Germany; manufacture: Königl. Porzellanmanufaktur Berlin; vase with red flamed glaze;* porcelain; h-25.6 cm; sig. on base: sceptre (very indistinct) 6469 (?); Darmstadt, Hessisches Landesmus., Inv.-No. Kg. 65:11

1428 *Ernest Chaplet; vase;* porcelain; h-58 cm; sig. on base: rosary as stamp with enclosed E 1889; Paris, Mus. des Arts Décoratifs, Inv.-No. 5695; plate

1429 *China, Ch'ing Dynasty (1644–1912); vase;* porcelain with red flambé glaze, inner neck grey-white; h-44 cm; 18th/19th cent.; Paris, Mus. Cernuschi, Inv.-No. 3484

1430 *England; manufacture: Royal Doulton, Burslem; small vase;* earthenware; h-14.2 cm; c. 1905; Zürich, Kunstgewerbemus., Inv.-No. 6667

1431 *England; manufacture: Royal Doulton, Burslem; vase;* earthenware; h-21.8 cm; c. 1907; Zürich, Kunstgewerbemus., Inv.-No. 6956

1432 *England; manufacture: Royal Doulton, Burslem; vase;* earthenware; h-12.6 cm; c. 1905; Zürich, Kunstgewerbemus., Inv.-No. 6662

1433 *China, Ch'ing Dynasty (1644–1912); shallow bowl;* porcelain with

rouge-de-cuivre glaze; ⌀ 18 cm; Ch'ien-lung Period (1736–1795); Paris, Mus. Guimet, Inv.-No. G 128

1434 *Görge Hohlt (Munich 1930, lives at Katzbach, Upper Bavaria); bowl;* fine earthenware; ⌀ 18.5 cm; sig. on base: stamp–cat on wavy line (= Katzbach) and two five-pointed stars; 1965; Hamburg, Thiemann Coll.

1435 *Görge Hohlt; bowl;* porcelain; ⌀ 14.8 cm; sig. on base: stamp–cat over wavy line (= Katzbach) and GH; 1967; Hamburg, Thiemann Coll.

1436 *England; manufacture: Royal Doulton, Burslem; shallow bowl;* earthenware; ⌀ 10.3 cm; c. 1907; Zürich, Kunstgewerbemus., Inv.-No. 1961

1437 *China, Ch'ing Dynasty (1644–1912); vase on wooden base;* porcelain with blue, red and violet flambé glaze; h-46.4 cm; sig. on base: mark of Ch'ien-lung Period (1736–1795); Vienna, Österreichisches Mus. für angewandte Kunst, Inv.-No. 30 620/Ke. 8075

1438 *China, Ch'ing Dynasty (1644–1912); vase;* porcelain; h-32.8 cm;

1428
Chaplet,
Vase

Ch'ien-lung Period (1736–1795); Vienna, Österreichisches Mus. für angewandte Kunst, Inv.-No. 9617/Ke. 1544 a

1439 *China, Ch'ing Dynasty (1644–1912); long-necked vase;* porcelain; h-34.5 cm; 18th/19th cent.; Paris, Mus. Cernuschi, Inv.-No. 3370

1440 *China, Ch'ing Dynasty (1644–1912); vase;* porcelain; h-35.5 cm; Ch'ien-lung Period (1736–1795); London, Victoria & Albert Mus., Inv.-No. 6838-1860

1441 *China, Ch'ing Dynasty (1644–1912); vase;* porcelain with red flambé glaze; h-44 cm; second half of 18th cent.; Ch'ien-lung Period (1732–1795); London, Victoria & Albert Mus., Inv.-No. C 1292-1917

1442 *China, Ch'ing Dynasty (1644–1912); vase;* porcelain; h-32.5 cm; Yung-Cheng Period (1723–1735); Nuremberg, Gewerbemus. der Landesgewerbeanstalt Bayern, Inv.-No. 6065

1443 *China, Ch'ing Dynasty (1644–1912); baluster vase;* porcelain; h-33.5 cm; 18th/19th cent.; Paris, Mus. Cernuschi, Inv.-No. 2613

1444 *Albrecht Hohlt (Freiburg in Breisgau 1928–1960 Munich); vase in bottle-form;* fine earthenware; h-69.7 cm; sig. on base: Hohlt stamp; c. 1958; Nuremberg, Gewerbemus. der Landesgewerbeanstalt Bayern, Inv.-No. St. 10929

1445 *Germany: manufacture: Königl. Porzellanmanufaktur Berlin; vase;* porcelain with overflow glaze in blue-red, violet, green and grey, large red irregular stripes; h-26 cm; sig. on base: sceptre, SgrP, 17653 and M; c. 1902; Berlin, Staatliche Museen Preußischer Kulturbesitz, Kunstgewerbemus., Inv.-No. 64,1

1446 *Germany; Hermann Seger (?); manufacture: Königl. Porzellanmanufaktur Berlin; narrow-necked vase;* porcelain with reddish violet overflow glaze; h-17 cm; sig. on base: sceptre, SgrP, 6077 11 M 11, 1904 (?); model Mai 1899; glaze 1904; Berlin, Staatliche Museen Preußischer Kulturbesitz, Kunstgewerbemus., Inv.-No. 64,3; plate

1447 *England; manufacture: Ruskin Pottery; vase;* earthenware; h-36.5 cm; sig. on base: stamp P; 1903–04; London, Victoria & Albert Mus., Inv.-No. 855/1904

1448 *Bernhard Moore; vase;* porcelain; h-27 cm; sig. and inscribed on base: W. B. from B. M., Amicus amico; c. 1906; London, Victoria & Albert Mus., Inv.-No. Circ. 305-1953

1449 *Hermann Seger; manufacture: Königl. Porzellanmanufaktur Berlin; vase;* porcelain; h-31.6 cm; sig. on base: sceptre, SgrP; c. 1888; Nuremberg, Gewerbemus. der Landesgewerbeanstalt Bayern, Inv.-No. 7241; plate

1450 *Albrecht Hohlt; vase;* porcelain; h-24 cm; sig. on base: Hohlt stamp; Munich, priv. owned.

1451 *Gusso Reuss (Göggingen, near Augsburg, 1885–1962 Fürstenfeldbruck); vase;* earthenware; h-16 cm; sig. on base: Reuss stamp; c. 1950; Karlsruhe, Badisches Landesmus., Inv.-No. 18/97

1452 *Albrecht Hohlt; vase;* porcelain; h - 15.5 cm; sig. on base: Hohlt stamp; Munich, priv. owned

1453 *Gusso Reuss; vase;* fine earthenware; h - 27.7 cm; sig. on foot ring: Reuss stamp; 1954; Hamburg, Thiemann Coll.

1455 China, Vase

East and
South-East
Asia

Ceramics
and Glass

1161–1587

1454 *Albrecht Hohlt; vase; porcelain;*
h - 28.7 cm; sig. on base: Hohlt stamp;
Munich, priv. owned

1455 *China, Ch'ing Dynasty (1644–*
1912); vase, Mei p'ing type; porcelain;
h - 22 cm; K'ang Hsi reign (1662–1722);
Vienna, Österreichisches Mus. für ange-
wandte Kunst, Inv.-No. 17,446/Or. 636;
plate

1456 *China, Ch'ing Dynasty (1644–*
1912); vase; porcelain; h - 19.4 cm;
Ch'ien-lung Period (1636–1795);
Vienna, Österreichisches Mus. für ange-
wandte Kunst; Inv.-No. 17488/r. 638

1457 *China, Ch'ing Dynasty (1644–*
1912); vase; porcelain with too strongly
fired (discoloured) rouge-de-cuivre
glaze; h - 21.5 cm; end of 18th cent.;
Paris, Mus. Guimet, Inv.-No. G 4699

1458 *Gusso Reuss; vase;* earthenware;
h - 13 cm; sig. on stand ring: Reuss;
c. 1937; Hinang, Wolf Coll., No. 180002

1459 *Jan Bontjes van Beek (Vejle,*
Jütland 1899–1969 Berlin); bottle vase;
fine earthenware; h - 25.3 cm; sig. on
base: monogram JBvB; 1965; Hamburg,
Thiemann Coll.

1446 Berlin, Narrow-Necked Vase

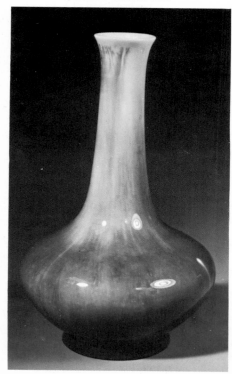

The Blue Glazes

Mariela D. Siepmann

The Ch'ing dynasty (1644–1912) pro-
duced an unbelievable wealth of glazes
in every possible colour the nuances of
which are almost indescribable – one
must experience them oneself to appre-
ciate this. Among the glazes fired at high
temperatures are also to be numbered
cobalt blue and manganese violet with
all their various nuances.
The cobalt blue, which had been used
since the Yüan period (1279–1367) for
underglaze decoration, had long been
imported from Persia on account of the
better quality produced there. It was this
material which laid the basis for the
splendid achievements of succeeding
centuries. The monochrome glazes pro-
duced during the reigns of K'ang Hsi
(1662–1722), Yung Chêng (1722–35)
and Ch'ien Lung (1735–1795) may
justifiably be counted among the excep-
tional achievements of this period. They
have been imitated innumerable times in
later years. The technique and colour is
taken over directly from the Ming period
(1368–1644), but through the refinement
of the forms, the complete mastery of the
technique of flux glazing, and the inten-
sity of the colours the Ch'ing potters
plumb undreamt-of depths and attain a
rich range of tones and tints never achie-
ved before (cf. Cat. no. 1461). The man-
ganese violet reminds one of the velvet
softness of the amethyst, whereas the
cobalt blue shimmers in its purity and
deep opalescence like a saphire (cf. Cat.
no. 1461).
Later Chinese potters tried to mix green
with the blue of this classical glaze in
order to attain more striking colour
harmonies. Vases of this glaze, some-
times with additional admixture of black,
have had a considerable influence on
ceramists of the nineteenth century.
Modern artist potters have also been
stimulated by these cloudy blue glazes,
which augur already the later style of
Chinese ceramic art.

Summary and Translation P. J. D.

1460 *China, Ch'ing Dynasty (1644–*
1912); vase in form of bottle; porcelain
with blue glaze (bleu de manganèse);
h - 17.5 cm; K'ang Hsi reign (1662–
1722); Paris, Mus. Guimet, Inv.-No.
G 402

1461 *China, Ch'ing Dynasty (1644–*
1912); tear-shaped vase; porcelain with

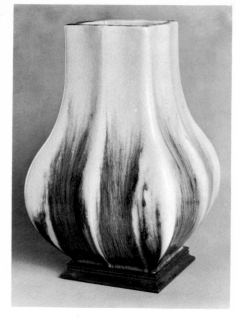

1419 Chaplet, Vase

cobalt blue glaze, inside white; h - 35 cm;
18th cent.; Paris, Mus. Guimet, Inv.-No.
G 3426

1462 *China, Ch'ing Dynasty (1644–*
1912); vase in form of a long-necked
bottle; porcelain with lemon-yellow
glaze; h - 34 cm; 18th cent.; Vienna,
Österreichisches Mus. für angewandte
Kunst, Inv.-No. 32234/Ke. 8848

1463 *Hermann Seger (Posen 1839–*
1893 Berlin); vase; red and violet;
h - 20 cm; sig. on base: sceptre with
SgrP; Munich, Paul Tauchner Coll.

1464 *F. Ludwigsen (Denmark); manu-*
facture: Royal Porcelain Factory, Copen-
hagen; vase on ebony stand; porcelain;
grey and cobalt-blue glaze with dark
spots and light flow-lines; h - 14.5 cm;
pre 1915; Zürich, Kunstgewerbemus.,
Inv.-No. 7570

1465 *China, Ch'ing Dynasty (1644–*
1912); vase; porcelain; h - 31.5 cm;
18th/19th cent.; Paris, Mus. Cernuschi,
Inv.-No. 3490

1466 *China, Ch'ing Dynasty (1644–*
1912); vase; earthenware; h - 29 cm;
sig. on base: Ko Ming-siang; 18th/19th
cent.; Paris, Mus. Cernuschi, Inv.-No.
1878

1467 *China, Ch'ing Dynasty (1644–*
1912); jug; earthenware; h - 15.5 cm;

18th/19th cent.; Paris, Mus. Cernuschi, Inv.-No. 2790

1468 *China, Ch'ing Dynasty (1644–1912); vase* porcelain with speckled blue-green glaze with blackish inclusions and aubergine-coloured stripes; h - 31 cm; 18th/19th cent.; Paris, Mus. Cernuschi, Inv.-No. 3279

1469 *E. Jacob & Cie.; vase;* earthenware; h - 15 cm; sig. on base: factory mark EGB, monogram JP; pre 1892; Paris, Mus. des Arts Décoratifs; Inv.-No. 7331

1470 *England; vase;* earthenware; h - 25 cm; unsigned; c. 1900; London, Victoria & Albert Mus., Inv.-No. 236-1902

1471 *Robert Wallace Martin (London 1873–1914); ribbed vase;* earthenware; h - 27 cm; sig. on base: Martin Broth, London Southall 9-1909; 1909; Munich, priv. owned

1472 *Albrecht Hohlt (Freiburg in Breisgau 1928–1960 Munich); vase;* fine earthenware; h - 26.5 cm; sig. on base: Hohlt stamp; Munich, priv. owned

1473 *Johann Julius Scharvogel (1854 1938); vase;* earthenware with overflow glaze in various tones of blue; h - 26 cm; sig. on base: stamp and monogram SKM; 1905; Nuremberg, Gewerbemus. der Landesgewerbeanstalt Bayern, Inv.-No. St. 8893

1474 *Hermann Seger; manufacture: Königl. Porzellanmanufactur Berlin; vase with overflow glaze;* porcelain; h - 32 cm; sig. on base: sceptre with monogram SgrP and 15 M (letter for year 1912); 1912; Karlsruhe, Badisches Landesmus., Inv.-No. 70/49

1475 *China, Ch'ing Dynasty (1644–1912); vase;* porcelain with blue speckled glaze; h - 26.7 cm; 18th cent.; Vienna, Österreichisches Mus. für angewandte Kunst, Inv.-No. 30789/Ke. 8242

1476 *Albrecht Hohlt; floor vase;* fine earthenware; h - 43 cm; sig. on base: Hohlt stamp; 1959; Zürich, Kunstgewerbemus., Inv.-No. 1964-55 (from the estate, No. 288)

1477 *Albrecht Hohlt; vase;* porcelain; h-26.5 cm; sig. on base: Hohlt stamp; Munich, priv. owned

1478 *China, Ming Dynasty (1368–1644); bowl;* porcelain with cobalt-blue

sharp-fire glaze; ⌀ 19 cm; sig. on base: Hsüan-tê mark (1426–1435); Vienna, Österreichisches Mus. für angewandte Kunst, Inv.-No. 30694/Ke. 8147

1479 *China, Ch'ing Dynasty (1644–1912); bowl;* porcelain with powder blue glaze on engraved decoration in white outline; imitation of a Ming piece; ⌀ 18 cm; 18th cent.; Paris, Mus. Guimet, Inv.-No. G 718

1480 *Francine Del Pierre (Paris 1913–1968); bowl;* fine earthenware; ⌀ 23.5 cm; 1962; Paris, Fina Gomez Coll.

1481 *Christine Atmer de Reig (Hamburg 1935); bowl;* soft porcelain; ⌀ 14.4 cm; sig. on base: monogram CA and 69; 1969; Hamburg, Thiemann Coll.

1482 *Gertrud and Otto Natzler; bowl;* earthenware with blue to dark-blue glaze; ⌀ 19.5 cm; signed; c. 1951; Zürich, Kunstgewerbemus., Inv.-No. 1962-107

1483 *Görge Hohlt (Munich 1930, lives at Katzbach, Upper Bavaria); bowl;* earthenware; ⌀ 16.5 cm; sig. on base: stamp of cat on wavy line (= Katzbach), GH; 1968; Hamburg, Thiemann Coll.

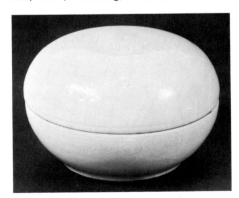

1486 China, Round Box with Lid

1489 Austria, Round Box with Lid

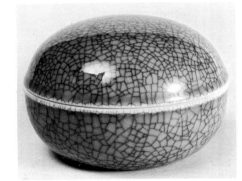

1484 *Albrecht Hohlt; bowl;* earthenware; ⌀ 14 cm; sig. on base: Hohlt stamp; 1957; Hamburg, Thiemann Coll.

1485 *Albrecht Hohlt; bowl;* porcelain with blue-violet glaze and discoloured rim; ⌀ 10.8 cm; sig. on base: Hohlt stamp; Munich, priv. owned

Chinese and European Covered Receptacles

1486 *China, Ch'ing Dynasty (1644–1912); small, round box with lid on wooden base;* porcelain with white-grey crackled glaze and engraved decoration of lotus plants and spirals; ⌀ 6.2 cm; 18th cent.; Vienna, Österreichisches Mus. für angewandte Kunst, Inv.-No. 17 538/Or. 728; plate

1487 *Liebfriede Bernstiel (Hamburg 1915); box;* fine earthenware, yellowish white body with white dull glaze with rose-coloured film; spherical; ⌀ 12.2 cm; sig. on base: LB; 1966; Hamburg, Thiemann Coll.

1488 *Austria; manufacture: Porzellan-Manufactur Augarten, Vienna; round box with lid;* porcelain with celadon glaze, near rim two narrow gold lines; ⌀ 6.8 cm; early 20th cent.; Vienna, Österreichisches Mus. für angewandte Kunst, Inv.-No. 28 694/Ke. 7494

1489 *Austria; manufacture: Porzellan-Manufaktur Augarten, Vienna; round box with lid;* pottery, celadon glaze with grey crackling; spherical shape; ⌀ 11.2 cm; Vienna, Österreichisches Mus. für angewandte Kunst, Inv.-No. 28692/Ke. 7492; plate

1490 *Algot Erikson (born in Stockholm 1868); manufacture: Rörstrands Aktiebolaget, Porslinsfabriker Stockholm; round box with lid;* porcelain with tulips in underglaze painting on ground of mignonette; ⌀ 13 cm; sig. on base: factory mark and monogram A. E.; Berlin, Bröhan Coll.

1491 *Annam; box with lid;* porcelain with painting in underglaze blue, ornamentation in tendrils of chrysanthemum flowers; spherical; ⌀ 7.1 cm; 15th/16th cent.; Vienna, Österreichisches Mus. für angewandte Kunst, Inv.-No. 31 407/Ke. 8545

1492 *Bernard Leach (Hongkong 1887, lives at St. Ives, Cornwall); box with lid;* porcelain, thrown, white glaze,

East and
South-East
Asia

Ceramics
and Glass

1161–1587

painted in cobalt-blue and red glaze;
⌀ 9 cm; 1963; Paris, Dr. Daniel Ginestet

1493 *Japan; box (hako); dark, olive-brown patinated shibuichi (copper alloy);* peonies and phoenixes in hammered silver-thread inlay; ⌀ 8.2 cm; Vienna, Mus. für Völkerkunde, Inv.-No. 124 223

1494 *Ursula Scheid (Freiburg in Breisgau 1932, lives at Düdelsheim, Upper Hessia); small box;* porcelain with dull white glaze and rose-coloured film, brownish rims, cylindrical container with convex lid; ⌀ 6.8 cm; sig. on base: stamp UD (= Ursula Duntze) with inscribed Scheid 69; 1969; Hamburg, Thiemann Coll.

1495 *China, Sung Dynasty (960–1279); shallow, round box with lid;* porcelain with creamy-white glaze (ting-yao); ⌀ 11 cm; Vienna, Österreichisches Mus. für angewandte Kunst, Inv.-No. 30 732/Ke. 8185

1496 *Ursula Scheid; box with lid;* porcelain, thrown, dull grey reduction glaze with dark-grey crystalline deposits, container with opaque greenish-grey glaze; sig. on base: US; 1969; Hinang, Wolf Coll., No. 558 153

Special Forms

1497 *Korea, Yi Dynasty (1392–1910); pot with lid;* earthenware with speckled glaze in brown and yellow; h - (with lid) 25.2 cm; 19th cent.; Vienna, Österreichisches Mus. für angewandte Kunst, Inv.-No. 17994/Or. 1184; plate

1498 *Korea, Yi Dynasty (1392–1910); pot with lid;* porcelain with engraved decoration under yellow-brown glaze; h - 24 cm; 17th/18th cent.; London, Victoria & Albert Mus., Inv.-No. C 46-1942

1499 *Bernard Leach (Hongkong 1887, lives at St. Ives, Cornwall); pot with lid;* earthenware, ocher-coloured body with porous, matt gloss, black glaze; h - 25 cm; 1963; London, Victoria & Albert Mus., Inv.-No. Circ. 551 +a–1963

1500 *Japan, Meiji Period (1868–1912); basket;* asymmetrical wickerwork; h - 11 cm; 19th cent.; Vienna, Österreichisches Mus. für angewandte Kunst, Inv.-No. 19099/Or. 2289

1501 *Ursula Scheid (Freiburg in Breisgau 1932, lives at Düdelsheim, Upper*

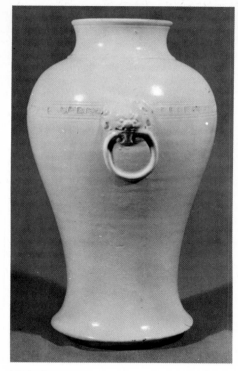

1512 England, Vase

Hessia); vase; porcelain, thrown, with silken matt, olive-grey reduction glaze; h - 7.5 cm; sig. on base: US; 1967; Hinang, Wolf Coll., No. 413095

1502 *China, Ch'ing Dynasty (1644–1912); vase;* earthenware, kuang-tung, with speckled glaze in brown, dark blue and white; h - 18.5 cm; 18th cent.; Vienna, Österreichisches Mus. für angewandte Kunst, Inv.-No. 32228/Ke. 8842

1503 *China, Ch'ing Dynasty (1644–1912); vase;* porcelain with light-green celadon glaze; h - 28 cm; sig. on base: T'ung Chih reign (1862–1874); Vienna, Österreichisches Mus. für angewandte Kunst, Inv.-No. 17623/Or. 813

1504 *Fance Franck; vase;* earthenware, thrown in sections, with brown-black glaze; h - 23 cm; 1968; Paris, owned by the artist herself

1505 *China, Ch'ing Dynasty (1644–1912); bowl;* porcelain with cobalt-blue sharp-fired glaze; high, tapering foot and calix-curved wall; h - 11.5 cm; nien hao Chia-ching; Stockholm, Östasiatiska Mus., Inv.-No. ÖM 266/64

1506 *Christine Atmer de Reig (Hamburg 1935); bowl with foot;* soft porce-

lain (1280°–1300°C) with purple-red, sprayed glaze; h - 12.4 cm; 1970; Hamburg, Thiemann Coll.

1507 *Fance Franck; Manufacture National de Sèvres; bowl with foot;* porcelain with ox-blood (rouge-de-cuivre) glaze h-22.5 cm; 1972; Paris, owned by the artist herself

1508 *Japan, late Tokugawa Period (1765–1868); rice-wine bottle in form of a book;* earthenware, type Kokiyo-midzu, brown body with thin, sand-foloured glaze, fine crackling; h - 15.9 cm; 18th/19th cent.; Karlsruhe, Badisches Landesmus., Inv.-No.A10089

1509 *Konrad Quillmann (Berlin 1936); vase;* earthenware with golden brown glaze, white markings, blue and brown splashed colour and fine crackling; h - 22.6 cm; sig. on base: Q; 1964; Hamburg, Thiemann Coll.

1510 *Dieter Crumbiegel (Essen 1938, lives at Fulda); vase;* earthenware, fire-clay body, free composition and mounting, matt, stony ash glaze in rust-red brown and blue-black; h - 21 cm; sig. on base: DK; 1969; Hinang, Wolf Coll., No. 577004

1511 *China, Ch'ing Dynasty (1644–1912); vase;* earthenware with creamy white glaze; h - 31.5 cm; inscribed: Ho ho wan yu (precious plaything of the gods of harmony); Nien-hao of the Ch'ien-lung reign (1736–1795); London, Victoria & Albert Mus., Inv.-No. C 49–1962

1512 *England; manufacture: Minto & Co., Stoke-upon-Trent; vase;* porcelain with greyish white, finely crackled glaze; h - 37.2 cm; sig. on stand ring: Minto stamp; 19th cent.; London, Victoria & Albert Mus., Inv.-No. 8106–1863; plate

1513 *China, Ch'ing Dynasty (1644–1912); sumi water container;* porcelain with peach-bloom glaze; rim with metal edging, metal stopper; sig. on base: K'ang Hsi reign mark; 16th/17th cent.; Paris, Mus. Guimet, Inv.-No. G 2999

1514 *Jan Bontjes van Beek (Vejle, Jütland 1899–1969 Berlin); vase;* fine earthenware, yellowish-white body with brown mottled glaze; in form of sumi water container; h - 11.5 cm; sig. on base: JBvB; 1962; Hamburg, Thiemann Coll.

Japanese Tea Ceramics

1515 *Japan, Tokugawa Period (1603–1868); container for pulverized tea (chaire) with ivory lid;* earthenware; h - (without lid) 8.1 cm; 18th cent.; Vienna, Österreichisches Mus. für angewandte Kunst, Inv.-No. 36917/Ke. 9424

1516 *Japan, Edo Period (1615–1868); container for pulverized tea (chaire) Bizen-yaki;* ceramic, type irikata; h - 7.5 cm; Berlin, Mus. für Ostasiatische Kunst, Inv.-No. 1262

1517 *Mario Mascarin (Venice 1901– 1966 Muttenz, near Basel, Switzerland); container;* fine earthenware; h - 13.8 cm; sig. on the base: stamp M in oval; c. 1960; Hamburg, Thiemann Coll.

1518 *Mario Mascarin; box with lid;* earthenware; h - 12 cm; 1960; Zürich, Kunstgewerbemus., Inv.-No. 1961–37

1519 *Elisabeth Köhnke-Nebe (Plauen in Vogtland 1938); container with wooden lid;* earthenware; h - 12.5 cm; sig. on base: engraved marking; 1963; Deidesheim, Mus. für moderne Keramik

1520 *Charlotte Epton; box with lid;* earthenware; h - 18 cm; sig. on base: stamp EP and workshop mark S. I.; c. 1930; London, Victoria & Albert Mus., Inv.-No. Circ. 766+A–1931

1521 *Heinz H. Engler (Biberach 1928); tea caddy;* earthenware; h - 12 cm; sig. on base: stamp; 1954; Hinang, Wolf Coll., No. 111004

1522 *Japan, Tokugawa Period (1603– 1868); container for pulverized tea (chaire) with ivory lid;* earthenware with blackish brown glaze; h - (without lid) 9.3 cm; 18th cent.; Vienna, Österreichisches Mus. für angewandte Kunst, Inv.-No. 36921/Ke. 9428; coloured plate

1523 *Georges Hoentschel; box with lid;* earthenware; h - 14.5 cm; sig. on base: GH; Paris, Alain Lesieutre; coloured plate

1524 *Paul Jeanneney (Strassburg 1861–1920 St-Amend-en-Puysage); vase;* earthenware; h - 9 cm; sig. on base: Jeanneney; pre 1900; Paris, Mus. des Arts Décoratifs, Inv.-No. 22293

1525 *Japan, Tokugawa Period (1603– 1912); container for pulverized tea (chaire) with ivory lid, Seto type;*

earthenware with crackled overflow glaze in olive-green, blue and white; h - 15 cm; unsigned; 18th cent.; Hamburg, Mus. für Kunst und Gewerbe, Inv.-No. 1897.290

1526 *Japan Edo Period (1614-1868); container for pulverized tea (chaire) with ivory lid;* ceramic; h -10.3 cm; prob. 17th cent.; Province of Tamba; Berlin, Mus.für Ostasiatische Kunst, Inv. No. 6148; plate

1527 *Japan, Tokugawa Period (1603– 1868); container for pulverized tea (chaire) with ivory lid;* earthenware, seto-yaki; h - (without lid) 9.1 cm; 17th/18th cent.; Vienna, Österreichisches Mus. für angewandte Kunst, Inv.-No. 36919/Ke. 9426; plate

1528 *Georges Hoentschel (Paris 1855– 1915); vase;* earthenware; h - 12.5 cm; sig. on base: GH and marking; c. 1895– 1900; Hamburg, Heuser Coll.

1529 *Georges Hoentschel; vase;* earthenware; h - 11 cm; sig. on base: GH and G für Emile Grittel; pre 1902; Paris, Mus. des Arts Décoratifs, Inv.-No. 10191

1530 *Georges Hoentschel; vase;* earthenware; h - 25 cm; sig. on base:

Gh; c. 1900; Munich, Paul Tauchner Coll.

1531 *Georges Hoentschel; vase;* earthenware; h - 14 cm; sig. on base: GH and 4; Paris, Mus. des Arts Décoratifs, no Inv.-No.

1532 *Japan; container for pulverized tea (chaire) with ivory lid;* earthenware, irregular brown glaze; h - (without lid) 7.6 cm; 17th/18th cent.; Vienna, Österreichisches Mus. für angewandte Kunst, Inv.-No. 36922/Ke. 9429; plate

1533 *Japan, late Tokugawa Period (1765–1868); container for pulverized tea (chaire) with ivory lid;* earthenware; h - (without lid) 5.7 cm; 18th/19th cent.; Vienna, Österreichisches Mus. für angewandte Kunst, Inv.-No. 36923/Ke. 9430; plate

1534 *Georges Hoentschel; vase;* earthenware; h - 7 cm; sig. on base: GH and G for Emile Grittel; pre 1902; Paris, Mus. des Arts Décoratifs, Inv.-No. 10201

1535 *Japan, Tokugawa Period (1603– 1868); water holder, Mizusashi;* earthenware, seto-yaki; h - 15.3 cm; 17th/18th cent.; Vienna, Österreichi-

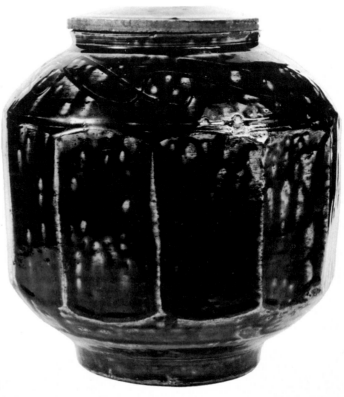

1497 Korea, Pot with lid

East and
South-East
Asia

Ceramics
and Glass

1161–1587

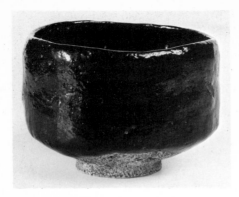

1558 Japan, Tea Bowl

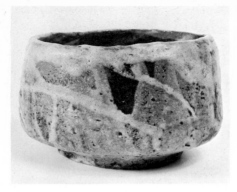

1546 Ohnsorg, Dish

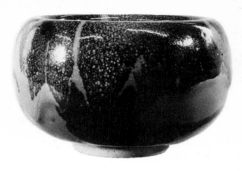

1570 Popp, Dish

sches Mus. für angewandte Kunst, Inv.-No. 2734/Ke. 6961;

1536 *Japan, Late Tokugawa Period (1765–1868); water holder (Mizusashi);* earthenware; h - 19 cm; 18th/19th cent.; Paris, Mus. Cernuschi, Inv.-No. 3013

1537 *Horst Kerstan (Frankfurt 1941, lives at Kandern, S. Black Forest); pot;* earthenware; h - 15 cm; sig. on base: HK; 1968; Hinang, Wolf Coll., No. 646038

1538 *Japan, Momoyama (1568–1614) or early Edo Period (1615–1868); water holder (Mizusashi);* heavy, reddish grey earthenware, around rim and within yellowish grey glaze; black lacquered wooden lid; ∅ 23.5 cm; sig. on base: Iwao (=rock) and a kakihan; 17th cent.; Berlin, Mus. für Ostasiatische Kunst, Inv.-No. 1190; plate

1539 *Japan, Momoyama Period (1568–1615); pot (tsubo);* earthenware, E-Garatsu, brownish body painted under blue-grey glaze; end of 16th cent.; Province of Bizen; Hamburg, Mus. für Kunst und Gewerbe, Inv.-No. 1913.22

1540 *Fernand Rumèbe (1875–1952); pot with lid;* earthenware; h 25.5 cm; sig. on base: F. Rumèbe; c. 1910; Munich, Paul Tauchner Coll.

1541 *Robert Obsieger (Lundenburg 1884–1958 Vienna); covered pot;* earthenware with blue glaze; h-26 cm; pre 1947; Vienna, Österreichisches Mus. für angewandte Kunst, Inv.-No. 30426/Ke. 8013

1542 *Anne Kjaersgaard-Linard (Copenhagen 1933); vase;* earthenware with

thick, glacier-blue glaze spreckled with dark brown and blue; h-16.5 cm; sig. on base: 69 Ann; c. 1966; Hamburg, Thiemann Coll.

1543 *Japan, Mamoyama Period (1568–1615); tea bowl (chawan), Mino (today Gifu-ken) yaki;* earthenware, E. Shina, sand-coloured body, reddish and leather-coloured discolourations in firing; thick, opaque, greyish-white glaze; ∅ 14 cm; c. 1600; Berlin, Mus. für Ostasiatische Kunst, Inv.-No. 23; plate

1544 *Japan, Edo Period (1615–1868); tea bowl (chawan), raku-yaki;* earthen-

1526 Japan, Tea Container

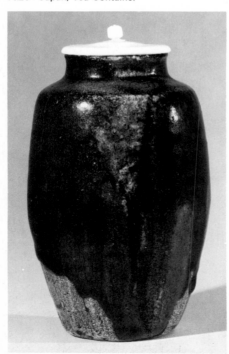

ware, Kiyomidzu type; ∅ 10.5 cm; 17th/18th cent.; Karlsruhe, Badisches Landesmus., Inv.-No. A 10080

1545 *Japan, Edo Period (1615–1868); tea bowl (chawan);* earthenware; ∅ 9.5 cm; c. 1700; Karlsruhe, Badisches Landesmus., Inv.-No. A 11961

1546 *Kurt Ohnsorg (Sigmundsherberg 1927–1970 Gmunden); bowl;* earthenware; h-7.8 cm; 1960; Vienna, priv. owned; plate

1547 *Margarete Schott (Berlin 1911); deep bowl;* fine earthenware; ∅ 12.2 cm; sig. on outside of foot ring: m stamped in a square; 1965; Hamburg, Thiemann Coll.

1548 *Lotte Reimers (Hamburg 1932); vase;* earthenware; h-22 cm; sig. on base: engraved markings; 1969; Deidesheim, Mus. für moderne Keramik

1549 *Japan, Tokugawa Period (1603–1868); tea bowl (chawan), raku-yaki;* earthenware; ∅ 12.5 cm; sig. on base: mark; 1750; London, Victoria & Albert Mus., Inv.-No. 242-1877

1550 *Japan, Edo Period (1615–1868); tea bowl (chawan), kô-raku;* earthenware; ∅ 14 cm; 18th/19th cent.; Paris, Mus. Cernuschi, Inv.-No. 4161

1551 *Japan, Tokugawa Period (1603–1868); tea bowl (chawan), raku-yaki after manner of koetsu (1558–1637);* pottery, red body with transparent, partially iridescent glaze; ∅ 11.8 cm; 17th/18th cent.; Vienna, Österreichisches Mus. für angewandte Kunst, Inv.-No. 18007/Or. 1197

1552 *Japan, Edo Period (1615–1868); tea bowl (chawan);* earthenware, kuro-saka type, red-grey body with reddish,

brown, dark-brown mottled glaze; ∅ 11 cm; 17th cent.; Karlsruhe, Badisches Landesmus., Inv.-No. A 12075

1553 *Japan, Tokugawa Period (1603–1868); tea bowl (chawan), hagiyama-yaki;* pottery with salmon-red colouring and Aoi coat of arms of the Tokugawa under a transparent glaze; ∅ 11.5 cm; sig. on base: Hagizama-yaki mark; Vienna, Österreichisches Mus. für angewandte Kunst, Inv.-No. 11022/Ke. 4230

1554 *Japan, Tokugawa Period (1603–1868); tea bowl (chawan), raku-yaki;* pottery, thin film of mainly salmon-red colouring with grey spots, three flambé pearls in white, thin transparent glaze; ∅ 11.7 cm; sig. on base: Seiki mark; c. 1800; Vienna, Österreichisches Mus. für angewandte Kunst, Inv.-No. 36914/Ke. 9421

1555 *Japan, Tokugawa Period (1603–1868); tea bowl (chawan), raku-yaki;* pottery with milky-pink, finely crackled glaze, gold lacquer repair spots, cylindrical form; ∅ 11.2 cm; unsigned; 18th cent.; Hamburg, Mus. für Kunst und Gewerbe, Inv.-No. 1898.18

1556 *Margarete Schott; bowl;* fine earthenware; ∅ 12.5 cm; sig. on outside of foot ring: m stamped in a square; 1965; Hamburg, Thiemann Coll.

1557 *Mathias Schwenkenbacher (Leipzig 1940); bowl;* earthenware; ∅ c. 10 cm; c. 1970; Deidesheim, Mus. für moderne Keramik

1558 *Japan, Tokugawa Period (1603–1868); tea bowl (chawan), raku-yaki;* pottery with glaze in various tones of brown; ∅ 7.7 cm; 18th cent.; Vienna, Österreichisches Mus. für angewandte Kunst, Inv.-No. 18015/Or. 1205; plate

1559 *Japan, Tokugawa Period (1603–1868); tea bowl (chawan), raku-yaki;* pottery; ∅ 10.2 cm; sig. on underside: Inoue coat of arms; 18th cent.; Vienna, Österreichisches Mus. für angewandte Kunst, Inv.-No. 36915/Ke. 9422

1560 *Japan, Tokugawa Period (1603–1868); tea bowl (chawan);* earthenware with dark brownish-black glaze; ∅ 14 cm; 17th/18th cent.; Vienna, Österreichisches Mus. für angewandte Kunst, Inv.-No. 31423/Ke. 8561

1561 *Japan, Tokugawa Period (1603–1868); tea bowl (chawan), raku-yaki;* pottery with black glossy overflow glaze;

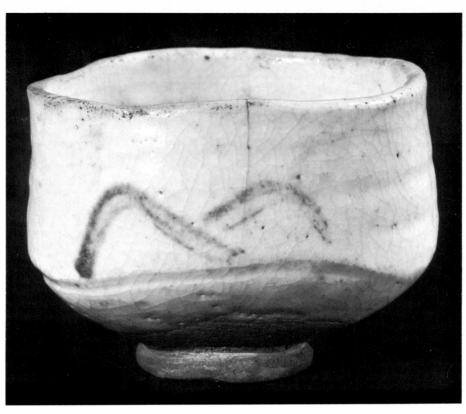

1543 Japan, Tea Bowl

∅ 11.4 cm; sig. on stand ring: Raku; 19th cent.; Hamburg, Mus. für Kunst und Gewerbe, Inv.-No. 1901.143

1562 *Japan, Tokugawa Period (1603–1868); tea bowl (chawan), raku-yaki;* pottery with black glossy overflow glaze; in white the tip of the Fuji; ∅ 11.5 cm; unsigned; 19th cent.; Hamburg, Mus. für Kunst und Gewerbe, Inv.-No. 1895.235

1563 *Japan, late Tokugawa Period (1756–1868); tea bowl (chawan), izumo-yaki;* light pottery with metallic shining, brown flow-glaze, dry crystallized points and yellowish-red flambé overflow, high cylindrical form; h-9 cm; 18th/19th cent.; Hamburg, Mus. für Kunst und Gewerbe, Inv.-No. 1893.380

1564 *Horst Kerstan (Frankfurt 1941, lives at Kandern, S. Black Forest); bowl;* fine earthenware with glossy, blackish-brown temmoku glaze with rust-brown raised spots; ∅ 12 cm; sig. on base: Kerstan; 1971; Hamburg, Thiemann Coll.

1565 *Fance Franck; beaker;* earthenware, thrown, with brownish-black glaze, rust-red rim; ∅ 8 cm; Paris, Franco Roazzi

1566 *Horst Kerstan; beaker;* earthenware; h-9 cm; sig. on base: marking; 1966; Hinang, Wolf Coll., No. 459029

1567 *Horst Kerstan; bowl;* earthenware; h-10 cm; sig. on base: Kerstan; 1967; Hinang, Wolf Coll., No. 339014

1568 *China, Sung Dynasty (960–1279); bowl;* earthenware with brownish-black "hare-fur" glaze (temmoku) over a ferruginous brown ground glaze; ∅ 9 cm; 10th/13th cent.; Paris, Mus. Guimet, Ma 732, Legs Curtis

1569 *Bernard Leach (Hongkong 1887, lives at St. Ives, Cornwall); bowl;* earthenware, grey body with black, matt-glossy glaze over brown engobe; ∅ 11.8 cm; sig. on base: I. S. + B. L.; c. 1930; London, Victoria & Albert Mus., Inv.-No. C 1963-1935

1570 *Walter Popp (Bunzlau, Silesia 1913); bowl;* earthenware, thrown, beige-grey body, black glaze with dark-green spots; ∅ 17 cm; sig. on base: WP 63; 1963; Deidesheim, Mus. für moderne Kerámik; plate

213

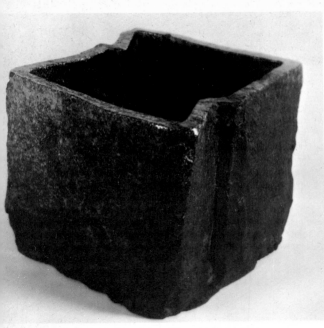

1538 Japan, Water Holder

1571 *Robert Obsieger (Lundenburg 1884–1958 Vienna); bowl;* earthenware; ∅ 12 cm; pre 1954; Vienna, Österreichisches Mus. für angewandte Kunst, Inv.-No. 36368/Ke. 9175

1572 *Robert Obsieger; bowl;* earthenware; ∅ 12 cm; pre 1954; Vienna, Österreichisches Mus. für angewandte Kunst, Inv.-No. 36369/Ke. 9176

Japanese Forms – European Commodities

Hans Wichmann

This exhibition whose objective it is to show or suggest the influence of Asian, African, Oceanian and Indian cultures on European art and music is taking an unconventional and unchartered course when it attempts to compare the formal aspects of the commodities of today or of the recent past. This is especially due to the fact that both the general public and the specialists are undecided whether it is legitimate to assign the utensils of daily life, especially those factory-produced, to the realm of art. After all, the European has long been conditioned to regarding only those commodities as works of art which have been "artified", so to speak. This concept stems, of course, from the

belief that "ordinary" things can only be saved from their ordinariness when art is brought in to elevate them. Certainly commodities cannot be subsumed under the notion of art in the traditional sense of this term. However, wherever a commodity is truly worthy of the name, that is truly serves a useful purpose, then this cannot be achieved without some element of creative activity and design. The small section of the exhibition in which forms produced in Japan are confronted with everyday commodities still produced in Europe today thus forms a sort of enclave apart and we may reasonably leave it to the visitor to decide for himself whether they are worthy of inclusion.

Quite independent of the question whether the term "art" is apposite in regard to the exhibits in this section or not, it would seem of far greater significance to ask, in view of the exhibition's main objective, whether the influence of the utensils produced in Japan is reflected in the corresponding European objects. We cannot expect direct formal conformity; the links must rather be sought in the nature of the objects exhibited, in a type of related approach.

This related approach deserves closer consideration. The objects of daily life in Japan do not merely document national peculiarity; they also witness to the historical and geographical links between Japan, China and Korea. Furthermore, they are part and parcel of that insoluble unity of dwelling habits and life to a much greater extent than is the case in Europe. Every commodity has a definite reason for its existence and Zen Buddhism has had a decisive part in shaping this existential basis. "For the Zen priest, life and doctrine are one. Everything that he does is guided by his deep religious experience: he sweeps the garden, an everyday occupation, but it has symbolical significance and is inspired by the same spiritual approach with which he executes the calligraphic signs when writing or with which he answers his partner in a conversation, sits lost in meditation or observes the ceremonies when preparing tea and empties the precious little bowl in two draughts. 'In Zen daily life brings enlightenment'." (Werner Blaser, Catalogue to Exhibition "Beispiel Japan, Bau und Gerät," Munich 1965, p. 38). This law of incorporation in a higher context – dwelling habits, house, garden, nature, faith – has given the individual utensil its character. We must also remember that the Japanese has concentrated his attentions on only a few objects which have varied only slightly

over the centuries and have always been subject to the same canon of forms; the European, in contrast, has surrounded himself with an ever-growing arsenal of artifacts. This concentration has led to an unsurpassable perfection in the execution, the selection of materials and the functional adaptation of the utensils, which has in turn led to ever greater simplification and condensation of form. If we now wish to confront the commodities of Europe with this Japanese formal world, then we must first remember the totally different circumstances under which they have been produced. European design has stood in a peculiar dialectic relation to continuity, ever since its real beginnings in the opening years of this century. On the one hand, the new style of living, the new buildung, and the new commodity aimed at a conscious break with tradition; on the other, Europeans endeavoured to link up with certain phases in their history which seemed to offer in retrospect the genuine and true elements they were aspiring after. The dynamically progressive industrialization has also faced the European with an entirely new situation. Whereas during the first quarter of this century most people were convinced that new things would lead to an overall improvement of the world, so that designers allowed themselves to be carried along on the wave of reform in modern art in developing functional forms in architecture, domestic design and utensil which should correspond to the high demands thus placed, the generation of designers coming to maturity in the meantime has fallen prey to scepticism and resignation. The recognition has won ground that, in our present-day political situation, design has fallen between Scylla and Charybdis. On the one hand, the aims of modern design and their coherent pursuit can be more consistently programmed and realized through the planned economy subjected to the will of a single party than through private economy hopelessly enmeshed in the competitive spirit, although, of course there is the danger that the changes in the entire environment which the designers envisage will be exploited by political interests (Cf. Werner Hofmann, Design, Berlin 1970, p. 62.). "In contrast, the capitalist world reveals the reverse of the dilemma. To the extent that design comes to terms with the 'laissez-faire' system which we know as pluralism, it withdraws from its claims to improve the world. Should it aspire to change the world entirely, however, then it interferes with 'free

214

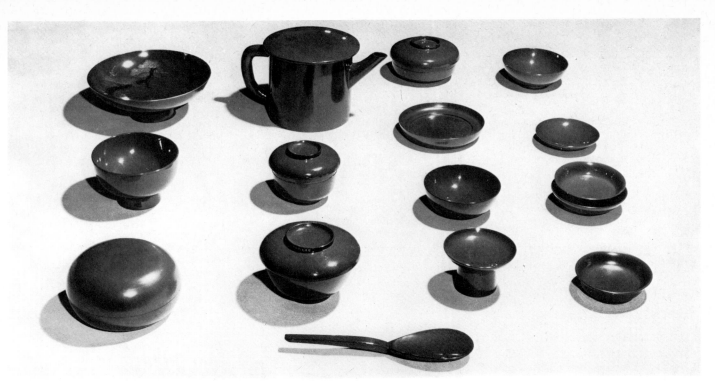

1573 Japan, Red Lacquerware

1584 Procopé, Earthenware Service

enterprise' and as a consequence abrogates one of the rules of our society. On a pluralist basis any change of the environment must remain fragmentary; consistency and formal coherence can at best be the exception that proves the rule" (Ibid., p. 62). Perhaps the decisive obstacle is to be seen in the individual's ever-increasing autonomy; in many cases he seems to have lost the correct standards for his own ego within the framework of the world as a whole. This latter is a situation that Japan is facing today as a highly industrialized state, too. In comparison with Japanese forms, the European commodity seems to bear the stamp of the individual, whereas the former are not isolated but revealed as part of a greater unity. However, beyond the barriers of space and time, especially where the hand-manufactured articles are concerned, there is an accord between certain essential components to be observed between Europe and Japan even if, in each case, this is the product of a totally different process. For example, strict concentration on the purpose and significance of a commodity, on its function in the material and spiritual sense and on the conditions and possibilities which the material and process of manufacture offer for the design has led, in both cases, to the beauty of pure form and the delicate balance of proportions.

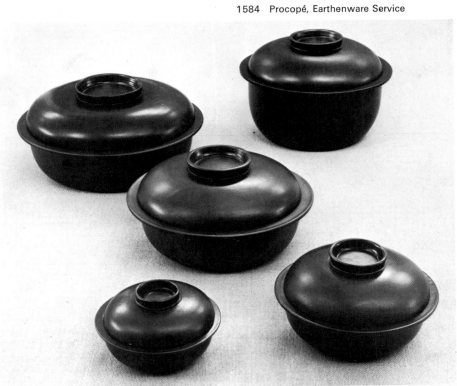

For the European this means a new relationship of men to the commodities they use: they are not a substitute for art but incorporate a design which is derived and developed from the objects themselves. "Things whose form is entirely their own form and not the presentation of art, of style, of fashion are not subject to the vicissitudes of passing fancy but have their own permanency: they exist for as long as they fulfil their function for men" (Cf. Wend Fischer, Catalogue to Exhibition, „seit langem bewährt, "Munich 1968). Completely independently of whether or not European designers, stimulated by visits to museums or to Asia, have consciously or unconsciously incorporated Asian forms in their developments, the agreement will surprise in numerous instances. This does not appear to be a coincidence; it appears rather to be determined by a worldwide search and experience of what is valid for all.

Summary and Translation P. J. D.

1573 *Japan; eighteen vessels;* red lacquerware; 19th cent.; Vienna, Mus. für Völkerkunde, acquired in 1893 by Archduke Franz Ferdinand of Austria-Este; plate

1574 *Adolf Loos (Brünn 1870–1933 Vienna); manufacture: J. L. Lobmeyr, Vienna; Service 248;* crystal glass; c. 1933; S. Germany, priv. owned

1575 *Wilhelm Wagenfeld (Bremen 1900); manufacture: Württembergische Metallwarenfabrik (WMF),Geisslingen; glass vase;* c. 1961; S. Germany, priv. owned

1576 *Arne Jacobsen (Copenhagen 1902–1971 Hellerup); manufacture: Stelton A/S, Gentofte, Denmark; "cylinda line" service;* high grade steel, plastic; c. 1963–1967; S. Germany, priv. owned; plate

1577 *Magnus Stephensen (born 1903); manufacture: George Jensen, Copenhagen; bowl with lid;* silver; S. Germany, priv. owned

1578 *Hans Harald Rath (Vienna 1904– 1969); manufacture: J. S. L. Lobmeyr, Vienna; "Alpha", set of beakers;* crystal; c. 1952; S. Germany, priv. owned

1579 *Piet Hein (born–1905); manufacture: Georg Jensen, Copenhagen; cigarette case;* silver; c. 1967; S. Germany, priv. owned

1580 *Trude Petri-Raben (Hamburg 1906); manufacture: Staatl. Porzellanmanufaktur Berlin; "Urbino" service;* porcelain; c. 1930; S. Germany, priv. owned

1581 *Kaj Franck (born 1911); manufacture: Wärtsilä AB, Helsinki; "Kilta" service;* fine earthenware, polychrome glazing; c. 1953; S. Germany, priv. owned

1582 *Kaj Franck; manufacture: Wärtsilä AB, Helsinki; "Finel" dishes;* steel; S. Germany, priv. owned; plate

1583 *Henning Koppel (Copenhagen 1918); manufacture: George Jensen, Copenhagen, covered bowl;* silver; c. 1962; S. Germany, priv. owned

1584 *Ulla Procopé (born 1921); manufacture: Wärtsilä AB, Helsinki; "Liekki" service;* earthenware; S. Germany, priv. owned; plate

1585 *Grete Meyer (born 1928); manufacture: Den Koneglige Porcelainsfabrik A/S, Copenhagen; "Blaukant" service;* faience, underglaze; c. 1964; S. Germany, priv. owned

1586 *Kristian Vedel (born 1929); manufacture: Torben Orskov Co., Copenhagen; containers;* plastic (Melamin); c. 1958; S. Germany, priv. owned

1587 *Horst Bühl (Nürnberg 1940); bowl;* bronze; c. 1968; owned by artist

1576 Arne Jacobsen, High-Grade Steel Covered Container

Calligraphy in the Far East

Roger Goepper

Numerous western painters of recent generations have testified to the Far East as a source of inspiration for their calligraphic work. Not infrequently, they start from faulty premises if not from direct misunderstandings, the results of which, however, must be regarded as equally "fruitful" as the impulses from the Japanese coloured woodcut in the last century.

The word "calligraphy" itself does not render the specific character of Far-Eastern writing; for it by no means involves "beautiful writing" in the traditional western sense. The attraction of Chinese and Japanese characters for western artists primarily appears to be of an optical nature, even where theoretical statements often try to provide a different basis. An ostensibly fanciful play with a "free line" (Kandinsky), whose spontaneity results from the unconstrained ductus, leads to equally free, graphic-formal figures. The expression, which reveals itself in this manner, must necessarily remain subjective.

In contrast, the brush technique of the Far East has every characteristic of genuine writing, which must function as a medium of communication and registration of thoughts. Its form is fixed and can only be modified within certain limits unless its readability is to be impaired; its technique is subject to specific rules and is closely affiliated with an aesthetic aspect which largely results from precisely this technique and form.

In the same way as most original writing forms of specific cultures, Chinese writing is also to a large extent adapted to the structure of the language optically determined by it. Chinese is monosyllabic, each word consisting of a single syllable. Due to the restricted stock of sounds, there is a large number of similar sounding words today which have to be distinguished in writing. The syntax isolates, i. e. the words stand in disconnected sequence in the sentence; there is no declination or conjugation and no affixes connecting with the word. The grammar is thus to a great degree syntactic. The position of a word in a sentence is determined by its grammatical function. In poetic language, but also in prose, this leads to rhythmical style forms in employing an order of words; to parallelism or antithesis. Finally, Chinese is a musical language: each word is firmly linked with an expressional tone,

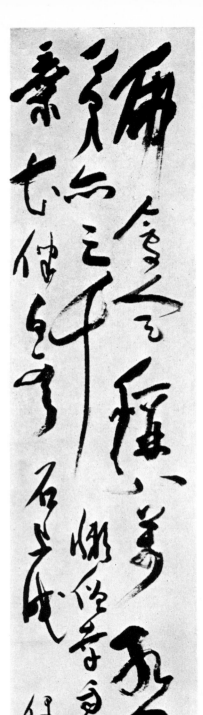

so that the melody of the sentence ultimately has little value of its own, but derives rather from the sum and sequence of the word tones. This also has considerable consequences for the art of poetry, which plays on every register of this word and language melody.

The monosyllabic Chinese word as a concentrated tone emblem of the widest significance (ta = large, size, to be large, to make large, wide, elevated, very, grown, etc.) and evocative implication (feng = wind, breath, custom, habit, manner, style, taste, inspiration etc.), must also do justice to the graphic structure of the written sign. Its form is absolutely binding. Since the establishment of brush writing in the centuries before the onset of the new era, the sequence in which the brush-strokes are drawn has also remained immutable. Even complex graphic structures with thirty or more strokes are precisely codified in the sequence of their execution and by no means open to personal choice.

In their early phase, in the second millenium before Christ, the characters were still frequently obscure pictures. This is especially true for concrete objects: man, woman, tree, carriage. Abstract concepts were formed either by components of such pictures (woman + child = love, woman underneath roof = peace), or by the adoption of characters for consonant words. Such phonetically used characters were already furnished with a radical or demonstrative sign to convey meaning (hsi = west; west + 'heart' = hsi, "annoying"; west + 'tree' = hsi, "roost"). This practical system was already canonized in the second century B. C. The earlier small stock of characters subsequently grew to 40,000, of which about 4,000 are used today.

As a consequence of the earliest book form, a bundle of small wood or bamboo panels, the lines run from top to bottom. Although the basic strokes are drawn from left to right, the lines follow each other from right to left. This reverse course of a text or book is, for example, of great importance for the mode of vision and accordingly for the composition of a picture.

Chinese word and ideographic writing has, to a great degree, become a "cultural" form of writing. The written signs are condensation points of a plexus of evocative conceptions, to an extent greater than the spoken word. The complexity of the signs makes the learning of them an

◀ 1648 Teng Che-Jou, Calligraphy in Seal Style

1668 Sengai, Poem on Himself ▶

esoteric undertaking. Reading, not to speak of writing, was synonymous with an acquired education and led to an allocation of status within the fluctuating intellectual hierarchy. The symbolical character of the writing made it appear suitable for other languages and it was adopted together with Chinese civilization in Korea and Japan. This homogeneous writing enabled barriers to understanding between languages of totally different structures and groups to be removed.

Since the third or fourth century A. D., all the types of writing today, the normal hand *(K'ai-shu)*, which resembles printing type, running hand *(Hsing-hsu)*, and draft script *(Ts'ao-shu)*, which is almost reminiscent of stenography, have remained so constant that, with certain restrictions, it is possible for an East Asian living now to read an almost two thousand year old text as if it had been written today.

Since that time, writing has also been regarded from an aesthetic standpoint. The characters should not only be correct, but above all written well. Although strict rules determine their sequence, the style of execution and accenting remains with the writer. The composition of a character or text does not imply symmetry or dimensioning of its components, but rather a balancing of the forces of form and ductus, which become active in the structure of the written character.

It takes many years to learn the correct writing technique with the brush. The writer always follows the established handwriting of a master of the past, whose artistic status is generally recognized. The pupil attempts to reproduce the form and expression of this handwriting as accurately as possible. When he has fully mastered it, he begins to experiment with what he has learned, until, in old age, he achieves the harmonic simplicity of a mature style. At least, this is what one seventh century theorist took to be the ideal development of a calligrapher. What applies, mutatis mutandis, to most other Far-Eastern art is therefore also true of writing: that instruction and schooling are essentially intimation of a tradition. This primarily entails the use of the collections of classical handwriting *(fa-t'ieh)* published officially and privately since the tenth century as lithographic copies of famous calligraphers. They contain what are more or less recognized as genuine "brush-traces" of the fourth century masters, particularly those of the patriarch of calligraphy, Wang Hsi-chih and his son Hsien-chih, as well as of the classical

calligraphers of the T'ang dynasty (618–906). As a generalization, it can be said that the history of Chinese calligraphy continually oscillates between strict integration within the orthodox tradition deriving from Wang Hsi-chih, and a rejection and renunciation of this tradition. Such revolts, however, are ultimately influenced by tradition itself: it is intended to overcome traditional form with traditional means, and the result generally merges into traditions again. It is writing technique which has been the virtually unmodified backbone of Far-Eastern calligraphy for more than one and a half thousand years. Essentially, it entails rules for the ductus of the brush, whereas the laws of composition are actually of secondary significance.

The lines are applied on silk or on an absorbent paper, rather like blotting-paper, with a quite elastic and pointed hair brush held vertical to the writing surface. In order to prevent the black ink from flowing off the brush, the movement must be continuous; every interruption or uncertainty is registered as a small blot. In writing, the wrist remains stiff and the movement largely comes from the shoulder, i. e. directly from the axis of the body. The individual characters and the complete written texts are furnished with certain rhythmical qualities, which are mainly produced by a pressuring or a slackening in the duct of the brush, i. e. from an alternating expansion and contraction of the line. This characteristic has been pertinently described by theorists as the "bone method" *(ku-fa)*, or "structure." The ku-fa has spread from calligraphy to become a keyword of Chinese aesthetics. There are two further concepts which define the structure and expression of Chinese signs: the "flesh method," *jou-fa*, determines the consistency of the brushstroke, its slenderness or its fullness, and the thickness of the ink. The "tendon method," *chin-fa*, defines the number of individual strokes among themselves; in other words, the composition of the whole character.

Not until the writer has become absolutely sure in using the brush can he thus freely operate with this technique and the forms of style and composition. According to a formulation traceable to Wang Hsi-chih, such natural spontaneity *(tzu-jan)* requires complete accord between heart (spirit) and hand. The conception must already be formed in the mind of the writer before execution with the brush *(i tsai pi-hsien)*. Here, too, there is an essential difference compared with the creative process of the western artist: whereas the Chinese master em-

ploys his sure technique to set a preconceived idea into its adequate form, the western artist frequently struggles with form and material while working, so that a creative angle arises between conception and finished work.

Animation during the creative process is also not necessarily absolutely a positive factor for the Far-Eastern calligrapher; generally, inner quiet and harmony are regarded as the prerequisites for undisturbed work. Yü Shih-nan (558–638), one of the great masters of the early T'ang period, and a high official, made the following observation: "At the moment when one intends to write, the sensory activities of seeing and hearing must be restrained. One arrests one's thoughts and concentrates the mind. When one 'straightens' one's heart and brings one's vital power into harmony, then one is in accord with the wonderful qualities of art."

In this way, handwriting becomes the mirror of the author's personality. One can read from it, virtually in the graphological manner, the character and degree of maturity of the writer. A theorist of the fourteenth century said: "The art of writing – it is the trace of the heart (or spirit). Thus, it has its roots within, and from there it takes outward shape; one comprehends it with the heart and the hand responds."

As in music, in poetry, and also in painting, the emotions of a person are also reflected in his handwriting. The literary critic Liu Hsieh formulated this as early as the sixth century in the following significant words: "When the emotions are moved they take shape in words; and when the inner principle *(li)* makes its appearance it becomes visible in an artistic form."

For these reasons, many an eccentric master, especially during the eighth century, put himself into a suitable mood with generous portions of wine before writing; he then used brush, palm of the hand or his own long hair to deploy letters of great audacitiy and expression on to paper or the walls of his studio. Calligraphic criticism, which reached an advanced stage of development at quite an early date, had a broad spectrum of qualifying terms for the expressional value of the various styles of writing. They achieved every modulation between "graceful elegance" *(yen-mei)* to "manly power" *(ch'iung li)*.

The basic criterion, however, to which all others were more or less subordinated, was structural vitality *(ku-ch'i)*, i. e. the expression of the primitive vital power of the writer, which, with the help of

traditional rules, found shape in an artistic structure.

The differing political and social conditions in Japan modified Japanese attitudes to Chinese writing, which since the fourth to the fifth century had initially been accepted as it stood, and which was scarcely suited to rendering the differently structured Japanese language. Chinese remained the literary language for several centuries, and its characters were copied in the style of the fourth to the eighth century. However, after the middle of the eighth century, a tendency arose among the court nobility to represent polysyllabic Japanese words phonetically with Chinese signs. The sign was thereby treated as a mere sound symbol and no longer as a vehicle of meaning. Ultimately, the slurring of Chinese running-hand forms led to the emergence of Japanese syllable writing in the tenth and eleventh centuries, which was significantly called "kana," or "borrowed name." In contrast to the Chinese style of writing, the "kara-yô," the national Japanese "wa-yô," began to spread in court circles.

The refined technical perfection and the aristocratic elegance of line, which in graphological terms possessed a pronounced "thread-like character," made *kana* writing the suitable medium for composing poetry for the court poetry competitions *(uta-awase)*, diaries (nikki), lady's novels, and inscriptions on sliding-partitions and screens. The flow and softness of the duct complied closely with the basic feminine character of the Heian-culture, and was consequently also named "onna-de," "lady's style." Quite different in outward form are the "bokuseki," the "ink traces" of the Zen monks from the Kamakura (1192–1333) and Muromachi periods (1336–1573). They are almost always written in Chinese characters and in the free style of the Chinese men of letters and monks of the Sung and Yüan dynasties. They contain sayings, quotations or confirmation names which the Zen masters conferred upon their successful pupils as a form of diploma. These very self-assured and, on occasion, warlike men, naturally rejected the feminine forms of the *kana* signs and the elegant stylistic forms of Wang Hsi-chih. They strove for a direct expression of their own personality, even when this did not comply with the pretentious standards of traditional aesthetics. Their artistic ideals lay in the destruction of traditionalistic formalism and in a spontaneously expressed individuality.

An interesting phenomenon, which appeared during about the last two centuries and has become particularly conspicuous in recent decades, is the readoption of archaic styles of writing, such as that of the oracle bones dating from the second millenium B. C. and of primitive brush writing from first five-hundred years A. D.

However, modern artists only imitate the basic form which they distort and exaggerate and transform into attractive new creations by means of refined techniques. Precisely these styles of writing, which often consciously reveal the pictorial character of the original forms, have stimulated western artists in recent decades. This was all the more possible since, in the Far East, these artists largely dispensed with the orthodox rules of calligraphy and used effects produced by accident or dripping. Both in the West and the East, there actually appear to be parallel intellectual and artistic tendencies in this respect, which exert a genuinely fruitful influence upon each other.

Translation G. F. S.

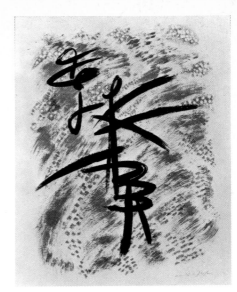

1599 Masson, Whirl

Zen Buddhism, Ink Painting and Modern Art

Manfred Schneckenburger

Impressionists and Post-Impressionists were interested in formal characteristics of Ukiyo-e: surface treatment, significant reduction of the scene, colouring. The cultural background of these woodcuts, the vigorous world of the populace of the late Edo period, sufficiently corresponded to nineteenth-century Europe to create superficial congruence. Even when Toulouse-Lautrec and individual Intimists included Zen-Buddhist ink paintings among their models, the impulse imparted was restricted to the sweeping brushwork, the language of the white surface. Where Japanese calligraphy has effect – among a number of designers of the art nouveau period and English illustrators – only the swirling line and the decorative vertical arrangement were adopted: formal elements, that is. The cultural context of Chinese or Japanese art was not considered.

This attitude is not altered by the interest of Gauguin and some Symbolists in Buddhism (hardly Zen Buddhism), an interest which leads to a type of inner conversion in Meyer de Han and to a vigorously committed rejection in Sérusier. Redon adopts the Buddha motif in his iconography. But all this remains merely peripheral or subject to fashion, not far from the realm of anthroposophy.

Affinity of Spirit
It is only since the twenties of this century that individual artists, then tendencies, and then groups have penetrated to deeper areas of Far-Eastern thought.

1673 Sengai, Sign of emptiness

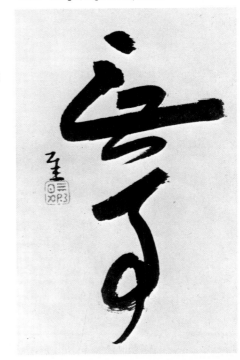

1664 Isshi, Kenshu Osho

1615 Bissier, 7. 6. 56

After two world wars and the crisis in European self-assurance, the immediate experience of being that is offered by Zen Buddhism attracts as a genuine alternative. Zen Buddhism and, more closely related, Taoism lead to that point of existence where the individual sacrifices himself in order to gain himself entirely: mysticism without mystification and obscurity. In contrast to the Impressionists, the twentieth-century artists are approaching Far-Eastern art via philosophy.

Affinity of a partially related approach and attitude comes before all formal reception. Among the basic experiences of numerous artists of the twentieth century belongs the conviction that the apparent order of a mechanically ruled, logically concatenated world is no longer capable of mediating the deeper truth of life and art. The old Romantic belief that submersion within oneself holds the key to the universe lies at the root of Breton's second surrealistic tenet: "Everything leads us to believe that there is a point of the spirit from which . . . the real and the imaginary . . ., the expressible and the inexpressible, above and below cease to be perceived as contradictories." The same belief in the final unity of mankind with the roots of the world finds its perfect formulation in the teachings of Taoism and Zen Buddhism. The Zen patriarch Keiznan remarks: "In reality there is no distinction between forms and colours, no opposition of object and subject, only one and the same eternity." In such a view of the world, the artist is a mere mediator who registers. André Masson compares him with the Far-Eastern Zen artist who — archer or painter — crosses the threshold of art as art: "All now takes places as if he were the bow which makes use of the archer instead of vice versa. It is the same with the painter of this same teaching. It is the élan vital which takes possession of him to reveal itself to him." There is no need to account for why this capacity to allow an "It" to speak from within oneself, whether it is the "emptiness" of the Zen Buddhists or the very different "It" of Freud, just had to fascinate the écriteurs automatiques, Masson or Michaux.

The connections with Zen Buddhism are as obvious as the differences to this latter, above all the renunciation of an ethical self-realization. It is above all the Surrealist quest for new techniques of liberation from self — Frottage, Automatism, chains of association — which leads back to the European spirit of invention, just as the eruptions of a Pollock or the oversensitization of a Wols are far from

the Far-Eastern aesthetics of the simple. The common framework is more extensive than the concrete contacts.

On the other hand, Tobey, Graves, Bissier, Baumeister, often Masson too, aspire after a unity of meditation and art — painting as a meditative process, contemplative concentration as source and aim of art, going beyond the subject-object relation of artist to work. This is one of the main areas of Zen influence. They are situated on the antipode to an attitude and approach which is likewise Far-Eastern in inspiration. Georges Mathieu has pinpointed the main characteristics: the speed of the painting process (partly stemming from the sumi-wash technique), the coalescence of idea and execution, their identity in a short, infallible action. Mathieu: "Far-Eastern calligraphy does indeed improvise with given characters, but speed is as much a part of it, like a type of ecstacy. When I was in Japan last year, I saw great masters of calligraphy dash off enormous drawings in a few seconds . . . Speed and improvisation demand: concentration of psychic energies and at the same time a condition of complete emptiness."

Not all western artists who have drawn close to the Orient have made contact in this way. The eastern-inspired Tobey, Baumeister, Soulages, Hartung remain true to the painstakingly methodical (in Mathieu: Academic) execution of European tradition by transposing the manual into the meditative. It would also be wrong to connect all forms of eruptive painting which is "discharged" within extremely short periods of time with Far-Eastern inspiration: Pollock's method is largely independent. Even Mathieu, Degottex, even Kline, are rooted in their own aesthetics which, nevertheless, have points of close contact with Far-Eastern calligraphy. It is especially difficult to say where influence and where parallel development begins and ends especially in Mathieu. Rapid spontaneity is part of the act of painting. Painting becomes — literally — as fast as thought. Whatever is to be said of the interpretation, the distancing from the European procedure of the painstaking application of paint layer upon paint layer is clearly to be traced to the influence of calligraphy.

Encounter of Forms

The changed questions give rise to new models. The woodcuts of changing life are now replaced by ink painting with its symbols of spiritual inwardness: cloud, mountain, waterfall, meditating people. A main achievement of the Orient

1623 Hartung, Design

1643 Sonderborg, Without title

1649 Tapies, Graphisme Central

takes us to deeper levels of the Far-Eastern spirit than the woodcut was ever able to unbare. From the formal viewpoint, interest shifts from the composition of the surface (up to 1900) to the individual brush stroke and dot. The stroke as a traced movement, the dot as the transitory in the artistic fixation: those are main elements in Japanese ink painting and at the same time corner-stones of main tendencies in modern art. The liberated line finds new orientations in the calligraphic process. Masson's écriture automatique is the reception of this impulse, just as are the calligraphic structures of Tobey or the virtuoso brush choreography of Mathieu. The possibilities range from ideogrammic signs to the fully-developed calligraphic network or the captured gesture. Informel and Tachisme adopt graphic rhythms. However, these external comparisons are not enough. The standards of Far-Eastern calligraphy make new demands on the use of the brush. The richer and bolder modulations, the broadening and thinning of the stroke, its enclosure within defined limits and its limitless sweep, its both sensual and spiritual beauty, the line not just as a means but as an independent object of representation in all the fulness of its potential in painting: all this has an effect on western painting which is over and above that of the calligraphic sign. This is what appears to be Japanese in Kline's splintering and Motherwell's compact beams, what Alechinsky brought back from Japan and what gives pictures like "Cobra Vivant"

their relationship to calligraphy. Alongside the liberation of the calligraphic line is to be placed the freeing and flowing expansion of colour. The "rough manner" of Che-Ko around 1100, that "boneless" painting to the Japanese art of the Tokugawa period with Sesshu are to be counted among the greatest achievements in painting. Again an eastern spiritual form coincides with the modern tendency towards the autonomy of the means. This is to be seen rather in the ink drawings of Bissier, Masson, Hartung and Sonderborg. The patch of colour becomes the trace of the moment in which the freedom of the explosion is combined with extreme concentration, the succinctness of the sketch is united with the spontaneity of chance: shared characteristics which go beyond the evocations of the medium ink. The stress can be placed in the Far East as in Europe on the explosion (Sonderborg) or the concentration (Bissier). The emancipation of the patch of colour is another contribution which Far-Eastern ink painting has made to modern art.
If Masson pushes the painting of the moment to the extreme, by applying his paint to the canvas by throwing, shaking or blowing it to bring about a merger of action and result, then he recalls: "To spit the ink out like the monks of the Tcham sect, to throw the paint-filled top at the picture, to shake the paint poured on the surface so that it finds its own form and way itself – to work after the manner of nature and as if it were concerned with nature."

Logically and consistently the patch of colour is combined with the element of change which – like the running ink or the running glaze – is a legitimate component of Far-Eastern art. Here, too, there is a point of contact with modern art: chance is employed as a vehicle of deeper wisdom and rightness of means, to Nolde's watercolours where the ground merges with the running trickle of colour to produce "Far-Eastern" effects. If we have already arrived here at one of the central thoughts of the East (which does not exclude its formalization in the West), some modern artists seek still further precision in the sense of one of the basic Chinese conceptions: the unity of all life in pairs of opposites, a sign of bipolar life, of Yin and Yang. Zen Buddhist brush drawings of the moon or of a circle with unconnected calligraphic characters strewn alongside also mediate impulses. Bissier's innumerable ink drawings between 1930 and 1940 are based on formal pairs, an enclosed and outward-looking form, male and female, calm and mobile, vigorous and ethereal. Adolpf Gottlieb has reduced his "Grandscapes" since 1954 to a large round disk and a formless and shapeless "ink-blot picture." The circle, as the symbol of the cosmos, hovers in the upper half of the picture, while below there is the black blot: chaos. In the dialogue of the elemental the great opposites become a unity: heaven and earth, form and "non-form." Hartung (in an ink drawing) and Mathieu, too, make round and self-contained and amor-

221

phously exploding blots of colour the meditative inventary of their work: traces of a "Taoist" abstract iconography in modern art.

Finally, the Far East also makes its contribution to the treatment of space in the picture in our century. The conception of space which is characteristic of ink painting leads to the abandonment of Renaissance perspective, not just formally but as an opposed conception. Kurt Badt has interpreted space in European art as the sum of concrete "places," as their function without a pre-existence of their own. This is certainly exaggerated but it does underline the contrast between the European definitions of space and the unlimited, universal all-embracing space, the expression of "emptiness" which is the "light and breath of the world," far removed from the courageous spiritlessness of our nothing. Space is the symbol of Buddha and of Tao, the true being of the world from which all phenomena arise and in which they again disappear. Here the technical means ink is transformed into the medium of a higher spirituality. Tobey and Masson have adopted this Far-Eastern feeling for space and have interwoven or suffused it with calligraphic particles. The landscape is liberated from all perspective principles; their space becomes "as for the Zen painter . . . the spirit of the painter" (Masson). European art which at first paid for the abandonment of illusionist Renaissance perspective with the renunciation of three-dimensionalism and had—under the influence of Japanese woodcuts—become flat arrives at a new concept of space which is not only the external space of the world but at the same time the inner space of the soul—this achievement it owes to Japanese ink painting.

Founders of the East-West Synthesis
The first substantial encounters with the spirit and form of Far-Eastern ink painting is found in various parts around the year 1925, quite independently: Mark Tobey in the USA, Julius Bissier and Willi Baumeister in Germany, and André Masson in France are the early masters of the East-West synthesis, even if their work does not always bear visible traces of their concerns and preoccupations in this respect. Nevertheless, eastern philosophy and art remain a generative ferment which has a decisive part to play in important periods of their work.
In Seattle in 1923, Mark Tobey is instructed in calligraphic traditions by the Chinese student, Teng Kuei: brush tech-

nique, compositional forms, cultural context. The idea of a "Pacific School" (it was hardly more than an idea) which is as open to the Far East as New York and Boston are to Europe also arises at this time. In 1934, Tobey visits China and Japan, meditates for a month on Kyoto painting as "concentration" and "consecration." Self-immersion of endless patience have characterized his work since then. In 1934, the series with the Zen title "The World of Animals under the Moon" is the first result of his encounter. In his series of "white writings" he has adopted calligraphic impulses since 1935, moving lines which spin a filigree network over the surface of the picture. From now on Tobey develops in extreme sublimation the calligraphic melody of the line to a universal chamber music. As much as the detailed care and minute completeness of this meditative technique and the patience of the execution to the end manifested therein is deeply rooted in European traditions, as fascinating as is the combination of Tobey's light traces with the vibrating electric lights and signs of the western city after dark, nevertheless, he is still deeply indebted to the Orient in the unity of the calligraphic characters with the immaterial spatial ground.
Other pictures and prints, particularly the sumi drawings of 1957, lay stress on the isolated calligraphic sign. His late production strews ornamentally calligraphic elements over the surface. Morris Graves' friendship with Tobey results in his conversion to Zen Buddhism. His subject matter: the animal, whose incorporation in nature and universe becomes the symbol of Graves' own experience of life, his own contemplation of the universe. The technique of "white writing" is combined in his "Inner Eye Series" or in his "Chinese Bronze Series" with western Romanticism: the result is prints of rare mood and enchantment.
One may dispute whether it was Jules Bissier or Willi Baumeister who first came into contact with Zen and Taoism in Germany. Bissier will have had his first discussions with Ernst Grosse, the sinologist, about the philosophy and art of the Orient. In 1930 he meets Brancusi in Paris who, on the way to absolutely essential sculpture, is reflecting on the insights of the East. This acquaintance marks a turning-point in Bissier's life: from 1930 to 1947 he devotes himself exclusively to work in Chinese ink: the production of these years are kernel works of the East-West synthesis. The utter silence of the ego, the waiting for the voices from the emptiness, the im-

mersion in their evocative depth take place so completely in accord with eastern meditation in a way probably only equalled in Tobey's work.
But Bissier also approaches the Chinese masters in his use of the technical means, always indepted to them but never purely imitative. Every sign is a completely abstract symbol, the coincidence of first concept with the perfected vision. The basic form of Mu Chi's famous six kaki persimmons are transmuted into the definite mould (should one add: which develops vitally?) of the male-female symbol of unity. The bipolarity of life is transmitted as the compositional opposed pairs of perfect singularity. From 1943 Bissier incorporated colour as well. From 1955 he changed from Chinese ink to egg and oil tempera: the calligraphic stroke gives way to sensitively placed flat figures whose relationship to the white of the ground, to the emptiness, is still related to the art of the Far East. Almost at the same time Baumeister turns his gaze to the east. Just as Tobey visits the Zen places of contemplation in China and Japan, Baumeister immerses himself in Germany, as if imprisoned, in writings and works. His definitions in "The Unknown Element in Art" reflect the Zen emptiness. This becomes for Baumeister the prerequisite for artistic intuition. Certainly the encounter begins in the twenties but it is only from 1938 that the inward path takes on visible external form. In the series of "Torii" executed in the forties, Baumeister merges calligraphic reminiscences with the buildings of Shintoism to monumental signs. Other than in Tobey, Bissier, Baumeister, Masson's encounter takes place on the broader basis of Surrealist écriture automatique: the endeavour to release subconscious psychic energies, to oppose an "it paints" to a conscious aesthetic "I paint". We have already cited Masson's reference to the Zen Buddhist bow that becomes the archer. Masson comprehends only too well the deeper wisdom of the eastern works and the subjectivism of the Surrealist creations, but it is precisely the interpretation of the Far East under the aspect of the psychogram and of the brushstroke liberated from the deliberate movement of the hand and the apparently freely running ink which contributes the fruitful impulse that the emigrant is able to impart to the Americans after 1942.
Among Surrealist artists, the latent tendency to react to Far-Eastern stimuli is a relatively late phenomenon. Although Masson had esteemed the ink painters from 1925, and made the acquaintance of

Sung painting in the splendid collection in Boston and embraced the cause of this "Art of the essential" in a brilliant essay, the influence of calligraphy only takes on visible form in his work during the fifties. Masson's declared purpose was to create an eastern experience of space with western means. In a self-portrait, a paraphrase of the early ink paintings of patriarchs, the artist acknowledges expressis formis his Japanese inspiration.

From 1927 to 1937 Henri Michau makes several journeys to the Far East; mescaline helps him achieve the extinction of his ego. However, it is less the graphically accentuated drawings while under the influence of mescaline which evoke Far-Eastern impressions, but rather his water-colours and gouaches.

Among the Surrealists, Max Ernst merges écriture automatique, cryptographic mystification and collage effects again and again with the external forms of eastern calligraphy in his series of engravings "Maximiliana." One can hardly speak of a deep relationship here, yet this work, as also the illustrations to Lewis Carroll, does witness to the complex fascination of eastern calligraphy even where the intentions of the artist are far removed.

Calligraphic Tendencies up to the Present Day

Since World War II and entirely since 1950 these early links with Far-Eastern ink painting and calligraphy have merged into one. On the geometrical construction of the thirties and the "mythical" ideo-grams of the forties has followed a scriptural tendency on a broad basis ranging from Pollock's dynamic, virtual bursting of the bounds of space to the oversensitized self-contemplation of Wols. Catchwords: abstraction lyrique, action painting, abstract expressionism, tachisme, informel. Here the priority of the European or of the American initiatives is not important: whether the invention of "dripping" should be traced back to Max Ernst via Pollock or whether Mathieu stands at the beginning is far less important than the fact of the parallelism of the phenomena on the European and the American artistic scene.

Tobey, Bissier and Baumeister saw painting as a quiet process of meditation. Now the ecstatic art of painting itself dominates: the freeing and ordering of the painter's hand, the merger of stroke and graphic trace. This corresponds to those Tchan monks who, as Masson tells us, are supposed to spit the paint on to the paper. It also corresponds to the eastern

teaching that the brush, even where it is not applied, must keep on moving until the living organism of the drawing has been completely painted. As early as 1937, Chang Ching Ming declared that

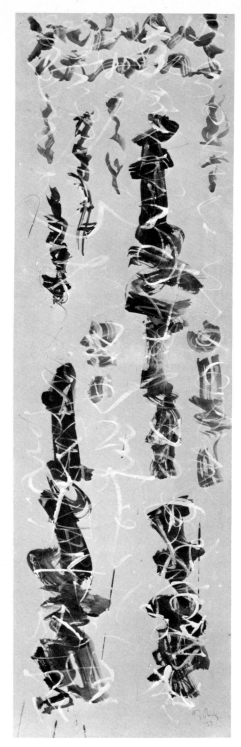

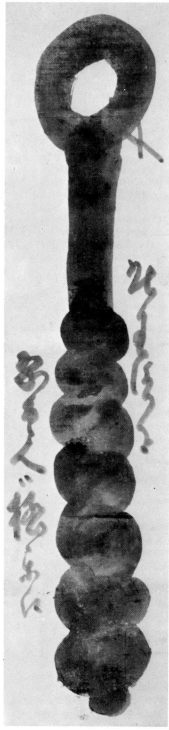

1659　Hakuin, Iron Bar ▲

◄ 1588　Tobey, Without title

1651　Kiai Tsin,
Cursive Script (detail) ▶

▲ 1637 Kline, Caboose ▼ 1638 Motherwell, Elegy for the Spanish Republic

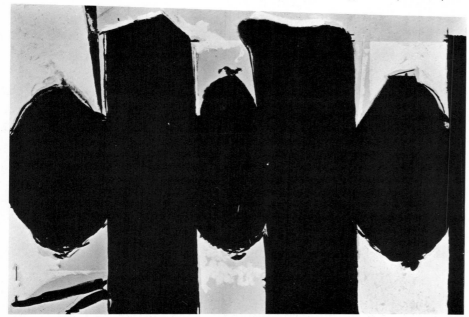

In the USA, the lines can be traced back most clearly. Firstly, Tobey, whose influence since his first New York exhibition in 1944 has continually increased, prepares the soil. The Pacific influx of ideas thus brings directly Far-Eastern elements to New York in the forties (where at the moment all art-historical advances are concentrated). The Surrealist écriture automatique, which Masson has been mediating since 1942, takes on greater importance: Masson is one of the great stimulators of the New York School in the écriture of which there has been a marked element of eastern influence from the beginning. Oriental impulses are thus acting on American painting in two indirect ways, even before the direct encounter which is added quite perceptibly after 1950.

Nevertheless it would be wrong to seek Far-Eastern influence in all script-oriented Americans. Pollock's psychic, physical actionism stands apart. Differentiation is necessary elsewhere, too.

Franz Kline, whose pictures have been lyrically received by the abstract calligraphists of Japan, himself emphasizes the separation: oriental script is located on an endless surface, before an unlimited space; the paper is the ground and nothing else. In contrast, the bundles of energy in Kline's black beams are stretched over a surface of almost exactly measured format: a specifically western view of the picture which has its roots in Giotto and van Eyck. There is no contradiction when we add that this subtle fabric of beams and the tempo of the act of painting draw close to the external manifestations (not, however, to the compositional syntax) of Far-Eastern calligraphy.

At the end of the fifties, Robert Motherwell concentrates the largescale beams of his pictures, like Kline, as monumental signs of calligraphic effect. The oils attempt to produce Chinese ink effects, as witnessed to also by the restriction to black and white. However, when Motherwell writes: "My Spanish elegies are free associations. Black is death, white is life, éclat…," his renunciation of the rainbow variegation of the world has little to do with the oriental spiritual approach: he emphasizes dualism, instead of abolishing it – the European spirit in eastern-oriented forms.

We have already referred to Gottlieb's Taoist, bipolar formal vocabulary that mixes "ink-blot pictures" with "brushes." Gottlieb's pictures tend towards meditation and thus connect up with the more tranquil calligraphic lyricism of a Twombly or Tomlin.

the Chinese script was a dead gesture. These are the components which are influential now.

Without a doubt the movement is autarchic in its beginnings: since Kandinsky's and Arp's first attempts at an écriture automatique (1916), the European line has been continuous; the distinctions from oriental art are evident.

Instead of the meaningful sign, the product of contemplation, we are often faced with the monumental or intimate psychograph, alongside the purely calligraphic cantilena. We may concede to the sinologists: the history of the extra-European reception is in the last analysis also a history of fruitful misunderstandings.

The European tendencies concentrate on the École de Paris (which also attracts some important Belgian artists) and in Germany Wols was the tragic example: the flourishing microstructures of his sensitive inspiration, which are self-destructively subjective and yet world-embracing in one, are located outside the sphere of oriental influence, although they prepare the way for impulses from the East. Hans Hartung, too, who has produced ink paintings since the thirties which are imbued with Far-Eastern freedom, anticipates much that is to come. However, the écriture automatique seems to have contributed less to developments here than in the USA.

Instead of the American monumental simplification of forms, the Europeans cultivate a more sensualist approach to colour: dramatic tension becomes explosive (Sonderborg), weight meditative (Soulages), but there is also a certain elegance about the brushwork which at times amounts to a cultivated calligraphic arrangement.

Mathieu remains, within the framework of the École de Paris, a central figure for the East-West encounter, even if the theatrical mise-en-scène of his own person has rather tended to conceal than underline his significance for the abstraction lyrique. His interpretation of oriental calligraphy under the aspect of speed has marked out the basic tendency of the encounter down to the present day: emptiness, concentration, rapid action are the guarantee of the spontaneity of the psychograph. At the other extreme to Mathieu's scintillating capriccios stands the heavy fabric of beams of Pierre Sou-

lages which has recently begun to take on more and more something of the lissomness of calligraphy: abstract icons, meditations on black symbols, within the compass of calligraphy, but imbued with a grandiloquence alien to the East. Jean Degottex has concerned himself most intensively with Zen Buddhism ever since Breton, in 1955, pointed out the affinity of his painting: virtuose brushwork, abstract scriptoral features which flash forth from a black or white ground, extreme format (kake-mono) characterize a new stage in the synthesis. Between Far- and Near-Eastern script Camille Bryen (one of Mathieu's first companions along the road to abstraction lyrique) and Henri Dotremont have developed a style of their own. Hans Hartung does not take Far-Eastern art as his starting-point but is drawn towards it via the psychograph. Complete openness of approach to any psychic impulse, liberation and sovereign compression of the gesture creates a line complex of the highest calligraphic tension. The pictures of the late fifties evoke the classical theme of the East: bamboo. Other than these pictures, which are built up in carefully applied layers of paint and thus redirect us back to European traditions, the ink drawings cast a bridge to the East by the very aesthetic nature of the medium used.

The Belgian Pierre Alechinsky, who studied calligraphy in Japan, has translated the calligraphic impulse into art informel. His variations on Sengai's "Signs of the Universe" are the expression of a genuine empathic approach to Zen Buddhism: circle, triangle, rectangle,

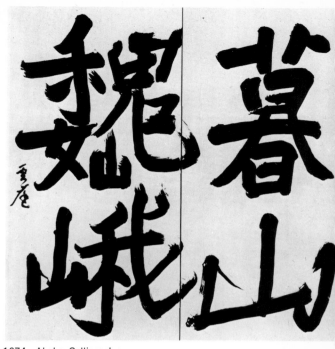

1674 Akaba, Calligraphy

the simplest symbols for the unity of the world, receive a lithographical framework within which the pencil is restlessly on the move; in the western urge for action the lines entangle, but all the loops and confusion conduct the viewer back again and again to the circle, triangle, rectangle. The step to the idea of Antonio Tapies, one of the great artists of the informel tendency (or however we like to charac-

1626 Soulages, 27. 3. 71

1605 Michaux, Without Title

terize his work), is short: he telescopes the Sengai signs; he anchors them on the basis of the triangle with two crossbeams which seem like fragments of a calligraphy. In 1949 various artists associate in the group ZEN 49: Baumeister, Cavael, Geiger, Winter and others; Bissier, Nay,

1635 Dotremont, En hiver...

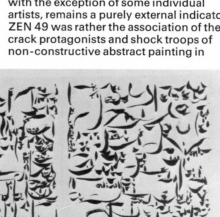

Sonderborg, H. O. Götz join the group later. The main representatives of the eastern trend are among these artists. The very name points to a professed programmatic intention, although this, with the exception of some individual artists, remains a purely external indicator. ZEN 49 was rather the association of the crack protagonists and shock troops of non-constructive abstract painting in

Germany; they combined for as long as they felt collective action was necessary. After 1955, the task set had been fulfilled, so that the group breaks up. For the rest, the scriptory trends in Germany run parallel to international developments. In 1950, Sonderborg begins – like Kline – with ink drawings the dynamic blots and patches of which integrate the speed of the recording. On pictures of largescale format associations with modern technology, of dynamism and intoxication with speed, are added to the calligraphic impulse: it is precisely this combination which is the foundation of a specifically German variety of psychographic painting. In a similar way, H. O. Götz incorporates tempo in his headlong scripts – in so doing he expressly refers to Japanese calligraphy. Close contacts link up with Morita who consciously strives to synthesize traditional Japanese calligraphy with modern abstraction and whose periodicals are read by numerous European artists. Finally, towards the close of the fifties, calligraphy also points the way to a recordering of the informel. However, the central phase in which eastern calligraphy and ink painting come into contact with and overlap western abstraction, comes to an end after 1960, even if the painters who have their roots in that decade have remained true to this encounter in their creative endeavours down to the present day.

Translation P. J. D.

1588 *Mark Tobey (Canterville, Wisconsin 1890, lives in Basel, Switzerland); Calligraphy without a title;* tempera on wood; 19×30.5 cm; sig. bottom right: Tobey 53; Seattle, Art Mus.; plate

1589 *Mark Tobey; Attuned to Genesis;* tempera on paper; 100×70.5 cm; sig. bottom right: Tobey 1970; Basel, Gall. Beyerle

1590 *Mark Tobey; October;* tempera on wood; 95.3×78 cm; 1957; Basel, Gall. Beyerle

1591 *Morris Graves (Fox Valley, Oregon 1910, lives at Seattle); The Individual State of the World;* gouache on paper; 76×61 cm; 1947; New York, Mus. of Modern Art

1592 *Morris Grayes; Blind Bird;* gouache on paper; 82×64 cm; sig. bottom left: Blind Bird; 1940; New York, Mus. of Modern Art

1593 *Hua Yen (1682–1762); Singing*

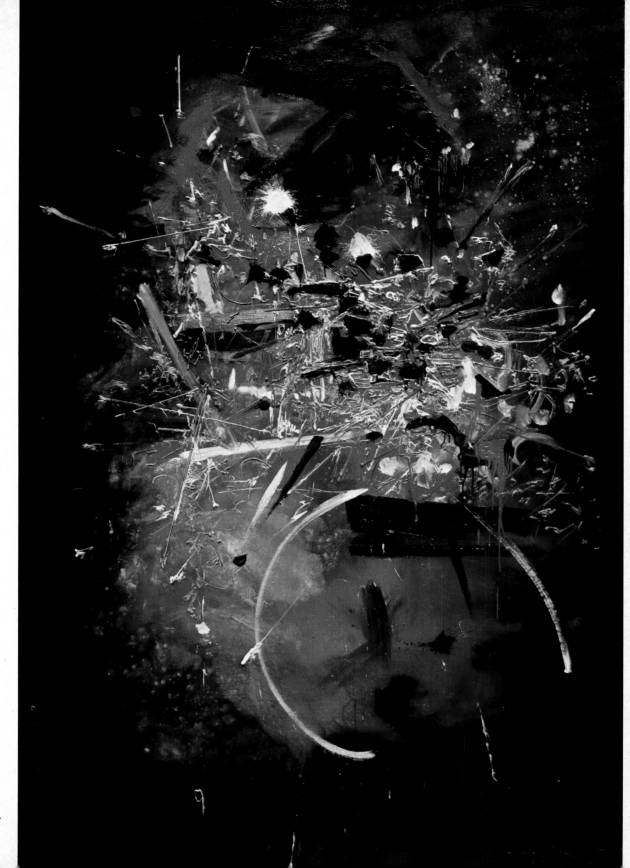

1627 Mathieu, "Le dernier
Festin d'Attila"

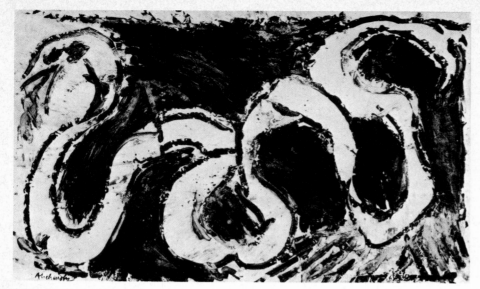

1633 Alechinsky, Living Cobra

Bird at the Waterfall; ink on paper;
76×37 cm; Luzern, Chiang Er-shih Coll.

1594 *André Masson (Balagny, Oise
1896, lives in Paris); Migration en Vert;*
oil on canvas; 150×60 cm; 1959; Paris,
Gal. Louise Leiris

1595 *André Masson; Migration 3;* oil on
canvas; 81×100 cm; Paris, Gal. Louise
Leiris; plate

1596 *André Masson; Chinese Actors;*
coloured etching; 57×76 cm; sig. bottom
left: A. M. 55; Paris, Gal. Louise Leiris

1597 *André Masson; Chinese Actors;*
coloured etching; 76×57 cm; sig. bottom
left: A. M.; 1957; Paris, Gal. Louise Leiris

1598 *André Masson; Message in May;*
coloured lithography; 65×50 cm; 1957;
Paris, Gal. Louise Leiris

1599 *André Masson; Whirl;* coloured
lithography on paper; 66×50.5 cm; 1956;
Paris, Gal. Louise Leiris; plate

1600 *André Masson; The Great Moun-
tain;* coloured lithography; 53×36.5 cm;
1951; Paris, Gal. Louise Leiris

1601 *André Masson; Woodcocks;* col-

oured lithography; 46×64 cm; 1952;
Paris, Gal. Louise Leiris

1602 *André Masson; Voyage to Venice;*
text by André Masson with 41 coloured
lithographies; 1952; Paris, Gal. Louise
Leiris

1603 *Tch'en Pong-Nien (1664–1723);
Calligraphy in cursive script;* ink on
paper (ts'ao); 160.5×41 cm; sig. bottom
left: two stamps of the calligrapher, two
collector's stamps; Luzern, Chiang Er-
shih Coll.

1604 *Wen Tcheng-Ming (1470–1559);
Calligraphy in cursive script;* ink on
paper; 109.5×33.5 cm; sig. bottom left:
two collector's stamps; Luzern, Chiang
Er-shih Coll.

1605 *Henri Michaux (Namur 1899,
lives in Paris); no title;* ink on paper;
57×75.5 cm; sig. bottom right: M; 1961;
Munich, Van de Loo Gall.; plate

1606 *Wou Hi-Tsai (1799–1870);
Calligraphy in cursive script (ts'ao);* ink
on paper; 116×53.5 cm; sig.: two stamps
of the calligrapher, two collector's
stamps; Luzern, Chiang Er-shih Coll.

1607 *Henri Michaux; no title;* sepia on
paper; 48×64 cm; sig. bottom right: M;
1962; Munich, Van de Loo Gall.

1608 *Henri Michaux; no title;* ink on
paper; 50×65 cm; sig. bottom right: M;
1961; Munich, Van de Loo Gall.

1609 *Max Ernst (Brühl, Cologne 1891,*

1630 Degottex, Hagakure (VII)

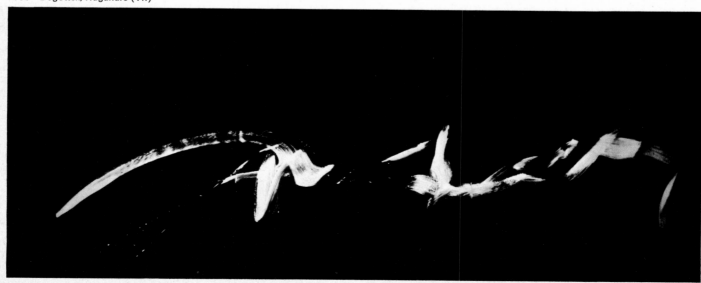

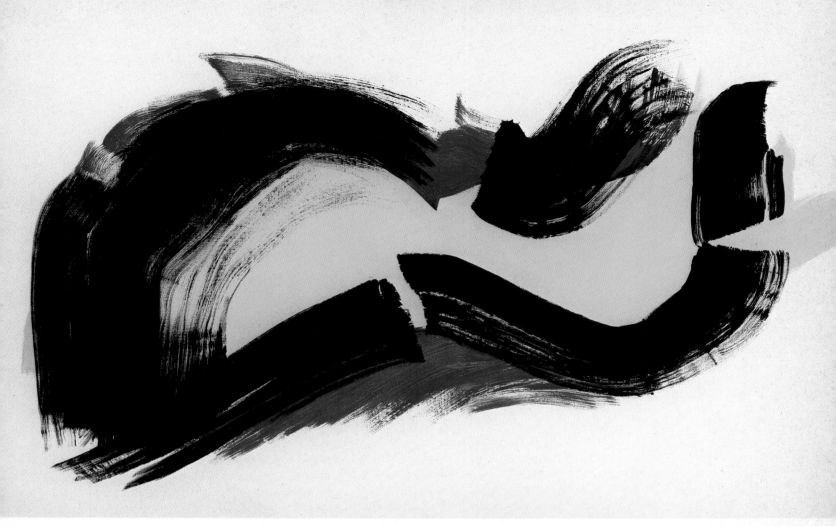

1624 Hartung, T1971–H19

1663 Takuan, Calligraphy

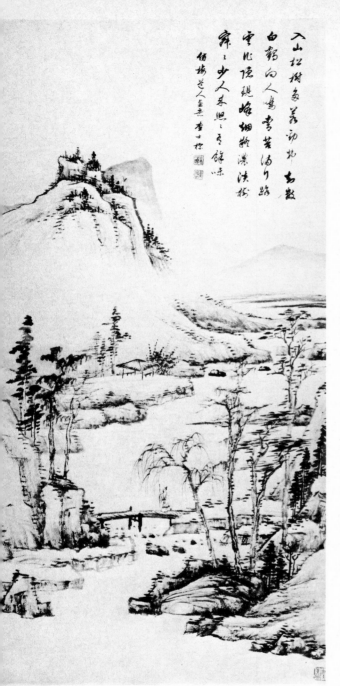

入山松樹多蒼勁北古歓
白頭向人啼苦涛り路
雲此渓頭峭物漠淡拎
屏々少人未照り令餘味

佰梅老人畫屏

1653 Wang Mong, Landscape

lives at Huismes); *Maximiliana*; etchings; Brühl, Stadt Brühl

1610 *Willi Baumeister (Stuttgart 1889–1955)*; *Tori*; oil on canvas; 100×73 cm; sig.: Baumeister; 1938; Stuttgart, priv.coll.

1611 *Joan Miro (Barcelona 1893, lives near Barcelona)*; *Triptych*; oil on canvas;

150×14 cm, 133×16 cm, 150×14 cm; sig. bottom left: Miro; 7. 8. 1963; Barcelona, Gift of Joan Miro to the city of Barcelona

1612 *Julius Bissier (Freiburg in Breisgau 1893–1965 Ascona)*; *Male-Female Symbol of Unity*; ink on Japanese paper; 24.5×16.6 cm; sig. top left: 1934 Julius Bissier; Düsseldorf, Kunstslg. Nordrhein-Westfalen

1613 *Julius Bissier*; *Nests in the Thorn Bush*; ink on white Ingres paper; 63×47 cm; sig. top right: 38 Julius Bissier; 1938; Düsseldorf, Kunstslg. Nordrhein-Westfalen

1614 *Julius Bissier*; *25. 12. 55*; ink on pink Ingres paper; 49×62.2 cm; sig. bottom left: Julius Bissier 25. 12. 55; Düsseldorf, Kunstslg. Nordrhein-Westfalen

1615 *Julius Bissier*; *7. 6. 56*; ink on Ingres paper; 24.8×31.2 cm; sig. bottom right: 7. 6. 56 Julius Bissier; Düsseldorf, Kunstslg. Nordrhein-Westfalen; plate

1616 *Julius Bissier*; *28. 10. 57*; ink on Japanese paper; 52.3×39.3 cm; sig. bottom right: Julius Bissier 28. 10. 57; 1957; Düsseldorf, Kunstslg. Nordrhein-Westfalen

1617 *Julius Bissier*; *8 Oct. 58 Ascona*; egg and oil tempera on linen; 17.5×26.8 cm; sig. bottom left: Julius Bissier, 8 Oct. 58, Ascona; 1958; Düsseldorf, Kunstslg. Nordrhein-Westfalen

1618 *Julius Bissier*; *Monti 60. 59*; egg and oil tempera on gold and cotton; 19.2×21.8 cm; sig. top left: Monti 60, 59 Julius Bissier; 3. 6. 1960; Düsseldorf, Kunstslg. Nordrhein-Westfalen

1619 *Julius Bissier*; *24. 5. 62 K*; watercolour on white Ingres paper; 16.7×23.9 cm; sig. centre: 25. 562 K Julius Bissier; 1962; Düsseldorf, Kunstslg. Nordrhein-Westfalen

1620 *Hans Hartung (Leipzig 1904, lives in Paris)*; *drawing*; ink on paper; 47.8×31 cm; sig. bottom left: HH 37; Paris; owned by artist; plate

1621 *Hans Hartung*; *drawing*; black crayon; 32×30.5 cm; sig. bottom right: H. Hartung 8. 1. 24; Paris, owned by artist

1622 *Hans Hartung*; *drawing*; ink on paper; 47.8×30.5 cm; sig. bottom left: HH 37; Paris, owned by artist

1623 *Hans Hartung*; *drawing*; ink on paper; 79×60 cm; sig. bottom left: HH 38; Paris, owned by artist; plate

1624 *Hans Hartung*; *T 1971–H. 19*; oil on canvas; 154×250 cm; 1971; Paris, Gal. de France; coloured plate

1625 *Pierre Soulages (Rodez 1919, lives in Paris)*; *Composition No. 30*; oil on canvas; 162×114.5 cm; sig. bottom right: soulages; 1956; Munich, Bayerische Staatsgemäldeslg.; plate

1626 *Pierre Soulages*; *27. 3. 71*; oil on canvas; 162×434 cm; 1971; Paris, Gal. de France; plate

1627 *Georges Mathieu (Boulogne-sur-Mer 1921, lives in Paris)*; *Le dernier Festin d'Attila*; oil on canvas; 302×210 cm; sig.: Mathieu; Paris, owned by artist; coloured plate

1628 *Georges Mathieu*; *The Birth of Osiris*; oil on canvas; 97×162 cm; sig.: left centre: Mathieu 70; Paris, owned by artist

1629 *Georges Mathieu*; *Pelée*; oil on canvas; 97×195 cm; sig.: Mathieu 1970; Paris, owned by artist

1630 *Jean Degottex (Sathoney 1918, lives in Paris)*; *Hagakur (VII)*; oil on paper, mounted on wood; 240×106 cm; November 1957; Paris, owned by artist; plate

1631 *Jean Degottex*; *IBN*; ink on paper; 105×75 cm; sig. bottom right: Degottex 1962; Paris, owned by artist

1632 *Jean Degottex*; *Ishet (I)*; ink on paper; 105×75 cm; sig. bottom right: Degottex 25. 4. 62; Paris, owned by artist

1633 *Pierre Alechinsky (Brussels 1927, lives in Paris)*; *Living Cobra*; ink on paper, mounted on canvas; 124×250 cm; sig. bottom left: Alechinsky; 1966; Paris, Gal. de France; plate

1634 *Pierre Alechinsky*; *Tête chercheuse*; ink on paper, mounted on canvas; 154×240 cm; 1967; Paris, Gal. de France

1635 *Christian Dotremont (Tervuren 1922, lives in Paris)*; *En hiver un jour lapon donc de nuit …*; ink on paper; 136×201 cm; sig. bottom left: Dotremont 1971; Paris, Gal. de France; plate

1636 *Zao Wou-Ki (Peking 1920, lives in Paris)*; *18. 1. 68*; oil on canvas; 130×162

cm; sig. bottom right: Zao Wou; 1968;
Paris, Gal. de France; plate

1637 *Franz Kline (Wilkes-Barre 1910–
1962 New York); Caboose;* oil on canvas;
202×272 cm; sig. on back: Kline 1961;
New York, Marlborough-Gerson Gal.;
plate

1638 *Robert Motherwell (Aberdeen,
Washington 1915, lives in New York);
Elegy for the Spanish Republic;* oil on
canvas; New York, Marlborough-Gerson
Gall.; plate

1639 *Robert Motherwell; Africa Series,
Print 1;* screen printed on paper; 80.7×60
cm; sig. bottom: Motherwell; 1970;
Zürich, Marlborough Gal.

1640 *Robert Motherwell; Africa Series,
Print VIII;* screen printed on paper;
80.7×60 cm; sig. bottom right: Mother-
well; 1970; Zürich, Marlborough Gal.

1641 *Robert Motherwell; Africa Series,
Print X;* screen printed on paper; 80.7×70
cm; sig. bottom right: Motherwell; 1970;
Zürich, Marlborough Gal.

1642 *Adolph Gottlieb (New York 1903,
lives in New York); Open 1968;* acrylic
paint on canvas; 212×278.7 cm; sig. on

back: Gottlieb; 1968; Zürich, Marl-
borough Gal.

1643 *K. R. H. Sonderborg (Sonderborg,
Denmark 1923, lives at Stuttgart); no
title;* ink on paper; 63×49 cm; sig. bottom
right: Sonderborg 58; Munich, Van de
Loo Gall.; plate

1644 *K. R. H. Sonderborg; no title;* ink
on paper; 49×63 cm; sig. bottom right:
Sonderborg 59; Munich, Van de Loo Gall.

1645 *Arnulf Rainer (Baden bei Wien
1929, living in Vienna); The Samurai and
the fly;* crayon, ink, photo on paper,
61.5×50.5 cm; sig. left of the mid:
A. Rainer; 1971; Munich, Gall. van de Loo

1645 a *Arnulf Rainer; Portrait of Samuel
D.;* oil, ink, photo on paper; 61.5×50.5
cm; sig. bottom right: A. Rainer; 1971;
Vienna, owned by artist

1646 *Pierre Alechinsky; Variations after
Sengai's Sign of the Universe;* lithograph
and ink on paper; 55×76 cm; 1960;
Munich, Gall. van de Loo; plate

1647 *Antonio Tapies (Barcelona 1923,
lives in Barcelona); Sign;* ink and circles
on paper; 45×64 cm; sig. bottom right:
Tapies 1965; Munich, Van de Loo Gall.;
plate

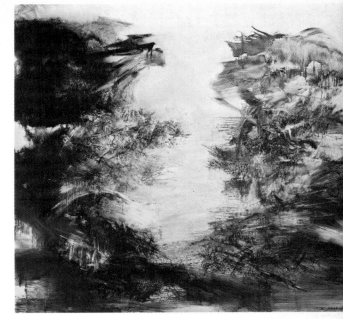

1636 Zao Wou-Ki, 18. 1. 68

1648 *Teng Che-Jou (1743–1805);
Calligraphy in Seal Style (chuan);* ink on
paper; 168×39.5 cm; sig. bottom left:
two stamps of the calligrapher, two col-
lector's stamps; Luzern, Chiang Er-shih
Coll.; plate

1649 *Antonio Tapies; Graphisme
Central,* acryle on japanese paper, 93,5×
64 cm; sig.: Tapies 1967; Munich, Gall.
van de Loo; plate

1650 *Chao Chi-Ts'un (1781–1860);
Calligraphy;* ink on paper; 114×37 cm;
Luzern, Chiang Er-shih Coll.

1651 *Kiai Tsin (1369–1415); Calli-
graphy in cursive script (ts'ao);* ink on
paper; 123×58.5 cm; sig. bottom left:
two stamps of the calligrapher, four col-
lector's stamps; Luzern, Chiang Er-shih
Coll.; plate

1652 *Chinese (19th century); books of
model scripts;* stone rubs; Cologne, Mus.
für Ostasiatische Kunst

1653 *Wang Mong (c. 1309–1385);
Landscape;* ink on paper; 120×50 cm;
Luzern, Chiang Er-shih Coll.; plate

1654 *Kano Eitoku (1543–1590);
Mountain Scenery with House and
Waterfall;* ink on paper; 29×48.5 cm;
Munich, Preetorius Coll.

1595 Masson, Migration 3

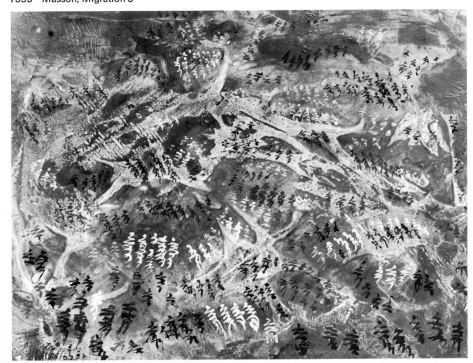

231

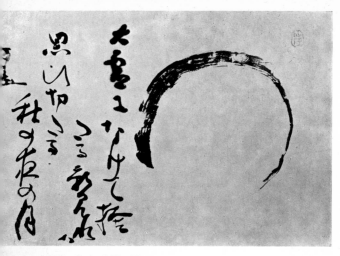

▲ 1671 Sengai, The Moon

1620 Hartung, Design ▶

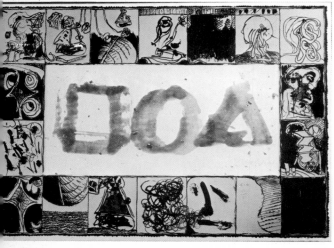

▲ 1646 Alechinsky, Variations after Sengai

1667 Sengai, Sign of the Universe ▶

▼ 1647 Tapies, Sign

1655 *Wen-chin (first half of 15th century); Shore with Buildings;* ink on silk; 122×68 cm; sig. top right: Wen-chin; Munich, Preetorius Coll.

1656 *Kano School (16th century); Winter;* ink on paper; 103.5×37.5 cm; Munich, Preetorius Coll.

1657 *Tch'a Che-Piao (1615–1698); Landscape;* ink on paper; 94×48 cm; sig. top right: two stamps of the artists; bottom right and left: two collector's stamps; Luzern, Chiang Er-shih Coll.

1658 *Ho-ling (14th century); Epidendrum;* ink on paper; 29×41 cm; sig. left: Ch-i-shih-erh weng Ho-ling hsie (painted by the seventy-two-year-old Ho-ling); Munich, Preetorius Coll.

1659 *Hakuin, Ekaku (1685–1768); Iron Bar (kanabo);* hanging scroll; ink on paper; 21.6×36.6 cm; Tokyo, Eisei-Bunko; plate

1660 *Hakuin; Siddham Sign (Bonji);* hanging scroll; ink on paper; 203×80.5 cm; two seals, magic sign (shuji) for a divinity; Tokyo, Eisei-Bunko

1661 *Hakuin; Daruma;* hanging scroll; ink on paper; 230×78.5 cm; two seals; Tokyo, Eisei-Bunko

1662 *Hakuin; Blind Man on the Bridge (Zatotokyo);* hanging scroll; ink on paper; 107×82 cm; ink painting in Haiga style, a shorthand style of painting with a short poem (Haiku); Tokyo, Eisei-Bunko

1663 *Takuan, Shùh (Iwade 1573–1645); Kakkikan;* hanging scroll; ink on paper; 94×127 cm; Tokyo, Idemitsu Mus.; plate

1664 *Isshi Bunshu (1608–1645); Kensu, the Priest (Kensu Osho);* hanging scroll; ink on paper; 206×62.5 cm; legendary figure of a priest eating a crab; Tokyo, Eisei-Bunko; plate

1665 *Sengai, Gibon (Mino 1750–1837); Radiating Spirit (kishin);* hanging scroll; ink on paper; 40×87 cm; calligraphy; Tokyo, Idemitsu Mus.

1666 *Sengai; Buji (muji);* hanging scroll; ink on paper; 26×26 cm; "Free of Activity"; Tokyo, Idemitsu Mus.; plate

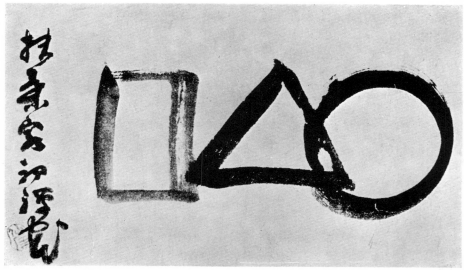

1667 *Sengai (1750–1837); Sign of the Universe;* ink on paper; 51 × 109 cm; Tokyo, Idemitsu Mus.; plate

1668 *Sengai; Sengai's Poem on Himself;* ink on paper; the text reads: "Buddha's community, it is said, numbered eighty-thousand souls; Confucius also had disciples, as many as three thousand. How happy this monk is that he is deserted by his fellow monks! Accompanied only by a cloud, he sleeps his long sleep on the rock." Tokyo, Idemitsu Mus.; plate

1669 *Sengai; The Bird Uso (Bullfinch);* ink on paper; the text, which refers to the custom of exchanging small Uso figures once a year to bring good luck, runs: "May the Uso birds of the world be exchanged for the makato; for, whether you pray or not to God, he will still care for you." Makato means truth and is a play on a second meaning of the word uso in the meaning of "lie"; Tokyo, Idemitsu Mus.

1670 *Sengai; Lightning;* ink on paper; the text reads: "With what shall I compare this life of ours? Before I can say it is a flash of lightning or a drop of dew it has passed"; Tokyo, Idemitsu Mus.

1671 *Sengai; The Moon;* ink on paper; the text reads: "When I look into the shadow thrown into the emptiness of space, how boldly the moon stands out against the autumn night"; Tokyo, Idemitsu Mus.; plate

1672 *Sengai; The Ladle and the Pestle;* the text reads "If the mother-in-law uses the ladle too strictly, the legs of the daughter-in-law will become as stiff as the pestle"; Tokyo, Idemitsu Mus.

1673 *Sengai; Sign of Emptiness;* ink on paper; Tokyo, Idemitsu Mus.; plate

1673a *Untei Akaba (Tokyo 1912, lives in Tokyo); Calligraphy;* ink on paper; 59 × 109 cm; 1972; text: "A woman's heart is touched"; Tokyo, owned by the artist

1674 *Untei Akaba; Calligraphy on Screen;* ink on silk; text: "Mountains, towering into the sky, in the evening sun"; Tokyo, owned by the artist; plate

1675/76 *Untei Akaba; Calligraphy;* ink on paper; each 318 × 90 cm; 1972; text: "World cultures and modern art"; Tokyo, owned by the artist

Asia
and Music
since
Debussy

Musical Exoticism around the Year 1900: Claude Debussy

Ramón Pelinski

The Cultural Crisis at the Close of the 19th Century

At the end of the last century, the culture of Europe was called into question as never before. The continual advances in technology discredited the rationalist viewpoint—the need was felt for a new approach more in keeping with the dynamism of modern life. The Bergsonian vision of reality as subject to incessant change was opposed to the positivist view of the world. The artist, convinced he was living at a time of decadence, sought refuge in flight, a flight which took the form either of "inner emigration" or of a genuine escape to far-off exotic lands.

Debussy and Exoticism

It is within this context of scepticism towards one's own European culture that the works of Debussy were written. Debussy showed a keen interest in distant lands. He liked to surround himself with objects d'art from far countries and greatly admired the fine detail of the Japanese woodcut — Hokusai's "Wave" adorned the title page of "La Mer" in the 1903 edition. After visiting an exhibition of Chinese art, he wrote to his publisher, Durand: "Ça ne se décrit, ni se raconte, mais je n'ai rien vu, ou rarement, atteindre une beauté aussi raffinée." His imagination was captured by literature of an exotic tinge: "Zuleima" (1886) after Heine's "Almanzor," "Chansons de Billitis" (1898), or the drama "Sidharta" of his friend Sengalen. The titles of some of his

Gamelan at the World Exhibition, Paris 1889
Drawing by René Lacker, B. N. Paris

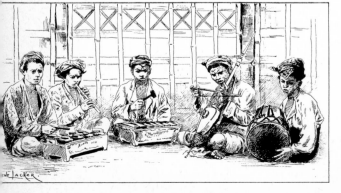

pieces witness to the same tendency: his Egyptian ballet "Khamma," "Pour l'Egyptienne," "Pagodes" and "La Terrasse des audiences du clair de lune."

The Paris Exposition Universelle, 1889, Encounter with Far-Eastern Music

However, this phase of imaginative stimulation pales into insignificance before Debussy's experience at the colonial exhibition of 1889 (held to commemorate the centenary of the French Revolution). There, among other things, he saw Asian musical instruments, heard Japanese Sho (mouth organ) music and Javanese gamelan, watched Cambodian dances and Vietnamese music-dramas. All this meant a real concrete encounter with the music of distant lands, an encounter which leaves its permanent mark on his work as a composer and is mentioned time and again in his writings: "Rapelle-toi la musique javanaise qui contenait toutes les nuances, même celles qu'on ne peut plus nommer, où la tonique et la dominante n'étaient plus que vains fantômes à l'usage des petits enfants passages," he writes in a letter to Pierre Louys in 1895. 24 years later, all the natural freshness of Far-Eastern music is still in his memory:
"Il y a eu, il y a même encore, malgré les désordres qu'apporte la civilization, de charmants petits peuples qui apprirent la musique aussi simplement qu'on apprend à respirer. Leur conservatoire c'est: le rythme éternel de la mer, le vent dans les feuilles, et mille petits bruits qu'ils écoutèrent avec soin, sans jamais regarder dans d'arbitraires traités. Leurs traditions n'existent que dans de très vieilles chansons, mêlées de danses, où chacun, siècle par siècle, apporta sa respectueuse contribution. Cependant, la musique javanaise observe un contrepoint auprès duquel celui de Palestrina n'est qu'un jeu d'enfant. Et si l'on écoute sans parti pris européen, le charme de leur percussion, on est obligé de constater que la nôtre n'est qu'un bruit barbare de cirque forain. Chez les Annamites on réprésente une sorte d'embryon de drame lyrique, d'influence chinoise, où se reconnaît la formule tétralogique; il y a seulement plus de Dieux, et moins de décors … Une petite clarinette rageuse conduit l'émotion; un Tam-Tam organise la terreur, et c'est tout! Plus de théatre spécial, plus d'orchestre caché. Rien qu'un instinctif besoin d'art, ingénique à se satisfaire; aucune trace de mauvais goût! — Dire que ces gens-là n'ont jamais eu l'idée d'aller chercher leurs formules à l'école de Munich: à quoi pensent-ils?"
InJavanese gamelan and the music-drama

of Annam Debussy saw a music which was capable of achieving incredible nuances, spontaneous freedom and supreme theatrical effect with reduced means. Certainly his impression of freedom was based on complete ignorance of the strict conventions underlying Far-Eastern music. However, this experience of the music of the Far East was not the cause of Debussy's style as a composer, but the opportunity which gave tendencies latent in his music the confirmation and enrichment they required.

The Break with Wagnerianism

Debussy's personal style as a composer is to a large extent the fruit of his rejection of Wagner. His encounter with the Vietnamese music-drama occasioned his confrontation with the Wagnerian music-drama, which he had got to know personally at Bayreuth (1888 and 1889). As a consequence of his experience of the Annamese music-drama, Debussy abandons florid melodrama and monumental scenic construction. It takes Debussy ten years to transform this experience into a valid counterpart to the Wagnerian conception: in his lyrical drama "Pelléas et Mélisande" (1902). However, more radical still is Debussy's break with Wagnerianism in the realm of the musical material which the composer has at his disposal. Wagner's chromaticism involves the tonal system in a crisis which will end in the complete dissolution of major-minor tonality at the beginning of the twentieth century: Wagner's chromatism strains the tonal material and produces an incessant modulation which imperils the traditional tonic relationships. Tonality is suspended in practice in atonality; the theoretical justification is provided by the "composition with twelve tones (notes) related only to one another" (Schönberg).
Debussy's solution to this problem of suspended tonality has certain parallels with the system of Javanese gamelan music. For the Wagnerian panchromaticism he substitutes the constructive use of a reduced tonal system in which especially the pentatonic (c, d, e, g, a, c) and the hexatonic (c, d, e, f ♯, g ♯, a ♯, c) scales have a decisive role. Characteristic of both of these scales is the absence of the semi-tone which, in contrast to chromaticism, imparts to the music a certain lack of tension and static scintillation. Javanese gamelan music is similar: the slendro and pelog systems are also based on five- and seven-note scales respectively which the performers build up into a static surface of sound by modifying the "kernel melody."

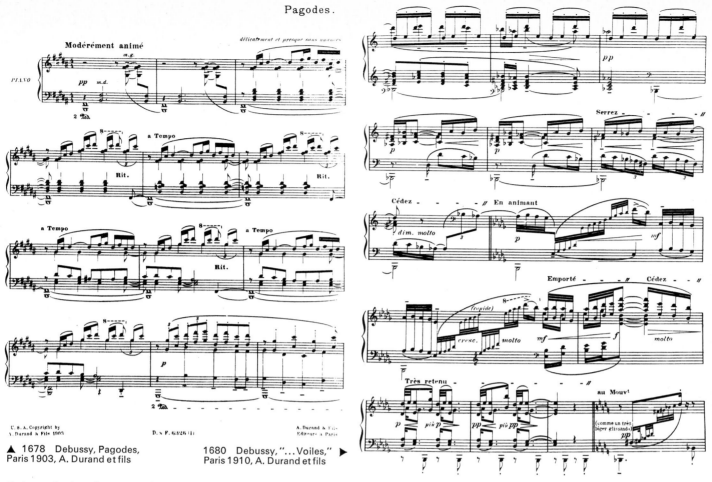

Pagodes.

▲ 1678 Debussy, Pagodes, Paris 1903, A. Durand et fils

1680 Debussy, "...Voiles," ▶ Paris 1910, A. Durand et fils

Debussy's abandonment of chromaticism and the consistent employment of reduced scales also has a tectonic function to fulfil, too. Debussy composes works which are based, not only in their melody but in the harmony, too, exclusively or mainly on the selected tonal material (pentatonic or whole-tone scales. In addition, Debussy aspires after a constructive alternation by which, in one and the same composition, he contrasts pentatonic and whole-tone scales.

He systematically tests the possibility of building up an overall sound which embraces all the tones of the selected scale. In place of the traditional chord relationships we have a static, hovering sound. An analogous principle would lead by another route and with diverse consequences to Schönberg's twelve-tone music. A free ornamentation technique helps produce this overall sound. In contrast to gamelan music in which the "kernel melody" (patet) is modified by layers of tone registers and heterophonic techniques, Debussy's ornamental figurations stand in a loose relationship to the main melody. The result is in both cases the same: a static scintillating surface of sound which is coincident with the selected scale and merely suggests the passage of time with undynamic means.

Debussy's rhythmic innovations are just as remarkable: the production of rhythmic mobility within the tonal mobility just described. The traditional system of the tonality-related beat is thus relaxed. Debussy's rhythm—based on the principle of the uniformity of the rhythmic duration—contains, in potency, elements of the succeeding generation of jazz-influenced composers. With V. Jankélévitch one could say:

"Debussy est tellement génial, qu'il contient déjà en lui-même tous les éléments de la future réaction antidebussyste. Debussy implique à la fois le debussysme et son propre contraire." However, in Debussy we also find another conception of rhythm which is to stimulate Messiaen and his successors.

Debussy's interest in Far-Eastern music was no "nostalgie du pittoresque à bon marché" such as we often find among the orientalizing composers of the nineteenth century. To him must be credited the insight that extra-European music can stand in complete accord with his own aims as a composer, is a worthy alternative. Extra-European man and his music is thus placed on an entirely equal footing.

Translation and Digest P. J. D.

235

Music Program

Far-Eastern impulses in the music of Claude Debussy

1677 *Indonesia; Sri Karuron; system: slendro; patet: sanga; BR, D. Dreyer V. D. T.; gamelan of the karton by Sultan of Surakarta, Sri Susuhunan Paku Buwani XII (Central Java, Indonesia)*

1678 *Claude Debussy (St-Germain-en-Laye 1862–1918 Paris); Estampes, 1903, No. 1: Pagodes; DSV 836.811; Werner Haas, piano: plate*

1679 *Claude Debussy; Images II, 1907, No. 1: Cloches à travers les feuilles; DSV 836.807; Werner Haas, piano*

1680 *Claude Debussy; Préludes I, 1910, No. 2: "… Voiles"; SLPM 13831; Monique Haas, piano; plate*

1696 Mahler, Das Lied von der Erde, Vienna 1912, Universal edition

Das Lied von der Erde

Aufführungsrecht vorbehalten.
Droits d'exécution réservés

I. Das Trinklied vom Jammer der Erde.

Gustav Mahler
(1860–1911)

Allegro pesante. (Ganze Takte, nicht schnell.)

Kleine Flöte.
1. 2. 3. Flöte.
1. 2. Oboe.
3. Oboe.
Klarinette in Es.
Klarinette in B.
3-Klarinette in B.
1. 2. Fagott.
3. Fagott.
1. 3. Horn in F.
2. 4. Horn in F.
Trompete in F.
3. Trompete in F.
1. 2. Posaune.
3. Posaune.
Glockenspiel.
Becken.
1. Harfe.
2. Harfe.

Allegro pesante. (Ganze Takte, nicht schnell.)

1. Violine.
2. Violine.
Bratsche.
Tenor-Stimme.
Violoncell.
Kontrabaß.

*) Klingt, wie angegeben!

Copyright 1912 by Universal-Edition.

U. E. 3391. 3397.

1681 *Java; Pangkur Laras (film); system: pelog in the patet barang with a change to slendro in the patet manjura; BR-Television; Klaus Kirschner, director; Pitt Koch, camera; Dieter Dreyer VDT, sound; gamelan of the kraton of the Sultan of Surakarta Sri Susuhunan Paku Bawana XII (Central Java, Indonesia)*

1682 *Maurice Ravel (Ciboure 1875–1937 Paris); Jeux d'eau, 1901; SVBX 5410; Vlado Perlemuter, piano*

1683 *Vietnam; Hat Tuông (Hat Boi); Traditional Music-Drama from Central Vietnam; recording: Trân-Van-Khê*

1684 *Claude Debussy; Pelléas et Mélisande, Paris 1902; Act V; Decca B. I. E. M. Set 277/279; sung by Erna Spoorenberg, Camille Maurane, George London, Guus Hoekman; played by L'Orchestre de la Suisse Romande, conducted by Ernest Ansermet*

1685 *Java; Tukung; system: pelog; patet: barang; BR, Dieter Dreyer VDT; gamel of the kraton by the Sultan of Surakarta Sri Susuhunan Paku Buwana XII (Central Java, Indonesia).*

1686 *Claude Debussy; Nocturnes, 1897/99, No. 1: Nuages; Lon. 6023; Orchestre de la Suisse Romande, conducted by Ernest Ansermet*

1687 *Claude Debussy; La Mer, 1903–1905, No. 1: De l'aube à midi sur la mer; CBS S 72533; New Philharmonia Orchestra; conductor: Pierre Boulez*

Influence of Gamelan Music in the 20th century

Western composers after Debussy have tried either to freely transpose gamelan music to the realm of the symphony orchestra (McPhee, Britten) or to reproduce its highly attractive instrumental sound (Orff, Cage, Messiaen, Kagel). Composers seeking new tonal and rhythmic experiences have been most inspired by Balinese gamelan because of its musical virtuosity, rhythmic complexity and wealth of percussion instruments. Percussion instruments like the gong, tom-tom, celesta and vibraphone together form a subdivision of the orchestra which is used to represent gamelan (Messiaen).

1688 *Bali; Pinda; Oleg Tamulilingan (Lobster Dance); Balinese gamelan music; system: pelog scale reduced to 5 notes (say e-f-g-b-c); Gamelan Gong*

Gedé, 23 instruments; recording: Rainer Goedl and Ramón Pelinski (18. 4. 70)*

1689 *Colin McPhee (Montreal 1901); Tabu-Tabuhan, 1936, Ostinato, Nocturne, Finale; Victor 1414 AB*

1690 *Bali; Blayu; processional music; portable Balinese gamelan; recording: Ramón Pelinski (16. 4. 1970)*

1691 *John Cage (Los Angeles 1912); First Construction (in Metal), 1939; Ma 30 926; Das Kölner Ensemble für Neue Musik; conductor: Mauricio Kagel*

1692 *John Cage; Sonatas and Interludes, 1946–1948, Nos. 5, 14, 15; BR; piano: Peter Roggenkamp*

1693 *Bali; Blayu; Ramayana Dance, with instrumental introduction; Balinese gamelan music; system: slendro; recording: Ramón Pelinski (16. 4. 70)*

1694 *Olivier Messiaen (Avignon 1908); Turangalila-Symphonie, 1946–1948, No. III: "Turangalila"; LSC-7051-B-1-2; Toronto Symphony Orchestra; conductor: Seiji Ozawa*

Contribution of Chinese and Indian Music

Around the year 1900, in a way parallel to Debussy's interest in Javanese music, we find definite traces of Chinese and Indian influence in the works of other composers of note: Mahler, Busoni, Ravel, Roussel, Stravinsky. On the one hand, this is partially a mere continuation of the orientalizing tendencies of the 19th century. On the other, the "exotic" elements either influence the very structure of the music or, as in Mahler, exercise an organizational function in the piece by being used as motifs.

1695 *China; Classical Chinese Music: "Song of Memory" (bells, cymbals, gongs, drums, mouth organ; P'i-P'a, T'i) Two Buddhist Chants (bells, symbalu, gongs, drums, hiao, seh); Berliner Phonogramm-Archiv, Laufer Coll.*

1696 *Gustav Mahler (Kalischt 1860–1911 Vienna); Das Lied von der Erde, 1908, Chinese poems translated by Hans Bethge: "On Beauty," "The Farewell"; Col. SMC 91639; mezzo-soprano: Christa Ludwig; tenor: Fritz Wunderlich; New Philharmonic Orchestra London; conductor: Otto Klemperer; plate*

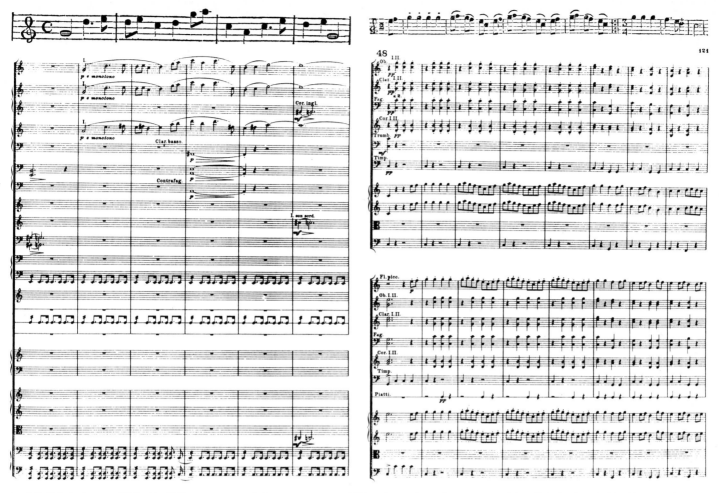

Tsi - tschong.

Air Bédouin.

top left: Tsi – tschong published by F. H. von
Dalberg in "Über die Musik der Inder," Erfurt 1802

1700 bottom: Busoni, Turandot, orchestral
suite, op. 41, Leizpig 1906, Breitkopf und Härtel

top right: Air bedouin, published by J. M. de la
Borde in "Essai sur la musique ancienne et
moderne," Paris 1780 B. I.

1697 *Igor Stravinsky (Oranienbaum near
St Petersburg 1882–1971 Hollywood);
The Song of the Nightingale, symphonic
poem, 1919: Chinese March;* SLPM
138006; Radio-Symphonie-Orchester
Berlin; conductor: Lorin Maazel

1698 *Maurice Ravel (Ciboure 1875–
1937 Paris); Ma mère L'Oye, Suite,
orchestral version, 1912: Laideronnette,
Impératrice des Pagodes;* Dec. SXL 2062;
Orchestre de la Suisse Romande; con-
ductor: Ernest Ansermet.

1699 *China; Classical Chinese Music;
"Visions of Life";* mouth organ (shêng)
and zither (ch'in); Berliner Phono-
gramm-Archiv

1700 *Ferruccio Busoni (Empoli 1866–*

*1924 Berlin); Turandot, orchestral suite,
op. 41, 1917, No. 6: Tanz und Gesang;
No. 8: In modo di marcia funebre e finale
alla Turca;* BR; Simphony Orchestra of
the BR; conductor: Meinhard von Zallin-
ger; plate

1701 *Giacomo Puccini (Lucca 1858–
1924 Brussels); Turandot, opera, unfin-
ished; completed 1926 by Franco Alfano;
III Act Tu che di gel sei cinta;* Electrola
SMA 914705; Soloists, Choir and Or-
chestra of the Rome Opera, conducted by
Gianni Lazzari

1702 *Carl Maria von Weber (Eutin 1786–
1826 London); Turandot, Overture;* cf.
Cat. no. 535

1703 *Paul Hindemith (Hanau 1895–*

*1963 USA); Symphonic Metamorphoses
C. M. v. Weber's Themes for Large Or-
chestra, 1943; Turandot, Scherzo;* Sym-
phonieorchester des Bayerischen Rund-
funks, conducter Raphael Kubelik

1704 *Maurice Delage (Paris 1879);
Quatre poèmes hindous, 1912;* SOL 298;
Melos Ensemble, London; Janet Baker,
mezzo-soprano

1705 *Javanese Gamelan;* see p. 238;
coloured plate

1706 *Audiovisual program of gamelan
music;* slides and recordings have been
made with the "Pramuda Budaja" game-
lan orchestra of the Tropical Museum of
Amsterdam

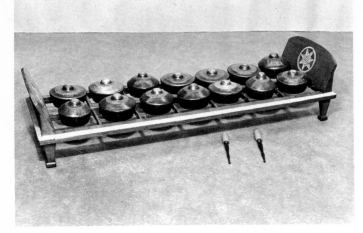

1705 Bonang

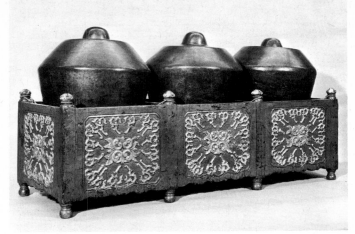

▲ 1705 3 Kenongs
▼ 1705 Gender barung

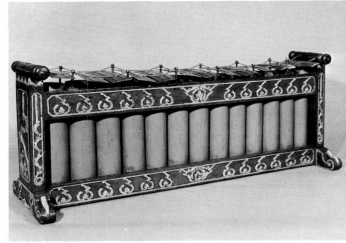

▲ 1705 Ketuk
▼ 1705 6 Kempuls, 1 Gong suwukan, 1 Gong ageng

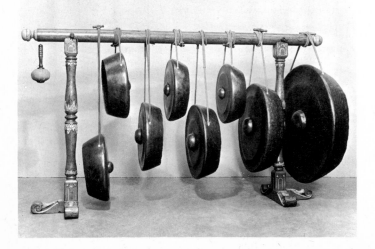

Gamelan Instruments

1705 Javanese Gamelan "Jjai Paridjata"; 26 instruments (two sets: slendro and pelog); Delft, Indonesisch Ethnografisch Mus. Delft.
Instruments punctuating the composition gong ageng: large vertically suspended gong; gong suwukan: small vertically suspended gong; 6 kempuls: small suspended gongs; 10 konongs: horizontally placed gongs; ketuk: one horizontally placed gong;
Instruments giving the central melodic theme of a piece of gamelan music: saron demung, slendro, a metallophone with metal bars over a resonance box; saron demung, pelog; saron barung, slendro; saron barung, pelog; saron panerus of Peking, slendro; saron panerus of Peking,

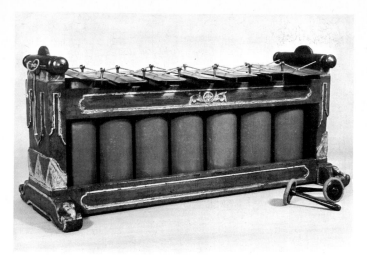

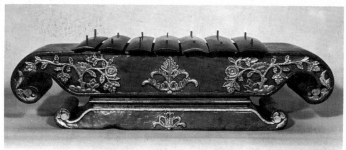

▲ 1705 Saron demung

▼ 1705 Gambang kaju

▲ 1705 Slentem

▼ 1705 Kendang tjiblon

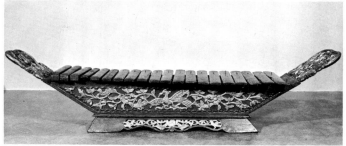

1705 Rebab

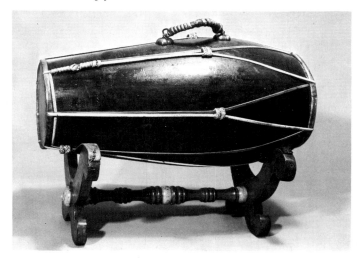

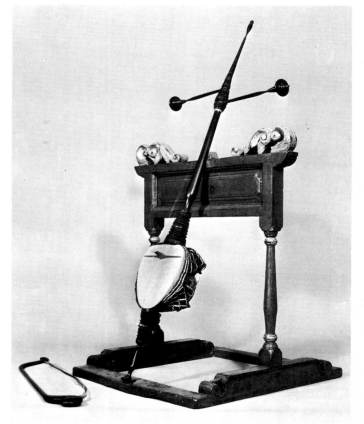

pelog; slentem, slendro, bass metallo-
phone with seven metal bars over reso-
nance pipes; slentem, pelog;
*Accompanying instruments producing
flourishes around the nuclear melody:*
bonang barung, slendro, a row of 14
flat-lying gongs; bonang barung, pelog;
bonang barung panerus, slendro; bonang
barung panerus, peolog; gender barung,
gender panerus, slendro; gender panerus,
pelog; pelog; gambang kaju, slendro,
xylophone; gambang kaju, pelog;
melody-bearing instrument: rebab: a
bowed string instrument; *agogic instru-
ments:* kendang gending, large two-
headed drum; kendang tiblon, small two-
headed drum

Africa Oceania Amerindia

Primitivism in Modern Art

Robert Goldwater

It has become the custom to refer to a "discovery," early in this century, of the so-called primitive arts, and to attribute to it certain radical alterations in the painting and sculpture of the modern era. The term refers to the fact that, about 1905, in Paris and Berlin, a number of artists of the avant-garde, unknown to each other, became conscious of the sculptures of Africa and Oceania, looked upon them with enthusiasm in museums and curio shops, and even began to acquire them for their own studios. This "discovery" (and the consequent primitivism it engendered), it is said, had fateful consequences; it did more than have an immediate influence upon the art of a few artists; it changed the course of western art in general in fundamental ways that are still evident today.

The phrase is of course an historical shorthand, and as such it is useful enough. So far as it goes, its reference is accurate: there is no doubt that Matisse, Picasso, Vlaminck and Derain in Paris, Kirchner and Nolde in Dresden and Berlin, did, rather suddenly, find artistic value in works until then largely ignored by artists and public alike (or examined by specialists only as ethnological documents), and, seeing certain qualities in them, derived inspiration for their own creations. The reverse is also true: the artists' vision, based upon a direct confrontation with culturally isolated individual examples, has continued to affect our appreciation of the aboriginal arts, often to the dismay of more objective, scientifically-minded investigators who believe that social understanding must precede any esthetic satisfaction. Thus in a certain sense an important discovery was made, however ethnocentric the implications of the word may be, and however partial our subsequent knowledge has revealed that first awareness to have been.

Like most such apparently fortuitous encounters, this one had been well prepared, and could indeed only have taken place against a background of events which made primitive art not only objectively available, but also subjectively accessible to two different groups of artists at almost the same moment. Seen within the narrower terms of art history and its influences, the immediate predecessor of the painters of 1905 and their "discovery" is of course Paul Gauguin. It was he who had been the first to

appreciate "Maori" art, to adapt some of its forms and motifs, just as it had been he who had abandoned Europe for a primitive mode of life in order to achieve a literal renewal of his art through a parallel simplification of its means. But though he was its most dramatic (and influential) embodiment before 1900, Gauguin was by no means alone in his yearning for the primitive. Quite generally, the artists of the symbolist generation looked backward to the sources and origins of art. Like Gauguin, for whom "the great error was the Greek," they admired and found inspiration in the arts of earlier and simpler times, arts whose strength and meaning were rooted in their still unbroken connection with the invisible, pervasive sources of creation. But these arts, to which the Symbolists gave the generic name of "primitive" (a term of praise), were anything but the product of rough aboriginal cultures, and were more refined than savage. They were besides very various, including as they did the Egyptian, the Assyrian, the Cambodian and the Japanese as well as the early Renaissance. Nevertheless, they were seen as sharing certain essential qualities held to be characteristic of all original, uncorrupted art: a sense of the hieratic, a feeling for synthesis; and a purpose at once decorative and symbolic. This meant that unlike the arts of more "civilized" and developed cultures, these early arts were the very opposite of naturalistic and imitative. Not copying nature, their forms were ruled by an internal coherence of design, and those forms, not being imitative, had their own meanings, free of reminiscence and association. Thus the artists of 1890 felt a strong attraction to early art and believed its qualities were due its being primitive. That their own art, despite occasional borrowings, bears little relation to these for the most part exotic arts in no way belies the importance of the primitivist impulse that prompted their own "synthesizing" simplifications.

Thus the "discovery" of primitive art early in the twentieth century had been well prepared. For some fifteen years before 1905 artists had been looking backward, not as artists had done in the past, to the high points of some previous Golden Age (Greek or Renaissance) whose subtle civilization gave the measure of a subsequent decline, but to an earlier age whose grasp upon essentials had not yet been corrupted by irrelevant sophistications. Since then there had been a cancerous growth of complications, attractive but blinding, beneath which the essentials lay hidden; a conscious effort

had to be made to strip these away, in order to reformulate by an effort of the will what had once been naturally understood.

This effort proceeded upon two assumptions, the one visual, the other psychological: on the one hand, there was the conviction that the forms of art had to be simplified, that by ridding representation of the accidental and the individual, by reduction and elimination of the particular, some essential structure, previously hidden, would come to light. On the other, it was accepted that, once achieved, such basic, summarizing forms expressed (for the artist) and revealed (for his audience) certain fundamentals of personal emotion and generalized insight that would otherwise remain concealed. And there was, of course, the underlying assumption that both these enterprises were worthwhile, and that it was highly desirable to cast off externals to set free the primary which is, by definition, more profound and more valuable.

It is thus clear enough that these years set the stage; the consciousness of the primitive preceded the availability of aboriginal art and made possible its recognition. And one can only conclude that its subsequent influence upon modern art, whether immediate or long range, and however great or small, was not fortuitous. The arts of Africa, and later of Oceania, did not impose themselves by force upon the modern artist. They were available, but not in overwhelming quantity. Had they meant nothing to him, they could have been ignored, as they had been and as some of them continued to be. If the artist sought them out it was because he found in them (or read into them, which was effectively the same) qualities which fulfilled a need because they reinforced a movement already under way, pre-existing desires and directions which now made the primitive arts accessible and their discovery possible.

It is therefore not surprising that the essential influence of the primitive upon the modern makes itself felt at a deeper level and in a more pervasive fashion than that of appearance. This is to say that there are in fact very few modern paintings and sculptures which are based on individual examples of African or Oceanic art (and none at all which could be mistaken for aboriginal creations), There are to be sure instances of more or less general derivation: artists have imitated the heavy bent legs and large pedestal-like feet of certain African sculptures, the concentric circles of the faces on Papuan Gulf boards, the geometric stylizations

1863 Mumuye, Ancestor ▶

1866 Ibo, Figure ▼

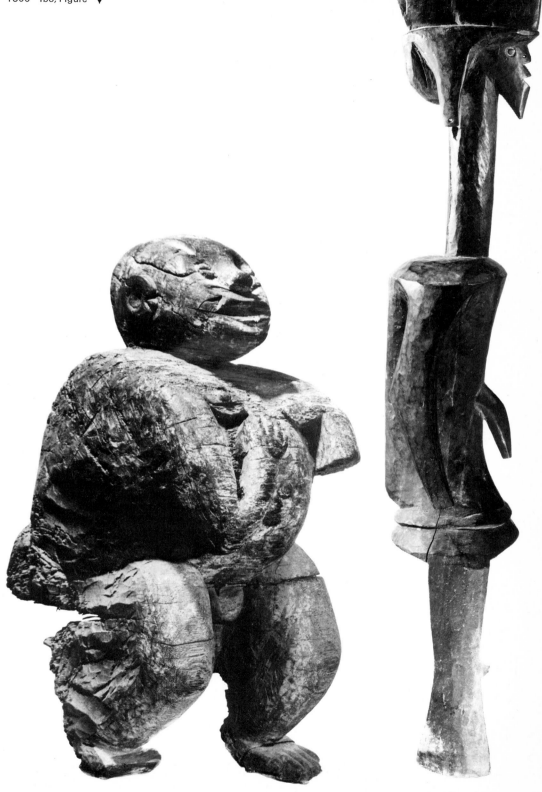

and openwork of Mexican stone masks, but these are rare; they are experimental signs, momentary if not exactly incidental, of a much more pervasive and fundamental primitivist orientation. The few famous cases of explicit influence – Picasso's *Demoiselles d'Avignon* and his *Guitar*, Brancusi's *King*, or Modigliani's *Head of a Woman* are the most notorious – are exceptional rather than typical, and even here the motifs, though recognizable, have been transformed so as to accommodate and carry out the artist's own intentions, very different from those the primitive sculptor had had in mind.

Modern primitivism in the plastic arts is then not simply a matter of style – although it has stylistic consequences. The artist is inspired by a double faith: he believes in the value of origins, and so desires to unearth them; and he is sure that, once found, they will be whole and therefore important. His assumption is that the further one goes back – historically, psychologically, or esthetically – the simpler things become, and that because they are simpler they are more profound and more valuable. Broadly speaking, he has pursued his goal of essential rediscovery along two routes – the one emotional, the other intellectual, the first putting its emphasis on the basic elements of human experience, the second seeking out the fundamentals of external form.

Within the first group fall the artists who have concentrated on the fundamental emotions and passions as the themes of their works. Their desire is to present these subjects with the greatest immediacy and as little "psychic distance" as possible. Their purpose is to involve and absorb the spectator, to persuade him to lose himself in the work, and they have been captured by the emotion that prompted it. For this reason they may be called, quite generally, expressionists – whether figurative or abstract. This would not in itself make them primitivist, except that this desire for the immediate experience carries with it a belief in its simplicity and a high valuation of the unitary and overwhelming. Hence the deliberate broadness and coarseness of the *Brücke* methods and the over-all gestural directness and rapidity of the abstract expressionists, both meant to record and render an unreflective emotional intensity. The first was intended to portray a return to an emotional state and an unquestioning union with nature presumed to have been enjoyed at an earlier time by mankind as a whole (and still enjoyed by aboriginal peoples); the second to reflect the unordered, unstructured flow presumed to be the condition of the human psyche uncorrupted by analytical reflection. In their different ways, each identifies the primitive (whether of society or of impulse) with the savage, and finds it a desirable, expressive goal. The tone of the *fauves* has none of this fierceness; their figures live in a gentler, more classical Eden, yet even here there is congruence between a simplicity of joyful, harmonious emotion and a simplification of the means employed. In Matisse's *Joie de Vivre*, in *Le Luxe*, the refinement of Watteau's Cythera has been corrected by Gauguin's dream of a barbaric paradise: subject and manner alike have (deliberately) cast off complication (and the figures their clothes) in order to rediscover an original state of grace. Milder in tone than the *Brücke*, the primitivising desire for an unreflective union with nature is much the same.

In contrast to this more emotional trend of primitivism, which has approached the actual form of the primitive arts only indirectly and by emphasizing their expressive characteristics, the intellectual tendency has examined these arts directly, and with more analytic eyes. Although their relationship to the aboriginal arts was never as purely rational as they imagined it to be, their first concern was with structure and composition. In African sculpture especially they found, or so it seemed to them, an intuitive (or perhaps an instinctive) understanding of the fundamentals of formal construction, and an ability to embody them in self-consistent compositions. For Picasso and his friends African art was (as he said) reasonable, i. e. it obeyed its internal laws, followed its own logic, and thus attained its own character, independent of conventional appearance. This result was not valued for itself, nor was there any question of art for art's sake. It was rather that by concentrating on the rhythmic, interlocking structure of a few uncomplicated forms, by ignoring the superficialities of surface and detail, the primitive artist knew how to reveal the pervasive structure of a universe of form: his simplicities were powerful because they brought to light fundamental laws of nature and of its perception. Because they were still close to their own sources, both in psychology and environment, the primitives still had a natural access to them: this was evident in the formal clarity of their art. But the modern artist, whose vision had been corrupted by mistaken refinements, and who tended to replace the general by the particular and creation by imitation, could only retrace his steps by a conscious effort. He could, by analysis of structure and an exercise of will, approximate what for the primitive artist was inborn knowledge. And he had no doubt of the essential simplicity of these forgotten truths which he had to rediscover; he found the demonstration in the primitive arts themselves, whose apparent awkwardness was in fact an awareness of essential structure and its direct embodiment in reductive, unencumbered form. Yet this supposed "reasonableness" of primitive art as a microcosmic exposition of universal laws was not the only attraction of primitive art, nor the sole reason for primitivising simplifications. The intellectual and the emotional could not be so neatly divorced, and it is clear from Picasso's "negroid" works, as well as from much modern sculpture, that geometrically reductive form, however intellectually achieved, carried with it a connotation of elemental force, a savagery that was welcomed because it too was revelatory and truthful. Thus, in the end basic form and basic emotion are seen as matched, and whichever one initially takes precedence it will finally bring the other along with it; both are sought after because they are presumed to be primitive, since the primitive and the simple are assumed to be identical.

In thus finding inspiration in the arts of primitive peoples, modern painters and sculptors have made certain assumptions concerning their character and their purpose. We may well ask with what justification. Because, by modern western standards, most primitive art is non-naturalistic, it has also been thought to be non-specific and non-literary in its reference – i. e. to represent a type rather than an individual, and to avoid the extra-visual accretions of a traditional iconographic detail. The modern artist, pre-occupied with the search for meaningful form and composition, ignorant of the traditions of the primitive, was happy to assume that the aboriginal artist avoided the distracting associations of both imitative and iconographic representation and conveyed his meaning directly through generalized symbolic form. In fact this was hardly the case. Most primitive art is exact in both iconography and representation; its references are precise and conform to a traditional language employed by the artist and understood by his audience. That these references may be multivalent in no way alters their legibility; and that the representation is not to be measured by the

2048 Papuan-Gulf, Ceremonial Bord

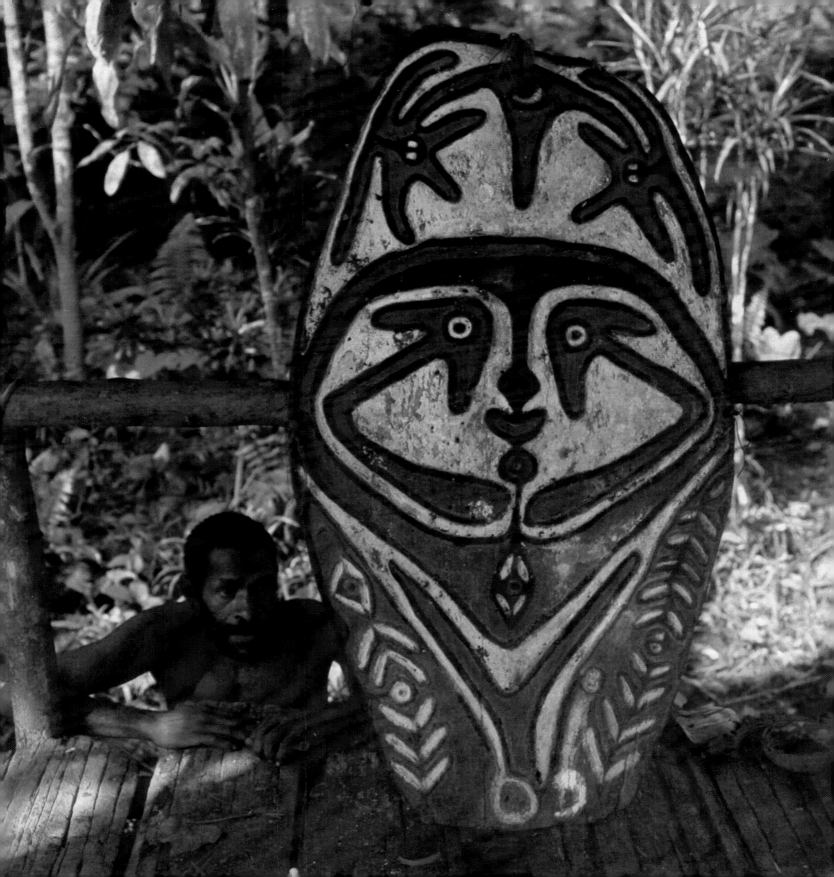

standards of naturalism in no way lessens its reality. Contrary to the wishful belief of the primitivising moderns, the primitive artist is not concerned with generalizing symbols. (In the same way, the careful finish, smooth surface, and refinement of detail characteristic of much primitive art was overlooked because it spoiled the emotionally desired image of elemental expressiveness.) If his representations do not attempt to reproduce nature (although they often do), it is because they present mythical or spiritual beings who, for this reason, are different from the ordinary. For the native artist and his audience, familiar with the religious world in which gods, spirits and humans form a continuity, these figurations are both individual and real. The modern artist was ignorant of this context of belief, though he sensed its power in the work itself; and, as Guillaume Apollinaire already understood, this ignorance (which he shrewdly observed could not last) served the artist's purpose. He was searching for an art which would be meaningful — not as illustration and not as allegory — through form alone. His situation was the reverse of that of the primitive artist who worked within severe limitations of subject and of style and was supported by a strong tradition. The modern artist was, in contrast, dependent on his own resources. He had renounced, or been abandoned by his traditions (religious and artistic): his freedom was limitless. He was searching for symbolic form, form that conveyed meaning in and for itself. And since the strong rhythms, the basic shapes, the essential logic of African and Oceanic art, were satisfying and expressive in themselves — or so they seemed to him who knew nothing of their background, the emulation of their apparent simplicity would also help him towards his goal.

What the goal was can perhaps also be suggested by that "presence" so often said to be the outstanding quality of the primitives: it implies conviction, intensity, and the material concretion of ideas and emotions; the visually formulated language of societies without writing. The modern artist, sensing this "presence", believed he could recapture it by returning his art to those fundamental simplicities of form and emotion which he thought were its cause among the primitives. This is the basic motivation of the primitivising strand that runs through the painting and sculpture of the twentieth century. And, if that strand has any unity, it is a unity of attitude, not of style. Because if modern primitivising art is also generally a non-naturalistic art, it is not

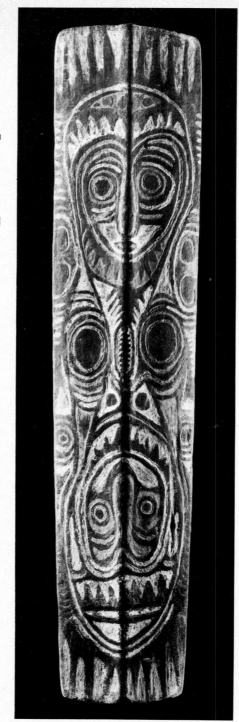

2053 Sepic, Shield

because it imitates the primitive as such, but because its reductive attitude compels the elimination of mere appearance. The important thing was to uncover the

essential core of personal emotion and of universal structure. The modern artist did not doubt that the artistic metaphors of these sources would be as simple, as coherent, as primevally forceful as all origins in themselves necessarily are.

The Magic Element in Modern Art

Werner Hofmann

"It began with anguish, anguish and desire, and a frightened curiosity as to what was coming. It was night, and his senses were on the watch. From far off a grumble, an uproar, was approaching, a jumble of noises. Clanking, blaring, and dull thunder, with shrill shouts and a definite whine in a long-drawn-out u-sound —all this was sweetly, ominously interspersed and dominated by the deep cooing of wickedly persistent flutes which charmed the bowels in a shamelessly penetrative manner. But he knew one word; it was veiled, and yet would name what was approaching: "The foreign god". Vaporous fire began to glow; then he recognized mountains like those about his summer-house. And in the scattered light, from high up in the woods, among tree-trunks and crumbling moss-grown rocks — people, beasts, a throng, a raging mob plunged twisting and whirling downwards, and made the hill swarm with bodies, flames, tumult, and a riotous round dance. Women, tripped by overlong fur draperies which hung from their waists, were holding up tambourines and beating on them, their groaning heads flung back. Others swung sparking firebrands and bare daggers, or wore hissing snakes about the middle of their bodies, or shrieking held their breasts in their two hands. Men with horns on their foreheads, shaggyhaired, girded with hides, bent back their necks and raised their arms and thighs, clashed brass cymbals and beat furiously at kettledrums, while smooth boys prodded he—goats with wreathed sticks, climbing on their horns and falling off with shouts when they bounded. And the bacchantes wailed the word with the soft consonants and the drawn-out u-sound, at once sweet and savage like nothing ever heard before. In one place it rang out as though piped into the air by stags, and it was echoed in another by many voices, in wild triumph — with it they incited one another to dance and to fling out their arms and

244

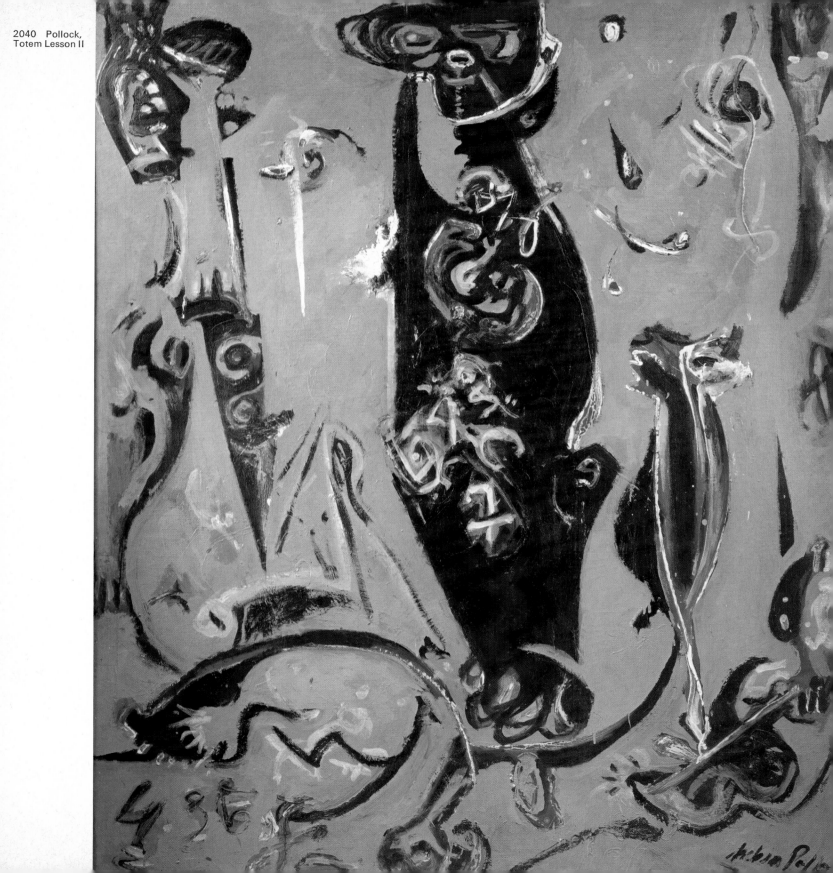

2040 Pollock,
Totem Lesson II

legs, and it was never silent. But everything was pierced and dominated by the deep coaxing flute. He who was fighting against this experience—did it not coax him too with its shameless penetration into the feast and the excesses of the extreme sacrifice? His repugnance, his fear, were keen — he was honorably set on defending himself to the very last against the barbarian, the foe to intellectual poise and dignity. But the noise, the howling, multiplied by the resonant walls of the hills, grew, took the upper hand, swelled to a fury of rapture. Odors opressed the senses, the pungent smell of the bucks, the scent of moist bodies, and a waft of stagnant water, with another smell, something familiar, the smell of wounds and prevalent disease. At the beating of the drum his heart fluttered, his head was spinning, he was caught in a frenzy, in a blinding deafening lewdness — and he yearned to join the ranks of the god. The obscene symbol, huge, wooden, was uncovered and raised up; then they howled the magic word with more abandon. Foaming at the mouth, they raged, teased one another with ruttish gestures and caressing hands; laughing and groaning, they stuck the goads into one another's flesh and licked the blood from their limbs. But the dreamer now was with them, in them, and he belonged to the foreign god. Yes, they were he himself, as they hurled themselves biting and tearing upon the animals, got entangled in steaming rags, and fell in promiscuous unions on the torn moss, in sacrifice to their god. And his soul tasted the unchastity and fury of decay.

When he awakened from the affliction of this dream he was unnerved, shattered, and hopelessly under the power of the demon."

The person thus afflicted is Gustav Aschenbach. His dream is recorded in Thomas Mann's "Death in Venice" written in 1911 and published in the following year (qt. from Great German Short Novels and Stories, Random House, New York, 1933, pp. 388–390). If this imaginary figure were to have stepped out of its literary context into the reality of those years, what would have happened? Gustav Aschenbach could well have experienced his chaotic nightmare with open eyes on the evening of May 28, 1913, during the tumultuous première of Stravinsky's "Sacre du Printemps" at the Paris Théâtre des Champs Elysées. The programme announced pictures of pagan Russia in two parts: "The Adoration of the Earth" and "The Sacrifice." At first, the public reacted with loud laughter and

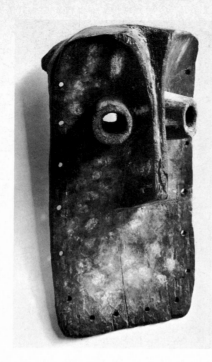

1924 Congo, Mask

derisive cat-calls, but were gradually roused to wild fits of rage. The pun "Massacre du Printemps" soon began to go the rounds in Paris. Aschenbach could have discussed the motives behind his lapse and behind his dreams with Sigmund Freud, whose study "Totem and Taboo" had appeared in the first two volumes of "Imago" in 1912/13. Had he not gone to Venice and his death, but chosen to visit Florence for the International Congress of Art Historians in October, 1912 — not all at unlikely for an author whose works were said by Thomas Mann to include a treatise on "Intellect and Art" — he would have heard Aby Warburg's lecture on "Ancient Cosmology in the Representations of the Months in the Palazzo Schifanoya at Ferrara", and afterwards could have reflected upon the connections between art and magic. Nor would he have remained empty handed had he preferred to stay in Munich: the two exhibitions of "The Blue Rider" circle in December 1911 and March 1912 would have acquainted him with the work of the European avantgarde, and if he had read the almanac bearing the name of this group of artists he might well have underlined the following sentence in August Macke's essay "Die Masken": "For us, form is mystery, since it is the expression of mysterious forces. Through it alone are

we able to sense the mysterious forces, the 'invisible god'. — Creation of forms means: to live. Aren't children creators who create directly from the mystery of their senses, and more so than the imitators of Grecian form? Aren't the savages artists who possess their own form, as fixed as the form of thunder?"

2.
If we free these details from their anecdotal-imaginary nexus, they do reveal that a diversely orientated critical discussion of the "primitive" took place within a short interval of time. From our present-day standpoint, we distort this confrontation by sharply focusing our attention upon the multidimensional aspect, a process which impairs the activity of every person's consciousness.

The discovery of what we term the primitive, the elemental or the unconscious, occurred and is occurring under conflicting omens. In the form of barbaric nightmare, Thomas Mann describes how suppressed desires and instincts break through the barrier of the "excessive morality" (Übermoral) of our "avoidance culture" (Vermeidungskultur), both terms used by Freud in "Totem and Taboo". To continue in Freud's terminology, the pleasure-orientated *id* subdues the *ego*, which is dominated and cramped by a regard for security. Aschenbach, an intellectual living in reflective detachment from the outside world, overcomes his introspected isolation by breaking down the delimiting controlling instances and giving himself up to the delirium of the mob. What is gained from this is an insensate merger of the individual in the collective; that is, participation in ritualized group action. In his dream, Aschenbach abandons the inhibiting conventions and barriers that simultaneously protect and fetter him. According to Freud, it is precisely this which distinguishes the primitive from the neurotic person; while both are unaware of the sharp border between thinking and doing "It is the neurotic who is above all inhibited in his actions: with him the thought is the complete substitute for the deed. The primitive is uninhibited, the thought can easily be put into action..." Related to the contrast between thinking and doing, the work of art is a hybrid: it is both a liberating and compensating act. Understood as a product of sublimation that transposes the original doing into a symbolic act and revokes it, art is always joined to its apotropous origins. Freud and Warburg recognized this independently of one another. Even when the artist

acts in effigy, designing imaginary conclusions, he is engaged in performing the oldest social task: to conjure and to exorcise. Ancestral lines develop from this orientation which lead from the high art of the Renaissance back to animistic custom. The following example is contained in the notebook kept by Aby Warburg: "From head-hunting: Judith, Salome, the Maenads, via the Nymphs, the fruit-giver, Fortuna, the autumn Horae to the water-giver, Rachel at the well, the woman extinguishing the flames at Borgo..." Is this path from the sphere of action via the "devotional sphere" into the "thought dimension" to be comprehended as linear progress, or does it permit a turning back, a reflection on the past? Stravinsky examined this question in his criticism of Wagner. He found the Bayreuth custom of imitating ecclesiastical rites disagreeable and demanded a clear separation of the categories: "It is now time to put an end to the inadequate and profane conception of art as religion and the theatre as temple. — Whoever confuses these things only reveals that he has not the slightest discernment and has unmistakably poor taste. But how can one wonder about such a confusion at a time when the triumphant progress of secularization, through its degradation of intellectual values and its abasement of the human spirit, leads us inevitably into total stupidity?" It did not occur to Stravinsky to regard Bayreuth as a counterbalance to progressive secularization; leaving this, he abruptly turned his mind to the "Sacre". Evidently convinced that his music could not arouse suspicion of being a pseudo-ritual, he failed to secure it against those pagan cultic rites which it was meant to evoke. The public's reaction conflicted with his conviction; not only did the public take exception to the work's aesthetic opposition to every musical convention, it also hysterically resisted the orgiastic inhibition to the same degree as it allowed itself to be incited and swept away. This refusal to participate turned into malicious rejection. How would Stravinsky have reacted if adoration and sacrificial ritual had communicated itself to the public and its acclamation had moved it to action, to fulfilment in collective participation? Would he have countered the de-sublimation, that is, the transition from contemplation to action, with the censure that this was a demonstration of poor taste? This question reveals the ambivalence in every confrontation with the "primitive": can it merely be revived as a formal gesture, or must whoever desires to appropriate it also accept dimensions

of significance which lie well below the aesthetic surface, and question their unity? August Macke treated this dual aspect with great intuition and perspicuity: his short essay sides with the "savages" and the children, which is not new, but at the same time he uncovers the same *vital* principle lying behind every art form: "Creation of art means: to live." For this reason, the expression of art and life interlock. Macke illustrates this with an ennumeration, which does not follow traditional rehabilitational aesthetics (ars una, species mille), however, but radically ranks the non-artistic factum brutum with the product of artistic sublimation: "The lamplight in Ibsen and Maeterlinck, the painting of village streets and ruins, the mystery plays in the Middle Ages, and the stimulation of fear among children, a landscape by van Gogh and a still-life by Cézanne, the burring of a propellor and the whinnying of a horse, the roar of a cavalry charge and the battle-dress of an Indian warrior, the cello and the bell, the shrill whistle of the locomotive and the cathedral effect of a beech wood, the masks and stages of the Japanese and Greeks, and the mysterious muffled drumming of the Indian fakir." This is followed by a question without a question-mark which yields up the work of art to the superordinate instance of "life": "Does not life count more than food, and the body more than the clothes."

3.

Clothing as disguise, form as an enveloping cloak — this was suspected and discussed just two hundred years ago, as the desire for renovation was touched, but not yet dominated by the fascination for the primitive. According to Reynolds in his third Academy Address on December 14, 1770, things were easier for the ancient than for the modern. They probably had little or nothing to unlearn, for their mode of expression corresponded very closely to this desirable simplicity (of which Reynolds had spoken earlier), whereas for the modern artist to be able to perceive the things of truth , he must first lift the veil which with the fashion of centuries has covered them. The confrontation with the "primitive" belongs to the processes of renovation due to which the course of the history of thought in the West has repeatedly undergone reorientation. The Renaissance was also "renovatio" in this sense, since it thought to reveal the forms of antiquity, which had been veiled and burried by the Middle Ages, in their original purity. The "primitive" minded artists of the David school

acted in the same way around the year 1800. Renovatio signified partisanship for one specific attitude to form and rejection of another. This clear alternative, however, succumbed to an expansive levelling of categories of values in the course of the nineteenth century, for which the historical consciousness shows itself to be responsible. In the attempt to prove that every cultural epoch has a right to its own language (from which, strictly speaking, it follows that the appropriations from other "primitive" epochs reveal a lack of staying-power) this relativizing consciousness unfolds the global panorama of an aestetic culture in which everything can be treated alike. The view-point is substantiated by cave drawings, negro fetishes and Renaissance portraits "that art always remains the same" (Herbert Read). The registering cultural expansionism turns into cultural conformism. The display-window of this aesthetic-contemplative cultural concept is the museum: it possesses a clear integrating impulse which halts neither at the cave-drawing nor the negro fetish. The year 1912 is also significant for this aspect of our consideration: African sculptures were exhibited at the Folkwang Museum in Essen as works of art. Since then, it would appear that the game was as good as won for the "Integrationists." Divested of their "utility value," the objects of "primitive" art were aesthetically domesticated and integrated under the traditional contemplative concept of art and culture, which invested them with the exclusive aura of "exhibition value" in its centres of culture — the museums. Is this perhaps another vestment which disguises?
According to the judgement of a "poised and dignified intellect," which Aschenbach — a St. Antonius in dire temptation — endeavoured to preserve, the "primitive" represents a fatal menace. Although it betrays resistance, this standpoint penetrates deeper into the problem than aestetic integrationism, whose naive raison d'être is the unrestricted expansion (not opening) of the limits of taste, and whose sole aim is to help the negro fetish, just as well as the sculpture of Brancusi and the ready-made of Duchamp to achieve museum status. This embracing procedure remains on the surface, it evolves smoothly and appeasingly by electing the "primitive" to the devotional temples of the sacred cultural domain for subsequent emasculation.
The "primitive" in the service of catholic taste and total integration in the museum — this is also the "official" history of

discovery of the primordial and elementary, which necessarily proceeds parallel to the integration and institutionalization of "modern art" in the museum. This process is assailed by an opposing mind, which rebels against the rigid position of the "poised and dignified intellect," and attempts to break through the closed façade of art and culture – another disguise? – to a refuge in which art and life can enter into a new relationship. This begins with Gauguin's flight from the ghetto of civilization – a romantic gesture – and leads on to the contempt for art of the Dadaists to the communes of the American Hippies, body art, direct art, land art... Admittedly, from the defensive perspective – intra muros – this and other impulses towards a "self-opening" can be experienced as a danger or threat. The claim for freedom, which they want to help unfold, does not search for formal models, but concerns itself all the more persistently with open practices and the trans-aesthetic multilamination of "primitive" art. Now, a few relevant observations.

4.

The claim for freedom seeks the autonomy of artistic creation and its correlate: the transcendence of the compact artistic concept amputated for the optical attainment of "detached pleasure." It is evident that the compact artistic concept is a product of secularization, which made its impact in every field during the transition from the medieval to the modern age. To the same degree that the work of art constituted itself in its own autonomous sphere, and then had to detach itself from its manifold "utility value," it lost the charm of pictorial magic–the actual effective power. (An Egyptian designation of the sculptor: he, who preserves life.) The proclamation of the intrinsic power and meaning of artistic reality has yielded rich creative spoils in the last five-hundred years of European history. This overall development extending from the work of genius to mere imitation, has responded to the call for compactness. This characteristic has various levels of significance, which merge into one another. Compactness is claimed for artistic reality. Works of art do not only unambiguously contrast with non-artistic reality; they should also be immutable and final. Theoretical speculation upon art with the object of delineation, then attempts to establish generic features on the basis of elements of content, form and media. From then on, decorative art, sculpture, architecture and the "applied" arts constitute their own compact cate-

gories. The proclamation of precedences once more adheres to this: the delimiting tendency gains the function of creating hierarchies. In conformity with the basic empiricist approach, which Burkhardt reduced to the formula of the discovery of the world and man, painting is graded highest because it can report the facts and events of the world of perception in greatest detail. Moreover, from this capacity it is concluded that the artist must restrict himself to the instruments of empiricism – perspective space and figure composition, and anatomically derived proportions. This normative restriction also strengthens the compact system: from it emerge the doctrine of ideal beauty and the criteria of a "true" or "false" depiction of reality–pseudo-legitimations supported by which art and aesthetic doctrine within the closed artistic circle demark the sphere of "highest beauty." Painting at the easel is the prototype of this doctrine and its favoured object of meditation. It is the work-place of the genius (the aesthetics of genius are based upon the postulate of integral compactness), it depicts a world of appearances detached from reality and given dignity within a nice frame. This fictitiousness arises because it is a formal act performed entirely by the painter: a materially homogenous surface covered with colour, on which no alien body adheres. This compact "as-though" reality is adequate for an observer who reflects aesthetically upon his autonomous dignity. He does this in so far as he does not reach up for the painted grapes but, respecting the "as though" arrangement of illusionism, erects the wall of contemplation between himself and the painting.

This approach creates the appropriate, exclusive "devotional chambers" in museums and exhibitions. Detachment escalates to isolation: it is obvious from the obsession with museums and exhibitions that the claim for aesthetic autonomy must inevitably end in isolation if it is to fully achieve its objective. Linked with the experience of detachment, therefore, is also the fact that artists and non-artists confront eachother as compact categories, and that the category "public" forms a species of its own, an élite distinguished by connoisseurs who segregate themselves from the "broad masses." The connoisseur and specialist approve of the specialization within the artistic field, i. e. the segregation of the individual fields of activity.

The attempt outlined above, to demolish, embarrass or to disrupt the "compactness," which has been undertaken since

the turn of the century, has two main aspects: it extends to an opening of that character of reality possessed by the work of art, and an opening of the lines of communication between the "transmitter" (artist) and "receiver" (public) of art.

5.

Kandinsky already recognized in 1912 that the opening of this character of reality belonged to the main features of the art of his day, which was announcing the advent of a new intellectual epoch. He meant that the mind "has the entire store-room at its disposal today; i. e. all matter from the 'hardest' to the two-dimensional living (abstract) matter, is employed as an element of form." Such multi-materiality destroys the compact fictitiousness of the easel painting, for it confronts different planes of reality with one another; for instance, a painted surface with an adhering object. Proclaimed by the multi-materiality of the Jugendstil artists, this reaching out for "non-artistic" materials has–since the *papiers collés* of the Cubists and the ready-mades of Duchamp–come to belong to those "opening" practices which, in the last analysis, question the compact concept of artistic reality (when not rejecting it completely) and, by virtue of an act of designation, declare the entire world of experience as the actual or potential work of art. There has been no lack of proclamations of this type in recent years. Time and time again we are assured that everything is art, everything is a potential happening, everything is music... We should not be surprised by such notions, for the dynamic process of "opening" ourselves also entails the utopian desire to fuse art and life, art and reality, to let the special position of the artistic understanding of the world merge into total structures of reality. Let us call to memory the models which have become classics of this trans-aesthetic expansion.

Fifty years ago Mondrian and his De-Stijl friends formulated a new comprehensive concept of beauty for which the individual work of art seemed to be dispensable. "We observe how pure beauty appears on its own accord in those structures built solely out of necessity and expediency; in housing complexes, in factories and shop-building etc. But as soon as luxury supervenes, one begins to think of art and pure beauty is destroyed." The object of this attitude is to diffuse the creative impulse throughout the entire sphere of reality, which ultimately means a dissolution of the self. "Life is substitution for as long

as life lacks beauty; it will disappear to the extent that life gains equilibrium." In accordance with this ideal, the versatile creative being—the designation "artist" would be obsolete because it becomes too narrow—no longer creates appearances, but reality itself; he constructs a new society, which according to Mondrian's conviction "will be a society of balanced relationships."

The Dadaist also went to the limits at more or less the same time. He strove for a seamless continuity of reality which denied the work of art a categorical and presumptious seclusion. Art was to ally itself with the unfathomableness of life and nature. "Life is the meaning of art for the Dadaist." (Arp.) The demand for the truth of life claims total directness, frank spontaneity. It distrusts the generic sphere "art" because it scents the danger of rigidity, of irreality and segregation in every creative schema, in all intentionality. "By adapting art to everyday life and the particular experience, it becomes subject to the same risks and the same rules of the unpredicted, and chance becomes subject to the play of vital forces. Art is no longer the 'serious and momentous' flow of emotions, nor a sentimental tragedy, but simply the product of the experience and joy of living." (Marcel Janco.)

Within the extreme standpoints proclaimed by the Constructivists and Dadaists fifty years ago, there has since been the most diverse blurring and infringement of borders. Transitory expansion entails above all the blurring of generic borders: we already find ourselves in an open multi-dimensional artistic sphere shared by painter and actor, dancer and filmmaker, actionist and musician. The age of the specialist is over. Multi-materiality has, on the one hand, distorted the demarcation lines between painting and sculpture, sculpture and architecture; on the other hand, painting and sculpture have long ceased to regard empirical facts as their sole theme, i. e. to restrict themselves to an imitation of reality, but are now empowered to discover reality, whereby they step into the territory of architecture. This results in hybrids, such as the Environmentalists. Furthermore, the demise of the idea that the work of art has an absolutely fixed character belongs to the consequences of this disregard of borders; in other words, the rejection of the idea of the fixedness of the object. Since Naum Gabo constructed the first kinetic sculpture in 1919, works of art have increasingly appeared as processes, and certain constellations have been constructed on a temporal basis without

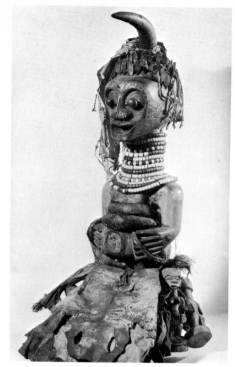

▲ 2056 Songye, Fetish

2055 Van den Berghe, Fetishs ▶

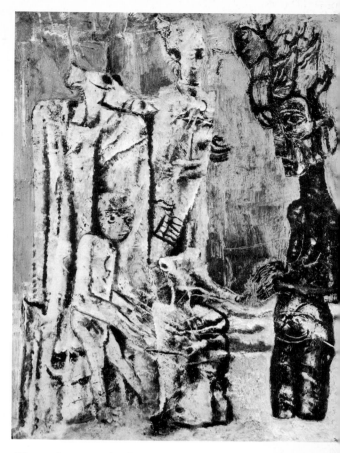

regard for "durability." This approach anticipates material changes and change interference, and on occasion auto-destruction is even taken as a theme in itself (Tinguely). The range of action extends from the mutability of objects, operated either mechanically or by the "receiving" person himself for the purpose of inducing action sequences or happenings, to exhibitionistic autism, self-painting (Hundertwasser, Rainer), or self-mutilation (Brus). In a certain way, body art is also represented by land art: the body of the earth becomes a potential work of art. In this form, transitoriness is taken as a theme, a new form of play with the vanitas idea, but not transposed on to the fictitious objects of "as though" aesthetics (still-life with hour-glass) but on to the body of actual reality. Finally, in concept art the materiality of the work of art is not dissipated but left out from the very beginning. Artistic fulfilment intentionally occurs in the imagination of the "transmitter" and "receiver," whereby the material is not fixed.

We have now touched upon the second aspect of "opening"; namely the opening

of lines of communication. This process goes hand in hand with the one just described. The optimistic conviction that every human being is a potential artist was already proclaimed by the Surrealists, and in the Soviet Union it belongs to the credo of constructivist visions of the future. (As a marginal note, it featured in the young Marx as a memory of a lost paradise destroyed by the division of labour.) Today, this conviction is put into action everywhere where one wishes to pull down the barriers between artist and public. The open concept of art reckons with deciphering participation, it is dependent just as much upon joint-thinking as upon joint-playing and joint-acting "receivers." Karl Gerstner speaks succinctly of "do-it-yourself-art." Such art arises in proposals and suggestions of alternatives, in impulses for thought and action—it creates game-situations. Participation means the resonance with which, for instance, the mutable form design of a Vasarely calculates the collective action of the happening and the kinetic contrivances.

Divested of his special dignity, the artist thus loses his monopoly over "art."

249

Every domain created during the reign of the compact concept of art to serve the institutionalization of art and artistic dignity, has to take the respective consequences. Understood as the surmounting and demolishing of closed institutions, the opening of lines of communication in the interest of the anti-museum concept has inescapable consequences. Both aspects of this "opening" combine pluralistic significance, a Janus-faced characteristic which looks in both directions of utility and the esoteric obscurity. The definition of the phenomenon "art," that is its limits, means and objectives, now dispenses with the constituitive non-ambiguities of the compact concept of art. If it were otherwise, the practices employed in "erasing borders" would be accused of new dogmatic segregation and consolidation, and thus of inconsistency.

6.
The question now is what links this open, transitory conception of art with the "primitive"? The art historian is denied the last word in this manner, he can only record the essential points of contact as seen from his own standpoint, from his own attitude to the complex of primitive art and its "behaviour pattern." Starting from the barrier to the consciousness presented by *any* recourse to the "primitive" under the token of non-naive "sentimentality" (in the sense of Schiller), we must detach fact and symptom from fancy. Pluralistic significance belongs to fact: the possibility of giving different interpretations to formal codifications is not one of the new freedoms of current hieroglyphics and emblems, it constitutes the intrinsic multidimensional and transitory elements of primitive art. A further parallel is represented by the reciprocal pervasion in the different species of art. The magically coloured multi-materiality and the fluctuating juxtaposition and interlocking of different planes of reality are factors which a formal comparison of "modern" and "primitive" art should take into account. We need only look at the dadaist-surrealistic poetics of the resolved or alienated object. The pseudo-relicts and pseudo-cultic dreams of Beuys and Pichler derive from this category. If we view these objects against the religious cult of relicts and fetish magic, it is shown that the same aura of the factum brutum is invoked which Hegel already described as satisfying religious expediency rather than the beauty sublimated in the work of art. According to the right-wing interpreter of Hegel, Rosenkranz: "It is well known that the aestheti-

cally perfect works of art do not work wonders" (Aesthetik des Hässlichen, 1853). These thoughts presumably derive from Charles de Brosses' study on fetish gods translated in 1785 into German (Über den Dienst der Fetischengötter...). Fact, symptom and fancy in one, is the attempt to de-institutionalize the autonomous aesthetic structure, to push it off the pedestal which the devotionalism of the museum has ordained for it. De-sublimation transforms the devotional temple back into an *action room*. This is a primitivist conception: intellectually and materially, works of art are once more to become objects of use, objects to be manipulated or "interviewed," both of which are processes involving participation. Does this ideal conform with the facts? Only the person who still agrees with Giambattista Vico that primitive man was "by nature a poet," and is convinced that the "state of innocence," proclaimed by Kleist at the end of his essay on the marionette theatre, can only be attained by the person either without, or with an "infinite consciousness," can unconditionally identify the pathos of the current border-erasing practices with a free space in which art has abandoned its special existence and has reunited with life. On the other hand, the person who views this perspective with certain reservations because he suspects that every disintegration incorporates the beginnings of a re-integration, will soon find his scepticism confirmed.
In truth, many of the anti-aesthetic practices flourishing today do possess institutionalizing featues. The communes of the sub-culture correspond to the primitive clans, the happenings are ordained initiation and invocation rites, the Great Mother of Niki de Saint-Phalle is a sophisticated fertility idol, Christo's packages are successors of the veiled picture of Saïs. In the orgy-mystery theatre of Hermann Nitsch, pseudo-licentiousness is regulated to ritual. Groups with common objectives are exclusive circles, clandestine élites. The artist acts as medicine-man making use of esoteric arrangements. Frequently, he also performs totem functions.
However free these rituals may appear, in the sense of their non-conformist and open behaviour, they aim to attract a following of believers, and they win over their community by preaching collectiveness of a specific order. The motives are based upon an ethos of renunciation and taboo requirements joined in protest against the economic and aesthetic conventions of competitive society. All of these blue-prints proclaim a new form of

"avoidance culture" against the old. Although such reservations do not fit into the utopia envisaged by total de-institutionalization, they by no means impair the comparison between our present situation and primitive art: they merely re-orientate it by focusing upon aspects of the present which converge with exactly those practices which are institutionalized in all primitive art. This shifts the comparison to the plane of *structures* and introduces the structuralist method in two ways: firstly, as an instrument for illuminating our comparison from a new angle, and secondly, as object of this comparison.

7.
How much weight is to be attributed to border-erasing practices?
For the person who believingly and unreflectingly performs them, they offer a prospect of lasting freedom from compulsion and conventions. The objective analysis attempted here seeks a middle-path between this commitment and the rejection of the conservative observer, who orientates himself to the standards and authority of the "poised and dignified intellect," which deplores any weakening of this position as a return to barbarity and chaos. In his view, the processes described here conflict with an essential characteristic of the process of civilization – the capacity for increasing differentiation. Assuming that retrogression is in fact occurring here, it must be concluded that, in so far as it aims far beyond the formal-aesthetic renovatio, the process of appropriating the "primitive" has achieved its extremest consequences in total submission. The spirits, the "unknown gods," which are constantly invoked, draw the rash conjurer under their spell. To be spellbound means to be unfree, security at the price of one's freedom. Consequently, the attempts to break through to unveiled truth in the encounter with the "primitive" ends in total submission to irrational derangement – in a new form of mental disguise. For good or bad, these conclusions would appear to be inescapable, for to contradict them would entail disavowal of either the impulse of the de-institutionalizing practices or their ideal – the attainment of a new, open concept of art. Appearances deceive, and the dilemma resolves itself when we discard the arrogant certainty that the primitive, mythical forms of "world-understanding" are not basically comparable with those of logical-conceptual thinking. More than half a century ago, Ernst Cassirer proved in a study, which anticipated

the decisive standpoints of current structuralism, that every intrusion into the material of sensual experience has a choice of different points of view: one of these modalities is represented by the "conceptual forms of mythical thinking"; they are not based upon arbitrariness but upon laws of a specific type and definition. While the conservative standpoint contents itself with the diagnosis of dissolution and undifferentiated promiscuity, it is time to ask if the processes of erasing borders described here do not in fact embody the outlines of designs for new potential systems.

The reversion of disentegration to re-integration is based in the insight that all data of experience are of multiple value and can accordingly be appropriated by different "systems." Cassirer states that "the certainties and relations which we assume in 'being,' change according to the orientation of the manner of thinking, to the standpoint dominating it." Myth, religion, speech and art provide Cassirer with the evidence "that the classes and forms of being are not fixed for all time, as assumed by naive realism, but that their delineation must first be achieved, and that this depends upon the work of the mind." Naive philosophical realism finds its partner in the concept of art which suppresses every element of pluralistic significance, which derives all relations from the values of experience offered by the world of perception, and measures them against these values. Certainly, such an understanding of the world, which only recognizes intransigent and unambiguous connexions, will be threatened in its consistency and compactness, and unmasked as pretentious fiction, when, in the name of pluralistic significance, it is asserted that experiental data always permit "several possible systematisations" (Levi-Strauss), or when the Surrealists commit themselves to the motto of "Everything can be compared with everything" (Eluard), and thereby to total utility as the premise of all selection and classification.

The mythical understanding of the world proceeds analogously: one and the same form is amenable to different significance: for the Australien aboriginals everything is a potential totem.

This mode of thinking in variable formal connexions is not merely a prerogative of the mythical-primitive understanding of the world. It was, for example, the sponsor of the prescientific attempt to determine certain constellations of the stars, fixed patterns whose more or less plain course still governs our perception today. The scholar gains access to the structures of

his study material in a similar way. He first isolates a literary phenomenon and designates it. From a number of such findings he gains a "system of points." "One can connect them with lines; this gives figures. If one observes them and links them together, one has an over-lapping relation." (Ernst Robert Curtius). George Bachelard wrote that the historian chooses *his* own history from history itself. The artist proceeds in the same way. Let us keep to the example of the points and their linkage: in "Point and Line on Surface" (1926) in which Kandinsky first draws a star-shaped arrangement of dots, and next to it one of many possible linkages, whereby it strikes one that he totally contradicts the expectations given by the schema. Projected into this context, the countless modalities of the artistic understanding of the world lose their generic character: art no longer possesses the monopoly of pictorial and graphic understanding, it shares this characteristic with myth and religion, and with the intellectual symbols of perception. (Structuralism also works with configurations of selected signs). Common to *all* of these ways of orientation, is that they do not reproduce specific patterns of reality, but produce them; that they do not reflect what is empirically given, but generate it. Behind this stands the premise "that the sensual elements can be grouped in classes of similarity in quite different ways according to the standpoint from which they are considered. In effect, there is nothing identical or unidentical, similar or dissimilar – it is first made so by thought... The most dissimilar thing can still be similar or identical in one relation or another, and the most similar can also be observed as different in some particular respect". (Cassirer). Measured against the passive mode of reception of "naive realism," the plurality of significance advocated in the practices of erasing borders represents a gain in freedom and openness. Instead of proclaiming fixed relationships as irrevocable, it offers the possibility of chosing a possible relationship. Is this just as valid for the primitive regulation of the world as for contemporary acts of choise? The mythical manner of thinking produced coherent, inappellable explanations of the world, whose claim for exclusiveness stood in conflict with other systematisations. As far as the intransigence of artistic reference systems is concerned, not much has changed so far: everyone makes his own system absolute. Were the structural analyst to adopt this naive standpoint, he would be a chronicler of myths. However, in as much as he integrates every practice

of art and anti-art based on the erasing of borders into a spectrum of "systematisation possibles" (Levi-Strauss), he identifies himself with their system-breaking impetus and preserves them from claims for finality and exclusiveness. In this way, our ordering and correlating consciousness is not compressed into the cogency of specific "patterns" or – what would be equivalent to its emasculation – committed to pre-determined developmental contingencies and historical laws, but empowered to exploit the broad spectrum of significance. We owe the insight into fundamental openness, availability and polyvalency of the material of sensual experience to structuralistic ethnography and anthropology. This insight is the last

From Kandinsky, "Point and Line on Surface"

chapter in the confrontation with the "primitive." The structuralist base of thought removed the demonic element from the picture of "primitive" behaviour patterns (including art practices) and rendered it more lucid, at the same time proving the presence of "primitive" thought and behaviour patterns in our own enlightened conceptuality. In consequence, the "primitive" has forfeited the charm of its grandeur, originality, and absolute uniqueness. It has thereby come closer to us, but this closeness has nothing to do with security which anti-civilizational, romantic escapist thinking anticipated. Nevertheless, it does help us to productively negotiate, without progressivist arrogance, the cleft between thought and action and to represent it in our recurring drafts of new systems.

Translation G. F. S.

The Negative Reception of the Art of the Traditional Societies of Africa

Jean Louis Paudrat

Five dark centuries of continual misunderstanding of African sculpture have only been illuminated by some brief flashes of objective and lucid comprehension: the "discovery" of African art, some studies of Negro sculpture and, nearer our own times, an incipient ethnoaesthetics.

The history of Europe's views on the arts of Africa is tantamount to an almost undiluted ethnocentrism, the product of Europe's persuasion of its universal vocation to spread the ideals of western civilization: monotheistic religion and monogamous family life, private property and material possessions, Christian morality and Academic art.

The relations which some painters and art critics entertained towards Negro art mark a break with this ideology as complete as that provoked say by Marx, Freud, Mallarmé or Joyce in their particular fields. At stake during the break was, one suspects, modernity. In art an aesthetics of expression was to be replaced by an aesthetics of creation.

Nevertheless, the reception which these artists granted the African work of art between 1905 and 1914, although prophetic in character, has remained, until recently, marginal and restricted. We would be deluding ourselves were we to maintain that they were thus able to change overnight the judgment, the "doxa," of Europe about the art of the "primitive" societies of Africa. The barely initiated work of decolonization, that is the abandonment of generally accepted ideas, of prejudices, of hasty conclusions and of misunderstanding, cannot come to fruition all at once.

The colonial idea presented an almost insurmountable obstacle. The economic expansion in the European countries could not but favour the negation of other values and the extension of their own. Once admit that the African societies had a culture of their own and one has by the same token denied the universality of one's own, undermined the moral basis for the "mission" of the West and laid bare the cynical reality underlying the entire colonial undertaking.

Our knowledge of the European perception of signs of culture among the African societies during that long period (which has been characterized as "curious")

from the end of the fourteenth–1368 is the hypothetical date for the establishment of Dieppe merchants and sailors on the Senegambian coastline–to the seventeenth century. On the one hand, from 1450 onwards we find the rich dwellings of princes and merchants also house a room for their collections of "curiosities." It would appear that during this first period of exoticism no fine distinction was drawn between the natural products of the countries visited by the ambassadors, sailors and explorers and the cultural productions of their inhabitants. The collections embrace the widest variety of objects from unknown countries: skins of animals, the bark of trees, stones, ivory arrow- and spear-heads, and rare woods are placed side by side with the materials, the articles of clothing, the arms and the idols of the "savages." On the other hand, the flourishing trade between Spain and Portugal with the feudalities along the coasts of Africa not only brought spices and other exotic commodities to Europe but ivory work which adorned the tables of the European courts: covered goblets, salt-cellars, pepper-pots, spoons and the like. These ivories, whether already in existence before the arrival of the strangers or executed at their behest, were regarded in the West as beautifully carved and decorated, but nevertheless purely utilitarian objects which served the same purpose in their countries of origin, that is they were for the use of the rulers of those affluent kingdoms of Africa. The commercial relations, which still benefit both sides, encouraged the belief that power was organized in exactly the same way in the partner countries. This identification also involves a degree of recognition. Even if the Portuguese sailors witness rituals they qualify as diabolic, the bronze portals of the palace of the oba or king are there to reassure them: art, as in their own country, seems to be bound up with the spiritual and temporal power of the king and his priests.

However, the same fate was not shared by the "idols." These vindications of the supernatural and of the divine prohibition exercised a peculiar attraction. This Negro sculpture was given a new meaning by recourse to the biblical and medieval mythologies. These signs of an idolatrous, indeed of an heretical religion were but the outcome of the divine curse placed on the sons of Ham in Genesis. The whole fantastic world of medieval man, the monsters of the bestiaries, the occult and esoteric nature of his science, his belief in diabolic possession and in witchcraft and sorcery led him to read into "black" art an interpretation which was at the

same time "primitivizing," pre-evolutionist and expressionist. The missionaries, about whom Voltaire humorously remarked, "every statue is a devil for them, every assembly a sabbat, every symbolic figure a talisman, every brahman a sorcerer," went out to exorcise the "demons" and to destroy their "féticaoes," their "charms." Thus, his superstitions place the Negro at the very origins of the history of mankind, immediately after the Fall. His being in league with the Evil One even colours the terminology used. Nevertheless, as survivors of the earliest chapter in the history of the world, they are a living witness to the fantastic, the irrational and the imaginary in primeval man. This mixture of repulsion and attraction for the abscure and aboriginal is at the root not only of a lasting incomprehension of the sculptural creations of Africa but also of a long neglect in describing objectively the societies themselves and their organization.

During this first period, the African work of art, whether it appears on the table of an Othello or in the den of a Caliban, is rejected rather than recognized. The ivories from Benin are collected perhaps rather because of the rarity of the material than for their skilful workmanship. If they are, in a certain sense, "assimilated," this is especially because of their functional ambiguity: profane character and utilitarian universality. The "fetich," in contrast, is only a magical object, a manifestation of man deprived of God.

In the seventeenth century, the attraction of the "curiosity" waned and it was not until the year 1840 that the first military, commercial, confessionalist and ethnographic missions transformed the cabinets of "rarities" into museums.

In 1843, de Siebold, a French traveller, sent a letter to Jomard, conservator of the geographical collection in Paris, on "the utility of ethnographical museums and the importance of their creation in the European states with colonial possessions or with trade connections with the other parts of the world." The title of the letter is enough to betray its perspectives. The ethnological museums were to fulfil a didactic and a pragmatic function at the same time: on the one hand, they were to trace the path of civilization from its beginnings precisely in serving as the depot for the remains collected among the survivors of man's origins; on the other hand, they were to provide the missionaries with the requisite knowledge of the cults and rites of the peoples they were setting out to Christianize "so as to avoid seeing the seed of Faith fall on ground unprepared by the plough," to

show the colonial administrators the social institutions of the locality, to acquaint the military with "the arms, the armour and other instruments of defence employed by the indigenous population" and, finally, to draw the attention of the merchants to the raw materials which they could exploit. Here the connection between the foundation of these museums and colonial considerations is clearly underlined. Thus, more than twenty thousand objects were brought to Europe in less than 30 years, in accordance with the clarion call of Bastion, the ethnologist and founder of the *Königliches Museum für Völkerkunde*, Berlin, "let us buy the products of the civilization of the savages to store them in our museums." In addition to the fact that this systematic plundering by the European missions meant the irreparable loss of numerous African cultures, it does not appear that the exhibition of these objects contributed to their understanding or modified the prevailing attitudes.

The external principle which governed the system of classification employed by the conservators is only to be understood in the light of the scientific ideology of the age. With the aid of the monogenetic theory and the transference of Darwin's evolutionism from the realm of biology to that of cultural phenomena, too, Europe was made aware of her intellectual and technical superiority. Western civilization, example par excellence of completed evolution, through the scientific guarantee accorded by comparison with the state of the "other" societies, was in fact erecting with its ethnological museums temples to its own good conscience and, at the same time, necropolises for the "alien" cultures. The very organization of these monuments to Civilized Man was established a priori and according to the order implicit in the contemporary scientific ideology; by its axiologically oriented categories, it fossilized the living tissue which goes to make up the real nature of the society of the "primitive" peoples and which could reveal their true creative nature, that is their rightful place in history. The "others," the "primitives" become the object; the European is the supreme subject, the one who civilizes. Through his museum, civilized man is able to view his own history in its totality and the evolutionary height he has attained. Because he thus looks down on it from above, he can only view the "primitive" state as defective and full of shortcomings. The museum by presenting him with these traces of the distant past of man without Man makes the European aware of his noble mission: he

is to bring dignity through colonization to these peoples without history, without memory. The sections "Our Empire" in the world fairs and exhibitions, the colonial exhibitions, had no other function. Do the numerous articles, memoirs and treatises which the colonial officials write from the end of the nineteenth century to about 1930 on the societies among which they live reveal the slightest modification in the comprehension of the cultural systems in Africa, do they bear witness to a reaction against the dogmatism of the prevailing views? Although there are undoubtedly striking exceptions, like the work of Governor General Delafosse, these only prove the rule: the rejection and negation persists. How could it have been otherwise? The political and economic strategy of the European states which were partitioning Africa among themselves would have been completely thrown out of gear if the principle of the coexistence of civilizations had been adopted. When the authors consider the native art for a few pages, it is more often than not only to reject it and this because of its non-conformity with the normative aesthetic criteria of western humanism, which, codified for the occasion by the colonizer is identical in every detail with bourgeois Academicism. These writings inform us, for instance, that "primitive" art contravenes, among other things, the Greco-Roman ideal of the representation of the good and the true. Is not the "monstrousness" of these zoomorphic figures with their lack of conventional proportions opposed to the "verisimilitude of the delusion" which "civilized" art seeks? Is not artistic expression in sculpture precisely the sign of primitiveness? Are not the anonymity of the works and their utilitarian character contrary to the strongly individualistic and disinterested creativity of the inspired artistic genius? Can the materials of this art and its rudimentary and archaic technology pander to the taste for what is perfect, brilliant, agreeable? Do not the immodest exaltation of sexuality and the coarseness of the sentiments expressed shock the moral sensibilities of the refined man? And, to crown all, can one talk of art at all when one knows that these figurines stained with the blood of innocent victims are employed in the rites of fetishism and witchcraft?

Such were the particularly weighty ideological arguments which inform and justify colonial practice and render impossible a breakaway from normative aesthetics. The recognition that sculpture can fulfil a funktion which is not merely decorative and accessory would have led

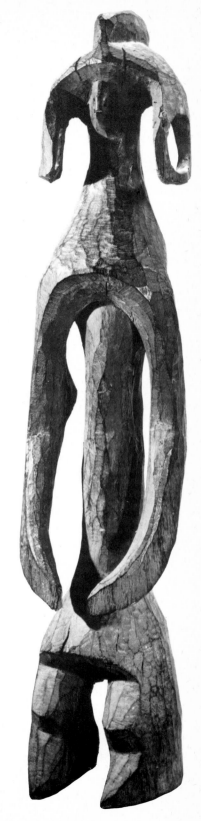

1863 Mumuye, Ancestor

them to grasp the object of African art as reflecting a culture which formed an homogeneous and alien whole. This would have meant relativizing at the same time the ethical intentions which masked the economic exploitation. The more scientific and less "committed" evaluation of "primitive art" by the historians of art and the first ethnologists, in spite of the gulf separating their attitude of mind from that of the empire builders, does not achieve more, if at all, than a modest beginning in the process of recognition. They differed but little from the prevailing opinion on the possible implications of evolutionism. As a proof of this statement we have only to think of the controversy during the closing years of the nineteenth century on the superiority of painting over sculpture because of the historical anteriority of this latter. Baudelaire remarked with scorn that sculpture is "an art of the Carribeans." Or again, all the analyses of ornamentation are taken over a priori by Haeckel to show that "primitive" statues have no sculptural reality. Although in Andrée in 1878 we have the first signs of a break with this convenient but erroneous application of scientific laws, the *Kunstwissenschaft*, the science of art, so set on greater precision, regarded with suspicion what some regarded as falling within the realm of art: a work which is difficult to locate in space and time and, what is more, is opposed to the criterium of aesthetic enjoyment. F. Hermann in his "Die Bildnerei der Naturvölker als Forschungsgegenstand" has struck the balance: "... the negative conclusion was arrived at that the aesthetic point of view is not absolutely determinative. It was hardly in accord with the evolutionary tendencies of the time (which permit you to place yourself at the summit of evolution in every respect) to seek aesthetic charms precisely in its lowest expressions. These were not considered as art, at most as its preliminaries. And if, as a consequence, they are examined scientifically then this is done especially in so far as they are documents of evolution, as evidence of the beginnings."

It is not for us to point out here the profound reversal which was produced by the "discovery" of "Negro art". If a retrospect fifty years later permits us to realize its power of destruction and innovation, we must be on our guard against believing that it immediately and irrevocably overcame all the prejudices against the arts of Africa. We should like to conclude by demonstrating this where ethnology is concerned, the example par excellence it would seen of a closed mind towards the sculpture of Africa. We had to wait until quite recently before it turned its attentions to art and asked itself what was the fundamental law which governed the activity of the sculptor in the structure and dynamic context of the traditional societies. Before the first world war, the "discoverers" had already tacitly presupposed this. Ethnology, in reality far removed from any colonial intention, nonetheless constitutes a science with a procedure which reproduces, under another guise, the same desire for simplification, the same ideological foundation: the refusal of the right to social practices like that of sculptural creation to be part of history. The functionalist viewpoint of the ethnologist causes him more often than not to describe the character of the objekt under consideration as a utensil, to reduce its form to the description of its function. The priority accorded to its function means that the object is not granted any role to play other than of interpreting, of reflecting, of representing certain elements of the myth. Function and signification are separated from the form, indeed they are given precedence. Defined in this way the form has no necessity whatsoever. It does not appear as essential to the life of the community. It is something superadded. To define the utility of an object is not the same as defining the object; it is solely to give it a name and not to show the formal ways and means of its function and utilization. To do this, it is necessary to consider what these forms signify and how they signify what they do. To understand the signification one must understand the form. The extreme morphological diversity, the infinite variety of the vocabulary of sculpture, the impossibility of finding two objects which are identical in spite of their fulfilling the same function, all this shows immediately the distance which separates the creations of sculpture from the inevitable representation of a primary model which is stable and enduring. The activity of the sculptor cannot be reduced to that of repeating objects of which one has only to establish their conformity with the initial model. In fact, the object is no illustration of a myth or of a model, and the myth is no authoritarian and strict cultural storehouse. Each new object informs and reconstitutes the myth. Behaviour is regulated by this relation of the forms to history. The creations of sculpture both make and express the history experienced by a culture. The African sculptor does not aim at fixing a reality which is evading him. But, on the contrary, to go beyond the instability of reality. Thus, in starting from a de-formation of reality, of experience, and of the dynamic formal structures, art in the traditional societies leads to a continuous modification of the collective consciousness; not by servile subjection to a culturally empty substratum, but by an intellectual restructuring of historical variations.

The exploratory nature of the masks and statues, and the innovational character of sculptural activity are difficult to reconcile with the regressive aesthetic ideology of post-evolutionary ethnology. To grasp art as a dynamic activity, with sculptural, semantic and historical functions was impossible on the basis of a science of cultural concretions. Ethno-aesthetics proposes to understand the African figurative reality as it is, indistinctly: forms, signification and history. Thus oriented, it is possible to see to what an extent this approach is indebted to the first attempts at "decolonization" of "Negro art" made by those painters at the beginning of this century.
After five centuries of rejection of what was different, the modern artist, at the same time as he dis-covered Negro art of its opaque veil of prejudices and errors, has realized himself and committed himself irrevocably to the path of the "auto-decolonization" of his own art and his own society.

Translation P. J. D.

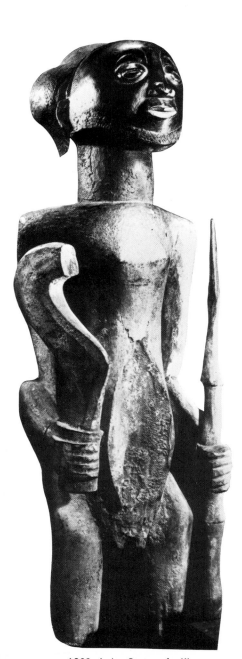

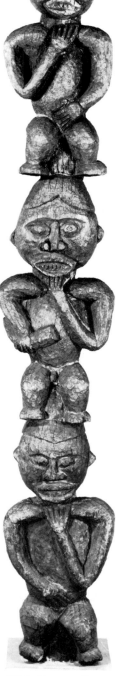

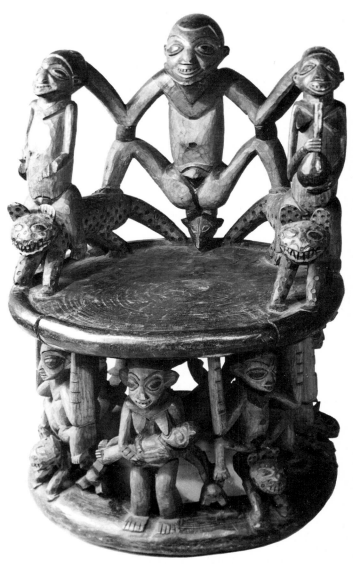

1869 Luba, Statue of a King

1826 Bangwa, Grass-
land, House Post

1828 Grassland, Cameroon, Chieftain's Chair

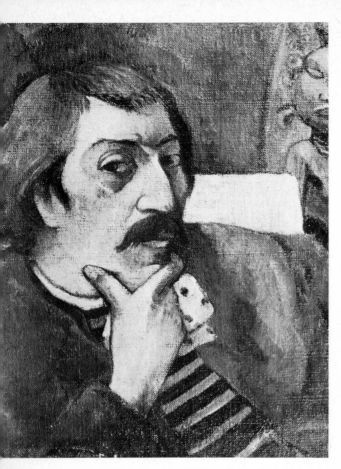

1707 Gauguin, Self Portrait with Idol

Gauguin's Encounter with the World of Primitive Peoples

Werner Schmalenbach

It is customary, and to a certain extent justified, to interpret Gauguin's primitivism as a late form of Rousseauism and romanticism, and to detect in Guguin's art a cultivated European element just as pronounced as the primitive. Nevertheless, the fact remains that Gauguin was the first important European artist to leave Europe, not for the Orient, however, but for the world of primitive peoples. In the year 1887 he left with the painter Charles Laval for the island of Martinique in the Lesser Antilles. His first visit to Tahiti lasted from 1891 to 1893, his second from 1895 to 1901. In August 1901 he moved to the island Hiva Oa (La Dominique) in the Marquesas where he

died in 1903. His plans to travel to other places, Tonkin and Madagascar, were never realized.

The object of all Gauguin's travels, and this is proved by his choice of Martinique and by the numerous papers he left, was not to discover primitive art but primitive life. Not even his own art provided the primary motivation for his travels, in the sense, perhaps, that he anticipated a heightened colour intensity from the tropical environment. In contrast to Gauguin, this is the decisive reason for van Gogh's stay in southern France where he dreamt of an "Atelier du Midi" analogous to Gauguin's project for an "Atelier des Tropiques." But as van Gogh wrote to his brother Theo in 1888: "I have now seen the sea here and I feel with my whole heart how important it is to remain in the South. One must not keep too far away from Africa if one is to intensify colours to their limit." If such motives play any role for Gauguin, then only in a subordinate sense. He is concerned with the transformation of his entire existence: with the life of, and living among primitive peoples in contrast to life in Europe. Nor is this contrast diminished by his life in Oceania, not only because European influences extended into this part of the world, but because Gauguin can not evade his fate of belonging to Europe. His constant insistance that he is now a primitive, a sauvage, an Oviri, only reveals all the more tragically that basically he is no savage but only clinging desperately to a vision of a lost paradise. His experience of the primitive world is for him always the experience of a remoteness from his own world.

However, Gauguin's Europeanism is not the sole reason which prevents him from achieving the identification he longed for with the natives of the South Seas. Neither is it due to the infiltration and dissolution of these cultures by the European if he fails to encounter the paradise of which he had dreamt (and which he still paints!). Nor, is it finally the "realistic" apprehension of the fact that the life of primitive peoples is also subject to sinister menace – and for this one reason is hardly paradisic – which destroys all hope of his realizing his ideal. He is actually concerned with an ideal that he does not actually want to see in reality, but wants to invoke as a hidden mystery, a dream. He can only experience it as a mystery so that all obscurities, however much he suffers from them, serve to enhance the magic power of his virsion. An identification with the primitive world would revoke its ideality and destroy rather than

fulfil his dream; and his art would lose its actual source of energy. In fact, his Europeanism and Europeanization of the native's world implicity help him to preserve the purity of the ideal, of the illusion; and the fact that the life of the native islander is subject to the threat of sinister powers does not impair his fascination for this world, but increases it. Contrary to van Gogh, Gauguin's dream of simplicity does not fulfil him in the everyday things of life, but in an ideal and consequently distant, foreign world. This is the essence of his detachment, which is only seemingly grounded in Europeanism. Gauguin experiences the burning desire for identification – and, of course, also the self-deception – but, compared with van Gogh, not the impassioned identification itself. If the negative aspect of Gauguin's motive for leaving Europe is economic insecurity, and his letters actually indicate that this is the essential reason, the positive aspect is not so much a desire for simplicity and primitiveness as a desire for happiness, which he thought he could find in this form of life: "Le Rêve du Bonheur dans un décor any where out of the world avec le poids nécessaire de la réalité objective." This concept of happiness incorporates two components of his nature which appear to be diametrically opposed: a passionate sensuousness free of any intellectual harness, and a similarly non-intellectual, very general spiritualism. For Gauguin, sensuousness and the presence of the supersensual are the components of that happiness which he hoped to find unspoiled in the world of the "savage." If he yearns for simplicity, then not for its own sake but for the happiness entailed in the sensual and supersensual.

Certainly, in this respect Gauguin is in the tradition of Jean-Jacques Rousseau and the Tahiti cult; but his concept of happiness differs from the rationalist – moralist basis of Rousseau's primitivism in that it is connected with irrational hopes on the one hand, and the expectation of paradisical sensuality on the other. A virtual confession of this conception is demonstrated by the two reliefs on the front of his hut on Hiva Oa – new versions of works from the Bretagne period of 1889 to 1890 – which bear the inscriptions: "Soyez amoureuses, vous serez heureuses" and "Soyes mystérieuses, vous serez heureuses."

It is the second of these two sides to his nature, an inclination to the "mysterious," which makes the dominant characteristic feature of his art spiritual rather than sensual. Gauguin shared the basic atti-

tude of the generation of artists following impressionism, especially that of the Symbolists gathered round his close friend Stéphane Mallarmé, and he uses the following words to express his criticism of the Impressionists: "Ils cherchèrent autour de l'œil, et non au centre mystérieux de la pensée." This "centre mystérieux de la pensée," however, is the organ through which this "mystère" so revered by Gauguin, can alone be perceived. He speaks himself of the "mystérieuse sensation de ce mystère." He is not interested in analyzing the "mystère" but in experiencing its profoundity. He intimates repeatedly that he does not want to understand, but to experience, to sense and to dream. It is in the unfamiliar Oceanian scenery and in the strangeness and "animalité" of the native inhabitants that he experiences the mysterious presence of what can perhaps best be described as the "numen" — a presiding spirit or divinity.

The different religions are experienced by Gauguin in exactly the same way. Their significance for him is their fascinating magic as manifestations of this spirit, whether it be in them directly or in the religiousness of the believers. Gauguin venerates the spiritual aspect of the most varied religious and mythological forms: in the imagination of the Polynesian, in Christianity and, above all, in Buddhism his life-long preoccupation. His small concern for their distinguishing features is demonstrated by the fact that he eliminates the borderlines between the most strictly contrasting religions and is not afraid to allow Christian and Buddhist elements to appear in Polynesian dress. This is not solely due to Gauguin's own lack of belief, but also to his inclination to experience the influence of a presiding spirit, a form of sacred awe for religion and, ultimately, for nature and human beings, too. Moreover, the fact that the imaginative reserves of the Polynesian have largely disappeared today, and exist largely only as memories, enhances their solemn significance; he also projects this chronologically into the future, into a profounder, darker and more mysterious sphere. Accordingly, it is not surprising when, in Gauguin's papers and his picture titles, the word "autrefois" repeatedly appears with a certain dark luminescence. Gauguin's notes on the religions and myths of the inhabitants of Tahiti in "Ancien Culte Mahorie" and "Noa Noa" refer to what is virtually a long-lost belief, which is expressed in the words of his "vahine" Tehura or in age-old memories, a belief that betrays Gauguin's own "nostalgie" to an even

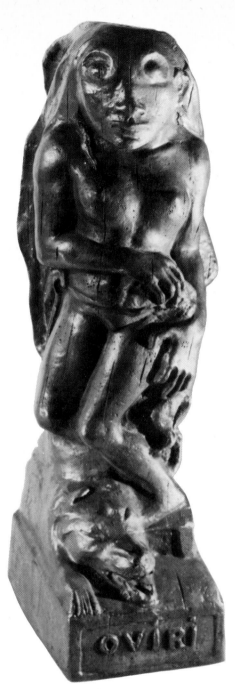

1726 Gauguin, Oviri

greater extent, since in this form it is a falsification based upon knowledge gained almost word for word from the travelogue "Voyages aux Iles du Grand Océan" of I. A. Moerenhout.

In compliance with all this, when Gauguin allows gods and spirits to appear in his pictures, they are represented in such

a way as to virtually exude solemnity, secrecy and mystery. They, too, are very strange figures and, from the point of view of composition, are frequently moved into the background where, contrasting with the naturalness of the overall scenery, their alien character is all the more enhanced. The fact that he prefers to depict them as pictorial compositions is a further indication of his direct, detached experience, and ultimately also for his own isolation.

Gauguin's primitivism represents a highly complex artistic and spiritual phenomenon. It can not be disputed that there was an intensive confrontation with the art of primitive peoples; but even where this becomes visible in his art, the point of gravity appears to shift from the primitive to the art of the advanced civilizations, indeed Gauguin's interpretation of primitive art largely takes the form of a civilized falsification. It is thus questionable whether Gauguin really penetrated to the core of primitive art, which means virtually the same as whether this art really entered into Gauguin himself. The one fact, which should not be underestimated, that Gauguin was the only artist of his day to experience the effect of primitive art, already indicates that the aesthetic consciousness of the European artist was not yet prepared for it. The objection that only Gauguin travelled to the South Sea Islands explains nothing, except to underline it as a historically isolated event. In addition, the relevant "material" was already accessible in museums; but one overlooked the ethnographical collections of the Trocadéro Museum and, if at all, went to the Musée Guimet with its wealth of Indian works of art. If people had actually wanted to see primitive art, they could have done so without visiting the South Seas. Today it might appear that Gauguin, in view of the isolated nature of his primitiveness, was in advance of his time — a widespread conception corresponding generally to the artist's historical function. In reality, however, he was very much a painter of his time, as is probably true of every important artist, and limits were thus set to his primitiveness which become conspicuous in a number of ways. While these limits are also of a psychological nature, they are suprapersonal in so far as Gauguin's historical position is definitely confirmed in them. Indeed, from the psychological aspect, there may have well been a certain élan for a genuine discovery of the primitive world, in so far as it is possible to conceive such a cleft between individual readiness on the one side and the propitiousness of the

historical moment on the other. Wilhelm Barth, one of Gauguin's biographers, wrote: "In all his comments on life, which reveal his naked honesty, he is perhaps more of a 'savage' than in his art"; whereby it is difficult to discern what European civilization understood as "savage" at the close of the nineteenth century. A savage in this psychological sense, especially when, like Gauguin, he actively participates in the progressive intellectual movements of his epoch, will employ the artistic means available at that particular time, even when he participates in extending them. Artistic temperament is not commensurate with a style indirectly and outside all history. The question of inspiration and influence by any form of art, especially a far distant art, only becomes psychological or individual when the time allows such an individual decision to be taken at all. The time, or more accurately Gauguin's generation, was not ripe for an artistic confrontation with primitive peoples, even if it naturally provided the prerequisite for the following generation for which such a confrontation became a fundamental experience.

The "discovery" of primitive art by early twentieth century artists represented a radical break with historical tradition. In sharp contrast to this, Gauguin's work presents itself as a new and, to a certain extent, revolutionary return to tradition, as a "Neo-Traditionnisme," through which, not academic naturalism but a traditional feeling for form and composition is given in answer to impressionism. The undertone of classicism in this emphasized renewal of tradition can not be overheard. Significantly, Gauguin was described by Maurice Denis as a "Poussin sans culture classique." Thus, even a classical element is attributed to this "savage," although not by the circles, or in the sense of the academic classicists, but by their "modern" opponents. The classical form melody of Gauguin's art, its Arcadian scenery transposed from Greek shores to the islands of Polynesia, has been scarcely overlooked by a single author. More than this, Gauguin was even inspired by the art of the Parthenon: among the photographs he preserved in the South Seas, there was at least one of a section of the Parthenon frieze, which occasionally served as a model for minor works. The extent to which his work tended towards a "renaissance of the classical" is ultimately demonstrated by its effect upon such an artist as Maillol, who developed his neo-classical style under the direct influence of Gauguin, his considerably

older friend. On the other hand, this fact must not cause us to forget Gauguin's influence on the quite anti-classical Fauves and Expressionists.

Moreover, Gauguin's traditionalism is verified by his appreciation of a number of earlier artists: Cimabue and Giotto, the Flemish and French "primitives" of the fifteenth century, Fra Angelico, Botticelli, Holbein, Raffael and Michelangelo. With this pronounced inclination, he stands quite firmly in his own epoch sharing it with other representative artists of that time, and even if much can be attributed to personal preferences, they are marked by a uniform traditionalist tendency combined with a preference for the art of the old civilizations. One other stream can be mentioned which is not far removed from Gauguin's primitive or archaic traditionalism: the English Pre-Raphaelites are part of this reactivating movement of the second half of the nineteenth century, for which reason Gauguin was occasionally termed a "Pré-raphaélite franco-tahitien." Greater and more essential than Gauguin's admiration for Oceanian art is his admiration for the art of the ancient civilizations, which is already expressed in his discovery of what is the basically medieval art of Brittany which he diverts into exoticism by his predilection for the peculiar. Here, too, there is not only a private inclination of the artist involved but also a general tendency of the period, especially apparent among the Symbolists. The art of ancient civilizations in Gauguin's terminology — and in French generally — is primitive art, as is Gothic and quattrocentist art. The limits of his artistic credo are laid down in the words "Ayez toujours devant vous les Persans, les Cambodgiens et un peu l'Egyptien," and "La vérité, c'est l'art cérébral pur, c'est l'art primitif — le plus savant de tous, c'est l'Egypte." Persian art, therefore, must be eliminated as the decisive source of his inspiration, and Japan added as a further source, whose importance only appears to be lessened by the fact that the Impressionists had already come to regard it as one of the great sources of different artistic qualities for their own work. Gauguin's debt to the art of the advanced oriental culture, however, becomes most evident when we observe how he even brings the art of the South Seas into contact with the stylistic mood of highly civilized art. His work shows numerous features also shared by Egyptian and Indian art (Borobudur). Thus, the most "archaic," most "primitive" art of his aesthetic confession is not that of the "savages" but that of the early advanced

cultures. Gauguin only seemingly descended to a level below this "plane" of historical development.

The common feature of the early advanced civilizations is in the first place social: we are concerned with distinctly feudal cultures. This is not necessarily important for an artist who admires them: but even this one aspect of the cultures of Egypt, India, Persia and the Far East is part of the fascination they have held for artists. Apart from other, more essential aspects, Gauguin was also receptive in this respect, and it is precisely this side of his being that is touched by Polynesian reality, above all the Tahitian. For, in contrast to the Melanesian cultures, the Polynesian have a highly civilized tone due to extensive sea-faring and the superposing of other cultures. The tendency to develop aristocratic and hierarchic structures within the various forms of society is widespread. For these reasons, it was already possible in Rousseau's time for Tahiti, which possessed an advanced court-structured culture, to gain the affections of educated seafarers, who had by no means shed the courtly attitudes still prevailing in France at that time; far more so than the Melanesian Islands, whose unaffected primitiveness was a thing feared. It is also true in the case of Gauguin that it is not, or not only, the primitiveness but also the cultural level which attracts him here; or more accurately, it is the level of development that gives him access to the primitiveness and provides a medium into which he can project his ideal of an earthly paradise. He may complain that Tahiti's old feudal culture has long disappeared; on the other hand this increases the hold of its magic power. He is greatly preoccupied with the aristocratic caste, the "Ari'i," and its women are a familiar subject of his pictures. In the famous "Ta Matete," the representation of noble Tahitian women invokes a natural comparison with the noble Egyptian women of a Theban fresco. However, he is not only affected by the aristocratic element in the South Seas; he experiences fascination for the dark and even the cruel side of native life, for the lurid customs of the past, for human sacrifice and cannibalism. This is all part of the disquieting, primitive foundation of a feudal world that is by no means absolute and untroubled. Gauguin certainly experienced the mysterious attraction of the primitive, but only as an unsettling element within an otherwise secure culture, for him full of beauty, elegance, charm, and spoiled only by the infiltration of European civilization. His

1725 Gauguin, The Birth

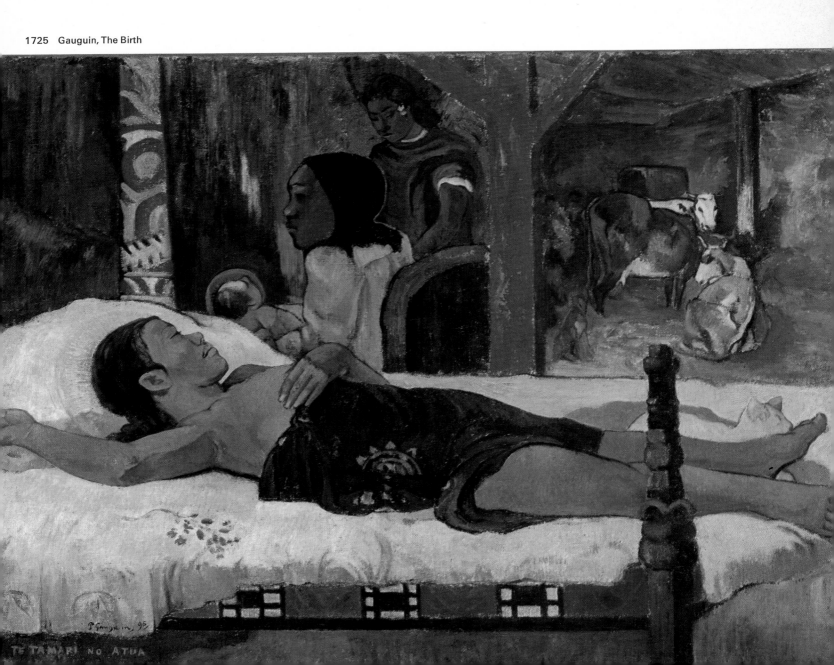

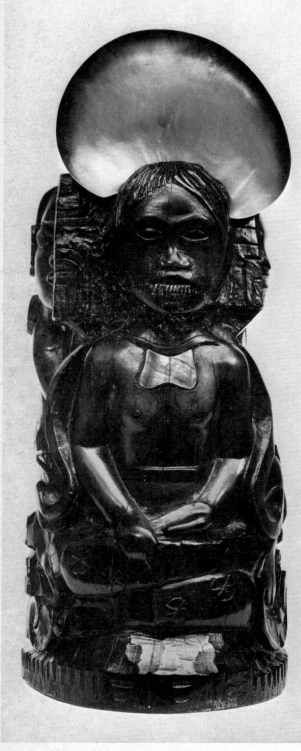

1717 Gauguin, Idole à la Coquille

art may well be influenced by the primitive, or as Gauguin would prefer to say, always touched and troubled by the savage, barbaric background, but its essence is ultimately the civilized character of this world. Moreover, when he idealizes not only the members of the Tahitian nobility but also the simple inhabitants, then he gives them more of an aristocratic, poised, and even elegant aura than of primitive savageness. Thereby, he is saved from a merely courtly, ceremonial art by the vitality and sensuality of his expression. The same becomes evident when we consider Gauguin's attitude towards the religion of the natives. It should be mentioned here, too, that Polynesia had already reached a high stage of cultural development in religion. We encounter polytheism, and there is also "religion" in the strict sense of the word: as an ordered, hierarchic, objective system of superior powers with clearly defined notions of deities, powerful myths and cosmogonies; a form of religion, therefore, which corresponds in a smaller degree to the religions of highly developed civilizations. Naturally, the primitive basis, the belief in spirits and demons still prevails, but it is superimposed, transcended by the hierarchy of the superior and supreme deities. Gauguin also has a feeling for both zones in religion: for the solemn, majestic, aristocratic and highly symbolic world of the gods which, following Moerenhout, he treats in the "Ancien Culte Mahorie" and "Noa Noa" and continually invokes in his pictures; but he also feels the substratum of dark, fear-derived fantasies as shown in his treatment of the spirits, the Tupapau, and their power over the natives. For, although demonism and animism form the older, more primitive stratum of the religion, it still prevails in Gauguin's period, whereas the ancient gods have lost their significance. Gauguin's sensitivity to these primitive powers below the Oceanian Olympus is reminiscent of Nietzsche's preference for the "Dionysian" element, which similarly disturbs and menaces the "Apollonian" from below. Of course, despite this stream of more primitive feelings, Gauguin's art can scarcely attain greater expressiveness, except perhaps that godlike idols together with spiritual figures and other symbols of religious disturbance (phosphorescent flowers, strange supernatural faces), affect modes of expression. The human figures themselves are generally represented almost non-expressively, and even in the odd exceptions this involves — apart from the expressive effect of the

race as such — mimicry and gesture rather than style. The stylistic aspect of Gauguin's art is not affected by "primitive" disturbance.

His confrontation with religion, therefore, also proves that the focal point of Gauguin's art lies in the tranquil and secure world of advanced cultures, which does not preclude that he submits to the dark elements of primitive religion at the same time. Furthermore, one may well assume that he would have been responsive to precisely these elements in every highly civilized environment — Indochina for instance — in the same way as he experienced the medieval folk art of Brittany not only as an expression of "religion" but also as the religiousness of the farmers and thereby as something "primitive."

The symptom of his responsiveness to the spirit of the advanced civilizations and the simultaneous fascination for the spirit of primitive religiousness which they have not wholly absorbed, is the very modulated expressiveness of his art. This ambivalence becomes particularly evident when his art is considered according to the principle of embodiment.

It is the decisive question in the present context, since this principle entails the sole criterion that clearly and unmistakably separates primitive art from the art of all advanced cultures. However, this question should only be applied to painting with certain reservations, for painting is by nature surface projection and can therefore not quite dispense with the principle of representation. Nevertheless, surface art can also obey the principle of embodiment. This is demonstrated both by primitive art — even though it seldom restricts itself to the surface — and modern art, art of the twentieth century.

Diverse components of a picture can function basically as "vehicles" of an embodied "power"; for instance, the represented human body when it sheds its representing character. They can also be other concrete forms such as a landscape element; in fact, any type of object. They can be abstract, but expressive figures in the sense of an embodiment of "living" figures. Finally, they may be lines or even brush strokes. "Power" can be embodied in all of these examples.

The expansion of the principle of embodiment in art, including painting, since the turn of the century is of great importance. It can already be observed in the early Expressionists: a certain power appears to directly create forms — concrete forms as

well as lines and surfaces. This power does not lie in the objects themselves or use organic channels, even if the formal character still remains organic. We find here an essential element which contrasts, for instance, with the expressive romanticism of a Delacroix who escalates the organic into the expressive, so that one is inclined to speak of dramatization rather than expressiveness. A landscape by Munch or a cypress by van Gogh is imbued with a power other than natural and, in order for this to be expressed, the concrete must become rudimentary. Basically, German expressionism also orientates in this direction. Characteristic is that one of the most important devices of expressiveness employed here in expressionism is movement, which primitive art virtually dispenses with. Cubism, too, which deals most strictly with the art of primitive peoples, and to a large extent even surrealism, dispense with all movement. The expression of embodied power is achieved because the power does not actually discharge. It is true that when power does discharge in expressionist painting, then it is still pure power that is expressed since it is not channelled organically but captured at the moment of explosion. But the individual structural forms are not mere accumulators as in the works of the primitives, where the utmost outward stillness is imposed upon them to achieve just this embodiment.

If we approach Gauguin from this type of consideration, there is no doubt that his art is an art of representation, all the more so since the feeling for detachment is an essential feature of his artistic and human outlook. Gauguin represents the world of the native in an observing and composing manner, whether he idealizes it as a paradisical idyll or describes it as a simple, and perhaps even anxiety-filled, reality. Above all, he represents man in the environment of nature. It is true that this is done with a minimum of movement and dramatic effect. Vivid action is seldom encountered in his work; but in the passive juxtaposition of the figures there is still scarcely a hint of that actual primitivism which isolates the figures from one another, since any active contact between them would mean a discharge of power. This juxtaposition corresponds closer to the classical juxtaposition of ideal figures in ideal space.

Different, however, is the frequent juxtaposition of natural and supernatural figures: here, one world contrasts with another; and when one of Gauguin's idols is set into the natural scenery in a most natural way, it still appears isolated precisely due to the suggestive confrontation. It emits its power, its deep significance, not through outward directed action but through its mere passive presence. Although it is intelligible as a scenic motif, it stands in another dimension. If these idols are still not unorganic compositions, their power still resting entirely in the organic, this power does actually "rest" and does not discharge.

Gauguin shows a tendency to humanize his idols, to make them more organic than they appear in the art of the Polynesian (in so far as they are inspired from this source at all). The expressive moment is more developed in his own plastic idols and the affinity with primitive carvings is greater. But even here, Gauguin can not abandon the organic principle and, in common with his entire generation, he is bound by its limits. Finally, his graphic idols show features similar to those of his painted idols: here, too, he does not regard them as isolated vehicles of power but as components of his real surroundings, to which they are intended to impart the same "mystère" as transmitted by the painted idols to the scenery of his pictures. Thus, the scenic conception is even maintained here, and once more it is less the embodied power than the general significance that constitutes the value of the idolous figure for the artist. To a considerable degree, however, these figures do possess the character of "objects" whereby one easily forgets the representation, and the figure is taken as figure. They are already forerunners of those "objects" which attain such great importance in twentieth century art, especially where they show primitive tendencies.

The step towards a style of the embodied power is therefore not taken. It is a style of the "significative," a style, however, that conveys no information on significance itself. This symbolistic approach leads up to expressionist art but stops before reaching it. Accordingly, it also halts directly before the art of the primitives, which only appears not to remain closed to it since it is understood as something significant, something higher, something mysteriously alien, and is therewith misunderstood: interest in the folk-lore element is greater than interest in the artistic.

The principle of embodiment, however, does finally enter into Gauguin's painting. It does not change the figures, but it is expressed in those elements of form that Gauguin himself would have described as the "decorative" or "musical"; i. e. primarily in the line of his compositions, which began to attain considerable autonomy. The potential for independent expression entailed in the line was discovered by Gauguin together with other artists of his generation, probably under the influence of Japanese woodengravings. In his work, line is not determined by the concrete but by a power immanent to it. Power dictates line: its course, its expansion and attenuation, its tautness and relaxation; indeed, it demands line at a point where nothing concrete asserts claims on it. The organic, fluid, undulating character of the line is thereby preserved; it is precisely this that avails itself of the power here, and this also represents its limit. This energetic conception of line becomes – via Gauguin, van Gogh, Munch, Toulouse-Lautrec and other artists of the Fin-de-Siècle – the general basis of that phenomenon occurring around 1900 which was not restricted to pictorial art, namely "Jugendstil." "A line is a force. It derives its power from the energy of the person who has drawn it" is a celebrated pragmatic statement by van de Velde. There is, however, a covibrating symbolistic element throughout the entire Jugendstil movement: it is not so much the expressive force of the line in the sense of an individual expression of power by the artist, or in the sense of an embodiment of "power in itself"; but once more a "signification," which can not be deciphered further, is imparted to the line. Cornelius Gurlitt defines Jugendstil as nothing less than the "art of the symbolic line." Jugendstil can thus be recognized as essentially a more symbolistic than expressionistic phenomenon. It would also appear to be characteristic that the "Jugendstil line" in Gauguin celebrates its passionate orgies in its actual symbolistic period, that is during the years 1889/90 in Brittany, and during his first visit to Tahiti. Moreover, there is the colourfulness, which although he was to tone it down later, was so striking at the time that, according to Gauguin, it attracted the following response from Mallarmé at a Durand-Ruel exhibition of his work in 1893: "Il est extra-ordinaire qu'on puisse mettre tant de mystère dans tant d'éclat."

On the other hand, there is also an unorganic element in Gauguin, even if it is not dominant and features only at the fringe of his work. It is mainly to be found when he closely follows the works of South Sea art; for instance, in a few of the water colours of the "Ancien Culte Mahorie." But even here it is restricted to ornaments and stylizing details, whereas the figures are organic, human

261

compositions. His interest in geometric ornaments is proved by the carbon copies of Marquesanian ornaments in "Noa Noa," but they remain copies and are not utilized further in his art. This interest in particular is not genuinely primitivist, for the geometrical ornament is a phenomenon of highly civilized art: it signifies rules, order, dimensions. Expressiveness has come to rest, has been masterfully subdued. The typical faces and figures of the Tikis in Marquesanian ornamentation have virtually forfeited all expressiveness to their geometric form, and affect Gauguin as mysterious relicts of an ancient and almost lost significance. The outgoing nineteenth century was generally quite receptive to geometric ornamentation; not only artists were fascinated, it was also treated in the science and philosophy of art, where it was regarded as the origin of all art – an origin to which the artists of Gauguin's circle, especially in Pont-Aven and Le Pouldu, desired to return. It is archaic and not primitive ornamentation. One still had no eye for the more primitive ornamentation of Melanesia despite its relatively organic character.

If surface art is limited from the start by embodiment, this is especially true in Gauguin since his art is also stylistically conditioned by an orientation to the surface. Not that space and solidity is entirely eliminated, or that it is interpreted in terms of patches of colour as in the later Matisse; but both are always treated with an eye to the surface. Space in particular, even when it extends to a certain depth, remains closely related to the surface; similarly, the composition of figures always has its firm hold on the surface. If impressionism, with the homogenity of its scenic structure, signifies a certain rehabilitation of the picture surface in contrast to the illusionary space of naturalism, then in Gauguin and other leading artists of his generation – prepared by Cézanne – surface comes into its own formally and not only structurally. It becomes nothing short of the essence of the new artistic credo around the year 1900. Since Gauguin also held this belief, it is natural that he should appreciate all the great surface art in art history, particularly that of the Orient from Egypt to Japan. This line of development definitely does not include primitive art, even if the art of Polynesia, especially that of the Marquesas and New Zealand, shows a measure of advanced cultural development: in contrast to most primitive art its tendency is towards a surface conception. The strong inclination of Gauguin and his contemporaries in general towards

monumental art ultimately conforms with the acceptance of surface. That Gauguin's art, more than almost any other, is predestined for the large mural, for architectonic "application," was felt by the artist himself and the more perceptive of his contemporaries.

This monumental and generally "decorative" pretension was sustained by the notion – widespread in the second half of the nineteenth century – of an "integrated art" within which all art would be given one function. This is how "decorative" art was understood before the concept was eventually corrupted in common usage. The monumental tendencies focused once again on the art of those cultures which had possessed genuine monumentality, and therewith something like an "integrated art." It was thought to have found its fulfilment in Egyptian frescoes and Indian reliefs, not, however, in primitive art. The South Seas had nothing to offer Gauguin in this respect, except perhaps that his monumental conception of idols may have been influenced by the more colossal than monumental statues which he knew to exist on the Easter Islands. Apparently, he had not heard of the stone figures on the Marquesas and other islands.

The more systematically one examines the primitivism of an artist, the more negative the results must be, for the conceptual fulfilment lies in the primitive itself, and thus in the overcoming of primitivism. It lies, therefore, beyond the artist himself, beyond the border that separates him sharply and conclusively from the primitive. If primitivism also endeavours to draw close to primitive art and perhaps even to primitive life, then precisely this undertaking causes the artist to remain diametrically opposed. Its prerequisite is nothing less than the extreme detachment from the primitive. Moreover, this prerequisite, which is much too complex to allow an extensive analysis of its significance for Gauguin, for it lies in the entire cultural and individual origins of an artist, can not be cast off. It can not, however, be regarded only as a negative factor, as a borderline of primitivism, since it is the artist's actual nutritive substratum, his whole existence, and as such it plainly functions as a positive element. Nevertheless, in order to identify the primitivism of an artist or a particular generation one has to speak of this borderline, which becomes more and more conspicuous in Gauguin the longer we study him. Apart from this historical explicitness of the boundary of all primitivism, a further artistic motive should be mentioned which prevents the identification of

Gauguin's primitivism – and probably that of every artist, especially recent painters – with primitive art: the fact that every work of art primarily represents a statement made by an individual. The direct self-expression of the individual has become more and more important in recent art, whereby the artistic "handwriting" has also gained importance. Where the will to embody power becomes conspicuous in modern art – in the form described in Gauguin, or in more radical artists of the twentieth century – it is ultimately not the "embodied" power but the power of the artist's "handwriting" that is decisive. Naturally, the question of value is not affected by the principle of embodiment, or any other principle. In any case, the artist can not dispense with "handwriting" after he has once accepted it as the final criterion. In this respect, twentieth century art, and Gauguin's more so, connects organically and smoothly with the tradition of European painting since the Renaissance. If, at the beginning of the twentieth century, primitivism makes a dynamic move in the direction of the art of the primitives, it encounters this border and is forced to retreat just at this point. Picasso's way from the "période nègre" (1907/08) to cubism demonstrates this admirably. It entails the maintenance of form against content at that stage where content itself almost becomes form; i. e. form-embodied power. Even where power and form have been welded into one, it can not be confused for long with the artist's "handwriting." The two elements are distinctly separate again in surrealism even though there is frequently an overemphasizing of content in which the observer does not need to participate: nor should he!

Of course, this peripeteia does not yet occur in Gauguin. For him, artistic accomplishment, cultivated art, remains an objective which he even takes as a matter of course, and the "handwriting" still supplies nothing to the content, not even a rudimentary "power." The influences from the art of past cultures, to which he submits, do not yet threaten to penetrate the pictorial structure of his works; this applies particularly where he works with "primitive" materials, above all wood.

If it was not the art, but the life of the primitive peoples and life among them, that fascinated Gauguin in the South Seas, this is expressed clearly in his work, which, although devoted to native life, was orientated in a wholly different direction. Where Oceanian figures and even Oceanian ornaments or stylizing

forms appear in his work, they belong to the "milieu," to the "local colour," and as such are understood more as motifs than as formal compositions, even when a higher, "divine" significance looms suggestively over this descriptive function. Gauguin's primitivism is more affective than artistic, whereby the affective moment loses its intensity to the degree that the environment becomes increasingly familiar to the artist; this is most vividly expressed during his first stay on Tahiti. It is precisely this affective relation to his environment that prevents Gauguin from making a "genuine" discovery of primitive art – apart from the fact that the proper historical moment had not arrived. Since Gauguin is concerned with an ideal and therefore with maintaining detachment, he experiences native art as a symbol of this ideal; thus, as something which neither artistically nor intellectually corresponds to what it actually is. This is made especially clear by the "discovery" of primitive art by artists at the beginning of the twentieth century; for this preserved the foreign character of primitive art, allowed it to be experienced and studied on an equal footing with other art, which then incurred a loss of interest in the "primitives." The principle of representation would correspond to this form of interest; a principle which, if not entirely supplanted, was stripped of considerable authority. Only when freed from the fascination for primitive life does the view of primitive art become clear. The "exotic" has no significance for Picasso, who understands the art of the primitives as a formal principle more radically than anyone else; nor for the Surrealists, who take it literally as an embodiment of superior powers. "Sentimentalist" and, thus, exotic features still prevail to a less evident degree in the work of the Fauves in France, and the German Expressionists. A whole generation lies between Gauguin and those artists who experienced the art of primitive peoples as a revelation; but the discovery of primitive art by modern, twentieth century artists is close in time to Gauguin. In 1903 Gauguin died on Hiva Oa. In 1905 Parisian artists began to show interest in negro sculpture. In 1904 Kirchner and his friends in the Ethnographic Museum in Dresden were influenced by primitive carvings. Indeed, an early influence of primitive art can be observed in a pen and ink drawing by Klee done in 1897. Gauguin's life thus ended directly before the classical period of modern primitivism began.

Translation by Graham Fulton-Smith

1707 *Paul Gauguin (Paris 1848–1903 Hiva Oa, Marquesas Islands); Self-portrait with Idol (hina);* oil on canvas; 44×32.5 cm; sig. right top: PGO; 1893, according to Wildenstein 1891; Wildenstein 415; San Antonio, Texas, Marion Koogler McNay Art Institute; plate

Gauguin's Ties to Pre-Columbian America

Since 1886 Gauguin (who grew up in Peru) had begun to take an interest in ceramics, in shaping pots and vases, straight from his hand, without using a potter's wheel, without the usual cylindrical shapes and the classical repertoire of forms, and these works – in the face of the 2000-year-old European tradition of the potter's wheel – rank with the only ceramic works which were made without the wheel: those of ancient America. If Gauguin is guided in the matter of glazes (which did not exist either in ancient America) by Japanese formulas and Chinese examples to influence his inventiveness, he turns in his techniques and shapes to Peru. (Although it is true that the English designer Dresser had already used individual forms of the Nasza and Tiahuanaco cultures in his designs for Linthorpe as early as 1880, this remains within the framework of the various historical styles. Picasso was the first, in the circus vases of 1954, to take up once again quite clearly the bowed handled vessels of the Mochica culture.) Head vessels, such as Gauguin frequently modelled, are also characteristic of the Mochica culture to which the Stockholm self-portrait undoubtedly forms a direct bridge: acknowledgement by the "Indian" to the non-European tradition down to the selection of the shape. The block-connection of the head to a partial upper body, as if grown together like one rock (see Cat. no. 1708), has its counterparts in the Chimu culture. Even at this early stage Gauguin crystallises out the block principle of old American art, which in the 20th century became a central motif of the reception. The head combines with the elementary form of the block: this, too, is an incunable of modern sculpture.

Another type recalls the vessels of the Nasza and Chancay cultures: extending the handle into an aesthetically effective bridge over the body of the vessel or into a double vessel. One vase, now lost, goes as far as imitating an example of Nasza ceramics (see photo), others modify the principle in extreme fragility. There are also many examples in the Chimu culture of Gauguin's liking for small plastic fig-

ures leaning against the cuvre of the handle (the vessel as the stage of genre scenes). It cannot always be clearly distinguished in how far Gauguin made use of direct stimulation for some individual (not a few) pieces, in how far he made very free variations of a generally old Peruvian repertoire of shapes, without copying the detail. The result is no different from in Peru: a ceramic art which is, at the same time, fully-fledged sculpture. M. Sch.

1708 *Paul Gauguin; Tobacco pot in the form of a self-portrait;* stoneware with dark brown glaze; h 30 cm; inscription on the inside of the base: La sincérité d'un songe à l'idéaliste Schuffenecker, Souvenir Paul Gauguin; spring 1887 (Gray) ? beginning of 1889 (Bodelsen) ?; Gray 66, Bodelsen 53; Paris, Musée National du Louvre

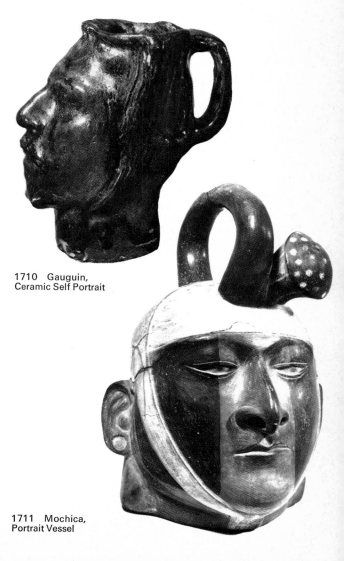

1710 Gauguin, Ceramic Self Portrait

1711 Mochica, Portrait Vessel

1713 Gauguin, Pot in form of pumkin

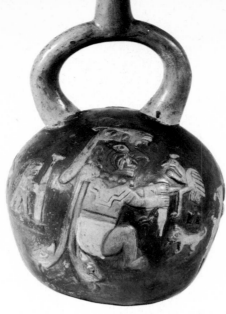

1715 Mochica, Vessel with stirrup-shaped spout

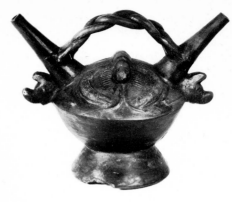

1714 Nasza, Vessel with double spout

1709 *Paul Gauguin; pot in the form of a grotesque head;* ceramic; made from a model; 15.5×21.5 cm; cf. Cat. no. 1711; Paris, priv. coll.

1710 *Paul Gauguin; cup in the form of self-portrait* (photo); stoneware; green-gray glaze with red patches; h - 19.5 cm; 1899; see Cat. no. 1708; Copenhagen, Mus. of Applied Arts; plate

1711 *Mochica culture (Peru); portrait vessel;* clay; painted; h - 27 cm; 4th–8th cent. A. D.; Stuttgart, Linden-Mus.; plate

1712 *Mochica culture (Peru); portrait vessel;* clay; painted; h - 19 cm; 4th–8th cent. A. D.; see Cat. no. 1711; Stuttgart, Linden-Mus.

1713 *Paul Gauguin; pot in the form of a pumkin;* brown stoneware with dark green glaze and shiny golden patches; h - 20 cm; sig.: P. Go, 80; 1880; Paris, Alain Lesieutre; plate

1714 *Nasza culture (Peru); vessel with double spout;* clay; painted in various colours; h 17.5×23.5 cm; 4th/6th cent. A. D.; Stuttgart, Linden-Mus.; plate

1715 *Mochica culture (Peru); vessel with stirrup-shaped spout;* clay; painted black; h - 22 cm; 3rd/8th cent. A. D.; Stuttgart, Linden-Mus.; plate

Borobudur and Buddhist Iconography in Gauguin

Gauguin had two approaches to Buddhist culture: on the one hand the Buddhist element constituted a considerable part of his theosophically determined syncretism. On the other, the reliefs in the temple of Borobudur (Central Java) became a constant source of inspiration for his art. It is here that he finds the pure arrangement of the surface of the relief, which for him is hieratic and original, but

also a repertoire of expressively moved figures filled with perfect statics. The variations on Borobudur comprise painting, water-colours, woodcuts and carvings.

Figurial motifs from Borobudur take effect in breadth during his first stay in Tahiti: Tahiti's cosmological mythology, which knows hardly anything of anthropomorphous embodiments and no actual iconography, encouraged him to adopt from Buddhist iconography.

It appears as if Gauguin chooses the fixed gesture language of Buddhism in particular for representations to which he attaches a more generally valid, heightened symbolic message. Moreover, Danielson has pointed out the natural affinity of the Tahitians to heavy-limbed gracefulness, to the lithely retarded charm and the artistically archaic rhythm of Borobudur, whereas the figurial style of the Javanese relief finds its ideal correlation in the Tahitian physical constitution. Buddha's sitting position is removed from its meditative sphere and reinterpreted as the hieratic frontality of the idol, vitalised by barbaric attributes. Buddha and the chief Tahitian divinity Ta'or fuse into one. That the Buddha association is not merely a superficial reminiscence, but also has some weight in the content is shown from the reverse figures in the "Idole à la Perle": here the overcoming of the material world which is expressed in Buddha's position finds its Tahitian analogy in the mythical conversation of Hina and Tefatou, who symbolise mind and matter.

In addition, standing and walking motifs, combined with some hand positions, also gain importance. It is not only that the round-hipped type of the Hina representations in which she is lithely turning out of her hip (especially in the carved cylinders) reflects any less the block statics of the Marquesas as an Indonesian ideal. M. Sch.

1716 *Paul Gauguin; Idole à la Perle;* bronze cast by Valsuani (1959) after original in tamanu wood with black painted hair of the figures, inlaid pearl and gilt necklace and niche; h - 25 cm; sig. top: PGO; 1892; M. S. Paris; Paul Spies Coll.; plate

1717 *Paul Gauguin; Idole à la cocquille;* bronze cast after an original in ironwood; mother-of-pearl (aureole, breastplate), bones (teeth); 27×14 cm; sig. top: PGO; Paris, Jeu du Paume; plate

1718 *Paul Gauguin; Buddha;* woodcut; printed in black on India paper; 30.3× 22.2 cm; sig. top left: PG; after 1895; Paris, Bibliothèque Nationale

1719 *North Thailand; Buddha;* bronze; h - 42 cm; 16th cent.; Munich, R. Gedon Coll.

1720 *Paul Gauguin; tahitian eve;* water colours on paper; 40×32 cm; 1891; Grenoble, Musée des Beaux-Arts

1721 *Paul Gauguin; hina and the fatou;* tamanu wood; h - 32 cm, ⌀ 14 cm; sig. top: PGO; 1982/93; Gray 96; Paris, priv. coll.

1722 *Paul Gauguin; cylinder with the figure of Hina;* tamanu wood; painted black and gold; h - 36 cm, ⌀ 13 cm; sig. top: PGO; Paris, priv. coll.

1723 *Paul Gauguin; Posthumous documents;* a) photos of the reliefs of the Temple of Borobudur (Java) from the 12th cent.; b) liste of objects, bought by Victor Segalen 1903 on the auction of Gauguin at Tahiti; Bourg la Reine, Mme Jolie-Ségalen Coll.

1724 *Borobudur (Java); Reliefs from the Temple* (photo); 12th cent.; see text to Cat.no. 1723

1725 *Paul Gauguin; The Birth of Christ;* oil on canvas; 96×129 cm; sig. top left: P. Gauguin 96 Te Tamari No Atua; 1896; Munich, Bayerische Staats-gemäldeslgn.; coloured plate

1726 *Paul Gauguin; Oviri (the wild woman);* bronze; h - 87 cm; winter 1894/95; Paris, priv. coll.; plate

1727 *Paul Gauguin; L'Après-Midi d'un faun;* tamanu wood; coloured light yellow; 34×12×9 cm; sig. top: PGO; Paris, priv. coll.

1728 *Paul Gauguin; Cylinder of Christ on the Cross;* toa wood; h - 50 cm; sig. top: PGO; c. 1898; Paris, priv. coll.; plate

1729 *Marquesas; club;* casuarini wood; 149×19 cm (head); Berlin, Mus. für Völkerkunde; plate

1730 *Marquesas; club;* casuarini wood; 140×17 cm; see Cat. no. 1729; Bremen, Übersee-Mus.

1731 *Easter Island; inscribed plate;* tono-miro wood; 28.5×14 cm; Vienna, Mus. für Völkerkunde

1732 *Paul Gauguin; Thérèse;* rosewood; partly gilded; h - 66 cm; sig. under right hand: PGO; inscribed under left hand: Thérèse; after 1900; Paris, Madame Wertheimer Coll.

1733 *Paul Gauguin; walking-stick with Polynesian motifs;* whitethorn wood with iron fixtures; l - 88 cm; sig. above middle: PG; 1894/95; Paris, priv. coll.

1734 *Paul Gauguin; walking-stick with hina;* nono wood; iron band; l - 91 cm; sig. on iron band in gold inlay: PGO; Paris, Mus. Jeu de Paume

1735 *Paul Gauguin; bowl;* tamanu wood; l - 46 cm; w - 20.5 cm; sig. in centre: PGO; Paris, Mus. Jeu de Paume

1736 *Paul Gauguin; Tahitian woman;* oil on canvas, 62×81 cm; 1898; Lenin-grad, Heremitage

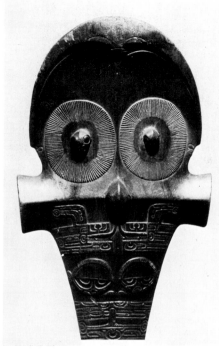

1729 Marquesas, Ceremonial Club

1738 *Paul Gauguin; Ancien culte Mahorie;* facsimile according to the hand-written manuscript with water-colour painting; 1892, facsimile edition 1951

1739 *Paul Gauguin; Noa Noa;* facsi-mile according to the hand-written manuscript with water-colour paintings, woodcut, photos fitted in

1740 *Paul Gauguin; sketchbook, seven pages of drawings, mostly Polynesian motifs;* pencil and Indian ink on paper; 20×15 cm; plate

1741 *Paul Gauguin; stone rubbings of Marquesanian ornaments;* chalk on paper; 8.7×10.5 cm; Bourg-La-Reine, Madame Annie Jolie-Ségalen

1742 *Marquesas; wooden arm with tattoo patterns;* wood; l - 59 cm; Berlin, Mus. für Völkerkunde

1743 *Marquesas; carved lid;* wood; 13×23 cm; Berlin, Mus. für Völkerkunde

1744 *Paul Gauguin; two Tahitian women and a Marquesanian ear plug;* pencil and Indian ink on paper; 23.8× 31.6 cm; Chicago, Art Institute

1745 *Marquesas; ear plugs (putaiana);*

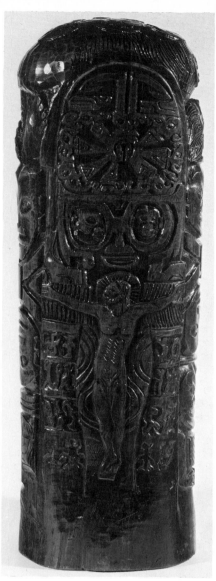

1728 Gauguin, Christ on the Cross

a) sperm whale tooth, shell, 1.8×4.6 cm;
b) boar tooth, shell 1.9×6.3 cm;
c) sperm whale tooth, shell 2×5 cm;
d) boar tooth, 1.7×4.8 cm; Berlin, Mus. für Völkerkunde

The Tikis of Hivaoa

Tikis were for Polynesia, and especially for the Marquesas, the representative embodiment of the numinous. They represent deified ancestors between men and gods. The figure acts as the seat of their soul. The original significance, the Tiki as the mythical creator of the first man, was superimposed by a variety of ancestral divinities. It was their task to confer

265

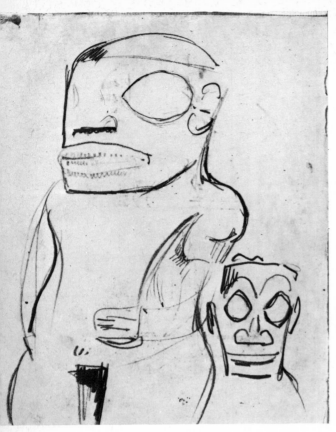

1740 Gauguin, Tiki from the Sketch Book

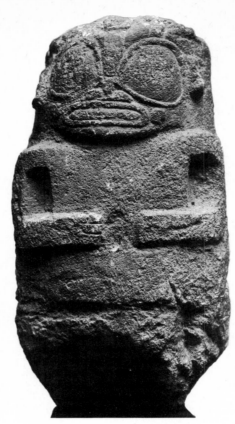

1746 Marquesas, Tiki

1746 *Marquesas; tiki;* basalt; h - 46 cm; Paris, Musée de l'Homme; plate

1747 *Marquesas; tiki;* stone; h - 31 cm; Berlin, Mus. für Völkerkunde

1748 *Marquesas; canoe tiki (tiki vaha);* wood; 35×13.5×11.5 cm; Berlin, Mus. für Völkerkunde

1749 *Marquesas; tiki;* wood; h - 48 cm, b. of shoulders 13.5 cm; Cologne, Rautenstrauch-Joest-Mus.

1750 *Marquesas; step on stilts with tiki;* wood; 33×8 cm; Berlin, Mus. für Völkerkunde

1751 *Marquesas; step on stilts with tiki;* wood; 31×7 cm; see text to Cat. no. 1750; Paris, Musée de l'Homme

1752 *Marquesas; tiki;* human bones; h - 5.4 cm; Berlin, Mus. für Völkerkunde

1753 *Marquesas; "Crown" with tikis;* tortoiseshell; l - c. 70 cm; Stuttgart, Linden-Mus.

Gauguin's Woodcuts

In the woodcut Gauguin found a medium which was bound to appear to him "more primitive" than the music in the lines and colour of his painting, more original than lithography and etching, which were preferred by the Impressionists. The directness of cutting and printing, the relief character of the wood block, the renunciation of smoothness, but not of differentiation and details (Gauguin never thought of the "savage" as a crude craftsman) bring him so close to Polynesian art that he sought Marquesanian woodcuts and thought he had identified them in photos.

Gauguin dissociated himself radically from the reproduction woodcut, gave new, autonomous importance to technique between relief and painting and tried out new means of colour differentiation and decorative concentration. Although the reform of the woodcut took place on a broad front, Gauguin pursued his way the most inventively, the most consistently and with the most significant results. He created incunables of the modern woodcut.

The drawing was engraved in fine lines (and often covered over afterwards), while larger areas were hollowed out deeply with a knife. The wooden block almost has the appearance of a relief, as was later the case with the "Brücke." The printing of the hollowed out parts,

happiness and life force — mana —, a central aspect of Oceanian ideas.

All the exhibited sculptures show the Hiva type: a squat, block-like body, short, bent legs, arms tight up against the belly, a large head with flat features, dominated by huge round eyes, a nose with strongly developed wings and a broad horizontal mouth. Very often there are the tattoos which were so especially richly developed on Hiva. A wide variety of sizes, materials and functions occurred: from monumental basalt tikis in places of worship, life-size wooden Tikis which were used as house posts over chieftain's graves to the small house gods or the tiny ear plugs made of bone, showing Tiki scenes with several figures. Sculpted Tikis permeated every facet of life.

Also from the point of view of form, the Marquesanian Tikis are among the most fascinating of Polynesian sculptures. Their firmly constructed tectonics, the rhythm of their volumes produce powerful plastic existence, even though the actual working of the surface is limited to a very low relief. The region around the eyes and mouth often has the effect of

being two layers of thin skin. A decline in Tiki art is unmistakable as early as the late 19th century. Good and old Tikis combine a soft and supple low relief with precise carving; the best examples are hard with sharply cut edges, the use of metal tools certainly being only a factor of change.

Gauguin, too, must have come across very mixed qualities (if this expression of European aestheticians is permitted). Nevertheless evidence of his contact with Tikis extend from the precise sketch of a monumental stone Tiki in the interior of the country (after a photo, cf. Cat. no. 1740) to a drawing note of an ear plug (cf. Cat. no. 1744). According to reports, Gauguin's house on Hivaoa was surrounded by Tikis he had carved himself. The physiognomic type, however, has also left its mark on a number of his sculpted works and has entered pictures and woodcuts (cf. Cat. no. 1716, 1722, 1727, 1759). Hina combines Tiki features with the pose and gestures of Borobudur. Thus the Tikis consistently provide, again and again, elements of Gauguin's iconography of the numinous. M. Sch.

which could be coloured in or left out, allowed many variants. Since Gauguin printed different colours two or three times from the same block, each print became a new experiment. Gauguin went even further in the variations of the coloured woodcut in the sheets from the second stay in Tahiti, which are simpler in composition than the complex designs on Noa Noa; he printed one colour from the block, then worked over this again in order to print the altered block over the first version. Unique in all this is that the second print was made on very fine India paper which Gauguin stuck into the thicker India paper of the first print: a clever graphic diaphany resulted, which superimposes itself over the simple composition.

The unique aspect of these techniques gives each print almost the features of a monotype. Their chiaroscuro, the fluorescence of the layerings, turn the great woodcuts from the years 1893–1895 into the medium preferred for that nocturnal secret sphere in which the demon-filled counter-world takes the shape of an idyllic day, the Arcadia of many pictures: "The night was dark. Impossible to make anything out except a kind of phosphorescent dust close to my body, which strangely disturbed me. I laughed at the thought of the stories of Maoris about the Tupapaiis, those evil spirits which awake in the night to startle sleeping men," thus Gauguin describes the magic and menace of such tropical nights with their phosphorescent lights out of which the restless landscape of the mind as seen in the woodcuts arose: conjuring up the Tahitian past, its gods, spirits, myths, which are given their intense expression in the woodcuts, not in the pictures. M. Sch.

1754 *Paul Gauguin; L'univers est créé;* woodcut; handprint by Gauguin, black and brown on India paper, heightened with watercolour; 20.6×35.6 cm; sig. on the block bottom right: PGO, and left: L'univers est créé 1893-95; Paris, Bibliothèque Nationale, Cabinet des Estampes

1755 *Paul Gauguin; Te Atua (the gods);* woodcut; handprint by Gauguin in black and yellow, coloured in places green and red, on India paper; 20.3×34.9 cm; sig. on the block bottom left: PGO, centre top: te Atua, on back: PG 15 mars 1893–1895; Chicago, Art Institute

1756 *Paul Gauguin; Te Po (the great night);* woodcut; handprint; black and

brown from the same block; heightened with watercolours; 20.3×34.9 cm; sig. on the block top left: PGO, writing bottom left: TEPO 1893–1895; Paris, Bibliothèque Nationale, Cabinet des Estampes

1757 *Paul Gauguin; Maruru (thanksgiving);* woodcut; printed twice in black and in brown from the same block on India paper, coloured in red in some places; 20.4×35.4 cm; sig.: PGO; 1893–1895; Chicago, Art Institute

1758 *Paul Gauguin; Nave nave fenua;* woodcut; black and yellow on India paper; 35.4×20.4 cm; sig. on the block: PGO; 1893–1895; Munich, Staatliche Graphische Slg.

1759 *Paul Gauguin; Te Atua (the gods);* woodcut; handprint by Gauguin; first state in black on thin India paper stuck over the second state in brown into heavy black India paper; 24.4× 22.1 cm; sig. in the centre of the block: PG Te ATUA; after 1895; Chicago, Art Institute; plate

1760 *Paul Gauguin; Manao tupapau (the spirit of the Deathwatch);* lithograph heightened with chalk, pen, and ink; 18.1×27.2 cm; sig. top left in the stone: PGO; 1894; Ulm, Städtische Slgn. für Kunst und Kulturgeschichte

1761 *Paul Gauguin; Auti te pape (the women at the river);* woodcut; printed in black on India paper; 20.6×35.6 cm; sig. on the block bottom left: PGO, bottom right: Auti te Pape; 1893–1895; Ulm, Städtische Slgn. für Kunst- und Kulturgeschichte

1762 *Paul Gauguin; Femmes, feuillages et animaux;* woodcut printed in black on paper; after 1895; Paris, Bibliothèque Nationale

1763 *Paul Gauguin; Changement de résidence;* woodcut; first state in black on thin India paper stuck over the second state in brown on heavy India paper; 16×27 cm; 1898/99; Paris, Bibliothèque Nationale, Cabinet des Estampes

1764 *Paul Gauguin; Angel, peacock and three women;* monotype in brown and black; 24.2×39.8 cm; after 1895; Chicago, Art Institute

1765 *Paul Gauguin; Tahitian idol;* woodcut; printed in violet on India paper, heightened with watercolours; 14.1×

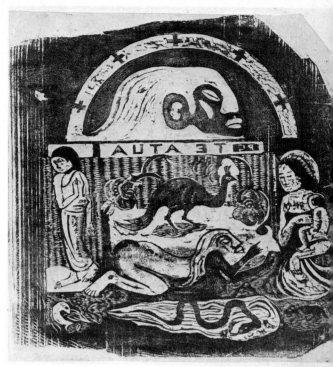

1759 Gauguin, Te Atua

9.8 cm; sig. on the block bottom left: PGO; 1893–1895; Chicago, Art Institute; plate

1765 Gauguin, Tahitian Idol

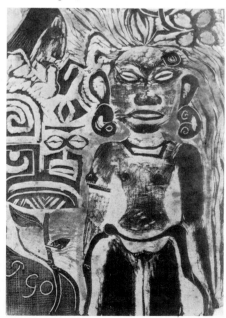

267

The "Brücke" and "Primitive" Art: Some Observations

Manfred Schneckenburger

Ernst Ludwig Kirchner's encounter with the painted bas-reliefs of the house-beams of the Palau Islands in the Ethnographic Museum at Dresden and Vlaminck's confrontation with the Dohomey figures in the Parisian suburb — both events took place in 1905 — mark turning-points in the history of modern art. We are accustomed to speak, from that time on, of the "discovery" of primitive art by the Brücke painters and the Fauves. Noted ethnologists are quite right when they point out how much scientifically arranged and classified material was already accessible in European museums by the year 1900. However, only the radical isolation of this material from its ethnological context made possible its artistic assimilation. Only when these objects became models of a new style could they be aesthetically appreciated to the full and truly "discovered."

However, this "discovery" did not take place in a vacuum. The reaction of the Brücke group to extra-European art was determined by two influences drawn from the context of contemporary European thought. Firstly, the enthusiasm of the Brücke painters for "primitive" art is bound up with their enthusiasm for the "primitive" life. This is an element which had appeared time and again among European thinkers from Rousseau (the simple life) to Nietzsche (the savage and barbaric). This return to nature was seen as a remedy against civilization and empty virtuosity long before Gauguin and the Brücke. This is the first premise which places the Brücke within a much wider context of sentimental, Romantic aspiration.

The second premise is provided by the evolutionary ideas of the nineteenth century, which regarded "primitive" art as an earlier stage of development on the way to the higher achievements of Europe, as the primal art in which Europe could study and understand its origins.

These two premises form the background to the Brücke's preoccupation with primitive art. However, the piercing gaze of the unprejudiced artistic eye was needed to penetrate the barriers and obstacles raised by traditional aesthetic views. It

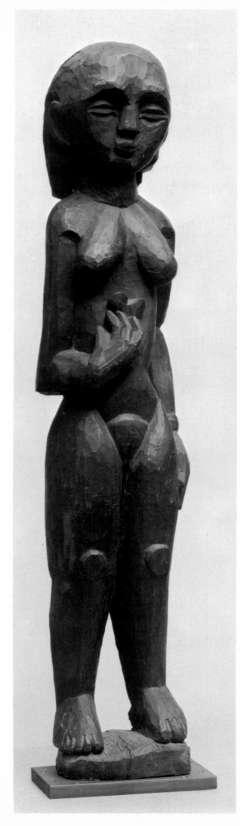

was this artistic penetration alone which was capable of transforming the house-beams of the Palau Islands into objects of key importance for modern art. This marks the transition from knowledge to appreciation of an art which had, until then, been regarded as witnessing to barbaric customs outside the bounds of aesthetic categories.

Nevertheless, critics from Carl Einstein to Robert Goldwater, Jean Laude and L. D. Ettlinger have time and again contrasted the emotional commitment of the "Brücke" with the purist formal analysis of African sculpture as practised by Picasso, Derain and Matisse. Certainly the Brücke painters confront African and Oceanican art emotionally rather than analytically. But it would be wrong to dismiss their encounter as a type of mystic approach without formal comprehension. Both the overall encounter in itself and its individual manifestation in the various artists of the group makes differentiation necessary.

When Kirchner discovered those Palau relief beams in 1905 (as is so often the case with him, he dates the event two years earlier — an indication of the importance he attaches to it) it is not the "primitive" aspect which aroused his enthusiasm but the analogies in formal language which he uncovered. In those beams he saw the confirmation of his own artistic efforts and tendencies; he felt they showed he was on the right track. Everything points to close, if not causal, connections. In what do they consist?

During the first few years after 1905, the encounter left hardly any effect on Brücke painting. It was not until the summer of 1910, which Kirchner spent with Heckel and Pechstein near the Moritzburg lakes; that the early impulse, dormant till then, began to bear fruit. The Moritzburg dream of nakedness, of sun and vegetation conducts them to the stylistic means of the Palau beams; the "primitive" life leads to the "primitive" form, which is just as high in its formal aspirations and is not regarded as a surrender of formal demands. The Brücke style of the year 1910 is determined by the abbreviated but lively row of figures in the Palau frieze.

However, no matter how close the affinity, the differences are still considerable. The human beings in the Brücke pictures are embedded in the landscape and flora and harmonize completely with them (the essence of the 1910 experience!), whereas the figures af the Palau reliefs are depicted in isolation. This is a specifically European conception of the happy links with nature of which the "primitive"

could and would have no conception. The painters of the Brücke group are able to avoid mere imitation and fashionable exoticism because their roots are so deep in European conceptions.

The observation that the "primitivism" of the Brücke is ideologically determined and lacks any profounder formal dimension is a far too onesided application of the measure of Picasso's formal researches and overlooks the fact that the analytic neutrality which is – partially – characteristic of Picasso's relationship to Negro art just could not be the outcome of this link of attitude and style. And it is precisely in this that the Brücke represents a new stage in the reception of "primitive" art. Primitivism as a style of life, that was perhaps the passing effect of a happy summer; but primitivism as a style of art, that was to become the formula for the Expressionist renewal of art in the twentieth century.

In Kirchner the Palau style is evident in the pictures painted in 1910, associated with the Moritzburg idyll. It is interesting to note that Kirchner's island holiday in the summer of 1912 coincides with a return to the angular, stenographic style of the relief beams, whereas the Berlin pictures, enriched by the experience brought by the Ajanta frescoes, are full of the hectic life of the town and of war time. Palau is a mere transition for Kirchner until the return to the simple life, from 1917 in Davos, which is characterized by the rough sculptured forcefulness of Camerounian figures.

In contrast, Schmidt-Rottluff is immersed in an intense study of African plastic art in 1912, a development which comes to a head in the year 1920. His abandonment of idyll and exoticism is documented by his shift of interest from the South Seas to Africa. He sees in the African mask a spiritual power which is counter to the idyllic, which is the channel of fear and the demonic. The extremely individual typology of his heads is oriented on the expressive power of the masks. It is this element which characterizes his figure style. Bieri heads and Fang figures, Baule and Kran masks, the forceful style of Cameroun provide the physiognomic vocabulary from which Schmidt-Rottluff builds up the Expressionist outburst of his men and women. All this is true of his pictures, but still more of his woodcuts, like the "Girl from Kowno." He succeeds in extracting a physiognomic pattern from the African masks; the New Man of Expressionism is given credibility with a vocabulary that must have seemed far more unacademic around the year 1920 than it does today.

His "Worker in Cap," a wood-carving, recalls the figures of Bebembe or Ndengese chieftains. However, the African formula for dignity, the squatting, erect chieftain, is turned to opposite effect: the legs cut off at the thighs emphasize the helpless isolation of the trunk, amputation instead of the torso, and the open hand points – the year is 1920 – to the begging disabled veteran of the war. All trace of the exotic has vanished here. The essential humanity of Expressionism has led Schmidt-Rottluff to grasp the formal intensity of African sculpture.

He has also produced works like the "Blue-Red Head," which transmutes the flowing lines of the Guro masks into receding concaves. It represents a conception of the primitive which is reflected in Stravinsky's "Sacre du printemps" and which Worringer referred to on many occasions between the years 1910 and 1920: fear, dread, ecstasy amidst an incomprehended environment. This immersion in the primeval fear of the "primitive" is fused with the reaction to the war year 1917. Other works of his completely alienate the features of the human face after the manner of the mask.

There are obvious points of contact among the Brücke artists, such as the inclusion of exotic masks and figures in the still-life. Here we are faced with a new iconographical type cultivated by the Brücke. Otto Müller, Erich Heckel, Max Pechstein and Emil Nolde each develop a purely personal relationship to "primitive" art. In Müller's work the gypsies take the place of the South Seas, Egyptian murals the models of tribal art. In Heckel the influence seems small except in the works executed in the year 1910. There are definite Romantic elements about the enthusiasm felt by Pechstein and Nolde, who was a member of the group from 1906–1908. Their enthusiasm takes both on a journey to Oceania, but this emotional commitment leaves little or no trace on their intensely colourful paintings. Nolde, in fact, informs us quite expressly that he regards the formal languages of the races as non-transferable; each race must express itself in the vocabulary it has itself developed. This excludes any direct assimilation of African or Oceanian stylistic principles. Wherever exotic motifs do appear in his work, they have been translated into the language of his own violent colour. Only in his still-life paintings do we come across literal quotations. There is also another category of Nolde pictures which we could dub "Quotation Pictures": in them he groups works of extra-European art, masks and figures from his own pri-

vate collection or from the Berlin museum, in scenes located between action and still-life and presented in all the attractive rigidity of marionettes.

These are just a few aspects of the primitivism of the Brücke, but they are enough to show how finely differentiated the reception was.

Africa
Oceania
Amerindia

"Brücke"

1766–1845

1766 *Ernst Ludwig Kirchner (Aschaffenburg 1880–1938 Frauenkirch, Davos); nudes in the sun;* oil on

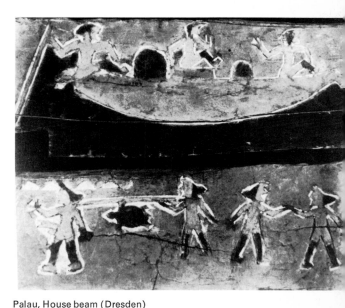

Palau, House beam (Dresden)

1766 Kirchner, Nudes in the Sun

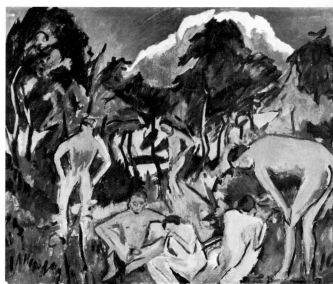

1777 Palau, House beam

canvas; 100×120 cm; 1910/1920; Neviges, Willy Schniewind Coll.; plate

1767 *Ernst Ludwig Kirchner; Bathers;* oil on canvas; 151×198 cm; 1908; Saarbrücken, Saarland Mus.

1768 *Erich Heckel (Döbeln 1893–1968 Hemmenhofen, Lake Constance); Forest Pond;* oil on canvas; 96×120 cm; sig. right bottom: E. Heckel; Feldafing, Lothar Buchheim Coll.; plate

1769 *Karl Schmidt-Rottluff (Rottluff near Chemnitz 1884, lives in Berlin); Two Female Nudes;* flat relief in wood; painted; 19.5×27.8 cm; sig. on back: Weihnacht 1911 S. Rottluff; Berlin, Brücke-Mus., on permanent loan from Professor Paul Neurath, New York; plate

1770 *Ernst Ludwig Kirchner; Membership List of the "Brücke";* woodcut; 8×14 cm; sig. on lower left of block: ELK; 1910; Berlin, Brücke-Mus.

1771 *Erich Heckel; Invitation Ticket to the Exhibition of the "K. G. Brücke" at the Art Dealer's Fritz Gurlitt, Berlin;* woodcut in black, blue, green; 9.7×7.5 cm; sig. in the block: E. H.; Berlin, Brücke-Mus.

1772 *Max Pechstein; Cover of the "Brücke" Folder 1911;* woodcut; Berlin, Brücke-Mus.

1773 *Max Pechstein; Two People of Palau;* woodcut; 17.4×11 cm; c. 1915/16; Bremen, Kunsthalle

1774 *Karl Schmidt-Rottluff; Bathers;* etching; 32×48 cm; df. cat. no. 1778; Hamburg, Kunsthalle

1775 *Ernst Ludwig Kirchner; Photograph of the Atelier in Dresden;* 1707/08

1776 *Max Pechstein; Photograph of the Atelier in Dresden showing a frieze similar to the beam of Palau;* 1918

1777 *Palau (Micronesia); Decorated beam of a men's club;* wood, painted in black, red, yellow, and white; h - 22 cm, l - 226 cm; Hamburg, Mus. für Völkerkunde; plate

1778 *Palau (Micronesia); Plank from a men's meeting house with a female gable figure;* wood with remnants of white Lime-wash; w - 371 cm, h - of the figure 83 cm; 1890–1909; Hamburg, Mus. für Völkerkunde

1779 *Karl Schmidt-Rottluff; Girl in front of the Mirror;* oil on canvas; 101×87 cm; sig. left bottom: Rottluff 1915; cf. Bambara figure, Cat. no. 1780; Berlin, Neue Nationalgal.

1780 *Bambara; Female Figure;* wood; h - 55 cm; Paris, Helène Kamer Coll.

1781 *Karl Schmidt-Rottluff (Rottluff near Chemnitz 1884, lives in Berlin); Worker Wearing Ballon-cap;* wood; h - 66 cm; sig. on the left leg: S. Rottluff 1920; Berlin, Brücke-Mus.; plate

1782 *Babembe (Kongo, Brazzaville); Sitting ancestor figure with beard as*

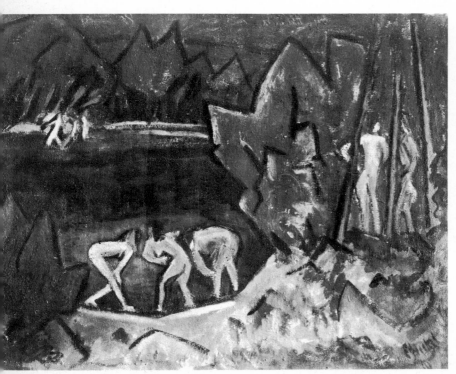

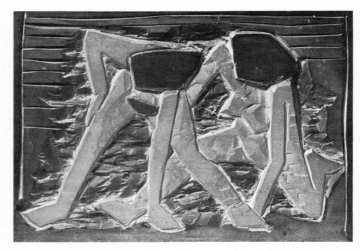

▲
1769 Schmidt-Rottluff, Female Nudes

◄
1768 Heckel, Forest Pond

power symbol; wood with kauri-shell eyes; h - 47.5 cm; Bruxelles, Delenne Coll.; plate

1783 *Karl Schmidt-Rottluff; Blue-red Head (Panic stricken);* wood, coloured, h - 30 cm; sig. on the base: S. Rottluff; 1917; Berlin, Brücke-Mus.

1784 *Baule (Ivory Coast); Mask;* wood, brown patinated, with slight orange shade; h - 33 cm; Stuttgart, Walter Kaiser Coll.

1785 *Karl Schmidt-Rottluff (Rottluff near Chemnitz 1884, lives in Berlin); Green Head;* alder-wood, coloured green; h - 41 cm; 1917; Berlin, Brücke-Mus.

1786 *Karl Schmidt-Rottluff; Double Portrait;* oil on canvas; 90×76 cm; sig. bottom left: Rottluff 1919; Berlin, Frau Martha Kruss; coloured plate

1787 *Karl Schmidt-Rottluff; A Talk about Death;* oil on canvas; 112×97.5 cm; 1920; cf. Cat. no. 1790; Berlin, Frau Martha Kruss

1788 *Pangwe (Gabon); Skull Container with Head (Bieri);* box made of rind, head of wood with feather adornments; h - 70 cm; Stuttgart, Linden-Mus.

1789 *Pangwe (Cameroon); Female Bieri Figure;* wood; brass nails and sheet brass, pearls; h - 46 cm; see Cat. no. 1788; cf. Cat. no. 1785; Berlin, Mus. für Völkerkunde

1790 *Pangwe (Gabon); Reliquary Figure;* wood; patinated; h - 71 cm; Stuttgart, Linden-Mus.

1791 *Pangwe (Gabon); Bieri Head;* wood, patinated in black; h - 27.5 cm; Stuttgart, Linden-Mus.; plate

1792 *Ernst Ludwig Kirchner; Seated Woman with Wooden Sculpture;* oil on canvas; 97×97 cm; sig. bottom left: E. L. Kirchner; 1912; Düsseldorf, priv. coll.

1793 *Ernst Ludwig Kirchner; Adam and Eve;* poplar wood, stained brown and burnt; h - of Adam 168.6, Eve 169.3 cm; 1912; Stuttgart, Staatsgalerie; plate

1794 *Grasslands, Cameroon; Ancestor Figure;* wood; h - 72 cm; Stuttgart, Linden-Mus.

1795 *Otto Müller (Liebau 1874–1930 Breslau); Mask;* wood, painted; h - 18.5 cm; Berlin, Brücke-Mus.

1796 *Dan (Ivory Coast); mask with round eyes;* wood, patinated in black: 21×11 cm; Munich, Hans Schneckenburger Coll.

1797 *Karl Schmidt-Rottluff; Girl from Kowno;* woodcut, 50×39 cm; 1918; plate

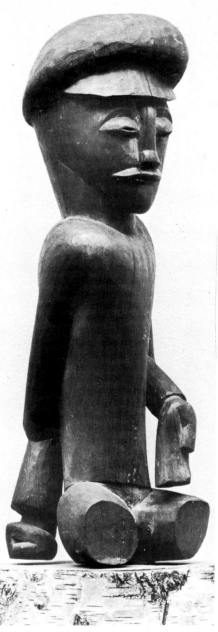

1781 Schmidt-Rottluff, Worker with Cap

1798 *Baule (Ivory Coast); ancestor;* wood, patinated in black; 66×14×14 cm; cf. Cat. no. 1797, Brussels, Madame Jean Krebs; plate

1799 *Baule (Ivory Coast); ancestor;* wood, patinated in black; h - 48 cm; cf. Cat. no. 1797; Cologne, Rautenstrauch-Joest-Mus.

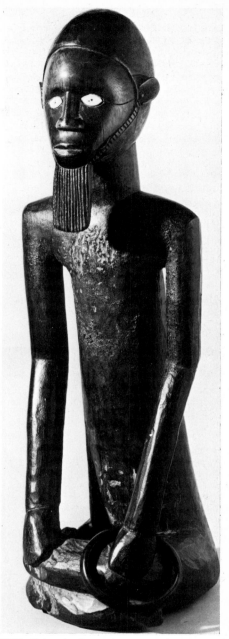

1782 Babembe, Ancestor

Schmidt-Rottluff's woodcuts on the life of Christ

When Schmidt-Rottluff returned home from the war in 1918, he brought back with him a heightened sensitivity for the numinous, for the religious, far remote from any denominational or church-centred fixation. Schmidt-Rottluff formed his new woodcuts on the life of Christ in a few expressive gestures reduced to love and hatred, adoration, amazement, fright, the grammar of forms and phys-

271

iognomic formulas for which he found in large measure in African figures and masks. African sculptures contributed to the expressive re-formulation of the plastic potential, which develops—without any illusionistic modelling—from angular fragments of surface, projecting cubes, joints like hinges. Masks inspire the faces, add the physiognomic signs: the bulge of the mouth arching forward in isolation, which recalls Cameroonian aspects, the small round mouths, the protruding cheeks of the chin, which originate from Baule types (and the "Girl from Kowno" confirms this), the "broken" nose of Christ, which derives from the angularly short noses of the Pangwe figures. The "primitive" aspect has become the vehicle of a stronger and deeper humanity, in which the divine is also centred. M. Sch.

1800 *Karl Schmidt-Rottluff; Christ 1918;* woodcut; 50.1 × 39.1 cm; inscrip-

1804 *Karl Schmidt-Rottluff; Christ and Judas;* woodcut; 39.4 × 51 cm; 1918; Hamburg, Kunsthalle

1805 *Karl Schmidt-Rottluff; The Road to Emmaus;* woodcut; 39.7 × 49.8 cm; 1918; Hamburg, Kunsthalle

1806 *Crane (Ivory Coast); Mask;* wood; h - 32 cm; Cologne, Rautenstrauch-Joest-Mus.

Exotic Still-life of the "Brücke"

The Cubists also collect African masks and sculptures which belong to the ambience of the studio. Yet Cubist pictures confine themselves to the simplest things in the surroundings: African masks are not motifs, but incorporate principles of form which can be better transferred to and demonstrated by pipes, guitars and newspapers.
The Brücke artists, on the other hand,

consciously fetch into the studio with their masks and figures the world of the "primitives," symbols of the exotic (just as Pechstein and Nolde look for them in their place of origin); they are not only subject of form analysis, not only the premises of a style of art, but part of a style and feeling for life. The Palau decorations in Kirchner's studio in Dresden, Pechstein's in Berlin, Kirchner's crudely sculpted "Cameroonian" furniture in Davos are in the same connection. In the case of the "Brücke" these exotica soon turn into motifs. Kirchner, Heckel, Schmidt-Rottluff, Pechstein and Nolde chose African or Oceanian (as well as their own) carvings again and again for their still-lifes: adoptions of motifs not connected with any deeper form-assimilation. A new iconographical genre arose, the incunables of which can already be found in Gauguin, but which were first fostered with continuation by the "Brücke": the exotic still-life. M. Sch.

1797 Schmidt-Rottluff, Girl

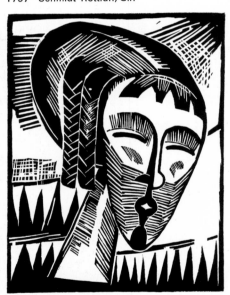

1798 Baule, Ancestor

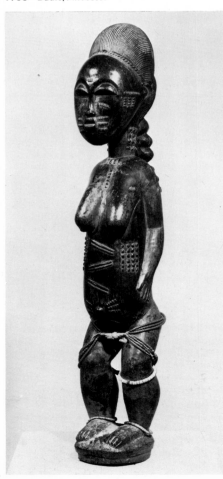

1791 Pangwe, Bieri Head

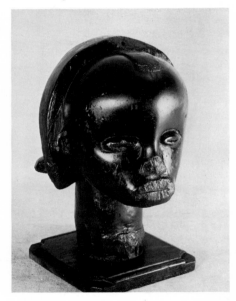

tion: Ist euch nicht Christus erschienen; 1918; Hamburg, Kunsthalle

1801 *Karl Schmidt-Rottluff; Christ Curses the Fig Tree;* woodcut; 39.4 × 50 × 39.2 cm; 1918; Hamburg, Kunsthalle

1802 *Karl Schmidt-Rottluff; Christ and the Adulteress;* woodcut; 39.7 × 49.8 cm; 1918; Hamburg, Kunsthalle

1803 *Karl Schmidt-Rottluff; Disciples;* woodcut; 50.1 × 39.1 cm; 1918; Hamburg, Kunsthalle

1807 *Erich Heckel; Still-life with Mask;* oil on canvas; 69 × 63 cm; sig. bottom left: E. Heckel 12; cf. Cat. no. 1868; Saarbrücken, Saarland-Mus.

1808 *Makonde? (Mozambique); Mask;* wood, painted; 21.5 × 19.5 cm; Hemmenhofen, Lake Constance, Frau Sidi Heckel

1809 *Karl Schmidt-Rottluff; Still-life with Pipe Heads from Cameroon;* oil on canvas; 1912

1786 Schmidt-Rottluff, Double Portrait ▶

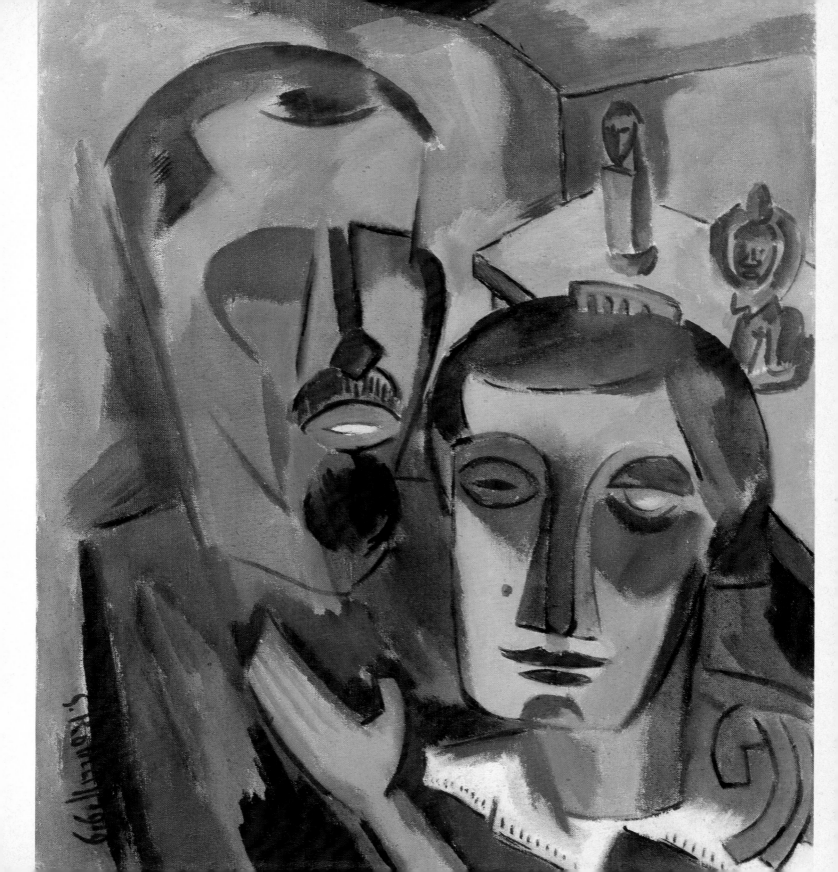

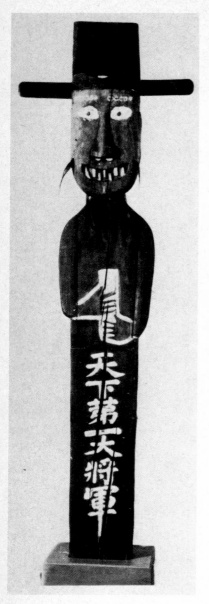

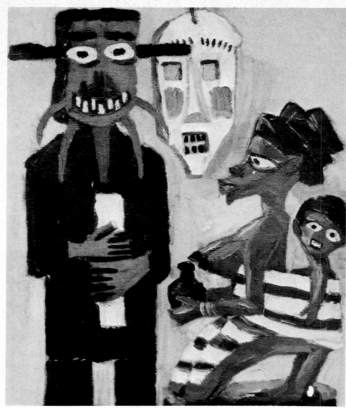

◀◀ 1816 Korea, God of the Roads
◀ 1812 Nolde, The Missionary
▶ 1815 Nolde, Bongo Mask
▼ 1817 Congo, Mother and Child

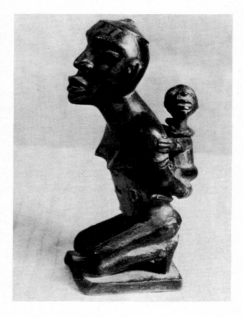

1810 *Grasslands Cameroon; Three Pipe Heads;* Stuttgart, Linden-Mus.

1811 *Max Pechstein; Still-life with Exotic Figures;* oil on canvas; 79 × 104 cm; Paris, Jacques Chalom

1812 *Emil Nolde (Nolde/North Schleswig 1867–1956 Seebüll); The Missionary;* oil on canvas; 79.7 × 65.5 cm; sig. bottom left: Nolde; 1912; Solingen, Berthold Glauerdt; plate

1813 *Emil Nolde; A God of the Roads from Korea;* pencil and crayon on paper;

28 × 21 cm; 1911/12; Seebüll, Nolde Foundation

1814 *Emil Nolde; Carving by the Yoruba of Mother and Child;* pencil and coloured chalk; 27.8 × 21.4 cm; 1911/12; Sebüll, Nolde Foundation

1815 *Emil Nolde; Dance Mask of the Bongo;* pencil on paper; 27.8 × 21.4 cm; 1911/12; Seebüll, Nolde Foundation; plate

1816 *Korea; A God of the Roads* (photo); wood, painted black, red and white; h - 291 cm; Berlin, Mus. für Völkerkunde; plate

1817 *Congo; Mother and Child;* Nolde's Model of Yoruba group was destroyed during the war, this Bakongo group is very similar, however; Rome, Museo Pigorini; plate

1818 *Bongo (East Sudan); Mask;* wood; h - 30 cm; cf. Nolde, Cat. no. 1812 and the studies Cat. no. 1815; Berlin, Mus. für Völkerkunde

1819 *Emil Nolde; Exotic Figures II;* oil on canvas; 65.5 × 78 cm; sig. bottom right:

Emil Nolde; 1911; Seebüll, Nolde Foundation

1820 *Hopi (Arizona, New Mexico); Katchina Doll;* wood, painted red, green and yellow; h - 24 cm; Berlin, Mus. für Völkerkunde

1821 *Inca Culture (Peru); Poncho Made of Feathers Showing Red Wildcat Figures;* feather-cloth; about 60 × 65 cm; c.1350–1352 A. D.; Stuttgart, Linden-Mus.

1822 *Emil Nolde; Still-life with Uli Figure (Still-life H, Great Tamburan Moscow Group);* oil on canvas; 88 × 73 cm; sig. bottom left: Emil Nolde; 1915; Seebüll, Nolde Foundation

1823 *Central New Ireland; Uli;* wood, painted white, red and black; h - 99 cm; Seebüll, Nolde Foundation

Kirchner's Furniture

While the masks of the still-lifes introduced an exotic element into the studio, Kirchner carved furniture and utensils for his house in Davos between 1919 and 1923. Its crudely sculpted powerfulness

274

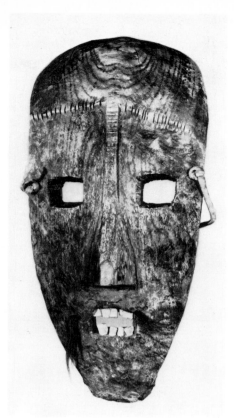

1824 Kirchner, ▶
Mirror frame

1825 Bangwa, ▶▶
House post

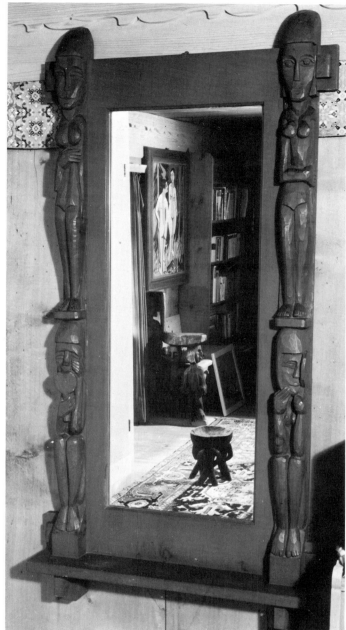

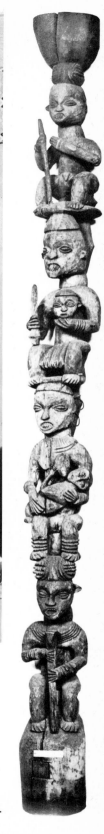

is inspired by Cameroonian work. Here primitivism is—in the sense of the "Brücke"—not only a style of art, but, quite concretely, a style of living, without superficial exoticism breaking through. Kirchner's "Cameroonian" furniture is at the same time not closed to Swiss folk art. It finds its artistic counterweight in the subtle colour harmony and in the rich decoration of oriental carpets, which Kirchner brought into his house after 1920 and used as a source of inspiration for his art.

1824 *Ernst Ludwig Kirchner; Mirror Frame;* stone-pine wood, painted red; 172×83 cm; c. 1923; Nuremberg, Germanisches Nationalmus.; plate

1825 *Bangwa (Grasslands, Cameroon); House Post;* wood; h - 218 cm; Munich, Mus. für Völkerkunde; plate

1826 *Bangwa (Grasslands, Cameroon); House Post;* wood; h - 220 cm; see Cat. no. 1825; Stuttgart, Linden-Mus.; plate

1827 *Ernst Ludwig Kirchner; Chair with Seated Woman and Standing Couple as a Back;* stone-pine wood painted with ox

blood; 88×48×46 cm; 1918/23; Berlin, Brücke-Mus.

1828 *Grasslands, Cameroon; Chieftain's Chair;* wood; h - 90 cm, ⌀ of seat 60 cm; early 20th cent.; Hamburg, Mus. für Völkerkunde; plate

1829 *Ernst Ludwig Kirchner; Fruit Bowl with Three Supporting Figures;* plane-tree wood, partly painted black and stained; h - 27 cm, ⌀ 23 cm; c. 1920; Berne, Kornfeld und Klipstein

1830 *Grasslands, Cameroon; Bowl;* wood; h - 34 cm, ⌀ 22 cm; cf. Cat. no. 1829; Stuttgart, Linden-Mus.

1831 *Bali (Cameroon); Stool;* wood; h - 28 cm; cf. the fruit bowl by Kirchner, Cat. no. 1829; Berlin, Mus. für Völkerkunde

Emil Nolde on New Guinea

In 1913 Nolde accompanied an expedition to New Guinea via Russia and Japan.

His official status was that of ethnological drawer; here Nolde ranked with a series of drawers who had accompanied journeys of exploration since the 19th century and who had recorded their results. But what Nolde brought back were not ethnological documents, but pictures and drawings, especially water-colours, in which his passionate coloration, liquid and relaxed, found its answer in the exotic scenery. M. Sch.

1832 *Emil Nolde; South Sea Islanders;* water-colours on paper; 51×38.7 cm; sig. bottom right: Nolde; 1913/14; Seebüll, Nolde Foundation

1833 *Emil Nolde; Native in Boat;* water-colour on paper; 37.9×50.5 cm; sig. bottom left: Nolde; 1913/14; Seebüll, Nolde Foundation

1834 *Emil Nolde; Woman and Child;* water-colour on paper; 51.1×38 cm; sig. bottom left: Nolde; 1913/14; Seebüll, Nolde Foundation

1835 *Emil Nolde; Seated Native;* water-colour on paper; 35.6×48.5 cm; 1913/14; Seebüll, Nolde Foundation

1836 *Emil Nolde; Junk;* water-colour on paper; 28.9×32.1 cm; sig. bottom right: Nolde; 1913; Seebüll, Nolde Foundation

Pechstein's Indian Ink Drawings from Palau

In April 1914 Pechstein, together with his wife, embarked in Genua for Palau. Travelling via Ceylon, India, China, from the Philippines on a Japanese fishing steamer, he reached, at the end of May, the island which had been a German colony since 1899. Pechstein intended to stay for some years, and settled down like a native of the island; a host of pictures, water-colours and sketches, were produced; the Expressionist gesture of force receded, Pechstein's hand became more sensitive without losing anything of its vitality, and the Indian ink drawings give a lively picture of the natives. On September 10, 1915, Pechstein reached Holland. M. Sch.

1837 *Max Pechstein (Zwickau 1881–1955 Berlin); Men's House under Palms;* Indian ink pen on paper; 20×26.5 cm; 1914; Berlin, Nationalgal.; plate

1838 *Max Pechstein; Outrigger;* Indian ink pen on paper; 23.4×18.5 cm; sig. bottom right: HM Pechstein 1914; Berlin, Marta Pechstein

1839 *Max Pechstein; Village Scene on Palau;* Indian ink pen on paper; 15×22.5 cm; sig. bottom right: HM Pechstein 1914; Berlin, Marta Pechstein

1840 *Max Pechstein; Landing-place on Palau;* Indian ink pen on paper; 28.3×35.5 cm; sig. bottom right: HM Pechstein 1914; Berlin, Marta Pechstein

1841 *Max Pechstein; Canoe Putting Out;* Indian ink pen on paper; 14.2×22.8 cm; sig. bottom right: HM Pechstein 1914; Berlin, Marta Pechstein; plate

1842 *Max Pechstein; In the Valley;* Indian ink pen on paper; 30.2×36.7 cm; sig. bottom right: HM Pechstein 1914; Berlin, Marta Pechstein

1843 *Max Pechstein; The Cry;* Indian ink pen on paper; 31.2×23.2 cm; sig. bottom right: HM Pechstein 1914; Berlin, Marta Pechstein

1844 *Ernst Ludwig Kirchner; Women in the Bath;* oil on canvas; 150×200 cm; 1911; Berlin, Brücke-Mus.

1845 *Ajanta (India); Fresco in the Cave Temple* (photo); 5th/6th cent.

1837 Pechstein, House on Palau

1841 Pechstein, Canoe Putting out

French Painting and "Art Nègre"

Jean Laude

To Angela Davis
and the Soledad Brothers

In his "Demoiselles d'Avignon" (1906/07) Picasso effects a decisive change in the formal language of the West. It is a work which has lost nothing of its subversive power since. Incontestably, it marked a point of no return. Exciting in its brevity, it condenses and designates a crisis, a profound change in values, revaluation in fact of western aesthetic concepts. It does not merely reflect this crisis, this change, but effects it in the realm to which it itself belongs, that of painting. And it produces this change dialectically. It neither rejects nor denies the past, as did the Futurists. It is a component of a confrontation embodied in the two figures on the right which, it must be admitted, were elaborated and conceived after his study of "Negro art." By not completing the picture, Picasso makes his intention clear: in contrast to Cézanne, who is at the same time sum, perfection and culmination of the traditional painting of the West, he derives his forms from an art which was despised then, that of the "colonies." The formal structure of the picture marks this break. He turns to Africa as a source because it is clear to him that the real value of African art lies in its unity, its integrity, its formal quality as an absolute, all unknown to Western art which has inherited the dualism of the Classical view of the world: matter and spirit, the particular and the general, things and space. "Negro art" which condenses the whole of space in the plastic structure is the one extreme of a dialectic relationship, of a problem; the other is represented by Cézanne who resolves particular forms in the structure of space.

This is not the beginning of a new style. The intense study made by Picasso, Braque and Gris goes far beyond what was disparagingly referred to as Cubism, which second-rate artists codified into a doctrine and reduced to a "way of viewing" things. Around 1920, it would have been quite possible to believe that Cubism was an "appeal for order," for the calculated harmony of French painting. It was in fact a revolutionary act, methodically and long prepared by Picasso, which sustains and at times advances beyond future developments in art.

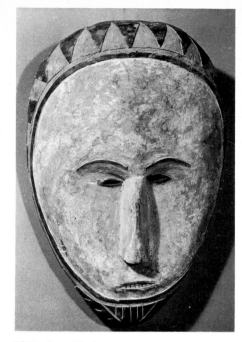

1857 Fang, Mask

Of course, the problem is not as simple as I have presented it above. There are critics who dispute that "Negro art" was a codetermining element in the production of "Demoiselles d'Avignon." And Picasso himself has never stopped from denying this influence, too. Iberian works, he maintains, were adapted in the two figures on the right. But even if the intervention of "Negro art" was recognized or well-grounded, it would still remain to ask: is the change contemporaneous with the intervention or can one go so far as to call this latter the cause of the change? Certainly it was not Picasso who discovered "Negro art." It had been discovered before – by Matisse, Derain, Vlaminck, each for quite different personal reasons. The reception of "Negro art" is not the result of a sudden and compelling insight. The preoccupation with this art is expressed, if not in a mental orientation, at least in a quite definite problem. This was a problem born of the age: it was raised between the taste and the need for stability and certainty, for models, on the one hand, and the fact, the necessity of change, on the other. The keen consciousness of change had been followed by the costly sacrifice of all that was changing in light: one can say that for the Impressionists the weather was the metaphor for time. In 1898, there is a new ideological motif which crystallizes in a new relationship to

time: "The world is young. It belongs to the strong and the good," the very first edition of the "Jugend" maintains. Ten years later, the Futurists interpreted this in their own way: in a reasoned tabula-rasa method, an entirely Romantic submission to the élan vital, a violence which regards itself as the end and wishes to accelerate events. The last decades of the nineteenth century are quite conscious that a change was imminent and that its symptoms were visible throughout the whole of Europe. A change expected, desired and feared at the same time. At any rate, all are aware of its existence.

And where did French painting stand in regard to this confused consciousness? When Cézanne preferred the moment to the "petite sensation," this same Cézanne was attempting to give Impressionism the permanence of the art of the museums. Behind the changing and clouded veil of the visible, Seurat is struggling for a definition of what was essential: at night he paints by artificial light according to sketches he had made from nature during the day. In all that Gauguin does, until his restless spirit draws its inspiration from Oceanian art, he is not searching for immutable and timeless forms; he wishes to grasp what—immutable, universal, timeless—refers form to itself, legitimates it and fills it with life.

At the beginning of the twentieth century the situation in art was that of a practice which knew it was threatened, which, without being conservative or academic, could no longer rely on a definite and assured model: the sources and their language had to be renewed and rediscovered. Art was fully conscious of having moved further away from tradition and of having exhausted the sources and their language. Perhaps Vlaminck did not grasp the actual intellectual extent of this situation; but he did experience it, live it. He discovered "Negro art" as an unacademic art which he could employ as a defensive weapon against the École des Beaux Arts and the Louvre. Certainly he misinterpreted it: it just is not a spontaneous expression, a response to the biological stimuli called forth by the "savage" environment, as he conceived it. He regarded it in fact in the same way as the other exotic objects in his collection: not genuine art, but creations bordering on art—outside the official streams and of no interest to the dealers. He is so consistent here that he again rejects everything he has regarded as authentic the moment the intellectuals and the bourgeoisie begin to show an interest in them. He has a dim presenti-

277

Africa
Oceania
Amerindia

French
Painting
and "Art
Nègre"

1846–1861

ment that our criteria of taste are actually criteria of social class. In spite of this false attitude of mind and his angry outburst of hatred against Picasso during World War II which led him to inadmissible extremes and even worse compromises, he has still put his finger on a motif located, if one conceives it somewhat differently, right at the heart of our current concerns: How can art escape the clutches of a consumer society which will immediately rob it of its authenticity and its aims? How can it escape from the status of a cultural value which is the symbol of its alienation and its recovery by the ruling classes?

It is in this sense that "Negro art" confirms Vlaminck in his convictions and in his violent rejection of both museum art *and* the avant-garde, although "Negro art" does not modify his own production even superficially. In spite of the apparent points of contact, Vlaminck wanted above all to be a colourist and, with very few exceptions, African sculpture is monochrome. If colour is employed, it never has a decorative or expressive character: it is constructive. It is always the problem of form which is dominant. In contrast to Vlaminck, Derain tries to see things a little more clearly. In so doing he places his discovery of "Negro art" in the contemporary context, for, from 1906–1910, he was collaborating closely with Picasso. Gertrud Stein relates that it was probably he who introduced Picasso to the masks and figures of Black Africa. Since Derain had already integrated those works in his reflections, it is highly likely that the discussion was not at the general level but that it was theoretically deepened by corresponding study.

If Vlaminck lived the situation described above, Derain tried to transpose it intellectually and at the artistic level. As early as 1901 Derain realized that a change was in the offing: but he at first saw it as decay, degeneration; he grasped only the negative aspect. This means that, in painting, the problems of expression and of form are more important to him than those of expressivity, of dissected light, of decomposition (analysis) and of recomposition (invention) of the formal language.

In the summer of the year 1910, he worked with Picasso at Cadaquès. At the time Picasso was painting his more "hermetic" pictures. The two friends began then to grow conscious of their fundamentally different conceptions of form. Picasso carried the analysis to the end and arrived at a new encoding of the universe. Derain tries—as E. Faure tells

us—to rediscover the movement which forms the basis of and imbues form in the great classical epochs, his refuge after the crisis has been lived through and met. Today we recognize that the discovery of "Negro art" occurred at the very moment when the innovators among the painters were combatting the dissolution of form. It is no mere coincidence that in 1905 Matisse and Derain, and a little later Picasso too, are creating pieces of sculpture which are based on their studies in painting. We are here faced again with the evident contradiction that a sculptural and monochrome art is being studied by painters who wish to organize their surfaces by means of colour.

From the moment when the two disintegrating factors of form—light and atmosphere—are replaced by the luminosity inherent in colour then this must have inevitable repercussions. Above all, colour was no longer imitative: the incontrovertible proof of this is Matisse's picture "Desserte Bleue" (1908) which he painted in red. This has no symbolic value as in Gauguin: it has a spatial function and is the source of luminous intensity. Matisse deforms not for Expressionist but for aesthetic ends: his form is accommodated to the intensity of light he wishes to attain. "I do not paint things," he confides to Aragon, "I paint the relations between things." We find a similar thought expressed by Braque ... and by Mondrian. I consider it one of the keys to the understanding of the whole of contemporary art. It also exactly covers African sculpture, without even having to except Ife and Benin. Once integrated into the thought of the Russian formalists these words would have momentous consequences.

We may presume that, when illusionism is abandoned at the beginning of this century, other conceptions and other values are effective and influencing the artistic works. The world is no longer beyond our gaze, the inaccessible object and focus of our nostalgia (nostalgia for the lost unity), an object we desire and wish to possess. On the other hand, it is no spectacle before which we are to remain purely passive and which we may, at a pinch, have to interprete. From the last decade of the nineteenth century it becomes quite concretely the site of our activity, the field of our experience: man can reshape it and, in reshaping it, reshape himself.

What Nietzsche had forecast as the death of God was the denial of what until Hegel, and even until Marx, had constituted the continuity of the civilization

of the West, of a system which discovers itself only in its own destruction. This coherence is lacking in the social order and also, although in a way more difficult to follow, in the order of values, in as much as these are intellectually legitimated and empirically experienced too, objects of reason and of faith. From now on, the world no longer appears ordered, even less so as western civilization, as a result of its expansion, comes into contact, for better or for worse, with other systems of values, with other forms of coherence, and its universalist claims disintegrate in the course of the venture. One realizes that at this moment the logical connections which are the expression of the coherence of the system no longer seem so clear or, to put it more precisely, no longer appear to be based on reason but on suprastructures which legitimate and keep them alive. The consequences are no less remarkable in regard to aesthetic values. History is called into question; the present is now given the precedence. And now it is a present which witnesses a synthesis of emotions and sensations. Accordingly, the return to the lived experience of which the picture is no longer either the recital nor the trace, but the substance itself.

A turning-point in western aesthetics has been reached, although not overnight, and does not reflect the contemporary cultural changes. The work of art is reduced to what it is, a work whose significance arises only from its immanent function: it is reality and not an image or expression of reality. Now the formal interrelations must replace the logical connexions, whereby these logical interconnections are not so much shattered or dissolved, as differently disposed. In view of this, Derain hesitates in 1910 and does not take the decisive step. He breaks with the avant-garde, for he is bound too fast to the object, its corporality, to what—for him—are the essential characteristics. He is convinced that novelty, originality is not a matter of the manipulation of the signs but of the renewal of meaning. In a certain sense, Derain is an eclectic: he is torn between his inclination towards pure colour, matter and form; he dreams of a synthesis. In this dream he is afflicted by the conception of the museum. Together with Picasso's his formal language is among the most impressive and self-assured. However, he cannot break away from it; he cannot burst its bounds. The last third of the nineteenth century witnessed the way in which the theoretical models of the previous centuries lost their efficacity. From then on, artists had been

discovering the variety of arts and styles for themselves. The beginning of the twentieth century saw a renewal and an extension of the sources of inspiration, because travel and scholarship made these sources accessible but also because these sources, as direct witnesses, compensated for the absence of a theoretical model, of a consensus. This phenomenon accounts in part for the astonishing disparity of languages with which the artists attempt to speak and the proliferation of "schools" since Impressionism. If Derain cannot take the decisive step, if he is fascinated by the wealth of problems and solutions (and tries to find a common denominator for them all), then it is for him also a matter of trying to ensure the survival of the past: the very past which at this time of crisis he inevitably regarded as the haven of safety and certainty. If he turns his back on the avant-garde, among whom he had been one of the most active members, then that is because he sees here the gradual abolition of a view to which he had remained faithful since the time (1901) when he had copied the Italian primitives in the Louvre.

Strangely enough "Negro art" does not place means at Derain's disposal with which he would have been able to sever the bonds of classical formal conceptions: "Negro art" is always present when he is again seeking a closely circumscribed form which does not threaten the logical connections. In 1941 he subdivides the constitutive elements of the painted picture into three categories in which he lists only some ten attributes of painting. Derain is quite obviously concerned with the problem of the stable form. When he paints the "View from Cadaquès" in 1910 he seems to be drawing close to Cézanne, however without using the "passages" which interrupt slightly the contour lines in the work of the master of Aix and thus mediate between the colour and the line. The "passages" obviously lead to a disintegration of form and this Derain wanted to avoid. On the other hand, one of the basic elements he mentions is extremely typical for him: his insistence on "ligatures," that is on the connection between the unity of the object and the unity of its formal translation. If in "Les Baigneuses," "La Baignade" and "La Toilette" (1908) he employs the vocabulary and viewpoint of "Negro art," he does this only with the objective of achieving simplification of form. Various experiences since 1906 have caused him to combine light and form. However, he grasps this as independent of the lighting and does

1847 Picasso, Sketch for "Demoiselles d'Avignon"

1848 Babangi, Mask

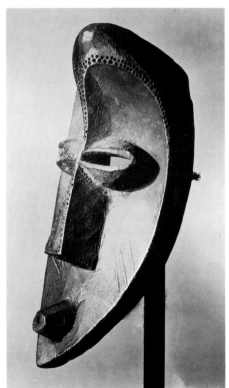

not identify it with colour. This distinguishes him both from Matisse and from Picasso. Simplification of forms means for him: withdrawing them from the destructive light, bringing the light under control. Thus he must take still greater

pains with the construction: a significance is now imparted to volumes which had only been present to a very limited extent before—during a brief interlude of Cézanne influence in 1904.
The interest which Derain shows for volumes, particularly from the year 1911 on, causes him to return to modelling and chiaroscuro. The still-lifes from this period manifest his will to achieve coherence as expressed in complex rhythm and poetic proportions. At this time one can see quite clearly that he does not regard "Negro art" as a stimulus to remould his formal language. In classifying his African figures he is said to have uttered the sentence which shocked the avant-garde in 1910: Raffael! He is the greatest among the misunderstood artists! In other words, he sees in "Negro art" a confirmation of his aesthetic conceptions and as encouraging him in his neo-Classical tendencies. This is quite clear in a number of pictures painted after 1912. "Negro art" determines the external form of the masses, but not the inner structures. From now on, Derain does not stop striving for a "style" and to this end he feverishly questions all the artistic tendencies of the past.
"Negro art" is discovered within the framework of a renewal and extension of the sources which had been prepared by Gauguin. However, it only begins to take effect when its own inherent problems have been given precedence over the other non-European and non-classical forms of art. Matisse draws on "Negro art" as an aid in his own work as a sculptor. Between 1906–1911 it contributes greatly to his plastic art: Matisse sees all this as a confirmation of his efforts to generalize his figures, to give them simple and yet synthetic expressions.
However, what about his work as a painter? In his triptych "Three Sisters" (1917), we can see the traces of a Bambara sculpture which was in his possession at the time. In his portrait of Yvonne Landsberg, he speculates with the rhythmic power of the arabesques on New Zealand Hei-Tikis. During this period, the tendency to give the human face the features of the African mask is also apparent. Indeed, if one takes account only of externals, his art only bears traces of "Negro" influence occasionally, episodically. However Matisse does discover a sign language at the level of the grammar of forms which enables him to make movement visible in the tension of the gesture. On the other hand, in African sculpture he finds that feeling for tectonic composition which he had

*Africa
Oceania
Amerindia*

*French
Painting
and "Art
Nègre"*

1846–1861

sought in Cézanne. He recognizes in the masks flat reliefs which can more easily be incorporated in the surface, but also types of formal expressivity which excludes the anecdotal element dependent on individual psychology.

"Damned psychologists!" Even if Dostoyevski's exclamation was not repeated everywhere immediately, it is still the common denominator (perhaps the only one, but of what significance it is!) for all the tendencies no matter what the name they were known under. A new picture of man is in process of formation which dispossesses man of his former prerogatives. If in the realm of painting the boundaries of the individualistic characterization of man is crossed, then that had a definite significance. And this significance is made clearer through the explicit reference to an art considered anonymous and collective, to a despised art: "Negro art."

In his recourse to "Negro art," Matisse wants in the last analysis more a reshaping of reality than a change in formal structure such as that effected by Picasso. It is true that Picasso has always denied

any reception of "Negro art" in the two right-hand figures of "Demoiselles d'Avignon." And if one studies the works of Iberian sculpture which Picasso assures us formed his source of inspiration, then one must admit that the analogies are in fact not at all clear or evident, nor are they of the structural order. Picasso hardly attempts to convey the "magical" tension of an African mask (which he is perfectly capable of doing) in his own work; still less does he try to view "Negro art" from the historical perspective. He keeps strictly within the confines of a formal solution. This and this alone can form the basis of our discussion. In 1906, Picasso only had to look around among the artists of his day to know what was being discussed with such commitment: in the studios of Matisse and Derain, for example, there were "Negro" works to be seen. But seeing is one thing; to interest oneself for something and to grasp the problems it raises is another. In art we only come across solved problems. Picasso translates: I do not seek, I find. Pierre Daix thinks that, in his "Demoiselles d'Avi-

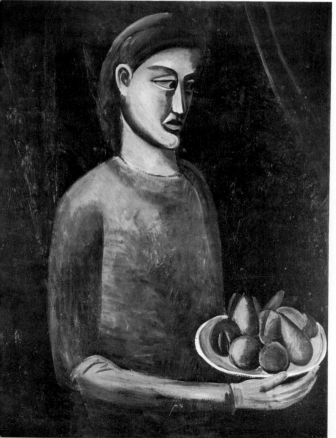

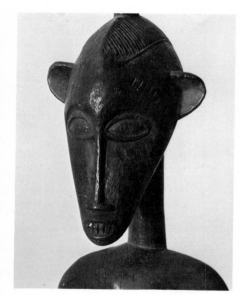

▲ 1859　Senufo, Rhythm Figure
◄ 1858　Derain, The Offering

gnon," Picasso wanted to constitute a "modèle d'intelligibilité," formal interrelations which could stand the test of rational analysis. This work initiates a theme that is both extremely important and at the same time tautological in modern art: the subject of the picture is the picture itself. Any painting represents

a reflection on painting. For Picasso the problem consists in "taking the work apart"; he takes possession in order to discover among all the constituent elements that one which enables the picture to achieve its effect, which explains how the picture works. From now on it is a matter of affirming the painted work like a product, like a piece of work, like the product of work. Such a conception marks a radical break with the system of values of his day, with the Religion of Art, with the world of Platonic ideas on which the culture of the West was oriented and according to which any work is the reflection, more or less altered, or the shadow of an idea; the work can only "move" the viewer to the extent that this reflection or shadow faithfully reproduces the idea. The analytic approach by which Picasso regulates his reading of the works of the past (his own included) and the production of his pictures is not concerned with the realm of pure, inaccessible beings: it tends towards disclosing the structures. This is why "Negro art" has neither a reference to the exotic nor a "magic" finality, but is effective in the strict order of forms and thus works to achieve the renewal of the problem of form. Emotional realism becomes a realism of plastic form. After any trace of Symbolism has at last disappeared from his work (it is still present at times in 1905), Picasso suddenly attempts—after the painful experience of his portrait of Gertrud Stein (which still was not finished after 80 sittings; he finally completes it from memory after a break of some months)—to realize what Braque terms the "fait pictural." Hardly does he succeed in doing this, then the problem of space arises for him. His radical inclination towards realism causes him to pass immediately to the investigation of "formlight" and of "volumes-surface." It would be a mistake to maintain that Picasso had all these aspects of the problem in mind when he began the "Demoiselles d'Avignon." His progress is never systematic. His work consists of "series," that is of groups of works which revolve around a particular problem, which ring the changes on the problem in order to master it the better. But between 1907 and 1909, that is at a time when "Negro art" is at the centre of interest, Picasso arrives at most varied solutions. This is true: the most varied solutions, but solutions of a problem of the same kind. Beyond the thought of Matisse, Picasso is striving after the unity of non-illusionist space in which the figure is integrated with the ground, without any compromise with

lyricism, in a spirit of radical realism. This is extremely important. For behind the white unrest of the canvas the most varied concepts become visible which can only be explained by their relationships. Let us jump a number of years: in 1920, Mondrian speaks of the necessity of overcoming the concept of "a realistically abstract picture," i. e. of a picture whose subject has no reference either to a definite object or to the viewer, but which is, for all that, depicted in the picture.

From 1907 to 1909 there are two tendencies present in Picasso's work: at one time he distributes the front-viewed volume over the surface and unifies the picture with arabesques; the forms become flat; from 1910 bodies are depicted from all sides simultaneously. At another time he places figures from the sculptural aspect in a constricted space. "Negro art" intervenes here through the study both of the masks and the statues: thence is derived a repertoire of forms which both furnish the space and create it at the same time. At the end of 1908 the relation of figure to ground changes until they are fused in perfect solidarity. In 1909, at Horta di San Juan, a closer study of Cézanne and of the form-colour-light relationship prepares the way for the great forward leap of 1910: after a serious study of the behaviour of volumes composed of surface in light, Picasso creates a plastic art, segmented, which is the prelude to the decisive pictures of 1910 and the illustrations to Max Jacob's "Saint Matorel." The picture as an autonomous reality ("fait pictural") is a reality; the difficulty has been mastered with the invention of the "papiers collés."

In 1913, Picasso commences a series of "constructions," the importance of which has perhaps still not been sufficiently grasped. A Guere-Wobe mask has eyes in the form of protruding cylinders. This is a motif which he transposes into the central sound-hole of a guitar. D. H. Kahnweiler expressly pointed out the consequences of this discovery: it was now possible to signify reality without imitating it—and to signify it with elements which are the product of free invention. On the other hand, the way was now free for the "sculpture ajourée" in which the hole has an active role to play, where the interior and exterior spaces interpenetrate.

We can and should go further here. We should recount an event which takes on such decisive importance that it becomes more than a mere anecdote. In 1913, Tatlin comes to visit Picasso on his way through Paris. He shows only an average interest in his paintings, but the "con-

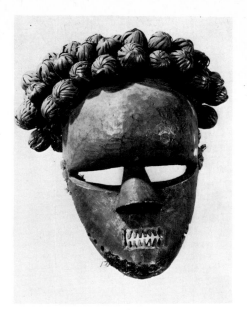

1854 Salampasu, Mask

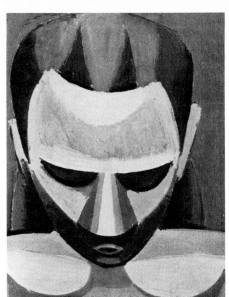

1851 Picasso, Head

structions" immediately produce such a deep impression on him that, hardly has he returned to Moscow, but he exhibits a series of "reliefs" created under the impression of this revelation. We would not be doing justice to this event were we to try to reduce it to the mere fact of influence. Picasso's work takes on a significance which arouses an echo in other fields, too: in the Moscow circle, in Opoiaz and in Lef, all of which finds its expression in the films of Vertov and Eisenstein.

What is at stake here? Since the end of the nineteenth century, painting had been convinced it had a language of its own. And this at a time when its language is itself changing. With his "Demoiselles d'Avignon" Picasso wanted to construct a "modèle d'intelligibilité." When around 1910 his and Braque's works become so difficult to decipher that they were dubbed "hermetic," both artists do not rest until—without making any concessions—they have achieved greater legibility. The "papiers collés," the "constructions," facilitate a more complex exploration of pictorial space; they also brought a series of experiments into the incorporation of the object. From now on, one could designate reality with the aid of inimitable elements: the attention of the viewer was no longer to be directed to these elements but to their combination, to their function: things no longer carry a meaning all of their own and on their own; they are given meaning by their connections, their relationships. What happens above all

here is the invention of the "montage," of such significance for the future not only in the realm of art but also in that of literature, the theatre, and the cinema. Certainly the term "montage" goes back to 1914, to a consideration raised by Fellonosa around Far-Eastern calligraphy. However, in fact, the inclusion of the Chinese and Japanese ideograms only effects the generalization and continuation of an invention that we in fact owe to "Negro art."

The first masks and figures studied were enigmatic since entirely anonymous. Without the name of an artist, these objects express a conception of art which allowed the sculptor to efface himself in favour of his work. The works are not seen as the trappings of the dialectic of the art market and an ideological religion of art; neither creator nor his creation are alienated in a situation which perverts their meaning. In 1912 Picasso and Braque stop signing their pictures for a time. They thus escape the highest bid of the market which identifies the value of a work of art with the signature of the artist. They assign the work precedence over the artist. The work exists, has its own significance, must be judged on its own merits, independently of the artist who has created it.

Let us return to a point which is just as decisive. Without a reference to a mythology, without a context, the objects of "Negro art" signify nothing but themselves, they signify their own language. What Picasso, Braque and Gris grasped

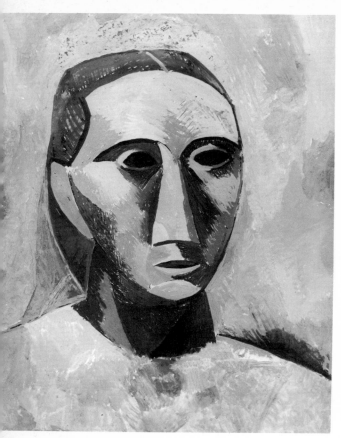

1852 Picasso, Woman's Head ▲

1890 Ebrie, Female Figure ▶

—and ethnology has confirmed their view—was that this language in signifying only itself, signified the world, did not represent it. In 1920, Juan Gris remarked: "Negro works of sculpture have proven to us the possibility of an anti-idealistic art. Animated by the spirit of religion, they are diverse but precise manifestations of great principles and general ideas. How can one not admit as art an art which, proceeding in this way, is able to individualize the general and each time in a different way? It contrasts with Greek art which, in searching for the ideal type, started from the individual." Gris has put his finger on the essence of "Negro art" here: its power of combining, of imparting meaning through the combination of its formal elements. A piece of African sculpture can easily be dismembered into as many elements as go to make it up. These forms are stereotype and conventional; they are also the relevant criteria for the identification of the ethnological origin of a particular work. To a certain extent, one can even attribute the status of linguistic signs to them. To the European, once isolated they are not semantically convincing: they only signify within the sculpture they constitute, within the structure they compose. In other words: the signification is not intrinsic to the sign; this is only clarified by the combination of the sign with the other signs. More specifically: the presence or absence of a sign places the work in a well-defined class which reflects this or that mythological context. In isolation a sign is neutral rather than meaningless. It receives its semantic charge from the nature of all the signs, taken individually and in combination, with which it constitutes a structure. At one level, certain signs can be considered as indicators of a class which, in the languages of Africa, are prefixed or suffixed to words, thus assigning them to categories according to the nature of the beings or objects signified: person, agent, number, etc. At another level, this neutral quality of the sign also makes it polysemantic in that its signification is created by the context and what the context refers to. Finally: each sculptured figure is the sum of a whole series of significations to which one has access according to the degree of initiation. In certain cases, this mesh of significations can be articulated, altered and reconstituted (among the Dogon and the Senufo) within the context of all the figures belonging to the same series. After Picasso's short period of experimentation with African forms, "Negro art" played a more precise, if less clearly definable, role. The picture and the work of sculpture (the dividing-line has become blurred) are now real objects in a real space; they no longer point beyond themselves, but to themselves. Henceforth, our artistic conceptions (which Negro art has decisively influenced rather through the arrangement of its forms than through the forms themselves) must be described in terms of their forms and their functions and not, as was formerly the case, thematically.

Translation P. J. D.

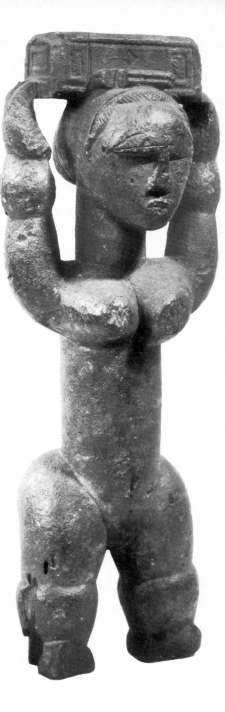

282

1846 *Pablo Picasso (Malaga 1891, lives in Mougins); Draped Nude;* oil on canvas; 151×100 cm; 1907; Leningrad, Hermitage

1847 *Pablo Picasso; Study for the Demoiselles d'Avignon;* gouache and oil on paper; 61×48 cm; 1907; Liège, Graindorge Coll.; plate

1848 *Babangi (Congo-Brazzaville); Mask;* wood; h - 35.6 cm; New York, Mus. of Modern Art; plate

1849 *Dogon (Mali); Door to a Granary;* wood; 57×41 cm; cf. Cat. no. 1846; Paris, Musée de l'Homme

1850 *Pablo Picasso; Woman with Fan;* oil on canvas; 152×100 cm; 1908; Leningrad, Hermitage

1851 *Pablo Picasso; Tête d'Homme;* oil on wood; 27×21 cm; sig. on the back in pencil: Picasso; 1908; Berne, Kunstmus., Stiftung Rupf; plate

1852 *Pablo Picasso; Woman's Head;* tempera on paper; 64×50 cm; 1908; Mainz, Mittelrheinisches Landesmus.; plate

1853 *Salampasu (Congo); Male Figure;* wood, painted; h - 21 cm; cf. Cat. no. 1850; Tervuren, Musée de l'Afrique Centrale

1854 *Salampasu (Congo-Zaire); Mask;* wood, painted red; h - 33 cm; cf. Picasso, Cat. no. 1851; Berlin, Mus. für Völkerkunde; plate

1855 *Pablo Picasso (Malaga 1881, lives in Mougins); L'Offrande (The Offering);* gouache on paper and canvas; 46.5×51.5 cm; 1908; Wuppertal, Vander-Heydt-Mus.

1856 *Salampasu (Kongo); figure;* wood, h - 48 cm; Tervuren, Mus. de l'Afrique Centrale

1857 *Fang; A Male and a Female Mask;* wood, painted white; Antwerp, Ethnographical Mus. of the City of Antwerp; plate

1858 *André Derain (Chaton 1880–1954 Paris); L'Offrande (The Offering);* oil on canvas; 116×90 cm; sig. right bottom: A. Derain; 1913; Bremen, Kunsthalle; plate

1859 *Senufo (Ivory Coast); Rhythm Statue (deble);* wood, patinated in black; h - 108 cm; Hans Schneckenburger Coll.; plate

1860 *Henri Matisse (Le Cateau 1869–1954 Nizza); Jeanette V.;* bronze; h - 58 cm; 1910/11; Paris, Madame Marguerete Duthuit; plate

1861 *Grasslands, Cameroon; Head;* wood; h - 48 cm; Mannheim, Reiss-Mus.; plate

Africa Oceania Amerindia

African Proportion

1862–1900

African and Oceanian Contribution to the Presentation of Man

I. African Proportion

Manfred Schneckenburger

Since the days of Polyclitus and since Durer's lay figure and Leonardo's ideal human form, the aim in European art has always been correct proportion. And, even where artists did not consciously adopt this ideal, they always oriented their works on the human form as they found it in nature. A second consequence of the Greek tradition was that it was the organism itself which determined the interplay of the members and muscles, which necessitated the "balance" of a composition. Free movement and static stability were contrapositioned, and this was no more than an aesthetic (indeed almost an ideological) interpretation of a functional organic unity, the expression of a vision of man which was ideally located between freedom from and subjection to rule. The figure is composed, even where the play of taut muscles is concerned, according to strict organic laws and transforms these then into a tectonic equilibrium and finally into binding aesthetic principles.

Correct proportion and contrapositioning of the members of the body are at the heart of the continuity of the Greco-Latin tradition which has endured for two and a half millenia. The Academic training given till the end of the last century took these two principles as their point of departure, so that they could become the symbol, for some time almost a negative symbol, of sterile Academicism.

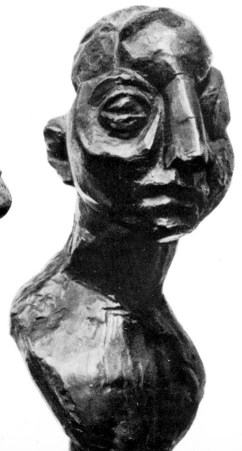

1861 Grassland Cameroon, Head

1860 Matisse, Jeanette V. ▶

283

Africa
Oceania
Amerindia

African
Proportion

1862–1900

African figures (and in addition those of "primitive" art, too) are based on entirely different laws the chief characteristics of which have been elucidated by Werner Schmalenbach. The relation of head to body is not oriented on a natural or ideal proportion but on a spiritual scale of values. Head and trunk, the seat of the body's power and vitality, are larger than life; the legs are mere mechanically operated tools which have been given the new function of a pedestal, have been abbreviated to mere supports which are, in the literal sense of the term, powerless in the shape or curve they assume.

▼ 1872 Pangwe, Bieri Figure

1862 Dogon, Ancestor ▼

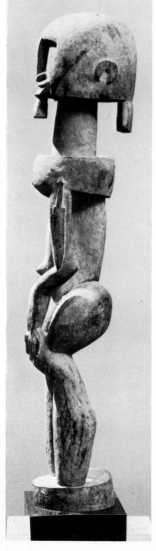

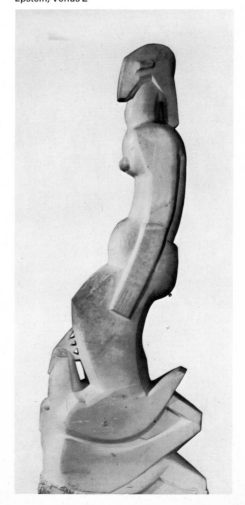

This is a measure of importance, a proportion of significance, such as was applied in the European Middle Ages less to the individual figure than to the relationship between the figures. William Fagg was perfectly justified in talking about an "African proportion," for although the same also holds good for Oceanian, North-American and Amerindian art, it has found the most precise rhythmic expression in African plastic art. The bearing or comportment forms part of "African proportion." The figure is fraught with power, but this is not conveyed by means of the fine balance of the interplay of members but as the magical possession of the body which is transformed accordingly. The high trunk rises frontally, without the suspicion of a turn, above legs that are held strictly parallel. Between the loosely hanging or slightly bent arms, which are sometimes suggested only in flat relief, the stiff transverse axes of the shoulders connect upper arm with upper arm; the trunk is elongated as a vertical axis through the neck and head: ancestors who have left this world of movement and change and are now the emphatic expression of permanence and eternity.

There can be no doubt that this principle of frontality and of rigid axiality is a phenomenon parallel to the Archaic period of early Greek sculpture or to the figures of the early Romanesque. Nevertheless, it would be entirely wrong to classify African art as "archaic" or "early," for the proportion of significance and the principle of frontality provide a framework for classical or manneristic variations which would be unthinkable within the limits of the above-mentioned early periods in European artistic development. In Europe we are faced with a severely delimited stylistic range of Archaic forms; in Africa we are confronted with a far more complex framework which allows for a much greater stylistic variety embracing the mature classicism of the Luba-Hemba kings (cp. Cat. no. 1869) and the over-refined, almost decadent mannerism of some Baule figures (Cat. no 1875). We here have multiplicity in transverse and not in longitudinal section.

It goes without saying that all this leaves much room for rich variation. Where the figure is meant to signalize fertility, the breasts and belly gain in significance in relation to the head (cf. Cat. no. 1866); where a decided pillar-style is the point of departure, as in the Sudan (cf. Cat. no. 2025) and in parts of Nigeria (e. g. among the Mumuye, cf. Cat. no. 1865), the head is kept narrow within the diameter of the pillar. Fieldwork (that is if this is

not already too late) must reveal how the tribes themselves interpret the proportions of their plastic art. To give but one example: James Fernandez reported recently that the Fang interpret the large heads and round members of their Bieri figures as representing the proportions of the child (Cat. no. 1872). The newborn baby is closest to the tribal ancestors and can only be transformed into an adult by rites, especially that of initiation. The Bieri figures thus incorporate ancestors and children at the same time. It requires no pointing out that this opens up broad vistas of theology and mythology. African art recreates men at the level of ancestors and spirits according to a spiritual approach which may allow little scope for individual artistic expression but which also implies freedom from naturalistic imitation. This was the decisive point of contact for the moderns who—

Epstein, Venus 2

between the years 1905 and 1925—turned their backs on the Greco-Latin canon and devoted their attentions to a new proportion which may justifiably be seen as derived from the African. Anti-Academicism thus develops into an affront to Europe.

Jacob Epstein crystallized this change in the piece of sculpture he entitled "Second Venus". Here he experiments with the African formal impulses on the classical model of Venus and using the classical material, marble. The title of the piece shows us that recourse to the "primitive" by no means implies a renunciation either of beauty or of ideality, but merely signifies a new orientation in European art. This second Venus bears the external traits of a Dogon or Baule figure and shares with them the faint aura of manneristic elegance and elongation. The head is not oversized, as is often the case with the Baule figures, too. The overlengthy arms and the massive neck extend the trunk longitudinally. Head, arms and parallel-held (better, parallel-bent) legs are executed in rigid frontality which again ensures a perfect view in profile. Any evocation of the interplay of members or of contrapositioning has been sacrificed in the legs in favour of exact parallelism. Their breadth renders them into a pedestal which is incorporated into the rhythm inherent in the entire figure, a rhythm which has no organic foundation whatsoever. Just as the legs are treated from the viewpoint of parallelism and of the block, so, too, the arms are rigidly connected with the body: they form a concave counterpoint to the convex curve of the legs which is again echoed in the slight bend of the neck and head—a further fine contrast to the rounded belly and depression of the ribs. The result is: an expressive rhythmic composition of sweeping concave and convex lines instead of the careful balance of members such as we should expect in Greek sculpture.

Brancusi's "Caryatid" carries the transformation of the human form a step further: here we have a rhythmic composition of concave forms and horizontal intermediate members. African proportion—shortened legs curved forward without knee joint, an exaggerately long trunk curving forward, the anti-contraposited parallel leg posture and pillarstyle—is connected with old conceptions of loads and supports. African anthropometry and the Greek concept of the column are combined in a new form of caryatid. Modigliani connects up here, too, with his (painted) variants of the Luba caryatids.

In the same year (1915) as Brancusi carved his caryatid, Lipchitz made a preliminary sketch for a piece of sculpture (Cat. no. 1874) which looks like the Cubist counterpart to Epstein's "Second Venus": the Cubist analysis of a seated Baule figure. This forms the link with a series of figures executed between 1915 and 1920 which present "African" proportions in the language of Cubism—even where the abstraction is extreme, they can be recognized within the context of the series as derived from African proportion. Any form of organic differentiation is sacrificed in favour of Cubist rhythms; the non-organic in African sculpture is here developed to a high degree of abstraction. African proportion quite clearly acted as more than a catalyst in the formation of Cubist views on the human form.

Henri Laurens develops African proportion and pillar-style still further. But, as we can see in his "Two Sisters" (Cat. no. 1887), the African forms are pervaded with Greek movement. The new proportion acquires flowing lines and grace, disassociates itself from the hieratic and frontal approach. "African" statues are now the sisters of the Kore. Laurens has thus overcome the incipient dualism in the antithesis "primitive"/"Greek." The traditions merge into one: African art is

*Africa
Oceania
Amerindia*

*African
Proportion*

1862–1900

1875 Baule, Ancestor ▶

▼ 1874 Lipchitz, Study for Sculpture

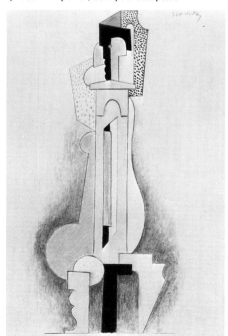

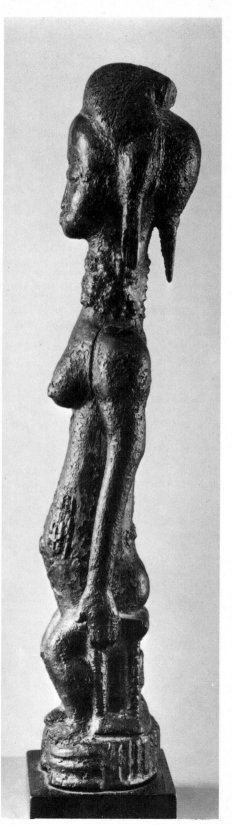

285

Africa
Oceania
Amerindia

African
Proportion

1862–1900

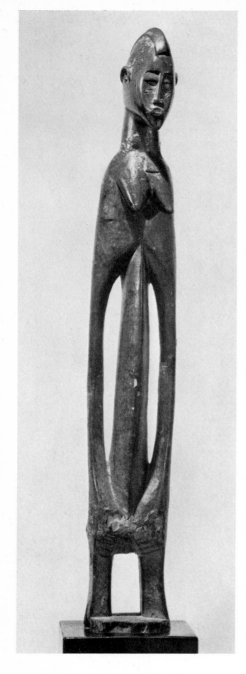

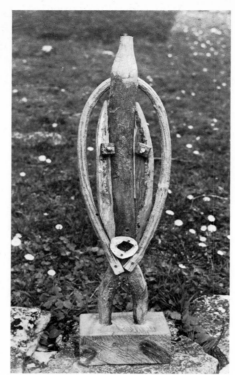

▲ 1895 Bissière, Personnages
◄ 1896 Senufo, Rhythm figure

transform this tendency. Ernst Ludwig Kirchner and Schmidt-Rottluff exemplify the fact that Expressionism, too, in its affirmation of the proportion of significance and of the primacy of inwardness, has points of contact with African plastic art. We are hardly going too far, when we say that between 1910 and 1925 "African proportion" is adopted by leading artists among the moderns. European art turns to extra-European traditions at a time when the portrayal of the human figure had become an Academic cliché.

Summary and Translation P. J. D.

freed from its rigidity and hieratic context; European art is liberated from naturalism and imitation. A synthesis is the result. Laurens' figures evoke other associations, too: the massivity of the thighs and the sturdy might of the bodies has, since the period of ice-age art, been the symbol of and signal for fertility, the maternal form of the female. Lespugue's Venus is sister to the Ibo Woman (Cat. no. 1866). Henry Moore and Coutourier both evolve and

1862 *Dogon (Mali); Female Ancestral Figure;* wood; h - 100 cm; Brussels, Delenne Coll.; plate

1863 *Mumuye (Nigeria); Ancestral Figure;* wood; h - 120 cm; Paris, Monsieur Kerchache; plate

1864 *Mumuye (Nigeria); Ancestral Figure;* wood; h - 133 cm; cf. text to Cat. no. 1863; Paris, Monsieur Kerchache

1865 *Mumuye (Nigeria); Ancestral Figure;* wood; h - 100 cm; Paris, Monsieur Kerchache

1866 *Ibo (Nigeria); Figure of a Woman;* wood; h - 74 cm; Paris, Monsieur Kerchache; plate

1867 *Ibo (Nigeria); Ikunga Statue;* wood; h - 98 cm; Paris, Monsieur Kerchache

1868 *Lumba Hemba (Congo-Leopoldville); Male Ancestral Figure;* wood, patinated in black; h - 88 cm; Antwerp, Ethnographical Mus. of the City of Antwerp

1869 *Luba (Central Congo); Statue of a King;* wood; h - 87 cm; cf. Cat. no. 1868; Paris, Monsieur Kerchache; plate

1870 *Wabembe (Central Congo); Ancestral Statue;* wood; h - 84 cm; Paris, Monsieur Kerchache

1871 *Dogon (Mali); Ancestral Couple;* wood; h - 65 cm; Paris, Monsieur Kerchache

1872 *Pangwe (Gaboon); Bieri Figure;* wood, patinated in black; h - 49 cm; Paris, Monsieur Kerchache; plate

1873 *Ngumba (Cameroon); Female Bieri Figure;* wood, with traces of red paint, sheet brass; h - 43 cm; cf. Cat. no. 7930; Berlin, Mus. für Völkerkunde

1874 *Jacques Lipchitz (Druskieniki, Lithuania 1891, lives near Pisa); Study for a Sculpture;* pencil, pastel and Indian ink on paper; 51 × 32 cm; sig. top right: J. Lipchitz; 1915; New York, Marlborough-Gerson Gall.; plate

1875 *Baule (Ivory Coast); Female Ancestral Figure;* wood; encrusted with black chicken's blood; 36 × 7.5 × 7.5 cm; cf. the "Study to a sculpture" by Lipchitz, Cat. no. 1874; Munich, Hans Schneckenburger Coll.; plate

1876 *Jacques Lipchitz; Standing Figure;* bronze; h - 98 cm; 1920; Zurich, priv. coll.

1877 *Baule; Ancestor's figure;* wood, h - 47 cm; Brussels, Delenne coll.

1878 *Amadeo Modigliani (Livorno 1884–1920 Paris); Caryatid;* oil on

canvas; 72.5×50 cm; c. 1910; Düsseldorf, Kunstslg. Nordrhein-Westfalen; coloured plate

1879 *Luba (South East Congo); Chieftain's Chair with Caryatid;* wood; h - 54 cm; Paris, Monsieur Kerchache; plate

1880 *Henri Gaudier-Brzeska (Saint Jean de Braye 1891–1915 Neuville Saint-Vaast); Man Molesting a Woman;* pen on paper; 50×34.5 cm; c. 1913/14; Paris, Musée National d'Art Moderne

1881 *Henri Gaudier-Brzeska; Wrestlers;* pen on paper; 36.5×24.5 cm; c. 1913/14; Paris, Musée National d'Art Moderne

1882 *Henri Gaudier-Brzeska; The Family;* pen on paper; 25.5×38 cm; c. 1913/14; Paris, Musée National d'Art Moderne

1883 *Baule; Ancestor's figure;* wood, h - 51 cm; Munich, Mus. für Völkerkunde

1884 *Ossip Zadkine (Smolensk 1890–1967 Paris); Seated Woman;* bronze; 79×32 cm; 1928; Paris, Gal. Schmit; plate

1885 *Congo (Angola); Tomb Statue;* steatite; h - 38.7 cm; Brussels, Musées Royaux des Arts et d'Histoire; plate

1886 *Hermann Kruyder; Standing Figure;* wood; 67×7×13 cm; sig. bottom right: H. Kruyder; 1932; Amsterdam, Stedelijk-Mus.

1887 *Henri Laurens (Paris 1885–1954); Two Sisters;* bronze; 88×43 cm; 1951; Paris, Musée National d'Art Moderne

1888 *Henri Laurens; Woman Standing with a Mirror;* bronze; 28×9.5 cm; 1949; Paris, Musée National d'Art Moderne (Donation Laurens)

1889 *Henri Laurens; The little sister;* bronze; 29×10 cm; 1949; cf. Cat. no. 1890; Paris Musée National d'Art Moderne (Donation Laurens)

1890 *Ebrie (Ivory Coast); Female Figure;* wood; h - 27.4 cm; Antwerp, Ethnographical Mus. of the City of Antwerp; plate

1891 *Henry Moore (Castleford, Yorkshire 1898, living in Much Hadham); Standing Woman;* wood; h - 38.7 cm;

1923; cf. Cat. no. 1866; Manchester, City Art Gall.; plate

1892 *Max Ernst (Brühl near Cologne, lives in Huismes); Bachelor with Beating Heart;* bronze; h - 65 cm; 1944; Paris, Morgues Coll.; plate

1893 *Wilfredo Lam (Saguala Grande, Luba 1902, lives in Paris); The Couple;* oil on canvas, 118×81 cm; Brussels, Madame Jean Krebs

1894 *Dan (Ivory Coast); Spoon;* wood; patinated in black; h - 56 cm; see Cat. no. 1893; Cologne, Rautenstrauch-Joest Mus.

1895 *Roger Bissière (1886 Villereal); Personnage;* wood, iron and bone; 66×18×12 cm; 1945; Paris, Gal. Jeanne Bucher; plate

1896 *Senufo (Ivory Coast); Deble Statue;* wood; h - 76 cm; see Cat. no. 1759; Paris, Boussard Coll.; plate

1897 *Robert Coutourier (Angouleme 1905, lives in Paris); Torse Concave;*

1892 Max Ernst, Bachelor with Beating Heart ▶

▼ 1894 Dan, Rice spoon

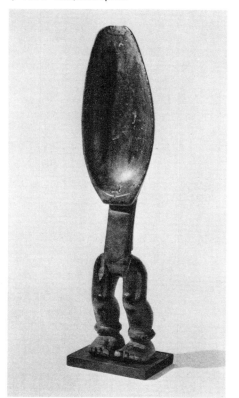

bronze; 175×35×35 cm; sig. on the palm: Coutourier; 1965/66; Paris, priv. coll.

1898 *Robert Coutourier; Small Tree;* bronze; 27×10×10 cm; sig. on the surface of the stand: Coutourier; 1961; Paris, priv. coll.

1899 *Robert Coutourier; Nu Cylindrique;* bronze; 30×5×5 cm; sig.: Coutourier; Paris, priv. coll.

1900 *Bambara (Mali); Ancestral Figure;* wood; h - 49 cm; Munich, Hans Schneckenburger Coll.

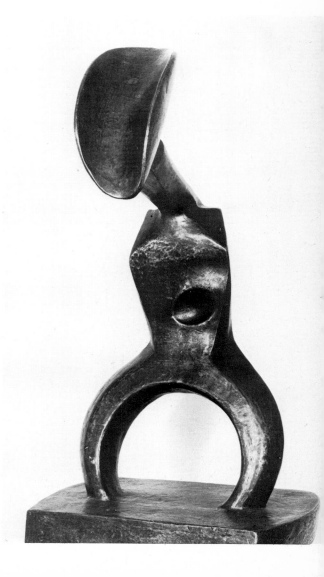

II. Masks in Tribal Art, "Masks" in Modern Art

Manfred Schneckenburger

If Europe must be regarded as poor in any field, then it is in that of physiognomic imagination. There is no important area of cultural expression reserved to the representation of the human face: from the face of the Romanesque madonna to the smile of the "Mona Lisa," from the psychic mystery of Rembrandt's self-portraits to the "passing impression" caught by the Impressionist portrait, we find but moderate stylization within the same limits. Differentiation in Europe was inward-regarding: the face is the mirror of the soul. Nowhere do we come across physiognomic invention and re-formulation of the basic features. The mask and whatever is evocative of

the mask in European art calls forth associations with the waxen rigidity of Mannerist portraits, the masquerades depicted in eighteenth-century pictures of carnival in Venice and of Goya's and Ensor's demonization of carnival, but nowhere are new forms created. Perhaps the infernal carnival of Hieronymus Bosch should be regarded as an exception, although he, too, links the animalic with the sub- not the supra-human. The horned might of animals, in African art the quintessential expression of vitality and vigour, becomes the goat of medieval representations of the devil. Metamorphosis is reduced to distortion; the grimace or caricature is the result. In the great gallery of world art, that of Europe stands alone in its inward-regarding delimitation and in its neglect of the mask, its surrender of the mask in fact to folk art and folklore. European art was undoubtedly more than ready for external

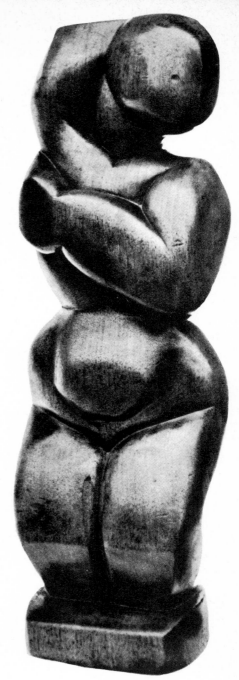

1891 Moore, Standing Woman

◀ 1884 Zadkine, Sitting woman

1885 Congo, Tomb Statue ▼

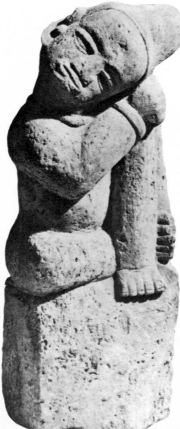

inspiration here, especially as its own tradition was so sparse. The introduction of the mask to modern art, the emancipation of mask-like features in the portrait, the relearning of the sacred language of the idol, the innumerable refractions of nuances of psychology: all this is part of one of the most fascinating but oft disregarded innovations in the art of the

twentieth century. Of course, the mask has influenced the moderns as an isolated museum exhibit or wall decoration and not as experienced within its original context of cult, costume, rhythm and dance. First, let us briefly consider this ethnological context.

Masks in Tribal Art

Masks — the transformations and re-creations of the features of the human face — represent one of the great contributions of West Africa and the Congo region, of Melanesia and north-western America to world art. Streams of creative vigour merge in the complex wealth of their forms and functions; religion, myth, art, and political and social life have all had a part to play in this kernel artistic achievement. The importance of the masks in African (and with reservations also in Melanesian) culture has justly been compared to the significance of the Gothic cathedrals for the Middle Ages. What role does the mask play within the framework of tribal art?

The mask is not merely the face-covering (usually carved in wood but made of other materials, too) and the attached garment which envelops the entire body. It is worn by one or more of the tribal dignitaries who celebrate(s) a rhythmically concentrated ritual for the benefit of the village (although, of course, we are oversimplifying here!). The mask is not a mere disguise but a numinous entity of a very special kind: a special functionary accompanies it, translates its message, gathers up the fibres which have fallen from the garment so that they may not be misused in magic rites. The mask actuates the help of the souls of ancestors, of bush spirits and of persons who have played a decisive role in the tribal culture — rarely does it actuate the help of a god. It does not become this being by a sort of mystical union, although one often reads this. It takes on the form of the spirit and concentrates its suprahuman vital energies in itself. This seems to be the essential element and this accounts for the superior power attributed to the wearer of the mask. The ultimate reality of men, animals and plants is not to be sought in matter but in this vital energy which pervades every living being to a greater or lesser degree. This is the real secret of the mask. The ambivalence of its numinous powers is the source of its danger for women and children and the initiated. And it is this aspect which accounts in part for the male secret societies so often linked with the cult of the masks. The Dan, for instance, lock their masks away in the

hut of the village smithy, the Baule conceal them outside the village. Himmelheber tells us how his African helpers shouted cries of warning to women they saw so that they would know that masks were being transported. And yet there are many legends that recount that the masks were originally in the possession of the women until the men stole them by subterfuge and thus wrested the power from the women. Such legends are very widespread — we meet them in Africa and Melanesia, and as far afield as Tierra del Fuego. There is obviously a relic of the ancient matriarchal setup connected with vegetational cults. In fact, African and Melanese masks are bound up with both vegetational cults and ancestor worship. These people think in continuities both in regard to man and nature, from generation to generation, from one sowing to the next. The occasion and aim of the masked dances are manifold and varied. There are firstly the masks of initiation. They accompany all the great divisions in the lives of the members of the tribe, especially the transition from childhood to adulthood, which marks the death of the child and his second birth. The masks appear again at the burial of the initiated and take care of their passage to the realm of the dead — in some tribes this is regarded as the third birth. A second group is formed by the fertility masks. They accompany all the major stages in the growth of the crops, the seasons of the agricultural year, the sowing and reaping of the crops. A third major group, which in part comes under the first two as well, consists of the masks connected with the secret societies: masks set the members apart and designate their rank. Large secret societies, like say the Poro among the Liberian tribes, have been able to exert political power via the power of the masks. Political practices are often linked with social functions, too: the mother mask of the Dan and the large masks of the Guere and Kono administer justice, for example. Among the tribes of the Sudan, the masks are the embodiment of the drama of creation; they repeat the great mythological act when God created the world. M. Griaule has made a detailed study of the backgrounds of a largescale cosmology among the Dogon; A. Schwegel-Hebel has done the same among the Kurnuba. In all probability, thoroughgoing research among other tribes would uncover remnants of the same conceptual complex, too. The dance drama among the Marind-anim on New Guinea also harks back to tribal origins, and the

double masks of the Eskimoes and North-American Indians recall those mythical early times when spirits could adopt at will the form of man or animal, though of course this latter approach is based on the cultural background of the hunter.

Africa
Oceania
Amerindia

"Masks"

1901–1984

1936 Gonzalez, Oncle Jean 2

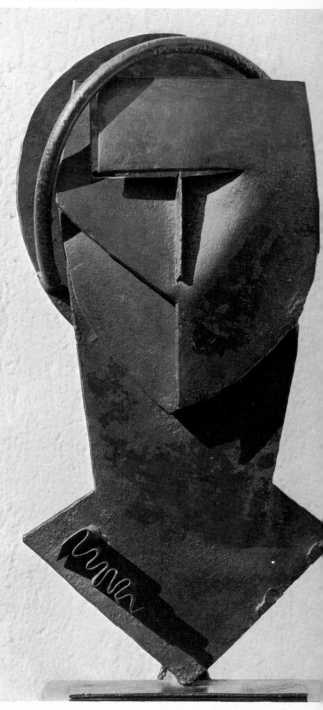

It thus seems that the dance can celebrate early myths, too — this seems an important, if oft long forgotten, root of the cult of masks. The dance repeats the first days of creation and gives creation permanence and continuity.

The animal masks of the hunter cultures, of the Eskimoes and the Indians of the north-west-American seaboard form a special group apart. Both the desire to appropriate to oneself by magic means the speed and power of man's great adversary, the animal, and the intent to creep up on the game with the aid of the camouflage mask account for the origin of these masks. But here mention must be made above all of the great complex of shamanism, with its masked dances to heal the sick and propitiate animal spirits: masks are auxiliary spirits which accompany the shaman on his trance-journey to the world of the spirits (Cat. no. 2043).

Any attempt to reduce the rich variety of masks to one common denominator (or even to several) appears doomed to failure from the very outset. One can categorize according to the method of wearing but this remains but a schematic help, nothing more (good illustrations of the possibilities here can be seen in Cat. no. 1950, 1949, 1067 and 2048). Another principle behind the transformation the mask brings about is the exaggeration of the function of this or that feature so that it takes on the nature of a "signal": gigantic eye sockets "signalize" the power of human gaze. But again the "beautiful" masks of the Ivory Coast cannot be fitted into this category and African masks (and in part those of the coastlands of north-west America), where every detail is subordinated to the overall unity, fall outside such a classification. A. Lommel divides masks into "beautiful" masks, animal masks, abstract (Dogon, Teké) and Expressionist masks. Apart from the questionable validity of applying the concepts of western art to other cultures in this way, it will suffice to point out that abstraction is a variable principle without which an African mask would hardly be conceivable. Thus, however we try, we are always faced with generalizations, classifications which illuminate the rich abundance of our subject matter but remain mere aids to optical appreciation and genuine understanding.

Finally, a word about the carvers. They are generally specialists who have learnt their craft and the rules which govern it in long years of apprenticeship to an old master of the art. As a rule, they are village carvers (or smithies) whose

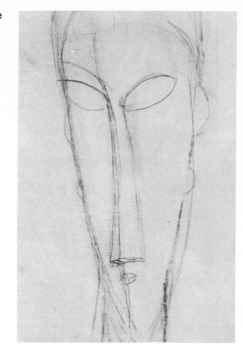

1904 Modigliani, Head

1906 Pangwe, Mask

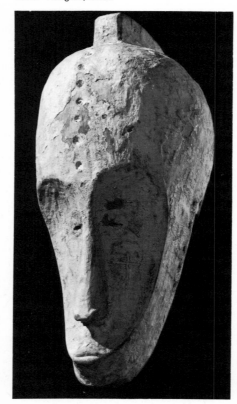

stylistic sureness of hand arises from an intermingling of tradition, the collective mission and personal gifts. A sense for individual expression within the framework of stable convention is quite evident, especially within the borders of Liberia and Nigeria, on the Ivory Coast and in the Congo. There are even instances of downright artistic individualists. At the other extreme stand the Dogon peasants who carve their simple, monumental masks themselves. However, this by no means involves a loss of formal intensity or a simplification of spiritual content as is shown by the complexity of the polysymbolism of Dogon masks and dances — a final reminder that we must beware of European clichés if we wish to grasp the masks of tribal art in all their peculiarity and inherent artistic worth.

"Masks" in Modern Art

It needs no emphasizing that the moderns have been influenced by tribal masks out of the context just described. On the one hand, they have transmuted the cultic mask into a formal type; the result is autonomous works of art. On the other, characteristics of the mask have even been allowed to pervade traditional categories, like portrait, figure, scene, bust or head. In view of the dimensions of the subject, we can of course only sketch in here in very broad outline the influence of tribal masks on modern art. A first group illustrative of the abstract and a naturalistic treatment typical of our century is represented by the geometric stylizations: eyes, nose and mouth are transformed into an axial arrangement of thin lines imposed on the surface. Such abstraction is the natural outcome of modern tendencies but has been modified again and again by the influence of Baule and other masks. If this axiality is combined with extreme elongation, then the Fang mask stands model. Modigliani's gracefully spiritualized "heads" evoke the sensitive formal perfection of both Baule and Fang plastic art. During the twenties, Gastave Miklos proceeds along these same line but he imparts a more hieratic, even fashionable, note to his work: Modigliani's "heads" become the fashion-conscious "Divinité Solaire". Belling goes even further in his important "Head 23" (1923) and combines axial and spatial aspects; in his "heads" and "meditations", Jawlensky lays still greater stress on the surface and spiritual depth — the closest analogy here is to be seen in the gable masks of the Mortlock Islands. An extreme variant on surface stress is represented by the faces which

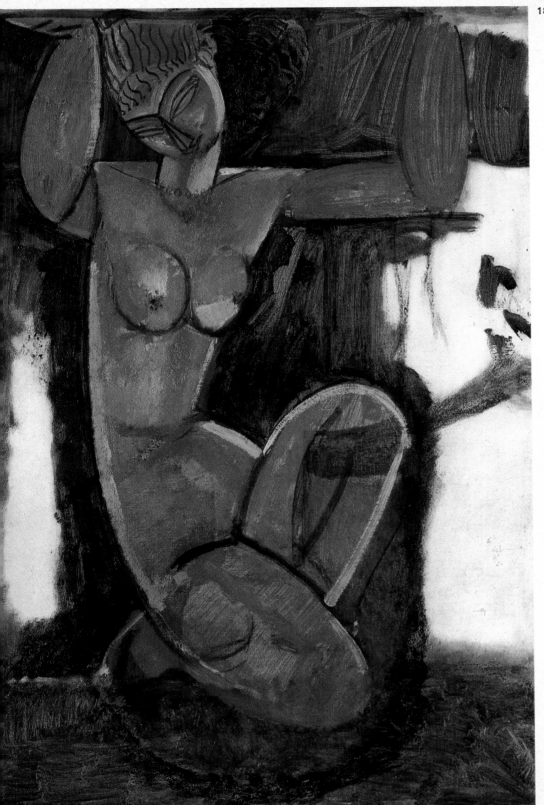

1878　Modigliani, Caryatid

1879　Luba, Chieftain's Chair

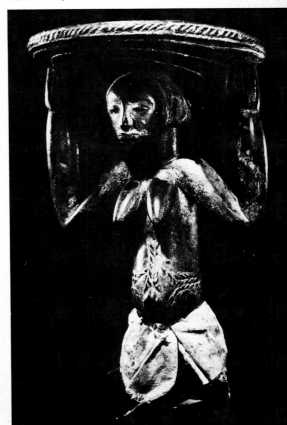

result from the orthogonal scaffolding of Constructivism. J. Torres-Garcia combines Mondrian's experience with the thin lining of the Katchina masks of America's South-West: Neoplasticism and "primitive" art here meet in heads fascinating in their self-contained compactness.

At this stage at the latest, it becomes clear that the geometric approach is more than a matter of formal discipline and rational simplification. The Constructivist calls forth visions of the idol again; the human is stylized into the transhuman. We would expect the tribal masks to make their contribution here. The deep shafts of the eyes are one of the stable components of "primitive" art in Africa, Oceania and America. Indeed, this is a motif that has a history all of its own. Picasso rang the changes on these eye-cylinders (based on a Wobe mask) in his guitar reliefs of 1912 and transformed them into the positive protruding (not negative hollowed-out) cavity, the outjutting "hole" of the guitar: the magic gaze is here neutralized as a formal element in a still-life. Laurens and Lipchitz take over this same motif, so that the outjutting cavity becomes one of the leitmotifs of Cubist sculpture. Lipchitz retranslates it into eyes again; Moore and Miró transpose the eye-cylinders into the expression of piercing sight.

The second main influence of the tribal masks on modern art is to be seen in the plastic and spatial vitalization of the face. This takes the form of overstressed modelling or of Cubist two-in-one dimensionality. Picasso's right-hand heads in the "Demoiselles d'Avignon" emphasize the interplay of concave and convex surfaces in the face; the "Female Head" (1909) is another example of concavo-convex composition. We are strongly reminded of Cameroon masks here, and in Matisse's "Jeanette V" the connection is indisputable. Matisse presents us with his personal experience of Cameroon plastic art, which has also left its mark on Duchamp-Villon's "Horse's Head", "Portrait of Professor Gosset" and "Maggy". Cameroon masks thus make a decisive contribution towards the actualization of the plastic potential in French art between the years 1910 and 1920.

In 1924, Antoine Pevsner tried to convey the concavo-convex harmony of facial surfaces in a plexiglass mask. However, this correlation of positive and negative forms stems from the Dan masks composed on the same principle. Pevsner developed this tendency still further until it merged entirely into Constructivism.

There are obvious points of contact, too, between Henri Laurens' painted "heads" in stone and the Kifwebe masks of the Basonge. These same masks and the bull masks of the Bobo have also left their mark on Picasso's portraits around the year 1940.

These same pictures produced around the year 1940 also reveal another aspect of "primitive" influence: the incorporation of zoomorphic elements. Marcel Duchamp's "Portrait of Professor Gosset" deserves mention here. And Schmidt-Rottluff derives his physiognomic types of elemental expressiveness and humanity from the masks of the Kran, Baule and Fang tribes. González was the artist who transformed the inspiration of African masks most decisively into that deeper level of humanity which is often one of suffering. Sometimes, too, the masks are given a psychological interpretation which rather hinders than furthers their correct understanding. Paul Steinburg went furthest here when he translated the Wabembe mask with its large owl-eyes and its bright row of teeth into the grimace of a businessman's broad grin: Business Mask.

The masks of Africa and Oceania have influenced the modern artist's presentation of the human face more intermittently than consistently. However, the influence was often most felt at great turning-points or a short way from memorable achievements. It is a mask, not a figure, which influences "Demoiselles d'Avignons" in 1907. Since that time, the masks not only form part of the artist's repertoire; they are one of the very sources of modern art.

Translation P. J. D.

Amadeo Modigliani
(Livorno 1884–1920 Paris)

Between 1910 and 1915 Modigliani executed a number of "heads" in soft limestone; about 25 are extant, although originally there must have been several times this number. The vertically stylized but psychologically precise race of men in the portraits is here raised to the supraindividual, to androgynous gracefulness between "primitive" idol and late archaic Kore. Modigliani takes elements of physiognomic stylization from African sculpture, in particular from the delicately refined Baule art: from here come—without any trace of imitation—the lengthening of the face, the reduction of the features to close, slit eyes, the thin bone of the nose, a narrowly pointed mouth. Of less influence are the long-face masks of

the Fang or the concave overlappings of Baluba faces (cf. Cat.-no. 1788).

1901 *Amadeo Modigliani; Head;* stone; h - 56 cm; 1910–1915; Paris, priv. coll.

1902 *Amadeo Modigliani; Woman's Head;* limestone; 58×12×16 cm; sig. top left: Modigliani; c. 1912; Paris, Musée National d'Art Moderne

1903 *Baule (Ivory Coast); Mask;* wood; h - 60 cm; New York, priv. coll.

1904 *Amadeo Modigliani; Head;* pencil and pen on paper; 26×18 cm; London, Hanover Gallery; plate

1905 *Amadeo Modigliani; Head;* pen on paper; 24×17 cm; 1910–1915; plate

1906 *Pangwe; Dancing-mask of the Ngi Secret Society;* wood, painted white, h - 65 cm; Brussels, Delenne Coll.; plate

1907 *Gustave Miklos (Budapest 1898–1967 Oyonnax); Head (Divinité Solaire);* polished bronze, 65×20×10 cm; sig. on the base: G. Miklos fonte cire perdue Valsuani No 4/4; 1928; Paris, Gal. L'Enseigne de Cerceau

1908 *Gustave Miklos; Head;* bronze, 66×28 cm; 1924; Paris, Alain Lesieutre

1909 *Constantin Brancusi (Pestisani 1876–1957 Paris); Portrait of Madame L. R.;* wood, 120×35 cm; 1914–1917; Biot, Madame Nadia Léger; plate

1959 Basonge, Kifwebe Mask ▶

1948 Gonzalez, Masque Sevère ▼

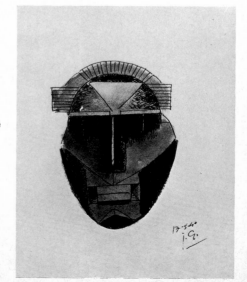

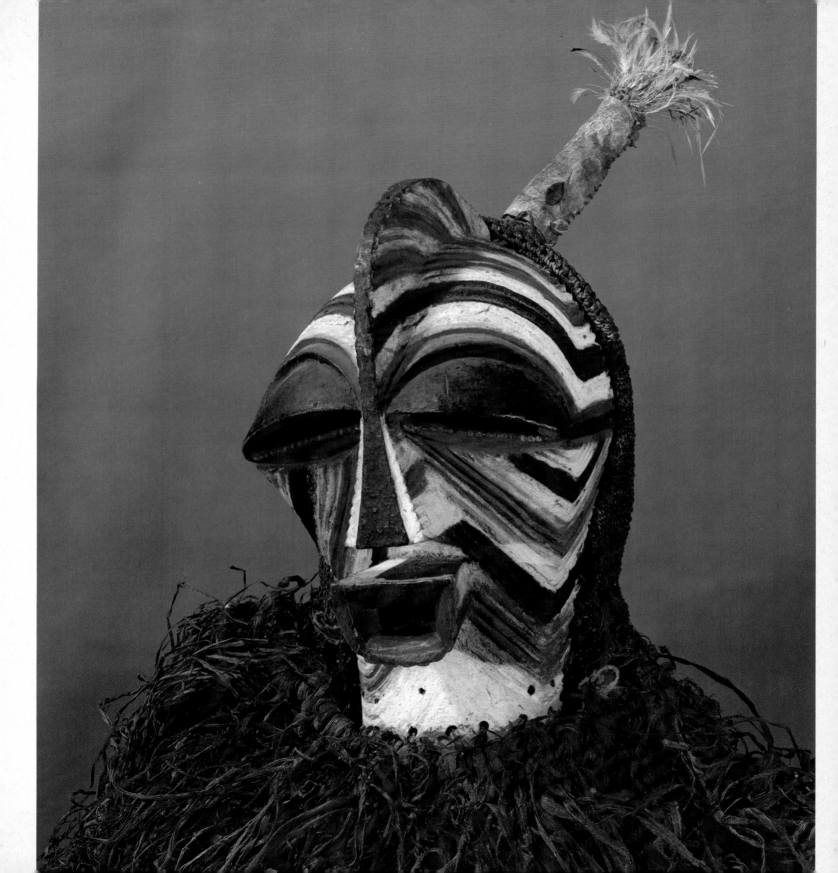

1910 *Mahongwe (Congo); Reliquary Figure (Bweti);* wood and strips of metal, 53×19,5 cm; Paris, Monsieur Kerchache; plate

1911 *Constantin Brancusi; The First Step;* pencil on paper, c. 90×40 cm; 1913; New York, Mus. of Modern Art

1912 *Constantin Brancusi; The First Cry;* polished bronze; 25.1 cm; 1914; Zollikon, Dr. W. Bechtle; plate

1913 *Upper Niger; Ancestral Figure;* wood; h - 87 cm; cf. Cat. no. 1911; Paris, Musée de l'Homme; plate

1909 Brancusi, Madame L. R.

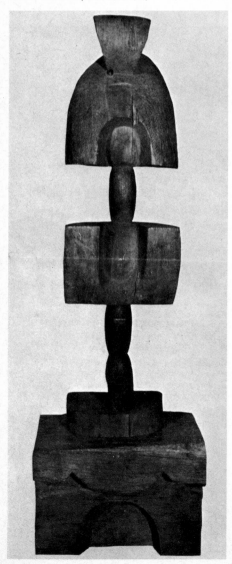

1914 *Rudolf Belling (Berlin 1886, lives near Munich); Head 1923;* brass, polished, h - 23 cm; Munich, Professor Rudolf Belling

1915 *Raymond Duchamp-Villon (Damville Eure 1876–1918 Cannes); The Horse;* bronze, first version; 48×52× 40 cm; sig.: Duchamp-Villon 1914; Zürich, Kunsthaus

1916 *Grasslands, Cameroon (Bangwa?); Large Pullover Mask;* wood; h - 45 cm; cf. Cat. no. 1915; Darmstadt, Hessisches Landes-Mus.

1917 *Raymond Duchamp-Villon; Portrait of Professor Gosset;* bronze; h - 31 cm; 1917; Munich, Neue Staatsgal.

1918 *Marquesas; Tiki;* wood; h - 34 cm; see Cat. no. 1917; Cologne, Rautenstrauch-Joest-Mus.

1919 *André Derain (Chatou 1880– 1954); Mask No. 19;* bronze; 16×13× 6 cm; sig. on the back: André Derain 3/11; post 1939; Paris, Musée National d'Art Moderne

1920 *André Derain; Mask No. 16;* bronze; 19×15.5×9 cm; sig. on the back: At. André Derain 3/11; post 1939; Paris, Musée National d'Art Moderne

1921 *André Derain; Mask No. 3;* bronze; 17×15×8 cm; sig. on the back: At. André Derain 3/15; post 1939; Paris, Musée National d'Art Moderne

1922 *Roger Bissière (1886 Villereal); Head;* wood, painted, 43.5×33×27 cm; 1945; Paris, Gal. Jeanne Bucher

1923 *Henry Moore; Helmet Head No. 2;* bronze; h - 34.5 cm; 1950; Bochum, Städtische Kunstgal.

1924 *Congo; Mask;* wood; h - 49 cm; Munich, Professor Robert Jacobsen; plate

1925 *Joan Miró (Montroig near Tarragona 1893, lives near Barcelona); Sculpture;* bronze, cast by Joseph Paradella, 77×21×18 cm; 1968; Barcelona, donated by Joan Miró to the City of Barcelona

1926 *Joan Miró; Sculpture;* bronze, cast by Joseph Paradella, 55×29×17 cm; 1968; Barcelona, donated by Joan Miró to the City of Barcelona

1927 *New Hebrides, South Malekula (Melanesia); "Temes nevinbur" Doll;*

banana leaves and tree fern, vegetable matters; h - about 60 cm; Paris, Musée de l'Homme

1928 *Henry Moore; Mask;* stone; h - 27 cm; 1924; Much Hadham, Mrs. Irina Moore

1929 *Henry Moore; Mask;* stone; h - 21 cm; 1924; cf. the Aztec mask Cat. no. 1930; Much Hadham, Mrs. Irina Moore; plate

1930 *Teotiuhacan (Mexico); Mask;* hornstone, 16×14.5 cm; 100 B. C – 400 A. D.; Vienna, Mus. für Völkerkunde; plate

1931 *Teotiuhacan (Mexico); Mask;* stone, 15.5×18 cm; c. 100 B. C. – 400 A. D.; cf. Cat. no. 1930; cf. Moore Cat. no. 1928; Vienna, Mus. für Völkerkunde

1932 *David Alfaro Siqueiros (Chihuahu, Mexico 1896, lives in Mexico); Ethnography;* pyroxyline on canvas, 122× 82 cm; 1938; New York, Mus. of Modern Art; plate

1933 *Olmec (Southern Gulf Coast of*

1957 Picasso, Woman on Sofa ▶
1910 Mahongwe, Reliquary Figure ▼

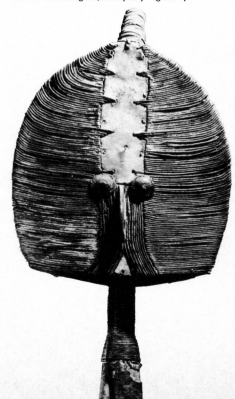

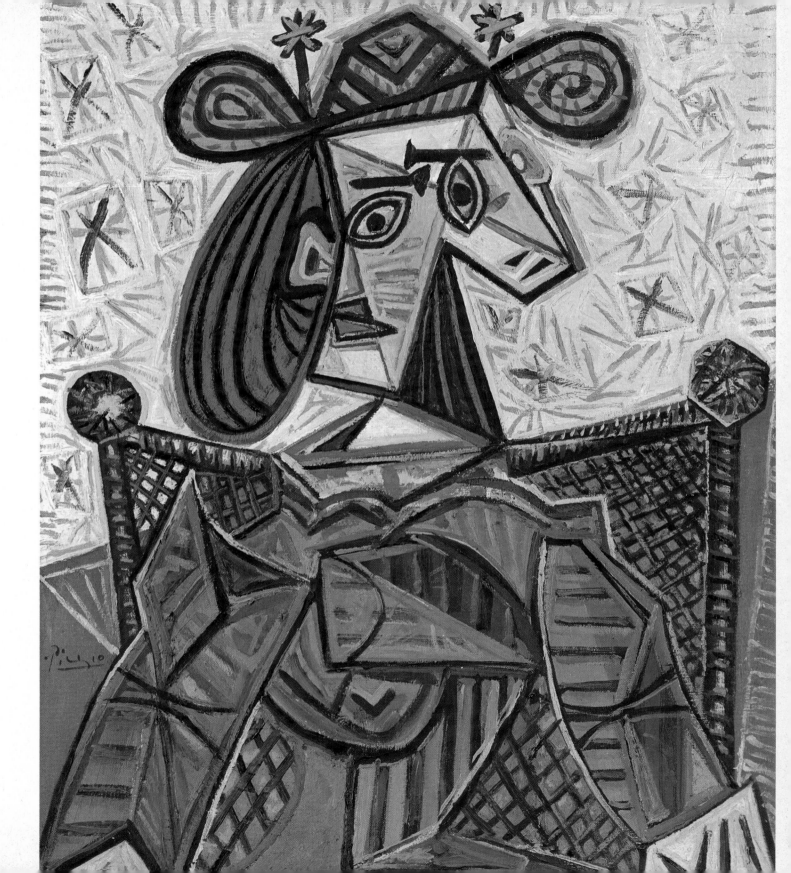

1968 Torres-Garcia, Masque Constructif

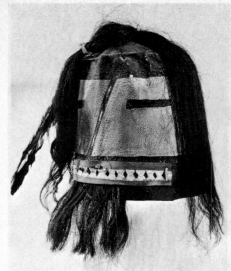

1969 Hopi, Katchina Mask

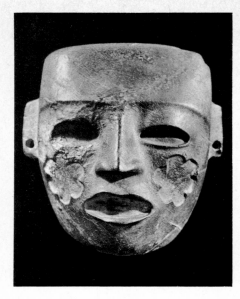

1930 Teotiuhacan, Stone Mask

Mexico); Mask; wood, with remnants of jade inlay, 17.8×20.3 cm; New York, American Mus. of Natural History; plate

1934 *Robert Jacobsen (Copenhagen 1912, lives in Denmark and Munich); Le Précolombien;* iron, 132×55 cm;

1960; Paris, Gal. de France; plate

1935 *Ica Region (Southern Coast of Peru); Face Mask;* gold sheet with remnants of red paint, 16×17.5 cm; 1200–1500 A. D.; Munich, Mus. für Völkerkunde

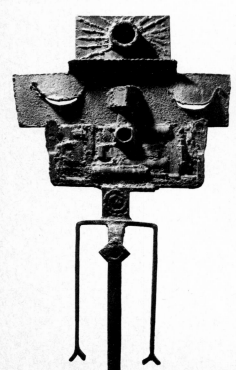

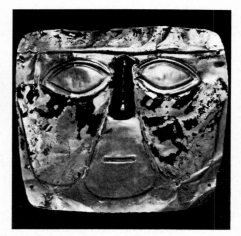

▲ 1935 Ica Region, Gold Mask

◄ 1934 Jacobsen, Le Précolumbien

The Masks of Julio Gonzalez

After 1910 impressionistic masks had already become the prelude for Gonzalez' autonomous metal sculpture. But it was not until 1940, when the horrors of the war were giving rise to a new formal language, that the expressive physiognomic vocabulary of the African masks became fully effective.

Indications of the encounter are the firmly mounted triangle or the thin bridge of the nose, slit eyes, the blocking-off of the features in squares or the reduction of the eyes, nose, and mouth to a thin axis, details of the hair style. Again and again the most essential feature is the drawing in of an internal face between the eyes and the mouth, which hardens the typical African heart shape into a triangle. Examples which inspired his masks can be found now among the Baule, Senufo and Dan, now the Basonge and Babindji. An exact determination is usually difficult: Gonzalez does not adopt types, but uses various elements. M. Sch.

1936 *Julio Gonzalez (Barcelona 1876– 1942 Paris); "Oncle Jean II";* iron, 37×16.4×8.7 cm; 1930; Paris, Hans Hartung Coll.; plate

1937 *Julio Gonzalez; Masque Ombre et Lumière;* bronze; 28×10 cm; 1930–1940; Paris, Gal. de France

1938 *Bambara (Mali); Elephant Mask;* wood, encrusted with millet gruel and blood; h - 98 cm; Stuttgart, Linden-Mus.

1967 Beaudin, Head of Paul Eluard ▶

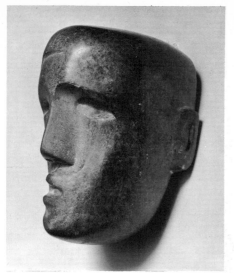

1929 Moore, Mask

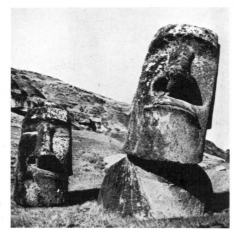

1965 Easter Islands, Heads

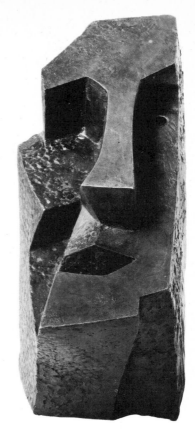

1932 Siqueiros, Ethnography (detail) ▼

1939 *Julio Gonzalez; Masque Couché Dit "Le Religieux"*; bronze, 18×11 cm; 1940–1942; Paris, Galerie de France; plate

1940 *Dan (Ivory Coast); Mother Mask*; wood, patinated in black; 28×18 cm; Stuttgart, priv. coll.; plate

1941 *Julio Gonzalez; Tête Couchée Petite*; bronze; l - 16 cm; 1935–1937; Paris, Gal. de France

1942 *Julio Gonzalez; Le Cagoulard*; bronze; h - 22 cm; Paris, Gal. de France

1943 *Baga (Sierra Leone); Double Mask*; wood, blackened; h - 52.8 cm; Vienna, Mus. für Völkerkunde

1944 *Julio Gonzalez; Masque Africain*; ink pen on paper; 31.7×24 cm; sig. bottom right: 28 4.40 J. G.; cf. the Babindji Mask, Cat. no. 1947; Argenteuil, Roberta Gonzalez; plate

1945 *Julio Gonzalez; Tête de Vierge*; ink pen and watercolours on paper; 20.2×17.4 cm; sig. right of centre: 15.4.41 J. G.; cf. the "Masque Africain", Cat. no. 1947; Argenteuil, Roberta Gonzalez; plate

1946 *Julio Gonzalez; Masque Sauvage*; ink pen on paper; 31.7×23.8 cm; sig. bottom left: 15.5.40 J. G.; Argenteuil, Roberta Gonzalez; plate

1947 *Mbagani (Congo)*; wood, painted black and white; 27 cm; cf. Cat. no. 1944;

Tervuren, Mus. Royal de l'Afrique Centrale; plate

1948 *Julio Gonzalez; Masque Sevère*; Indian ink on paper; 31.4×24.1 cm; sig. bottom right: 17.5.40 J. G.; Argenteuil, Roberta Gonzalez; plate

1949 *Basonge (Congo); Kifwebe Mask*; wood, with notched lines painted white, h - 38 cm; Herten, H. W. Socha Coll.

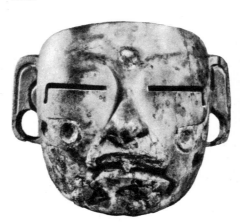

1933 Olmec (Mexico), Wooden Mask

1950 *Senufo (Ivory Coast); Kpelie Mask*; wood, coloured dark, mouth and teeth coloured slightly red; h - 36 cm; Vienna, Mus. für Völkerkunde

1951 *Kuba (Central Congo); Bombo Mask with Horns*; wood, painted black,

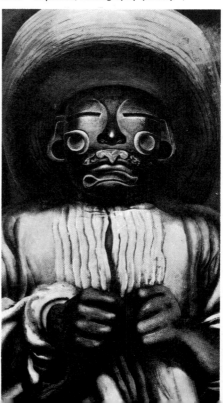

297

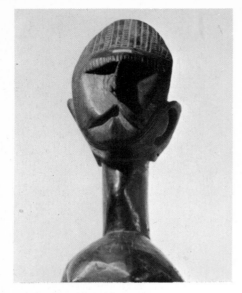

1913 Upper Niger, Figure

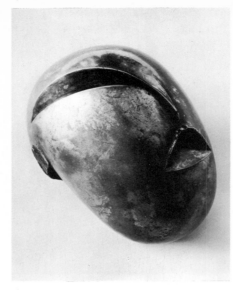

1912 Brancusi, The first cry

white and red, with sheet-copper fittings h - 48 cm; Paris, Monsieur Kerchache

1952 *Julio Gonzalez; Masque Sombre;* Indian ink on paper, 31.6 × 24 cm; sig. bottom right: 14.5.40 J. G.; Argenteuil, Roberta Gonzalez

1953 *Guere (Liberia); Face Mask;* wood, coloured black; h - 26 cm; Vienna, Mus. für Völkerkunde

1954 *Pende (Angola); Small Hand*

Mask; wood; h - 16.5 cm; Vienna, Mus. für Völkerkunde

1955 *Julio Gonzalez; Drawing;* charcoal on paper; 32.3 × 24.9 cm; sig. bottom left: 16.2.42 J. G.; cf. long face masks of the Fang; Paris, Hans Hartung Coll.; plate

1956 *Fang (Gabon); Dancing-Mask of the Ngil Society;* wood, painted white with fibre attached; h - 58 cm; cf. Cat. no. 1956; Geneva, priv. coll.; plate

1939 Gonzalez, Le Religieux

1940 Dan, Mother Mask

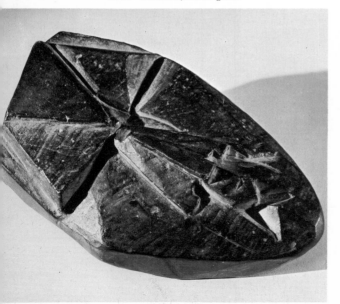

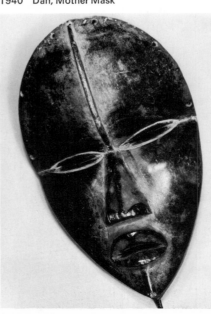

1957 *Pablo Picasso (Malaga 1881, lives in Mougins); Woman on a Sofa;* oil on canvas, 80.7 × 65 cm; sig. bottom left: Picasso; 12 October 1941; Düsseldorf, Kunstslg. Nordrhein-Westfalen; plate

1958 *Pablo Picasso; Le Chapeau aux Fleurs (The Flower Hat);* oil on canvas; 66 × 54 cm; sig. bottom right: Picasso 1940; see Cat. no. 1957; Paris, Daniel-Henry Kahnweiler

1959 *Basonge (Congo); Kifwebe Mask;* wood, painted red, blue and white, h - 57 cm; see Cat. no. 1957; Tervuren, Musée Royal de l'Afrique Centrale; plate

1960 *Bobo (Upper Volta); Buffalo Mask;* wood, painted blue, black and red, h - 62 cm; Stuttgart, Walter Kaiser Coll.

1961 *Henry Moore; Head of a Warrior;* bronze, 25 × 21 × 24 cm; 1953; Brussels, Musées Royaux des Beaux Arts de Belgique

1962 *Mumuye (Nigeria); Ancestral Figure;* wood; h - 96 cm; see Cat. no. 1863; Munich, priv. coll.

1963 *Henry Moore; Three Points;* bronze; l - 19.1 cm; 1939/40; cf. Cat. no. 1964; Much Hadham, Mrs. Irina Moore

1964 *Corewori (New Guinea); Hook Figure;* wood; h - 140 cm; Herten, W. Socha Coll.

1965 *Easter Islands; Heads* (photo); plate

1966 *Otto Freundlich (1878 Stolp, Pomerania – 1943 Lublin-Maidanek, Poland); Mask;* bronze; 32.7 × 22 cm; sig. under the chin: OF 1909; cf. Cat. no. 1965; Berlin, Dr. Detlev Wissinger

1967 *André Beaudin (Mennecy 1895, lives in Paris); Head of Paul Eluard;* bronze; 102 × 35.7 cm; 1947; Paris, Gal. Louise Leiris; plate

1968 *Joaquín Torres García (Montevideo 1874–1949); Masque Constructif;* oil on canvas; 59.4 × 59.4 cm; sig. bottom left: JTG, bottom right: 30; Garcia, Montevideo, Olimpia Torres Collection; plate

1969 *Hopi (Arizona, New Mexico); Katchina Mask;* leather, painted in bright colours, h - 44 cm; Antwerp, Ethnographical Mus. of the City of Antwerp; plate

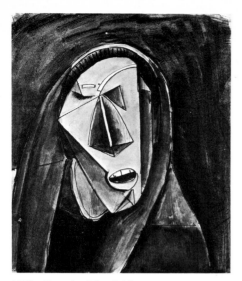

1945 Gonzalez, Tête de Vierge

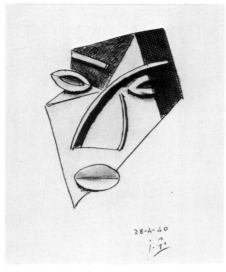

1944 Gonzalez, Masque Africain

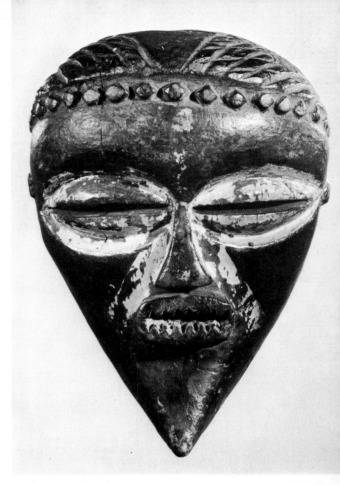

1947 Mbagani, Mask

1970 *Joaquín Torres García; Abstract Metaphysical Forms;* oil on canvas; 146×114.3 cm; sig. bottom left: J.Torres García, bottom right: 30; Montevideo, Torres García family

1971 *Zuni (New Mexico); Katchina Doll;* wood, with remnants of white, yellow, green, red and black paint; h - 17.7 cm; cf. Cat.-no. 1820; cf. Torres García, Cat.-no. 1968; Vienna, Mus. für Völkerkunde

1972 *Hopi (Arizona); Katchina Doll;*

wood; h - 22 cm; cf. Cat. no. 1820, 1968; Paris, Monsieur Kerchache

1973 *Hopi (Arizona); Katchina Doll (Snake Katchina);* wood, painted yellow, black, white, brown; h - 30.5 cm; cf. Cat. no. 1820; Vienna, Mus. für Völkerkunde

1974 *Hopi (New Mexico); Dance Board;* wood, painted; 46×6 cm; Paris, Musée de l'Homme

1975 *Jean Dubuffet (1901 Le Havre,*

lives in Paris); L'Albinos; oil on canvas; 92×73 cm; sig. top left: Dubuffet 58; cf. Quimbaya figures, Cat. no. 1976; Cologne, Wilhelm Hack Coll.

1976 *Quimbaya Culture (Columbia); Flat Clay Figure;* clay; 33×21.5 cm; 6th to 11th cent. (?); cf. Cat. no. 1975; Cologne, Rautenstrauch-Joest-Mus.

1977 *Quimbaya (Columbia); Flat Clay Figure;* clay; 19× 18.5 cm; 6th to 11th cent.; cf. Cat. no. 1975; Cologne, Rautenstrauch-Joest-Mus.

1978 *Saul Steinberg (Bucharest, 1914 lives in New York); Business Mask;* collage and drawing, 102×77 cm; sig. bottom left: Steinberg; 1964; cf. Cat. no. 1964; Paris, Gal. Maeght

1979 *Wabembe (Congo-Kinshasa); Mask;* wood; h - 57 cm; Thervuren, Mus. de l'Afrique Centrale

1956 Fang, Dancing Mask

1955 Gonzalez, Drawing

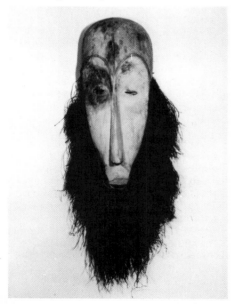

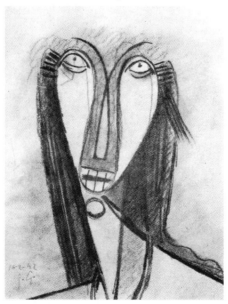

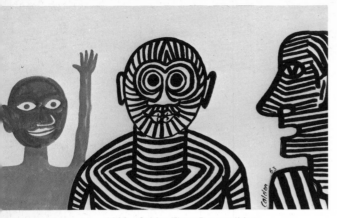

1983 Calder, Three Personalities

1980 *Saul Steinberg; Philanthropic Mask;* collage and coloured circles, 72×58.5 cm; 1964/65; cf. Cat. no. 1978; cf. Sepik, Cat. no. 1981; Paris, Gal. Maeght

1981 *Sepik (New Guinea); Gable Mask;* wood, painted red and white; h - 93 cm; Stuttgart, Linden-Mus.

1982 *Alexander Calder (Philadelphia, 1898 lives in New York); Moonlight in a Gust of Wind;* lithograph; 47.5×65 cm; 1966; Paris, Gal. Maeght

1983 *Alexander Calder; Three Personalities;* gouache, 40×62 cm; Paris, Musée National d'Art Moderne; plate

1984 *Luba; Kifwebe Mask;* wood, partly painted white, h - 34 cm; Paris, Monsieur Kerchache; plate

1984 Luba, Kifwebe Mask

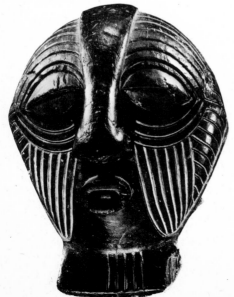

Pre-Columbian Stone Sculpture and Modern Art

Manfred Schneckenburger

Europeans early had their attention drawn to the works of art of pre-Columbian America: Dürer's enthusiastic comment in his diary is the first in a long series of admiring and appreciatory remarks. When Franz Kugler published his history of art in 1842, there was no reference whatsoever to the art of the "primitive" peoples; however, he did give a brief appreciation of ancient American art. In 1894 Julius Lange analysed the principle of frontality in art and parallels Greek archaic art and Aztec stone sculpture when providing examples to bolster his argument. These American civilizations uncovered by archaeology have thus long enjoyed acceptance, even if ignorance and rejection were still to be met with at times; pre-Columbian art was appreciated long before the art of the "primitive peoples" was even seriously considered.

For all that, pre-Columbian art served as a stimulus to modern artists only after African and Oceanian sculpture had begun to exercise a telling influence. There were some few exceptions: Gauguin takes over the forms of Mochica and Nasza ceramic ware; Dresser, the English designer, includes pottery forms of the Nasza and Tiahuanacán cultures in his historical repertoire as early as 1882. In his ceramic self-portraits Gauguin feels his way towards a formal principle which is a pre-Columbian motif with an effect reaching far into our times: the elemental form of the block.

Indeed, the principle of the block must be our point of departure. The block (does it form part of the heritage of the Olmec "mother culture"?) is the dominant form in pre-Columbian art from the squatting gods of the Aztecs to the differentiated block ornamentation of the Maya and the ashlars of Cuzco. What Moore admires about Aztec sculpture —its stone character, by which he means the complete conformity to the nature of the material and the colossal power without loss of sensitivity—coincides with modern tendencies towards material-conform treatment not only of the surface but affecting the form as well. Accordingly, the pre-Columbian block and the African pillar both exercise a decisive formal influence on the regenerative forces in modern art.

This regeneration of modern sculpture rooted in the prefigurative power of the material gets under way before Pre-Columbian plastic art exercises a direct influence. Derain's fundamental "covering form" is an incunabulum of the modern period and recalls the crouching figures of the Aztecs. In 1910, Brancusi draws very close to the ashlar work of Peru: his kissing sculptures seem to be anthropomorphic transformations of the masonry at Cuzco. We cannot exclude the possibility of a direct confrontation with ancient American stone sculpture: in 1935—38 his "Gate of the Kiss" finds its nearest analogy in the monolithic "Gateway of the Sun" at Tiahuanaco. Even if Brancusi did not have the ancient Peruvian model in mind, the affinity of the elemental forms and the approximation in formal principles could not be clearer. That modern art would come to fruitful terms with these ancient masterpieces was inevitable.

Mayan and Zapotecan architecture first exercise a demonstrable influence. From 1915 onwards, F. L. Wright rings the changes on the block in the large residential buildings he erected in California. Jacques Lipchitz seems to have been the first artist to have supplemented the impulses from African sculpture with the stimulating influence of pre-Columbian art. Such a synthesis can be seen in "Man with Guitar" (1920), a composition of wide, predominantly horizontal ashlars (horizontal dominants are characteristic of the Valley of Mexico from Teotihuacán to the Aztecs). The graphic flat relief of the goddess Chalchiutlicue is here transformed into the Cubist forward leap of the rectilinear form, without the strict awareness of the basic block being in any way impaired.

One sculptor of note has found a lasting source of inspiration in pre-Columbian stone sculpture since the twenties of this century: Henry Moore. His development towards utter conformity to the nature of his material and towards the elemental form has led him to pre-Columbian (and later to Egyptian and Mesopotamian) sculpture in stone—the process of learning is so deliberate and conscious that his work at times borders on imitation. A number of squatting figures consciously recall Aztec models; one snake of his is practically a literal translation of the basalt snakes of the Aztecs into marble, the classical medium; and their are masks in soft stone which vary the themes of the stone masks of the Teotihuacán culture.

However, it is especially Moore's basic theme of the "reclining figure" which assumes definite shape around the year

300

1929 under the influence of the Mayan-Toltec reclining Chac-Mool figures. Moore's experience of Mexico, mediated by his studies at the British Museum, finds its most successful expression here. The reclining figure executed in 1929, now at Leeds, and that of 1930, today in Ottawa, reflect the pre-Columbian prototype most closely. The figures are block-oriented both in the overall conception and in the square head, the closed fists. The raised arm which curves towards the head unifies the whole with almost geometric precision. The material character and material form of the block is never lost sight of. No matter how far Moore's later work has progressed from the primeval reclining figure of the year 1929, the tense equilibrium between the raised summit of the knee and the massif formed by the leg and the looming trunk of the body is always maintained, always too the arms mediate between these two masses. In the Chac-Mool Moore was presented with more than a postural motif; it is also gave him that elemental feeling for the polarization of the reclining body into two masses. Seen from this viewpoint, then even the division of the two volumes into two parts—as in later reclining figures—is but the logical outcome of the original Chac-Mool experience.

In a similar way, the work of Laurens and Wotruba also revolves around the theme of the figure in recline—the body reposing, the knees held high, the head turned aside (originally inclined in the direction of the sun).

According to Derain, the anthropomorphic ideal type of the block, the crouching figure, is also developed in the direction of confrontation with Aztec art. Max Ernst adopted this principle and used it for his own ends in his sculpture "Musée de l'homme"—the derivation of this work from the Aztec prototypes is beyond dispute. We can go even further: the abstract treatment of the block, this sculpting of a form into a cube while completely preserving the stereometric volume, has overshot the prototype and presents the principle of the block as the crowning formal element.

However, the block is not the whole of the story. Around 1940, Moore sculpts a number of heads and "square forms" which link up with Totonacan "hachas," the stone accompaniments of the cultic ball game from the Tajin culture.

The Mexican experience encouraged Moore to give "negative space" an equal place in his work. Exterior and interior, plastic volume and negative space appear as coequal complementary forms. One thinks of Picasso here: like the guitar reliefs of 1922, these heads also break one of the basic tenets of western sculpture since the Greeks—the intact skin— and thus impart a new three-dimensional freedom to a piece of sculpture. It is no mere coincidence that both corrections in the occidental tradition link up with extra-European forms.

The ancient American contribution to modern art is thus concentrated on the realm of sculpture: the awareness of the inherent power of the material, an aware-

*Africa
Oceania
Amerindia*

*Pre-
Columbian
Art*

1985–2022

◄ 1987 Aztec, Squatting God

▼ 1989 Wotruba, Sitting Figure

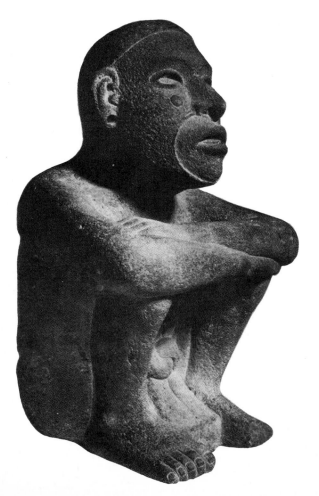

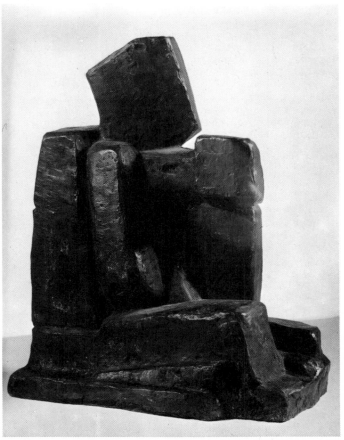

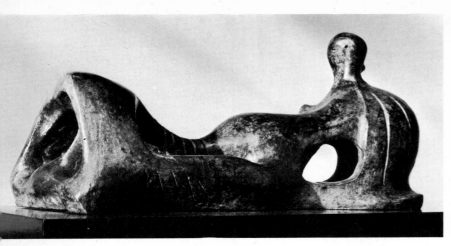

1993 Moore, Reclining Figure

Chichen Itza, Chac-Mool

ness which is alive not just in the primeval and archaic. This consciousness of the nature of the material is in fact a definite quality of pre-Columbian style which is always evident, even in differentiated compositions or where the surface is given a peerless polish. The markedly abstracted art of pre-Columbian times has had a major part to play in helping the Latin-American artist to find his place in the world of modern plastic art. In the countries of Latin America, the middle generation of sculptors—Cardenas, Narvarez, Negret, Marina Ninez del Prado, to mention but some—have been able to adopt the "hacha" (and other impulses) and combine them with their experience of European (largely Parisian) modern art. This has evolved from an echo of the past into a credo in the autochthonic heritage. The way is thus signposted for breaking the "monopoly" of the European models: a return to the traditions of the ancient Mesoamerican cultures which have raised Latin-American stone sculpture during the last decades to its present position and have made possible a synthesis in which the pre-Columbian forms are completely and validly integrated.
A second main area of pre-Columbian reception was in Surrealism. The universal mythical phantasy and artistic power of the early American cultures was necessarily conceived here as part of the heritage from a world dominated by magic in which the conceptual reglementation of western rationality did not have a place. Victor Brauner has most intensively combined the hieroglyphs of Aztec manuscripts, of Teotihuacán frescoes and of Pracas fabrics with the evocations of his own personal mythology. But also Klee's later pictures in which he "took a line for a walk" can be

included here. The manifold pictorial expressions of myths must also be numbered among the archetypal sources of modern art; they are the counterpart to the sculptural reduction to the monumental block in modern plastic art in stone.

Summary and Translation J. P. D.

1985 *Aztec (Mexico); Figure of a Squatting God;* stone; h - 39 cm; c. 1500; Berlin, Mus. für Völkerkunde

1986 *Aztec (Mexico); Figure of the Macuilxochitl;* sandstone; 53×24× 23 cm; 1324–1521 A. D.; Vienna, Mus. für Völkerkunde

1987 *Aztec (Mountain Valley of Mexico); Squatting God* (photo); stone;

Moore, Square Form

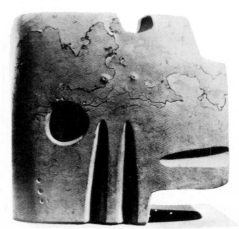

h - 45 cm; c. 1370–1521; Basle, Mus. für Völkerkunde; plate

1988 *André Derain (Chatou 1880– 1954 Garches); Squatting Figure;* stone; 33×28 cm; 1907; Vienna, Mus. des 20. Jahrhunderts

1989 *Fritz Wotruba (Vienna 1907, lives in Vienna); Seated Figure;* bronze; 52×43 cm; sig.: WOTRUBA 1951 FW 2 3/3; Mannheim, Kunsthalle; plate

1990 *Max Ernst (Brühl near Cologne 1891, lives in the south of France); Musée de l'Homme* (photo); plaster of Paris; h - 60 cm; 1968; Turin, priv. coll.

1991 *Maya – Toltec; Chac-Mool;* stone; l - 157 cm; 12th/13th cent. A. D.; Mexico City, Mus. Nacional de Anthropologia

2009 Xochicalco, Head of an Ara Parrot

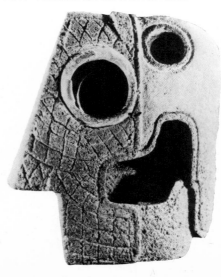

1992 *Henry Moore; Reclining Woman* (photo); stone; l - 94 cm; 1929; Leeds, City Art Gallery

1993 *Henry Moore; Reclining Figure;* bronze; l - 43 cm; 1946, cast 1968; Much Hadham, Henry Moore; plate

1994 *Henry Moore; Reclining Figure;* bronze; l - 29.9 cm; 1939; Much Hadham, Mrs. Irina Moore

1995 *Maya-Toltec; Chac-Mool;* stone, 148 cm; 12th/13th cent. p. Chr.; Mexico City, Mus. Nacional de Anthropologia

1996 *Fritz Wotruba; Reclining Figure;* bronze; l - approx. 150 cm

1997 *Henry Moore; Seated Figure;* stone, h - 25.5 cm; 1924; Much Hadham, owned by the artist

1998 *Henry Moore; Dog;* marble, 18 cm; 1923, Much Hadham, owned by the artist

1999 *Henry Moore; Two Heads;* Mother and Child; stone, h - 19 cm; 1923; Much Hadham, owned by the artist

2000 *Constantin Brancusi; Gateway of the Kiss in Targuiju* (photo); stone; 1935–1938

2001 *Tiahuanaco (Bolivia); Sun Gateway* (photo); stone; h - c. 300 cm; c. 300–600 A. D.

2002 *Aztec (Mexico); Rattlesnake;* stone; 35×28×34 cm; c. 1500 B. C.; Hamburg, Mus. für Völkerkunde und Vorgeschichte

2003 *Aztec (Mexico); Snake;* stone; h - 84 cm; c. 1500; Berlin, Mus. für Völkerkunde; plate

2004 *Henry Moore; Snake;* marble; 15.3 cm; 1924; cf. the Aztec snakes, Cat. no. 2002, 2003; Much Hadham, Henry Moore; plate

"Hachas"

"Hachas" are so called from the Spanish word for axe. But these hatchet-shaped, flat heads, which close together on the profile side like the blade of an axe, are not ceremonial axes. "Hachas" or "flat heads" (as it was suggested they might be more precisely called) are thought to have been used as part of the scenery for ritual ball games on the Gulf coast of Mexico and in Guatemala.

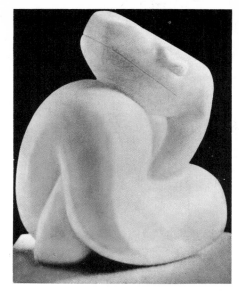

2004 Moore, Snake

Their aesthetic value lies not only in their high degree of abstraction, but even more in the perfect combination of natural form and abstract art form. In the Tajin culture in particular, the accompaniments of the ball game have developed into an independent, wide-ranging art branch. Their abstract charm soon attracted the attention of modern sculptors to the "hachas." Giacometti was approaching the type with his abstract "heads" around 1930. At the end of the thirties Henry Moore with his "heads" or "square forms" consciously adopts the hacha type: in the outline shape, the implication

2005 Antigua, "Hacha"

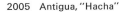

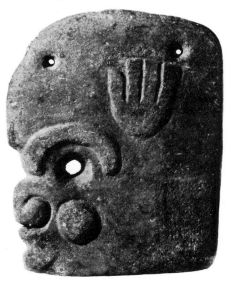

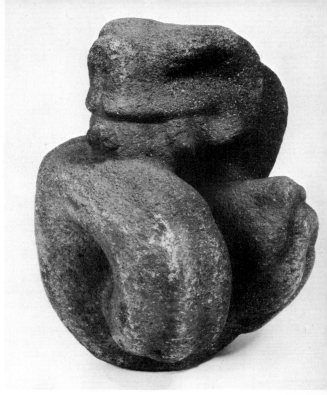

2003 Aztec, Rattlesnake

2010 Moore, Head

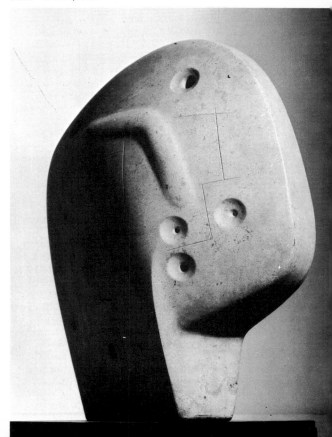

*Africa
Oceania
Amerindia*

*Pre-
Columbian
Art*

1985–2022

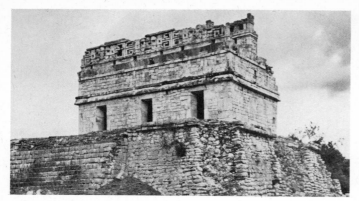

2015 Chichen Itza, Red House

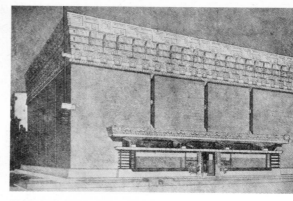

2014 Wright, German Warehouse

of a head with strong curved lines, the sparsely imposed low relief, the graphic sensitisation of the surface by etching. The "hachas" are undergoing a veritable resurrection from the grave with the Latin American sculptors of the middle or younger generation as an abstract form which after all joins up with a Latin American tradition. See Cardenas, Cat.-no. 2013. M. Sch.

2005 *Antigua (Guatemala); Hacha;* stone, 27×20 cm; 5th–8th cent. A. D.; cf. Moore, Cat. no. 2010; Berlin, Mus. für Völkerkunde; plate

2006 *Tajin Culture (Mexico); Hacha in the Form of a Monkey's Head;* bright green onyx, 17.5×13.5×19.5 cm; 100–500 A. D.; cf. Moore, Cat. no. 2010; Vienna, Mus. für Völkerkunde

2007 *Gulf Coast (Mexico); Head;* stone; h - 27 cm; Bremen, Übersee-Mus.

2008 *Veracruz (Mexico); Hacha;* stone; h - 28 cm; 400/800 A. D.; Mexico City, Mus. Nacional de Anthropologia

2009 *Xochicalco (Morelos); Head of an Ara Parrot;* stone; h - 55 cm; 6th–9th cent. A. D.; Mexico City, Mus. Nacional de Anthropologia; plate

2010 *Henry Moore (Castleford, 1898 Yorkshire, lives in Much Hadham); Head;* stone; h - 53.8 cm; 1937; New York, Martha Jackson Gallery; plate

2011 *Morice Lipsi (Lodz, Poland, 1898 lives in the shouth of France); L'Océanique* (photo); stone

2012 *Augustin Cardenas (Mantanzas, Cuba 1927, lives in Paris); Sculpture;* marble; h - 52×37 cm; cf. Cat. no. 2006; Paris, Gal. du Dragon

2013 *Augustin Cardenas; "Hacha"*

(Axe); gold bronze, 37×20 cm; sig. on the base: Cardenas 1961; Brussels, Collection of Madame Jean Krebs

Frank Lloyd Wright and Pre-Columbian Architecture

Around 1915, the American architect Frank Lloyd Wright adopts motifs from Mayan and Zapotecan architecture: a return to an autochthonous American tradition which, though contrasting with the functionalism of the European avant-garde, is still completely in accord with modern architecture. Characteristics are: the fusion of the compactly situated edifices with the landscape, "sedentary" architecture which translates the landscape into the language of geometry; the summation of components into a monumental block, a principle of ancient American art; the use of rich decoration, the sum total of small block elements

2017 Palenque, Sun Temple

2016 Wright, Barnsdall House

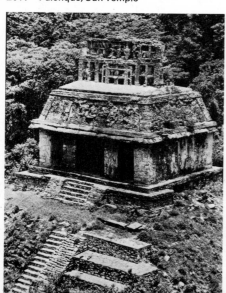

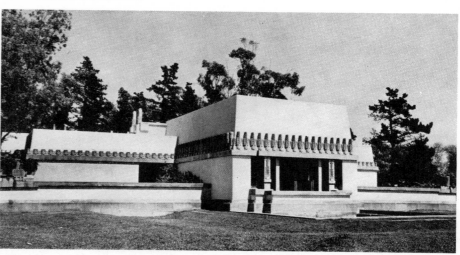

with impressed ornamentation. The decoration becomes an integral part of the construction. On the analogy of the brick friezes or ornamental walls of northern Yucatan, the necessary prerequisite here was the invention of prefabricated concrete blocks in different sizes. Thus, the smallest decorative element used to resolve the block-oriented mass is itself a block.

Individual examples demonstrate the debt, too. Like the edifices of Chichen-Itzá, the German Warehouse (Wisconsin) is a cubic structure pierced by narrow vertical openings and crowned by a high frieze of prefabricated concrete elements: a variant on the ancient American steeped meander of squares within squares. Hollyhock House (Los Angeles) with its asymmetrical pillars and truncated pyramid recalls temples at Chichen-Itzá or the Sun Temple at Palenque. From 1924 onwards, Wright's views on monumentality and rich decoration are expressed in a constructive system of reinforced concrete which smacks less and less of imitation. M. Sch. Transl. P. J. D.

2014 *Frank Lloyd Wright; German Warehouse, Wisconsin* (photo); pencil, crayon and water-colour on paper; about 72 × 84 cm; 1915; cf. Cat. no. 2015; Talesien, Wright legacy; plate

2015 *Chichen Itza; Chichan Chob (Red House)* (photo); 10th/11th cent.; cf. Cat. no. 2014; plate

2016 *Frank Lloyd Wright; Alice Barnsdall "Hollyhock House" (Los Angeles)* (photo); plate

2017 *Palenque (Guatemala); Sun Temple* (photo); 642 A. D.; cf. Cat. no. 2016; plate

2018 *Frank Lloyd Wright; Charles Ennis House* (photo); pencil and crayon on paper; about 60 × 100 cm; 1924

2019 *Frank Lloyd Wright; Charles Ennis House* (photo); 1924; cf. Cat. no. 2020

2020 *Uxmal (Yukatan); Governor's Palace* (photo); l - c. 98 m, b - 12 m, h - 8.60 m; 8th/9th cent. A. D.

2021 *Frank Lloyd Wright; Project for the Summer Colony on Lake Tahoe* (photo); pencil and crayon on paper; about 60 × 52 cm; 1923

2022 *Chichen Itza (Yukatan); Castillo* (photo); l - c. 55 m, h - 30 m; 10th/11th cent.; cf. Cat. no. 2021

Elementar Form "Pillar"

If pre-Columbian sculpture in stone inspired the elemental form of the "Block", African or Oceanian woodcarving did that of the "Pillar". The form determines the aesthetic and the material-conform treatment. Not just "primitive" but even Gothic art is at work here. However, Zadkine's "Prophet" recalls Sudanese carved pillars and Koblasa's figures evoke Oceanian associations.

2023 *Konso (Ethiopia); Funeral Pole;* wood; h - 213 cm; Paris, Monsieur Kerchache; plate

2024 *Ossip Zadkine (Smolensk 1890–1967 Paris); The Prophet;* oak wood; h - 219 cm; 1915; Grenoble, Musée des Beaux Arts; plate

2025 *Dogon (Mali); Ancestral Figure;* wood, h - 101 cm; Antwerp, Ethnographical Mus. of the City of Antwerp; plate

2026 *Gustave Miklos (Budapest 1898–1967 Oyonnax); Tour Architectural;* bronze, patinated in black, 125 × 25 × 18 cm; sig. on the base: G. Miklos, fonte cire perdu Valsuani No. 4/4; c. 1924; Paris, Gal. l'Enseigne de Cerceau; plate

2027 *Fritz Wotruba (Vienna 1907, lives in Vienna); Standing Figure;* bronze, h - 80 cm; sig. on the base: FW; 1958; Düsseldorf, Gal. Grosshennig

2028 *Jan Koblasa (Tabor 1932, lives in Kiel); The Gradual Total Decay;* elm wood, 104 × 21 cm; 1964; Munich, Gal. Christoph Dürr; plate

2029 *Jan Koblasa; King XV – Death;* elm wood, 95 × 20 cm; 1962; Munich, Gal. Wolfgang Ketterer

2030 *Kerewo Region of the Papua Gulf (New Guinea); Male Figure (nua goho);* wood, painted red, white and black, arm bands made of knous snails, modesty cloth of shells, h - 150 cm; Otoia Coll.; plate

2031 *Turama River, Papua Gulf (New Guinea); Male Figure (daimo nania);* wood, traces of red, white and black painting, h - 64 cm; Otoia Collection

2023 Konso, Funeral Pole

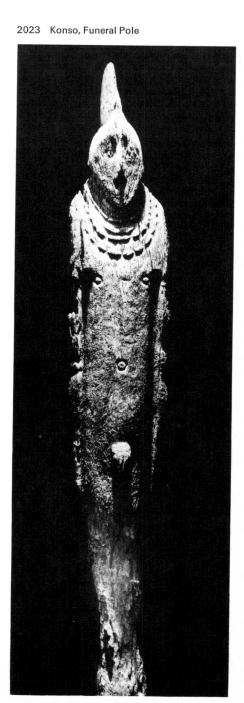

Africa
Oceania
Amerindia

Pillar

2023–2031

Left to right:

2028 Koblasa, The Gradual Total Decay
2030 Papua Gulf, Male Figure
2025 Dogon, Ancestor
2026 Miklos, Tour Architectural
2024 Zadkine, Prophet

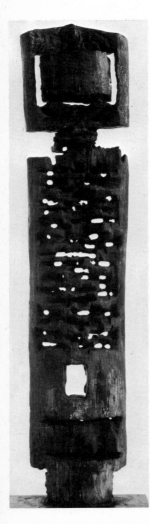

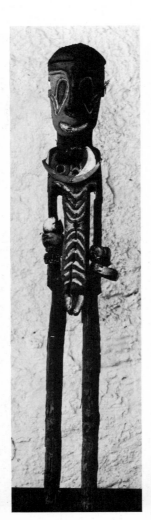

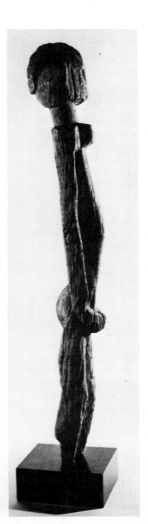

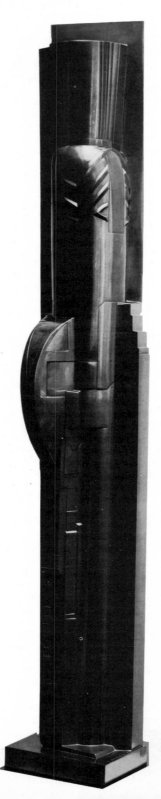

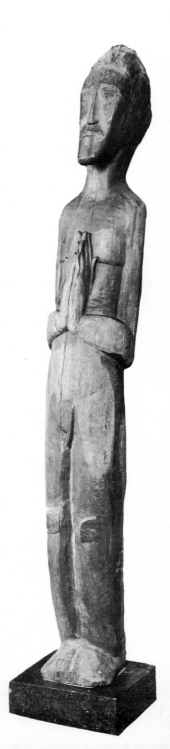

Magic Signs

Manfred Schneckenburger

With the aid of complicated techniques —automatism, frottage—the Surrealists had conjured up pictures from the individual subconscious. Oceanian and Amerindian medicine men and artists had drawn their signs from the collective subconscious, access to which was still possible at the prescientific level of magic. Surrealism's new relationship to "primitive art" springs from this (theoretical) affinity: first there had come the formal analysis of the Cubists and the emotional commitment of the Expressionists; now the magical aspects, the participation in primordial levels of the psyche and their archetypes, was the centre of artistic interest. In the myths and signs of the primitives, an iconography of archetypal symbols is laid bare layer by layer—this is one of the main reasons accounting for the value of "primitive art" as a source for streams of artistic thought lying outside Surrealism. And yet, for all that, the Surrealist viewpoint is one of the roots of the reception of extra-European art during the forties.

The magic sign, graphic symbol of the world, comes to the fore shortly before 1940. The post-1918 Constructivist tendencies formulate an ideal world of technological rationality, presented in its most rigorous form in the Neo-Plasticism of Mondrian. In contrast, the first world war had rudely awakened a whole series of political and social subjects. The magic appeal is thus presented with the naturalistic precision of the *Neue Sachlichkeit*. Around the year 1940 the situation is different: a world which was almost destroying itself in war hardly attracted either to a harmonious view of the world nor to satisfaction with the external appearance of things. As opposed to the way their confreres had reacted after the first world war, artists now turned from civilization and society to the mythical explanation of the world offered by the "primitive" peoples. Painting still wants to remain in and of this world, but at a different level which acknowledges only the mythical bonds (or lack of bonds). This excludes both descriptive definition and the confinement to pure abstraction, and leads to the evocative sign. Ideograms form the decisive element in the art of the decade after 1940.

The Surrealists had not only resorted to the individual subconscious (following Freud) but had also had recourse to the signs and myths of the "primitive" peoples in which the collective consciousness is manifested (as advocated by Jung). They enthroned the bizarre, phantastic art of Oceania (as opposed to the tectonic formal perfection of "Cubist" Africa). Around 1940, the influence of Indian art is added in the work of the outstanding American artists, with a decidedly anti-European stress on the autochthonic aspects: Amerindian art is an art of the sign and the symbol to a much greater extent than African sculpture and even than the extremely signal-laden art of Oceania. The tendency towards ideographic artistic expression is nowhere so highly developed as in the analytic abstraction of the north-west coast and in the symbols of south-west America.

Pollock had discovered this source of inspiration as early as 1938 and objectivized his eruptions of the ego in archetypal, totemistic material, eyes, pillars and spirals. Rothko, Newman and Gottlieb turn to "primitive art" after 1940. "We favour the simple expression of the complex thought" they wrote in a letter which they addressed to the New York Times in 1940: a programmatic formulation which emphasizes the sign as the simplest expression of philosophical, mythical and metaphysical interrelations. This forms the bridge to the (thus subjectively interpreted) sign of the primitives: Newman expressly links the painting of the New York School with the still effective art of the Kwakiutl Indians, in the catalogue for the exhibition "Ideographic Pictures" (1947). The Indian and Oceanian elements are most completely incorporated into the "Pictographs" of Gottlieb. Head, eyes and hands—signs of the entire body as in the abstractions of the north-west coast—and circles, spirals, triangles—like the cosmographic symbols of the south west—are arranged for reading in fields and bands. Perhaps Gottlieb's division into fields forms a link with the work of Torres-García, who had started fusing Mondrian's Neo-Plastic heritage with elements reminiscent of the pre-Columbian and the folkloristic, Indian contribution as early as 1932. Even Tobey sought a more profound view of the world during the forties not just in Zen-Buddhist self-forgetfulness but in a reversion to shaman masks and totemic affiliations.

Newman may contrast the American development progammatically with that of Europe, and yet it still remains true that the first steps towards magically suggestive ideographs were taken in the art of Europe. As early as 1930, Kandinsky had already been including in his pictures lines of hieroglyphic script clearly redo-

2036 Sudan, Painting on fabric

2035 Klee, Forest Witches

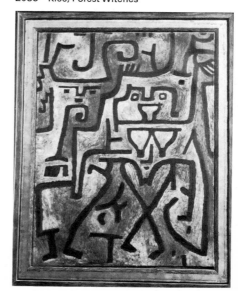

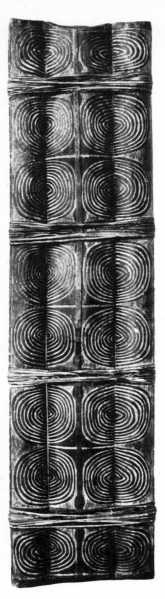

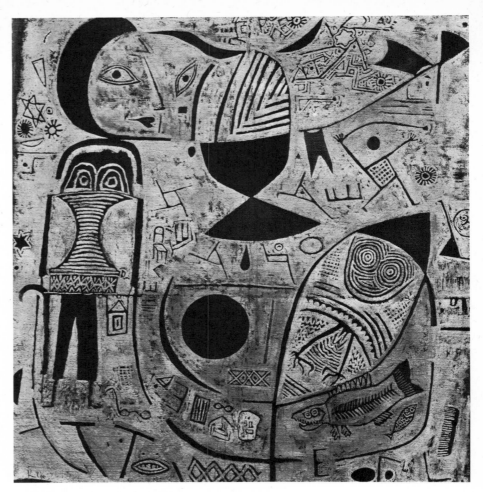

◀ 2033 Western New Britain, Shield

2032 Klee, Picture Album

lent of Egypt. Circles, triangles, squares are not just the poles of the dynamic activation of the picture surface but formal archetypes with philosophic content, like the Buddhist mandalas. Undoubtedly the connection with primitive art is absent here, but the pictures are the fruit of a related conception of the sign. In 1937, the connection takes more concrete form in the work of Paul Klee: his "Bilderbogen" (picture sheet) plays with spirals and eyes, strews them over the sheet like an Australian magician over the rock face. The evocative lines of Klee's late style conjures up pre-Columbian and African associations. In Masson, who emigrated to the USA in 1942, the free-flowing gesture assumes the more fixed form of

the sign with occasional Amerindian reminiscences. After his ideograms, Baumeister paints around the year 1940 "African" tales, dances, the Epic of Gilgamesh: disapproved by the Third Reich, the painter has recourse to the internal emigration to the realm of the myth. Here, too, the signs summarize the world, with all its antitheses, in self-contained figures and thus recall its essential unity. It is this unifying power which accounts for the spread of ideographic art during the forties.

Since 1950, the sign, the definitive symbolic form, has fused with the gesture of painting; the picture writing becomes part of the flow of writing and heralds a new period of calligraphic reception. Among the Americans, colour is spread over large monochrome pictures which see the myth no longer in the restrictive sign. The link with "primitive art" is no longer present.
Translation P. J. D.

2032 *Paul Klee (Münchenbuchsee 1881–1941 Berne); Picture Album;* oil on canvas, 59 × 56 cm; sig. bottom left: Klee; 1937; Washington, Phillips Collection; plate

2033 *Western New Britain (Melanesia); Shield;* wood, painted red, white and black, h - 139 cm; Otoia Coll.; plate

2034 *Liverpool River (Australia); Fish;* violet-red natural paints on tapa, redrawn by K. Lommer, 45 × 39 cm; Munich, Staatliches Mus. für Völkerkunde

2035 *Paul Klee; Forest Witches;* oil on jute, stuck over with paper, 58 × 42 cm; 1938; Berne, Fritz Gygi; plate

2036 *Africa; Painting on cotton;* c. 180 × 90 cm; Paris, Mus. d'Arts Africains et Océaniens; plate

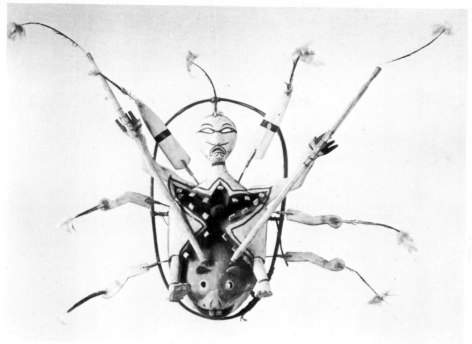

▲ 2043 Eskimo, Shaman Mask

2042 Tobey, Eskimo Idiom ▶

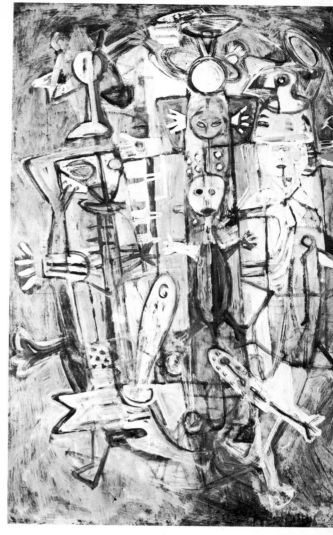

2037 *Willi Baumeister; Africa I;* oil on canvas and primer on cardboard, 36 × 46 cm; sig. bottom right: Baumeister 1942; Stuttgart, priv. coll.

2038 *Corewoi Region (New Guinea); Hook figure;* wood, h - 98 cm; Herten, Socha Coll.

2039 *Haida (British Columbia); Wooden Box;* wood, painted black, blue and red; c. 140×90×80 cm; Bremen, Übersee-Mus.

2040 *Jackson Pollock (Cody, Wyoming 1912–1956 New York); Totem Lesson II;* oil on canvas, 1945; Marlborough-Gerson Gallery, Pollock Estate; coloured plate

2041 *Mark Rothko (Dvinsk, Russia 1903–1969 New York); Phalanx of the Spirit;* oil on canvas, 189×123 cm; sig. bottom right: Mark Rothko; 1945; New York, Marlborough Gal.

2042 *Mark Tobey (Centerville, Wisconsin 1890, lives in Basle); Eskimo Idiom;* tempera on wood, 109×69 cm; 1946; Seattle, Art Mus.; plate

2043 *Kuskowkim River (Alaska); Shaman Mask "Tunghat";* walrus tooth wood, etc., h - 61 cm; Hamburg, Mus.

für Völkerkunde und Vorgeschichte; plate

2044 *Gope Region of the Papuan Gulf (New Guinea); Ceremonial board (kope);* wood, painted white, red and black, h - 111 cm; Otoia Coll.

2045 *Adolph Gottlieb; (New York 1903, living in New York); The Alkahest of Paracelsus;* oil on canvas; 210×146 cm; sig. right of centre: Adolph Gottlieb; 1945; New York, owned by the artist

2046 *Adolph Gottlieb; Vigil;* oil on canvas; 91.5×122 cm; 1948; New York, Whitney Mus. of Art; plate

2047 *Kerewo Region of the Papuan Gulf (New Guinea); Ceremonial Board (titi ebihai);* wood, painted red, white and black, h - 253 cm; Otoia Coll.; plate

2048 *Gope Region of the Papuan Gulf (New Guinea); Ceremonial Board (kope);* wood, painted red, white and black, h - 126 cm; Otoia Coll.; col. plate

2049 *Baining (New Britian); Fragment of a Mask (nepgig);* tapa material, painted black and red, h - 43 cm; Otoia Coll.

2050 *Central Sepik (New Guinea); Dance Spear with Mask;* wood, painted

red, black and white, cassowary feathers, mother-of-pearl (eyes), total l - 242 cm; mask 40 ×16.5×5.5 cm; Berlin, Mus. für Völkerkunde

2051 *Roger Bissière (Villéreal 1880, lives in Paris); Composition;* oil on canvas; 38×46 cm, sig. bottom right: Bissière; 1950; Paris, Gal. Jeanne Bucher

2052 *Alan Davie (Grangemouth, Scotland 1920, lives near Herford); Lush Life 2;* oil on canvas; 152×122 cm, sig. on the back: Davie 1961; Vienna, Mus. des 20. Jahrhunderts

2053 *Sepik (New Guinea); Shield;* wood, painted white, red, yellow and black, 157×34 cm; Berlin, Mus. für Völkerkunde; plate

309

2054 *Sepik (New Guinea); Shield;* wood, painted yellow, red and white, l - 131 cm, w - 61 cm; Berlin, Mus. für Völkerkunde

Idol, Totem and Fetish in Modern Art

Manfred Schneckenburger

◄ 2047 Papuan Gulf Ceremonial Board (detail)

The representation of superhuman beings is confined to two complexes in the history of European art: Christian iconography and Classical tradition. Menacing figments of the imagination demanding subjection and submission, the summations of our fears, were tamed and vanquished in the Christian view of the world or in the mythology of Classical literature: demons and idols as part of a diabolic underworld or the negative heroes of Antiquity. Painting also has a role for them as exponents of plot and counterplot, although it does not assign them a place in the pantheon of autonomous statues which would mean conceding them respect and dignity. Idols fall under the ban.

A decisive turning-point is thus reached when the twentieth century grants a multiplicity of superhuman beings—demons, idols, totems, fetishes, according to the designation the artist chooses— pictorial or plastic form. Goya and Fuseli had initiated this development around 1800 and the late 19th century made a fashion of bejewelled idols, the femme fatale depicted in sheer verticality. However, the breakthrough did not come until the twentieth century under the influence of new impulses from the realm of prehistory and ethnography: idols, totems, fetishes become the subjects of modern art, at the latest from the time of the Surrealist manifesto. Psycho-analysis provided a scientific explanation of the horrific creations of the subconscious without diminishing their menace. It assured them complete psychic reality. The broadening of the aesthetic horizon, the abandonment of naturalistic and idealistic norms, revealed the expressive beauty of the world of magic and of hieratic mystery but also of the grotesque and ugly.

In a Viennese Exhibition "Idols and Demons" (1963), Werner Hofmann staked out the limits of the superhuman. On the one hand, we have the idol in the old hieratic context: frontality, axial symmetry, statical stability, hermetic and encoded form, the magic of submission. As one of the primeval themes of plastic art, the idol is also given statuesque expression in modern sculpture. On the other hand, we are faced with the demons: bursting the formal bounds, convulsive, aggressive, threatening and destructive. This is a theme for disturbing

2046 Gottlieb, Vigil ▼

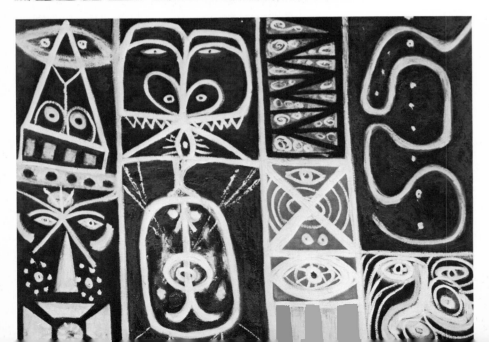

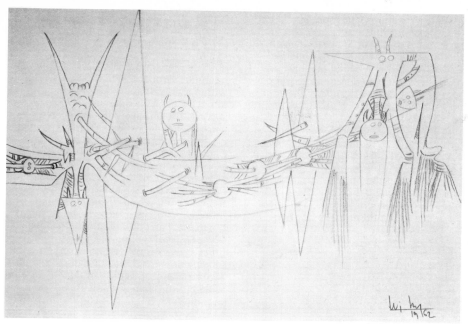

2065 Lam, Drawing

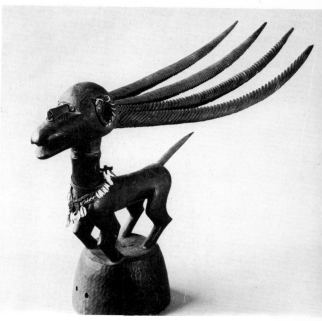

2067 Bambara, Tjiwara

painting and drawing. The boundaries are shifting; both types can lead to the early totemic and vital world of animals and plants as also to the technological Utopia of robots and automata. Nevertheless, it would be wrong to see these polymorphic higher powers only in the destructive, overwhelming dimension of idol, totem and fetish. A parallel development produces more genial, indeed ingenious, relatives, creatures of a "lower mythology" of the moderns, practically Surrealist descendants of dwarfs and elves. Max Ernst's "Habakuk", one of the disquieting bird-beings at the centre of his mythology, is most closely related to the idols but is also intimately united with the grotesque dignity of the marabou. The exuberant growth of "Soul Sisters" or "Moon Asparagus" is an ironical comment on the favourite idea of flower children among the German Romantics. Lam's involved and horned spirits are often on a level below the demonic sphere, very close to Picasso's playful fauns. This aspect, too, is part of the superhuman repertoire of modern art. The interconnections and sources of inspiration do not just lie within the realm of "primitive art" here. A newly understood Antiquity also provides motifs (Picasso's Minotaur!), as does a natural demonology, the fruit of the artist's personal experience, too (Ernst's tropical forests). However, we must still point out that the most numerous and compelling prototypes are drawn from the sculptural production of the "primitive" races: not merely details and formal suggestions, but a plastic type which transcends the purely aesthetic and is not just the depiction but the embodiment of magic powers. Inevitably, in so far as the modern artist was not just satisfied with the formal experience, he would regard this as solving one of his fundamental dilemmas in advance.

Gauguin marks the beginning of the reception here. In his "Idole à la Coquille", the glorified posture of Buddha takes on threatening significance and is fused with the barbarous savagery of filed-down cannibal teeth and tatoos. Even if Gauguin found no direct imitators here, he is nevertheless the founder of the attempt to charge plastic art with the suggestive power of magic. Modigliani's and Schmidt-Rottluff's "Heads" border on the African source of the idol realm without, however, entirely relinquishing their own character. Among the Surrealists, it is Giacometti in his early period who is most clearly indebted to

2076 Brignoni, Head

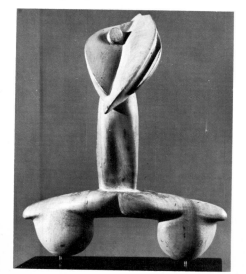

2077 Bangwa, Bird

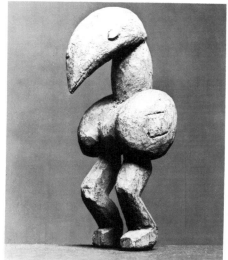

311

Africa
Oceania
Amerindia

Idol Totem
Fetish

2055–2100

African models. "The Couple" sublimates the anthropomorphous elements in drums to a rigid emblem; the "Spoon Woman" in the "idolizing" severity of its composition perhaps reflects the rice spoon of the Dan. Victor Brauner interweaves the lapidary ritual of his own personal mythology with pre-Columbian cat-demons and warriors with their feathered headdress. Atlan evokes ecstatic dances in his oversized line figures. There is hardly a Surrealist who does not incorporate the fascination of Oceanian (Matta), Amerindian (Ernst) or African (Lam) spirit incarnations in his work. Other prototypes of the superhuman in the twentieth century form groups according to their ethnological models. "Totem" and totem-pole have become one of the basic forms of plastic expression, from the archetypal concentration of Moore's work to the biomorphic transmutations in Cardenas and the disturbing compositions of Louise Nevelson. Totemic vocabulary permeates Pollock's early pictures and the work of Lam.

A further group of works focuses on the African "fetish." Van den Berghe, the Belgian painter, takes up this motif as early as 1928. After 1945, the tendencies in plastic art employing non-traditional materials centre on the Congolese nail-fetishes. Arman constructs a "Fetiche à Clous" of nails and revolvers, a menacingly intense expression of armed aggression lying at the antipole to the perfect formalization of the nail motif in the work of Uecker and Dzamonja. In addition, the term "fetish," like "totem," becomes a collective term for sculpture with a magic emanation, even where direct influence is definitely to be excluded. The impulse from tribal art inspires not just formal details; it also emancipates the vocabulary of magic which finds its own independent formal expression in modern art.

Without a doubt there is in process of formation a darker "counter-world" to the everyday world of technological rationality and its geometric harmonics: the fears of an epoch but also the reservoir of primeval certainty and safety. The artist's gaze is now turned in retrospect to early times and the "primitive" peoples: Moore's "erect motifs" connect the megalithic monuments with the totem-poles of Indian art. But it is not enough to emphasize this polarization. What at first appears as a rational counter-world —technology, science, Utopia—is revealed on closer examination to be previous to the demonic. In "Being With," Matta furnishes the offspring of the melanggane of New Ireland with protuberances like telescope eyes and oxygen masks. In other pictures the constrictive interior of a spacecraft encloses pilots and embryos of a Mars future or the Malanggane creatures are the products of the retorts of a laboratory which has slipped out of control. The demons of the "primitives" become the demons of a technological Utopia. Paolozzi, the British sculptor, forges and solders around the year 1960 hybrid beings with a defensive shell of wheels and cogs, nails, bits of metal—the rubbish dumps of a technological civilization, the exposed innards of a robot made of steel and sheet metal, and yet at the same time the direct relatives of the nail-fetishes of the Congo whose surfaces are strewn with nails and pieces of iron. Robot and fetish fuse into a transitional figure located between Utopia and tribal art. Behind the functional mechanisms of our modern age, the old magic of the medicine man is emerging. The future is deriving its mythical creatures from its receptivity for the "primitive" past, a past it needs to make pictorially visible and tangible the latent demonic stratum concealed within the technological world of space flight, artificial genesis, automation, in short its mythical potential. Here, too, we are face to face with another contribution of "primitive" art to the iconography of our century.

Translation P. J. D.

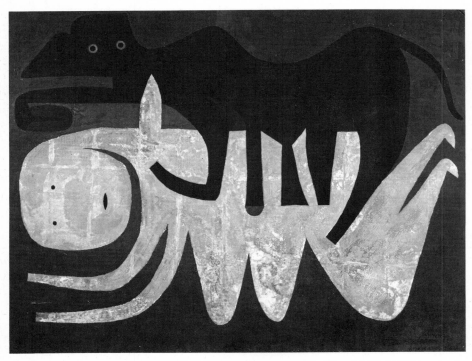

▲ 2074 Brauner, Le Plaisir de la Martyre Privée ▼ 2075 Paracas Necropolis Culture

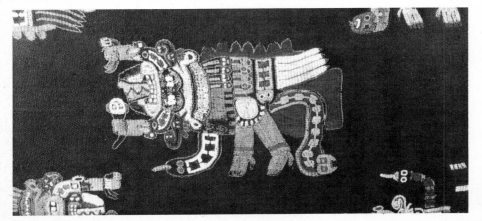

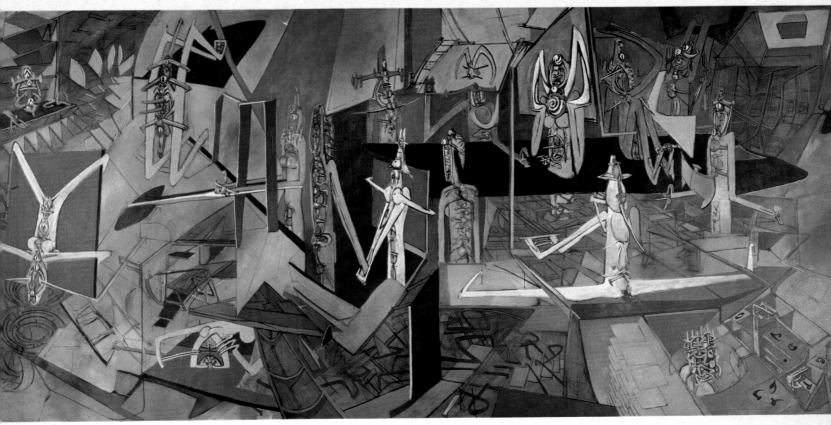

2082 Matta, Being With

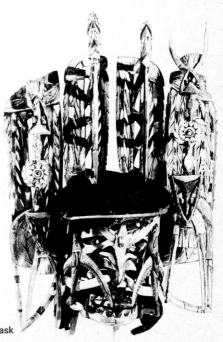

2083 New Ireland, Malangganes Mask

Africa
Oceania
Amerindia

Idol Totem
Fetish

2055–2100

2055 *Fritz van den Berghe (Ghent 1883–1939); Fetishes;* oil on canvas, 49×39 cm; 1928; Louvain, M. André Peters; plate

2056 *Songye (Congo-Leopoldville); Fetish Figure;* wood, horn, beads, snakeskin, magic substances, h - 90.5 cm; Antwerp, Ethnographical Mus. of the City of Antwerp; plate

2057 *Alberto Giacometti (Stampa 1901–1968 Paris); The Couple;* bronze, 60×37×18 cm; 1926; Zürich, Kunstmus.; plate

2058 *Ashanti (Ghana); Drum;* wood; h - 98 cm; cf. Cat. no. 2057

2059 *Max Ernst; Ames-Sœurs;* bronze; h - 93 cm; 1961; Paris, Luvie Coll.

2060 *Baule (Ivory Coast); Kplekple Mask;* wood, painted red and black, ⌀ 42 cm; Munich, Professor Robert Jacobsen

2057 Giacometti, The Couple

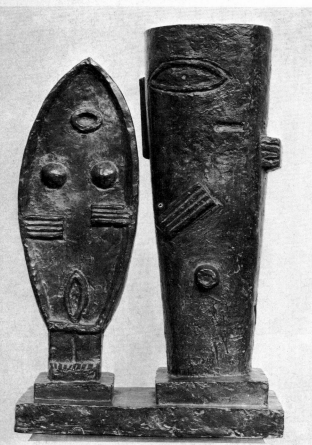

2061 *Max Ernst (Brühl near Cologne 1891, lives in Huismes, Loire); Un Microbe Vu à travers un Temperament;* wood, iron, 303×85 cm; 1964; New York, Milan, Paris, Alexandre Iolas Coll.

2062 *Marka (Mali); Antilope Mask;* wood with brass attachments; h - 76 cm; Schweiz, priv. coll.

2063 *Max Ernst; Habakuk;* bronze; h - 52 cm; 1928–1930; Cologne, Wilhelm Hack

2064 *Senufo (Ivory Coast); Tribal Bird "porgaga";* wood, painted red-brown; h - 141 cm; Munich, Staatliches Mus. für Völkerkunde

2065 *Wilfredo Lam (Saguala Grande, Cuba 1902, lives in Paris and Havanna); Drawing on Grey Ground;* pencil on paper, 50×70 cm; sig. bottom right: Wi Lam 1957; Brussels, Madame Jean Krebs; plate

2066 *Wilfredo Lam; Red and Yellow Cock;* crayons on paper, 50×65 cm; sig. bottom right: Wi Lam 1957; Brussels, Madame Jean Krebs

2067 *Bambara; Mask Attachment "tjiwara";* wood; h - 45 cm, l - 80 cm; Hamburg, Mus. für Völkerkunde; plate

2068 *Bambara; Mask Attachment "tjiwara";* wood; h - 70 cm; before 1911; see Cat. no. 2067; Hamburg, Mus. für Völkerkunde

2069 *Bambara; Mask Attachment "tjiwara"; wood;* h - 70 cm; before 1911; Hamburg, Mus. für Völkerkunde

2070 *Bambara; Mask Attachment "tjiwara";* wood, h - 75 cm; before 1911, see Cat. no. 2067; Hamburg, Mus. für Völkerkunde

2071 *Baga (Guinea); Anok;* wood, 51×84 cm; Paris, Monsieur Kerchache

2072 *Jean Atlan (Constantine, Algeria 1913–1960 Paris); Black Dancer;* oil, gouache and chalk on canvas, 63×47.5 cm; sig. bottom left: Atlan; 1954; Louvain, André Peters; plate

2073 *Dogon (Mali); Rock Painting of a Masked Dancer;* charcoal, iron oxide on stone, h - 38 cm; Paris, Musée de l'Homme; plate

2087 New Ireland, Malanggane ▶

2089 New Ireland, Malanggane ▼

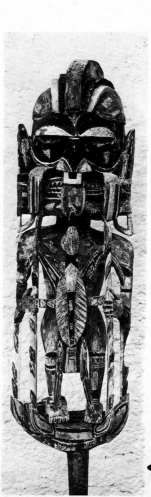

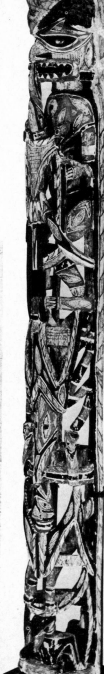

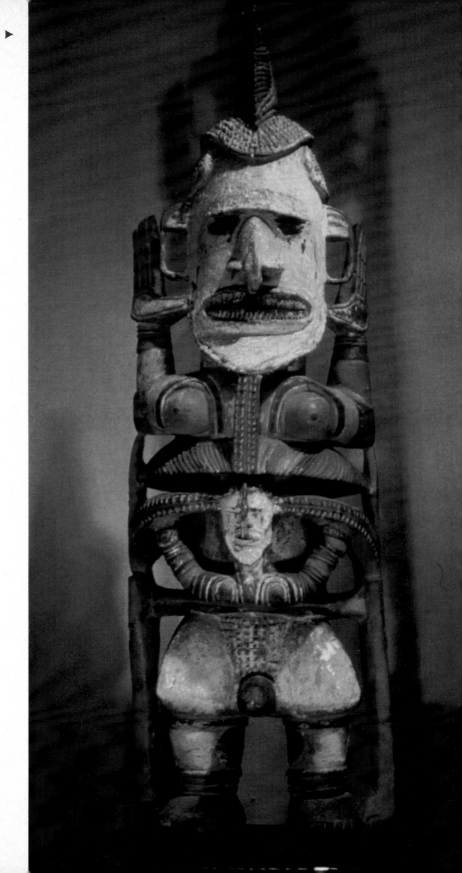

2082 Matta, Being with (detail) ▼

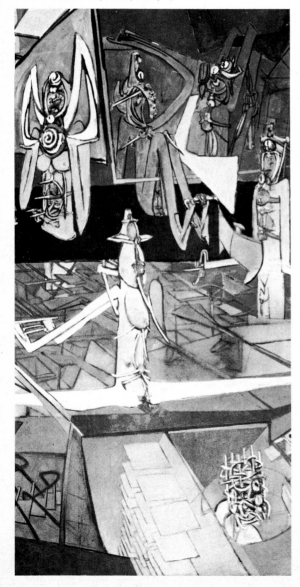

Africa
Oceania
Amerindia

Idol Totem
Fetish

2055–2100

2074 *Victor Brauner (Piatra 1903–1964 Paris); Le Plaisir de la Martyre Privée;* oil on canvas; 89×116 cm; sig. bottom right: Victor Brauner 1962; Brussels, Madame Jean Krebs; plate

2075 *Paracas Necropolis Culture (South Peru) or Proto Deaht Shroud (manto);* cotton material embroidered with alpaca wool, c. 140×90 cm;c. 200–600 A. D.; Stuttgart, Linden-Mus.; plate

2076 *Sergei Brignoni (Chiasso 1903, lives in Berne); Head;* wood, 31 × 25 × 9 cm; Zürich, Kunsthaus; plate

2077 *Bangwa (Cameroon); Figure with a Bird's Head (Moawe);* wood; h - 19 cm; cf. Brignoni Cat. no. 2076; Berlin, Mus. für Völkerkunde; plate

2078 *Ettore Colla; Il Re (The King);* iron; 135×105×40 cm; 1951; Amsterdam, from the property of the Rothman's Foundation

2072 Atlan, Black dancer

2079 *Bambara (Mali); Lock from the Door of a Granary;* wood, with four iron pegs; h - 28.6 cm; cf. Cat. no. 2078; Munich, O. Schädler Coll.

2080 *Joan Miró (Barcelona 1893, lives near Barcelona); Man and Woman standing at a Dungheap;* oil on copper, 32×44 cm; Barcelona, priv. coll.

2081 *Sulka, New Britain (Melanesia); mask;* pith, painted red; h - 121 cm; Bremen, Übersee-Mus.

2073 Dogon, Rock painting

2081 a *Sulka, New Britain (Melanesia); Top part of a mask;* pith, human hair, painted black and white, h - 40 cm; Otoia Coll.

2082 *Roberto Sebastian Matta (Santiago de Chile 1911, lives in Paris); Being With;* oil an canvas, 222×455 cm; 1945/46; Paris, property of the artist; coloured plate

Malangganes of New Ireland

The Malangganes were carved for the great ritual death ceremonies in northern New Ireland, which at the same time accompanied the initiation of the young boys. They were preceded by months of secret carving, interrupted by smaller ceremonies for felling the trees, transport, beginning the carving and painting. During the celebration the Malangganes were placed (during weeks of ritual dancing and feasting) in Malangganes display houses which were only accessible to the men: representatives of the great dead heroes of the tribe, but also the embodiment of mythical pre-time figures. Although individual tribes have a monopoly of certain ornamental forms (which they may sell to others), the variety of the Malangganes is practically unlimited. It is not only that pole and frieze Malangganes, three different forms of mask with all surfaces dissolved into polyaphanous and diaphanous tracery, display one of the highest levels of technical virtuosity of "primitive" art—they are usually carved out of one piece of bark-like round wood—but also the combination possibilities between men, boars, rhinoceros birds, eagles, fish and crabs seem inexhaustible. The eyes peering out of the greenish covering of the turbos snail add to the bizarrely phantastic stylisation an almost naturalistically gross detail. M. Sch.

2083 *Northern New Ireland; Ancestral Mask "Matua";* wood, painted red, black and white, h - 122, w - 56 cm; Bremen, Übersee-Mus.; plate

2084 *Central New Ireland; Uli;* wood, painted; h - 112 cm; Stuttgart, Linden-Mus.

2085 *Central New Ireland; Uli;* wood, painted; h - 157 cm; see Cat. no. 1823; Paris, Monsieur Kerchache; coloured plate

2086 *New Ireland; Bird Malangganes;* wood, painted black, white, red and green; 43×150 cm; Stuttgart, Linden-Mus.

2087 *New Ireland; Malangganes Pole;* wood, painted black and red, h - 150 cm; Stuttgart, Linden-Mus.; plate

2088 *New Ireland (Melanesia); Malangganes Pole;* wood, painted red, h - 221 cm; Bremen, Übersee-Mus.

2089 *New Ireland; Malangganes Pole;* wood, painted red, white, black, h - 139 cm; Otoia Coll.; plate

Totem Poles and Modern Art

In the minds of Europeans totem poles have become a symbol of Indian culture, just like the feather headdresses and the tents of the prairie Indians, although their distribution is confined to the "wood culture" of the north-west coast, to the Tlingit, Haida, Tsimshian, Kwatkiutl, Chola and a few other tribes. Vast cedar forests supplied the basic material for poles from three to 65 feet in height with animals (more rarely human beings) towering one above the other in the typical stylization of the north-west coast, in which the eyes, mouths and claws are laid out in the surface and are ornamentally connected. The bear, wolf, raven, grampus and frog predominate: heraldic animals of the tribe. For this reason they have quite rightly been referred to as heraldic poles, yet there remains—in spite of counter-arguments by Levy-Strauss which are shrewd in their principles—an originally totemistic connection.

The artist's freedom of form extended further than otherwise in primitive art, which is no doubt a result of the high degree of profanation of the originally totemistic and religious poles. The Indians of the wild north-west coast abounding in fish were largely spared the worry for their daily requirements of living; property was not only to satisfy their needs, but recorded and created social status. Wealth became a matter of prestige: one of the strongest driving forces in late Indian culture was to outwardly display wealth. It is within this framework —marked most clearly by the Potlatch ceremonies, great competitions in giving presents—that the ever growing totem poles of distinguished families must be seen, which stood in front of the houses becoming house posts at the front (with a door opening at the lower end) or as grave posts.

It could almost be said that the totem pole in modern art has regained something of its original magic. The totemistic vocabulary, but also the principle of rising forms and horizontal interstices, enriches the basic form "pole": as its mythical variant "totem" becomes a fundamental form of modern expressiveness.

Moore combines the totems of Indian art with megalithic monuments. Jackson Pollock, in the mythical pictures of the forties, fuses totemistic signs and the arrangements of the verticals with the images of his own subconscious. Louise Nevelson builds her "totems" and "columns": fragile mountings and structures in strict arrangements between Constructivism and magic transformation. But Le Corbusier had already tested the legacy of the puristic breakdown of form on the principle of the "totem pole," to give this name to his freely invented "totem" figure. "Totem" has become, even beyond concrete inspiration, a central keyword of transhuman expressiveness, a formula of the mythical, of which the moderns repeatedly avail themselves.
M. Sch.

Translation P. J. D.

2090 *Haida (British Columbia); Totem Pole,* wood; h - 325 cm; Hamburg, Mus. für Völkerkunde und Vorgeschichte; plate

2091 *Henry Moore (Castleford, Yorkshire 1898, lives in Much Hadham); Upright Motif No. 7;* bronze, h - 320 cm; 1955/56; Zürich, Willy Staehelin

2092 *Henry Moore; Upright Motif No. 5;* bronze, h - 210 cm; 1956, Much Hadham, owned by the artist

2093 *Haida (British Columbia); Model of a House Pole;* wood, painted red and black, 65 × 8 × 9.2 cm; Vienna, Mus. für Völkerkunde

2094 *Haida (British Columbia); Grave Post;* basalt fir tree wood, painted blue, red, orange and white, 95 × 16 cm; c. 1870; Vienna, Mus. für Völkerkunde

2095 *Sesostris Vitullo (Buenos Aires 1899–1953 Paris); Chola;* wood; h - 75 cm; 1949; Plessis-Robinson, Pierre Vitullo

2096 *Le Corbusier (La Chaux-de-Fonds, Switzerland 1887–1965 near Nizza); Totem 3;* oil on canvas, 162 × 130 cm; sig. bottom right: Totem 3. Le Corbusier. 1926–1939–1961. 31. Octobre; Paris, Le Corbusier-Foundation

2090 Haida, Totem pole ▶
2098 Nevelson, Pillar ▶▶

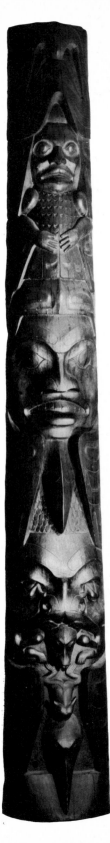
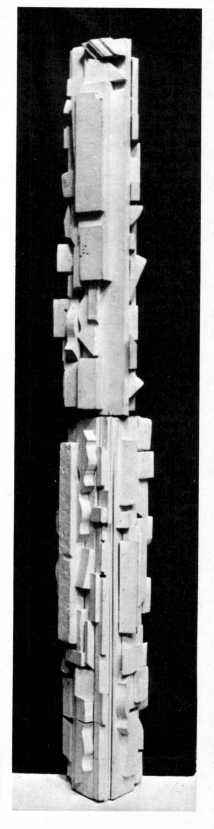

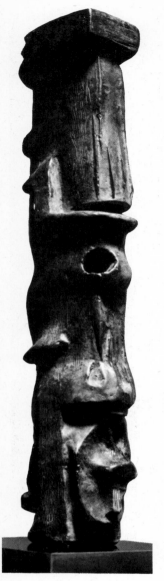

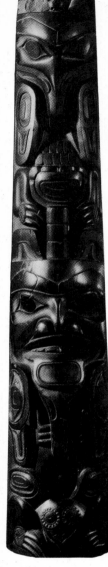

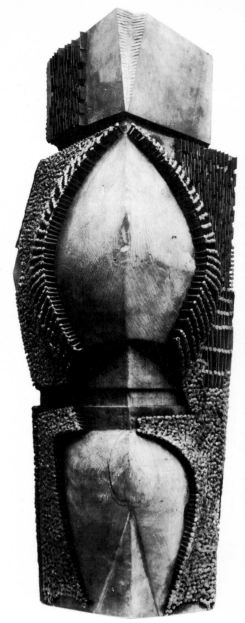

2108 Moore, Upright Motif No. 11, Maquette

2102 Haida, Model of a House pole

2097 *Le Corbusier / Savina; Totem;* wood, iron, h - 122 cm; 1950; Paris, Le Corbusier-Foundation

2098 *Louise Nevelson (Kiev 1900, lives in New York); Column IV;* wood, painted white, 224×26×25.5 cm; 1959; St. Etienne, Musée Municipal; plate

2099 *Augustin Cardenas (Matenzas, Cuba 1927, lives in Paris); Totem;* wood, h - 300 cm; Paris, Priv. coll.

2100 *Pierre Caille; Ancestors;* wood, painted; h - 177 cm; owned by the artist

318

2102 *Haida (British Columbia); Model of a House Pole;* argillite slate; h - 69 cm; Cologne, Rautenstrauch-Joest-Mus.; plate

2103 *Haida (British Columbia); Model of a House Pole;* argillite slate; h - 52 cm; Cologne, Rautenstrauch-Joest-Mus.

2104 *Mark Tobey (Centerville, Wisconsin 1890, living in Basle); Animal Totem;* tempera on paper; 35.5×17 cm; sig. bottom right: M. Tobey; 1944; Paris, Gal. Jeanne Bucher

2105 *Henry Moore; Upright Motif No. 1;* maquette; bronze, h - 30.5 cm; 1955; Much Hadham, owned by the artist

2106 *Henry Moore; Upright Motif No. 3;* maquette; bronze, h - 25.5 cm; 1955; Much Hadham, owned by the artist

2107 *Henry Moore; Upright Motif No. 6;* maquette; bronze, h - 29 cm; 1955; Much Hadham, owned by the artist

2108 *Henry Moore; Upright Motif No. 11;* maquette; bronze, h - 30.5 cm; 1955; Much Hadham, owned by the artist; plate

Nail Fetish and Material Sculpture

Fetishes—the word means "made" objects (Portuguese feiçito = product)—develop aggressive or protective power, harnessing the forces of nature for the purposes of their user: a magical analogy to electricity and to the scientific use of natural forces generally. Nail fetishes, in which the magic act is connected with hitting nails or blades into an anthropomorphic wooden core, occur among the Bakongo and Loango in the lower reaches of the Congo.

Their forces serve various, often quite specialised, purposes. They make evil wishes against the enemy come true, avert harm, prevent and cure illnesses, serve as oracles, god's judgments. Magic substances (leopard's teeth and hair) concealed in an abdominal cavity near the navel and on the head, ensure success. The cavity is closed with a mirror, which catches spirits in its image and exposes them to the effects of the magic substances. According to other ideas it reflects the sunlight and projects it against evil spirits.

There are varying observations on the importance of the nails. They strengthen the force of the fetish or attract its attention. In some villages thieves became ill on striking in the nail and the nail would

2116 Dzamonja, Sculpture R II

only be removed after he had paid a fine: the fetish in the service of justice. M. Sch.

Translation P. J. D.

2109 *Bakongo (Congo-Brazzaville); Nail Fetish;* wood, nails, blades, magic substances, h - 68 cm; late 19th cent.; Stuttgart, Linden-Mus.; plate

2110 *Bakongo; Nail Fetish;* wood, iron, h - 47 cm; Stuttgart, Linden-Mus.

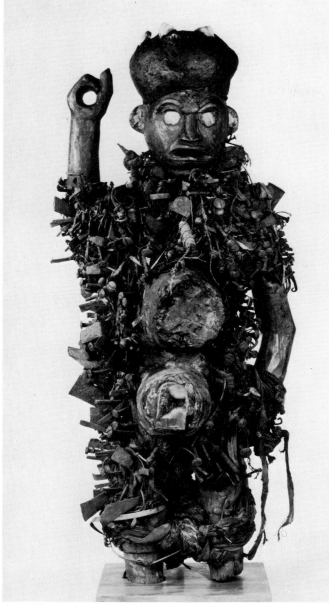

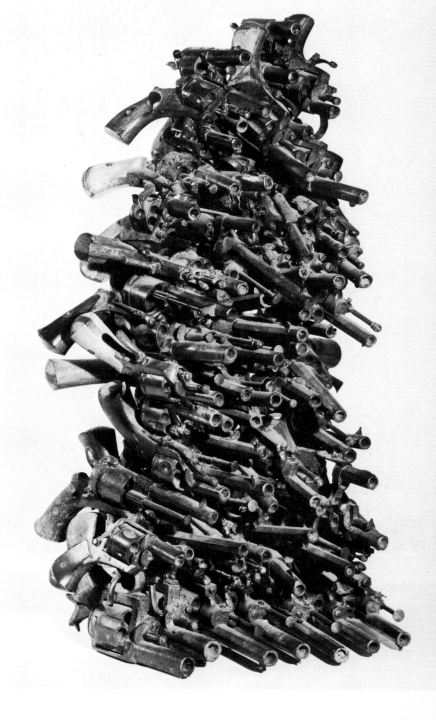

2109 Congo, Nail Fetish 2115 Arman, Nail Fetish ▶

2111 *Bakongo; Nail Fetish;* wood, iron; h - 70 cm; Berg-en-Dal, Africa Mus.

2112 *Bakongo; Magic Animal (Nail Fetish);* wood, iron, l - 77 cm; Munich, Mus. für Völkerkunde

2113 *Arnold d'Altri (Zürich 1904, lives in Zürich); Mutation;* bronze, 45 × 30 × 27 cm; sig. on the plinth: A. d'Altri; 1958; Duisburg, Wilhelm-Lehmbruck-Mus.; plate

2114 *Günther Uecker (Wendorf, Mecklenburg 1930, lives in Düsseldorf); Nail Sculpture;* wood and nails, 58 × 58 cm; 1955; Cologne, owned by the artist

2115 *Fernandez Arman (Nice 1928, lives in Paris); Nail Fetish;* wood, pistols, revolvers, nails, h - 60 cm; sig. on a revolver: Arman 1962; Paris, priv. coll.; plate

319

Africa
Oceania
Amerindia

Idol Totem
Fetish

2055–2100

2116 *Dusan Dzamonja (Strumica, Mazedonien 1928, living in Zagreb); Sculpture R II;* wood, iron, h - 104 cm; 1963; plate

2117 *Dusan Dzamonja; Metal sculpture 62;* iron, 64×54×53 cm; 1968; cf. Cat. no. 1216; Zagreb, Dusan Dzamonja

2118 *Dusan Dzamonja; Sculpture LXIX;* iron, 26×20×19 cm; 1971; cf. Cat. no. 1216; Zagreb, Dusan Dzamonja

2119 *Paul van Hoeydonck (living in Wynegen, Belgium); Small Astronaut (small black fetish);* metal, plexiglass, plastic, h - 45 cm; sig. base: P. van Hoeydonck; 1968; Wynegen, Paul van Hoeydonck

2120 *Roel d'Haese (Gent 1920, living in Nieuwpoort-Bad, Belgium); Tour de France;* bronze; h - 85 cm; 1960; Antwerp, Mus. des Beaux-Arts

2121 *Henry Moore; Large Totem Head;* bronze, h - 244 cm; 1968; Much Hadham, Henry Moore

2113 D'Altri, Mutation

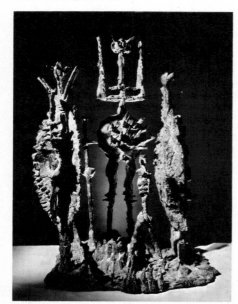

Music
of Negroes
and
American
Indians

Difficulties in the Fusion of Jazz and Symphonic Music

Claus Raab

Right from the beginning jazz has been the musical outlet of a suppressed people. If anyone had been as cruelly prevented from sharing in social progress and compelled to make do with the waste products of society as has the Negro of North America, then he would hardly be in a position to produce a rich and highly developed music. Jazz had early been confined to the limits within which it was to fulfil its function: the provision of dance music and entertainment. The satisfaction of immediate needs imposed conformity on this music and determined the style of playing. This explains why dances which became well-known in America and Europe between 1900 and 1920 as typical products of jazz, like the cakewalk, ragtime, shimmy and foxtrot, to mention but some, did not constitute a musical genre. They remained ambivalent types of instrumental music in quick 2/4 or 4/4 time, standardized in form and harmony, with a rather florid melody and rhythm. This stereotyping is

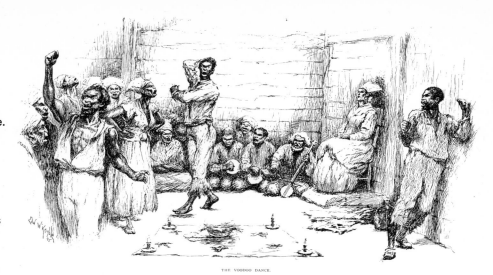

2123 The Voodoo Dance, etching: E. W. Kemble

Slave Transport, photo: The Record Changer

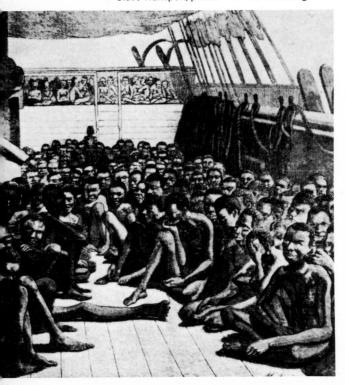

intelligible when we consider the situation of the first jazz musicians. During the day they played in street parades and at funerals, if they did not earn their living in some other way, and at night they played in bars, dives, saloons and brothels. There could be no question of musical training; this was not even required. Unsuitable as an object of aesthetic reflection and enjoyment, this music-making at least earned money, and, if it did not win the recognition that was universally denied, then at least it did create something of a stir. There is thus no difficulty in recognizing improvisation, the most striking characteristic of jazz, as a type of music making explicable on the basis of the social situation which called it forth. After all, we are here treating of a type of music created by a socially handicapped class subject to the demands of an industrial state and not of some form of extra-European music rooted in the people or furthered by the privileged class and whose homogeneous development has been safeguarded, in spite of improvisation, by strict oral tradition. In jazz, improvisation is the musical equivalent of impeded possibilities of social development.

This also accounts for the vagueness of jazz terminology. Attempts at definition resemble efforts to place a taboo under taboo. Besides the musical phenomena themselves, it is precisely the desire to speak about jazz in well-defined terms which raises cultic and occultic associations. The harmony does not cause the difficulty here, for this is subject to reduced European rules; characteristically it is

melody and especially rhythm which is spoken off in such archaic terms. The safest definition of what "swing" and "drive" are is still the statement that the jazz musician "has" them—of course, this is taboo for the concert musician. "Blues" can designate a text form, a musical form, a basis for harmony and improvisation, or a certain type of "feeling"—the blue mood. Basically this latter is no more than the consciousness of social repression, at times supplanted to a greater or lesser degree by sentiment or irony, wit or longing, religious feeling or sexual desire, sadness or virtuosity. These are always the themes of blues or genuine jazz. It was long considered the greatest honour and highest praise for a jazz musician if you could say of him he knew how to "play the blues." This is another taboo for the concert musician. The basic dissimilarity between jazz and the compositions of symphonic music cannot be presented more crassly. Attempts at fusion from both sides, if they aimed at more than mere formal borrowing and "hobnobbing", were thus doomed to failure from the outset. What interested composers was the formal and technical elements. This was completely in line anyway with the European weakness for curiosities and the liking for annual fairs, circuses and anything archaic. Besides the manner of playing and the instrumentation, the composer felt he had found the following elements in jazz: improvisation, spontaneity, virtuosity, originality, reduction of the musical material, sexuality, irony and satire. However, these, once assimi-

lated into their new environment, were no longer recognizable as the expression of a music originally stunted by suppression; in most cases, too, they inevitably contributed towards the complete eradication of the by then suspect individual expression. Out of its context, jazz, or rather what people thought was jazz, was still capable of shocking bourgeois concert- and opera-goers. As late as 1928, there was an uproar when the Hoch Conservatory at Frankfurt announced plans to start a special class in jazz—a music type which was difficult to learn anyway. In the "Berliner Börsen-Courier," Heinrich Strobel commented: "People foam at the mouth about jazz, this 'product of the gutter'; they curse and revile; in a demagogic torrent of catchphrases they mix up atonality, anti-German, Negro invasion, Americanism and pacificism, instead of coming to terms with the facts." However, this situation did not last for long. Jazz soon imagined it was worthy of the concert hall, became commercially interesting, and the new slogan "Jazz—Tempo and Expression of our Age" witnesses to the change of heart. From now on it served members of society for the glorification of the mass-production processes of our technological age. "Motorial Music" and "Machine Music" were synonyms for this tendency. Whenever elements of jazz appear in "serious" music, it was within the framework of this program.

The efforts of jazz musicians during the twenties and thirties to attain social acceptance for the colour of their skin by means of their music could, under the given circumstances, only lead to their striving after commercial success. American and European composers by their borrowings and the Paul Whiteman Orchestra with its "symphonized" and thus polished jazz paved the way for them here—later the rise of the big bands and especially the rapid growth of the record and radio industries helped them still further. The limits within which jazz could move were thus carefully staked out: suppression or commercial exploitation, conformity or rebellion. At first it looked as though the improvised character of jazz would serve economic purposes admirably. A commercially interesting production was possible without long rehearsals and with a small number of musicians. The shortness of the pieces corresponded in most cases to technical realities. However, the only too evident lack of polish of these recordings did not bring the high sales and the desired profit. The element of polish was contributed by the big bands. They employed skilful arrangers

—from now on a professional group much in demand—who gradually standardized the "sound" and the number of players in the orchestra so as to "sell" the music better. They were dependent, too, on publicity and concert agencies, on hoteliers, on recording companies and radio stations. Jazz thus became a satellite of the music industry. This commercial success jazz paid for with the loss of much of its honesty. However, this economic boom did not effect the majority of black musicians; it changed nothing of the precariousness of their existence. On the one hand, their scant musical education was a barrier—hardly any of them could read music. On the other hand, it needed great powers of persuasion to open hotels and dance halls to black musicians. At first not welcome, the Negro musician was later admitted as a "star" who was allowed to run wild against a background of pleasing rich arrangements. From the start he was thus dismissed as an "eccentric," so that those feelings began to well up inside him which later led to the explosive protest of the forties, to bebop and cool jazz. The "cool" here was not so much in contrast to the earlier hot jazz, as much more the cold, scornful attitude of the musician towards his audience. The big-band jazz of the "swing time" of the decade from 1935 to 1945 brought in enormous profits, and a number of band leaders and quite a few musicians were highly successful fiancially. Jazz was also admitted to the concert halls, the citadels of symphonic music, of which it regarded itself as an equal from now on. This was a fatal mistake for it glossed euphorically over the true position of the Negro. It can be considered more than doubtful whether the fact of the appearance of jazz orchestras and combos in concert halls really raised jazz to the level of "concert music." If jazz reflects the history and social position of the North-American Negro—and even the most light-hearted pieces have something of the air of the frightened man trying to appear unconcerned by whistling in hostile surroundings—, if the music the Negroes made is accepted by the White listeners and musicians as a standard of quality, then the concertante affectations of the thirties and forties can only be regarded as the commercial corruption of jazz by clever managers. The original unadorned candour has given way to conformist jazzifying. The details of the arrangement techniques betray this: the flirting with what have become in the meantime customary chords, their skilful evocation of past music presented as sickly im-

pressionism or angular neo-classicism, striking melodic fragments—the prerequisite of any hit—, rhythms well adapted to dancing. The "riff"—the name for repetitions of short phrases—was also familiar in early jazz and had a useful function to fulfil while the musicians still improvised: the "riff" gave the musicians the opportunity to have a "breather"; during it they were not expected to create continuously and spontaneously. It was also intended to have a stimulating effect on the dancers and listeners. In reality utterly superfluous in "swing" music, it was brought to perfection then and was employed ad nauseam in nearly all arrangements. In his "The Story of Jazz," Marshall W. Stearn regards riffing as a fine art which heightens the number from chorus to chorus, in a way similar to the Bolero. This reference reveals the ridiculousness of the ideas entertained by jazz ideologists, commentators and journalists who talk of the "riff" as a "fine art," name it in the same breath as Ravel's Bolero, and arouse associations of symphonic music. They may have done jazz a great service in helping its practi-

2124 Gottschalk, The Banjo

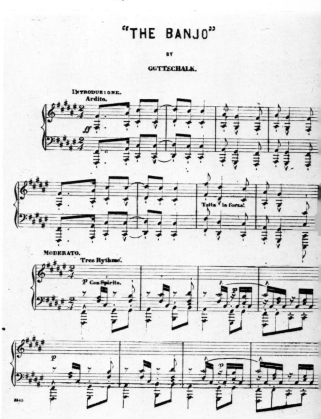

"THE BANJO"

BY

GOTTSCHALK.

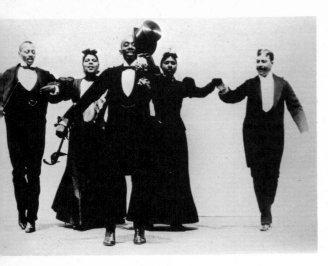

2128 Cake walk, photo: United States Information Service

2129 Debussy, Golliwogg's cake walk, Ed. Durand

tioners to overcome a morbid sense of inferiority, but, unwittingly, they have also shown that the jazz of the "swing" years had lost its original power of speech.

During the fifties it looked as though some contact had been made between jazz and the New Music when this too was also assigned to a ghetto. However, the underlying reasons were utterly different and they did not reduce the problems involved in a fusion. Improvisation, which had gained the respect of composers, and the novel sounds of Free Jazz did stimulate towards experimentation in this direction, too. The entirely different musical experience of the musicians still excluded any possibility of assimilation. It cannot be denied that the development of the New Music since 1900 is completely out of keeping with the intentions of Jazz and that musical knowledge, and aims are still miles apart. The juxtaposition of Jazz and New Music in some recent experiments merely raises the question of tolerance limits only to then give a clear negative answer. What appears most ominous though is that the existing contradictions are being blurred over and dismissed as mere figments of the imagination, so that the picture imparted is completely out of focus.

Translation P. J. D.

Music Program

The first Encounter with Negro Music in the Nineteenth Century

2122 *Drums of the Yoruba of Nigeria;* a) for Shango (God of Thunder); b) for Oya (his wife); Folkways FE 4441; three Bata drums (hour-glass drums)

2123 *Voodoo Ceremonie in Haiti; Voodoo drums;* Richesse du Folklore no. 15 (421.076 P); plate

2124 *Louis Moreau Gottschalk (New Orleans 1829–1869 Rio de Janeiro); The Banjo (c. 1851);* op. 15; hr-Archiv no. 157 329; Roman Rudnytsky, piano; plate

2125 *Louis Moreau Gottschalk; Le Bananier ("The Banana Tree");* c. 1845; hr-Archiv no. 157 329; Roman Rudnytsky, piano

2126 *"Swing Low, Sweet Chariot" (Spiritual);* Robert McFerrin, vocal;

Norman Johnson, piano; Riverside RLP 12-812

2127 *Antonín Dvořák (Muhlhausen/ Moldau 1841–1904 Prague); Symphony in E Minor, op. 95 (From the New World): first movement, Allegro, Allegro Molto;* BR-Archiv no. 71/20 397; BR Symphony Orchestra; conductor: Raphael Kubelik

Cake-walk

The cake-walk—originally an ironical pantomime dance of the North American negroes—became widespread in Europe after 1900, above all as a dance for the stage and for dance shows. This was due in part to visiting American orchestras; that of John Souza in Paris in 1903, for example. The dance is characterized by a rapid, syncopated 2/4 measure, which conceals the following latent, bimetrical rhythmic pattern: 3/16+3/16+2/16 against four equal quaver beats. The more recent Charleston displays a similar pattern: 4/4 to 3/8+3/8+2/8.

2128 *John Philip Sousa; Washington Post (Charleston);* BR-Archiv St67/ 9424; adaptation of 7722 Guint; Pat Gomez and his Crazy Seven; plate

2129 *Claude Debussy (St.-Germain-en-Laye 1862–1918 Paris); Children's*

2138 Jelly Roll Morton, photo: George Hoefer

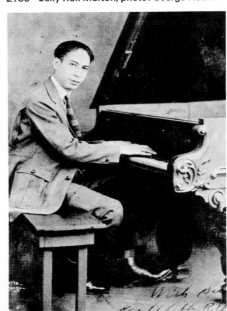

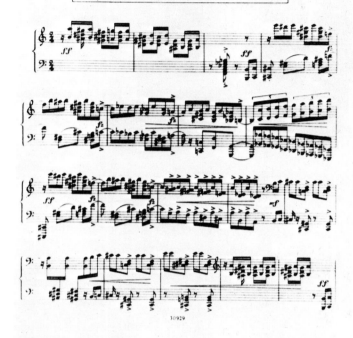

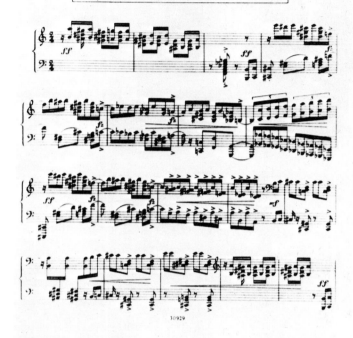

2139 Stravinsky, Piano-Rag-Music, Ed. J. & W. Chester

2143 Hindemith, "1922" Ed. Schott & Söhne

Corner, No. VI: Golliwogg's Cake-Walk (1906–1908); Philips 836.807 DSY; Werner Haas, piano; plate

2130 *Claude Debussy; Préludes (2ème livre) No. VI…"General Lavine" – eccentric – (1913); Dans le Style et le Mouvement d'un Cake-Walk;* Amadeo AVRS 130.031 St; Jörg Demus, piano

2132 *Claude Debussy; "Boîte à Joujoux: Le petit Nègre" (1913–1917; instrumentation not finished);* Philips 836.811 DSY; Werner Haas, piano

Ragtime

Ragtime can be synonymous for early jazz. It was the name especially applied to a way of playing the piano which originated in America at the end of the 19th century and which was also taken over by bands after 1900. This practice,

created by Negro musicians, reveals a bimetrical structure like the cake-walk syncope mentioned above; melodic triplets against a strictly continuous double beat and a consequent displacement of the accent over longer stretches. Rudiments of African rhythm combinations are certainly present in this so-called off-beat technique. Ragtime corresponds largely to European march and dance forms, as far as formal disposition is concerned, and like these it consists of several independent sections. Although many ragtimes were taken over by jazz and used as improvisation patterns, they differ from jazz in some essential respects. Thus the early ragtimes were frequently written down. Their melodies mainly derived from European popular, entertainment and salon music and from the concert and operatic repertoire. The method of playing depended on the sound of the instrument. In jazz, on the contrary, it was not so much the musical

content that mattered as the method of the improvised performance. The melodies became increasingly self-composed or were taken from the work-songs and spirituals. The instrumental music was vocalized, the instruments began to speak. A greater complexity of rhythm and an intonation suggestive of African origins was added to this. In the same way, the melodic shape of jazz can be traced back to the model of African rhythm and melody. In ragtime the European elements were predominant. Protagonists, like Scott Joplin, James Scott, Jelly Roll Morton and Joseph Lamb, played their rag compositions for the most part themselves on the piano. Of all the precursors of jazz, ragtime held the greatest and most lasting attraction for European composers, even if for very different motives. Igor Stravinsky was the first to find material in ragtime which suited his intentions. He procured music from America and was probably also

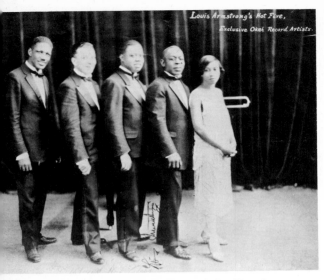

2147 Louis Armstrong's Hot Five, photo: New Orleans Jazz Museum

2148 Milhaud, La Création du Monde, Ed. Max Eschig

familiar with the recordings which the composer Ernest Ansermet brought from the USA to Switzerland during the First World War. Just as the rag pianist Jelly Roll Morton called the rearrangement of the rhythm and the syncopating of given melodies the real metier of ragtime playing and consequently a type of arrangement suited to every kind of music, so Stravinsky's compositions—in the same way "music about music," as Rudolf Kollisch called it—can be interpreted as musical parodies. Each in its own way testifies to violent appropriation. "Damit wird die Gefahr des Gefahrlosen akut, die Parodie dessen, was ohnehin so veraltet ist, dass es der Parodie nicht bedarf, und an dessen überlegener Imitation gerade der Kulturbürger seine hämische Freude hat." (Theodor W. Adorno, "Philosophie der Neuen Musik," Frankfurt a. M. 1958, p. 176.) Writing about Stravinsky's motivations, Adorno says that, contrary to the countless composers who hoped to help along their "vitality," whatever that may mean musically, through their chumming up with jazz, Stravinsky, by means of distortion, exposes all that is shabby, worn out and a slave to the market in the established dance music of the previous thirty years (p. 158). He goes on to say (p. 159) that Stravinsky's pieces are composed of the ruins of commodities just as many a picture or sculpture of the same time was made of hair, razor blades and tinfoil, and that, as part of the same comparison, the composers' every interest in jazz was a naive, side-long glance at the public, a plain sell-out. Adorno adds that Stravinsky, however, actually ritualizes this sell-out, this connection with the commodity, and that he is dancing the dance of death around its fetishistic character. C. R.

2133 *Tiger Rag (1919);* mfp 5007; Original Dixieland Jazzband

2134 *Igor Stravinsky (Oranienbaum, near St. Petersburg 1882–1971 Hollywood); Histoire du Soldat (1918); for reading, for playing and for dancing; text by Ch. F. Ramuz; concert suite 1923: Three Dances: Tango, Waltz and Ragtime;* Platte L 10707 (A 011931); conductor: Igor Stravinsky

2135 *High Society Rag (1923);* Odeon OPXH 1016; King Oliver's Jazzband

2136 *Igor Stravinsky; Ragtime for Eleven Instruments (1918);* CBS ST

SBRG 72071; The Columbia Chamber Ensemble; conductor: Igor Stravinsky

2137 *Igor Stravinsky; Ragtime (piano version of 1919);* Nonesuch ST H – 71212; Noël Lee, piano

2138 *Jelly Roll Morton; Grandpa's Spells; Swaggie* 1214A; Jelly Roll Morton, piano; plate

2139 *Igor Stravinsky; Piano Rag Music (1919);* La Voix de son Maître; C 061 - 11300; Igor Stravinsky, piano; plate

2140 *Eric Satie (Honfleur 1866–1925 Paris); Parade: Ragtime du Paquebot;* BR-Archiv no. 61/8237; BR Symphony Orchestra; conductor: Igor Markewitch

2141 *Darius Milhaud (Aix-en-Provence 1892); Trois Rag Caprices (1922);* BR-Archiv no. 61/2747; Clementine von Seckendorf, piano

2142 *Francis Poulenc (Paris 1899); Les Biches (ballet): Rag Mazurka (1924);* Angel S-35932 Paris Conserv. Orch.; conductor: Prêtre

2143 *Paul Hindemith (Hanau 1895–1963); "1922," Piano Suite: Shimmy, Boston, Ragtime;* BR-Archiv no. 66/28799 SF; Ludger Maria Maxsein, piano; plate

2144 *Maurice Ravel (Ciboure 1875–1937 Paris); L'Enfant et les Sortilèges: Foxtrot (1925);* DGG ST 138675 SLPM; Chœur et la Maîtrise de la RFT, Orchestre National, Paris; conductor: Lorin Maazel

Blues

The secular vocal solo of the American negro gave rise to a standard model serving as a basis for jazz improvisation, which was later known as "blues." Primitive African archaic forms, such as the call and answer form, types of refrains ("breaks"), deszending melos, the flattening of the third and the seventh ("blue notes") in predominantly pentatonic scales, are combined with European elements in the mostly instrumental performances of today. The old three line stanza "statement–repetition–answer" (four bars of each) remained superimposed on the harmonic pattern with the intervals I-IV-I-V-I in the measure structure of 4-2-2-2-2; this led to frequent bitonality. This blues model proved to be sound and commercially exploitable. C. R.

2145 *Edith Johnson; Good Chib Blues;* Riverside 8819; Roosevelt Sykes, piano; Edith Johnson, vocal; (1929–1932)

2146 *W. C. Handy; St. Louis Blues;* Parlophone PMC 7045; Louis Armstrong and his Orchestra; (New York 1929)

2147 *Lil Hardin; The King of the Zulus;* Odeon OPXH 1018; Louis Armstrong and his Hot Five (1926); plate

2148 *Darius Milhaud (Aix-en-Provence 1892); La Création du Monde; ballet (1923);* Nonesuch 71122; conductor: Darius Milhaud; plate

2149 *Mary Johnson; Mary Johnson Blues;* Riverside 8819; Mary Johnson, vocal: Roosevelt Sykes, piano; Curtis Mosby, violin

2150 *Maurice Ravel (Ciboure 1875–1937 Paris); Sonata for Violin and Piano, second movement "Blues" (1927);* DGG ST 183016 SLPM; Max Rostal, violin; Monique Haas, piano

2151 *Arthur Honegger (Le Havre 1892–1955 Paris); Concertino pour Piano et Orchestre (1925–1926);* BR-Archiv no. 69/8168 ST; Claude France Journès, piano; Münchner Philharmoniker; conductor: Jan Koetsier

2152 *Art Tatum Trio; I know that you know;* Jazztone J-701; Art Tatum, piano, Tiny Grimes, guitar; Slam Stewart, bass

2153 *Maurice Ravel (Ciboure 1875–1937 Paris), Concerto pour la main gauche (1931);* adaptation from IS Dok 21660; Alfred Cortot, piano; Orchestre de la Société de Concerts du Conservatoire de Paris; conductor: Charles Munch

Jazz Compositions from 1946–1954

Right up until the thirties the composers were taken in by what Ernst called a "Vexierbild" (illusory picture) of jazz. Following the prohibition and discrimination of the Hitler regime, a new interest in jazz was aroused in America and Europe. It differed from the earlier interest, in that jazz, or what was considered jazz, was no longer thinned down to commercial material and elements, but that the "notion of jazz," as Stravinsky formulated it, began to gain more influence. The

consequences drawn from the mostly unsuccessful attempts to combine jazz and symphonic music only permitted two technical processes: to compose solely for a jazz ensemble or to contrast instrumental jazz formations with a symphony orchestra. The reason for the fact that, subsequently, the second alternative was far more frequently chosen, can only be that new problems are more easily evaded on the technical groundfloor. Real contrasts hardly arose, as either the jazz part or the symphonic section was too weak. Perhaps it was because the effective Concerto Grosso style was still regarded as being laden with substance and the alternation of composed and improvised particles as sufficing. C. R.

2154 *Drake-Juan Tizol; Perdido;* Decca DL 79229; Woody Herman Orchestra; plate

2155 *Igor Stravinsky (Oranienbaum, near St. Petersburg 1882–1971 Hollywood); Ebony Concerto (1946);* Philips - G 03621 L; The Woody Herman Orchestra; conductor: Igor Stravinsky; plate

2156 *Duke Ellington; Creole Rhapsody;* Coral 94006 EPC; Duke Ellington and his Orchestra; plate

2157 *Charlie Parker/Dizzy Gillespie; Salt Peanuts;* BYG 529121

2158 *André Jolivet (Paris 1905); Concerto pour Piano et Orchestre: first and second movements (1949–1950);* BR-Archiv no. 57/11789 mono; Yvonne Loriod, piano; BR Symphony Orchestra; conductor: Rudolf Albert

2159 *Rolf Liebermann (Zurich 1910); Concerto for Jazz-Band and Symphony Orchestra (1954);* BR-Archiv no. 55/13102 mono; Kurt Edelhagen Orchestra; BR Symphony Orchestra; conductor: Paul Strauss

Jazz and American Composers

America's composers, in search of a national music, profited from the proximity of jazz. Dvořák had already discovered a productive and effervescent source in the Negro plantation songs and spirituals. The jazz forerunners constituted only a part of the musical environmental material of Charles Ives, the pioneer and "American hero." The dances and songs of the farmers, European folk songs, hymns, military marches and everyday noises were for him equally stimulating.

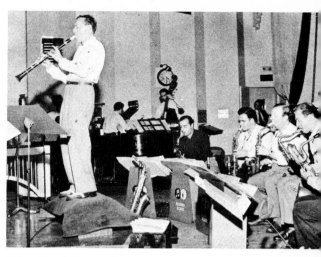

2154 Woody Herman Orchestra, photo: The Record Changer

2155 Stravinsky, Ebony Concerto, Ed. Edwin H. Morris & Co.

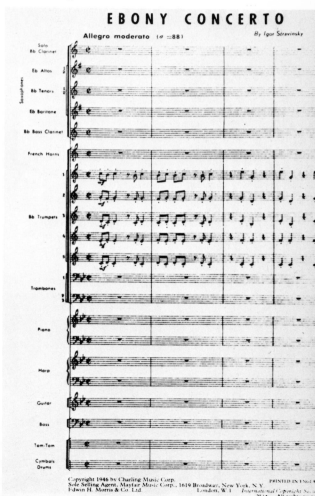

2156 Duke Ellington, photo: The Record
Changer

He was one of the first in the 20th cen-
tury not to be concerned at all with the
exotic value of existing conditions, which
stood in the way of compositions that
did justice to the material. Rather, he
consequently acquired methods and
techniques from it which did not become
musical actuality until fifty years later,
in the works of Stravinsky, Milhaud and
Bartok: heterophony, coincidence of
differing metres, multi-layered rhythm,
harmony and melody, inclusion of chance
and noise factors and statistical proce-
dures. Central importance is attached to
the composition of the effect of two
military bands playing completely
different pieces as they pass each other.
C. R.

2160 *Charles Ives (Danbury 1874–
1954 New York); Three Places in New
England (1912–1914), second move-
ment: Putnam's Camp, Redding, Con-
necticut;* DGG ST 2530048; Boston
Symphony Orchestra; conductor: Tilson
Thomas

2161 *Aaron Copland (Brooklyn 1900);
Concerto for Piano and Orchestra
(1926–1927);* CBS 72352; New York
Philharmonic Orchestra; Leonard Bern-
stein, piano

2162 *George Antheil (Trenton 1900);
Ballet Mécanique (1926–1927);*
Philips ML 4956; New York Percussion
Group; conductor: Carlos Surinach

2163 *George Gershwin (Brooklyn
1898–1937 Hollywood); Second
Rhapsody;* CAP SP 8581; Leonard
Pemmario, piano; The Hollywood Bowl
Symphony; conductor: Alfred Neumann

2164 *Louis Gruenberg (Brest-Litowsk
1884); Violin Concerto, second move-
ment (1944);* Vic. LVT 1017; Jascha
Heifetz, violin; San Francisco Symphony
Orchestra; conductor: Pierre Monteux

Opera

Jazz and related dances remained a
means par excellence of demonstrating
reality. What they were to be responsible
for is shown most clearly in operatic
productions.
In Ernst Křenek's "Jonny spielt auf,"
a work declared to be a "Zeitoper," jazz,
shimmy, ragtime and blues rank on the
same level as telephone, gramophone,
saxophone and banjo – the implements
of bourgeois self-glorification. The
general opinion demanded from the
story that justice be done to the solitary
composer, Max, without, however,
having to forgo any enthusiasm for
Daniello, the violin virtuoso, and Jonny,
the triumphant jazz band violinist.
Křenek's intention of characterizing and
contrasting the worlds of Jonny and
Max by using a sort of jazz and sym-
phonic music was hardly noticed and got
lost in the brilliantly functioning appara-
tus in which the spectator had no problem
in recognizing his unscathed – or so it
seemed to him – environment. A further
dimension, the music industry, opened
up the economy. In the last analysis, it is
only thus that Jonny's world-wide
success can be understood.
It was left to Weill and Brecht to lay bare
ostentatious behaviour, and to render
the darling child of the bourgeoisie, the
opera, accessible in new clothing to a
potentially new public. Right at the
beginning of the "Threepenny Opera,"
the spectator is told that this evening
he is going to see an opera for beggars.
Since this opera was intended to be as
splendid as only beggars dream it to be,
and since it should, however, only be as
cheap as beggars can afford it, it is called
the "Threepenny Opera." The songs are
by no means a parody, but are "the
original good music composed of refuse,
dreams and rags" (Ernst Bloch).
The importance that Weill attached to
jazz can be seen in his "Notiz zum Jazz"
(in the journal "Anbruch," 1929, vol. 3),
which extends far and away beyond the

ideas prevalent at that time. In the article
he says that it seemed more important to
him that at last the jazz method of making
music should break through the rigid
system of music performance to be found
in theatres and concerts, than that it
should influence musical composition.
Whoever has worked together with a
good jazz band will have been pleasantly
surprised by an enthusiasm, a devotion
and a will to work of the kind that can be
searched for in vain in many concert and
theatre orchestras. He goes on to say
that a good jazz musician has complete
command of three or four instruments, he
plays by ear, and he is accustomed to
a kind of coordinated playing in which
each individual contributes to the sound
effect of the whole, but above all he can
improvise, he cultivates a free and easy
form of music making in which the
interpreter accomplishes productive work
in its widest sense. Weill adds that
questions of economy play a part here,
too: the jazz musician is no official, he is
exposed to competition, his artistic
ambitions are greater due to the fact that
a better performance brings him more
money. It is, however, perfectly possible
that this will lead to a reorganization of
the question of interpretation, both
artistically and economically.
"Splendid isolation" and the traditional
framework of the institution of opera
were by no means blasted by this. In
Alban Berg's "Lulu", Weill and Brecht are
once more present "behind the scenes,"
where the ragtimes are played by a jazz
band. Clearly audible, but unobstrusive
and in careful doses. Once again the
opera takes place in a hall before an
audience that enjoys being shocked. C. R.

2165 *Ernst Křenek (Vienna 1900);
Jonny spielt auf: first part "Shimmy"
(1927);* BR-Archiv no. 69/23127 st.;
1-11563-564; Phonogram 905038
AVRS St.; Akademie-Kammerorchester
Wien; Orchester der Wiener Volksoper;
conductor: Heinrich Hollreiser

2166 *Kurt Weill (Dessau 1900–1950
New York); Dreigroschenoper (1928);
a) No. 2 Moritat von Mackie Messer
(blues tempo);* Suhrkamp-Verlag;
Bertolt Brecht and an orchestra;
*b) No. 12 Zuhälterballade (tango
tempo);* BR-Archiv no. ST 22222/23/24;
HR Symphony Orchestra; conductor:
Joh. Pütz; vocal: Gudrun Thielemann,
Horst Tappert

2167 *Alban Berg (Vienna 1885–1935);
Lulu (1928–1935): Act I Scene III:
Eine Theatergarderobe;* ragtime, English

waltz, ragtime (trio); Elec. SME 91714/16; Alwa: Gerhard Unger; Lulu: Anneliese Rothenberger; the prince: Jürgen Förster; the wardrobe mistress: Maria von Ilosváy; the theatre director: Karl Otto; Philh. Staatsorch. Hamburg; conductor: Leopold Ludwig

Negro Music in Latin America

Claus Raab

In contrast to the jazz of the North American negro the music of the black population of Latin America long remained folk-music. Essentially, this is connected with slave-trade and slave-holding, which despite condemnation by the Congress of Vienna in 1815, its prohibition in England in 1807, in America in 1863, and by Pope Gregory XVI in 1839, continued to flourish and bring concrete economic advantages in Middle and South America. A total of four million negro slaves were still deported to America in the nineteenth century. There was scarcely any separation of classes as, for example, in the negro population of New Orleans.
Among other things, this meant that the occupation of musician was closed to the negro. The slave-holders ensured that the playing of music was the prerogative of the layman — as in many West African tribes — and linked with concrete events of daily life: work on the plantation, the end of a day's work, celebrations, birth, marriage, death, ritual and religion. For that reason it did not become functionally dependent upon the metropolitan music industry — a monopoly of the whites.
The oppression of the colonial slave-masters created some distortion of the music (for example, by prohibition of drumming, which they feared might incite to rebellion) and new reasons for performing it (for instance, carnival), but just as the deported negroes had been obliged to adapt themselves to their new environment over the centuries and elements of Christian religion were fused with old rituals, European musical influences were absorbed without much being changed initially. The mentality, content and form of the songs, instruments and rhythm remained largely African. The simplified harmony of European music corresponded strikingly with the frequent construction of thirds

common to West African polyphonic music; adopted melodies were coloured with both blue notes and pentatonics (cf. Gunther Schuler, Early Jazz, New York, 1968).
Rhythm proved to be the element most resistant to processes of assimilation. In no respect does its complexity, versatility and inherent regularity touch European traditions. It was long before composers began to show an interest in its characteristic features. The restriction to physical movements (dance, work) demands an even pulsation which, without exception, is based upon very small time-units. Due to the fact that this basic beat is subject to no time scheme and cuts off buoyantly, every impulse can be accentuated. The rhythmic basis is formed by models of a specific length in symmetrical or asymmetrical order; this means the employment of only double and triple elements, or both alternatingly. Depending on their particular function, the rhythms are furnished with magical names or designated by nonsense syllables. Their lingual character enabled them to be used in Africa for the transmission of messages (speaking-xylophone, speaking-drums, drum language, cf. Cat. no. 2168).
The metric structure of a model can be varied in the course of a piece of music. The result is horizontal polymetry. A model with a length of twelve time-units may thus undergo the following metric variation: homochronic (=divisive): 3+3+3+3 (=6+6), 2+2+2+2+2+2 (=6+6 or 4+4+4); heterochronic (=additive): 3+3+2+2+2 or 2+2+2+3+3 (=alternating beat), 2+3+2+2+3, or alternatively 3+2+3+2+2 (=5+7), or 2+2+2+3+2+3, or 3+2+2+3+2 (=7+5), and many others. There appear to be no limits set to fantasy in juggling with double and triple elements.
Generally, a model of a certain length simultaneously rolls out in varied metric arrangement. This results in vertical polymetry. The main accents, however,

2186 Carnaval à Santiago de Cuba, Le Chant du Monde, LDX A 4250

by no means always coincide, but can be shifted against each other in cross-rhythm. The individual rhythmic planes become audible on different types of drums (high-middle - low) or variable pitches of notes (cf. Cat. no. 2170), on xylophones (cf. Cat. no. 2172), rattles and scrapers (cf. Cat. no. 2173) by hand-clapping and singing (cf. Cat. no. 2174), or they become visible in body movement during dancing and work.
The rhythmically inexperienced European ear was presented with scarcely any melodic and harmonic indications of how to distinguish and correlate the diverse rhythmic planes, so that it was surrendered helplessly to the apparent hubbub of sounds. One certainly noticed the ecstatic element in this music, and the reports of travellers during the nineteenth century fluctuated between repellance and fascination. In America, the original music of the negroes lost some of its occult character and became more profane, commonplace and accessible: a good reason for European schooled composers to occupy themselves with it. Growing commercialization in the advancing twentieth century attempted to compete against the rhythmical originality with elaborate arrangements (cf. Cat. no. 2176). The music which Louis Moreau Gottschalk encountered during his travels in Middle and South America in 1856, appeared just as fresh to Darius Milhaud in 1917 when he reached Rio de Janeiro on a diplomatic mission with Paul Claudel.

Translation: G. F. S.

Music Program

2168 *Musique Centrafricaine;* OCORA OCR 43; Xylophone "lingassio," "instrumental language"

2169 *The Topoke People of the Congo;* Folkways FE 4477; wooden slit drum; drum language

2170 *Music of the Dan; Bärenreiter;* Musicaphon BM 30 L 2301 A/No. 3; drum rhythm for the circumcision festival

2171 *Black Music of South America: Candomble;* Nonesuch H-72036

2174 *Musiques Dahoméennes (Bariba);* OCORA OCR 17; funeral songs; the singers accompany themselves with gourd rattles

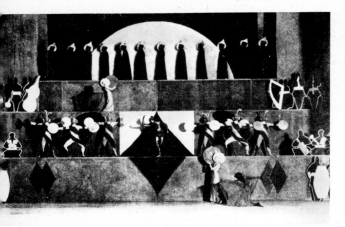

2180 Milhaud, L'Homme et son Désir, stage design and costumes by Andrée Parr

2175 *Murillo Pessoa; Folklore e Bossa Nova do Brasil: Tema pro Luis;* Saba SB 15102; Rosinha de Valenca, guitar; Sergio, bass; Meirelles, reco-reco; Chico tambourine; Jorge, atabaque; Rubens, pandeiro

2180 Milhaud, L'Homme et son Désir, Universal Edition, page 35

Latin American Dances

The forerunners of sambas and rumbas are African dances. The basic, heterochrone model of each only comes to life in simultaneously polyrhythmic and cross-rhythmic combinations. The influence of jazz in the fifties created the bossa nova as a variant of the samba.

2176 *Noel Rosa; Folklore e Bossa Nova do Brasil: O Orvalho vem caindo (1966);* Saba SB 15102, Mairelles, tenor sax; Chico, drums; Sergio, bass reco-reco; Salvador, piano, agôgô; Rubens, pandiero; Jorge, atabaque, apito

2177 *Louis Moreau Gottschalk (New Orleans 1829–1869 Rio de Janeiro); A Night in the Tropics, second movement: Allegro moderato (1859);* Vanguard SRV–275 SD; Utah Symphony Orchestra; conductor: Maurice Abravanel

2178 *Tango; La última copa;* LDS 800A; Carlos Gardel, vocal

2179 *Igor Stravinsky (Oranienbaum 1882–1971 Hollywood); Tango (1940);* BR-Archiv no. 65/7437; Klaus Billing, piano

2180 *Darius Milhaud; L'Homme et son Désir (1917–1918);* Can. 31008; Luxemburg Radio Orch.; conductor: Darius Milhaud; plates

2181 *Darius Milhaud; Le Bœuf sur le Toit (1919);* NDR-Archiv no. F. 5906; NDR Symphony Orchestra; conductor: Leopold Ludwig

2182 *Heitor Villa-Lobos (Rio de Janeiro 1887); Chôros I (1920);* Rias Berlin Archiv no. 114–201/V; Fernand Fernandez Lavie, guitar

2183 *Heitor Villa-Lobos; Chôros V (1920);* Rias Berlin Archiv no. 206–684/VI; Yara Bernette, piano

2184 *Heitor Villa-Lobos; Bachianas Brasileiras No. 2: Toccata (1930);* BR-Archiv no. 65/9435; L 14872 Angel 35547; Orchestre National de la Radiodiffusion Française; conductor: Heitor Villa-Lobos

2185 *Oscar Lorenzo Fernández (Rio de Janeiro 1897–1948); Batuque;* BR-Archiv no. L 13862; CBS-BRG 72186 ML 5914; New York Philharmonic Orchestra; conductor: Leonhard Bernstein

Latin American Composers

The Latin American composers, partly self-taught, partly academically trained, could not have foreseen the outmoded prejudices which the European public gave vent to as soon as the compositions mentioned Negro folk music and dances — they suspected a menacing circus world. Their creativity was based rather on musical nationalism, which protected the music of many countries ideologically, in Europe as a reaction against Wagner and the Romantic movement or overseas as a new beginning. As a result it became obligatory to pursue native or foreign folk music, as well as formally composed music as long as it only aroused the impression of authenticity and originality. "Secondhand" music, such as that from the fair, the circus, variety and music-hall, was also included.
After the abolition of slavery in Brazil in 1871 and 1888 and the founding of the republic in 1889 the necessity for an independent, national kind of music seemed to arise of its own accord. The conditions in Mexico and Cuba were similar to the starting-point of the Brazilian composer. Musical composition, which was to a certain extent interested in European musical events, could start with indigenous material without immediately disturbing the aesthetic preserves of any established concert life. Performance ceremonies and works were otherwise imported from Europe and the USA and only available to the rich. Concerts, operas and ballets, which were colonial grafts rather than historical growths, added the necessary glamour. There were hardly any rumbles of cultural starvation. What was lacking was the solidity of European audiences, which was the butt for musical shock and which gave many composers an additional incentive to commit sacrilege. The composers Alejandro Caturla, Amadeo Roldan and Silvestre Revueltas, by their inclusion of indigenous folk music, simply installed recent Western conventions with the same idyllic or barbaric gestures as their national-minded colleagues elsewhere. The awareness that they were dealing with colonial wares stood in the way of a natural attitude to their native music for a long time. C. R.

2186 *Carnaval a Santiago de Cuba: Gloire a Cuba;* Le Chant du Monde LDX-A-4250; Los Matanceros; plate

2187 *Silvestre Revueltas (Durango/ Mexico 1899–1940); Sensemayá (1938);* BR-Archiv no. L 13862; CBS-

BRG 72186 ML 5914; New York Philharmonic Orchestra; conductor: Leonhard Bernstein

2188 *Orgy in Ryhthm: Toffi (1957);* Blue Note BLP-1554/81 554; Art Blakey, Arthur Taylor: drums; Jo Jones "Specs" Wright: drums and timpani; Sabu: bongos and timbales; "Potato" Valdez, José Valiente: congas: Ubaldo Nieto: timbales; Evilio Quintero: cencerro, maracas and tree log; Herbie Mann: flute; Ray Bryant: piano; Wendell Marshall: bass

2189 *Pedro Sanjoan; Liturgia Negra (excerpts);* BR-Archiv no. 57/7241; Münchner Philharmoniker; conductor: George Byrd

Musical Nationalism in Latin America

"Si la Havanne envoie a l'Europe d'excellents cigarres, pour n'être pas en reste de politesse, l'Europe lui expédie un opéra italien, qui jette l'exaltation dans les têtes chaudes de cette contrée…" (Revue et Gazette Musicales Paris III, Jg. Nr. 25, 19. VI. 1836.)
In the end, however, the Latin American countries stopped exchanging manufactured products for items of European culture. As a result of their release from domination by colonial conquerors—nearly all the colonies achieved political independence between 1820 and 1830—these countries have felt the need to emacipate themselves from European domination in the cultural field, too. The first stages in the development of an individual cultural heritage generally only began towards the end of the 19th century, and the process has since been being carried out in clear opposition to European trends. Faced with the historical necessity of using indigenous sources for the creation of a national musical style, the composers have, however, found themselves in a paradoxical situation:
—The idea of creating formally composed music by elevating folk music sources was in itself a child of European Romanticism.
The refinement of musical expression that musical nationalism was striving after drew on European methods of composition, in order to give a generally acceptable form to the artistic result. The flavour of the music was Indo-American, its guarantee of permanence remained European.
—In their efforts to create a national style the composers relied on the music of

that section of the population which was still being oppressed and exploited—but it was still the bourgeoisie who paid for and enjoyed the music originating in this way.
—By virtue of having been a colonial power for centuries, America became a country of the West. Accordingly, a large section of Indian music was obliged to become integrated with European music. Thus the creative scope of the composers was usually limited by the need to conform to an advanced stage of integration into existing cultural patterns and there-

fore the possibility of basic originality was severely limited.
Pentatonic melodies, sustained (rarely asymmetrical) rhythms, and sometimes original Indian instruments find their way into compositions which have an un-sentimental, primitive edge to them. The most famous composers to have adapted Indian sources—Villa-Lobos, Chavez, Ginastera—often avoided direct borrowings; they preferred to be "genuine without being authentic." Asked to define folklore, Villa-Lobos replied that he himself personified

2201 H. Villa-Lobos, Chôros No. 10, Paris, Ed. Max Eschig

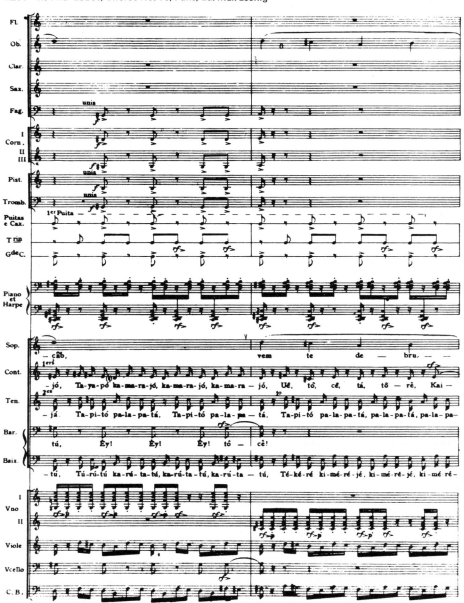

folklore. The younger generation of Latin-American composers finally carried the implications of the futile search for musical nationalism to their logical conclusion by joining in the ever-increasing trend towards musical universality. Although at first sight the universalist attitude seems to imply a rejection of ethnic music, it in fact opens up the possibility of a new approach to the basic elements of ethnic music: the release from traditional European methods of composition (the systems of beat and notation, form, etc.) and the rise of electronic processes in the production of musical sounds make it possible to include more subtle features of ethnic music as material for composition, whereas formerly they were rejected by the Procrustian bed of "formally composed" Western music. R. P.

Music Program

2190 *Peyote Cult Song (South Dakota, USA)*; Ethnic Folkways Library FE 4401; Sioux Indians

2191 *Edward A. MacDowell (New York 1861–1908 New York); Second (Indian) Suite; 1895; Legend, Lovesong, At War, Dirge, Day of Plague;* Desto 6408; Wiener Symphoniker; conductor: Dean Dixon

2192 *Night-Song (Colorado, USA)*; Ethnic Folkways Library No. FE 4420; Navajo Indians

2193 *Ferruccio Busoni (Empoli 1866–1924 Berlin); Indian Fantasy, 1913: Fantasia, Canzone, Finale;* NDR Symphony Orchestra; piano: F. Gebhardt; conductor: H. Schmidt-Isserstedt

2194 *Ferruccio Busoni (Empoli 1866–1924 Berlin); Indian Diary I: 4 Piano Studies on American Redskin Motifs;* Gunner Johanson: piano

2195 *Stag Dance (México);* Yaqui Indians from Potam (Sonora, Mexico); record "Música indígena del Noroeste" produced by the Museo Nacional de Antropología, México

2196 *Peggy Glanville-Hicks (Melbourne 1912); Prelude and Presto for ancient American instruments;* H8OU-6552; Andre Emmerich Gallery, New York; Charles Collingwood introduces the piece with a commentary on pre-Columbian music

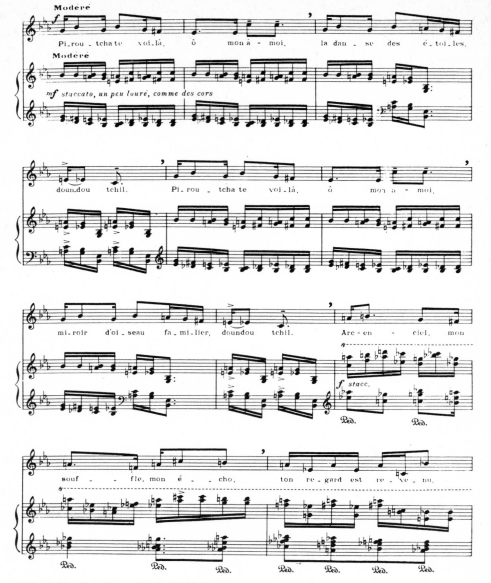

2203 O. Messiaen, Harawi, Paris, Ed. Alphons Leduc

2197 *Silvestre Revueltas (Santiago Papasquiaro 1899–1940 México D.F.O.); Cuanahuac, 1931;* SWF; SWF Symphony Orchestra; conductor: Alfons Rischner

2198 *Carlos Chávez (México 1899); Sinfonía India; 1936;* Col. MS-6514; New York Philharmonic Orchestra; conductor: Leonard Bernstein

2199 *Song of the Kraho Indians (Brazil);* Ethnic Folkways Library FE 4311

2200 *Heitor Villa-Lobos (Rio de Janeiro 1887–1959 Rio de Janeiro); Uirapurú, 1917, symphonic poem;*

Everest 5 DBR-3016; Stadium Symphony Orchestra of New York; conductor: Leopold Stokowski

2201 *Heirot Villa-Lobos (Rio de Janeiro 1887–1959 Rio de Janeiro); Chôros No. 10, 1925;* Cop. L 8043; Los Angeles Symphony Orchestra and Choir; conductor: Werner Janssen; plate

2202 *Maisadito Quebradino (Perú);* OCR 30; Indian Q'eros (Paucartambo/Perú)

2203 *Olivier Messiaen (Avignon 1916); Harawi, Chant d'amour et de mort, 1945;*

IV: *Doundou Tchil; V: L'amour de Piroutcha; VIII: Syllabes; XI: Katchi-katchi les Étoiles; XII: Dans le noir;* BR, Dok. 777/778; Gabriele Dumaine: soprano; Olivier Messiaen: piano; plate

2204 *Yaravi (Perú);* OCR 30; Indian Q'eros (Paucartambo/Perú);

2205 *Alberto Ginastera (Buenos Aires 1916); Cantata para América Mágica; prelude and song of dawn, nocturne and love-song, song for the warriors' farewell; fantastic interlude, song of death and destruction, prophetic song;* Raquel Adonaylo: soprano; Los Angeles Percussion Ensemble; conductor: Henri Temjanka

The Instruments

The instruments alone, of all the various features of the music belonging to the colonized tribes of Africa and America, were capable of indicating their own power and greatness in the colonial museums. They acted more as political exhibits than as instruments available for musical use. Their sound, usually associated with a high resonance factor, conflicted with the rationalized nature of European music, with its commitment to standardized systems of pitch. Where importance was attached to sound, it was not as a quality desired for itself but as a means to an end in presenting the rhythm or in conveying mystical, magical "irrational" ideas. The sound, as an element of music, remained locked in a pre-aesthetic state and could therefore later be taken over unadulterated, together with the aura one associates with primitive peoples. Just as in 19th century opera the choice of themes with an oriental flavour and the use of a few metal idiophones, here the so-called "primitive" instruments served to lend the scores an exotic atmosphere. Discreetly hidden at first, like the pumpkin-scraper "Guiro" in the orchestral tutti of Stravinsky's "Le Sacre du Printemps," it later came to the fore in Milhaud's music as a means of reinforcing the rhythm or in order to imitate primeval forest sounds. "The Story of the Soldiers" marks a turning-point. In the varied modes of playing among the percussion instruments Stravinsky tries to rationalize the sound and render it more pliable musically and to enrich the limited range of tonal quality. Without the influence of jazz percussion instruments, and without the upheaval of the war, (which called

into question the authority of the colonial powers) the instrumental combination in Stravinsky's "Soldaten" would be almost inconceivable.
The resulting change of attitude can immediately be deduced from the number of percussion and shaking instruments in proportion to the number of string and wind instruments.
Edgar Varese was the most consistent of all in this respect. His aims, it is true, were directed towards a form of music that could be performed by electronic devices. However, since these devices were still in the process of development in the twenties, and were therefore unusable, he resorted to instrumental combinations that were somewhat unusual for that time. "Offrandes" (1921) is scored for performance by a soprano voice in combination with a harp, 8 wind instruments, a 5-piece string orchestra, and nine percussion and shaking instruments to be played by one instrumentalist. In "Integrales" (1926) Varese employs 11 wind players and 4 percussion players on 19 instruments. "Ionisation" (1934) is performed by 12 percussion players on 35 instruments, and one pianist; the instruments include several Afro-American types such as cencerros, bongos, guiros, claves and maracas. Varese did not regard these instrumental means as an archaic form of release from unwanted tradition and therefore unsuited to his purposes. It was not until two to three decades later that musical development reached the point where quality of sound became an acceptable component of composition, and thus became a musical element in its own right. No longer restricted to magical settings, no longer in the role of a primitivistic counterbalance to the more subdued system, but now occupying a position on the edge of a fully integrated fabric of sound. Called into existence and brought to the level of consciousness by the problem of the opposition between determinative and non-determinative— instrumentally discordant, as a sinus-tone resonance strip point of departure in electronic rendering. Conditioned by the quality of sound and method of playing, the imponderables of instrumental composition and rendering were accepted without question. Sound and acoustic affect were no longer seen as fundamentally contrasting features but as varying degrees of unknown quantities. European-American music acquired a new dimension through the concept of a continuum of sound; and as a result the problem of transition and contrast in the field of leit-motif and theme was substantially transferred to that of tonal

colouring and texture. It was above all the non-European, African and Afro-American musical cultures that provided the fresh range of instruments to put this into practice. C. R.

African and Afro-American Instruments and their Use in Symphonic Music

A program of recorded music demonstrates sounds from original sources (Africa and America) as well as certain recent musical compositions. A simultaneous photo-mural program shows methods of playing the instruments and the scores. C. R.

Rattles

2206 *Cameroon; Dance Rattle (Double Rattle);* wickerwork with rattle filling; h - 10 cm, w - 7 cm; acquired in 1896; Hannover, Niedersächsisches Landesmus., Völkerkunde-Abt.

2207 *Cameroon; Dance Rattle (Double Rattle);* wickerwork with rattle filling; h - 36 cm, w - 30 cm, ⌀ 15 cm; acquired in 1915; Hannover, Niedersächsisches Landesmus., Völkerkunde-Abt.

2208 *Latin America; Two Maracas* (»Rumbakugeln«); hollow calabashes with handles and rattle filling; rhythm instrument of Latin American music; Munich, Karl Peinkofer

Recordings
Dahomey (Mariba); Calabash Rattles; Funeral Song; OCORA OCR 17, Side A, no. 9
Pierre Boulez; Le Marteau sans Maître (1954); conductor: Robert Craft; Odyssey 32 16 0154; publisher: U. E. 12652, pp. 47/48 (slide)

2209 *Ivory Coast (Baule); Gourd Rattle;* bottle-gourd with string net and seeds; h - 38 cm, ⌀ 18 cm; Basle, Mus. für Völkerkunde und Schweizerisches Mus. für Volkskunde

2210 *Haiti; Gourd Rattle;* net cover, snake knuckles and glass beads; l - 18.5 cm; Basle, Mus. für Völkerkunde und Schweizerisches Mus. für Volkskunde

2211 *Brazil; Gourd Rattle »Cabaza«;* net covering made of fruit pips is rubbed against the body of the rattle; rhythm

instrument of the Brazilian samba;
Munich, Karl Peinkofer

Recordings
*Ivory Coast (Baule); Gourd Rattle
"Towa";* outer rattle covering of kauris or
beads; Song for the Arrival of the Mask;
OCORA OCR 34, Side A, no. 1

*Heitor Villa-Lobos; Bachianas Brasileiras
No. 2: Toccata (1930);* Orchestre Na-
tional de la Radiodiffusion Française;
conductor: Heitor Villa-Lobos; BR-
Archiv no. 65/9435; L 14872; Angel
35547

2212 *Brazil; Two Chocalhos (tubular
rattles);* closed bamboo or metal tube
with rattle filling; rhythm instrument of
the Brazilian samba; Munich, Karl Pein-
kofer

Recordings
Cameroon (Bamun); tubular rattles
(bamboo); King's dance "Ndanjé" at the
court of the Sultan of Bamun; OCORA
OCR 25, p. A. no. 5

Columbia (Guapi); tubular rattles
"Guasá"; "Currulao Cantado"; None-
such H-72036 ST

Rolf Liebermann; Concerto for Jazzband
and Symphony Orchestra (1954)
(Mambo); Kurt Edelhagen Orchestra;
BR Symphony Orchestra; conductor:
Paul Strauss; BR-Archiv no. 55/13102;
publishers: U. E. 12358, p. 99 (slide)

2213 *Guinea (Kissi); a) Calabash
Sistrum "Wasamba";* angular branch of
which one part is the handle, while on
the other fruit skins are loosely assem-
bled; l - 64 cm, w - 36 cm; Basle, Mus.
für Völkerkunde und Schweizerisches
Mus. für Volkskunde; *b) a European copy
of a wasamba rattle;* Carl Orff uses the
instrument in "Prometheus"; Munich,
Karl Peinkofer

Recording
Ivory Coast (Baule); Sistrum "Krindiè";
Music for an Initiation Ceremony;
OCORA OCR 34, side A, no. 8

2214 *Latin America; Stick Rattle (Stab-
pandeira);* a wooden frame with a handle
contains two metal bars, each hung with
two brass plate discs; rhythm instrument
in Latin American music; Munich,
Studio 49

Recording
Pierre Boulez; Le Marteau sans Maître
(1954); conductor: Robert Craft;

Odyssey 32160154; publisher: U. E.
12652, p. 19 (slide)

Scrapers

2215 *México; Guiro (Gourd Scraper);*
notches on the back of a gourd (usually
fish-shaped) are scraped with a small
stick; l - 63 cm, ⌀ 11.5 cm; Basle, Mus.
für Völkerkunde und Schweizerisches
Mus. für Volkskunde

Recording
Karlheinz Stockhausen; Zyklus für einen
Schlagzeuger (1960); Max Neuhaus;
Wergo WER 60010; publisher: U. E.
131860, one page (slide)

2216 *Latin America; Reco-Reco
(Wooden Scraper);* grooves carved into
the back of a bamboo section are used as
a scraping surface; the scraping is carried
out with a spliced bamboo leaf; Latin
American rhythm instrument; Munich,
Karl Peinkofer

Recordings
Cameroon (Banun); Wooden Scraper;
Youth Dance; OCORA OCR 25, side A,
no. 6

Brazil; Reco-Reco no. 1; Batucada
Fantastica; Riviera 521006 P

Heitor Villa-Lobos; Uirapurú (1917);
Stadium Symphony Orchestra of New
York; conductor: Leopold Stokowski;
Everest 31409 ST; publisher: Associated
Music Publishers 19461, no. 9 (slide)

Percussion Bells

2217 *West Africa; Double Bell;* iron,
clapperless; hit on the exterior; h - 30,
w - 22, ⌀ 8 cm; war bell; acquisition:
1927; Hanover, Niedersächsisches
Landesmus., Völkerkunde-Abt.

2218 *West Africa; Double Bell;* clapper-
less; hit on the exterior; h - 55, w - 34,
⌀ 12 cm; dance bell; Hanover, Nieder-
sächsisches Landesmus., Völkerkunde-
Abt.

2219 *Latin America; Two Cencerros;*
iron, straight sides, clapperless; hit on the
exterior; rhythm instrument of Latin
American popular music and dance
music. The African double bells is the
forerunner of the cencerro and the
Brazilian double bell "agôgô"; Munich,
Karl Peinkofer

Recordings
Dahomey (Abomey); clapperless double
bell made of iron; Music for the Prince
Festival; Contrepoint M. C. 20093,
side A, no. 1

Brazil; clapperless double bell "agôgô";
Saba SB 15102 ST, side A, no. 1

Pierre Boulez; Le Marteau sans Maître
(1954); conductor: Robert Craft; Odys-
sey 32 16 0154; publisher: U. E. 12652,
p. 65 (slide)

Percussion sticks

2220 *Latin America; A Pair of Claves;*
sticks made of ebony or palisander; the
claves player is the timekeeper of the
Latin American orchestra; Munich, Karl
Peinkofer

Recordings
Claves; Carnaval à Santiago de Cuba;
Le Chant du Monde LDX-A-4250, side B,
no. 7

Orgy in Rhythm ("Ya, Ya"); the wood-
block heard in this piece takes over the
role of the claves; Blue Note BLP 1555

Pedro Sanjoan; Liturgia Negra; Münch-
ner Philharmoniker; conductor: George
Byrd; BR-Archiv no. 57/7241

Drums

2221 *Latin America; A Pair of Bongos;*
single-headed, open drums; Munich,
Studio 49

Recordings
Ivory Coast (Dan); several small, single-
headed, open drums are tied to the main
drum and played by a drummer with his
hands; Drum Music for the Circumcision
Ceremony; Bärenreiter-Musicaphon
BM 30 L 2301, side A, no. 3

Orgy in Rhythm ("Abdallah's Delight");
bongos, played with sticks; Blue Note
BLP-1555

Pierre Boulez; Le Marteau sans Maître
(1954); conductor: Robert Craft; Odys-
sey 32 16 0154; publisher: U. E. 12652,
p. 12 (slide)

2222 *West Africa; Chief's Palaver Drum*
with curved drumstick; single-headed
drum; stretched hide; h - 105, ⌀ 25 cm;
acquisition: 1910; Hanover, Nieder-

sächsisches Landesmus., Völkerkunde-Abt.

2223 *Togo* (Agotime); *Single-headed Cylinder Drum* with a carrying cord; wooden bowl with animal-skin membrane ;h - 52 cm; late 19th cent.; Berlin, Mus. für Völkerkunde, Musik-ethnologische Abt.

2224 *Latin America; Three Congas* (also Tumbas or Tumbadoras); cylindrical, single-headed, open, upright drum; Munich, Studio 49

Recordings
Kongo (Ba-Congo-Nseke); cylindrical, single-headed, open drums; Dance for the Conclusion of the Funeral Ceremony; OCORA OCR 35

Orgy in Rhythm ("Come out and meet me tonight"); congas; Blue Note BLP-1555

Brazil; the "atabaques" drums are of a similar shape to the congas, only bigger; like the congas they are played with the hands; Saba SB 15102 ST, side A, no. 1

Karlheinz Stockhausen; Tumbas (= Congas); Kreuzspiel (1951); WDR MU 10368/3 (Fr. 6388); publisher: U. E. 13117, p. 1, (slide)

2225 *Two Tom-Toms;* barrel-shaped drum, originally single-headed and open, nowadays double-headed; Munich, Studio 49

Recordings
Nigeria (Hausa, Zaria); heavy peasant drum ("masugangan noma"); barrel-shaped, double-headed drum played with two hooked sticks; Song of Praise; Bärenreiter Musicaphon BM 30 L 2306, side A, no. 4

Dave Brubeck Quartett; Tom-tom; Time further out (Far more drums); Joe Morello (percussion); CBS BPG 62078, side B no. 1

John Cage; Tom-tom; Amores (Trio II) (1943); publisher: Peters 6264, p. 6 (slide)

2226 *Ivory Coast* (Korhogo); *Hour-glass drum;* h - 37, ⌀ 16 cm; acquisition: 1960, Neuchâtel, Musée d'Ethnographie

2227 *Togo; hour-glass drum with stick;* h - 32, ⌀ 17 cm; acquisition: 1924; Hanover, Niedersächsisches Landesmus., Völkerkunde-Abt.

Recordings
Dahomey (Dendi); two hour-glass drums "Hara" and two double-headed drums "Gangan"; Song of Praise; OCORA OCR 17, side B, no. 3

2228 *Jazz Percussion Instruments:* a bass-drum, two tom-toms, a snare-drum, two cymbals, a sizzle cymbal; two cow-bells, a wood-block, a cylindrical drum and a triangle; Munich, Studio 49

Recordings
Orgy in Rhythm ("Split Skins"); jazz percussion; Art Blakey, Arthur Taylor, Jo Jones; Blue Note BLP 1554

2229 *Congo* (Batetela); *Wood-slit drum;* l - 36, h - 18, w - 12 cm; Basle, Mus. für Völkerkunde und Schweizerisches Mus. für Volkskunde

2230 *Europe; Imitation wood-slit drum;* Munich, Karl Peinkofer

Recordings
Congo (Topoke); Wood-slit drum ("talking drum"); Folkways FE 4477, side B, 4a

Karlheinz Stockhausen; "Gruppen" for three orchestras (1955–1957); conductors: Karlheinz Stockhausen, Bruno Maderna, Michael Gielen; DGG ST 137002; publisher: U. E. 13673 (slide)

Sansa

2231 *Cameroon; Sansa or Mbira;* l - 33, w - 14, h - 7 cm; acquisition: 1915; Hanover, Niedersächsisches Landesmus., Völkerkunde-Abt.

2232 *Ivory Coast* (Dan); *Sansa;* seven bamboo tongues; three heads are carved on top of the wooden resonance box: l - 42, w - 18, h - 4 cm; built before 1937; Neuchâtel, Musée d'Ethnographie

2233 *Angola* (Tyivokwe Lunda); *Sansa;* 23 metal tongues; the wooden body is ornamented with carvings; l - 26, w - 18, h - 6 cm; built before 1932–33; Neuchâtel, Musée d'Ethnographie

2234 *Europe; Imitation Sansa;* Munich, Karl Peinkofer

Recordings
Ivory Coast (Dan); Sansa; Bärenreiter-Musicaphon, side A, no. 7

Hans Werner Henze; El Cimarrón; conductor: Hans Werner Henze; DGG 2707050

Banjo

2235 *Senegal* (Wolof); *Halam;* four-stringed lute; the metal resonance box is covered with horse hide; the halam is probably the African forerunner of the banjo; h- 84, w - 13, ⌀ 12 cm; made before 1937; Neuchâtel, Musée d'Ethnographie

Recordings
Senegal (Wolof); Music of the Griots; two halams; instrumental duet. Collection Radiodiffusion Outre-Mer, side B, nos. 7–8

Louis Armstrong's Hot Five (1925); Johnny St. Cry (banjo); Odeon OPXH 1018, side A, no. 4

Ernst Křenek; Jonny spielt auf (1927); BR-Archiv no. 69/23127 ST; publisher: U. E. 8623, p. 46 (slide)

Percussion Idiophones: Xylophone, Marimbaphone, Vibraphone

It is highly probable that percussion instruments reached Africa from Indonesia. The music ethnologists A. M. Jones and Jaap Kunst have detected spectacular similarities and correspondences in Indonesian and African instruments by means of sound measurements. This relationship of origin is also shown by the construction of the resonators (calabash or wood trough), by the special playing method, with forked sticks or two sticks in either hand, and several people at one instrument, and by the employment of various exemplars in one orchestra. The xylophone crossed from Africa to America as the "marimba." In Europe, too, the xylophone had long been known by several different names (wooden laughter, Strohfiedel, Holz-harmonika, Zilafone, Claque-bois etc.), but was not used in the orchestra. It is not even mentioned in the Theory of Instrumentation by Berlioz/Strauss (1844, 1856, 1904). In about 1830 a Russian jew by the name of Joseph Gusikow went from one European capital to another and shone as a xylophone virtuoso. He attracted the attention of Chopin, Liszt and Mendelssohn. In 1870 or so, the instrument aroused new interest when Charles de Try, the manufacturer and virtuoso, produced it under the name of "Tryphone." It may be assumed that as a result of this, Camille Saint-Saëns was the first to use it in his works "Danse Macabre" (1874/75) and "Carnival of the Animals" (1886). As in "Danse

335

Macabre," where it was used to imitate the rattling of bones, it was subsequently employed programmatically and impressionistically, as in Humperdinck's "Hansel and Gretel," (1893), Mahler's Sixth Symphony (1904), Strauss's "Salome" (1905), Schönberg's "Gurrelieder" (1900, instrumental arrangement in 1911), Debussy's "Ibéria" (1910) and Stravinsky's "Firebird" (1910), "Petruschka" (1911) and "Les Noces" (1917). Since Bartók's "Sonata for Two Pianos and Percussion" (1938) at the latest, the xylophone has constituted an instrument that is "absolute," and free from programmatic associations. In the orchestra of today, three xylophones are generally distinguished according to their range: soprano, tenor and bass. All three possess metal pipe resonators; the notes are arranged in the form of a keyboard with the exception of the rare Trog xylophone, which has a row of metal plates. C. R.

2236 *Guinea (Malinke); Xylophone on wooden trinks with calabash resonators;* h - 92, w - 47, ∅ 29 cm; Basle, Mus. für Völkerkunde und Schweizerisches Mus. für Volkskunde

2237 *European orchestral xylophone;* Munich, Studio 49

2238 *Dogon (Africa); Two Balafonplayers;* carved wood; h - 44 cm; Paris, Hélène Kamer

Recordings
Gabon (Fang); Xylophone "Melane" (on banana-tree trunks without resonators); Death Cult Music; OCORA OCR 41, side A, no. 3

Charles-Camille Saint-Saëns; Danse Macabre (1874–75); NBC Symphony Orchestra; conductor: Arturo Toscanini; RCA LM 7001/2c

Béla Bartók; Sonata for two pianos and percussion, 3rd movement (1937); Karl Herrmann and Begonia Uriarte Mrongovius (piano); Hanug Hölzl and Horst Huber (percussion); BR-Archiv no. ST 70/22964; publisher: Boosey & Hawkes 8675, p. 65 (slide)

2239 *European Marimbaphone;* Munich, Studio 49

Recordings
Central Africa (Linda); Xylophone with calabash resonators; OCORA OCR 43, side A, no. 3

Cameroon (Beti); Orchestra of five different xylophones with rhythmical accompaniment form two bamboo shakers; instrumental version of a song of praise for an old, distinguished person; OCORA OCR 25, side A, no. 1

Columbia (Buenaventura); Marimba; lullaby and Christmas carol; Nonesuch H-72036 ST; plate

Pierre Boulez; Marimbaphon; Le Marteau sans Maître (1954); conducted by Robert Craft; Odyssey 32160154; publisher: U. E. 12652, p. 12 (slide)

2240 *Vibraphone*
In the "Handbuch des Schlagzeugs," Mainz 1969, by Karl Peinkofer and Fritz Tannigel, it is stated that the plates of the vibraphone are manufactured from a certain, very hard light metal alloy. They hang in the form of a keyboard, as does the marimbaphone, over metal resonance pipes. A "damping" effect is made possible by a pedal-controlled, felt-covered rod which is pressed against the end of the row of plates. A metal disc is made to rotate by a small electric motor over every pipe. The vibration of the sound tubes is caused by the fast air movement after the notes have been struck; slower and faster "vibrations" can be obtained if the rotation speed of the motor is adjusted. Munich, Studio 49
The vibraphone was used at first in the realm of entertainment music. It was due to the jazz musicians Lionel Hampton, Milt Jackson and others, who played with virtuosity and nuance, that composers, too, gradually began to make use of it.

2239 Marimbaphone, Mexico, Berlin, Staatliches Institut für Musikforschung, Musikinstrumentenmus., No. 4092

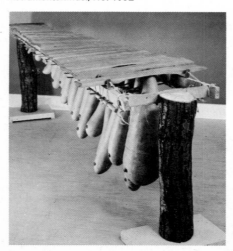

Recordings
The Modern Jazz Quartet; How High the Moon; Milt Jackson: vibraphone; Atlantic 1325, side B, no. 2

Pierre Boulez; Le Marteau sans Maître (1954); conductor: Robert Craft; Odyssey 32 160154; publisher: U. E. 12652, p. 60 (slide)

Musical Instruments of the American Indians

2241 *México Ayacaxtli;* rattle made of a gourd or clay; Gasparo Spontini used this rattle for the first time in his opera "Fernando Cortez" (1809)

Recording
México (Yaqui); Las Pascolas; Folkways FW 8851, side A, no. 3

2242 *Paraguay (Chamacoco); Chain rattle (rattle belt);* l - 103, w - 16 cm; Basle, Mus. für Völkerkunde und Schweizerisches Mus. für Volkskunde

Recording
North America (Great Lake Indians); dance rattle (foot bells); Folkways FM 4003, side A, no. 5

2243 *México; Jicara de Agua;* the upside-down half of a gourd swims in a basin of water and is hit with a stick; México, Ramón Pelinski

Recording
México (Yaqui) "Water drum" (Water gourd); Deer Dance; Folkways FW 8851; side A, no. 1

2244 *México; Double-headed drum;* México, Instituto Nacional de Bellas Artes

2245 *Europe; Two imitation Indian drums;* Munich, Karl Peinkofer

Recording
México (Zapoteken); Drum and Chirimía (flute); Firework Music; Folkways FW 8851, side A, no. 2

2246 *México; Teponaztli;* wooden tongue slit-drum (two tongues); acquisition: 1871; Hannover, Niedersächsisches Landesmus., Völkerkunde-Abt.

Recordings
Teponaztli; Folkways FW 8851, side B, no. 8

Carlos Chávez; Sinfonia India (1936); excerpts; New York Philharmonic

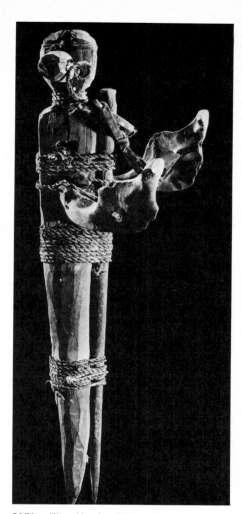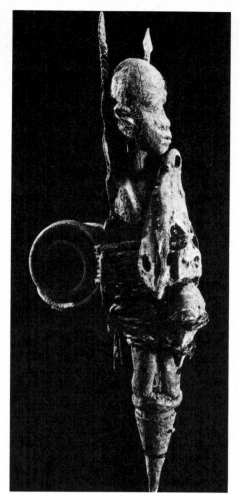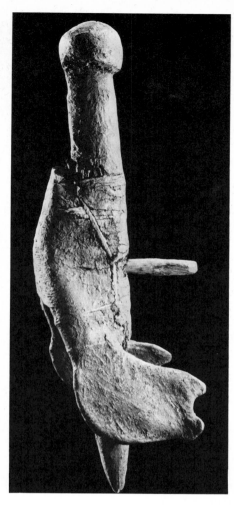

2251a Three Voodoo Objects, Dahomey, Monsieur Kerchache Coll., Paris

Orchestra; conductor: Leonhard Bernstein; BR-Archiv no. 69/11346 ST; publisher: Schirmer 56, p. 79 (slide)

Pre-Columbian music; various Ancient American instruments (commentary in English); H8OU-6552, side A; Andre Emmerich Gallery, New York

Peggy Clanville-Hicks; Prelude and Presto for Ancient

American Instruments (1957); H8OU-6553, side B; Andre Emmerich Gallery, New York

2247 *Brazil (Aparai); Two knuckle rattles* made of almond shells; Basle, Mus. für Völkerkunde und Schweizerisches Mus. für Volkskunde

2248 *North America; Padlermiut-Eskimo; frame drum of a shaman;* ⌀ 80 cm;

Basle, Mus. für Völkerkunde und Schweizerisches Mus. für Volkskunde

Jazz and Symphonic Music

2249 *A story in Pictures:* Africa – Slavery – America – First Meeting – Cakewalk – Ragtime – Blues – Jazz Compositions between 1945 and 1954 – Opera – Latin America

Film Section

2250 *Ivory Coast; Baule Tribe; Molonou Village;* Drum Music for a Dance of Welcome; BR television; Klaus Kirschner: producer; Pitt Koch: camera; Paco Joan: assistant; Christa Hegemann: cut; Volker Josewski: tone

2251 *Ivory Coast; Guere Tribe; Bledi Village;* Drum Music for a Mask-Dance; BR television; Klaus Kirschner: producer; Pitt Koch: camera; Paco Joan: assistant; Christa Hegemann: cut; Volker Josewski: tone

2251a *Dahomey (Fon); Five Voodoo Objects:* wood, cords, blood, h - 17 cm; wood, jawbones, cords, blood, h - 25 cm; wood, skullbones, iron, cords, h - 39 cm; wood, skullbones, h - 47 cm; wood, skullbones, iron, h - 49 cm; the nails which are hammered into the figures serve as magical means to harm an enemy; Paris, Monsieur Kerchache; plate 337

Sound Centre

New World Music

Dieter Schnebel

Uniform Musical Culture of the Industrial Countries
As the twentieth century advances, the official musical culture of the industrial countries has become increasingly standardized, even uniform. As was already the case in Europe during the second half of the last century, so today the musical organizational setup ensures that roughly the same programs are presented throughout the world. These universal programs, which vary from country to country at the most in a very slide national emphasis, are sub-divided into opera, symphony concerts, chamber music and solo concerts, which offer the standardized repertoire of the bourgeois music of Europe. Their monopoly is based on the various mediums of their production. The once established and today subsidized musical institutions of opera houses and concert halls with their ensembles, and the departments for classical music in radio modelled upon them, reproduce the repertoire which they have inherited.

Stress on Latent Traditions During the Early Twentieth Century
Standardized instrumental ensembles and established conventions in the reproduction set the tone, as it were, for new productions, so that these of course were severely restricted in scope. The outstanding composers of the early decades of this century sought to break out of these confines by attempting to save what was special and not commonplace, even in some specific culture, in that they, on the one hand, stressed the personal note in their music and, on the other, incorporated in their compositions the latent or, as was more often the case, the nonaccepted (i . e. not part of the official programs) music of their own countries. This is by no means the same as saying they disseminated the folklore of their homelands, which was in most cases already commercialized anyway. No, it means rather that, like Bartok and Janácek, Stravinsky and Ives, they unearthed half-forgotten music of the past or music not held in very high esteem. Even the composers of the Viennese School are not above relapsing occasionally into their Viennese dialect. These were elements which could all easily be brought into conformity with the standardized methods of production, but of course they were not particularly well

received unless they happened to be presented with the cosmopolitan aplomb of say Stravinsky. However, as soon as the composers rebelled against the accepted means of production by writing for unwieldy or even unusual ensembles or by breaking the conventions of reproduction—as did Ives and later Edgard Varèse and Webern—then they were punished with non-performance.

After 1945 a Musical World Language with Exotic Sounds
The music produced after the second world war, especially in Europe, marked a new beginning. The new music was distinguished from the old in that it lacked to a large extent both the traditional reglementation and regional colouring. We can almost talk of the birth of a futuristic world language. Although the new compositions stemmed from western music, they did not necessarily demand a knowledge of this for their understanding. They were the creations of composers hailing from all the industrialized countries, without more than hidden regional reminiscences: the serial music of a Korean has as little of the oriental about it as that of a Swede has of the Nordic. This rather uncharacteristic and seemingly traditionless world music of a technological age at first avoided employing the customary apparatus of the bourgeois era. The usual operatic and concert forms were scorned and the compositions were written for unorthodox ensembles—for example, Stockhausen in "Kreuzspiel" (written for oboe, bass clarinet, piano, six tom-toms, two congas and four cymbals) or Boulez in "Marteau" (for alto flute, vibraphone, guitar, viola and percussion drawn from even further afield than in Stockhausen). Or composers availed themselves of the means of production offered by modern radio-technology (musique concrète, electronic music).

New Levelling Process—Excursus on Messiaen
The sounds produced by these unorthodox ensembles were alien to western ears, especially as the newly discovered percussion instruments aroused associations of the distant lands from which they were derived. Thus, the universalist language of the new music began to acquire a sound of its own—and to have an exotic brilliance about it, although the musical languages of the other cultures were not assimilated. This assimilation only happened in individual cases like that of Messiaen. And perhaps Messiaen is the only composer who really does have a broadly based knowledge of ex-

otic music; he alone has mastered their composition techniques, so that his own work can be genuinely influenced by the music of these other cultures. The exotic elements in his music are not merely aesthetic or ideological—as is still most often the case down to the present day; they arise from the very material he employs: we find Indian, Balinese or Peruvian composition techniques used, however in such a way that the heterogeneous elements are merged into the overall conception of the composer. There is something of the mystic and visionary about this—redolent of the thinking of Teilhard de Chardin. Messiaen can also be regarded as one of the great protagonists where universalist music is concerned because he combines the mystical approach with his aspirations as a composer, a combination incidentally which is also noticeable in recent efforts to try and incorporate the music of other peoples. Otherwise the new music has once again lost this alien colouring—or reduced it to the mere decorative effect. For the more the new exoticism gained ground among composers, the more evident becomes the tendency to bring it into line with accepted cultural standards and the more often the available apparatus was taken advantage of: orchestral works, and even operas and pieces for soloist performance on traditional instruments flowed from the composer's pens once again. We also notice a regress of the musical language spoken in the direction of the monopolistic bourgeoise music.

Exotic Instruments in American Music from About 1930 to 1940
The instruments of exotic cultures were employed in America at a considerably earlier date. Varèse's "Ionization" (1931) was written for a whole arsenal of strange percussion instruments: Chinese gongs and woodblocks, African bongos, South-American güiros, cencetros, and maracas. (The percussion section has always been the area where exotic instruments have had the best chance of adoption in European music with its one-sided orientation on notes.) Varèse's example was followed by John Cage around 1940. At that time Cage composed a whole series of works for percussion (e. g. a "Quartet" for twelve tom-toms, a "Trio" for seven woodblocks or the "Third Construction" for a very colourful ensemble: rattles, bass and side drums, tin cans, claves, cow bells, lion's roar, cymbal, clapper, teponaztle, quijadas, cricket caller and conch shell). Such compositions were supplemented by others for the prepared piano. This new music arose as the result of the search for

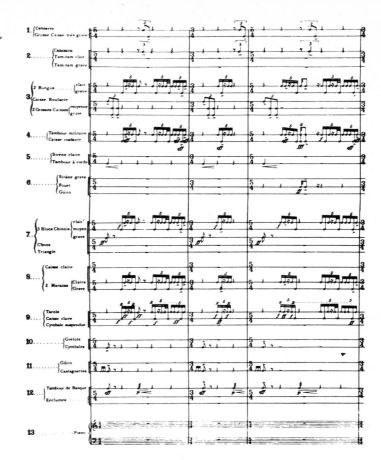

2267 Varèse, Ionisation, New York, Ed. Columbo

new, "unoccupied" sounds: composers left the overpopulated region of notes and entered the unchartered zones of noise, where much that was new awaited discovery. Accordingly, the exotic sounds in Cage's music, and later in that of Stockhausen and Boulez, are not so much quotations from foreign cultures; they have more of general strangeness about them—in other words, they are rather "atraditional": they are the attempt to avoid previous music.

Excursus on Debussy
Cage's relationship to exotic music is, in a certain sense, similar to that of Debussy, who was fascinated by the strangeness—because unaccustomed—of exotic sounds, and for whom the alien structure was welcome in any case since it contradicted the dictates of European academicism. "On the other hand, Javanese music cultivates the art of counterpoint in contrast to which Palestrina's appears to be mere child's play. And if, free of all European prejudice, one listens to the attraction of their percussion, then one will be forced to admit that what we call percussion is a barbaric circus noise." Since Debussy

was set on reorganizing the musical interrelationships and aimed at a composition of scintillating sound, exotic music coincided with his own intentions. However, the exoticisms in many of his works evoke an atmosphere of far away places, rather than cite the music directly or even incorporate it in the texture of his own. The result was that even Debussy brought no real confrontation with exotic music which would then have influenced the technique of composition, too.

The East as Expressed in the Music of Cage
Certainly Cage later incorporated exotic relationships into his own exotic pieces. "Bacchanale" (1938), his first composition for the prepared piano he explained by the need he felt to express percussive effects without percussion instruments. On the other hand, when speaking of the prepared piano in "Amores", he says: "Upon this instrument an attempt was made to express in combination the erotic and the tranquil, two of the permanent emotions of the Indian tradition." And, concerning the "Sonatas and Interludes" for the prepared piano, he comments:

339

MUSIC OF CHANGES

John Cage

2322 J. Cage,
Music of Changes,
New York,
Ed. C. F. Peters

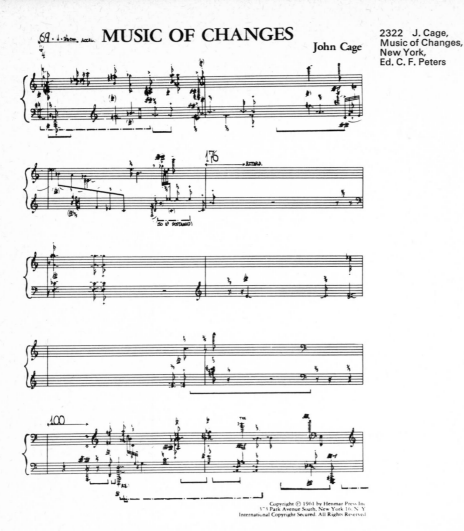

principles of Far-Eastern mystical philosophy employed as principles of composition.

The result sounded just as little like Far-Eastern, as it did like European music. The effect was rather of music utterly severed from tradition, which was to be expected, since, after all, we are here faced with experimental music whose aim it was to to bridge the gap between East and West, to do away with the distinctions. At first Cage's music only penetrated into the work of European composers sporadically. When Cage came to Europe in 1958, his influence became enormous and at the same time he was accorded more recognition at home in his own country. With the vigour of a catalyst, he suddenly released a whole series of forces, sparked off numerous processes. The new music became more varied and rich. The uniform language of serial music was abandoned in favour of more colourful idioms.

New Relations to Time in European Music

Cage's atraditionalism first of all aided the birth of a new relationship to time. "Feeling drawn to emptiness, to silence"—that means just letting time run its course, as it were, so that the sounds get enough space. In a whole number of compositions around the year 1960—for example, Stockhausen's "Kontakten" and "Carré," in Kagel's "Transicions," in Ligeti's "Apparitions"—space-giving processes are evident. This tendency caught on: Penderecki's sound surfaces, the flowing tonal clusters of Aldo Clementi's "Informels," the "markingtime" of Luc Ferrari's "Tautologos," and the unending vocalises of Bussotti's "Torso" are all expressions of the trend towards extensional music. This often sounds non-European in as much as it has now given up all pretensions to a thematic character, the work with set formulae, and has surrendered itself to the "instinctive life of the sounds," the flow of which one must listen to in quasimeditation rather than try to piece together into an aural synthesis the particles of the themes and motifs one has registered fragmentally.

Enrichment of the Instrumental Repertoire with Exotic Instruments

Cage's initiative in the field of experimental music also led to the extension of the reservoir of sound. Not only were the available instruments played differently, in an unaccustomed way, to entice every possible sound out of them in addition to the usual ones, but also composers went in search of uncommon instruments

"They are an attempt to express in music the 'permanent emotions' of Indian tradition: the heroic, the erotic, the wondrous, the mirthful, sorrow, fear, anger, the odious and their common tendency toward tranquillity." And in fact Cage—who was anyway far less rooted in tradition than the European composers—had made a thorough study of the quite differently constituted music of the Far East, especially of India, which led to an even greater relativization of tradition in his case. However, it was less Indian music than Indian thinking, indeed oriental thinking in general, which became of importance to him, as he shows in his essay "Forerunners of Modern Music" which he wrote during the late forties. Thus, the exoticism of Cage's music at this time is not so much to be located at the material level—for instance, in the reception of oriental composition techniques—as at the ideological: it is music inspired by the spirit and feeling of Indian thought.

Eastern Philosophy as a Principle of Composition

Nevertheless, a little later, Far-Eastern philosophy also influenced the composition technique. Cage's undermining of traditional musical conceptions led during the fifties to a dissolution of the compositional interrelationships so as to allow the sounds to develop a life of their own. The reasons for this tendency were also sought in eastern music: the musician "should feel drawn to emptiness, to silence. Then things, that is to say the sonic happenings, will enter into their existence of themselves. Why is this so necessary? That sounds can be just sounds. There are many ways of saying why. One of them is this: so that each sound becomes Buddha." Thus, in order to liberate sounds from their preordained and preconceived interconnections, Cage builds in the element of chance into his compositions. To this end he employs chance operations from the ancient Chinese book I-Ging—

and thus gradually discovered all the varieties of the exotic repertoire. Since his "Momente", Stockhausen has made fairly frequent use of the Chinese giant gong, which is stimulated to a wide range of sounds that are then monitored over microphones. Percussionists like Christoph Caskel or Michael Ranta have enlarged the range of instruments at their disposal with a whole number of percussion instruments from distant countries which they then use in their interpretations. In Kagel's film "Duo" a wide variety of native and exotic plucked instruments collected by the guitarist Boettner appear. In his compositions "Sound," "Under Current" and "Acustica", Kagel employs a number of instruments which he discovered himself in practically every corner of the globe. Thus, the outward garb of the new music is as exotic and colourful as that of the youth of today — and of their beat and pop music.

Assimilation of Exotic Music in the Compositions of Stockhausen
Since the instrumental sounds of exotic music had already been incorporated, it was no great step to assimilate the exotic music itself. Karlheinz Stockhausen attempted this in "Telemusik." The composer was not aiming here to write his own music but "a music of the entire earth, of all countries and races," a world music in which what was distant in time (historically) and space ("tele") should be brought together compositionally. Thus, in "Telemusic" modern electronic passages appear "together with taped recordings of music from the southern Sahara, of the Shipibos of the Amazon, of a Spanish village festivity, Hungarian and Balinese music, recordings of temple ceremonies in Japan, etc." as Stockhausen himself informs us. Certainly these materials are so completely fused in the composition that the original is rendered utterly unrecognizable at times and is nowhere able to pulsate with its own inner life. Within the framework of the piece they constitute nothing more than outlandish colouring.

Influence of Exotic Composition Techniques in La Monte Young and Riley
In the meantime the new instrumental music had changed in this sense that to an ever increasing degree the instrumentalist's part assumed greater importance. The musicians no longer played according to the notes they had in front of them; the course the music took was also set by their playing. This means that an improvised, or better a productive,

element now entered into the performance. Cage guided such performance processes experimentally, Stockhausen gave directions for the overall production, and Kagel tended to give detailed instructions. There are also other ways of initiating such processes—for instance, by practices which have been taken over from exotic music, as in the music of La Monte Young soon after 1960. In the compositions of his friend Terry Riley, the music is placed in a state of constant regeneration in that the instrumentalists repeat short motifs while varying them slightly at the same time. In their ensemble a continuous and iridescent sound is produced which gradually changes without any alteration being produced in the substance. Riley had heard a great deal of Indonesian music previously, especially from Bali.

Fusion of New with Exotic Music
Practices derived from exotic music also appear in the improvisation processes which other composers or groups of musicians lay down, such as is evidently the case in the music of Steve Reich or Philip Glass, or in many of the "Improvision Rites which Cornelius Cardew and his Scratch Orchestra have collected. As is well known, Beat groups have also adopted improvisation techniques, especially those of Indian music, or attention has been focused on the productions of the Indian sitar player.

Recently such musical processes have been taken up and so transformed that they are themselves converted into new music which in its turn is characterized by exotic sounds, so that in this way continuums of music of varied origin are created. Such conceptions have captured the imaginations of young musicians (for example, of Peter Hamel and his Sophrosyne Group).

Oriental Tendencies: an Escape from Western Capitalist Culture
Seen as a whole, music begins to sound extremely oriental—strangely enough not so very much southern and African, which is apparently still the preserve of jazz. This could be connected with a general development taking place in the West, in which again the integration of the industrial state Japan in the "western world" also has a role to play. Thus, during the forties in America, and after the war in Europe, the preoccupation of many intellectuals with oriental thought, especially with Zen Buddhism, which had not been without its fashionable element, became a factor to be reckoned with. This rejection of the "western view of the world" was probably bound up with the increasingly intolerable contradictions contained in the late capitalism of the industrial countries. Cage is probably the first to express this rejection among the composers of new music. When his influence increased in Europe

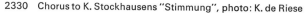

2330 Chorus to K. Stockhausens "Stimmung", photo: K. de Riese

and his concept began to make an impression—his concept of an experimental music which aimed at allowing sounds to evolve, which sought the spaciousness of the whole gamut of sounds, which was inward-regarding—then his leaning towards oriental philosophy began to find imitators, too.

Oriental Philosophy and Composition Techniques
As early as 1960, Karlheinz Stockhausen expressed the wish that "Carré," the work he had just composed, would convey "inner quiet, breadth and concentration"—which betrays his mystical intention. At this same time, Zen-Buddhist rituals—but certainly also the need to revolt—stimulated the Korean Nam June Paik to his absurd compositions with their magnificent explosive intensity. These tendencies became so pronounced that their development into a neo-dadaist movement which caused something of a stir in the European underground and even some sensations on the cultural surface. This was when La Monte Young was performed, who pushed timelessness to the extreme when, in his "Composition 1960, No. 7" or in "566 for Henry Flint," he confined music to eternal uniformity as it were by reducing the sound development to a single happening. Not much later (in 1962) he formulated his idea of a "Dream House" in which a Continuous Live Electronic Sound, and a Light Frequencey Environment are continuously played and in which, in addition, Sung Frequences are freely created by vocalists whenever they feel called upon to produce. "Dream Houses will allow music which, after a year, ten years, a hundred years or more of constant sound, would not only be a real living organism with a life and tradition all of its own but one with a capacity to propel by its own momentum. This music may play without stopping for thousands of years, just as the tortoise has continued for millions of years past, and perhaps only after the tortoise has again continued for as many million years as all of the next order of tortoise to come." All this has a very Far-Eastern ring about it—what Cage had rather hinted at and applied more to music in general is here already applied as a working idea.

Music as Ritual
And this development is carried further. In America, for instance in Riley who is clearly dependent on Zen, in Europe say in Cardew who appeals to Confucius, and soon in Stockhausen too who bases his ideas on Sri Aurobindo. Above all the music "From the Seven Days" is the fruit of quasi Indian mysticism, concretely indicated in the directions for meditation: "Play a vibration in the rhythm of your body ... of your heart ... of your breath... of your thought ... of your intuition ... of your illumination. Play a vibration in the rhythm of the universe." Music performed in this way is transformed into a meditation in which one is invited to take part. Under the influence of the thought of distant lands, the very form of the performance is changed: music as ritual.

World Music in the One World
Accordingly, the new music has been enriched with a number of exoticisms, especially from the Far East: continuous sounds which engulf one, unaccustomed instrumental colouring, quotations from the music of far countries, improvisation practices, alien rituals of performance, music imbued with another spirit—and another philosophy of music, too. In all this there may well be a large element of rejection of one's own native tradition which has been found wanting; all this may well document the failure of western civilization. However, what has still to be attained, even in the world of music which has become universal, is the music of the one world. This will require a great deal of effort to learn about the many strange and peculiar varieties of exotic music—and that means: really getting to know them. Only when one has learnt to appreciate the music of another culture precisely in its otherness and can approach it with sympathy and respect, will one truly be able to fuse it with one's own. Of course, as long as so little has been achieved in the political and social sphere, there is little chance of a genuine world music being created, either. It will only be able to sing of the harmonia mundi when this is a reality—and then not in harmony, but in an unprecedented polyphony.

Translation P. J. D.

The Music Program of the Sound Centre

Ramón Pelinski

The central theme of the "Sound Centre" comprises "the universalistic tendencies of the New Music."
The European musical idiom has become increasingly differentiated since the beginning of the nineteenth century. After the end of World War II this development turned into an attempt to prepare the ground for a synthesis of music cultures extending beyond the borders of Europe. The prerequisites for this were: the relativization of occidental music system, the awareness of affinities and structural analogies between diverse music cultures, the end of colonialism, and both the political and cultural activation of former colonial parts of the globe, the opening of the world, far-reaching information facilities and technical progress. The subsequent discussion took place upon different planes. In the foreground, we have the mastery of new sound material and the effect of foreign traditions of thought.
The western composer handles the sound material of extra-European music quite freely: the specific character of the melody and intonation, above all, however, rhythm and tone-colour, are estranged from their original context, analytically taken apart and employed constructively as sound material. All that remains of the "exotic" element is its essence in so far as it possesses intuitive features in common with new musical thought. The composers perceive and disseminate only that which conforms with the categories of thought of New Music (Kagel). The development of European music leads up to extra-European traditions which conform with its own objectives.
The improvisational technique of Indian music constitutes an analogy with "controlled chance" (Boulez) as a constructional factor of flexible forms of composition. Compositions with an open form, which are based upon static self-evolving time, link up with an eastern time conception: time does not progress teleologically but rotates spirally in itself. The extension of scales of tempo—extremely slow sound processes—and the structural significance of silence, find their models in Far-Eastern music (Stockhausen, Cage, Schnebel, La Monte Young). With the relativization of occidental music systems, the tone, which historically had crystallized out in its clearly delineated interval relations, gives way to momentary sound emission. That which was "not yet music" for the West coincides with western music, which, in the traditional sense, is "no longer music"; the New Music does not ponder on its historical origins, but on the archaically innate element. Past history and the present approach closer to each other (Georgiades). The approximation of composition and performance, the relative insignificance of the sheet of

notes combined with an increased pleasure in improvisation, and the resulting anonymity of musical creativity, are further symptoms of a tendency towards synthesis; outside Europe, music was generally handed down vocally so that the European concept of a compositional work could not arise here.

Ideas from eastern thought become effective over and above purely musical moments: the method of obtaining oracles described in the I-Gring (the old Chinese book of transformations), induces the indeterminancy (chance) in provision of material, invention and performance. Chance then becomes effective under stimulation of Far-Eastern calligraphy: the imperfections of the note sheets determine the position of the tones. In accordance with the Zen-Buddhist doctrine of the direct experience of objects, the tones are positioned autonomously and freed from both continuity and established arrangement (Cage). An eastern ideal is also finally to be noted in the endeavour to reach higher planes of consciousness by means of the meditative playing of music (Stockhausen). On the other hand, the attempts of Asian composers to fuse their own music tradition with "exotic," in this case western techniques of composition, point to the same tendency towards a synthesis of music cultures. Accurate knowledge of one's own musical tradition as available sound material combines here with the command of European techniques of composition, which, probably due to their thoroughly rationalized character, are easier to comprehend than the imponderable subtleties of the Asian music for European composers. The Sound Centre presents a weekly program of New Music of European and extra-European composers alternating with traditional music of Asia, Africa, Oceania and America. Each part of the globe is allocated to its own sphere of sound.

The public has the opportunity of playing the instruments themselves under guidance. Films are shown to demonstrate how the instruments are played in their country of origin.

Translation G. F. S.

Music Program

Traditional and New Music from the Near East

2252 *Turkey, Üçüncü ve Dördüncü Selâmar;* third and fourth salutation of the Mevlevî rite (dervishes); BM 30 L 2019

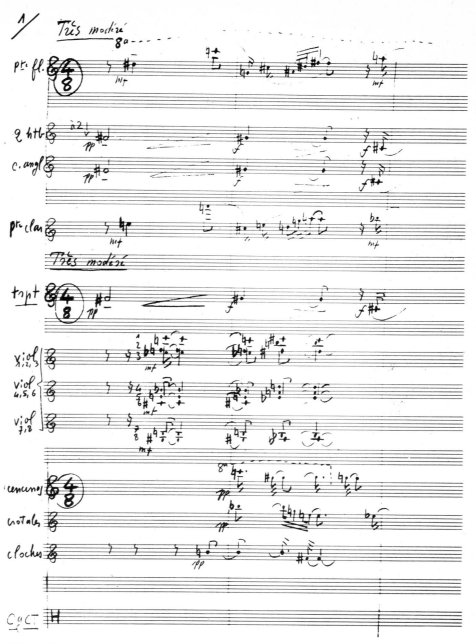

2288 O. Messiaen, Gagaku, from the Sept Haikai, autograph, Paris, Ed. Alphons Leduc

2253 *Iran; The Segâh Mode;* see Cat. no. 9021

2254 *Tunisia; Solo for Qânûn;* BM 30 L 2008

2255 *Iran; Solo for Dombak;* BM 30 L 2005; Teherani, Dombak

2256 *Tunisia; Solo for 'Ud (Tunisian lute);* BM 30 L 2008; improvisation in the Tunisian hasîn mode

2257 *Jacob Gilboa (Czechoslovakia 1920, since 1938 in Tel Aviv); Chagall's Twelve Jerusalem Stained Glass Windows; 1966;* Israel Broadcasting Authority

2258 *Zvi Avni (Saarland 1927, since 1935 in Tel Aviv) By the Waters of Babylon, 1971;* Israel Broadcasting Authority

Afro-American Music and Modern Techniques of Composition

2259 *New Orleans; Funeral Procession Music;* BR; Dieter Dreyer V. D. T.; sound recording; Dejan's Olympia Brass Band; conductor: Harold Dejan

2260 *Gunther Schuller (1925); The Visitation;* Opera; excerpt; BBC, London

2261 *Larry Austin; Improvisations for Orchestra and Jazz Soloists;* Columbia 6733; Don Ellis, trumpet; Barre Philips, bass; Joe Cocuzzo, jazz group; New York Philharmonic Orchestra; conductor: Leonard Bernstein

2262 *Leo Brouwer (La Habana 1939); Exaedros I;* SFB; Stomu Yamash'ta, percussion

2263 *Marlos Nobre (Recife 1939); Mosaico*

2264 *Bernd Alois Zimmermann (Bliesheim 1918–1970 Cologne); Improvisa-*

tions on the Jazz Episodes from the Opera "The Soldiers" Act II; Wer 60031; Manfred Schoof-Quintett

2265 *Hans Werner Henze (Gütersloh 1926); El Cimarrón, Biography of the escaped slave Esteban Montejo, 1969–1970: Part I, no. 4, The Escape; no. 5, The Wood; Part II, no. 8, The Women; no. 13, The Bad Victory;* DGG 2707050; William Person, baritone; Karlheinz Zöller, flute; Leo Brouwer, guitar; Stomu Yamash'ta, percussion; conductor: Hans Werner Henze

2266 *Alcides Lanza (Rosario 1938); Strobo I 1967;* for double-bass, various percussion instruments, lights, audience and electronic sounds; production: Electronic Music Center, Columbia University, N. Y.

Sound Enrichment by extra-European Instruments

2267 *Edgard Varèse (Paris 1885–1965 New York); Ionisation; 1931,* CBS S 75695; members of the Columbia symphony Orchestra, conductor: Robert Craft; plate

2268 *John Cage (Los Angeles 1912); Amores, 1943:* I: solo for prepared piano; II: Trio for 9 tom-toms and rattle; III: trio for 7 non-Chinese wood blocks; IV: solo for prepared piano; BR; Kölner Ensemble für Neue Musik; conductor: Mauricio Kagel

2269 *Lou Harrison (Portland 1917); Canticle No. 3, 1942;* Arrangement for two drummers and tape recorder by Michael W. Ranta; SFB; Michael W. Ranta and Michael Lewis, percussion

2270 *Pierre Boulez (Monbrison 1925); Le Marteau Sans Maître, 1953–1955:* II: Commentaire I de "bourreaux de solitude"; IV: Commentaire II de "bourreaux de solitude"; VIII: Commentaire III de "bourreaux de solitude"; Odyss. 32160154; instrumental ensemble; conductor: Robert Craft; plate

2271 *Japan, Fukui Province, Eiheiji Monastery; Zen Buddhist Music;* Music for the main ceremony in the main temple (Hatto); excerpts; BR; Dieter Dreyer V. D. T.: sound recording

2272 *Toshiro Mayuzumi (Tokyo 1929); Nirvana-Symphony, 1958:* Campanology I, Suramgamah; ILC 5003; NHK Sym-

phony Orchestra with choir; conductor: Wilhelm Schüchter

2273 *Toru Takemitsu (Tokyo 1930); November Steps, 1967;* RCA LSC 7051-B/1-2; Toronto Symphony Orchestra; biwa, Kinshi Tsuruta; shakuhachi, Katsuya Yokoyama; conductor: Seiji Ozawa

Rhythm. Improvisation. Music as gradual Process

2274 *Olivier Messiaen (Avignon 1908); Messe de la Pentecôte: II Offertoire, III Consécration;* BR; Almut Rössler, organ; plate

2275 *Olivier Messiaen; Oiseaux Exotiques, 1956;* Can. 31002; Czech. Philh.; Y. Loriod, piano; conductor: Václav Neumann

2276 *Pierre Boulez (Montbrison 1928); Piano Sonata No. III* (1957); Formant III, "Constellation-Miroir"; Formant II "Trope"; SMS 2590; Claude Helffer, piano; plate

2277 *Vinko Globokar (Anderny 1934); Correspondences, for four Players, 1969;* BR; New Phonic Art Ensemble

2278 *Free Improvisation;* Wergo; New Phonic Art Ensemble

2279 *Music from Bali;* Gilles Fresnais 1971

2280 *Terry Riley (Colfax, Cal. 1935); In C, 1964;* MS 7178

2281 *Dahomey, Bariba; Music for the Funeral of a Fetishist;* vocal; calabash rattles; OCR 17

2282 *Steve Reich (New York 1936); It's Gonna Rain, 1965;* MS 7265

2283 *Cameroon, Beti; Obama Ondoua Ebini;* OCR 25; François-Marie Ngoa group; five xylophones with calabash resonators and two bamboo rattles

Stimulus provided by the Nô drama and the Gagaku

Nô drama and European Music
The attention of European composers has been drawn to various aspects of the

Continued page 348

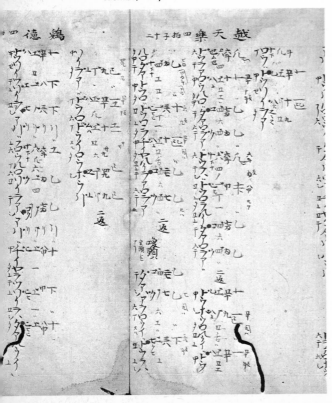

2288 The piece E ten Raku (Cat. no. 2342) in Japanese notes, early 17th cent., Prof. Shigeo Kishibe, Tokyo

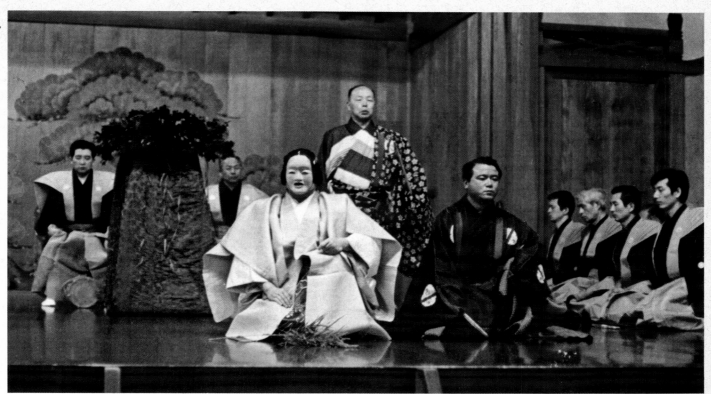

Scene from the Nô
drama Sumidagawa,
Hosho Ensemble,
Tokyo

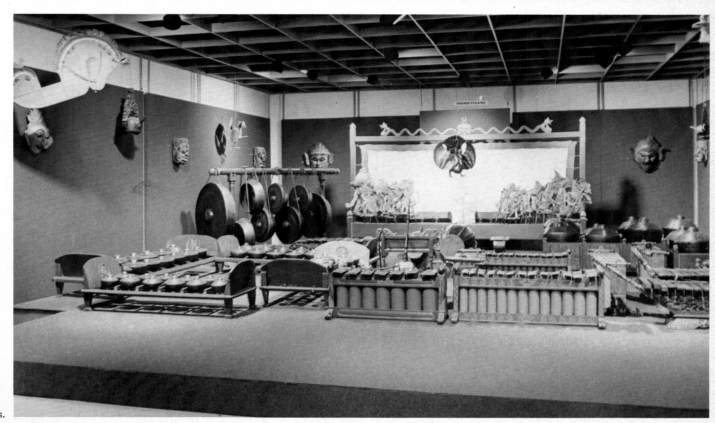

Javanese Gamelan
kjai Paridjata,
Delft, Indonesisch
Ethnographisch Mus.

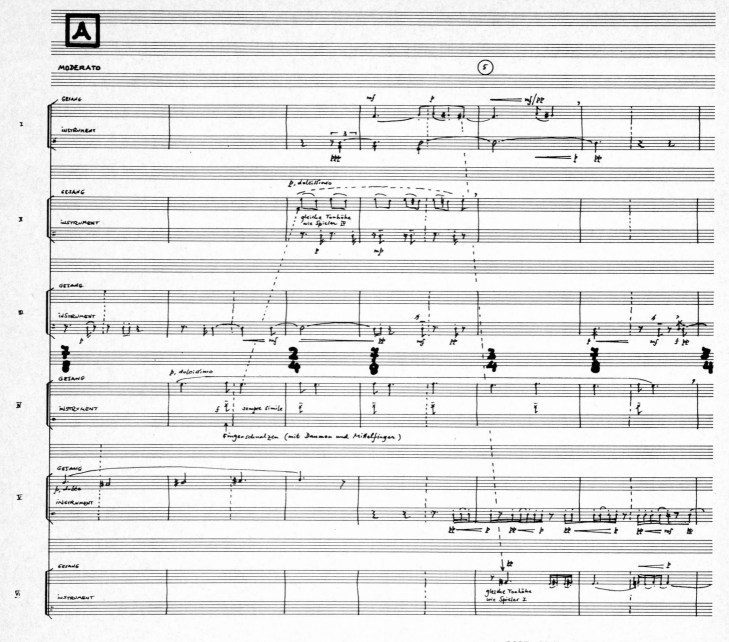

EXOTICA
für außereuropäische Instrumente

MAURICIO KAGEL 1970/71

2335 *Mauricio Kagel (Buenos Aires 1931); Exotica, 1970/71; for non-European instruments; composition commissioned for the exhibition "World cultures and Modern Art"; DGG; colour slides: Zoltan Nagy; Wilhelm Bruck, Christoph Caskel, Vinko Globokar, Siegfried Palm, Michel Portal, Theodor Ross; non-European instruments and singing; conducted by Mauricio Kagel*

▲ 2335 M. Kagel, Exotica, Vienna, Universal Edition

2335 M. Kagel, Exotica, cast: Vinko Globokar, Christoph Caskel, Michel Portal, Theodor Ross, Mauricio Kagel, Wilhelm Bruck, hidden behind: Siegfried Palm ▶

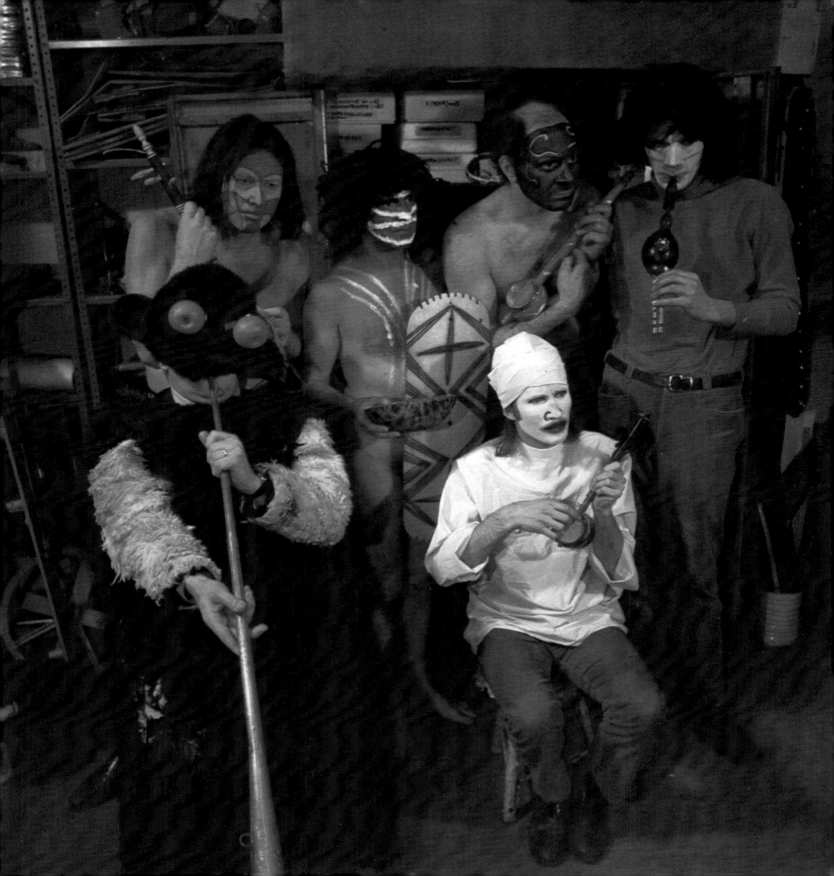

Japanese Nô drama: the "Kagekiyo" Nô drama by Motokiyo (1363?–1443) serves as the model for Renato de Granis' opera "The Blind Man of Hyuga" (1969). Benjamin Britten, too, in his mystery play "Curlew River" (1964) recourses to the Nô drama "Sumidagawa" by Motoharu Jûrô Kanze (1394–1432). In addition, Britten, who gathered new musical experience in Japan in 1956, attempts to reproduce the conception of sound found in Japanese music—mostly that of the Gagaku—using European instruments, without paying attention to the special characteristics of Nô music. The reduction in size of the orchestra (it only contains seven musicians), the static sound effect produced on the organ in the style of the Gagaku mouth organ, the drum accelerandi, the heterophonic sections, and so on, can be explained thus. Schnebel's relation to the Nô drama is on a level of more subtle affinity; it is revealed in the consequent, compository work which, according to Dieter Schnebel, lead to unknown, distant regions, where the proximity to the exotic suddenly dawns upon you. If one walks the roads of the West for long enough, one suddenly encounters the East . . . this explains the discovery by the keen-eared Pierre Boulez, in the theatre of the Far East, of stylistic and technical solutions for an ideal combination of speech and song; these, says Pierre Boulez in "Speaking, Singing and Playing," in Melos, XI, 1971, p. 456, are still to be discovered in Europe.
Finally, Stockhausen, in the extraordinarily slow and lengthy passages of some of his works sees an analogy with the lengthy tempo scale of the Japanese Nô drama and in general with the conception of "Japanese time" as it appears in the tea ceremony, the Sumo fight or temple ceremonies (cf. Karlheinz Stockhausen, Kriterien der Neuen Musik, in "Musik und Bildung" I, 1971, p. 1.) R. P.

2284 *Renato de Grandis (Venice 1927); The Blind Man from Hyuga, 1969;* one-act opera based on an old Japanese Nô drama; choral; WDR; Chor des Kölner Rundfunks; conducted by Herbert Schernuss

2285 *Dieter Schnebel (Lahr, Black Forest 1930); KI-NO, Night music for Projectors and Listeners;* new arrangement 1972; production: Dieter Schnebel; plate

Gagaku

Gagaku is the oldest music of Japan; it originated some 1200 years ago from

2285 D. Schnebel: picture sequence from: "Ki-no, Nachtmusik für Projektoren und Hörer", new version 1972

Korean and Chinese music and became an institution at the Imperial Palace. Today it still continues to be fostered both in the Imperial Palace and in some Shinhtó temples. Courtly Gagaku comprises pure instrumental music (Kangengaku) and instrumental music as the accompaniment for a dance (Bugaku). In both cases a distinction between left and right music (Dahô and Uhô) is drawn: the left music chiefly consists of the Chinese repertoire, whereas the right music is made up of pieces of Korean origin.
Left music: Ryûteki (transverse flute with seven keyholes); Hichiriki (oboe); and Shô (mouth organ); Biwa (four-stringed lute played with a plectron) and So-no-koto (curved board zither with thirteen strings); Kakko (cylindrical drum) Shôko (bronze gong) and Taiko (large drum suspended in a frame) Right music: Komabue (flute and Hichiriki); Sannotsuzumi (drum, Shôko and Taiko).

2286 *Henry Dixon Cowell (Menlo Park 1897); Ongaku;* XTV 60452; The Louisville Orchestra; conductor: R. Whithney

2287 *Benjamin Britten (Lowestoft 1913); Curlew River, 1964;* excerpts; Lon 1156

2288 *Olivier Messiaen; Sept Haïkaï, Ésquisses Japonaises; 1962, I: Introduction; II: Le Parc de Nara et les Laternes de Pierre; III: Yamanaka Cadence; IV: Gagaku; V: Miyajima et le Torii dans la Mer; VI: Les Oiseaux des Karuizawa; VII: Coda;* HMS 30841; Domaine Musical Orchestra, conductor: Pierre Boulez; plates

2289 *Maki Ishii; So-Gu II, Gagaku and Orchestra, 1971;* EMI AA-8872; The Japan Philharmonic Symphony Orchestra conducted by Seiji Ozawa

Integration of extra-European Music

2290 *Congo, Balari; Marching Song;* OCR 35; vocal, with sanza accompaniment

2291 *Brazil, Javahé; Indian Lullaby;* Ethnic Folkways Library FE 4311 B

2292 *Vietnam; Mây Che Bong Nguyêt;* sound recording: Trân-Van Khê

2293 *Japan; E-Ten-Raku;* BR, Dieter Dreyer, V. D. T.: Gagaku Orchestra, Imperial Palace, Tokyo

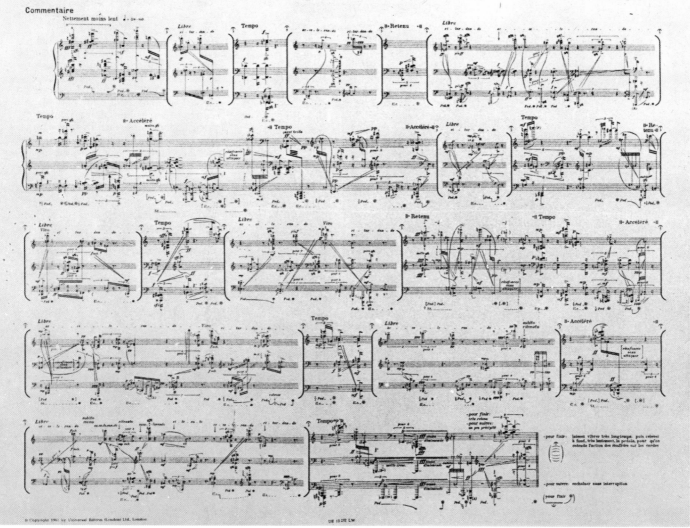

2276 Boulez, III. Piano Sonata, Vienna, Universal Edition

2294 *Echigojishi (Musical accompaniment to a Kabuki dance)* : BM 30 L 2014

2295 *Spain; Manitas de Plata : Bulerías Chico;* SBL 7844/844 213 BY

2296 *Bali; Ged Purana : Hudjan Mas (Golden Rain);* H-72028-A

2297 *Karlheinz Stockhausen (Mödrath 1928); Telemusic, 1966;* DG 137012; plate

2298 *Luis de Pablo (Bilbao 1930); WE;* 1972 version; production: Luis de Pablo

Concrete and Electronic Music of the Groupe de Recherches O.R.T.F. Paris

The works cited in the following programme of renderings demonstrate a tendency in electronic music which is of interest for the exhibition on account of its multiple connections with non-European music. These works attempt to leave aside the autonomous development of Western music and to achieve a "return to the original sources." The renewal of the constituents of sound and of the perception of the music is inspired by consideration of non-European music. Moreover, these compositions renounce the concept of a musical language that is typical of our culture, in order to conquer other musical manifestations and forms, whose goals are ones of effect rather than form. They oppose intellectual speculation in order to rediscover imminent modes of expression. The repetition of rhythmical patterns, subtle variations on melodic structures, multiple strata of tempo create a differentiated world of sound such as contained in traditional non-European music. (Guy Reibel)

2299 *Robert Cohen Solal (1943); Lapsus, 1970*

2300 *Jean Schwarz (Lille 1939); Hoiku, 1971*

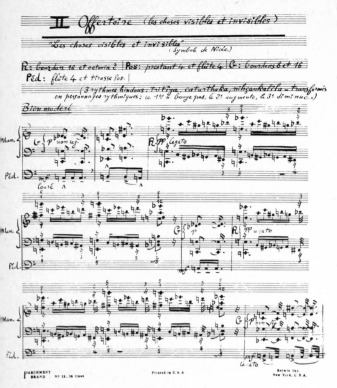

2274 Messaien, Messe de la Pentecôte, autograph, Alphons Leduc, Paris

2301 *Janez Maticic (Ljubljana 1926); Oscillations*

2302 *Beatriz Ferreyra (Córdoba, Argentine 1937); L'Orvietan, 1970*

2303 *Robert Cahen (1945); Craie, 1971*

2304 *Alain Savouret (1942); Tango:* Argentine, Couplet 1; Renaissance, Couplet 2; Traces, Couplet 3; Liszt, Couplet 4; Balset, Couplet 5

2305 *Michel Chion (1947); "Étude d'après Beethoven", 1971*

2306 *Roger Cochini (Marseilles 1946) Alap, 1971*

2307 *Ivo Malec (Zagreb 1925); Dahovi II, 1961*

2308 *Jacques Lejeune (Talence, 1940); Géodes*

2309 *Ivo Malec; Luminétudes*

2310 *Edgardo Cantón (Los Cisnes, Argentine, 1934); Mangés pour une espèce de Serpent, 1967*

2311 *François Bayle (Madagascar 1932); Espaces Inhabitables; 1967; Jardins de rien; Géophonie; Hommage à Robur; Le bleu du ciel; Amertumes*

2312 *Guy Reibel (Strasbourg 1936); "Durboth", 1965;* music for soprano soloist and tape recorder, based on a poem by R. Tagore; in Bengalese; Simone Rist, soprano

2313 *François Bayle (Madagascar 1932); Jeita, 1970*

2314 *Guy Reibel; Canon sur une Trompe Africaine et Continue*

2315 *Pierre Schaeffer (Nancy 1910); Simultané Camerounais, 1958*

2316 *Luc Ferrari (Paris 1929); Tête et queue du dragon, 1960*

2317 *Pierre Schaeffer; Flûte Mexicaine, 1949*

2318 *Pierre Schaeffer; Masquerage*

2319 *Bernard Pamegiani (Paris 1927); Bidule en Re, 1969*

2320 *Bernard Pamegiani; Un souffle, un rien*

2321 *Bernard Pamegiani; Capture Ephemère*

Eastern Thought influences Techniques of Composition

Chance, Music and Meditation

2322 *John Cage (Los Angeles 1912); Music of Changes, 1951;* excerpt; NDR; plate

2323 *John Cage; Music for Piano (1953)*

2324 *John Cage; Concerto for Piano and Orchestra, 1957–1958;* THC; David Tudor, piano; ensemble conducted by Merce Cunningham; plate

Shakuhachi Music

Zen Buddhist instrumental music can be divided into two groups: the percussion music which is used to signal activities in monastic life, and the melodic music of the Shakuhachi flute. The latter was practised by the Fuke sect, which flourished in the Dokugawa Age (1600–1867). The playing of the shakuhachi was a meditation exercise for the Fuke sect and correspondingly served to foster the inner development of the individual; the perfection of concentration attained by meditation manifests itself in deep, well-balanced breathing, which symbolizes the essence of the world and the human bonds with the Universe. Thus, in shakuhachi playing, breathing noises take precedence over pure sound (the breathing element seems to have led to the creation of new playing methods of the European transverse flute, by Western composers). "Kyorei" (spirit of the universe) and "Kokû" (void) belong to the oldest shakuhachi pieces of the Fuke sect. The following recordings illustrate two traditions of shakuhachi playing: Kuzan Takahasi, the eighty-year-old master of gardening, fencing, calligraphy and shakuhachi, represents the old Fuke sect tradition, while Goro Yamaguchi plays in the style of the later tradition of the Kin-ko school, in which the old shakuhachi methods are subject to strict fixation. R. P.

2325 *Japan; Shakuhachi Music; a) Yugure no Kyoku (Twilight); b) Shin no Kyorei (The Spirit of the Universe);* BR, Dieter Dreyer, V. D. T.; Goro Yamaguchi, Shakuhachi

2326 *Japan, Fukui Province, Eiheiji; Zen Buddhist Music;* music for meditation in the Sazendo; excerpts; BR, Dieter Dreyer, V. D. T.: sound recording

2327 *Karlheinz Stockhausen (Mödrath 1928); Stimmung, für sechs Vokalisten, 1968;* DG 2543003; Das Collegium Vocale, Cologne: Dagmar von Biel, Gaby Rodens, Helga Albrecht, Wolfgang Fromme, Georg Steinhoff, Hans-Alderich Billig; conducted by Wolfgang Fromme; electronic control: Karlheinz Stockhausen

2328 *India; Druphad Music; Les Frères Dagar;* film, 1965; directed by René Blanchard; production by the Groupes de Recherches Musicales, O. R. T. F., Paris

2329 *La Monte Young (Bern, USA, Idaho, 1935); 31 VII 69 10:26-10:49 PM;* vocal and sinus waves: La Monte Young; vocal: Marian Zazeela

2330 *Karlheinz Stockhausen; Aus den sieben Tagen, 1968: Es, unbegrenzt;* HM 30899 M; Johannes G. Fritsch, elec-

tric viola; Vinko Globokar, trumpet; Carlos Alsina, piano and Hammond organ; Jean-François Jenny-Clark, double bass; Jean-Pierre Drouet, percussion; Michel Portal, saxophone, flute and clarinet; Karlheinz Stockhausen, speaker (text by Sri Aurobindo, from Onyoga); 3 RIN; short wave receiver, whistle sirens, filters and regulators; plate

Asiatic Texts in Western Music

2331 *Isang Yun (Tongyong/Korea 1917); Om Mani Padme Hum, Oratorio, 1964;* WDR; Gloria Davy, soprano; Roland Hermann, baritone; the Cologne Rundfunkchor; choir director: Herbert Schernus; the SR Symphony Orchestra conducted by Michael Gielen

2332 *Cornelius Cardew; The great Learning, 1968–1970;* excerpts; text: the first chapter of the teachings of Confucius; DGG; Skretch Orchestra, London

2333 *Pierre Henry (Paris 1927); Le Voyage, 1962;* 836.899 DSY

Compositions commissioned for the exhibiton

2334 *Carlos Roqué Alsina (Buenos Aires 1941);Verbindung, 1972;* composition commissioned for the exhibition "World Cultures and Modern Art"; BR; New Phonic Art Ensemble; Carlos Roqué Alsina, Jean Pierre Drouet, Vinko Globokar, Michel Portal

2335 see page 346; plate

2336 *Josef Anton Riedl (Munich 1929); Parc Floral, 1970/72;* audiovisual excursion for audience; commissioned for the exhibition "World Cultures and Modern Art"; BR

2337 *Makoto Shinohara (Osaka 1931); Composition for European and Non-European Instruments;* commissioned for the exhibition "World Cultures and Modern Art"; Stomu Yamash'ta, various instruments; BR

Analytical Recordings

(Idea: Simha Arom, Paris)

2338 *Africa (Ghana, Ewe and North Rhodesia, Lala)*
The players: Ric Demenricy (congas), Karl Peinkofer (tom-toms and direction), Helmut Stier (bongos), Fritz Tannigel (maracas), Peter Weiner (cencerros). Although transcriptions of extra-European music were not made for the purposes of reproduction, the attempt was here made to have three dances from A. M. Jones' book "Studies in African Music," London 1969, vol. II, played by European musicians in Studio II of the Bavarian Radio. This eight-channel recording made it possible to regulate the volume of each of the rhythms individually over eight loudspeakers so that the extremely compact African polyrhythm is "disentangled," as it were, for the western ear. The aim was not to convey an authentic impression. The various levels of pitch of each voice are reproduced relatively (high-medium-deep); the tempo corresponds to the metronomic speeds given by A. M. Jones. There is hardly any need to add that, in spite of the late hour, the five percussionists enjoyed every minute of the recording!

Sovu Dance (Ghana) : five instrumental sounds and fivefold, rhythmically varied hand-clapping; the voices (solo, choir) were omitted.
The sound of African instruments was reproduced by accepted orchestral instruments:
Gankogui (double percussion bell of iron) : cencerros
Axatse (calabash rattle with external rattle pendants) : maracas
Atsimevu (main drum; large, one-headed open stand drum) : four congas
Kidi (small, single-headed open stand drum) : three tomtoms
Kagang (small, one-headed open stand drum) : two pair of bongos.
In accordance with the structure of the work with three rhythmic models for the main drum, three separate sections, A, B und C, were recorded in which the main model is repeated several times (generally three times) in each case. The basic metre consists of three units disposed in a 3+3+2 arrangement. All the instrumental sounds are related monometrically and run parallel, i. e. the main accents are coincident.

Sogba or Sogo Dance (Ghana) : five instrumental sounds and twofold,

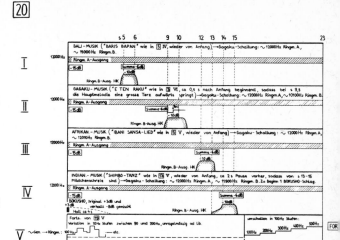

2297 K. Stockhausen, Telemusic, Vienna, Universal Edition

rhythmically varied hand-clapping; the song was omitted. The instruments are identical with those used in the Sovu dance. Here, too, the three main rhythmic models, A, B and C, were recorded separately with each model being repeated three times. The basic metre runs for twelve units; Gankogui (=cencerros) and Axatse (=maracas) articulate it thus: 2+3+4+3 (=5+7); hand-clapping I: 3+3+3+3, hand-clapping II: 2+2+2+2+2; the Kagang (=bongos): 3+3+3+3, however in cross-rhythm displaced by 4 units. The Kidi (=tom-toms) and the main drum, Atsimevu (=congas), frequently vary the

2324 J. Cage, Concerto for Piano and Orchestra, New York, Ed. C. F. Peters

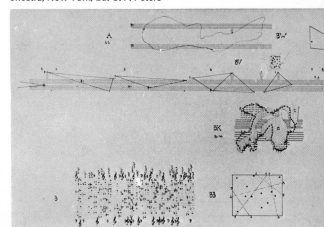

Sound Centre

2334–2394

subordinate metric disposition so that complex polyrhythm and cross-rhythm patterns result.

Icila Dance (North Rhodesia): three instrumental sounds and twofold, rhythmically varied hand-clapping, with original song omitted.
Instruments: Ikulua (main drum): four congas
Akache (drum): three tom-toms
Icibitiku (drum): two pair of bongos
The piece is not separated into sections. The basic metre over twelve units is partitioned among the various sounds as follows:
hand-clapping I: 3+3+3+3
hand-clapping II: 2+2+2+2+2+2
Icibitiku (bongos) 2+2+2+2+2+2
These three run rhythmically parallel, whereas the subdivisions of the Ikulu (congas) and Akache (tom-toms) sounds are varied and mostly cross-rhythmically displaced. C. R.

Translation P. J. D.

2270 Boulez, Le Marteau sans maître, autograph, Vienna, Universal Edition

Films

Of the films produced by the Bavarian Broadcasting Service together with the Olympic Committee for the exhibition "World Cultures and Modern Art", the following were shown in the Sound Centre.

2339 *Japan, Eiheiji Monastery; Main Ceremony in the Hatto (main temple);* BR-Television; director: Klaus Kirschner; camera: Pitt Koch; assistant: Paco Joan; cut: Christa Hegemann; Dieter Dreyer, V. D. T.: tone; musical advisor: Ramón Pelinski

2340 *Japan; Kokû (Room of Nothing);* Kutan Takahashi: shakuchachi flute; BR-Television; director: Klaus Kirschner; camera: Pitt Koch; assistant: Paco Joan; cut: Christa Hegemann; Dieter Dreyer, V. D. T.: tone; musical advisor: Ramón Pelinski

2341 *Japan; Nô drama Sumidagawa, Part 2: Scene of the Mother at her Son's Grave;* Hoshokai (Nô Ensemble), conducted by Fusao Hosho, Tokio; BR-Television; director: Klaus Kirschner; camera: Pitt Koch; Dieter Dreyer, V. D. T.: tone; musical advisor: Ramón Pelinski

2342 *Japan; Gagaku: E ten Raku;* Gagaku Orchestra of the Imperial Palace, Tokyo; BR-Television; director: Klaus Kirschner; camera: Pitt Koch; assistant: Paco Joan; cut: Christa Hegemann; Die-

ter Dreyer, V. D. T.: tone; musical advisor: Ramón Pelinski

2343 *India; Bharata Natyam: Abhinay Raga Neelambari Tala Ata;* dancers: Sucheta Bhide, Baratha Natyam; BR-Television; director: Klaus Kirschner; camera: Pitt Koch; assistant: Paco Joan; cut: Christa Hegemann; Dieter Dreyer, V. D. T.: tone; musical advisor: Ramón Pelinski

2344 *India; Raga Khamaj;* Shamin Ahmed: sitar; Manck Popatkar: tabla; Veena Patel: tanpura; BR-Television; director: Klaus Kirschner; camera: Pitt Koch; assistant: Paco Joan; cut: Christa Hegemann; Dieter Dreyer, V. D. T.: tone; musical advisor: Ramón Pelinski

2345 *Indonesia; Tarian Srimpi (Dance for four girls);* Four dancers, gamelan musicians and singers from the court of the Sultan of Surakarta, Sri Susuhunan Paku Buwana XII; BR-Television; director: Klaus Kirschner; camera: Pitt Koch; assistant: Paco Joan; cut: Christa Hegemann; Dieter Dreyer, V. D. T.: tone; musical advisor: Ramón Pelinski

2346 *Haiti—Port au Prince; Voodoo Cult;* BR-Television; director: Klaus Kirschner; camera: Pitt Koch; assistant: Paco Joan; cut: Christa Hegemann; Dieter Dreyer, V. D. T.: tone; musical advisor: Ramón Pelinski

2347 *Haiti; Improvisation on four Drums;* Tiroro: drummer; BR-Television; director: Klaus Kirschner; camera: Pitt Koch; assistant: Paco Joan; cut: Christa Hegemann; Dieter Dreyer, V. D. T.: tone; musical advisor: Ramón Pelinski

2348 *Funeral Procession Music (New Orleans);* Dejan's Olympia Brass Band conducted by Harold Dejan (cf. Cat. no. 2259); BR-Television; director: Klaus Kirschner; camera: Pitt Koch; assistant: Paco Joan; cut: Christa Hegemann; Dieter Dreyer, V. D. T.: tone; musical advisor: Ramón Pelinski

2349 *Ivory Coast; Guere Tribe; Bledi Village; Dance of the Wrestlers;* BR-Television; director: Klaus Kirschner; camera: Pitt Koch; assistant: Paco Joan; cut: Christa Hegemann; tone: Volker Josefski; musical advisor: Claus Raab

2350 *Ivory Coast; Guere Tribe; Bledi Village; Entertainment Dance of the "Oulosaé" Mask;* cf. Cat. no. 2251

2351 *Ivory Coast; Baule Tribe; Molonou*

Village; Greetings Dance; cf. Cat. no. 2250

2352 Bolivia; Quena-Quena Dance; BR-Television; director: Klaus Kirschner; camera: Pitt Koch; assistant: Paco Joan; cut: Christa Hegemann; Dieter Dreyer, V. D. T.: tone; colour slides: Pitt Koch; musical advisor: Ramón Pelinski

2353 Peru; Pisac Pututeros; BR-Television; director: Klaus Kirschner; camera: Pitt Koch; assistant: Paco Joan; cut: Christa Hegemann; Dieter Dreyer, V. D. T.: tone; musical advisor: Ramón Pelinski

Musical Instruments

Asia

2354 Java; Anklung (Rattle); bamboo, max. h - 98 cm, max. w - 49 cm; Carl Orff uses this instrument in "Prometheus"; Basle, Mus. für Völkerkunde und Schweizerisches Mus. für Volkskunde

2355 Nias; Percussion Fork; bamboo, l - 26.5 cm; Basle, Mus. für Völkerkunde und Schweizerisches Mus. für Volkskunde

2356 Tibet; Trumpet; copper and bronze, l - 48 cm, acquired in 1938; Hanover, Niedersächsisches Landesmus., Völkerkunde-Abt.

2357 Tibet; Temple Tuba "Radan-dun"; sheet copper, l - 344 cm; c. 1850; Berlin, Mus. für Völkerkunde, Musikethnologische Abt.

2358 Tibet; Cymbals "Rol-mo"; brass, ⌀ 23.5 cm; 19th cent., Berlin, Mus. für Völkerkunde, Musikethnologische Abt.

2359 Tibet; Hand-drum; wood with stretched hide, ⌀ 18 cm; h - 10 cm; acquired in 1938; Hanover, Niedersächsisches Landesmus., Völkerkunde-Abt.

2360 Tibet; double-headed drum; wood with stretched hide, ⌀ 36 cm; h - 17 cm; acquired in 1938; Hanover, Niedersächsisches Landesmus., Völkerkunde-Abt.

2361 Sikkim; Hour-glass drum of a Lama; double-headed drum with handle to which three cords with small weights on them are attached, ⌀ 17 cm; Basle, Mus. für Völkerkunde und Schweizerisches Mus. für Volkskunde

2362 China; Large Barrel-Drum

"Hsuan-ku" (Ying-Ku) for religious purposes; double-headed; wooden bowl; the two leather membranes are richly painted with birds, dragons and flowers, l - 76 cm, ⌀ 66—88 cm; Berlin, Mus. für Völkerkunde, Musikethnologische Abt.

2363 China; Barrel-Drum "Po-fu"; double-headed drum made of green lacquered wood, l - 34 cm, ⌀ 14.7—23 cm; 19th cent.; Berlin, Mus. für Völkerkunde, Musikethnologische Abt.

2364 China; Small Horizontal Drum "Hua-Ku"; double-headed drum; wooden bowl with nailed-down hides, h - 8 cm, ⌀ 22.5 cm; 19th cent.; Berlin, Mus. für Völkerkunde, Musikethnologische Abt.

2365 China; Small Horizontal Drum "Hua-ku"; double-headed drum with nailed-down hides; the arched frame is encompassed by a wide iron ring, h - 10 cm, ⌀ 25 cm; 20th cent.; Berlin, Mus. für Völkerkunde, Musikethnologische Abt.

2366 China; Mokugyô; wooden bell (wooden fish), h - 17 cm, w - 14 cm; Basle, Mus. für Völkerkunde und Schweizerisches Mus. für Volkskunde

2367 China; Percussion Sticks "Shang-mu" or "P'ai-pan"; percussion sticks, l - 25 cm, h - 3 cm; 20th cent.; Berlin, Mus. für Völkerkunde, Musikethnologische Abt.

2368 Japan; Conch; l - 20—26 cm; Basle, Mus. für Völkerkunde und Schweizerisches Mus. für Volkskunde

2369 Japan; Mouth-organ "sho"; instrument of the Gagaku orchestra, max. l - 30 cm; Basle, Mus. für Völkerkunde und Schweizerisches Mus. für Volkskunde

2370 Japan; Oboe "Hichiriki"; instrument of the Gagaku orchestra, l - 23 cm; 20th cent.; Berlin, Mus. für Völkerkunde, Musikethnologische Abt.

2371 Japan; Barrel-drum "O-daiko"; double-headed drum hung on a frame; hollow tree trunk with a carved relief; the painted hide is nailed down, ⌀ 70 cm, w - 66 cm; frame: h - 75 cm, w - 47 cm; Berlin, Staatl. Institut für Musikforschung Preußischer Kulturbesitz, Musikinstrumenten-Museum

2372 Japan; Bell on Stand "Kin" or "Uchinarashi"; with lacquered stand and

hammer; h - 32 cm, ⌀ 40 cm; Berlin, Mus. für Völkerkunde, Musikethnologische Abt.

2373 Japan; Skakuhachi; end-blown, bamboo flute, l - c. 54 cm; Tokyo, Japan Cultural Society

2374 Japan; the four instruments of the Nô Theatre: a) Nôkan; side-blown, bamboo flute; b) Ko-tsuzumi; smallest and most important instrument in the Nô drama; narrow, hour-glass wooden bowl, at the ends of which two hides are tied down with stretching strings; c) Ô-tsuzumi; resembles the Ko-tsuzumi in construction, but somewhat larger; d) Taiko; flat, barrel-shaped, double-headed drum on a stand with two sticks; Tokyo, Japan, Cultural Society

Africa

2375 West Africa; Xylophone; 15 slabs with gourd resonators, l - 80 cm, w - 44 cm, h - 24 cm; c. 1954; Neuchâtel, Musée d'Ethnographie

2376 Cameroon (Bagam); Sansa; nine bamboo tongues; two semi-cylindrical pieces of wood serve as resonators, l - 33 cm, w - 12 cm, h - 7 cm; before 1933; Neuchâtel, Musée d'Ethnographie

2377 Angola (Tyivokwa); Sansa; eight metal tongues; on the upper side of the resonator, to which three metal rings are fixed as rattles, a square, carved ornament is to be seen, l - 13 cm, w - 7 cm, h - 3 cm; c. 1932—33; Neuchâtel, Musée d'Ethnographie

2378 Cameroon; Wooden Drum with two sticks; acquired in 1900; Hanover, Niedersächsisches Landesmus., Musikethnologische Abt.

2379 Sierra Leone (Kenema, Mende); "Bondo or Sande" (fertility mask); wood, h - 45 cm, w - 26 cm; very old; Dakar, Institut Fondamental d'Afrique, Gouvernement du Sénégal

2380 Sierra Leone (Kenema, Mende) "Bondo or Sande" (fertility mask); wood and raffia, polychrome, h - 110 cm, w - 26 cm; cf. Cat.-no. 2379; Dakar, Institut Fondamental d'Afrique, Gouvernement du Sénégal

2381 Mali (Minianka); Harp; five gut strings, calabash, wood, h - 140 cm, ⌀ 50 cm; Dakar, Institut Fondamental d'Afrique, Gouvernement du Sénégal

2382 *Nigeria (Ibo); Harp;* five strings, originally six; wood, I - 70 cm; Dakar, Institut Fondamental d'Afrique, Gouvernement du Sénégal

Oceania

2383 *New Guinea; Conch;* side-blown, I - 28 cm, ⌀ 29 cm, acquired in 1904; Hanover, Niederländisches Landesmus., Völkerkunde-Abt.

2384 *Melanesia; Three end-blown flutes;* bamboo, two, three and four keyholes; I - 60 cm, 52 cm, 45 cm; Otoia Collection

2385 *Melanesia; Two Pan pipes;* bamboo, single row; seven and six pipes; max. I - 21.5 cm and 19 cm; Otoia Collection

2386 *Melanesia; Pan pipe;* bamboo, two rows of four pipes; max. I - 30 cm; Otoia Collection

2387 *Melanesia; Monochord;* metal string, wooden bridge; calabash resonator; h - 16 cm, I - 33 cm; Otoia Collection

2388 *Melanesia; Tube zither;* bamboo, five strings which are spliced and attached to small wooden pegs at either end; I - 58.5 cm, ⌀ 5 cm; Otoia Collection

2389 *Melanesia; Three jew's harps;* bamboo; I - 21.5 cm; Otoia Collection

2390 *Melanesia; Three drums;* wood, hour-glass shaped; single-ended open; reptile skin membrane; I - 42 cm, 75 cm, 90 cm; Otoia Collection

2391 *Melanesia; Three rattles;* shakers made of wood wrapped around a rattle filling; I - 20 cm, 19 cm, 16 cm; Otoia Collection

2392 *Melanesia; Shark rattle;* eight and seven coconut halves resp. are suspended from a bamboo shoot which has been bent into the form of a circle; ⌀ 28–30 cm; Otoia Collection

2393 *Melanesia; Rattle;* six small coconuts fastened on strings; Otoia Collection

2394 *Melanesia; Two bullroarers;* I - 34 cm, 40 cm; Otoia Collection

Instruments at the public's disposal

Asia:
India
Sitar
Tanpura
Tabla-Banya
Drums (various kinds)
Flutes (various kinds)
Hand cymbals
Snake charmer's schalmei
Vina
Shanhnai
Sarod
Mridangam
Utukkai
Kilukiluppai
Pucaro-kaiccilampu
Pakhavaj

Japan:
Shakubyôshi
Hyôshigi
O-byôshi
Ekiro
Sasara
Rei
Chappa
Orugôru
Atarigane
Mokugyô
Kin
Uchiwadaiko
Okedô
Gakudaiko
Dora
Sôban
Two shamises
Koto

America:
Indo-America
Four charangos

Six horizontal flutes
Four pan-flutes
Spiral horn
Drum
Ayotl
Teponaztli
Erquencho
Three cajas
Two bombos
Erque
Three pinquillos
Two anatas
Two sikus
Five quenas
Violins

Afro America:
Ganzá
Three xocalhòs
Stabpandeira
Afoxè Grande
Agôgô
Reco-Reco (metal)
Reco-Reco (bamboo)
Tamburine

Africa:
Three drums
Two xylophones

The instruments were provided by:
Bombay, National Centre for the Performing Arts
Tokyo, Japan Cultural Society
Buenos Aires, Fondo Nacional de las Artes
Rio de Janeiro, Marlos Nobre
Dakar, Institut Fondamental d'Afrique
Mexico, Instituto Nacional de Bellas Artes
Lima, Casa de la Cultura
Munich, Olympic Committee

Program of musical and art events during the exhibition

18. 6.	8 p. m.	*Javanese Gamelan music* *Gamelan "Pramuda Budaja"* Amsterdam, Tropenmuseum
23. 6. and 24.6	8 p. m.	*Mauricio Kagel* *Exotica*, Composition for Extra-European Instruments, Première
25. 6. and 26. 6.	8 p. m.	*Javanese Gamelan music* *Gamelan "Pramuda Budaja"*
30. 6.	8 p. m.	*Carlos Roqué Alsina* *Ver-Bindung* Première *Makoto Shinohara* *Composition for European and Extra-* *European Instruments* Première

1. to 6. 7. **Indian Week**

1. 7.	7 p. m.	*Opening* of the Indian Week by the Indian Ambassador, His Excellency Kewal Singh Special exhibition "Indian Art"
	8 p. m.	*Indian classical music* Ram Narain, sarangi; N. Ramani, flute; Yamini Krishnamurti Bharata Natyam
2. 7.	6 p. m.	*Lecture by Prof. Dr. Friedrich Wilhelm* *Das Indienbild Europas im 19. und* *20. Jahrhundert*
	8 p. m.	*Indian classical music* Ram Narain sarangi; N. Ramani, flute
3. 7.	6 p. m.	*Indian film* (Satyajit Ray)
	8 p. m.	*Indian classical dance* Yamini Krishnamurti, Bharata Natyam
4. 7.	6 p. m.	*Lecture by Prof. Dr. Joseph Kuckertz* *Indian Classical Music and its Reception* *in Europe in the 20th Century*
	8 p. m.	*Indian classical music* N. Ramani, flute
5. 7.	8 p. m.	*Indian classical music* Ram Narain, sarangi
6. 7.	8 p. m. to 3 a. m.	*Indian night* with all the listed artists
21. 7.	8 p. m.	*Josef Anton Riedl* *Parc Floral* Première

22. 7. and 23. 7.	8 p. m.	*Classical music from Persia* Faramarz Payvar and Nussien Therani santur	*Sound* *Centre*
4. 8.	8 p. m.	*Piano recital with Latin American music* Susana Frugone, piano and instrumentalists	
17. 8.	8 p. m.	*Lecture by Luis de Pablo* *Extra-European Elements in New Music* Première of new version by "WE"	
18. 8.	8 p. m.	*Lecture by Dolores Carrillo* *A new musical Message from Mexico*	
19. 8.	8 p. m.	*Sunilkumar and Shankarlal (Calcutta)* *Improvisationen on Indian Ragas*	
20. 8.	8 p. m.	*Yehudi Menuhin and Ravi Shankar* *Improvisation on Indian Ragas*	
21. 8.	8 p. m.	*Max Bührmann* *San mei hua pan ying shi* Chinese shadow show	

24./25.8.		**"Music with and without** **Loudspeaker"** **14 Concerts NONSTOP** **Groupe de Recherches Musicales"** **O. R. T. F., Paris** Responsible: François Bayle Soloists of the Choir of the O. R. T. F., Paris Conductor: Mr. Couraud Program arrangement: G. Reibel
24. 8.	4.30 p. m. to 6.30 p. m.	*Traditional Music* *Jean Schwarz* *Voix du Monde (1971)* *Gilles Fesnais* *Musiques à Bali (1971)* *Jean Schwarz* *Anticycle*
24. 8.	8 p. m. to 9.30 p. m.	*Vocal and electro-acoustical music* *Alain Savouret* *L'Arbre et Coetere (1971)* *Guy Reibel* *Les Tribuns (1972)* *Bernard Parmegiani* *Pour en finir avec le pouvoir d'Orphée* *(1969–1972)*
24. 8.	10 p. m. to 11.30 p. m.	*Vocal and electro-ecoustical music (B)* *Jacques Lejeune* *Oedipe Undergrund (1971)* *Ivo Malec* *Dodecameron (1971)* *Pierre Schaeffer* *Études aux objets (1960)*
25. 8.	12 p. m. to 2.30 a. m.	*Opus 16* *Group Opus "N"* *Free electric music*

Sound Centre	25.8.	4.30 p.m. to 6.30 p.m.	*Films* of the Groupe de Recherches Musicales de l'O. R. T. F., Paris *Katakali (1968)* Film by Jean-Claude See *Danse Coréenne (1962)* Film by Jacques Brissot *Nô-drama (1966)* Film by Sylvain Dhomme	27.8.	12 p.m. to 2.30 a.m.	*Acoustic experience* *François Bayle* *Acoustic experience (1970–1972)* *Second performance*	

Sound Centre

25.8. 4.30 p.m. to 6.30 p.m. *Films* of the Groupe de Recherches Musicales de l'O. R. T. F., Paris
Katakali (1968)
Film by Jean-Claude See
Danse Coréenne (1962)
Film by Jacques Brissot
Nô-drama (1966)
Film by Sylvain Dhomme

8. p.m. to 8.40 p.m. *Piano, guitar and tape-recorder*
Guy Reibel
Vertiges (1969)
Luc Ferrari
Und so weiter (1964)

9.30 p.m. to 11.30 p.m. *Acoustic experience*
François Bayle

26.8. 12 p.m. to 1.15 a.m. *Compositions for key instruments and tape-recorder*
Alain Savouret
Selon (1970)
Guest composers of the composing studio of the Groupe de Recherches Musicales X + (1972)

26.8. 1.30 a.m. to 2.30 a.m. *Music for drums and tape-recorder*
Jean Schwarz
Anticycle

26.8. 4.30 p.m. to 6.30 p.m. *Compositions for instruments and tape recorder*
Groupe Opus "N"
Opus 17
Carlos Alsina
On verra (1972)
Alain Savouret
Selon (1970)
Guest composers of the composing studio of the Groupe de Recherches Musicales X + (1972)

26.8. 8 p.m. to 9.30 p.m. *Vocal and electro-acoustic compositions (B)*
(Second performance)
Jacques Lejeune
Oedipe Underground (1971)
Ivo Malec
Dodecameron (1971)
Pierre Schaeffer
Étude aux Objets

26.8. 10. p.m. to 11.30 p.m. *Vocal and electro-acoustic compositions (A)*
(second performance)
Alain Savouret
L'Arbre et Coetera (1971)
Guy Reibel
Les Tribuns (1972)

Bernard Parmegiani
Pour en finir avec le pouvoir d'Orphée
(1969–1972)

27.8. 12 p.m. to 2.30 a.m. *Acoustic experience*
François Bayle
Acoustic experience (1970–1972)
Second performance

27.8. 8 p.m. *Contemporary music of Latin America*
compositions by Tauriello Gandini, Santoro, Guevara Camerata Bariloche, Argentine

10 p.m. to 5 a.m. *John Cage*
Night

28.8. 8 p.m. *Karlheinz Stockhausen*
Stimmung

30.8. 8 p.m. *Karlheinz Stockhausen*
Mikrophonie I
Aus den Sieben Tagen

31.8. 8 p.m. *Pandit Pran Nath*
Ragas in Kirana-song

1. to 6.9. **Japanese Week**

1.9. 8 p.m. *Dieter Schnebel*
Ki-no
New version 1972

2.9. 8 p.m. *Nô-drama*
Sumidagawa (Nô), Kakiyamabushi (Kyogen), Hagoromo (Nô)
Nô-Ensemble Hôshô Tokyo

3.9. and 11 a.m. *Nô-drama*
(as above)

4.9. 8 p.m. *Nô-drama*
(as above)

5.9. 9 p.m. *Nô-drama*
(as above)

6.9. 8 p.m. *Terry Riley*
Solo concerto with own compositions

7.9. 8 p.m. *La Monte Young and Marian Zazeela*
Performance, Tape-recorder, Light

8.9. and 10.9. 8 p.m. *Indian music from Argentine*
Music group "Cabrakan"

13., 14. and 15.9. 8 p.m. *Akin Euba*
Requiem after traditional and new African texts
Performed by members of Ile Ife University, Nigeria, Première

Film Sections

The films were made by the Bavarian Broadcasting Service together with the Exhibition Bureau of the Olympic Committee for the exhibition World Cultures and Modern Art

Orient
Islamic and European Architecture
1971
The film records Islamic architecture in Turkey and Egypt which was imitated and modified in Europe in the nineteenth century. (Persian and Magrebin architecture of the Mogul period, which was widely distributed in engravings and provided some impulses, is not treated here.) The influence of the mosques of Istanbul, with their domes, minarets and decorative tiles, and the buildings of Cairo, is to be seen in the Palais Beauharnais (Paris) in the Royal Pavilion at Brighton (especially Indian Mogul architecture), in the buildings of the Wilhelmia in Stuttgart, in Leighton House, London, and in the palaces of King Ludwig II.
A supplementary series of slides demonstrates the Egyptian and Islamic reception up to the Grosses Schauspielhaus (Great Theatre) by Poelzig in Berlin with its free imitation of Moorish stalactite vaults. Bavarian Broadcasting Service—Television, directed by Bernhard Dörries, Prof. Thomas Zacharias; camera Bernhard Dörries; assistant Helga Kirsten; technical advice, Dr. Horst Ludwig.

Far East
Japanese Architecture (Katsura Palace, Kyoto)
1971
Japanese Garden (Imperial Garden in Kyoto)
1971
Tea Ceremony (Family Urasenke, Tokyo)
1971
Japanese Calligraphy (Calligraphist Akaba, Tokyo)
1971
All films by Bavarian Broadcasting Service—Television, directed by Klaus Kirschner; camera, Pitt Koch; assistant, Paco Joan; cut, Christa Hegemann; editor, Dieter Dreyer.

Africa, Oceania, Indo-America
Mask Dances
Baule, Molonou village (Ivory Coast)
Goli Dance
1972
Goli is a buffalo spirit whom the god of the sky created first. His companion, Kplekple, also bears the horns of a buffalo together with the symbols of the sun: the circle and serrated wreath. Originally ritual masks in a ritual dance, the goli dance is now performed for entertainment. The retinue incites the dancers with shouts and rhythmic beats: a spectacle full of rhythmic precision and vitality.
Guere, Bloloquin village (Ivory Coast)
Entrance of the judges—masks, Oulia Vonbé
1972
Guere, Yoya village (Ivory Coast)
Entrance of the judges—masks, Tee Koko
1972
Guere, Bledi village (Ivory Coast)
Entrance of the judges—masks, kpandoho
1972
Guere, Bledi village (Ivory Coast)
Scene of the dance—mask oulosaé
1972
Dan, Koullen village (Ivory Coast)
Scene of the dance—mask Niolé
1972
All films by Bavarian Broadcasting Service—Television, directed by Klaus Kirschner; camera, Pitt Koch; assistant, Paco Joan; cut, Christa Hegemann; sound, Volker Josefsky

Sound Centre

Acknowledgements

The Organization Committee for the Games of the XXth Olympiad Munich 1972 and the management of the exhibition World Cultures and Modern Art thank all photographers who kindly provided or helped to procure picture material.

A. C. L., Brüssel Albright-Knox Art Gallery, Buffalo, N.Y. Foto Annan, Glasgow Ferdinand Anton, München Art Institute Chicago Art Museum, Seattle Associated Music Publishers, New York Barry, Buenos Aires, Bayerische Staatsbibliothek, München, Bayerische Staatsgemäldesammlungen, München Belaieff, Leipzig Bibliothèque Nationale, Paris Foto Paul Bijtebier, Brüssel, Bischofsberger, Zürich Werner Blaser, Basel, Kurt Blum, Bern Boni, New York Boosey & Hawkes, London Bote & Bock, Berlin Braunmüller, Staatliches Museum für Völkerkunde, München Breitkopf & Härtel, Leipzig Photographie Bulloz, Paris J. & W. Chester, London Geoffrey Clements, New York Colombo, New York Crown Publisher, New York, Galerie de France, Paris Igor Delmas, Paris, E. Demets, Paris Dörries, München Dover Publishers Inc., New York J. L. Dumont, Paris, Durand, Paris Durand Ruel et Cie., Paris, Dusan Dzamonia, Zagreb Max Eschig, Paris, Ernst Eulenburg, London Freies Deutsches Hochstift, Frankfurt Galerie Vallotton, Lausanne, Andre Emmerich Gallery, New York Rowan Gallery, London Claude Gastari, Paris, David Gebhard, Los Angeles Hessisches Landesmuseum, Darmstadt Gemeentemuseum, Den Haag Sophie-Renate Gnamm, München Goertz, München Pierre Jolendorf, Paris Goodwin & Tabb, London Sherwin Greenberg, McGranahan, Buffalo, N.Y. Photo Guilbaud, Paris Häussler, Zürich Hamburgisches Museum für Völkerkunde und Vorgeschichte Lichtbildner, Hamburg Fotos Heinrich Engel, Tuttle Company Heugel, Paris George Hoefer, United States Information Service USA Hubrich & Winkler oHG, Landshut Paul Hus, Amsterdam Jacqueline Hyde, Paris Idemitsu Museum, Tokyo Helmut Jäger, Übersee-Museum, Bremen Laurent Sully Jaulmes, Paris Laurent Sully Jaulmes, Paris C. F. Kant, Leipzig Pitt Koch (Diapositive), München Otto von Kotzebue, München Kornfeld und Klipstein, Bern Kunstgewerbemuseum, Zürich Kunsthalle Bremen Kunsthaus, Zürich Kunstmuseum Bern Kunstsammlungen der Stadt Dachau, Dachau Marc Lavrillier, Paris Alphonse Leduc, Paris, Monika Leonhardt, Berlin Les frères Némerlin, Brüssel Linden-Museum Stuttgart/Didoni, Galerie Louise Leiris, Paris Marlborough Gallery, New York Foto Hans Mayr, Wien Henry Moore, Much Hadham André Morain, Paris Edwin H. Morris, London Clive Morris, Brüssel Musée Cernuschi, Paris Musée des Arts Décoratifs, Paris Musée des Beaux Arts, Lüttich Musée Municipal, St. Etienne Museum für Kunst und Gewerbe, Hamburg Museum für Ostasiatische Kunst Köln Museum für Völkerkunde, Berlin Museum of Decorative Art, Kopenhagen Museum of Fine Arts, Boston Museum of Modern Art, New York Museum voor Land en Volkenkunde, Rotterdam Zoltan Nagy, Essen Nationalmuseum, Tokyo National Gallery of Scotland, Glasgow Cosmopress, Spadem, Paris/Genf Foto O. E. Nelson, New York Willibald Netto, Düsseldorf Niedersächsisches Landesmuseum, Hannover Oberösterreichisches Landesmuseum, Linz Österreichisches Museum für angewandte Kunst, Wien Österreichische Nationalbibliothek, Bildarchiv, Sammlung Otoia C. F. Peters, Frankfurt/Main Philharmonia, Wien Philips Collection, Washington Service Photographique Bibliothèque Nationale, Paris Photo Giraudon, Paris, Hugo Pohle, Hamburg Reid and Lefevre, London, Gerd Remmer, Flensburg Rheinländer, Hamburg, Ricordi, Mailand Karsten de Riese, München Rijksmuseum Kröller-Müller, Otterlo Rijksmuseum Vincent van Gogh, Amsterdam Rijksmuseum, Amsterdam Photo Robyns, Lüttich Henri Saas, Lausanne Mr. Dominique Denis, Saint-Germain-en-Laye Salabert, Paris Albin Salaün, Paris Sammlung Georg Schäfer, Obbach Schlesinger, Berlin B. Schott's Söhne, Mainz Senart, Paris Service de Documentation Photographique Reunion des Musées Nationaux, Paris Service Photographique des Musées Nationaux, Musée du Louvre, Musée National d'Art Moderne, Jeu de Paume, Paris R. de Seynes, Paris Simrock, Wiesbaden Sirène Paris Sammlung Delenne, Brüssel Smithsonian Institution Press, Washington Walter Socha Staatliche Museen Preußischer Kulturbesitz Museum für Ostasiatische Kunst, Berlin State Publishers Music, Moskau Staatsgalerie, Stuttgart Stedelijk Museum, Amsterdam Foto Stickelmann, Bremen Suhrkamp, Frankfurt/Main Henri Tabah, Paris The Tate Gallery, London Tropenmuseum, Amsterdam Universal Edition, Wien University of Glasgow, Glasgow Foto-Studio van Santvoort, Wuppertal Marc Vaux, Paris L. Vesoft, Antwerpen, Victoria & Albert Museum, London Yale University Gallery, New Haven Francois Walch, Paris Franz Winzinger, Regensburg, Suvini Zerboni, Mailand

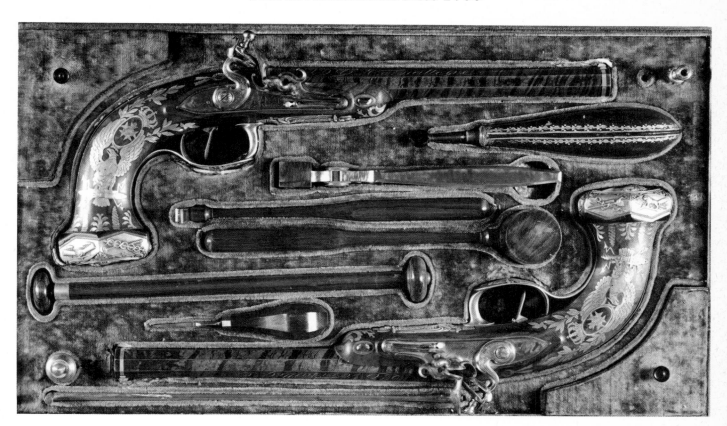

Studio Bruckmann

Studio Bruckmann was founded one year ago to serve as a communication center and gallery for the publishing and printing company Bruckmann München; within a few months, it has become a well-known institution in Munich.

Exhibitions, book presentations and lectures in Studio Bruckmann are attractive contributions to the cultural life of Munich, and give the public an impression of the manifold activities of the publishing and printing house Bruckmann München. Renowned artists and authors are presenting their new works in Studio Bruckmann:

Oskar Kokoschka
Max Bill
HAP Grieshaber
Rudolf Hagelstange
Friedensreich Hundertwasser
Victor Vasarely

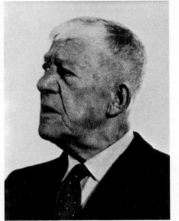

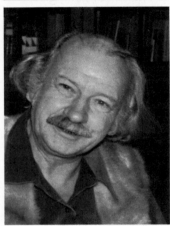

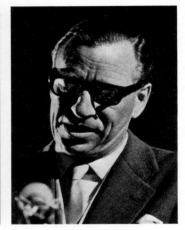

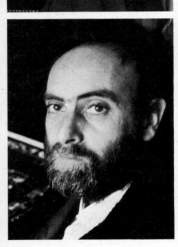

Edition Olympia 1972
Art Posters

From July 18 till September 15, Edition Olympia 1972 — a subsidiary of Bruckmann München and the Olympic Organizing Committee — will present all official Olympic Art Posters in a comprehensive exhibition. These graphic works by more than 30 internationally renowned artists are an important part of the art program for the Munich Olympic Games.

Studio Bruckmann
8 München 19
Nymphenburger Str. 84
Telefon: 12 57 / 3 49
open Monday through Friday

From an iron and steel works in Dortmund, a century of progress has seen Hoesch develop into a steel combine with steel mills, extensive processing and manufacturing plants, a vast production programme and a world-wide sales organisation. We are now effecting structural changes and expanding our activities to keep pace with industrial and economic progress. Together with Hoogovens of the Netherlands, we have set up the ESTEL NV Hoesch-Hoogovens with the object of continuing progress in the future. The new enterprise with 75,000 employees, a yearly crude steel output of 11 million tons and external turnover of DM 7,000,000,000 is the third biggest steel producer in Europe and the seventh biggest in the world.

HOESCH
THE
NAME
FOR
STEEL

Sport in der Kunst
Sport in Art
Le Sport dans l'Art
Спорт в искчсстве
El Deporte en el Arte
Lo Sport nell'Arte

Hundertwasser Regentag
Rainy Day
Jour de pluie

Open-air exhibition on the occasion of the Games of the XXth Olympiad, Munich 1972, 2nd August to 20th September.
Site of the exhibition: pedestrian zone–Weinstraße, behind the Munich Town Hall.

The catalogue of the exhibition "Sport in Art" describes the sporting activities displayed and offers an informative survey of threethousand years of European art. For all those interested in art and sport this publication will retain its documentary value long after the Olympic year of 1972.

Catalogue
in six languages: German/English/French/Russian/Spanish/Italian
144 pages, 24 colour plates, 24 black and white plates and 8 colour postcard inserts by Edition Olympia.
Size: 26×32 cm
Paper-board cover
DM 29,–

"Rainy Day"–this is the name of the ship that Friedensreich Hundertwasser converted for himself from an old cargo cutter into a seaworthy sailing vessel, and which has become his home, his studio, and his sanctuary–and what is a great deal more: a manifestation of his own personality.

Manfred Bockelmann, himself a painter and photographer, accompanied the artist on his ship's maiden voyage, and has used the photographs taken on this trip, Hundertwasser's own pictures and aerial photographs to create a most original and expressive documentation of Hundertwasser's art–a book that tells us more about the painter than any monograph.

Text by Friedensreich Hundertwasser in German, English and French. Idea, photography and design by Manfred Bockelmann.
88 pages, 77 illustrations, 36 in colour
Size 23×24 cm
DM 35,–
Handsigned special edition already sold out

Available
in all bookshops

Bruckmann München